GEORGIA O'KEEFFE

Georgia O'Keeffe

A LIFE

ROXANA ROBINSON

1817

An Edward Burlingame Book

HARPER & ROW, PUBLISHERS, New York
Grand Rapids, Philadelphia, St. Louis, San Francisco
London, Singapore, Sydney, Tokyo, Toronto

FIRST EDITION

Designed by Karen Savary
Picture sections researched, edited, and designed by Vincent Virga

Library of Congress Cataloging-in-Publication Data
Robinson, Roxana.
 Georgia O'Keeffe : a life / Roxana Robinson.
 p. cm.
 "An Edward Burlingame book."
 Bibliography: p.
 Includes index.
 ISBN 0–06–015965–0
 1. O'Keeffe, Georgia, 1887–1986. 2. Artists—United States—
Biography. I. Title.
N6537.039R64 1989
759.13—dc20
[B] 89–45061

89 90 91 92 93 DT/RRD 10 9 8 7 6 5 4 3 2 1

This book about a daughter
is for
my own beloved and most wonderful daughter,
Roxana Scoville Alger

CONTENTS

ACKNOWLEDGMENTS

MANY OF THE PEOPLE whom I interviewed gave their time and energy to a stranger, often welcoming me into their houses, offering me hospitality as well as attention. People I wrote and phoned were helpful and cooperative, often beyond my expectations.

For their generous assistance and their contributions of time, attention, and material, I would like to thank the following people and institutions: Ansel Adams Publishing Rights Trust; Perry Miller Adato, Channel 13; archivist, *Amarillo News-Globe* library; staff, Archives of American Art, New York; Art Institute of Chicago; Joan Baker, Santa Fe; Lorraine Baratti, library of Whitney Museum of American Art, New York; Peter Bunnell, Princeton University; Dan Budnik, Tucson; Roger Burlingame; John Cassel, Albuquerque; Maria Chabot, Albuquerque; Joe Chase, Sun Prairie Historical Society; Myrtle Cushing, Sauk City Historical Society; Donald Deskey; Terry Dintenfass; Cleta Downey; Richard Eldridge; Estate of Georgia O'Keeffe; Tish Frank, Santa Fe; Mrs. Melinda Fryerson, Albemarle County Historical Society, Charlottesville.

Connell B. Gallagher, Bailey-Howe Memorial Library, University of Vermont; Donald Gallup of the Stieglitz Archive, Beinecke Rare Book and Manuscript Library, Yale University; Rufus Gaut, Amarillo Historical Society; Eugenie Gavenchak; Sarah Greenough, National Gallery of Art, Washington; Diana Haskell, Newberry Library, Chicago; Barbara Haskell, Whitney Museum of American Art, New York; Rose Hass, Tenth Avenue Editions; Diana Schubart Heller; Allan Hines; Frances Hallam Hurt, Chatham; David Johnston, *Philadelphia Inquirer*; Robert Kadlec; Jonathan Kelly; Jean A. Kenamore, Art Institute of Chicago; Mar-

garet Kiskadden; the Klein family, Sun Prairie; Al Koschka, Amarillo Art Center; Sue Davidson Lowe; David McIntosh, Santa Fe; Wendy Maclaurin; Alan Macmahon; Louise March; Father Vidal Martinez, San Juan Pueblo; Herbert Miltzlaff, Clearwater, Florida; Anthony Montoya, Paul Strand Archives; Sarah Moody, Santa Fe; Beaumont Newhall; Jerrie Newsom; Dr. Michael Novacek, Department of Paleontology, American Museum of Natural History, New York; Alice Overbey, Chatham Historical Society; Morning Pastorok; Sarah Whitaker Peters; staff, Plains-Canyon Historical Society.

Dr. William Pollitzer; Aline and Eliot Porter; Mary Torr Rehm; Virginia Robertson; Amy Rule and staff, Photographic Archives, Center for Creative Photography, University of Arizona, Tucson; Keith Sandburg; Susan Loeb Sandburg; Cristina Sebring; Sandy Seth, Taos; John W. Smith; William Stapp, National Portrait Gallery; Mrs. Richard Stegall, Kappa Delta Society; Frances Steloff, Gotham Book Mart, New York; Diana Stoll, *Artforum*; Flora Stieglitz Straus; Geraldine Strey, State Historical Society, Madison, Wisconsin; Brother Carl Tiedt, Sun Prairie; Calvin Tomkins, *The New Yorker*; Louise Trigg, Santa Fe; David Turner, Museum of Fine Arts, Museum of New Mexico; Candace Wait, Yaddo, Saratoga; Patricia Willis and staff, Beinecke Rare Book and Manuscript Library, Yale Unversity; Vincent Virga; Leah Beth Ward, *Albuquerque Journal*.

I would also like to give heartfelt thanks to the people who gave me time and support in this project and wish to remain anonymous. Quotations from these undisclosed sources appear primarily at the end of the book and are not cited in the Notes.

Special thanks go to James Meyer, my research assistant, who was responsible for much of the meticulous assemblage of information; to Barbara Wynne, whose secretarial and organizational skills made this project possible; to my editor and friend, Edward Burlingame, who started me on this perilous and gratifying path; and, most important, to my husband, Hamilton, and my daughter, Roxana, whose support has been constant, crucial, and inexpressibly appreciated.

Last, I cannot thank sufficiently the members of the O'Keeffe family—June O'Keeffe Sebring, Catherine O'Keeffe Klenert, Catherine Klenert Krueger, and Ray Krueger—for their generosity and trust, and for permitting me such an intimate vision of this admirable American family.

PART I
1887 ~ 1902

SUN PRAIRIE:
THE WIDE
AND
GENEROUS LAND

1

*I remembered the beautiful fields of grain and wheat out there
—like snow—only yellow . . . in spring . . . They were
plowing and there were patterns of plowed ground and
patches where things were growing.*

—GEORGIA O'KEEFFE

THE O'KEEFFE PROPERTY in Sun Prairie, Wisconsin, is prime farmland: rounded swells of mahogany earth sloping against an enormous sky. In April the fields are newly plowed, and the furrows sweep together toward the skyline. Red-winged blackbirds nest in the high grasses along the narrow road, and the windy spring sky is full of their liquid song.

The landscape is spare and inescapably abstract. Uncluttered by trees or underbrush, the sweep of the earth is idealized, non-specific. For six months of the year the land is bare, its vast curves revealed. Even at the height of the summer, when the crop lies smoothly across the long rising slants, the shapes of the calm earth are always exposed.

There is no middle ground. There is nowhere for the eye to rest before the charged presence of the horizon, the long incantatory cusp between earth and sky. This is what breaks the hypnotic line of the earth, not another plane but another dimension: space.

• • •

SUN PRAIRIE was first discovered and named in June 1837, by the Bird party, a wagon train headed for the new territorial capital, Madison. Struggling through rainy weather and muddy forest trails, the wagons stopped when the sun came out to reveal an expanse of bright plains. One of the travelers, possibly Charles Bird himself, carved the words on a tree to record the event: Sun Prairie. The wagons continued on, however, and it was not until 1839 that Charles Bird left Madison and returned to become the first white settler of Sun Prairie. There were only twenty-nine settlers living in the whole of what is now Dane County.

A scant two years after Bird's arrival, the tiny community erected a log cabin to serve as school and social and religious center. The first election was held there in 1842. Sun Prairie was officially founded in 1846, and in that year the post office was established. By 1847, there were Congregationalist, Methodist, and Baptist churches in the village.

The establishment of social, religious, and political institutions was an important part of the pioneering process. The settlers on the northern plains were homesteading families, not wandering adventurers like trappers or herders. The farmers depended upon their ability to transform their environment. The vastness of the prairie was threatening and disorienting to them, and as soon as they arrived, the settlers began staking physical and psychological claims in the dangerous open space that surrounded them, and initiating the slow process of transformation: nature into society. The indigenous population was composed of Winnebago Indians, whose attitude toward the land was communal and spiritual. Threatened by this "irrational" approach, the settlers congratulated themselves on its banishment. They established a rational, objective system: the plains were surveyed into neat, geometrical parcels, and each parcel had a particular and individual owner.

Though the soil was potentially generous, the first year of working it, coaxing it toward fertility, was hard. The prairie sod, dense and heavy with the roots of a thousand years of wild grasses, had to be broken like damp stone, with plow and oxen. On the open grasslands, trees for lumber were scarce; many early homesteads were built of sod and set half underground. In the woodlands, log cabins, dark and cramped, were laboriously constructed. The first year's subsistence crop was a truck patch: a small piece of land, painstakingly plowed and sowed with corn,

potatoes, turnips, and other vegetables. With a few commercial supplies—flour, bacon, coffee—a rifle for the wild game, and some luck, a family could eke out a parlous living through the long first winter. Each year a piece of new ground was broken and the harvest was larger, until enough food was grown for the family to begin trading with the world. Margins widened, and the threats of failure and starvation receded.

If men bore the brunt of the physical labor, struggling with the heavy chores and wrestling with the resistant soil, it was the women who paid the emotional price of the move to the frontier. Studies of the diaries and reminiscences of the pioneer women who went west show that "not one wife initiated the idea; it was always the husband,"[1] and "When women wrote of the decision to leave their homes, it was always with anguish, a note conspicuously absent from the diaries of men."[2]

Reluctant and grieving, the women found themselves adrift in an alien landscape, without the comfort of support from friends, family, or neighbors, often without even a language in common with the nearest inhabitants. They were faced with a harsh climate, severe physical duress, and constant uncertainty regarding survival. The vastness of the landscape was itself deeply threatening to the pioneer woman. Willa Cather, whose family moved out to Nebraska in 1883, wrote about arrival on the Great Plains:

> There seemed to be nothing to see; no fences, no creeks or trees, no hills or fields. If there was a road, I could not make it out in the faint starlight. There was nothing but land: not a country at all, but the material out of which countries are made. No, there was nothing but land—slightly undulating . . . I had the feeling that the world was left behind, that we had got over the edge of it, and were outside man's jurisdiction.[3]

As Nancy Chodorow has imaginatively argued, "the basic feminine sense of the world is connected to the world, the basic masculine sense is separate."[4] A landscape without limits presents different aspects to the different genders. The men saw themselves as clearly distinct from the shapeless plains. They perceived the land as something they could transform, dominate, and control. But for women, such vastness contains the threat of the erasure of self, the annihilation of personality, a terrifying

dissolution in the great waves of land. For both men and women it was deeply and terrifyingly exigent.

• • •

PIERCE O'KEEFFE and his wife, Catherine Mary Shortall, arrived in Sun Prairie in the summer of 1848. Unlike many Irish immigrants of the period, O'Keeffe was a man of property. He left the family wool business in County Cork when it began to founder under heavy taxation. Bringing with them the small, portable elements of their lives in Ireland—emblematic fragments: family silver and a china tea service— Pierce and Catherine traveled by ship from Liverpool to New York, where they disembarked on April 22. From New York they continued their journey by water through the Great Lakes to Milwaukee; from there they went by oxcart to Sun Prairie. In July, Pierce bought land from the government along the Koshkonong Creek, at about a dollar an acre. It was excellent farmland, smooth, rolling, and fertile.

Pierce and Catherine had four sons, who would help them work the land— Boniface, Peter, Francis Calyxtus, and Bernard —and they prospered. Pierce built the first frame house in the community, and in this setting Catherine installed the silver and the family tea service. After their early struggles, order, comfort, and a certain modest elegance were achieved.

George Victor Totto arrived in Sun Prairie in the mid-1850s, nearly a decade after the O'Keeffes. Totto was a Hungarian count, born in Old Buda in 1820. Exiled after his participation in the 1848 revolution of Hungary against Austria, he came to America in that same year.[5] Though he may have been one of Kossuth's aides, Totto was not, as has been suggested, one of the four thousand refugees from Austrian rule who arrived in New York with the exiled governor of Hungary, Louis (Lajos) Kossuth. Kossuth was brought over in 1851 by the sympathetic U.S. government for a state visit. Totto was living in New York at the time, however, and he would certainly have benefited from the enthusiastic American response to the brave Hungarian attempt at self-rule. Two hundred thousand people had turned out to welcome Kossuth and his compatriots in New York. Many of his supporters remained in America when Kossuth left, George Victor Totto among them. Totto was committed to his adoptive country, where he would become a citizen. He decided boldly to move to a small frontier community in Wisconsin, named briefly

Haraszthy, though later incorporated as Sauk City.[6] By October of 1852, he was listed there as a member of the Freethinker Congregation. Before leaving for Wisconsin, however, Totto stayed at a hotel in New York City, where he met Charles Wyckoff and his two daughters.

The Wyckoff family, of Dutch origin, was well established in the New World: one ancestor, Edward Fuller, had made an impeccably early arrival on the *Mayflower*.[7] The family had intermarried with other important Dutch families, though by the mid-nineteenth century the Wyckoffs were far from grand.

Charles Wyckoff was one of fourteen children. He grew up in Somerville, New Jersey, where his father, Abraham, kept an inn. In February 1827, Charles married Alletta May Field, of Bound Brook. They had two daughters, Isabella Dunham,[8] named after Charles's mother, and Jane Eliza (called Jennie). Like his father, Charles was an innkeeper, but he was a restless one, who moved constantly between New Jersey, Pennsylvania, and New York.[9] In 1853, Wyckoff and two brothers started the Wyckoff Hotel, on Warren Street in New York, but even this family venture did not settle Charles down. Alletta had died, and the following year, with his new wife, Elizabeth (a widow from New Jersey), and his two grown daughters, Charles abandoned the family enterprise to his brothers and set out on his last and most perilous venture: managing a hotel in the small, primitive town of Sauk City, Wisconsin.

It is likely that the adventurous Hungarian count Totto played a part in the Wyckoffs' decision to move to Sauk City. Of the Wyckoffs, it may have been the older daughter, Isabella, who was the prime mover. Certainly an attraction was to develop between the exotic European and the young woman from New York, and it may well have begun on Warren Street.

In any case, Isabella was strong-willed. Her tiny diary (a succinct listing of important events in her life) begins with the stark announcement: "I Came West. April 1854." The first word is larger than the rest and embellished with flourishes. The bold use of the first person singular suggests autonomy and independence; the omission of family members suggests a journey made, metaphorically, in solitude.

Charles Wyckoff may have opened his inn in the raw, energetic frontier town; shortly after the family's arrival, however, an epidemic of cholera broke out. Before he could move his family

to safety, Wyckoff contracted the disease himself. There was no cure for cholera in 1854, and in her diary Isabella recorded: "The 10th of August. Pa died."

Isabella was twenty-five, and her sister, Jennie, was eighteen. Left with limited means in the rumbustious prairie community, without friends, their only kin a twice-widowed stepmother, the two girls chose matrimony as careers: they had few other options. Significantly, however, neither chose to return to the relative comfort and decorum of the East.

Jennie was married at once, to a Mr. Ezra L. Varney. She may have already been married when her father died: the cemetery records show the owners of the burial plot to be Isabella and Elizabeth Wyckoff and Jane Varney. Isabella waited until the following spring, when she noted: "May 21, 1855. Married George Victor Totto." Jennie and Ezra Varney were witnesses to the ceremony but did not stay in Sauk City. They set out on the perilous overland wagon route for gold rush California.

Since Sauk City was originally named for an adventurous Hungarian traveler, Totto may have assumed it would be full of his compatriots. In fact its ethnic makeup was almost entirely German. The local paper was written in German and remained so until well into the twentieth century. Discovering that he was part of a tiny minority in a German community, Totto moved to a more heterogeneous settlement. He went first to a log cabin in Waunakee, on the north side of Lake Mendota, and next to Westport, in 1864. By 1872, George Totto and his family had moved to the town of Sun Prairie. There Totto bought land in the southeastern sector, very near that of Pierce O'Keeffe.

In preindustrial Europe, aristocratic property was agricultural, and the Totto holdings in Hungary would have been farmland. Hungary was still semifeudal at midcentury, however: while George Totto may have supervised agricultural operations, it is very unlikely that he had ever set his noble hand to a plow. It is still more unlikely that in Europe, where the land has been tilled for centuries, he had ever encountered the need to break sod behind a team of oxen. And certainly Isabella, his wife, born and reared in an eastern environment and most recently from that most sophisticated and urban of all American settings, New York, would have known little of running a pioneering farmer's household.

Their venture—claiming the land, transforming the environ-

ment from hostile to benevolent—was to make extraordinary and unaccustomed demands on them both.

• • •

GEORGE AND ISABELLA Totto had six children. "Allie"— Alletta, later Ollie—"born March 6, 1856," wrote Isabella. Josephine followed in 1858. On a farm, girls were useful, but boys were a necessity. It was not until 1859 that the Tottos produced a son, Charles. Five years later, on January 13, 1864, Ida Ten Eyck was born in Westport. Another daughter, Lenore (Lola) followed, and at last another son, George.

The naming of the children follows the maternal line. The first daughter, Alletta, was named for Isabella's mother; the first son, Charles, for her father. It was not until the sixth and last child was born that George Totto was given a namesake. It is women who are keepers of a culture. Mothers, aunts, and grand-mothers tell the family stories, they recount the family traditions of manner, language, and behavior, weaving into the lives of their children strands from the lives of their parents. The Dutch strain of the Wyckoff line would be perpetuated through name and tradition: two generations later, the family members still talked proudly about Wyckoff family history. Ida inherited the portraits of Abraham and Isabella, her grandparents—physical proof of their faces, features, and world. The Totto heritage— language, customs, and ancestors—would be lost. The only relic from the palmy days of Hungarian nobility would be a pair of gold and emerald earrings, still in family hands. Tiny, intricate, mysterious, they were like golden hieroglyphics, symbols of a life both foreign and splendid, the speech, style, and premise of which were all utterly alien to the life on the Great Plains.

George Totto and his family worked hard and prospered. A town survey of 1873 shows Totto's land, adjacent to the O'Keeffe property, to be identical in size and quality; each family had two hundred acres of good arable land. The New World was living up to expectations: the exiled Hungarian count and the failed Irish businessman were successful; they were neighbors and equals.

The Totto household had expanded. Isabella's sister, Jennie, had moved in to live with them. After a harrowing trip west by wagon train, the adventurous Mr. Varney had died in California of tuberculosis, leaving Jennie abandoned once more in a strange

western landscape. Unwilling to retrace the overland trip alone, Jennie set out on a hazardous journey by sailing ship around the tip of South America, a voyage that ended at last in the safe haven of her sister Isabella's household.

In 1876, George Totto's sentence of exile was long over: a general amnesty had been declared in 1867. He was well established in America, with two hundred generous acres of land, a strong and capable wife, six healthy children, and a sister-in-law to help look after them. Now in his mid-fifties, Totto was still hale and active. There would be no better time to return to Hungary, to visit relatives and see the property.

"January 20, 1876. Georgi went to Europe," Isabella wrote. The older Totto son, Charly (*sic*), was only seventeen, and the younger, George, was under ten. If the family were to remain on the farm, Isabella would have to hire men to work it. She chose instead to move the family— Jennie and the six children—to Madison, in February of that year. The move was a temporary one, pending George's return, and the farm lands were rented out. The neighboring O'Keeffes, with their four strong sons, were an obvious choice as tenants.

The stay in Madison was lengthier than planned. George Totto's eyesight began to deteriorate. Left only with peripheral vision, and that fading, Totto felt less and less capable of making the lengthy and difficult trip back to America. Simple communication with Isabella became increasingly laborious: he was unable to write his own letters or to read hers. Finding a translator in Budapest was problematical. French, the language of diplomacy, was the accepted means of communication throughout nineteenth-century Europe, not English.

Upon his arrest, George Totto had forfeited the family property in exchange for a lightened sentence—exile instead of prison. Certainly not all the holdings were given up, but by the time of his return, thirty years later, the Totto property, whether confiscated by the crown or appropriated by another family member, was no longer in George Totto's hands. When he died of heart failure, in December 1895, it was not in the liveried splendor of a Totto castle in the hills but at the city residence of his nephew Emmanuel Tottis, a linen dealer in Budapest.[10] Whether Totto's abandonment of his family was due to despair at his circumstances or a matter of deliberate choice is impossible now to dis-

cover, but it created a lingering sense of betrayal within the family.

Francis Calyxtus,[11] the third of the four O'Keeffe brothers, was born in 1853. Frank was still in school when his father died of tuberculosis, but the land is ineluctable. Frank left school several years early, taking his place in the barns and the fields with his older brothers, Boniface and Peter.

When the youngest son, Bernard, was old enough to work the land, a fourth body was not so necessary, and Frank had grown restless. Third in line, he was an unlikely heir to the property; there was little to keep him at home. Struck by wanderlust, he set out across country, into the wilderness of the Dakotas. Distraught, his mother, Catherine, wrote to him, promising him whatever he would like if he would only return. Frank wrote back at once: what he would like was the neighboring Totto farm. Have it you shall, his mother replied, and back he came.

For seven years Frank O'Keeffe farmed the Totto fields. The connection between the farmer and the fields he plows is a deep and instinctive one, canonized by American law: a squatter who works land long enough will own it. Frank's strength had gone into the Totto fields, and the land was known to him, the supple contours, the smooth hollows, the rich black earth.

In October 1883, Frank O'Keeffe's older brother Peter succumbed, as had his father, to tuberculosis. Frank was thirty years old and now was next in line to Boniface as head of the family. Traditionally, Irish men married late, not taking wives until they were established as householders. It was not surprising that Frank waited so long before he began to drive his horse the twelve long country miles to Madison to call on Ida Totto.

Ida Ten Eyck Totto was twenty years old in January 1884. She had inherited the patrician characteristics of Count Totto: a lengthy, elegant nose, dark and hooded eyes, a honey-colored cast to her skin, and regal posture. Long-faced and straight-backed, she was not a conventional beauty but a woman of distinction. She had deep-set, luminous, intelligent eyes, a wide, sensitive mouth, and a crystalline sense of herself.

After the move to Madison, Isabella's children lived in a household governed entirely by women. Though the absent father, George, was a significant psychological presence, it was Isabella who established herself as authority in the masculine

bastion of the family finances. The children had seen her effectiveness in the traditionally female role of housekeeper, coping with all the laborious daily chores of nineteenth-century domestic life. They now saw her negotiating rents and paying bills: it was Isabella who decided finally when to sell the family fields, and to whom. The image of female independence presented by Isabella was in fact so powerful that only one of her four daughters married. Moreover, she had chosen to bring up her children in Madison, a university town, rather than in the country: only one of them returned to the land.

Though barely twenty, Ida had a strong sense of a woman's capabilities and a confidence in her own strength. In her diary she offered a clear picture of a warm, supportive relationship with her sisters and a rational, intelligent sense of herself. When Frank O'Keeffe presented her with his suit, she pondered the matter with great deliberation, rationally weighing the advantages and disadvantages. Her attitude was a far cry from the prevailing sensibility, which encouraged a young woman to view marriage as the only possible happy ending to her life. Isabella's legacy to her daughters was a rare and important one: she had taught them to value themselves as individuals and women, not merely as wives.

Frank O'Keeffe was eleven years Ida's senior, with strikingly Celtic looks. He had "black Irish" coloring: pale skin, blue eyes, and dark hair. His were the distinctive peaked eyebrows inherited by his daughters. He had a round, strong, handsome face, vital and enthusiastic. Industrious and energetic, he had been brought up in a tradition of hard and continual labor. He had grown into himself: from a restless and uncommitted young man, he had become a responsible member of his family and of the community. Socially unpretentious, academically impoverished, he was an aristocrat of the New World, one of the adventurous breed of settlers who had claimed the wilderness and, through diligence and faith, transformed it into a generous and productive partner.

Frank O'Keeffe and Ida Totto had grown up as neighbors in a landscape where neighbors were important. Their families had, for a quarter of a century, shared bad weather and good harvests, disasters and celebrations. They were both connected to the land on which they would live. Both were accustomed to working hard, both knew of the excellence and exigence of the life they

were undertaking. They knew what each would be expected to contribute and what they could expect the other to contribute: commitment, endurance, devotion to the task, and an absolute, unwavering belief in its importance.

2

Wedded—At the residence of the bride's mother, in the city
of Madison on Tuesday, February 19, 1884, by the Rev. J. B.
Pratt, Mr. Francis O'Keeffe, of Sun Prairie, to Miss Ida
Totto, of Madison. The contracting parties in the nuptial
affair above chronicled are well and favorably known
hereabouts, and the best wishes of the community are
extended to Frank and his charming bride.
　　　　　　　　　—*Sun Prairie Countryman,* February 28, 1884

B Y 1884, the desperation of the early days in Sun Prairie was over. The heavy sod had proved responsive and bountiful, and the farms had begun to flourish. The railroad had come through in the late 1850s; two hotels were built, and the bank opened. The advances were not only material but cultural, as is suggested in the genteel niceness of the literary style—"The contracting parties in the nuptial affair above chronicled." In 1864 a house on Main Street was remodeled in the latest Stick Gothic style, in 1876 the Sun Prairie Cornet Band gave its first free concert, and in 1882 the Free High School District began offering a three-year course of study.

During the last half of the nineteenth century, Sun Prairie, like many midwestern farm communities, embodied and celebrated the Protestant ethic. Here the inherent virtue of diligent labor was amply rewarded by the fruits of the land. The earth

was generous and the work itself spiritually sustaining: the life was hard, simple, and rewarding.[1]

People were proud to work the land; the cities were not yet draining the work force from the countryside. The early pioneering spirit of mutual support still remained, reflected by the kindly extension of "the best wishes of the community . . . to Frank and his charming bride."

• • •

WHEN FRANK and Ida O'Keeffe were married, the bride's mother took charge of the occasion, as was the custom. Though George Totto was not there to give his daughter away, Ida's brother Charles and one of her sisters signed and witnessed the marriage certificate. In spite of Isabella's awkward marital status, the wedding was an assertion of Totto strength and solidarity, as might be expected of an occasion put on by a strong woman possessed of valuable property, healthy children, and a mind of her own.

The ceremony was Episcopalian: religion, like family tradition, most frequently passes through the female line. George Totto was a Lutheran, Francis O'Keeffe a Catholic; both men deferred to the religious persuasions of their wives.

The newly married couple moved into the Totto homestead, which Frank still rented from his mother-in-law. Ida had spent the preceding eight years in a more urban environment, but the running of a farm household was not completely foreign to her. She had lived on a farm for her first twelve years, and, too, household chores in Madison were not so very different from those in Sun Prairie. Washing laundry, sewing clothes, cooking meals: almost everything was done by hand. Even if the hand belonged to a hired girl, the mistress of a modest household knew very well, herself, how to perform each task.

There was another, subtler, change that occurred for Ida. In the university town she had nourished the hope of becoming a doctor: a most unlikely career for a woman. That she entertained this idea, and was encouraged in it, reflected Isabella's attitude toward education, personal competence, and the life of the mind. The dwindling chances of her father's return, however, had made Ida's prospects of advanced study less and less likely. When she married Frank she effectively relinquished all thoughts of a medical career. She knew quite well that a farmer's wife devoted her energies and her life to her children and household, but her com-

mitment to the principle of education was deeply rooted and did not suffer in the move.

Frank and Ida had their first child, Francis Calyxtus, in 1885. Georgia Totto was born next, on November 15, 1887. Five more children followed: Ida Ten Eyck in 1889, Anita Natalie in 1891, Alexis Wyckoff in 1892, Catherine Blanche in 1895, and Claudia Ruth in 1899. Seven was not an unusual number of children. Infant mortality rates were high, and, on a farm, children were an important source of labor. They were, as well, a source of biological pride, tangible proof of a successful marriage: a fruitful union.

When Ida started having children, Jane Wyckoff Varney moved into the O'Keeffe household to help her niece. This was not uncommon; often a single woman, widow or spinster, of limited means would join a larger nuclear family, where she would help in the running of the household and share in the family fortunes. The presence of this alternate "mother" gave the real mother some respite from uninterrupted child care; it also gave the children a second role model, an alternate pattern of behavior to consider.

Jane Varney was called Jennie by the adults and "Auntie" by the children.[2] Auntie devoted her energies to the O'Keeffe children, sewing and mending their clothes, attending to their daily needs, and admonishing them for minor misdeeds. Some of the older children found Auntie's ministrations constraining: Georgia remembered Auntie as "the headache of my life," someone who presented her with an unending list of tiresome adjustments that a child should make to the adult world. "I can see her now, standing there with her hands clasped, inspecting her charges."[3]

For the younger children, however, Auntie was a haven of warmth and affection, often taking the children's part against their mother. "Ida, leave those children alone," she would insist, to the children's great delight. "She was our lover," Catherine said simply.

Auntie, who shared a bedroom with Catherine and Claudia, was a beloved member of the household. Emotionally accessible, softhearted, and vulnerable, Auntie was never asked by the children about her hapless marriage or about the terrible trips to and from California. "It made her very sorry," said Catherine; "she shed tears."

Ida's style was very different. "Ma," or "Mama," as she was

called, was energetic, stern, and self-disciplined. Ida's love was expressed in level-eyed approval rather than cuddling. Pity and praise were seldom dispensed, and indulgence never. High-principled and straight-backed, she held herself and her children to strict standards. She was a strong and reliable supporter of her children's efforts, but excellence was expected. If Auntie offered a warm, voluptuous bath of maternal affection, Ida's response was a cold, narrow ribbon of water: challenging, delicious, and never quite enough. "She loved us all," said Catherine firmly, and clearly this was true. But all the children were aware of a gap that could never quite be closed between themselves and their mother. Catherine, when asked which parent she was closer to, admitted she felt closer to Auntie than to either. Georgia told a friend later, "As a child, I think I craved a certain affection that my mother did not give."[4]

Ida's emotional frugality was, in part, a reflection of a rigorous life. Although in the closing decades of the nineteenth century life on the land was no longer desperate, neither was it easy. If there was one quality necessary for survival on the untried land, it was self-reliance, both physical and emotional. Since no external support or assurance was certain, any form of dependence was ultimately a risk. Ida's mother, Isabella, orphaned and abandoned, had learned this painfully: there was no protection against disaster.

This ethic of austerity set the tenor of family life. Physical demonstrations of affection were rare; when family members met, they tended to shake hands, not hug. In spite of Frank and Ida's deep commitment to each other, Catherine never saw them with their arms around each other. Their affection was expressed more subtly, austerely, and internally. "They were friendly," said Catherine, "very friendly."

The code of spareness extended to tangible things. Material comforts were few. Clothes and shoes were handed down from one child to the next. "The youngest ones got the oldest shoes," said Catherine.[5] The girls owned two dresses each; the second was a necessity: "Had to have one to get washed." Birthday celebrations were modest: a single present would appear at the child's place at the dinner table. At Christmas, the tree had two sorts of ornaments: homemade popcorn strings and lighted candles (full buckets of water stood nearby). Presents were, for the most part, handmade, not bought. "We had no money for that,"

Catherine said briskly. The children were not brought up with a sense of deprivation, however: material goals were not the point of this existence.

· · ·

GEORGIA OCCUPIED a fortunate position in the family. As the second child, she escaped the relentless parental scrutiny and the burden of expectation under which an oldest child often labors. As the oldest girl of five, Georgia achieved without effort a position of natural and boundless authority. Explaining why Georgia had a bedroom to herself while Ida and Anita shared one room and Claudia, Catherine, and Auntie squeezed into another, Catherine said simply. "She was It. She had everything about her way, and if she didn't she'd raise the devil."

Her power was innate. "Georgia run [*sic*] the girls," said Catherine. Glowing with authority, Georgia was a benevolent despot. Her subjects were smaller, weaker, and meeker, but beloved. It did not occur to them to resent her rule: "We were grown up with it," Catherine explained. "Paid no attention to it at all. We all expected that she was the queen that was crowned and we all loved her. She was always very nice to us all. She was a good older sister."

The other girls saw Georgia as a parental favorite as well as their queen. "Certain ones would get praise," Catherine said judicially. "Of course Georgia was always at the very top." But among all the children the boys ranked supreme. "The boys were the favorites. They came first with everything," said Catherine.

Georgia saw all this differently: in her view, the boys were sole favorites. "I was not a favorite child," she declared, "but I didn't mind at all."[6] From a child's solipsistic viewpoint, a limitless amount of parental attention is normal. For Georgia it seemed only natural that she be given more freedom, responsibility, and praise than the other, younger, girls; her parents' bias toward the boys seemed an aberration. Just as it seemed natural and inevitable that she be the tallest of her sisters, so she expected special treatment throughout her life and saw nothing special in her expectation. "I had a sense of power," she said later. "I always had it."[7]

· · ·

THE O'KEEFFE FARMHOUSE, like many nineteenth-century farm-houses, had been designed and built by the man who lived in it. Eastern farmers had a flair for this, and New York, New England, and Pennsylvania farmhouses share an inherent style and a ver-nacular grace. Domestic architecture in Wisconsin, however, often suffers by comparison. The farmhouses sit bolt upright, ungainly and cramped, too narrow, too high, and crowded by heavy, secretive hemlocks. The effort of Frank O'Keeffe did noth-ing to correct the situation. Early in his marriage, Frank built a house for his family on the O'Keeffe property. His intention had obviously been to create a house with some distinction, one with more dignity than that of a simple straight-angled box. The result, however, was awkward, with an uneven roofline, asymmetrical windows, and an unexpected, whimsical round tower.

It was the O'Keeffe barn that seemed right in the landscape. Capacious, serene, and beautifully proportioned, the big hay barn spread its solid red shape like a broody hen, awaiting the lumbering wagons with their sweet-smelling burden. "I can see the enormous loads of hay coming in, in the evening," Georgia remembered.[8] A hundred feet long, with seven interior bays, squared off by great massive beams, the barn settled calmly and absolutely into the gentle slope of the field.

Unsurprisingly, it was the barn, not the house, that became a symbol of this life for Georgia, one to which she returned as subject matter throughout her life. "The barn is a very healthy part of me," she wrote years later. "There should be more of it. It is something that I know . . . it is my childhood."[9]

Days on the farm were full. Frank O'Keeffe came downstairs just after the hired girl had lighted the fires. He ate breakfast in the kitchen, with the hired men who would work beside him throughout the day. The women and children came down next, and while they ate in the dining room, the cook and the hired girl filled the children's lunch pails for school. The O'Keeffe children attended the Number Five district schoolhouse, called the Town Hall School. Georgia started there just before her fifth birthday. The one-room building was on Totto property, and the children walked in a straggling herd across the road and down the narrow farm lanes. Behavior at school was exemplary: a disciplinary of-fender would be sent outdoors. "That was a disgrace," Catherine said firmly. "Everyone behaved."

After school there were chores. The boys joined their father and the hired men, tending the mild-eyed Jersey milk cows or working with the great sweet-breathed, slow-stepping draft horses. The girls were not allowed in the barns with the animals: "Lord knows we'd be kicked to pieces," Catherine said.[10] Although draft horses are known for their quiet dispositions, the principle was sound: children are small and skittish, animals large and unpredictable. Farm rules were not idle exercises of authority; they were based on safety and common sense.

The large vegetable garden was tended by the children. Though most of the girls grew up with a love of gardening, none of them was fond, in those days, of hoeing and weeding. They were given no choice by Frank. "There'd be no questions," said Catherine, "we'd just march along." If one of the children committed a serious crime—as, for example, Georgia's feeding the horses green oats and putting their lives at risk—punishment was severe: bed at four o'clock in the afternoon, bread and milk for dinner. Most excruciating, however, was the attendant disgrace.

Work was not the only outdoor activity: the children swung on the two big swings behind the house. "The boys would swing us up too high," said Catherine. "They'd do it to tease." They were allowed to play in the haylofts of the big barns. "We used to go up in the hay," said Catherine. "We played hide-and-seek, like country folks."[11]

Outdoor work was Frank's domain; indoor work was Ida's. The strict and simple delineation of territory made for a peaceable joint rule. "There were never any arguments between them," said Catherine. "He had his business and she had hers. He had the barn and she had the house." Ida supervised the domestic work. "We learned to sew as soon as we could hold a needle," said Catherine. "Each taught the other." The girls made their own clothes and learned to cook on the cook's day off.

Domestic help was not a luxury but a necessity. A large farm was an economic unit. The men required solid and nourishing meals to work the land, and with eight adults and seven children at every meal, a cook was essential. The hired girl helped with all domestic chores, and Ida and Auntie worked alongside the indoor help, just as Frank worked alongside the outdoor help. There were socially defined lines, however: the children were

friendly with the hired girl, but "not too friendly." The evening meal was taken by the family in the dining room; the hired help ate in the kitchen.

Dinner was a quiet meal—"Lord and we were quiet," said Catherine—and the children knew to clean their plates off. Afterward they all sat in the living room. Though this was where the best furniture was, it was not a formal parlor. "That's the room we lived in," said Catherine. "The piano was there, and mother would play the piano and sing." Ida was musically gifted and loved to play. She could play by ear anything she heard. There were games as well—dominoes or checkers—and often Ida read aloud to the children. "My mother was a great talker. She told wonderful stories," Georgia said. "She read to us on rainy days and weekends. My older brother had bad eyes, and she'd read to him, and I always listened, even after I could read myself. I think that reading was a good start to a lot of things."[12]

By the time Catherine came along, the reading had become a ritual: "She'd have us sit down in the middle of the floor and then she'd read the whole book to us," said Catherine. For her the experience was educational: "It was always history. We had to learn something if she was going to read to us." Georgia, who was older, remembered the books as adventure stories: they were both. *The Life of Hannibal, Stanley's Adventures in Africa,* the Leatherstocking Tales, *The Adventures of Kit Carson, The Last of the Mohicans,* and other swashbuckling stories were recounted to the circle of silent children on the living room floor.

The tales did, of course, transmit historical information, but there was a philosophical message as well. Both the real-life adventurers and the fictitious heroes were advocates for the romantic cult of the individual. Romantic literature places power in the hands of the individual, not society. The message conveyed by these triumphant heroes was that the individual has the power to act, to alter lives, to triumph over adversity, and to emerge victorious. The message was not lost on the listening children.

Besides reading to the children, Ida read to herself: "all the time," said Catherine. Her example demonstrated to the children the great pleasure and exhilaration to be derived from music, literature, ideas, imagination, and the life of the mind. Ida's commitment to education was absolute, and each child was sent to private school while this was economically possible. It was one of

the few things on which Frank and Ida disagreed: Frank wanted his sons to stay on the farm with him and knew that educating the boys lessened the chances of this. Nonetheless, Ida had her way, and the children went to the local private establishments— the boys to military school and the girls to convent school. "Education. Everyone had to have an education in this house," said Catherine.

Frank and Ida differed on religion as well. Frank was Catholic but lax about going to church. Ida was Episcopalian, but the Anglican church was in Madison and too far away for weekly attendance. The two maintained a continual, mild disagreement over their respective creeds. "She was down on the Catholic Church and he was down on the Episcopalian," said Catherine, "always making fun of the opposite church."

Frank's style differed generally from Ida's: "He was jolly, very jolly," said Catherine, "fun-loving." Georgia later described him: "He was like a chip on the water, taking the waves." He was ready for adventure and travel, and on the floor of the living room was the skin of a buffalo that he had shot in the Dakotas: Dad's travels in the wilderness were an important part of family legend. "I think that deep down I am like my father," Georgia said later. "When he wanted to see the country, he just got up and went."

In the fall of 1897, Georgia's grandmother O'Keeffe died of cancer. In the following year, a decade after Boniface's death from tuberculosis, Bernard, Frank's only surviving brother, began displaying the hectic flush and sinister cough that presaged that disease. As the illness advanced, Bernard moved in with the family; Ida nursed him during the final stages of the disease, and he died in the summer of 1898, in Frank's farmhouse. He willed his share of the property to Frank and Ida, for "one dollar, and love and affection bestowed." [13]

All Frank's brothers had died bachelors, and with Bernard's death the entire O'Keeffe property was joined to the Totto holdings, which Frank had bought from his mother-in-law. The farm now consisted of 640 acres—one thirty-sixth of a township, or an entire "section." The O'Keeffes had by now reached a level of considerable local standing. Through a combination of foresight, diligence, and chance, they had achieved social as well as economic eminence.

Frank was an intelligent manager, hard-working, flexible,

reasonable, and receptive to new ideas. It had been his plan to introduce the telephone to the outlying areas of Sun Prairie, and it was he who persuaded the other farmers to erect poles along the roadside stretches of their fields to carry the wires. The O'Keeffes had the first telephone in Sun Prairie: it hung in the dining room, full of mysterious portent. (It was seldom used: only in emergencies by adults, and never by children. "There wasn't any monkey business like that," said Catherine.) Another new invention Frank tried out was a complicated mechanical harvester he hired to bring in his corn. He was one of the adventurous farmers who had put in the new crop tobacco in the closing years of the century.

During these years, Georgia was growing up to be independent and free-spirited. "It may have come from not being the favorite child and not minding that—it left me very free. My older brother was the favorite child, and I can remember comparing myself to him and feeling I could do better." She gave her inclinations free rein: "All the time I was at home it was always, 'More of Georgia's crazy notions.' "[14] She recalled: "From the time I was small . . . I was always doing things other people don't do . . . I was always embarrassing my family, except for one brother."[15] The one brother who was not embarrassed by her antics was Alexis, who was a favorite of Georgia's.

A few years later, when her sisters wore different-colored sashes over their white dresses on Sundays, Georgia preferred no sash at all to being part of a continuum. And though it was the conscientious Auntie who took them all to church behind her horse, it was not Auntie who drove the buggy. "Georgia drove," remembers Catherine, "or someone like that." Someone energetic, authoritative, and full of conviction. It was no wonder that Georgia's concept of God was female.

Georgia was not a beautiful child. Her mouth was too wide and too strong, her brow too large. Though she had dimples (which she hated), there was nothing adorable about her. She did not prompt sentimental responses. Thoughtful, interested, observant, she established herself as a person rather than as a child. At the Town Hall School, Georgia was watchful and aloof: "I was satisfied to be all by myself."[16] A teacher remembered that she "did not mingle much with the other children . . . [and] would suddenly ask the most precise, unexpected questions." Georgia did not find the local school challenging. When one of her unex-

pected questions baffled the teacher, she would announce disdainfully that she would repeat the question to her aunt Lola, who taught school in Madison. "*She* knows everything," Georgia would say loftily.

Georgia put little value on this period of academia: "My memories of childhood are quite pleasant, although I hated school. I left the local school when I was twelve, and was sent to a convent school in Madison. It was the one year I ever really learned anything." [17]

Most of Georgia's familial role models were female. She knew neither of her grandfathers and only one of her father's three brothers: Bernard, who died when Georgia was eleven. Her two grandmothers were exemplars of order and discipline. Grandmother O'Keeffe, who was gentle and sweet-tempered, would not let the children indoors when they visited her. "Not in summer," Catherine said firmly; "we'd bring dirt in." Grandmother Totto was a tall and dignified woman with regal bearing and thick white hair. Her house was filled with fragile objects, which the children were forbidden to handle. "Georgia, you must not do that a-gain," she would say, with meticulous articulation. Though her grandmother was stern, she was not frightening. Her accent fascinated Georgia, who would disobey simply to hear the statement repeated.

Ida Totto O'Keeffe's sisters Ollie and Lola were strong and frequent presences in Georgia's life. They were models of vigor and independence. Lola used to visit the O'Keeffes in the summer. Her arrival would be reported in the social notes of the local newspaper, and in August 1897 the paper announced that Miss Lenore Totto had returned to Milwaukee (where she and Ollie now lived) after her stay with the O'Keeffes. "Accompanying her was Miss Georgia O'Keeffe." [18] Visiting the aunts was a great adventure and gave Georgia a new sort of life to consider.

Staying with the two women in the urban environment revealed an alternative to the domestic world her mother had chosen. Aunt Lola, Georgia believed, was a reliable source of all knowledge. Aunt Ollie, a fiercely independent woman, worked for a newspaper and was a source of great family pride.

The women who surrounded Georgia in her early years were strong ones. She was taught, through example, that women were powerful and effective presences, that, single or married, they

could live interesting lives. It was not only the women who delivered this message, but the life on the land. The life Georgia led was demanding, full of responsibility and commitment, and equally full of pleasure and gratification.

3

*The race of strong, hardy, cheerful girls . . . that could
wash, iron, brew, bake, harness a horse and drive him, no
less than . . . embroider, draw, paint and read innumerable
books—this race of women, pride of olden time, is daily
lessening.*

—CATHERINE BEECHER
The American Woman's Home, 1869

MISS BEECHER WAS writing of the changes in the
East, as industry transformed a society once based on agriculture.
She bemoaned the passing of the active, energetic, and capable
girls who had grown up on the farms of New England. The Great
Plains, however, were a generation behind in technological ad-
vance: the first factory did not appear in Sun Prairie until 1900.
Four years after Miss Beecher's plaint, the townspeople of Sun
Prairie were still struggling to deal with the problematical Win-
nebago Indians. The women of the town, although they were
proud of their cultural activities, were still a strong and capable
group: in 1897 the Ladies' Bucket Brigade was commended by the
Sun Prairie Countryman for its assistance in putting out a fire on
Main Street.

Indeed, Miss Beecher's nostalgic description might have
been written specifically about Ida O'Keeffe's daughters, who
grew up to believe that every sort of endeavor was easily within
reach. A consequential part of every nineteenth-century middle-
class girl's education was the acquisition of certain genteel skills.

26

Proficiency in art and music was deemed essential for a young woman with any cultural inclinations. Both of the O'Keeffe girls' grandmothers, Isabella Totto and Catherine Shortall O'Keeffe, had produced demure still lifes: simple studies of fruits and flowers. This did not suggest a strain of genius in the family; it was simply part of a sociological pattern. Women were expected to provide the decorations for life. Ida O'Keeffe belonged to a ladies' reading circle and believed firmly in the enrichment of life through the arts. She arranged for her daughters to begin instruction in both music and drawing. "I can't remember when I couldn't read music," Georgia said.[1] Though she decided early that she had little aptitude for singing, Georgia played both the violin and the piano with considerable skill. Music was a source of great pleasure and sustenance to her throughout her life, and her later decision to concentrate exclusively on art was a difficult one for her to make.

Drawing classes began at home in the winter of 1898–99, when Georgia was eleven. The teacher at the Town Hall School was boarding with the O'Keeffes, and she gave the three older girls lessons in the evenings. It was unlikely that Ida realized the talent her daughters possessed: of the five of them, four were quite remarkably gifted. Anita "was the one I thought had the real talent," Georgia said,[2] and both young Ida Ten Eyck and Catherine were to become accomplished painters, who exhibited their work in New York and elsewhere.

The importance of the visual world was apparent in Georgia's earliest memories. Her first was "of the brightness of the light—light all around."[3] She remembered sitting as an infant on a quilt, surrounded by big white pillows. The patchwork quilt had two patterns—small red stars on a white ground, and a red and white flower on a black ground. Her visual memory is astonishing, particularly since the episode probably took place when she was six or seven months old.[4] Not only were visual details recorded, they had emotional valences from the beginning. It was, for example, a matter of serious disappointment to her to discover that the hand-painted roses on her headboard were not visible to her as she lay in bed: she could see only the inferior pansies painted on the bureau. Her first successful attempt at reading occurred as a response to color: Georgia deciphered the boxing results in the pink sports section of the newspaper.

Her attempts into the creation of images began early, and

she remembered trying to draw the image of a man: first standing, then bending over, then lying on his back with his feet in the air. These earliest efforts were characterized by a sense of courageous exploration and by the intensity of her concentration: "I worked at it intensely—probably as hard as I ever worked at anything in my life."[5] The level of intensity was characteristic. "Everything is done with full attention," a friend said of her later. Georgia, folding a linen napkin, was "not thinking of anything else. She's right there, folding that napkin. That's the form she's observing."[6]

In Georgia's first memory of drawing she is largely concerned with technical problems—making the limned image conform to her sense of visual reality. Her solution was finally a shortcut: the man bending over from the hips looked unbalanced, as though he were about to fall on his nose. She found, however, that by turning the paper around so that he lay on his back with his legs in the air, he looked physically possible: a relief.

Another, less objective, component was already present in her response to making images and is revealed in another early reminiscence. She stood by an upstairs window on a winter's night, looking out at the back yard: a great pointed spruce tree, and beyond it a burr oak, black silhouettes against the snow. Across the field was another, distant, oak, and finally a line of woods. The image of bright moonlight, the black silent trees, and the magical presence of snow haunted her, and she began to draw it at once, by the light of the lamp.

The instinctive need to transform experience into image is a mysterious phenomenon. Discussion of it must take place in the realm of philosophy, or poetry, for it serves no objective function. "Forces are manifested in poems"—and paintings—"that do not pass through the circuits of knowledge."[7] These forces, vital and inexplicable, pass through the circuits of the soul. They are responsible for the sense of joyful recognition, interior resonance, and blissful confirmation that attend the sight of certain paintings.

Georgia's attempt to produce the image that glimmered in her mind meant the capturing of a purely subjective element—mood—as well as a factual rendering. The discrepancy between the color of things as they are known and as they are perceived engaged her at once. "The bare trees were black against the snow

in the moonlight—but dark blue had something to do with night." She added dark blue to the black trees, and made the strip of sky the color it seemed, improbably, to be: "a sort of lavenderish grey." For the nocturnal snow she left the paper bare, for, "at night snow isn't white, but it must be made to look white."[8] The problems of technical and emotional rendering would remain real to her throughout her life.

It was not art, however, which dominated Georgia's early years. By her own account, "the principal amusement" of her childhood was playing with a dollhouse she had made. She spent hours arranging this small, private, intricate world. The house was simple: two thin boards, with a slit halfway down each one, so they fit into each other, making a cross which represented the partitions between four rooms. Crucial to its nature was the portability of the dollhouse: in the summer it was carried outside near the apple trees, and a small park was created. The grass was neatly trimmed with scissors, tall weeds stood for trees, paths were made with sand and little stones, and a pan of water, edged with moss, was the lake. On this floated a shingle, shaped like a sailboat, and equipped with a white sail.

The world of the dollhouse holds an immense and soothing appeal. Suffused with a deep, affectionate nostalgia, the dollhouse presents a world without disorder or threat, a world biddable, intimate, beguiling. It is a world transformed by the magic of focus, scale, and intense examination. Georgia's dollhouse offered her unlimited control over an environment—emotional, physical, and aesthetic. These large and simple powers had great appeal, as did the opportunity to lose herself in solitary absorption. Privacy and solitude would continue to be of immense importance to Georgia throughout her life. "I don't take easily to being with people," she said.[9]

• • •

IN 1898, the year following the art instruction at home, the three older O'Keeffe girls were given lessons in Sun Prairie. One Saturday a month they were driven to the house of Mrs. Sarah Mann, a local—and indifferent—watercolorist. Both the lessons at home and those at Mrs. Mann's consisted of meticulous efforts to copy other, more accomplished, artists' work. At home, Georgia had struggled dutifully to reproduce the shaded cubes and

rounded spheres in a Prang drawing book. At Mrs. Mann's she was allowed to choose her own picture to copy, from her teacher's collection of reproductions.

Georgia's standards were exacting, and as she was accustomed to excelling, she was largely frustrated by her own efforts: the copies she made never looked precisely like the originals. Central to a successful artist's temperament, however, are perseverance and the ability to see a failed effort as merely a practice run. And rising to a challenge was instinctive for Georgia.

It was around this time—eighth grade—that Georgia made her first public commitment to the world of art. Standing in the schoolhouse one day, watching the other children wheeling and shouting outside, Georgia asked a friend named Lena what she planned to be when she grew up. Lena confessed to indecision and politely asked Georgia what her own plans were. The answer appeared in Georgia's head, magical, complete, and mysterious, as shapes were later to appear for her paintings. "I'm going to be an artist," she announced magnificently.[10]

Though Georgia's commitment was firm, her grasp of the specifics was vague. The intuitive yearning she felt toward certain images and the need she felt to create her own were strong and important to her. They were both unrelated to the questions she was asked by grownups.

"What kind of artist?" was a meaningless inquiry to her, and the classifications "portrait" and "commercial" art meant little. Pictures of her Wyckoff great-grandparents hung in the farmhouse, however, familiar and tangible. In order to answer in her parents' language, she declared her intention to paint pictures like those. Told she would have to paint whoever asked to be painted, Georgia was not pleased; she disliked the loss of control.

Her parents' questions did establish one thing. It was clear that being an artist was not a romantic but a pragmatic proposition. An artistic career did not absolve Georgia from any practical concerns. A living was to be made.

In the fall of 1901, Georgia left the little elementary school and was sent to board outside Madison, in the Sacred Heart convent school. Instruction in art was extra, and the O'Keeffes paid an additional twenty dollars for Georgia's lessons, besides the annual eighty-dollar tuition fee.

Georgia's description of the art teacher is characteristically vivid, combining visual details with psychological nuance. The

Sister was dark-eyed, with beautiful white hands, but to Georgia she seemed "a bit hot and stuffy."[11] Still, Georgia was determined to win approbation for her work. When the Sister criticized her first drawing effort as being too small and too dark, humiliation brought tears to Georgia's eyes. The public reprimand was intolerable, and she resolved never to let it happen again. For the rest of the year, all the images Georgia drew were determinedly bigger and lighter than she felt they should be.

Georgia was not by nature a rebel; she did not define herself through opposition. The rules on the O'Keeffe farm were strict but few, and they were founded on realities. Dangerous or insolent behavior was forbidden, but very little else was. When Georgia behaved eccentrically—she had very definite ideas about her clothes, for example—her conduct was tolerated as a facet of character. Though strong-willed, Georgia was sensible and did not need to challenge rules simply for the sake of challenge. Throughout her life she would ignore regulations that she found pointless and would take a certain glee in shocking small minds, but for her the act of confrontation was a means to an end, not an end in itself. Her goals were larger and more practical.

As an art student, Georgia was dutiful and eager to please, and her evident ability and her willingness invariably earned her praise. This had, however, a negative aspect: Georgia became so skilled at producing work her teachers wanted to see that her creative abilities risked atrophy. Her own facility and eagerness were, paradoxically, the independent artist's most insidious foes.

• • •

AT THE SACRED HEART School, Georgia was in the advanced section of her class. She did creditably in all her courses and won the school prize in ancient history. The gold pin she won for drawing left her mother unmoved. "I'd be surprised if you had *not* won it," said Ida, who expected excellence. In addition, Georgia received a gold medal for deportment.

Despite the restrictions on her freedom—the nuns reserved the right to read the students' mail, and visitors were allowed only on Sunday afternoons—Georgia responded to the rigorous academic stimulation and felt no resentment toward the strict rules. "At the convent in Madison I don't even remember wanting to do anything I shouldn't," she said.[12]

The next year, 1902, Georgia and her brother Francis were

sent to the big public high school in Milwaukee, where they lived with their aunt Lola. Ida and Anita, in their turn, were sent to Sacred Heart. Lola was a gentle woman, who loved children. As head of the small household, she was mild and sweet-natured—hardly authoritarian.

The year in Milwaukee was Georgia's first spent out in the world. The city had a population of nearly twenty thousand people, and for the two farm children, life was drastically altered. Agricultural requirements were no longer the framework of everyone's life: the world did not get up at five in Milwaukee to do the milking. Then, too, adolescents there had more importance than those in Sun Prairie and had even achieved notoriety, through the troublesome "boy problem."

> Boys, mostly teenagers, derailed streetcars, threw snowballs at persons in sleighs . . . made obscene comments to passing ladies, spat tobacco juice . . . and huddled together in boat houses where they smoked cigarettes, read lurid dime novels, and swore.[13]

To deal with these difficulties, and to prevent the spread of depravity, the town council passed "a stiff curfew" the year that Georgia and Francis were there, that required children under the age of sixteen to be at home by eight o'clock in winter, and by nine in summer.

"Adolescence was the crucial period of socialisation, when Victorian girls were taught the feminine virtues of dependence, submissiveness, selflessness and passivity," wrote Sharon O'Brien in her thoughtful and lucid biography of Willa Cather.[14] If this was the norm for girls growing up in the late nineteenth century, Georgia was some distance outside it. Her adolescence established quite a different pattern. Brought up by a decisive and effective mother, whose authority was unchallenged in her domain, Georgia found herself at the age of fifteen in a loosely structured society, vast in comparison to the one she had known. Here, authority at home was nearly nonexistent, and authority outside it was openly challenged by her peers. It was a heady introduction to the larger world.

At the high school, Georgia's cool detachment and calm assessment prevailed. She paid little attention to the academic side of the curriculum and was decidedly disparaging about the art

teacher: a gaunt maiden lady, with an over-eager manner, who wore an anxious spray of violets on her hat.

The devastating appraisal stripped the poor teacher of all innocent pretensions, but one of Georgia's strengths lay in her ability to recognize something of value when it was presented, no matter by whom. The art teacher brought a jack-in-the-pulpit into class, and pointed out to the students the marvels of its construction, and of its strange, rich coloring. Georgia was distinctly annoyed: she resented being shown something she admired by someone she did not. It was the first time she had ever looked at a plant with the idea of painting it, however, and the details and possibilities began to interest her.

In the art room of the high school she began to realize that the world through which she walked, which she had, without realizing it, memorized, could be a rich and inexhaustible source for her work: "You know how you walk along a country road and notice a little tuft of grass, and the next time you pass that way you stop to see how it is getting along and how much it has grown?" [15]

And again she discovered the possibilities of the magical transformation that took place in the world of the dollhouse—the strange enlarging significance that resulted from a shift in focus and deep, absolute attention. "When you take a flower in your hand and really look at it," she said later, "it's your world for the moment." [16]

• • •

DURING THE WINTER of Georgia's year in Milwaukee, her parents made an unusual decision. By then, every other male member of Frank's family had died of tuberculosis. For him to stay on in Sun Prairie seemed a deliberate acceptance of a similar fate.

The Wisconsin soil was generous, but the climate was punishing. "The winters were awfully cold," Georgia remembered; one day in February 1899 the temperature dropped to a cruel thirty-four below zero. Willa Cather, in *My Ántonia*, recalled the winters on the plains:

> Winter comes down savagely over a little town on the prairie . . . The pale, cold light of the winter sunset did not beautify—it was like the light of truth itself. When the smoky clouds hung low in the west and the red sun went

down behind them, leaving a pink flush on the snowy roofs and the blue drifts, then the wind sprang up afresh, with a kind of bitter song, as if it said, "This is reality, whether you like it or not. All those frivolities of summer, the light and shadow, the living mask of green that trembled over everything, they were lies, and this is what was underneath. This is the truth." [17]

During this period, a land promoter named Chandler Chapman was circulating a brochure advertising the halcyon climate of Virginia: Williamsburg was portrayed as "the garden spot." Frank's land, bought for less than a dollar an acre some fifty years earlier, was now worth nearly one hundred times that. In the bitter light of winter, he and Ida decided to sell their fields and move on.

The journey back across the country was a very different proposition from the pioneering enterprise of half a century before. The return east was seen as a temporal reward for all the years of austerity, of backbreaking labor. It represented a gentle, graceful life among civilized people, classical buildings, and a mild climate. "The south would be so warm and comfortable," Catherine said.

Frank and Ida took little with them from the farmhouse in Sun Prairie. Flush with ready cash for the first time in their lives, they bought new furniture and china: an elegant dinner service and a fragile Chinese porcelain tea set. They went down to Williamsburg alone, to settle into the large white clapboard house they had purchased. Auntie followed, by train, with Claudia, Catherine, Alexis, and Auntie's faithful carriage horse. Ida, Anita, Francis, and Georgia all followed in the early summer, at the end of their school terms.

It was a strange chapter in an American story, a retreat from the puritanical rigors of the pioneering experience, a return to a life of gentility and decorum. The exchange was made by the O'Keeffes with optimism and enthusiasm, but the move, initially successful, was to result in a gradual and devastating reversal of fortunes and to end in the eventual dissolution of the family. For although Frank and Ida were as diligent and foresighted as they had been in Wisconsin, luck was not on their side in Virginia.

PART II
1903 - 1918

DISTANT SKIES:
EXPLORATIONS
AND
INITIATIONS

4

A Girl's Ambition

At 14—To put up her hair and wear long dresses
At 16—To be an actress
At 18—To be a dreamy dancer and lead the cotillion with the
best-looking man in the club
At 20—To be the belle of Saratoga
At 22—To be able to count the greatest number of suitors
At 26—To marry a millionaire and lead the Four Hundred
At 28—To marry any man that should pop the question
At 30—Anything in trousers

—The Mortarboard,
Chatham Episcopal Institute Yearbook, 1905

THE TRANSITION FROM the northern plains to the southern lowlands required a substantial readjustment. The midwestern ethos stood foursquare in the uncompromising light of agrarian realities. The probity of farming is inexorable: land and livestock cannot be deceived. The ethnic diversity of this new society made for a variety of social overlays, but the underlying foundation was simple, severe, and pragmatic. There was a common purpose and a common means of achieving it. There was no common past: earlier generations had lived elsewhere and cast no shadow here. It made for a tightly knit, earnest, and straightforward community, in which social prestige was gained through manual labor, family background counted for nothing, and past generations were only hearsay.

In contrast to this severe and unvarnished structure was the spacious, graceful edifice of southern society, whose form was softened by the complicated shadows of tradition, whose high, airy ceilings were supported by the pillars of a vast black labor force, and whose classical lines were softened by the intricate tendrils of etiquette. The direct connection between man, the land, and labor had been lost.

There was no need for the southern white landowner to feel a passionate commitment to the soil: his attitude toward the land was abstract and feudal. The benevolent climate, the rich soil, and, most important, the black laborers all provided the whites with an elegant, stylized way of life that was far removed from the simple pragmatism of the Midwest. The stable and homogeneous population made for a socially insular community, in which prestige and status were based on an intricate set of kinship relationships: blood, not sweat. An appetite for hard labor was utterly irrelevant to the attainment of southern prestige.

The contrast between the two societies was described by Willa Cather, a near contemporary of Georgia's, whose story provides interesting and ironic parallels to Georgia's own. When she was ten, Cather and her family left a comfortable life in an old Virginia community and struck out for the bleak plains of Nebraska. Their move, like the O'Keeffes', was made for reasons of health: the Cathers, too, feared tuberculosis, which had already claimed two of their number. The Cathers had been assured that the disease was rare on the open, sweeping prairies; they knew very well—as the O'Keeffes did not—that it was common in the warm, torpid climate of Virginia. Her biographer notes:

> "Virginia was an old conservative society," wrote Cather, "where life was ordered and settled, where the people in good families were born good and the poor mountain people were not expected to amount to much . . . [In the Midwest she was] dropped down among struggling immigrants from all over the world" for whom the future could be different from the past. "Struggle appeals to a child more than comfort and picturesqueness because it is dramatic. No child with a spark of generosity could have kept from throwing herself heart and soul into the fight these people were making, to master the soil, to hold their land and to get ahead in the world."[1]

Though Georgia O'Keeffe and Willa Cather moved in opposite directions, they both settled in the same moral homeland and chose to adopt the ethics and values of the Midwest over those of the South.

• • •

THE ARRIVAL of the O'Keeffe family in the slumberous town of Williamsburg was like the unexpected appearance of a flock of exotic birds. The O'Keeffe children were numerous, energetic, and unschooled in the ways of southern decorum. The parents were similarly ignorant: coming from his rigorously egalitarian background, Frank did not understand that a white farmer was forbidden by custom from rolling up his sleeves and working next to his hired black laborers. And none of the O'Keeffes seemed to recognize that a new family, from the wild and uncivilized regions of the North, with no kinship connections in Virginia at all, would have to wait humbly at the bottom of the social staircase until those at the top should beckon them up.

Frank bought Wheatlands, a big house and nine acres on Peacock Hill—an area of handsome new dwellings that was named for a neighbor's collection of peafowl. The clapboard house stood at the end of a long drive, lined with pine trees. The grounds were full of oak and hackberry trees, and there were sweet mock orange bushes and climbing roses. Rambling and capacious, Wheatlands had a front porch, a side porch, and that beguiling southern amenity, an upstairs sleeping porch. There was a tennis court and a stable for Auntie's horse. Set in wide lawns and filled with the elegant new furniture, the house represented a blissful ease and security for the family.

In the long summer evenings, heavy with the scent of the mock orange and the roses, the family walked out along Duke of Gloucester Street. The roads were not yet paved, movement was slow and quiet, and the dusks were calm. Georgia's descriptions suggest peace and pleasure: "In Williamsburg, in spring, the country had a gentle kind of liveliness. The grass was full of pink and blue hyacinths, stars of Bethlehem, jonquils and crocuses."[2] And to a friend she wrote later: "As a youngster I lived in an old-fashioned house in the south—open fires—and a lot of brothers and sisters and horses and trees."[3]

The family rented a house on the York River during the first summer. The house was barely furnished, and the vigorous and

self-reliant O'Keeffes made tables from boards and sawhorses, and laid mattresses on the floor. They took their cook and lived for a month in an odd jumble of chaos and elegance.

If local eyebrows were raised at the outlanders, the O'Keeffes cheerfully returned the favor. "We thought the people talked a little funny, but it didn't bother us any," said Catherine equably. A family characteristic was a combination of serene self-confidence and a calm pragmatism that allowed them to concentrate on the task at hand, without the distractions of either self-doubt or antagonism.

It was hard for the surrounding community to make such a large and self-sufficient encampment feel seriously excluded. With seven children, Frank, Ida, and Auntie, the family constituted an active and entertaining community of its own. And despite their parents' reservations, neighboring children found the unpredictable O'Keeffe household irresistible. The living room was big enough for the children to put on two plays at once, at opposite ends; the big attics were used for more private pursuits — Catherine remembered sneaking up there to read forbidden magazines such as *Redbook*. There was a steady stream of visitors.

Upon their arrival in Williamsburg, the O'Keeffes enrolled Francis at the College of William and Mary, Ida and Anita at Stuart Hall, and Georgia at Chatham Episcopal Institute, deep in the countryside between Danville and Lynchburg. Most of the students at Chatham were the daughters of Episcopalian ministers. It was a "modern" school and emphasized education rather than social finish. Nonetheless, the girls who attended it were concerned chiefly with connubial achievements. The young ladies at Chatham saw themselves primarily as ornaments of society, not active participants in it.

The wife of a white southern landowner had few of the tasks and responsibilities allotted to her midwestern counterpart. Crucial to the fabric of an apartheid society is the strict division of labor: whites supervised, and blacks did the work. Above a certain economic level, white women were thus precluded from actual participation in domestic labor. Exclusion of a woman from the main business of the house meant that although she functioned as a symbol of authority, she had little to occupy her in the domestic arena. And by virtue of the powerfully patriarchal society governing the economic and political arenas, she had

even less outside. The void was often filled by social preoccupations.

At Chatham, one of Georgia's classmates was brought up in the happy conviction that "she'd never have to turn her hand over"; this attitude was not uncommon. These sheltered flowers were protected and cherished in preparation for their roles in life as decorative dependents.

The school took its role *in loco parentis* seriously and protected the girls with a dense thicket of rules. Sixteen-, seventeen-, and eighteen-year-olds were in bed with the lights out every night at ten o'clock. Walking alone or in pairs through the rural countryside was forbidden. The regulations encouraged the girls to think of themselves as fragile victims, incompetent and continually at risk. The gentle countryside itself represented the wilderness: an uncharted domain over which the laws of civilization did not hold sway. A young woman alone in it might fall victim to passion—a marauder's or, far worse, her own.

Georgia had grown up accustomed to absolute and inflexible rules. At Sacred Heart the rules had been even stricter than those at Chatham, but they were part of a larger, abstract, moral structure, which governed the nuns as well as the girls themselves and which Georgia had no trouble accepting. The following year, in Milwaukee, away from her parents, with little supervision at school and less at home, had served to develop Georgia's habits of independence and self-reliance. Given her temperament, background, and stage of development, Georgia's response to Chatham was inevitable:

> The atmosphere was entirely different from the convent. I used to stand there and think, "Now, what can I do that I shouldn't do and not get caught?" I'd go for long walks with another girl, which was not allowed. I had enough demerits to get expelled if I got one more. I wouldn't read my French lessons aloud three times to myself, as we were told to do; when they asked me whether I had done it I'd say no, I didn't have enough time for that.[4]

Georgia found the severe circumscription of her personal freedom illogical, unnecessary, and based on a set of utterly frivolous premises. Her flagrant refusal to accept these premises extended to all aspects of her behavior, and this was evident from

her first appearance at school. Some thirty years later, one of Georgia's classmates, Christine Cocke, wrote down her recollections of that occasion:

> How vividly I recall the first night Georgia walked into study hall at Chatham Episcopal Institute! As I had been in school a few days, perhaps a week, I felt perfectly competent to criticize this late-comer, especially as she was unusual looking. The most unusual thing about her was the absolute plainness of her attire. She wore a tan coat suit, short, severe, and loose, into this room filled with girls with small waists and tight-fitting dresses bedecked in ruffles and bows. Pompadours and ribbons vied with each other in size and elaborateness, but Georgia's hair was drawn smoothly back from her broad, prominent forehead and she had no bow on her head at all, only one at the bottom of her pigtail . . . Nearly every girl in that study hall planned just how she was going to dress Georgia up, but her plans came to naught, for this strong-minded girl knew what suited her, and would not be changed.[5]

Having been brought up to believe that hard work was a natural, central, and deeply gratifying part of real life, Georgia found the southern concept of woman-as-ornament deeply antipathetic. She took a radical stance against the values of the new community, her views firmly supported by her large and self-confident family. Though her roots were set firmly in the Midwest, it was the South that was responsible for the final form of her character; it took shape in vigorous contradistinction to the world around her:

> I spoke differently from the other people. I knew door was door. I knew it wasn't doe. They used to make fun of the way I talked. It went against my grain. But I knew my speech was all right. I started out not having any friends at all, but I didn't pay any attention to it. They were still fighting the Civil War.[6]

It was not simple arrogance that supported her conviction that her own ethos, like her speech, "was all right." Georgia recognized a real difference between herself and her classmates. With characteristic pragmatism, she accepted the consequences. "I just feel I'm bound to seem all wrong most of the time," she

once wrote cheerfully to a friend, "so there's nothing to do but walk ahead and make the best of it."[7]

In spite of Georgia's gauche accent and deplorable sartorial style, the other girls at Chatham were drawn to her.

> During recess . . . Georgia came up and began to talk in the friendliest way . . . I easily sensed Georgia's vivid personality, her exuberance and her enthusiasm. Everyone in the group could feel it.[8]

It was not only Georgia's personality that was distinctive; her looks were compelling, though she was not yet a beauty.

> Her features were plain—not ugly, for each one was good, but large and unusual looking; she would have made a strikingly handsome boy. Her brown eyes were pretty and set far apart, her skin dark, her hair straight and grown, while the shape of her head and the set of it on her shoulders was perfect.[9]

A girl from Texas, Alice Peretta, roundly announced her dislike of Georgia, who responded boldly by making a public wager that she could persuade Alice to like her. Georgia won her bet, and an important and enduring friendship ensued.

Georgia was entertaining and popular. She taught the other girls to play poker—an illicit farmhands' game that thrilled the ministers' daughters. "Georgia was in all kinds of mischief," wrote her classmate.

Submissiveness was a quality encouraged among southern girls, and Georgia, with her aura of natural authority, had little difficulty in establishing her reign over her classmates. Christine Cocke remonstrated her for this, and Georgia's response was straightforward: "When so few people ever think at all, isn't it all right for me to think for them, and get them to do what I want?"[10] Georgia had learned the first rule of politics: power belongs to whoever believes in her right to take it.

Paradoxically, in view of the matrimonial orientation of the school, boys were rigorously excluded from the girls' lives. At dances, some of the girls wore elaborate dresses, while others, in plain blue uniforms, represented boys. Georgia's response toward the rather obsessive preoccupation with boys and romantic fantasies was one of good-natured indifference, which resulted in her characterization in *The Mortarboard*, the 1905 yearbook, as

"A girl who would be different, in habit, style and dress,/A girl who doesn't give a cent for men—and boys still less."

During Georgia's two years at Chatham, she achieved a remarkably lusterless academic record and proved triumphantly obdurate about conventional methods of spelling. In her senior year, her record at spelling was so abysmal she was given a test; if she could not spell more than seventy-five of one hundred words she would fail to graduate. For once Georgia addressed herself to academics and studied diligently; she spelled seventy-six words correctly. As class prophet, she foresaw glittering futures for her classmates but predicted her own fate, in twenty years, as a wizened crone, still at Chatham, trying vainly to achieve a high enough score on the spelling test to graduate.

By modern terms, the curriculum at Chatham was oddly unbalanced. In Georgia's class four students graduated in Literature, three in Business, one (Georgia) in Art, and one in Elocution. For the period, the school was reasonably demanding, however. Mrs. Willis, the principal, was an impressive figure whose commitment to education was serious and very real.

What interested Georgia was neither the academic nor the extracurricular activities: art and music held her in thrall. Despite her portentous announcement in the classroom at Sun Prairie, Georgia's attentions were equally divided between art and music until the end of her second year at Chatham. She studied both piano and violin, and "She played beautifully," said Catherine. "She liked art very much and she liked the other, too, but she couldn't go on in both. She wasn't smart enough for that, she said." [11]

The family was kept current on Georgia's life at school. There was a warm and steady correspondence between Chatham and Williamsburg.

My dear little Catherine:
You wrote me a nice little letter and sent me some pictures a long time ago . . . I wish you would send me some more.
— It is only sixteen days before I will be at home. I am just crazy to see you all . . . This morning I taught the little boys Sunday school class. It was lots of fun but I don't think they had studied . . . Have you been drawing anything lately? There are some little colored children here that I have to pose for me . . . When I get home I am going to try my luck

on you and Claudie . . . love to all and hopeing [*sic*] you
will write me again—

Your loving sister, Georgia[12]

Elizabeth Mae Willis was both principal and art teacher at
Chatham. Georgia's energy and talent appealed to her, and she
encouraged the girl's interest in art. Georgia was given her own
table in the big, white-plastered studio, and she had permission
to go there in the evening and work by herself after dinner. When
the other students complained, Mrs. Willis rejoined, "When the
spirit moves Georgia, she can do more in a day than you can do
in a week."[13] Georgia's ingenuously egocentric view of the world
did not register these as special privileges.

> Sometimes at school I would work hard and sometimes I
> wouldn't do a thing for days. Years later my teacher . . .
> told me that I had been her pet. I never felt I was anybody's
> pet. I think I interested her, and was sort of a problem to
> her.[14]

All the students recognized Georgia's superior talents at art.

> In the studio . . . Georgia was queen. We were amazed at
> what she could do . . . even Mrs. Willis . . . admitted she
> had never seen such talent . . . Georgia would draw a
> picture of a girl that was like her as a photograph, but . . .
> she set no value on anything she did and rarely gave away
> any of her pictures. "No," she would say firmly, "I don't
> want any of these pictures floating around to haunt me in
> later years."[15]

Georgia had already begun to search the natural world for
subjects. "The privilege of walking in the woods with Georgia
and sketching with her was something to dream about," Chris-
tine Cocke wrote ecstatically.

By her second year at Chatham, Georgia was known to be
an aspiring artist. She was immortalized as such in the yearbook:
"O is for O'Keeffe, an artist divine./Her paintings are perfect and
drawings are fine." Georgia was art editor of the yearbook and
illustrated it with ink-and-white pen drawings. Capable, ener-
getic, and cheerfully irreverent, they are very much a product of
the period and suggest the work of Charles Dana Gibson with
their crosshatching and angular, stylized outlines.

Graduation was a time of high sentiment, rituals, and tearful farewells. Departing from her self-imposed rule, Georgia gave a watercolor of pansies in a vase to Susan Wilson. "Maybe I coerced her," Susan confessed. "It was the end of school and we were all giving each other presents." [16] Already Georgia had begun to establish a mythic persona. The act of withholding is powerful, and although Georgia's refusal to give her art work to her friends was not a deliberate effort to create a wish for it, still it had that effect. Her classmates wanted more of Georgia than she would give: it was a pattern that would persist.

Georgia's classmates said goodbye to each other, preparing to return home, ready for "the dreamy dancing, the cotillions, and the best-looking men in the clubs." Georgia made her own intentions clear. "I am going to live a different life from the rest of you girls," she announced. "I am going to give up everything for my art." [17]

5

Virginia was beautiful. I used to go walking through the
hills, but eventually I felt like I knew every tree in the forest.
—GEORGIA O'KEEFFE

IT WAS INEVITABLE that Georgia would leave Williamsburg. It held neither professional enticements nor a network of extended family affiliations. The social pattern had little appeal. Even the landscape, lush and verdant, began to pall. The greenery now gave Georgia a sense of exhausting intimacy, the circumscription of movement and vision. The trees muffled the sweep of the countryside. There was too much green in Virginia; it was too soft, too lush.

The landscape of childhood is the one that remains in the soul. For Georgia, a real landscape would always be clean, untroubled, swept bare.

• • •

GEORGIA'S DECISION to leave her parents, move to a large midwestern city, and continue her education started a pattern that did make her life different from those of the other girls at Chatham. She began to establish herself as an independent agent, ignoring the power structures and the conventions that traditionally governed young women's lives.

47

The study of art did not ordinarily disrupt the prevailing patterns: Susan Wilson, Georgia's friend at Chatham, also cherished ambitions as an artist. However, her further studies consisted of returning to Chatham for one postgraduate year, when she roomed with Anita and Ida O'Keeffe and painted on porcelain. Then she married, settled in Williamsburg, and produced a family. This docile pattern was considered natural. Girlish hobbies—like painting—were not expected to interfere with conventional sociobiological expectations.

In Georgia's case, the weakening of the social pattern was due partly to the O'Keeffes' move from the Midwest. In Sun Prairie, Ida O'Keeffe had had considerable social standing, but in Williamsburg her influence was limited, and the entrée she could provide was meager. She was no less interested in successful marriages for her daughters than any other mother, however, and when a young divinity student began paying calls on Georgia, Ida encouraged the relationship, though—more important—Georgia did not.

Validating Georgia's decision were three powerful women who had made very independent choices in their own lives. The primary role model, of course, was Ida: as Virginia Woolf says, "We think back through our mothers if we are women." Georgia's mother was a figure of great authority and determination, who supported absolutely her children's aspirations and encouraged their self-reliance and effectiveness. Ida's high standards and expectations made Georgia's choice a logical one: serious study at a great institution, rather than a postgraduate year painting china and waiting to marry.

Next came Elizabeth Mae Willis, head of Chatham. Remarkably for her era, Mrs. Willis had received a B.A. from the University of Syracuse. She had studied at the Art Students League in New York and had been head of the art department at the University of Arkansas before accepting the offer of principal at Chatham Episcopal Institute. A woman of considerable depth and presence, she was broad-minded, perceptive, and effective. She had overcome the physical handicap of partial facial paralysis, and the psychological one of being female, to combine a rewarding professional career with a productive domestic life. Married and a mother, she raised her own children at home, taught all the art courses as well as running the school, and accomplished it all with dignity and wisdom.

Third in this trio of strong women was Aunt Ollie, with whom Georgia was to live in Chicago. The oldest child of George and Isabella Wyckoff Totto, Ollie was possessed of a fierce independence, an abundant authority, and a trace of hauteur. "There was something about Aunt Ollie," said her grandniece Catherine Klenert Krueger. The "something" was a touch of imperiousness, the expectation of excellence, and a brisk impatience with anything second-rate: intelligence, integrity, or effort. This was a family trait, shared, to a slightly lesser degree, by Ollie's sister Ida. The bearing and raising of seven children tends to erode hauteur, but the two sisters had in common a great sense of pride and high patrician expectations. It was an attitude Ida passed on to her children; certainly it was inherited by Georgia, "the Queen."

When her father returned to Hungary, Aunt Ollie had taught school in Madison, helping to support the family when the other children were small. During the 1890s, after her mother and her sister Josephine died, Ollie and Lola moved to Milwaukee. There Ollie, amazingly and against all odds, became the only female proofreader at the *Milwaukee Sentinel*. This feat was much celebrated within the family: the image of tiny, indomitable Aunt Ollie, with her aristocratic profile and regal posture, taking her triumphant place among the serried ranks of disgruntled men was one in which they all exulted. Her attitude of fierce vigilance and her contempt for error made her brilliantly effective at her job. Aunt Ollie was famously self-sufficient; she maintained her own emotional and financial independence throughout her long and active life, and died, reluctantly, at the age of one hundred and three.

Mrs. Willis may well have suggested that the O'Keeffes send Georgia to the Art Students League in New York, but they were oriented toward the Midwest, and though New York was the center of the world of art, Chicago was the center of the world they knew: grain, cattle, and farming. Frank had gone there frequently on business from Sun Prairie, and Aunt Ollie and her brother Charlie now lived there.

Georgia was only seventeen when she arrived in Chicago, and despite her eagerness and determination, the move was an unsettling one. She wrote of the feeling she had "when I was a youngster and was going away from home on the train— It is a very *special* special sort of sick feeling."[1] Staying with her aunt

and uncle gave her a measure of familial protection from the vast new urban world; their apartment was within walking distance of the Art Institute, where Georgia had registered as a student. Nonetheless, the transitions were both serious and difficult ones for Georgia to make: from country to city, from parents to aunt and uncle, and, most threatening, from a small to a vast and impersonal institution.

The Art Institute of Chicago was founded in 1879; it was a dignified establishment, physically imposing and ideologically conservative. Its catalogue announced proudly:

> The principle upon which the school is founded is to maintain in the highest efficiency the severe practice of academic drawing and painting, from life, from the antique, and from objects, and around this practice as a living stem to group the various departments of art education.[2]

Like most similar institutions at the time, the Art Institute was deeply committed to the solemn American tradition of Europe-worship. Chicago fixed its gaze resolutely upon Europe and ignored the possibility of indigenous tradition.

"The school is conducted upon the most modern methods," the catalogue assures us. "The classes are organised upon the French 'Atelier and Concours' System. Constant communications and interchange are kept up with European art centres." So absolute was the assumption of the necessity for intercourse with France that instruction in the French language was offered as one of the art school courses. As a teaching institution, it slept peacefully, deep in the traditions of mid-nineteenth-century France. The work of Millet, Courbet, and Rosa Bonheur—the archbourgeoisie of the art world—were exhibited during the year that Georgia attended the institute. Solemn, large-scale, ambitious, and highly moral, these gilt-framed paintings seemed the embodiment of European grandeur and were accorded deeply reverential treatment. The school brochure promised that "a ready hearing is given to all new methods and theories." Any new methods and theories proposed by the French Impressionists, some twenty years earlier, or, more recently, by the Postimpressionists, might indeed have readily been given hearings, but they had apparently just as readily been dismissed, for these theories were not part of the school's course of study. In fact, so deeply opposed was the Chicago Institute to the trends of modernism

that when the controversial Armory Show of modern paintings traveled there in 1913, the students burned Matisse, Brancusi, and other offending artists in effigy, to demonstrate their outrage.

The school stressed the "severe" practice of drawing over the use of color, the importance of the classical tradition through copying of antique casts, and a studied and logical approach to composition, based on geometry and rationality.

The term began on October 2. Georgia had registered for the life class at the advanced level, skipping the elementary ones. During the first month, however, everyone was required to draw from antique casts—"severely," as the catalogue insisted. At the end of the first month the work was evaluated, and the students who merited it were sent on to more advanced courses. There were evaluations every month; these followed the "Atelier and Concours" system of ranking. Each month the teacher pinned up the last week's work on the wall and numbered the pictures according to merit. The better-ranked students were allowed to choose the better positions for their easels; the others took what was left.

The teaching rooms were vast, full of pomp and gloom. Georgia's first class, composed of forty-four students, was held in a vast first-floor gallery. Georgia was directed to draw a huge male torso, lacking both head and arms. She was less than enthusiastic, but dutifully she began.

Though the tedious copying "didn't particularly interest" her, her response was signally different from her response to the tedious tasks at Chatham. Georgia's response in Chicago was meek and conscientious. Another student, a boy her age, materialized in the gloomy gallery, and the two compared their work. The boy's drawings were bold and rich, full of heavy lines and dark shadows. Georgia's, by contrast, were pale and demure. It was clear, Georgia recalled later, that he had not had the benefit of a "good Sister," as she had.

There is mock humility in this anecdote, as the boy was ranked below Georgia in the monthly assessment. There is real humility as well: the seventeen-year-old Georgia—in the big cold spaces of these rooms—was beginning to encounter work which was, she admitted, richer, livelier and more skillful than her own. She was not prepared for this. For the first time she found herself a very junior member of a large, illustrious group, in a formal,

intimidating atmosphere. It was a daunting experience, and she felt, uncharacteristically, unsure of herself.

There was, as well, a crisis of sensibility early in the year. It began in a lugubrious teaching gallery, gloomy and ill-lit, which established at once a mood of anxiety for the sensitive girl. Georgia entered the room, which was already full of older students. The teacher called "Come out," and from behind a curtain a male model appeared, dark, handsome, and naked except for a tiny and immodest loincloth. Georgia felt very young and very exposed: she blushed flamboyantly, could not look at anyone, and suffered from a violent sense of exposure and embarrassment.

The O'Keeffe household, though governed by farmers' pragmatism, was governed equally by decorum and propriety, and Georgia was truly shocked at the sight of a nearly naked man in the dark interior. It was the context that created the discomfort; she had reacted very differently at seeing a boy outdoors in a bathing suit.

Struck by acute anxiety, Georgia felt suddenly alienated from the other students. Her sense of embarrassment was so acute that she considered abandoning art school altogether. If she were to continue at the Art Institute she would be promoted to the Life Class, where nude models would be the norm. It was an extremely difficult prospect for young Georgia, her hair hanging down her back in a braid with a bow on the bottom. The idea of being an artist finally triumphed, however, and when the rest of the class moved on to anatomy class, Georgia went determinedly along.

Georgia had been fortunate in choosing John Vanderpoel as her master, and she became a member of his atelier. Vanderpoel, a gentle Dutchman with a hunchback, was a well-known artist who was listed first among the instructors. His anatomy lectures were Georgia's favorites. "He was very clear . . . He was a very kind, generous little man—one of the few real teachers I have known." [3]

Georgia's conquest of her anxieties and her diligence were rewarded: she was fifth in her class in December, seventh in January, and in February she was first.

• • •

DURING THE WINTER of 1905–06, Georgia's ten-year-old sister Catherine caught malaria. Ida's response to the sickness was typ-

ical of her unconventional approach to child-rearing. When Catherine was well enough to feel bored, but not yet well enough to go back to school, Ida put her on the train to Chicago. With her Aunt Ollie, her Uncle Charlie, and Georgia she completed her convalescence, and there she went to school for the remainder of the term. At the end of the term she made the long trip back to Virginia, with a gift from Aunt Ollie: a large and bossy parrot, which took up its own red plush seat on the train. "I hung on to it," said Catherine firmly. "Made it behave."

While Catherine was in Chicago, Georgia did a watercolor of her wearing a red coat and hat and sitting on a couch. The picture is richly colored and densely patterned, a highly academic example of late-nineteenth-century style. The composition suggests a studio setting that was then popular: a faintly exotic environment filled with rich textures and rare objects. In Georgia's picture the model reclines on a couch, over which is thrown an Oriental rug. The choice of subject reflects the contemporary interest in the picturesque: the little girl in her red coat and hat is deliberately charming. The picture demonstrates an earnest studiousness; Georgia has not yet achieved her own vision. What stands out is the beginning of a voluptuous love of color and a richness of hue, even in the transparent medium of watercolor.

By the time Catherine arrived in Chicago, Georgia had already begun to feel her way. She had recovered from the initial shocks of being an outlander, young, and female (though being female put her in the substantial majority at the school—there were twice as many women as men in the daytime classes). She had conquered her anxiety over nude models. Her consistently high rankings had reestablished her self-confidence: "She was beginning to criticize" the school, said Catherine. "She was getting better than the rest of them."

At the end of the year, Professor Vanderpoel ranked Georgia first in her class of twenty-nine women—needless to say, the classes that worked from nude models were segregated. Vanderpoel gave her several honorable mentions as well, though she won no awards.

Leaving home for the northern metropolis had not been easy for Georgia, regardless of her apparent independence, and the months at the institute had been taxing. In the summer of 1906, back at home, Georgia came down with a severe case of typhoid, a dangerous illness from which there were a number of deaths

that season. Williamsburg, set on low ground between two slow rivers, was full of damp and miasmic swamp air—not at all the healthy climate the O'Keeffes had hoped for. Malaria, typhoid, and other tropical diseases were not uncommon. By the end of September, Georgia was no longer ill, but she was physically depleted. Her hair had fallen out, a common effect of the disease, which lowered her morale. In no state to return to her studies in Chicago, she lay in the hammock day after day, watching as her siblings left home for their academic destinations.

Georgia spent that winter at home with the younger children: Alexis, Catherine, and Claudia. She set up an easel in the basement and asked neighborhood children to pose for her. As her strength returned, Georgia began to help the kindergarten teacher, Mrs. Murphy, with her charges. "Georgia was great fun with the children," said a neighbor; "she was like her father that way. She would gather up all the kids in the neighborhood for an afternoon walk. You always saw her with a line of children behind her."[4] The O'Keeffe house was a neighborhood center: the tennis court, the swaybacked horse called Penelope—pronounced Penny-lope—the theatrical activities, the spacious attics, all were irresistibly magnetic. But it was the spirit of the household that drew people, a sense of purposeful and pleasureable activity, which was due to Ida. On baking days, the whole house would breathe the sweet, generous smell of warm bread.

Georgia adapted to her environment, painting on her own, since there was no instruction, and finding things to do. But although she still lived within the family environment, her own sense of independence was vigorous and infringed occasionally on family patterns. Catherine remembers Georgia's temper once taking over. Georgia had gone away for the weekend, and a young man had enraged her. Upon returning home, she was so angry that she took to her room and would neither speak nor appear. Ida's response was philosophical: she simply put a tray outside Georgia's door at mealtimes. Catherine, still a child, was allowed finally to come into the room but not ask questions. Inside, Georgia sat at her table, furiously writing letters.

The incident demonstrates the dynamics governing the family patterns of behavior. Ida's response showed her respect for her daughter's emotional life, and she insisted neither on Georgia's conforming to family regulations nor on her daughter's confiding the details. Her attitude reinforced and confirmed

Georgia's position that the real life of the emotions and the spirit takes precedence over social patterns; also, that it is absolutely private. This was integral: Ida's children would recognize one another's emotional strains, but their sympathy would be tacit and unintrusive. They would offer succor but not advice.

• • •

ON THEIR ARRIVAL in Williamsburg, Frank had set up a feed and grocery business. He had sold grain from his own fields in Sun Prairie. His business had prospered there, and he saw no reason to think that things would be different in Williamsburg. Feed was a business he knew, and groceries seemed a logical extension. He had, however, reckoned without the economic depression and without the clannish and inimical local response of Williamsburg residents toward northern newcomers.

When the capital invested in the feed store was gone, Frank made an inventive move. In 1907 he sold the large and pleasant Wheatlands house, keeping a strip of property along the road. The family moved into the smaller Travis house, an eighteenth-century building on Francis Street. At the end of August, the newspaper announced the latest project of the ingenious Mr. O'Keeffe: he and a partner were manufacturing concrete blocks from building materials they had bought up from an abandoned paving project. The anonymous "partner" was both of Frank's sons, and they set up a haphazard worksite near the railroad tracks. Here they mixed concrete with clamshells from the nearby river and poured it into building blocks, which they hoped to sell.

By that spring, Georgia had fully recovered, and she wrote to the Art Institute for a teaching recommendation. "Miss O'Keeffe is a young lady of attractive personality, and I feel that she will be very successful as a teacher of drawing," they wrote.[5] At the institute, students who intended to become teachers registered in the first year for general study and in the second for the normal—teaching—course. After a year away from the institute, Georgia decided not to return and planned initially to teach without finishing her course of studies.

She changed her mind during the summer, however, and returned to art school, but not to Chicago. In September 1907, Georgia enrolled at the Art Students League in New York City, the flaming center of the art world.

6

*There is a state of unrest all over the world in art as in all
other things. It is the same in literature, as in music, in
painting, and in sculpture. And I dislike unrest.*

— SIR CASPER PURDON CLARKE,
director, Metropolitan Museum of Art, 1908

NEW YORK IN THE early years of the century was in
the midst of a period of exhilarating expansion. In spite of a brief
economic drop in 1907, the year Georgia arrived in the city,
America as a whole was experiencing unprecedented long-term
economic growth. Industrial development, foreign trade, inter-
national finance, consumer goods, land development—each
played a part in the vigorous surge. Nowhere was this energy
more evident than in New York City. Farm laborers from rural
areas and immigrants from Europe came there seeking jobs. So-
cial reform was on the rise; union membership climbed from four
hundred thousand in 1900 to more than two million in 1904. The
city was crowded, boisterous, and full of excitement. Theodore
Roosevelt's expansionist policies involved America in the affairs
of other countries, and the rest of the world began to approach
America.

The art world was experiencing a parallel expansion and revitalization. American art had always suffered from a schizophrenic pull between indigenous talent, subject, and tradition, and European style and technique.

Toward the end of the nineteenth century, America was becoming increasingly wealthy, cosmopolitan, and sophisticated. Historically, its sources of wealth and trade were the subjects of its art: shipping and agriculture. But the new wealth had a problematic provenance—industry. American painters resolutely averted their eyes from it. Smokestacks, skyscrapers, and metal construction were all too new and too unnatural to be perceived as "pictorial." In 1896 an editor in *Scribner's* magazine complained that the new buildings in New York had "no architectural merit," because they suffered badly by comparison with medieval donjons and keeps; the writer went on to remark disdainfully that they were "faultily slight, and built like packing boxes with holes in them."[1]

In direct denial of the rise of technology, the landscapes of the period were painted in moods of elegiac peace; mothers and children were shown in wordless harmony; and chaste, aristocratic women were portrayed at their leisure: in hammocks, in front of tea trays, and at dressing tables. There was no trace of the humble, rural farmland, nor of the industrial scene.

As Georgia arrived in New York, in the first decade of the new century, some American artists were beginning to address themselves to urban imagery and social realism. A group of New York artists who called themselves "The Eight" used a fluid, painterly brush stroke to depict a wide variety of city scenes, ranging from the nighttime haunts of the very rich to the back-street arenas of the very poor. Robert Henri, the group's unofficial leader, taught at the Art Students League. Georgia, however, was not in Henri's sphere of influence but in an altogether different one, that of William Merritt Chase.

In the year of Georgia's attendance there, the league was dominated by the vivid personality of Chase, a man of great personal and aesthetic power. He was a reigning force among the loose constellation of painters called American Impressionists. Like the others of his generation, Chase had pursued the foreign muse, and when first offered the opportunity to go to Europe, he had replied exultantly, "My God! I'd rather go to Europe than to heaven!"[2] In 1872 he went to Germany to study at the Royal

Academy in Munich. The Munich school of painting was known for its emphasis on portraits, as opposed to history and genre painting. Students were taught somber underpainting of the canvas, strong dark-light contrasts, and a rapid, painterly "bravura" brush stroke. Chase mastered these elements with great skill, and the works he sent home won him substantial acclaim.

When Chase left Germany in the early 1880s, however, he became interested in landscape painting, and he abandoned the somber tones and old-master atmosphere of his earlier work. From 1891–1902 he headed a *plein air* school of his own in Shinnecock, Long Island. Here he painted a series of landscapes, using still the rapid, brushy stroke he had learned in Germany but with a fresh, higher-keyed palette. In these paintings he demonstrated attention to the architectural elements of the countryside, a brilliant mastery of the quality of natural, outdoor light, and a feeling of space and freshness.

By 1907, when Georgia began to study with him, Chase had evolved his own personal and eclectic style of painting. He had kept the Munich brush stroke—it suited his own rapid, vigorous approach—and he often used the strong contrasts of that school to give his light colors strength and structure. But he had espoused the Impressionists' warm, vivid palette and the plein-airist approach to the fleeting and transforming quality of light. Chase did not consider himself a member of any particular school; he saw himself as drawing benefits from them all. He followed the rule he gave his students: "Be in an absorbent frame of mind. Take the best from everything."[3]

Chase's emphasis on speed, color, and vitality was a great departure from the painstaking, methodical approaches of earlier schools. His method seemed exactly appropriate to the New York environment: full of people, velocity, and excitement. Chase liked brilliance, a flashing brush stroke, high-keyed colors, and an immediate appeal. One of his most important lessons for Georgia concerned rapidity and decisiveness; the students produced a painting each day, which Chase judged once a week. This encouraged them to work with certainty and decision.

> Making a painting every day for a year must do something for you. We didn't keep them. The next week we painted another picture on the same canvas until the canvas got too slick. You learned a great deal about the use of your

materials. I thought that he was a very good teacher . . . He was an experience as a person.[4]

Unlike the sober and conventional institute in Chicago, the Art Students League encouraged individuality. Chase's personal flamboyance demonstrated that an artist could choose to look and act very differently from most people. Chase made his own appearance a part of his oeuvre. He urged his students to "Seek to be artistic in every way."[5] Georgia remembered his presence vividly:

He arrived for class in a silk hat, flower in his button-hole, fur-lined coat, very light gloves, spats, and a neat brown suit. When he entered the building a rustle seemed to flow from the ground floor to the top that "Chase has arrived!"[6]

Chase was also impressive for his lack of gender prejudice. Many of his contemporaries were male chauvinists, but in 1898 Chase had presided over a committee that awarded the Gold Medal of the Carnegie Institute to Cecilia Beaux rather than a great many distinguished male artists. He pronounced Miss Beaux "not only the greatest living woman painter, but the best that has ever lived."[7] Notwithstanding the prevailing sociological blindness that prevented Chase from seeing Miss Beaux's work in a context even larger than that of all women painters, it was still a generous pronouncement, generously intended. This attitude toward women was felt by his students, and Georgia was conscious of his encouragement.

Chase taught, among other lessons, pride in the artist's work. He encouraged his students not to give away their paintings but to put a commercial value on them, so that they would take on a reality beyond the conceptual one given by the artist. Teaching his students that they must make the world take them seriously, in worldly terms, he made an important distinction between rank commercialism and insistence that art be seen as a serious endeavor. It was a lesson Georgia learned well.

Georgia plunged into this lively, energetic, and exacting world. She took a small room in a boardinghouse near the league, which she shared with a friend, Florence Cooney. It was here in New York, rather than during the year in Chicago, that she began to realize the choices she would have to make between being an attractive young woman and being a serious artist.

You know, when you're a country girl first come to the city, you have to make a lot of decisions. I had . . . lost all my hair, so when it grew in, I had the first really short hair in the city. It was soft and curly, and everybody wanted to run his fingers through my hair. There were lots of decisions.[8]

The young men at the league found the twenty-year-old Georgia very appealing. Her surname and her curly hair revealed her Irish blood, and she was given the feminine form of the nickname awarded the ubiquitous Irish immigrants: "Patsy." Her energy, her intellect, and her unconventional hair, with its irresistible loose curls, were full of exotic appeal. They wanted her to pose for them, dance with them, go on excursions with them. "I was everyone's pet," Georgia said, "which was sort of nice."[9]

Pethood was a novel experience for Georgia, who was accustomed to being a queen, not a darling. Being perceived as adorable has its merits for most young women, however, and Georgia was no exception. The flood of attention was naturally gratifying; it was also intellectually stimulating. These young men were interested in the same things that absorbed her.

It was not just art and conversation that occupied Georgia and the young men: there were dances and escapades. At a costume ball, Georgia dressed as Peter Pan, a highly appropriate choice. Androgynous, beguiling, outside the conventional notions of domesticity, he was the symbol of the wayward romantic who captivates society in spite of itself.

Georgia liked dancing, and she did quite a lot of it that first year in New York. But there were, she began to realize, consequences to dancing; there were consequences to having everyone want to run his fingers through her hair. Besides dancing with them, the young men wanted Patsy to pose for their paintings.

Eugene Speicher, an older student, often stopped Georgia and asked if she would pose for him. He was a handsome young man, and one morning he stood in his fresh linen smock, blocking the staircase as Georgia tried to pass on her way to class. Vexed, she asked him to move. From his superior vantage point —older, male, and higher—he announced, "It doesn't matter what you do. I'm going to be a great painter and you will probably end up teaching painting in some girls' school." Georgia did not answer and still tried to push past; Speicher offered to give

her the painting he did of her. When Georgia reached her life class she found a model posing there whom she could not bear. Giving up on the class, she went back to Speicher, in his fresh linen smock, and agreed to pose.

Georgia sat for the scornfully admiring Speicher for two successive days. On the first day, Speicher painted a portrait to give to the sitter; on the second, while he painted a picture for himself, other students came in and took advantage of Georgia's sitting. The portrait Speicher kept won him a prize at the league and is there still. It is an undistinguished work, very much under the influence of the Munich school. Against a dark, rich background is set the pale, bright face of the sitter, the vivid light tone echoed by a strip of white blouse below. The contrasts are bold and strong, and Speicher used a stylish, painterly brush stroke. Although it demonstrates Speicher's technical capacity, it says little about his creative ability, and the work is finally more interesting for its portrayal of Georgia, serious and bemused.

The experience obliged Georgia to examine her situation. She had deliberately chosen to pose for the handsome young man, she had deliberately abandoned the role of creator and meekly accepted the role of subject. Posing for Speicher meant playing the part of a pet, and a pet, by definition, belongs to someone. Posing meant Georgia's allowing other people's needs to determine her behavior, her role, and the allocation of her time and energy. And it was not only Speicher who asked her to pose: she was a popular favorite. A young woman student who had finished a female figure except for the face and hands asked Georgia to pose for those; that painting, too, won a prize.

The episode reveals a deep and surprising ambivalence on Georgia's part. Eugene Speicher "in his fresh linen smock" proved irresistible to her. She deliberately abandoned the active role of creator and meekly accepted the passive one of model for the taunting, dominating Speicher. It is a story uncharacteristic of the later Georgia but one that gives some indication of a struggle that took place.

It was at the Art Students League that Georgia made the choice between being "everyone's pet" and being her own person. It was a simple choice but not an easy one for her to make; she brought to the decision the plain-speaking pragmatism of a farmer's daughter.

I read a book, I forget the title, that made a great deal of sense to me. It taught me how to make decisions . . . so I got a notebook, and opened it up, and wrote "yes" at the top of the left-hand page and "no" at the top of the right-hand page. And for every decision that came up, I would write down "yes" why I should do this thing and "no" why I should not do this thing. I soon saw in front of me what I really wanted to do, and I did what I wanted to do from then on. The essential question was always if you want to do *this*, can you do *that*? [10]

It was this brisk and sensible approach that would thenceforth characterize Georgia's style. "I first learned to say no when I stopped dancing," she said later. "I liked to dance very much. But if I danced all night, I couldn't paint for three days." [11]

At the league, Georgia saw her choices clearly: she could dance, pose, and be petted, or she could paint. Seen in those terms, the choice was not a difficult one. From then on, the essential question was always about painting, and the answer was nearly always the same.

7

Cesnola gasped. "Mr. Stieglitz, you won't insist that a photograph can possibly be a work of art!"
—DOROTHY NORMAN,
Alfred Stieglitz: An American Seer

ALFRED STIEGLITZ WAS a fervent apostle whose primary mission was to achieve the acceptance of photography as an art form. Born in America, in 1864, to German-born parents, he studied in the early 1880s at the Polytechnikum in Berlin, under the great pioneer of photography Dr. Hermann Wilhelm Vogel. He then proceeded on his own to the forefront of the still nascent field and won his first photographic competition in the London *Amateur Photographer* in 1887. On his return to America, the following year, Stieglitz started his own photographic processing firm, but he became increasingly involved with aesthetics rather than technical issues. He joined photographic societies and began to contribute to periodicals.

In 1895 he resigned as editor of the *American Amateur Photographer*, because of differences with his colleagues: Stieglitz's aesthetic imperiousness and his personal style invariably aroused antagonism. His ruthless hostility toward dissenting views would place him in direct confrontation with every body of administrators in every organization that he encountered. It was a posture Stieglitz at first found exhilarating.

Stieglitz took it on himself to define the value and nature of photography. A precise and literal rendition of visual reality had been for centuries the goal of painters, and photography was

initially viewed with suspicion and outrage, as it appeared to render useless these centuries of effort. A painter could never produce the clarity and perfection of line, perspective, and detail that any amateur photographer could achieve after one lesson with a camera. While painters raged about the upstart technology, photographers, whose ideas of art were bound up in painting, turned out prints that imitated the paintings then in vogue, accomplished by means of careful posing, blurry focus, and manipulated negatives.

Stieglitz, decrying the slavish dependency of photography on painting, pointed out that literal realism was not the only goal in either field. Paradoxically, the availability of a breathtakingly precise reproduction of visual reality had rendered it valueless. And once this literal realism was no longer the only aim, then something more than literal realism was required of both. The work in both fields must then be judged both more subtly and more abstractly, according to new criteria.

Photography, argued Stieglitz, should be judged by purely aesthetic standards: line, tonality, technique, and, most important, composition: masses, lights and darks, the use of detail to form a whole that was aesthetically, intellectually, and emotionally compelling. Besides the technical aspects, Stieglitz required expressive power: the image should create an emotional response in the viewer. This line of reasoning, addressed originally to photography, carried Stieglitz, by logical extension, beyond realism to abstraction. That in turn resulted in his expansion of appreciation and his support of abstraction in painting and sculpture, which he began to promote at an early date.

For Stieglitz, the strengths of photography were clarity, precision, the perfect illusion of reality, and graphic and abstract design. The counterparts to these qualities, in painting, would be painterly technique and nonobjective imagery: images that would reorder reality instead of reproducing it.

Stieglitz's thinking, his activism, and his own photographic work, which made repeated advances, both technical and aesthetic, rendered him one of the real and important pioneers in that field. As well as his obdurate refusal to cooperate, his career reflected an equally obdurate insistence on excellence in all aspects of photography: technical, aesthetic, and moral. His fixed certainty that photography was an art form, his insistence on respect for the process and its product, was greatly responsible

for the change in attitude toward the work in this country. And his philosophy contributed to the advance of modern art in America.

After Stieglitz resigned from the *American Amateur Photographer*, he merged two rival groups, the Society of American Photographers and the Camera Club. In 1896 he founded a journal of the new organization, *Camera Notes*, a beautifully designed and produced periodical, which broadcast Stieglitz's ideas. The Camera Club gave Stieglitz his first one-man show in 1899; the next year it began a campaign against him. Stieglitz had rejected many members' photographs for the club's organ; moreover, his rejections were ruthless, and he had accepted the work of outsiders. Umbrage was taken, and ire was roused. Umbrage and ire were as nectar and ambrosia to Stieglitz: here was a feast.

In 1901 he began to create a rival federation, though remaining as editor of *Camera Notes*. Organizing an exhibition in 1902, Stieglitz coined a name for the group he was showing: the Photo-Secession, a reference to a group of German artists, the Secessionists, whose aim was to secede from the "academy." The idea of a radical group of aesthetes was highly appealing, and in choosing the name, Stieglitz established his alliance with revolutionary elements in the international art world.

Until 1907, most of Stieglitz's efforts were directed toward the acceptance of photography as an art form in America. In Europe this had already been achieved: photographs as well as paintings were included in large invitational art exhibitions. By entering American photographs in European exhibitions, and by organizing international exhibitions in America, Stieglitz tried to call attention to the discrepancy between the European and American approaches.

Though Stieglitz supported the photographic brotherhood as a whole, within the body of the movement there were differing factions. Pictorial photography, as opposed to portrait, scientific, or documentary photography, was his particular bailiwick; the intentions of the pictorialists were purely aesthetic.

Pictorial photography was much influenced by symbolist painting and infused by mystery: cloudy atmospheric effects and enigmatic imagery. Increasingly, however, Stieglitz became a proponent of the sharp-focus, straight approach to photography, as opposed to the blurred, romantic school, which obviously imitated painting. He advocated little or no manipulation of the

negative, maintaining that the photographer's eye, and the technical means at his disposal, should provide the artist with all the tools necessary.

Stieglitz largely ignored the social realist photographers of the period, who took truly sharply focused works (more so than his own) and whose unposed, unretouched documentary works often showed an attentiveness to aesthetic concerns and a standard of excellence that equaled his. Neither the social realists, however, nor the commercial photographers shared Stieglitz's fundamental intention: not to arouse indignation, nor to alert the public to social ills, nor to record a time and place, but to produce a work of art.[1]

In 1902, Stieglitz resigned as editor of *Camera Notes:* he had started a rival publication called *Camera Work.* This would center its attention on members of the Photo-Secession, which remained a loosely organized group of photographers and critics. Definition of membership was eccentric: Gertrude Kasebier, whose work was included in the first exhibition at the Arts Club, asked Stieglitz in bewilderment: "Am I a Photo-Secessionist?"

"Do you feel you are?" Stieglitz counterquestioned. When Kasebier admitted that she did, Stieglitz said, like a magician pulling out a rabbit, "Then that's all there is to it."[2]

Though it was Stieglitz who created the group, it was Eduard Steichen who persuaded Stieglitz to open the Little Galleries of the Photo-Secession. Steichen was, in fact, crucial to Stieglitz's activities in the field of modern art.

Eduard Steichen was born in Luxembourg, but his family moved to Michigan when he was two. He studied painting and photography in Chicago and in 1900 came to New York to show Stieglitz his photographs: Stieglitz encouraged him to continue. Steichen went on to study painting in Paris at the Académie Julien but soon left to concentrate on his photography. Returning to New York in 1902, he set up a studio at 291 Fifth Avenue. He began working closely with Stieglitz, as a photographer and a proselytizer. A frequent contributor to *Camera Work*, he designed its cover. Steichen was an original member of the Photo-Secession, and his work was consistently in the exhibitions Stieglitz arranged.

Steichen convinced Stieglitz to take over the studio at 291 Fifth Avenue as a permanent gallery space for photography. Stieglitz doubted that there was enough excellent work to sup-

port a full-time gallery, and Steichen suggested that other media be shown as well. This meant a logical extension of their philosophical premise: photography, as an art form, should be hung with examples of other art forms.

The Little Galleries of the Photo-Secession was inaugurated in November 1905, with a group show in an elegant interior designed by Steichen. It was a great success and was followed by a series of one-man exhibitions. In September 1906, Steichen left for Paris, vacating his top-floor premises, which the gallery took over. Steichen planned to study painting and to do his own photography; he would also act as an agent, informing Stieglitz of the developments in European art and watching out for American artists to be shown at "291," as the gallery was called.

Steichen wanted the first nonphotographic exhibition at the gallery to be composed of works by Auguste Rodin. Rodin agreed to this, and in the fall of 1906 Steichen set about making the arrangements. Stieglitz, however, took a sudden liking to the work of a young woman named Pamela Colman Smith. Without consulting Steichen, he offered Smith a show at once, before the Rodin work had arrived.

Pamela Colman Smith was born in America in 1878 but lived in London. Her work was influenced by the English Pre-Raphaelites, Aubrey Beardsley, and the Art Nouveau movement. Rife with symbolist imagery, it depicts enigmatic women with long flowing hair and mysterious intentions, set in surreal landscapes. Many of her pictures were inspired by music, an approach that was then much in vogue. Smith had also studied with the painter Arthur Wesley Dow, one of the few Americans to be influenced by Oriental rather than European concepts, and whose aesthetic theories were to have a significant effect on several of the American artists Stieglitz would champion. Though Smith's work itself did not demonstrate the sort of radical approach to art for which "291" would become known, there were reasons for its appeal to Stieglitz.

Stieglitz had spent his formative student years in Germany and had been deeply affected by the brooding romantic mood of the late-nineteenth-century German painters. By inclination more intuitive than rational, he was drawn to the symbolists and to the Secessionist movment that followed, both of which celebrated intuition over intellect. The pictorialist photography that Stieglitz supported was symbolist in mood, full of dream imagery, crepus-

cular landscapes, and enigmatic women.[3] Stieglitz felt, too, an affinity for the writings of Maurice Maeterlinck, the Belgian symbolist, who wrote of the human soul, its searches, journeys, and epiphanies. Enigma, ambiguity, and half-revealed knowledge were of great importance in this movement.

Related to Maeterlinck's philosophy was that of the German Secessionist movement, which held that the life of the spirit was intrinsically more valuable than that of the brain. The intellect was seen as suspect, feeling as superior to logic, and the rise of technology as the rise of a soulless society. These views were largely shared by the Photo-Secessionists in New York: the irrational, unconscious, and untutored self was perceived as the source of creativity.[4]

It is not surprising that Stieglitz was attracted to the work of Pamela Colman Smith. But another element very probably played a part: one of Stieglitz's great and abiding passions was young women. He was a vigorous proponent of women artists, and a number of them worked with him and exhibited in the gallery. He had always shown the work of women photographers and was committed to the idea of finding a great woman artist. Preponderantly the women he worked with were highly attractive, and it may be assumed that Miss Smith was a young lady of considerable charm.

Pamela Colman Smith did in any case demonstrate flair. She may well have been the very first performance artist: at her opening, in January 1907, she recited nursery tales from the West Indies and chanted ballads by Yeats.[5] The exhibition caused a stir, and "Whitneys, Havemeyers . . . and Vanderbilts" came to the little gallery.[6] It was characteristic of Stieglitz that his first show of nonphotographic work would involve an appealing young woman, drama, and a flamboyantly unconventional approach. His emphasis on confrontation and showmanship would at times create a smoke screen that would obscure his very real aesthetic fervor and his serious concerns. His style would be both a benefit and a liability.

Most of Stieglitz's European travels had been centered around Germany. The Photo-Secession exhibitions he arranged in 1905, for example, were shown in Berlin, Brussels, London, and Vienna. Temperamentally and ethnically, his inclinations would naturally draw him to the new German art of the Secessionists, intuitive, antirational, mystic, and emotive.

The French painters, conversely, were analytical, rational, anti-emotional purists. It was unlikely that Stieglitz would choose the French artists to champion. It was Steichen, born in France, who introduced Stieglitz to the great cultural ferment of that country. In the summer of 1907, Steichen took him to Paris and began a new chapter in Stieglitz's aesthetic education. On his first view of the watercolors of Cézanne, Stieglitz's response was as flagrantly philistine as any he would scorn later in his own gallery: "Why, there's nothing there but empty paper with a few splashes of color here and there."[7]

Stieglitz was intrigued by the energy he found in Paris, however, and, predictably, fired by the revolutionary spirit. "It was not that Stieglitz understood what it was all about, but he was aware that something was happening in the world that was the opposite of photography, something new and alive, and he was interested."[8] Intensely receptive to the new theories, he learned rapidly to appreciate the new work. The concept of abstraction was not inimical to him. The idea of judging art purely on the basis of its formal qualities was identical to the position he had taken on photography.

Starting in 1907, both the gallery and the magazine began to reflect Stieglitz's growing enthusiasm and involvement in all aspects of the visual arts. He had established himself in the New York art world as an impresario of aesthetics: volatile and unpredictable, but utterly sincere.

• • •

GEORGIA WAS POSING for Eugene Speicher—and for others, who took advantage of her modeling—when a student came into the studio and suggested that they all go down to "291" and see the Rodin show of pencil and watercolor drawings. The teachers at the league had told all the students not to miss the show: spare and simple, the pictures were so sketchy that they were rumored to have been executed by the artist with his eyes shut.

The idea took hold of the group, and painting was abandoned for the day. Speicher, O'Keeffe, and the others all set off through the snowy streets to the brownstone building at Fifth Avenue and Thirtieth Street. The original Little Galleries of the Photo-Secession had by January of 1908 moved next door to 293 Fifth Avenue. (The adjoining brownstones shared a common entrance, through 291. A doorway had been broken through the

upstairs wall of 291, leading to the gallery in the back rooms on the top floor of 293.) The gallery's name had been officially changed to the more manageable "291." The space was modest: a fifteen-foot-square room with a skylighted corridor, a long closet, and a bathroom, which doubled as a darkroom.

> We went up the steps to the front door where we took a very small elevator and came out into a bare room— windows to the back. Stieglitz came out of a sort of dark place with something photographic in his right hand—it was dripping water on the floor. He was a man with a shock of very dark hair standing up straight on the top of his head—making his face seem rather lean. He glared at us in rather unfriendly fashion when we said that we came to see Rodin drawings. He glared as if too many had asked before.
>
> On our way down to the gallery the men had said that they had heard that he was a great talker and as they put it —they wanted to "get him going." When they started to talk I went in to see the Rodin drawings—but I heard loud talk—louder and louder till it became quite violent. The drawings were just a lot of scribbles to me. I went in to the farthest room to wait . . . I didn't want to listen to them . . . nothing to do but stand and wait till we finally left.[9]

The twenty-year-old Georgia met Stieglitz on January 2, 1908, the day after his forty-fourth birthday, and the second day of her sitting for Eugene Speicher.

It was inevitable that O'Keeffe and Stieglitz would meet. It was ironic that their meeting should take place in the midst of Georgia's struggle over the issue of posing. Confronted by an older, handsome, and insistent man, she had succumbed to his needs as an artist and abandoned her own. The issue was one that would recur.

8

I love best to be a woman, but womanhood is . . . too straitly-bound to give me scope.

—MARGARET FULLER

GEORGIA'S WORK HAD BENEFITED from the stern excising of dilatory pastimes. At the end of the year, one of her still lifes won a prize from William Merritt Chase: a scholarship to Amitola, an artists' retreat established by Spencer and Katrina Trask on Lake George, in upstate New York.

Lake George is a long, narrow body of cold, clear water that meanders through the southern end of the thickly wooded Adirondack Mountains. Its pristine beauty appealed to wealthy East Coast vacationers, and in the mid-nineteenth century its colonization began. Huge summer "cottages," meticulously rustic, were built along the western shore. Amitola was on the wilder, eastern side of the lake.

The Trasks were wealthy patrons of the arts, who later founded the sumptuous artists' retreat Yaddo, in Saratoga. In 1902 they bought one hundred acres of woodland and the Crosbyside Hotel (previously the Stockwell cottage). There they remodeled the "cottage" to create a dormitory for "writers, sculptors, illustrators and craftsmen"—and artists—who wanted an inexpensive pastoral retreat. Moderate rates were charged, by

the week or month. The two-story building, built in the Gothic style, had sixteen rooms, and suggested

> something of the sturdy beauty of the pine woods, with its warm brown coloring and graceful proportions. At night when lighted with its rose colored lanterns the effect seen from the lake or through the trees is very beautiful.[1]

Georgia made her first trip to Lake George in the summer of 1908. At the time, she was dutifully producing work in her teachers' styles. Her prize-winning still life—the central figure a dead rabbit—closely followed a formula that Chase had perfected. Though technically skillful, it reveals little of the artist.

She was beginning to experiment with technique, however, to step gingerly over the bounds of convention. At the league she had tried underpainting a canvas with white, instead of the deep somber tones she had been taught to use. She put the finished canvas in her window to dry and later visited a friend nearby. Looking across at her own window, she was surprised and exhilarated by the bright, energetic quality she had produced, and by the realization that she could step off the carefully trodden path of academic tradition.

At Lake George, Georgia painted outdoors for the first time, but initially she was not taken with the scenic beauty: "We had a sailboat with a red sail, the daisies were blooming, the mountains were blue beyond the lake—but it just didn't seem to be anything I wanted to paint."[2]

Two of the young men at Amitola were admirers of Georgia's, and when one of them asked her to join him on a rowing trip across the lake, Georgia agreed and asked the other man too. This created some tension: the first man had neither expected nor wanted a second. Gloom hung heavily over the rowboat as it crossed the lake, and matters were not improved when, after a foraging expedition to the grocery store on the far side, the three found that their rowboat had been stolen. They had to tramp back halfway around the lake, carrying the supplies.

By this time it was evening, and during the long trek home Georgia paused to look at the marshland in the twilight. There was a still, reflective stretch of bright water, a dense stand of cattails, and beyond it, woods, threaded with the pale glimmer of birches. "In the darkness it all looked just like I felt—wet and swampy and gloomy, very gloomy."[3] Georgia was suddenly

struck by the realization that her feelings governed the way she saw the scene. It was a moment of transformation: the entire visual world, she realized, was dependent on the emotional world. The power of a painting depended not only upon technical skills but also upon emotive powers.

This was a revelation to the young artist. Line, perspective, composition, and technique would supply only half of a painting's real power; the rest would derive from spiritual content. It was not something she had been taught: the academic tradition taught through imitation of technique; emotional content was not included.

The next morning, Georgia returned to the marsh and painted the scene, trying to express the mood she had felt the night before. The picture meant something to her: it was an attempt to say something new; she felt it was her best painting that summer. One of the young men asked her to give him the picture, which she did. Georgia seldom gave away her paintings, but this young man was important to her.[4]

George Dannenberg, a handsome, energetic man, five years Georgia's senior, was a scholarship student from San Francisco. He was a member of the "Fakirs," a group of irreverent league students who parodied teachers' work. High-spirited and buoyant, he was Georgia's escort at the dance when she dressed as Peter Pan. The two shared mutual interests, beliefs, and backgrounds. Dannenberg, like Georgia, was talented, committed, and impecunious, and was a disciplined and motivated worker. Georgia called him "the man from The Far West"; he represented a place that had always held a strong romantic appeal for her. He was a vigorous outdoorsman, who hunted and fished in the western mountains, and at Amitola, Georgia could see the pleasure he took in the woods. Ease in the landscape implies an ease with the self; her father had this, and it was something she expected from a man. Then, most important, there was a strong mutual attraction between them. Trust and candor were crucial elements in their relationship, which would be maintained, despite geographical separation, for nearly ten years.

• • •

RETURNING HOME to Williamsburg after the summer, Georgia found the family in a new house her father had built on a strip of the old Wheatlands property. It was a family project: the house

was fashioned from the concrete blocks made by Frank and his sons. According to the local story, the children each built their own rooms.

Frank's venture in concrete blocks was not proving successful in Williamsburg, which was built of beautiful faded rose-colored bricks. Frank had to use up his inventory constructing the new house, and the money from the Sun Prairie land was slipping away. The family could not afford to send Georgia back to study in New York, nor Anita and Ida back to Chatham Episcopal Institute, although Alexis returned to the Academy of the College of William and Mary. The new house was a stark, unbalanced building: Francis O'Keeffe had, unfortunately, inherited his father's design skill.

The O'Keeffes continued to find pleasure in their days, however. The new gray house was full of energy, and spirits were high in spite of financial depression.[5] In the fall of that year, Georgia wrote a cheerful letter to Florence Cooney, her New York roommate:

> This morning I learned to make biscuits—every morning I make a dusting trip around the lower regions of the house. I read all the afternoon. Nights, there are usually some kids here . . . time just slides over my head in a rather agreeable manner and when I think of the fight to live up there it seems like this is the place for a girl. It doesn't seem like she ought to be bumping around New York alone . . . The family are too good to me. Papa told me two or three days ago that he would send me back to the League if he could, but that he couldn't just now. I certainly like to please him. He is having hard luck these days but never says much because he doesn't like to own up to it, even to himself, I guess. My private opinion is that his money is just going down the line and that the wisest thing for Pats to do is wake up . . . and see what she can do . . . I am going to get busy and see if I can do anything if I work regularly.[6]

One of the evening visitors was a young minister, Tuck Lawrence. He gave Georgia music for her piano, and a great deal of attention. Ida favored the match; Georgia did not.

Georgia was twenty-one years old and had lived away from her family in big cities twice. She had become accustomed to ordering her own life as an adult. If she had been essentially

rebellious, there would have been friction between herself and her mother, but Georgia's interest was never in proving her own authority on a personal level, and she avoided confrontations. "All the time I was at home it was always 'more of Georgia's crazy notions.' They didn't like the way I did my hair . . . It finally got so at home I did what my mother wanted and when I was away I did as I pleased."[7]

Georgia's recognition of the family's straitened circumstances induced her to "get busy." In the fall of 1908 she took the train north to Chicago, where again she stayed with Aunt Ollie and Uncle Charlie.[8] This time, however, she did not make her way daily to the palatial Institute of Art but worked as a freelance illustrator for advertising agencies. Besides drawing pictures of lace and embroidery for newspapers, she created a symbol still used to sell a cleaning agent: the Little Dutch Girl.

The grim industrial winter and the deadly commercial work made Georgia wretched. "I could make a living at it," she wrote later. "That is— I could exist on it—but it wasn't worth the price — Always thinking for a foolish idea for a foolish place didn't appeal to me for a steady diet."[9] For a year, Georgia labored at the dispiriting commercial work in the cold urban environment. Mercifully, she finally contracted a severe case of measles, which affected her eyesight. Unable to continue with the demanding, close-up illustration work, Georgia returned again to Virginia. Things at home did not improve. The South was to have been a reward, a refuge from the cold, the work, and the sickness that had been such constant and relentless elements in their lives in Wisconsin. "We thought it would be so warm and comfortable," Catherine said. But a painful irony was establishing itself. Frank was working as hard as he ever had on his farm but with far less gratifying results. He had known how to make his own smooth fields respond, but he could do little with the stubborn reluctance of his neighbors to patronize his business. Far worse, Ida had begun to show the early signs of tuberculosis. The damp cold of the concrete house, or her close contact with Frank's last surviving brother, had caused Ida to contract the disease they had moved three thousand miles to avoid.

There was no cure for consumption. It meant an inexorable degeneration of the lungs, increasingly frequent internal hemorrhaging, and, eventually, death. The only known treatment was the removal of the patient to high altitudes, where some tempo-

rary relief was achieved. The family hoped that Charlottesville, northwest of Williamsburg, miles away from the damp sea air and nearly five hundred feet above sea level, might offer Ida some respite.

In 1909, Ida and her daughters moved to Charlottesville.[10] Frank remained in Williamsburg, to dispose of the unpopular concrete house. Ida rented a brick house on Wertland Street, a good address but a cool environment. "There wasn't much visiting on that street," a neighbor recalled. The community did not casually welcome northern strangers. This time, the O'Keeffes were not prominent figures in the community. Their house was cramped and narrow, with an ungenerous strip of lawn. The girls went to public schools, and Ida offered hot lunches to students at the University of Virginia, in an effort to make the household pay for itself. Catherine remembered the young men coming for meals and the family sitting at table, waiting for the food to come up on the dumbwaiter from the kitchen. Despite their diminished status, the family did not give in to despair: tuberculosis can be glacially slow, and the O'Keeffes were accustomed to difficulties. Regardless of Ida's waning strength, her dignity and that of the household were still intact.

Frank O'Keeffe made frequent visits to Charlottesville, but it was three years until he rejoined his family full time and began a new venture—a creamery. The household was pervaded by an unvoiced sadness at Ida's illness and the gloomy awareness of financial strain. The marriage, however, was intact. Though other biographers have suggested that the separation was the result of emotional inclination, no hint of this was part of Catherine's recollection or of Claudia's. The temporary separation of Ida and Frank was due to economics; their commitment to each other was long-term and enduring.

• • •

DANNENBERG AND GEORGIA had maintained a correspondence, and the relationship was still strong and important to them both. Dannenberg wanted to develop it still further, though Georgia would not permit this. "Honest, Patsy, I feel like writing what I can't, because you won't let me," he wrote from New York in the winter of 1910.[11] The following summer, he wrote affectionately: "At times I long to have you as the little black-haired girl."[12] In

the margin of this, Georgia wrote: "I love you for your goodness and your badness."

In the fall of 1910, Dannenberg made plans to sail for Europe. He felt torn about leaving Georgia.

> It will only be about a month now before I can finish up what work I have on hand and shake these parts for the East. I hope I may see you before I sail. Wish I could take you with me. It is not so very impossible so don't laugh.[13]

Dannenberg very nearly did take Georgia with him.

> I sat on the bench on the Battery all night [before sailing] trying to decide whether I should come to see you or not. That morning I sailed for Holland. Am I crazy or stupid? Both I believe, because if there is anything in the world I want, it is Patsy.[14]

Despite his all-night vigil, the letter was dated from Paris, where he had arrived alone. It was a very close call, perhaps closer than he knew: Georgia later told a friend that if Dannenberg had come to take her away instead of writing about it, she would have married him.

Paris in 1910 was a feast for a handsome young American art student, and Dannenberg quite properly reveled in it. He took a studio in the old quarter, but did not forget Georgia.

> I have met old pals—in the Latin quarter, but to see you would be different. You stunned me into a daze that I simply can't shake off . . . I paint all the time. I should like to have you here.[15]

Dannenberg's letters held an ambivalent value for Georgia. They were a link to the larger world, but they reminded her of what she could no longer have. She had been Dannenberg's equal at the league, and it was difficult for her now to watch him pull so purposefully ahead. Financially unable to continue her education, physically unable to continue making a living from her art as she had done in Chicago, Georgia wrote despondently to Dannenberg. In the winter of 1910–11 she announced that she had given up painting. Dannenberg's answer was kind but distant:

They always frighten me, your letters . . . The fact that you
have abandoned paint does not mean that you have given
up art. You are and always will be an artist.[16]

But she was in earnest about quitting.

Georgia had achieved great independence in her personal
life, but this was not the case in her art. Her work at the league
was skillful but conventional; as her prize-winning still life had
shown, she was dutifully following other people's examples. "I
began to realize that a lot of people had done this same kind of
painting before I came along. It had been done and I didn't think
I could do it any better. It would have been just futile for me, so
I stopped painting for quite awhile." [17]

It was difficult for a woman at that time to become a painter:
there was little precedent. In examining the difficulties women
had in becoming writers, Sandra Gilbert and Susan Gubar have
pointed out the importance of the role of the predecessor. "That
writers assimilate and then consciously or unconsciously affirm
or deny the achievements of their predecessors is, of course, a
central fact of literary history." [18] The same can be said of painters.

For Georgia there were few women predecessors, and there
was no tradition of women artists. Mary Cassatt and Cecilia
Beaux, in the preceding generation, had established themselves
as artists, but this lone pair—neither of whom challenged aes-
thetic conventions—was not an effective counterbalance to the
overwhelming majority that made up the history of Western art.

William Merritt Chase, her last teacher, had been the most
powerful influence on Georgia. A technical virtuoso, he was so
successful at the style he had perfected that it was difficult for his
students to imagine moving past him. The scenes he portrayed
were reassuring and flattering to his wealthy patrons, suggesting
a tranquil continuation of the life they knew. Through reification
and iconization, the paintings confirmed the existing values of
the patron classes. Chase and his art represented the apotheosis
of the turn-of-the-century aesthetic sensibility.

Chase, like most of O'Keeffe's teachers, was male. And, as
Gilbert and Gubar point out, these male precursors "incarnate
patriarchal authority." The fact of embodiment complicates and
increases the difficulty of a woman artist's attempts to establish
her independence. Each male artist whose work Georgia admired
embodied a repressive psychological force by the very fact of his

physical existence: if this was an artist, then she was not. This patriarchal authority, by definition, prevented her from learning by its example to seize her own power, to achieve her own independence as an artist. It was this undercurrent of shared belief in men's authoritative and women's subsidiary roles that made possible Eugene Speicher's casual taunt—the claim that Georgia would only end up teaching art in a girls' school, while he, a man, could become a great artist.

The elegant, powerful William Merritt Chase demonstrated to perfection the phenomenon of the incarnation of patriarchal authority. "Imagine— Chase came to school in a tall silk hat!" Georgia said years later. "I was only twenty, so when somebody dressed up like Mr. Chase told me This was It, I was most apt to believe it."[19] Georgia's ingenuous admission demonstrates the instinctive obedience generated by the tremendous authority inherent in Chase's appearance and style. "I thought he was a very good teacher. I had no desire to follow him," she wrote.[20] But she had no choice. It was not possible for her to follow him: the fact of his male presence, his technical skill, and his commanding personality presented her with an equation that left her out. The virtuosity of his work was such that it was difficult for Georgia to imagine herself proceeding any further under his direction. And she could not, yet, imagine herself proceeding alone; she was not ready to declare her independence. She had reached a state of involuntary incapacity.

Georgia was caught in two opposing currents: her deep, instinctive, and unexpressed need for self-realization, and an equally deep wish to conform to the expectations of the institution she had chosen and to win praise through this conformity. The two seemed mutually exclusive. She had reached an impasse: "it was all or nothing. Since she could not devote herself to it, she never touched a brush—could not bear the smell of paint or turpentine because of the emotions they aroused."[21]

Georgia's self-imposed abstinence ended in the spring of 1911. Mrs. Willis wished to take a six-week leave of absence from Chatham and asked her to teach the art courses there. Georgia agreed to teach others to paint, even if she had forsworn it herself.

It was Georgia's first teaching experience, a modest one but important: she was a gifted teacher, by all accounts, interested, kind, and deeply absorbed in the process. The brief exposure to

the profession reminded Georgia of her original plan when she enrolled at Chicago: to be a schoolmarm.

A figure of modest means and stature, the schoolmarm nonetheless was an important model for women who wished respectably to escape the traditional male-dominated pattern of marital commitment. Underpaid, undervalued, and socially underwhelming, the schoolmarm was modestly but blessedly independent, and within her own sphere she wielded authority. For the energetic and strong-minded young woman, the life of the schoolmarm afforded an opportunity for independence and freedom of choice.

The six weeks at Chatham reminded Georgia of how she might pursue her art, live in the country, and make her own living. It suggested a life she might make for herself after all.

• • •

THE UNIVERSITY of Virginia, in Charlottesville, was open full time only to gentlemen, but it permitted young women to enroll in summer classes. Young Ida had taken an art course there the preceding year, and in the summer of 1912, both Ida and Anita signed up for a class with Alon Bement, a teacher from Columbia Teachers College, in New York. Anita reported to Georgia that the class was very peculiar and most stimulating; she coaxed her older sister to come and see what it was like. Initially reluctant, Georgia agreed: there she met the curious Bement.

Alon Bement was an eccentric bachelor in his late thirties, mannered, vain, and self-important; his airs kept him largely friendless. "I can see how you dislike him," Georgia wrote a friend; "it's curious—many people do. My sisters think he is a joke—almost detestable."[22] For Georgia, however, his vanity and airs were irrelevant. "Really he is fine inside . . . I so often feel sorry for him—to the extent that I want to love him because he seems so barren inside—and makes such a brave show of covering it with the sociableness and foolishness and ruffles of life— He is a queer little man . . . I am really very fond of him."[23]

Georgia's fondness is unsurprising; Bement was responsible for a crucial change in her life. "I had stopped arting when I just happened to meet him and get a new idea that interested me enough to start me going again."[24]

Bement taught the principles of Arthur Wesley Dow, who had conceived of an entirely fresh approach to art. Dow was a

gentle and unexciting professor from New England. His style and methods, though deeply revolutionary, provided a strong contrast to those of another aesthetic rebel of the period, Alfred Stieglitz.

Stieglitz's style was entirely personal. He chose to confront the art world directly, by means of exhibitions and publications. His own voice was paramount. His vehemently confrontational manner placed him in a position of aesthetic notoriety and made his theories public property, hotly debated and equally hotly challenged. His energy was directed at the public as much as it was at the artists; constantly he harangued, condemning the public's taste and aesthetic values.

Dow, a gentle, retiring man, chose to disseminate his theories through the mouths of others. Instead of speaking directly to the public, heckling, jeering, and vilifying it for its lack of taste and understanding, Dow spoke directly to art students and to their teachers. His own artwork was timid, and his students called him "Pa" behind his back. He was a public nonentity, and his theories slid quietly into the mainstream, without flourishes, their influence untrumpeted. They were, however, just as radical and valuable as the new theories from Europe that were being introduced so flamboyantly at the same time.

Georgia had first been exposed to Stieglitz and his theories in January 1908. This preliminary encounter left her feeling that the art he showed was "just scribbles" and that Stieglitz and his theories were too violent and antagonistic for her sensibility. It was Dow, not Stieglitz, who provided theories that revived Georgia's blocked creative interest. It was Dow's method that suggested, finally, an approach which allowed her a free, direct, and active role in her work.

Arthur Wesley Dow was born in 1857, in Ipswich, Massachusetts. Unable to afford art school, he taught himself drawing and painting until his efforts attracted patrons who financed his formal education in art. He embraced the theories of John Ruskin, the English artist and theorist, who taught a strict and unblinking attention to the forms of nature. Dow took on his own students, to whom he taught the obedient submerging of the individual into the tradition of art. He taught in an academic manner, through lessons in perspective and drawing from antique casts. In the mid-1880s, Dow went to Paris and studied at the Académie Julien. His studies were successful, and his work was accepted at

the Salon of 1887, but by 1890 he was back in Boston. Convinced of the sterility of his training and his work, Dow was in despair.

One evening in February 1890, he went to the Boston Museum of Fine Arts. He dated his aesthetic awakening from that day. His discovery of Japanese art transformed his views on everything:

> It is now clear to me that Whistler and Pennell, whom I have admired as great originals, are only copying the Japanese . . . One evening with Hokasai [sic] gave me more light on composition and decorative effect than years of studies of pictures. I surely ought to compose in an entirely different manner.[25]

Dow then met Ernest Fenollosa, a distinguished Harvard graduate who had taught in Tokyo, had managed the Imperial Museum there, and had been decorated by the Mikado. Fenollosa was the curator of Oriental art at the Boston Museum when Dow met him, and he opened the young artist's eyes to the splendors of his field.

Dow felt that Western art had lost a vital element and that part of its sterility was due to the separation of the fine and the decorative arts. In Oriental art, he wrote, "pictorial and ornamental art are inseparable."[26] The synthesis of fine and decorative art was emblematic of a larger synthesis: Dow felt that the elements of one's life should partake of the same defining rhythms and currents as one's art. The same sensibility should govern all aspects of life and work.

"It was quite clear in his mind that no American could originate any art technique nor produce an indigenous and distinctively American art."[27] Dow's own work demonstrated his interest in the decorative. Stylized and two-dimensional, it was not as radical as his teachings. It was, however, of primary importance. From 1891 on, Dow saw his first responsibility as that of a proselytizer of this new creed. He taught his students the difference between correctly copying objects from nature and composing a picture. "A pictorial composition," he wrote, "is not merely an assemblage of objects truthfully represented, it is the expression of an idea, and all the parts must be so related as to form a harmonious whole. It cannot be a work of art unless it has this quality of wholeness."

Dow's approach required an understanding of composition,

an intuitive, aesthetic understanding, rather than the "time-honored approach through Imitation." His method meant the development of the student's awareness and the involvement of his or her individual participation and aesthetic judgment.

His textbook *Composition* was first published in 1899. It was widely read, enormously popular, went into seven editions, and was reissued in 1913. In it he wrote that the first concern of the student was the development of appreciation, which is "a common human faculty, but may remain inactive. A way must be found to lay hold upon it and cause it to grow. A natural method is that of exercises in progressive order, first building up very simple harmonies, then proceeding to the highest forms of composition." The understanding of composition itself lay at the center of the theory: "There must be thorough grounding in the elementary relations of space cutting and simple massings of dark-and-light. This is essential to successful work in designing, drawing, modelling, painting and architecture and the crafts."

By asking the student to make his or her own aesthetic choices at once—initially simply by dividing the empty page with a line— Dow was challenging the entire Western tradition of imitation. He was denying the value of the mindless, dutiful copying of more accomplished artists' work, and thereby striking at the very foundations of art instruction in America.

Dow saw himself as a revolutionary. In order to influence the largest number of people possible with his theories, in 1904 he took the position of head of the art department at Columbia Teachers College—long "the outstanding center of art teaching in America," he judged, and therefore a suitable arena for his instruction. His intentions were truly radical: "His whole effort was to divorce art from its aristocratic and autocratic background . . . art was, in his teaching, a process of building, never a harsh commercial discipline but something more poetic, a sacramental way of living."[28]

The new approach appealed to Georgia like a fresh wind. A concept of art that allowed her to participate and required her to involve every aspect of her life was one she embraced, recognizing it at once as her own. And Alon Bement, the "queer little man," recognized at once her strength and her talent.

Bement gave more to Georgia than a new theory; what he did not do was as important as what he did do. "I had a teacher who was very good because he didn't know anything. He would

just tell me things to see and to read . . . And he'd tell me things that I should do but I never paid any attention to that. He was a timid soul. I'd probably be a teacher of art somewhere had I followed his advice."[29]

Not only his ideas but his presence allowed Georgia a new sense of freedom and possibility. Bement was the antithesis of the elegant and powerful William Merritt Chase. Small, plump, and silly, he lacked authority and was anything but an intimidating male force; neither Bement's person nor his work presented a threat or a challenge. Instead of wearing a silk hat, Bement was wont to wrap himself in lengths of silk fabric and pirouette during the design classes. In no way did he incarnate the patriarchal denial of female independence. The very fact of his ineffectual physical presence encouraged Georgia to take command of her ideas and of her work. "He told me this summer that I didn't have a bit of respect for him, then nearly killed himself laughing," she wrote a friend. "But it isn't so— I really think a lot of him."[30] Both Bement and Georgia were right: she did not have the sort of adulatory respect for him that the patriarchal tradition of male teachers usually commanded; she did, however, have another, wider, genderless respect, for Bement and his ideas. She also recognized the debt she owed him for enabling her to recover the sense of capability she had lost. It was a priceless gift, for certainly the encounter with Bement, and with Dow's theories, altered Georgia's life.

9

So I went off to Amarillo, Texas, which was something I'd wanted to do all my life. The Wild West, you see. I was beside myself.

—GEORGIA O'KEEFFE

FOR GEORGIA, the world had been enlarged: she had taken hold of her life again. Art was once more at the center of things, as it was meant to be. It had seized her imagination and her heart.

She had enrolled in Bement's most advanced class and had gratifyingly received a grade of 95. Further, Bement asked Georgia to be his teaching assistant at the university during the following summer term. In order to qualify, she needed teaching experience at the secondary level. Georgia wrote to her friend Alice Peretta and received in return an offer of a job teaching art in Amarillo.

Alice was the Texan who had declared her hatred for Georgia on her arrival at Chatham. By graduation, the two girls had been fast friends, and afterward they kept up a correspondence. Originally from Laredo, Alice was teaching in Amarillo and was a friend of the new superintendent at the high school, S. M. Byrd. When the art teacher left, Alice recommended Georgia to fill the vacancy.

The offer from Amarillo was met with an immediate, decisive acceptance. "I was very excited about going to Texas, where Billy the Kid had been."[1] By embracing the "Wild West, you see," Georgia was freely placing herself outside the bounds of feminine tradition—those reluctant pioneer women of the nineteenth century. Georgia's journey westward was far more consonant with male than female patterns. It was not, however, a pattern entirely outside the women known to Georgia: Mrs. Elizabeth Willis had gone into the relative wilds to teach at the University of Arkansas. And within Georgia's own family, there was a precedent both more direct and more intimately significant. Isabella Wyckoff, a half century earlier, had written her bold, grand declaration: "I Came West," as though the idea, the impulse, and the yearning for the journey had been hers alone, as though she embraced both its pleasures and its dangers in solitary splendor, like a monarch.

• • •

ON AUGUST 15, 1912, the *Amarillo Daily News* announced:

> The City Public School will open Monday, the second day of October . . . [with] a very strong, progressive course of study, marked by the absence of frills and fads . . . The drawing work will be under the supervision of Miss Georgia O'Keeffe, who has the highest degree known to her profession, and who studied in New York and Chicago with such masters as Louis Mora, William M. Chase and Rhoda Holmes Nichols. The authorities believe that the children in Amarillo's public schools have the advantages of the best talent to be secured.

The article went on to explain that Miss O'Keeffe had continued her training at Pratt Institute. The pompous claim to "the highest degree known to her profession" and the fictitious stint at Pratt may have been a fabrication of Alice's, Bement's, Georgia's, or a joint effort by all three. (It might equally have been a fantasy of the newspaper, which was given to hyperbole.) Regardless of its origin, the reality of the fraud was on Georgia's head, and because of a tragic and unexpected incident, she had no moral support in Amarillo. By the time she arrived there, her friend Alice had died of a sudden and virulent fever. Georgia was on her own in the strange, empty landscape.

• • •

AMARILLO DID NOT have a long history: it was first settled in 1887 and was thus exactly Georgia's age. Before the rise of technology, the patterns of settlement reflected a response to the landscape. Towns were formed around sheltering aspects of the land or at crossroads determined by terrain. Settlers were naturally sensitive to natural resources; they built near water and fertile soil. None of this was true of Amarillo.

Set in the center of the Texas Panhandle, the town sprang up out of nowhere. Its site was deep in the flat and barren plains, without trees and with only a bare, unreliable trickle of water—the Amarillo Creek. The last region in the United States to be settled, the Panhandle was known as the Great American Desert. The state did not even bother to lay out the counties in the Panhandle until 1876, because the population was so sparse.

Technology was responsible for the otherwise illogical site of the town: Amarillo marked the intersection of the railroads. The Great American Desert was an easy place to lay tracks, and the great western lines converged there: the Santa Fe, the Rock Island, and the Fort Worth and Denver. Amarillo would become the cattle-shipping center of the world, ranching its major industry.

People did not drift into Amarillo and settle there by chance, as had happened in many western towns; they came deliberately, by train, with some capital. Land was cheap, and many of the buyers were second sons of established families from the East. The settlers were not wild young drifters but people in their forties with resources: huge tracts of land were bought by individuals. There were no building materials available locally—these came, like the settlers, by train.

In 1890 the population was 482, the ranges were unfenced, and the houses were painted a cheerful *amarillo*—yellow, in Spanish. The cattle-shipping business was at its peak. The open land was superb for grazing, and a local saying claimed that "a steer could be raised on the open range for the cost of a chicken."

By 1910, two years before Georgia's arrival, the population was just under ten thousand, and the tone had changed. Economically vigorous, the town had become defensive about its arriviste nature and its provinciality. Anxious for sophistication, it adopted an attitude of assertive propriety. The new two-

thousand-seat opera house reflected the determinedly cultural approach.

The public high school was brand-new and cost sixty-five thousand dollars. "A gem of architectural beauty," it was made of gray pressed brick trimmed with stone and looked like a fortress drawn by a child. It boasted twenty-seven rooms for its students and "every convenience—steam heat, electric light, water and gas."[2] The newspaper described, with characteristic bombast, the educational assault against barbarism. HIGH SCHOOL TO TEACH BIG FOUR, it announced sensationally. The four in question were spelling, English, writing, and arithmetic. This can hardly have been a revelation, but it warranted two long columns in the paper. The article ended with the reassuring assertion that "That splendid public institution, the Amarillo High School, is aggressive and thoroughly wide-awake."[3] Elsewhere it noted proudly that the new members of the faculty were "the best products of the University of Texas . . . and the great art schools of Chicago and New York City."[4]

Georgia took a room at the Magnolia Hotel, on Polk Street where no other teachers stayed. This isolationism was deliberate, and was due not to misanthropy but to healthy terror. Georgia carefully resisted acquaintance with the other teachers because "I didn't want them to know how little I knew!"[5]

The Magnolia Hotel had no magnolia trees, only a pair of spindly, struggling lilacs by the doorway. This was emblematic of the gap between Amarillo's social aspirations and the reality. There was a wilder, looser side to life there, which bore no relation to the social teas chronicled by the newspaper but had a great deal to do with the town's economic vitality.

Despite its suggestion of southern gentility, the Magnolia was a pragmatic establishment, which catered to gold prospectors and cowboys. Cowboys were rough, disreputable, and crucial to the community. Sometimes as many as fifty thousand head of cattle were herded into Amarillo, waiting for loading onto the train to the stockyards. The cowboys brought them on long, slow drives across the plains; for days the herds were visible on the immense flatlands as they approached Amarillo. At night, campfires flared in the deep blackness. When the cattle were at last loaded, the cowboys were released from their responsibilities. They came into the Magnolia Hotel, their lips blistered and puffy from days under the great empty sky and their eyes bloodshot

from the dust. Georgia watched them: they sat down at the table and ordered a dinner, and when they finished, they ordered another. Sometimes they would "eat three dinners, one right after the other."[6]

By staying at the Magnolia, away from other teachers and in eccentric if not actually disreputable company, Georgia aligned herself with the free-spirited and asocial element in the community. The cowboys represented the real life of Texas, the actualities of the landscape, the terrible winds, the overwhelming sky, and the endless herds of cattle. It was perhaps not an intentional alignment but an important one. What Georgia liked about Texas was the physical reality of it: "The wind— I didn't even mind the dust. Sometimes when I came back from walking I would be the color of the road. I was there before they ploughed the plains. Oh, the sun was hot, and the wind was hard, and you got cold in the winter. I was just crazy about all of it."[7]

When Georgia arrived in Williamsburg she had established for herself the fact that she was not obliged to conform to local social mores. She had maintained and strengthened this pattern for herself, and in a place where she knew no one and owed no social debts, Georgia felt little inclination to adjust her own patterns to the rigid propriety that ruled Amarillo.

Georgia was visibly eccentric; she still had short hair, and she "dressed funny." A student, Cornelia Patton Wolflin, remembered: "She dressed like a man. I never saw her in anything except tailored suits. I mean men-tailored suits and oxfords that were square-toed. Her skirt was just calf-length, normal. Her hair was cut just like a man's, short . . . She wore a man's type felt hat."[8] Ladies' fashion was viewed with interest in Amarillo, and a social note in the newspaper commented archly: "The new *pannier* skirt appears to have exerted a hipknotic influence over Dame Fashion." Georgia's obvious indifference to the rules of decorum was faintly alarming, but she looked merely odd, not threatening. She was not confrontational, as her manner made clear. She was friendly, direct, and entirely sure of herself: it was hard for even the primmest and most suspicious types to take offense.

Despite the plaudits of the newspaper, the expensive high school was not quite finished at the start of the school year, and Georgia began the semester teaching out of "a little house . . . on the premises, waiting for the school . . . to be completed."[9] The students found the new art teacher beguiling. "She was a quiet

person. She didn't have to call for your attention. She just looked and she was very quiet," said Wolflin. Although Georgia's academic qualifications had been misrepresented, the most important qualification for a teacher was hers by birth. Personal authority cannot be counterfeited: one has it or one hasn't, and Georgia, at twenty-five, was amply equipped. "She had no trouble with discipline in her class. The children that were cutting up . . . never did that in her class." It was not because of an authoritarian approach, however; Georgia brought to the study of art a clarity and an attention that the students found exhilarating. "Everyone was interested, and she held their interest . . . it was seldom that teachers could completely hold your interest." Her concentration and attention were deep: "She never left you [feeling] 'What am I doing?' We knew what she was doing . . . and she was alert. She was one of the most alert people. She saw everything." [10] It was not only the students who reveled in this process: Georgia remembered her teaching experience with delight. "I wondered why I should be paid for what I was doing." [11]

Her students often brought smaller brothers and sisters to class. "They did that all the time and sometimes to disaster," said Wolflin, but Georgia was unruffled. "I never knew of her being out of order or frustrated. She was very calm at all times."

One of the Dow exercises involved placing a leaf on a seven-inch square, to learn the workings of the relationships between positive and negative spaces, between masses and voids. "There was not a respectable weed, not a leaf," for the children to use, said Georgia. [12] The school had nothing for the children to work with; Georgia had them draw a square and put a door in it somewhere: the children took on the crucial responsibility of dividing space.

Georgia taught her students an approach that embraced their personal lives too. Dow was responsible for her newly defined attitude: "Filling a space in a beautiful way. That's what art means to me." [13] This philosophy meant that all physical choices were aesthetic ones. "I liked to convey to them the idea that art is important in everyday life. I wanted them to learn the principle: that when you buy a pair of shoes or place a window in the front of a house or address a letter or comb your hair, consider it carefully, so that it looks well." [14]

Georgia impressed her pupils with the great pleasures to be taken from art. After school she would sometimes take students

out onto the prairie. Two of them, Horace Griggs and Cornelia Patton, went with her, a donkey carrying their equipment.

> The grass was all over the prairie . . . We . . . were out on the clean prairie with high prairie grass . . . we went out and sat on the grass and sat with our pads and we painted and she would suggest why it would be painted like this and discuss while we were drawing and help us with it . . . we enjoyed it and she enjoyed doing it.[15]

The children responded at once to Georgia's clear, warm current of enthusiasm. "I enjoyed teaching people who had no particular interest in art," Georgia said.[16]

"That splendid public institution, the Amarillo High School," proved to be so "aggressive and thoroughly wide-awake" that a struggle took place between the superintendent and the art teacher. Georgia's predecessor used a Prang drawing book, comprising tedious exercises that commanded obedience but no judgment. Georgia, predictably, found them "rigid and dead"; moreover, the students could not afford to buy the books, and she did not order them for her classes. Instead, she taught that anything might be a proper subject for art. One day a boy rode his pony to school, and Georgia and the youngsters helped the animal clamber onto a table so his shaggy shape could be considered as a problem in aesthetics. The school board predictably preferred textbooks to ponies, and a conflict arose.

In the spring of 1913, the state legislature voted to require the use of the hated textbooks. Georgia went back east for the summer, to assist Bement. She turned down an offer of teaching all year in Virginia, for a higher salary, and returned to Amarillo in the fall. She was furious to discover that the books had been ordered. Georgia dug in her heels and set herself in dead opposition to the entire bureaucracy. She was stubborn, unyielding, and, in the end, persuasive. Her classes did not use the books.

• • •

THE LINES OF the Great American Desert are stricter than those of the Wisconsin plains: there are no gentle curves, no softenings. The Texas Panhandle is ineluctable. The landscape itself is vast, and the sky is enormous: an extravagant blue waste the mind cannot easily encompass. And the low, blank horizon, insisting

on emptiness and space, suggests the lack of limits: it is at once exhilarating and unsettling.

Far from being threatened by the open space, Georgia's soul expanded blissfully into it. She felt nothing but relief: "The openness. The dry landscape. The beauty of that wild world." [17] Georgia had chosen, early, the kind of shelter she wanted. The dollhouse she had designed was movable and had no walls.

In that wide flatness, there was nothing but soft grass and weather. The sunrise and sunset were enormous, spectacular, panoramic events. The wind swept, uninterrupted, down on the plains, scouring and blasting relentlessly. "To see and hear such wind was good," Georgia wrote. Nowhere was more extreme a landscape; nowhere was there more distance, more sky, or more light. Georgia exulted.

During the winter of 1912–13, Dannenberg was still writing Georgia from Paris. On Mardi Gras he wrote:

> Already the streets are filled with music and dancing . . . In a few days I am going south on the Riviera and later, in the early summer, to America, and I hope to Virginia . . . I have plans ahead that cannot fail to materialize, they are so clear. The Georgia O'Keeffe that I appreciate exists only for me. You will realize it when you are forty. The frank, simple truth will easily disintegrate that funny little shell of doubt and uncertainty that you love to crawl in and out of. Sometime I shall prove to you what I mean. [18]

But though Georgia had once entertained the idea of being in Paris with Dannenberg, in choosing Texas she had chosen another path, and it did not lead to Europe.

• • •

THE SUMMER AFTER her first year in Amarillo, Georgia returned to Charlottesville, this time as Alon Bement's assistant, not his pupil. Her sister Anita signed up for Georgia's class, a gesture that reflects the trust, respect, and affection that existed among the O'Keeffe children. It had been Anita's idea to go to the university classes in the first place, and she might well have felt resentful that her sister, last year a pupil beside her, was now at the front of the room giving instruction. But the girls were generous with support and affection for each other, and Georgia's recollection supplies the counterpart to Anita's trust:

[Anita] was the one I thought had the real talent. She was my pupil at the University of Virginia, and I always tried to get her to let go. But she was always rather timid about her paintings. She had no fear about contact with people. It was just the paintings.[19]

The summer's teaching was successful, and Georgia repeated the pattern the following year. In the fall she returned to Amarillo, and she spent the next summer, 1914, teaching again in Charlottesville. But by then she was ready to make a break in the pattern. Alon Bement had urged her to return to New York and get her teacher's degree at Columbia Teachers College, where he taught. Georgia refused: she was caught up in the private world she had discovered in Texas, and besides, there was no money.

Georgia's plight paralleled that of the young woman in *A Room of One's Own*, written a decade later. Just as Virginia Woolf's young woman could not have pursued her career in writing without the modest fortune from her maiden aunt, so Georgia could not have continued her artistic education without the unexpected generosity of her aunt Ollie.

Aunt Ollie's gift reflected both the Tottos' strong commitment to education and a deep sense of familial support. As her sister Ida was slowly dying, Ollie offered her a vicarious gift, to expand the family, to extend Georgia's experience, to keep the Tottos alive, vigorous, and out in the world.

The O'Keeffe family was still in the brick house on Wertland Street, but they had not become a part of this community as they had, eventually, of the one in Williamsburg. A neighbor, Ethel Holsinger, said severely, "Everybody in Charlottesville who knew each other stuck together. We didn't know the O'Keeffes."[20]

The boys were away: Francis was studying to become an architect and Alexis to be an engineer. Between 1913 and 1916, Frank had abandoned the creamery; the community may have been reluctant to buy milk products from a man whose wife was tubercular. Frank found work as a construction inspector for a government agency. This meant spending much of his time traveling, but it also meant a steady income.

Georgia's plan to continue with her education was not considered to be a desertion of the family. The children were ex-

pected to carry on with their lives. Anita was planning to go into nurse's training, and Ida was still at home to help their mother with the younger girls. Ida took on the responsibility of nursing her mother (she later became a professional nurse).

Twice before, Georgia had set out from home with high hopes to study art. In the fall of 1914 she set off for the third time, with a new store of self-confidence and a theoretical premise that gave her a new view of art. She was at last equipped to take on her work.

10

The artist must be blind to distinctions between "recognized" or "unrecognized" conventions of form, deaf to the transitory teaching and demands of his particular age. He must watch only the trend of the inner need, and harken to its words alone.

—WASSILY KANDINSKY,
Concerning the Spiritual in Art

THE ART WORLD had changed dramatically since Georgia had last been in New York, in 1909. With the notorious International Exhibition of Modern Art (the Armory Show) in February 1913, American artists had declared their independence from every single tenet of classical theory. Color, form, technique, and intent were all given startlingly new interpretations, in styles that were as vehemently radical as the artists could make them.

The spirit of unrest was widespread. There was no one school of dissent, and groups formed and dissolved as shared interests and convictions flared and faded. The early group of radicals, The Eight— Robert Henri, John Sloan, George Luks, William Glackens, Everett Shinn, Maurice Prendergast, Ernest Lawson, and Arthur B. Davies—formed in 1908, was united more by opposition to tradition than by shared allegiance to a new approach. Their radicalism was manifested primarily through their subject matter.

George Luks, one of the most flamboyant of The Eight, was an unrepentantly arrogant figure, who made the pronouncement: "The world has but two artists, Frans Hals and little old George Luks."[1] His work combined reactionary and revolutionary elements. Although his style reflected his training in Munich, his imagery was stridently modern, even offensively so. From a working-class background, Luks was violently anti-intellectual and anti-genteel. In contrast to Chase's elegant upper-class vignettes, Luks presented lower-class life on back streets. "Guts! Guts! Life! Life! I can paint with a shoestring dipped in pitch and lard," he bragged.[2] Henri and Sloan shared his interest in the egalitarian vigor of the back streets, though they all used the Munich brush stroke, which reflected relentlessly the European "autocratic and aristocratic" tradition.

William Merritt Chase was ideologically opposed to the modernist movements. He voiced his disapproval of the narrative content in Henri's work, for example. Much of Henri's painting does make a direct appeal to the sympathies of the viewer and therefore imposes a framework of sentimentality on the subject, but Chase's disdain probably stemmed equally from the nature of the subject matter, which he found distasteful: some of the radical realists had been dubbed the "Ashcan School," because of the mildly squalid scenes they chose to portray.

Chase had responded appreciatively to Stieglitz's photography exhibitions and encouraged his students to visit "291." But according to Stieglitz, when he came to see the Rodin drawings —loose, simple scrawls of naked women— Chase was incensed. He demanded to know how Stieglitz thought the Rodin drawings would affect his students, implying that the influence, from such depravity, could only be pernicious. Stieglitz answered that the exhibition was put on entirely for the benefit of the students. He implied that it was he, Stieglitz, who had the best interests of the students at heart, not Chase. Enraged, Chase smashed his glossy silk hat down violently on the table, destroying it. Announcing that he would never set foot in "291" again, he departed forever, with his ruined hat.

(This was Stieglitz's version of the incident. Many of his anecdotes followed a similar pattern: an overwrought response by a philistine, with Stieglitz victorious. Georgia, on the other hand, remembered that all the teachers at the league had urged

the students to see the Rodin drawings. It is worth noting, too, that most high silk hats were fitted with an ingenious spring mechanism, so that they would collapse into black pancakes at the opera. To smash one on a table might serve as vehement punctuation, but it damaged the hat not in the least.)

The Eight had exhibited at the Macbeth Gallery in 1908, establishing an alternative to the strictly governed National Academy shows. Their loose organization did not last long, but the exhibition encouraged the growing sense of insurgency in American art. In 1910, The Eight organized the larger "Exhibition of Independent Artists," which included Rockwell Kent, George Bellows, and other realist renegades. All these artists challenged the academic tradition and reflected the strong revolutionary spirit that was gathering force.

The Eight were in opposition not only to the aristocratic Chase and his circle but also to Stieglitz and his group. The Eight and the radical realists derived their European influence largely from the Munich school, which was traditional and academic. They demonstrated their revolutionary attitude by their choice of subject matter, which they felt should reflect the consciousness of the individual artist. The Stieglitz circle was influenced largely by Paris, where they had encountered the concept of abstraction —fundamentally a far more radical notion and one that made the concept of subject matter virtually meaningless.

The two approaches shared a passionate belief in the individual's right to self-expression. The realist group celebrated the common man; the Stieglitz group celebrated the right of the individual to break down theoretical barriers. Beyond this shared territory, however, the two approaches diverged and could be characterized as egalitarian and elitist. Ironically, it was Stieglitz —devoutly democratic—whose art was elitist. The concepts he espoused resulted in work so demanding that it was accessible only to an esoteric coterie of intellectuals. This philosophical ambivalence between his genuine egalitarianism and his aesthetic snobbery would plague him for the rest of his life.

Stieglitz had been showing innovative paintings since 1907, when he began to shift his focus from photography to the other media, and the exhibition of Rodin watercolors had evoked vehement responses, as Chase's smashed hat demonstrated. On the other hand, the critic Arthur Symons reacted differently:

In these astonishing drawings from the nude we see woman
carried to a further point of simplicity than even in Degas:
woman the animal; woman, in a strange sense, the idol.
Not even the Japanese have simplified drawing to this
illuminating scrawl of four lines, enclosing the whole
mystery of the flesh. Each drawing indicates, as if in the
rough block of stone, a single violent movement. Here a
woman faces you, her legs thrown above her head; here she
faces you with her legs thrust out before her . . . she squats
like a toad, she stretches herself like a cat, she stands rigid,
she lies abandoned. Every movement of her body, violently
agitated by the remembrance, or the expectation, or the act
of desire, is seen at an expressive moment. She turns upon
herself in a hundred attitudes, turning always upon the
central pivot of the sex . . . It is hideous, overpowering,
and it has the beauty of all supreme energy. And these
drawings, with their violent simplicity of appeal, have the
distinction of all abstract thought or form. Even in Degas
there is a certain luxury, a possible low appeal, in those
heavy and creased bodies bending in tubs . . . But here
luxury becomes geometrical; its axioms are demonstrated
algebraically.[3]

Symons grasped the strengths of abstraction before it had
actually burst upon the art world, and his appreciation of the
drawings showed the sensitivity to line and intent that Stieglitz
so prized.

The last line of Symons's essay reflects a curious phenome-
non that then was taking place. "But here luxury becomes *geo-
metrical;* its axioms are demonstrated *algebraically.*" Although he
is dealing with subjective issues, Symons insists on the gratuitous
insertion of geometry and algebra in an attempt to create a scien-
tific tone. This attempt to ally subjective response with cold logic
was a characteristic of a period in which science, religion, and art
performed a strange interchange of functions and identities.

Important to the philosophical insurgency of the period was
the diminution of religious faith in intellectual circles. As new
philosophical ideas loosened the bonds of conventional religion,
religious dogma took on the character of unenlightened supersti-
tion. Simple faith seemed unsophisticated, and intellectuals

moved away from conventional religion toward other systems of abstract thought.

Science was one such system that attracted the growing ranks of atheistic and agnostic minds. Recent discoveries, such as the theory of relativity, Freud's charting of the unconscious, quantum physics, and the analysis of the atom, suggested a power, logic, and breadth that made science glamorous and potent. With its ineluctable laws based on pure reason, science seemed capable of providing the basis for new ethics and a new morality.

An intellectually fashionable attribute, "scientific" was used in remarkably inappropriate situations. Symons's odd conjunction of geometry, algebra, and the lyric Rodin nudes was one such example; there were many others. In a letter discussing his own efforts to present the idea of photography to the public, Stieglitz wrote: "I had felt that you might have some conception of my method in trying to establish, once and for all, the meaning of the idea photography. I have proceeded in doing this in an absolutely scientific way." [4] Stieglitz did undertake this project with great concentration, energy, and intelligence; there was, however, no hint of the scientific in his methods, which were throughout his life purely instinctive. But the example demonstrates the respect that intellectuals had for scientific methods and for processes governed by abstract laws.

During this period, Stieglitz was unquestionably the primary and most significant connection between the French and the American art worlds. Although he had been introduced to the new work by Steichen, he had made his own commitment to modernism. Fauvism, cubism, abstraction, Orphism, and the newly discovered African sculpture were all represented in his gallery. Stieglitz had a remarkable eye. Every single artist he showed did not prove to be a modern master, but his record demonstrates an amazing instinct for discovering and celebrating the great work being done during this period.

In 1908, besides showing the controversial Rodin watercolors, Stieglitz gave Matisse his first American exhibition. In the 1910–11 season, he gave both Picasso and Rousseau their first one-man exhibitions anywhere. He was the first in the United States to show Rodin, Cézanne, and Toulouse-Lautrec.

In 1910, Stieglitz continued to break aesthetic ground, with

an exhibition called "Younger American Painters in Paris," which included Arthur Dove, Marsden Hartley, John Marin, Alfred Maurer, and Max Weber. The French artists whom Stieglitz had shown were esteemed by the European cognoscenti, but these Americans were unknown quantities. Stieglitz was creating an American school of modernists, painters who were influenced by French ideas but producing American work: it was an important moment in the history of American art.

The realist show of 1910 had not included Stieglitz's artists, and the "291" shows included none of the New York realists. There existed an undeclared rivalry between the two groups, who were both outside the academic arena, each claiming leadership for the progressive movement in the arts. Despite the rivalry, the radical ideas presented by Stieglitz created influential cross-currents that reached the realists.

The spectacularly controversial Armory Show of 1913 included a wide representation of European modernism. It was organized by Walt Kuhn and Arthur B. Davies, both committed realists who nevertheless had become convinced of the importance of the revolutionary European ideas. Though Stieglitz was not active in organizing the show, the influence of his activities during the preceding years was crucial, and the introduction of European ideas into the mainstream of American art should properly be credited to him.

The Armory show was a dramatic culmination of the revolutionary movement. The exhibition opened on February 17, 1913, at the Sixty-ninth Regiment Armory on Lexington Avenue. It consisted of about thirteen hundred works. Three quarters of these were American, selected by the Impressionist William Glackens. The European works were largely French: Picasso, Matisse, Brancusi, Duchamp, Léger, Picabia, Braque, and Maillol. Kandinsky and Lehmbruck were also included; the Italian futurists were not, and the German expressionist movement was thinly represented. The show was intended to demonstrate the development of European art since the Romantic period, and it included Delacroix, Ingres, Corot, Courbet, and the Impressionists and Postimpressionists. Despite its intention, which was instructive, not combative, the press and the public perceived the show as a wildly insulting gesture. There were threats of violence, and public officials called for the closing of the exhibition because of the menace it posed to the public morals. "Pathologi-

cal" was how the *New York Times* described it,[5] and Royal Cortissoz, *doyen* of the critics, pronounced: "This is not a movement and a principle. It is unadulterated cheek."[6] Regardless of how the public felt about the new art, it could no longer be ignored. In contrast to the tiny backstairs premises of "291," the immensity of the Armory Show made the bizarre new products of modernism highly visible. The show toured to Chicago and Boston, and a quarter of a million people paid to see it. The new art had become part of the public consciousness. Whether the public characterized it as outrage or revelation, the knowledge of it had come into being and could not be dismissed or denied.

The result of all this was, just as Sir Casper Purdon Clarke had warned in 1908, a state of delirious unrest. New ideas were everywhere, and centuries-old beliefs were challenged in an exuberant spirit of freedom. It was an exhilarating moment to be in art school in New York.

• • •

GEORGIA ENTERED Columbia Teachers College in the fall of 1914, a year after the Armory Show. An atmosphere of daring and triumph still permeated the art world. The barriers were broken down, and Georgia felt an immediate empathy with the prevailing mood. During this year in New York, she lived by herself, in a small, simple, four-dollar-a-week room. A geranium in a pot on the fire escape pronounced a single flaming note of red. She was now twenty-seven years old and in a very different state of mind from that of seven years earlier, when she had studied at the Art Students League. Then there had been a sense of ample funds and time; now there was a limited supply of both. Aunt Ollie's money would give her only a year, and there was no more family money. Georgia was now a grown woman, with a growing certainty of her goals. Still not sure of how her life should go, she was increasingly sure of how it should not. Her sense of concentration and focus had increased. "There was something insatiable about her, as direct as an arrow, and completely independent," wrote a friend who met her then.[7]

The friend, Anita Pollitzer, was a beguiling young woman of great energy and warmth. Small, dark-haired, brown-eyed, and pretty, Anita was seven years Georgia's junior, the daughter of a cotton broker from South Carolina. The Pollitzers were an educated, upper-middle-class Jewish family, and Anita's mother, re-

markably for her generation, had graduated from Hunter College in New York. Anita was the youngest of four children and "the darling of the family." Bright, vivacious, and precocious, she was full of self-confidence and enthusiasm. At that time a college degree was still unusual for a woman of her background, and her presence at Columbia demonstrated Anita's energy and intellectual determination. Like Georgia, Anita was studying to be an art teacher, though she had equally compelling interests in other areas.

Anita was greatly absorbed in the "New Art" and was a frequent visitor at "291." Stieglitz remembered her at a Picasso exhibition: "radiant, a hundred percent alive, intelligent, unafraid of her own emotions."[8] Georgia remembered Anita as "a girl with very long hair, who . . . carried everything haphazardly under her arm—brush and comb, poetry books, notes . . . she usually had paint on her face and hair . . . a very lively, very interested little person."[9]

That winter at Columbia, the two young women saw a great deal of each other. In spite of their growing friendship, they followed the conventions, formally calling each other "Miss Pollitzer" and "Miss O'Keeffe." They would not become intimates until the following summer, when Anita took it upon herself to begin a correspondence. A friend of Georgia's from her year at the Art Students League, Dorothy True, joined the pair: they all took a drawing class from Charles Martin. The trio were given advanced status and allowed to set up a screen in the corner of the studio, where they drew what they wished, while lowlier students toiled away at the plaster casts from the antique. Martin was young and appealing, with flaming red hair and irresistible blushes. Georgia and Anita presented him with a gift at the end of the year, a copy of the Rodin issue of *Camera Work*.

Georgia did two small monotype portraits of Dorothy True and Anita Pollitzer during this period. Anita said enthusiastically, "Your monotype that you did of me is a masterpiece!" and referred to a portrait of True, exhibited in the fall of 1915, with "It's that one of Dorothy with the very red hair."[10] *Lady with Red Hair (Dorothy True?)* and *Unidentified Portrait of a Woman (Anita Pollitzer?)* may be those pictures, though the identification is conjectural. Whoever the subjects, the work shows no influence yet of the revolutionary French ideas. The one of True relates to the French poster movement, in its use of bold, flat color fields and

simplified outlines. The picture of Pollitzer shows strong influence both from symbolist painting and from pictorialist photography, with its diffused lighting and dissolving form.

• • •

GEORGIA ENTERED the college as a candidate for the Bachelor of Science degree in fine arts education. Her record shows that she continued in her serene disregard of subjects that did not interest her: she received a C in "The Principles of Teaching" and a D in English. With two years of teaching experience already behind her, Georgia ignored instruction in that direction: she was there to study art, and at that she excelled.

Outside Teachers College, Georgia plunged into the absorbing and stimulating New York art world. Not only the new art: Arthur Dow had traveled on a painting expedition to the Far West, and his paintings of the Grand Canyon were shown at the Montross Gallery in 1914; both Anita and Georgia saw them.[11] That year, "291" showed the works of Constantin Brancusi and Francis Picabia, and in December and January, Georgia made trips to the gallery to see the drawings by Braque and Picasso. The two painters "were so similar in that period that you could hardly tell which was which." The work did not strike an immediate response in Georgia: "I looked at it a long time but couldn't get much."[12] Still, the concept of abstraction was gaining force and momentum. She did not absorb it directly from these works, but "something was in the air. You pick up ideas here and there."[13]

In the spring, she and Anita went to the John Marin exhibition. Marin was another of Stieglitz's chosen artists, an American who had worked in Paris. His show in the spring of 1915 consisted of forty-seven works—skyscrapers, landscapes, and seascapes in watercolor and oil, among them his dynamic and exuberant *Woolworth Building*. The work reflected the influence of both the cubist and the futurist schools; Marin's forms were fragmented into insubstantial planes, and their interrelationship manifested the explosive energy inherent in futurist works. Georgia was drawn to his paintings. "I'd like to know him," she wrote Anita the following year. "Do you remember that little blue drawing that hung on the door . . . I was crazy about the Woolworth [Building] flying around—falling down."[14]

Georgia had still made no personal connection with Stieglitz.

When the two women visited the Picasso show, Stieglitz had been struck by Anita. Like him, she was outgoing and gregarious; they both delighted in conversational encounters and skirmishes. Like him, she was at heart a proselytizer and welcomed the challenge of conversion and the exchange of ideas. She had made an impression on him; when she wrote him the following summer, asking him to send a copy of *291* to Georgia, his response made clear that his recollection of Anita was vivid, that of Georgia less so. When Anita wrote shyly that she was not sure if he remembered her, his answer was reassuring: "I can see you among your friends." His reference to Georgia, however, is purely formal: "I am sending the Number Four of '291' to Miss O'Keefe [*sic*] as you directed. Of course I am always pleased to hear from my young friends."[15]

Unlike the gregarious Anita, the quieter Georgia made her trips to the gallery unnoticed. She found Stieglitz daunting and his pugnacious style utterly unlike her own manner. She had been unhappily struck by his behavior during the Rodin exhibition:

> I very well remember the fantastic violence of Stieglitz' defense when the students began talking with him . . . I had never heard anything like it, so I went into the farthest corner and waited for the storm to be over.[16]

When the two women went together to the gallery, Stieglitz started talking to Anita. Georgia recalled that he asked "such personal questions that I backed away, thinking, 'That isn't for me. Let them talk if they want to.'"[17] Her attitude was not unique; Dorothy True refused categorically to go into the gallery with Anita. Georgia's trips to "291" continued to be anonymous. Although she found Stieglitz personally unsettling, she was deeply impressed by the work he was doing for artists. He was continuing to show the work of Europeans but also supporting and encouraging American artists. He was innovative and courageous in exhibiting the work of relatively unknown talent. For both young women "291" represented an ideal of intellectual freedom, artistic encouragement, and absolute commitment.

Stieglitz challenged social as well as aesthetic conventions. He had consistently shown the work of women artists—both photographers and painters—throughout his career. His warmth and intense interest in the attractive young women he met would

recurrently result in confusion between aesthetic and romantic interests. Nevertheless, Stieglitz's interest in women and their work was genuine. He manifested none of the condescension that was so prevalent in a patriarchal society. Georgia had encountered this vividly in Eugene Speicher's taunt; it permeated the world of art. Stieglitz's attitude of professional attention to women's work was to be crucial to Georgia. It would validate her own efforts in the real world and establish the possibility of professional equality between the genders.

After the Braque-Picasso exhibition, Stieglitz showed the works of two young women, Marion H. Beckett and Katharine N. Rhoades. Both artists disappointed Georgia, and in fact, they were not among Stieglitz's great discoveries. It was the first and last show either woman had at "291," and the incident may have been an example of confusion between personal and professional appeal. Beckett, Rhoades, and a third friend, Agnes Ernst Meyer, all regular members of the "291" group, were known at the gallery as "The Three Graces." There was a romantic interest between Marion Beckett and Steichen.[18] Katharine Rhoades was fine-boned and beautiful, and Stieglitz's relationship with her does not, apparently, bear examination, for his letters to her during this period are still, some seventy years later, withheld from the eyes of the world.

• • •

ALTHOUGH ARTHUR DOW's ideas had been crucially important to her through Alon Bement and Dow's books on composition, which she had used as a teacher, at Columbia Georgia was experiencing her first exposure to the man himself. Her response was unencumbered by reverence, and she wrote Anita:

> Certainly Mr. Dow is a sweet old man. He is so nice that he puts my teeth on edge at times. But I will admit he is nice even when I want to slap him on the back and say "wake up old boy . . . don't let them feed you too many sugar plums." In that color class I used to nearly go crazy . . . they all flattered him so much . . . and I was liking such snorting things that his seemed disgustingly tame to me.[19]

It was Bement who continued to act as an intellectual mentor, plunging her deeply into the philosophical turmoil of the period. Georgia respected him as a guide, though not as an in-

structor. She looked at what he told her to look at and ignored what he told her to paint. Georgia did not take any of Bement's classes at Columbia, but she saw a good deal of him. One day, walking outside his classroom, she heard phonograph music inside, and, intrigued, she investigated. Bement was playing an odd low-toned piece for his students and asking them to interpret the sound in a drawing; next he did the same with a soprano piece. The notion interested Georgia at once: the exercise encouraged the unconscious mind to take control; it also emphasized the affinity between the abstract nature of music and that of art. Music and art were the two great pleasures of Georgia's life, and the idea of direct transliteration from one to the other appealed to her greatly.

It was Bement who suggested that she read Wassily Kandinsky's *Concerning the Spiritual in Art*, published in 1914. Kandinsky's seminal essay, which she read more than once, had a profound influence on Georgia.

Art, like science, was an abstract system of ideas that attracted intellectuals who were dissatisfied with conventional religions. All three systems—art, science, and religion—demanded a personal commitment to an impersonal code of values. Religion, of course, was morally highly charged. Science, though materially beneficial to mankind, was seen as morally neutral. Art had been, historically, an integral part of Western religion but had, over the past three centuries, become increasingly secularized. By the turn of the twentieth century it had reached a stasis. The images of that period were innocent of moral concerns; they were primarily a celebration of material pleasures. The voluptuous biomorphic patterns of Art Nouveau moved steadily toward the decorative, avoiding moral engagement, and in fact tending toward moral sterility. By the time Kandinsky wrote his thesis, art had become entirely discrete from the life of the spirit, a situation he sought to redress.

Kandinsky presented art as a moral system and endowed it with the attributes of a religion. In this, virtue is defined by a passionate commitment to a transcendental faith, the goal of which is the spiritual rehabilitation of mankind. The ideological dichotomy that Kandinsky created placed art/spiritualism in opposition to the creed of materialism.

The transformation of the modern world by technology and capitalism was seen as pernicious: "The nightmare of materialism

. . . has turned the life of the universe into an evil, useless game."[20] This was, generally speaking, the response of the German artists. (Although Kandinsky was Russian, he was working during this period in Germany, where he was a vital member of the artistic community.) While the French were concentrating on physical reality and maintaining a cool, cerebral point of view, German artists were taking the opposite tack and seeking an inner reality that bore little relation to the tangible world.

Germany had not become a unified nation until 1870; as a result of its late start, it had undergone a rapid transition and therefore experienced drastic feelings of psychological dislocation. The artistic community was particularly oppposed to the modern order—a rigidly structured centralized government, the emphasis on materialism, and the exaltation of logic. The artists of *Der Sturm, Die Brücke,* and *Der Blaue Reiter* continued the anti-mechanistic trend expressed by the earlier *Jugendstil.* The antitheses of materialism and logic—spirituality and intuition—became popular.

Kandinsky and the German artists examined the inner world of the soul. Passionate intensity and lyric strength were their goals. Their warm, bright, deliberately naive compositions celebrated the emotions and explored the intuitive unselfconscious appeal of children's, folk, and ethnic art. They believed that "all 'true art' shares a spiritual power unrelated to learned skills."[21]

Kandinsky saw the artist as a new leader of the faithful, whose task was the spiritual revitalization of mankind. Religious overtones began to figure in writing about art as the century progressed, but Kandinsky was one of the first to make a direct correlation between the two systems of thought.[22] By declaring art a faith, Kandinsky identified the artist as a priestly figure, whose task is transformed from a private, solipsistic one to a solemn and transcendental labor, enlarged and enhanced by the responsibility to mankind. Kandinsky drew the artist into a morally committed community and called his work saintly.

Kandinsky's assertion on a passionate commitment was revitalizing to the modern artist. As well as challenging the cool cerebral theories of the French, this attitude flouted the ethics of the *fin de siècle* aesthete: the artist as a languid, disaffected creature reclining on a silken divan. "The artist must have something to say," Kandinsky declared, "for mastery over form is not his goal but rather adapting of form to its inner meaning."[23]

Interestingly enough, Kandinsky's commitment to abstraction in this essay is not quite complete: he totters on the brink. "Nowadays we are still bound to external nature and must find our means of expression in her." His attitude is courageous, however: "But how are we to do it? In other words, how far may we go in altering the forms and colors of this nature? We may go as far as the artist is able to carry his emotion."[24]

Despite his incomplete allegiance to abstraction, Kandinsky's advice to artists clearly supported and validated the abstract movement, which destroyed the rigid codes of academic and realistic tradition.

Stieglitz was German by background and by temperament, and his response to Kandinsky's position was instinctive and absolute. He published an extract of the essay in 1912, in *Camera Work:* its denunciation of materialism and its earnest exhortation to seek inner truth matched his own inclination exactly. The role of the aesthetic guide and spiritual mentor also suited him very well.[25]

In spite of the number of American artists who traveled to Paris, and in spite of the exhibitions that championed its cause, cubism had remarkably little lasting effect upon American painters. Part of this is due to Stieglitz's own lack of sympathy with a cerebral, analytical approach. When Kandinsky produced an alternative approach, similarly radical aesthetically but based on spiritual values rather than analytical processes, Stieglitz espoused it wholeheartedly.

This exhortation to artists, urging them to create according to their own spiritual dictates, could hardly have been more welcome to Georgia, who was trying to evolve a form and style of her own. She was by now a virtuoso at technique; it was content that had not yet declared itself in her work. Helpful in this process, however, was Jerome Eddy's book *Cubists and Post-Impressionism.* Bement told her to look at the pictures in it: there she saw reproduced a painting by Arthur Dove, *Leaf Forms.*

This was Georgia's first exposure to Dove's work, and her response was immediate and sympathetic. This was unsurprising, for Dove's philosophy nearly exactly matched her own. He had gone to Europe in 1908. In Paris, Dove had been exposed to the radical new theories, but he had not been swept up into them. His response was quiet, thoughtful, and independent. In 1909 he

returned home and, characteristically, retreated to the woods, where he spent weeks camping alone. In 1910 he had produced what were probably the first purely abstract paintings in the world, a series of strong, self-assured compositions, done before Kandinsky had reached the point of purely nonobjective work. His work had appeared in Stieglitz's "Younger American Painters in Paris" show.

Dove's commitment to the natural world was deep and vital, and his aesthetic responses were more spiritual than intellectual. This found a strong echo in Georgia's developing aesthetic philosophy. Dove's work validated her own inclinations, and though she knew nothing of Dove's background when she saw the reproduction of *Leaf Forms*, she sensed the deep affinity between them.

• • •

THE "291" GALLERY continued to be a symbol of the liberating spirit of the new art, and Georgia was beginning to know Stieglitz the man as well as his work. Stieglitz's attitudes were bold and unconventional, and just what Georgia needed. He felt nothing was sacred, not even the art he hung himself. On view during the Picasso-Braque show was a large and enigmatic object balanced on a pedestal: a handsome wasp nest, complete with bits of branches.

That spring, before she left New York, Georgia went to the gallery for a last look. "The last time I went up to 291 there was nothing; on the walls—chairs just knocked around—tracks on the floor—and—talk behind the curtains. I even liked it when there was nothing." [26] What Georgia liked was the sense of a creative presence—something she possessed herself.

Georgia's presence had made a great impact at Columbia Teachers College. In a letter of recommendation, Arthur Dow described her as "one of the most talented people in art that we have ever had." [27] She was a favorite in all her art classes: Mr. Martin let her sit behind the screen and draw what she liked, Miss Comell put one of Georgia's designs on display in her glass case, Mr. Bement's admiration was well known.

The year was an important one for Georgia, a year of liberation and rising power. She was twenty-eight years old, skillful, sensitive, increasingly sure of herself, and rife with new ideas. She was radiant with energy and enthusiasm, and her potency

was visible, nearly tangible. Anita wrote Georgia at her new place the following fall: "Overhaul and renovate the college like you did at T[eachers] C[ollege] last year—but you can't help it."[28] Georgia could not.

11

But how impossible it must have been for them not to budge,
either to the right or to the left. What genius, what integrity
it must have required in the face of all that criticism, in the
midst of that purely patriarchal society, to hold fast to the
thing as they saw it without shrinking.

<div align="right">

—VIRGINIA WOOLF,
A Room of One's Own

</div>

DURING THE SUMMER of 1915, Georgia taught again at the University of Virginia with Alon Bement. In June she received a chatty letter from Anita Pollitzer: "Dear Miss O'Keefe [*sic*], I feel just like writing to you . . . I don't know where you are or anything like that of course but U.S.A. will reach you I suppose."[1] Anita's ebullient, confiding tone established her at once as a sympathetic presence. Art was of central interest in the letter. Anita had gone to "291" to buy an old copy of *Camera Work:* "it was an old Rodin number—the most exquisite thing you can possibly imagine— Oh I wish you might see it."

Anita's warmth and candor elicited a similar response from Georgia, who wrote back: "Dear litttle Pollitzer— Don't you like little spelled with three t's—but you are little you know and I like you little but I also like you a lot. I can't begin to tell you how much I enjoyed your letter—write me another—won't you?"[2]

In August, Anita wrote her: "Dear Pat— Mayn't I snitch Dorothy's name for you—it's the only thing that fits, and I do

love it so."[3] Georgia answered: "Dear Anita: Thank you for calling me Pat. I like it— It always seemed funny that we called each other Miss."[4]

It was during this first summer that Georgia began sending her work to Anita. She felt a need to dispose of the things she had done, and the physical act of dispersal freed her: "I'm awfully glad those drawings are gone— I like to feel that I am rid of them— It seems to give me more breathing space."[5] She was, however, ambivalent about the process: though she wanted response, the work was so personal that its exposure was painful.

> I feel bothered about that stuff I sent Dorothy. I wish I hadn't sent it. I always have a curious sort of feeling about some of my things— I hate to show them— I am perfectly inconsistent about it— I am afraid people won't understand —and I hope they won't—and am afraid they will . . . they are at your mercy—do as you please with them.[6]

Georgia's summer was full: besides teaching, she was working steadily on her own. She was doing portraits and flowers; one of the portraits was of her sister Catherine, then twenty.

As an economy measure, Catherine's portrait (which is on board) was painted on the reverse of another picture, produced while she was doing commercial work for advertising agencies. The latter is singularly undistinguished, done in a facile Art Nouveau style, and depicts a young woman with long swirling hair seated on a hillside. Georgia, embarrassed and scornful about the picture, gave Catherine her portrait on the condition that the reverse never be shown. The picture of her sister shows a strong Fauvist influence: it is boldly executed with a painterly brush stroke and exotic "Let them all be damned" colors: the hair, for example, is purple. Catherine had no use for purple hair—this was "more of Georgia's crazy notions." She kept the picture, however, and had it framed later, in Wisconsin. The framer exposed the long-haired advertisement, which he preferred, and hung it in his shop. Georgia, needless to say, was enraged.[7]

Art was not the only interesting element of her life, however:

> So far the events of the summer have been week-end camping trips and long walks and a very good friend—an interesting person is always a great event to me—you mustn't tell Dorothy because she always imagines things

and there is nothing to imagine. The good friend is a professor of Political Science here and at Columbia—and he is even very much interested in new Art.[8]

Arthur Whittier Macmahon, born in Brooklyn and raised in Lyndhurst, New Jersey, was a political science scholar, a prize-winning orator, a member of Phi Beta Kappa, and valedictorian at his graduation from Columbia University in 1912. He received his M.A. at Columbia the following year. His yearbook characterized him as "a man of fine presence, dignified personality, high thinking and sound words."

Macmahon came from a background of education and free thinking: his father, Benjamin, graduated from Trinity College, Dublin, and was a Christian Socialist. Arthur's mother, the former Abbie Duke, was a strong-minded, intelligent woman, active in the women's suffrage movement.

Besides politics, Macmahon had a great love for the outdoors, and that summer he took long cross-country hikes in the mountains around Charlottesville. In July he wrote to his mother about a weekend camping trip taken by a group that included Georgia. These trips were planned casually, with minimal equipment; anyone was welcome who enjoyed the rigors and beauties of the climb. After summer school was over, Arthur stayed on in Virginia an extra four days, "just for some extra walks." These excursions seemed to be taken mostly with Georgia.

Georgia wrote to Anita after Macmahon left. "We had a great time. I have almost a mania for walking and he did too so we just tramped—and tramped and tramped. He gave me so many new things to think about and we never fussed and never got slushy so I had a beautiful time and I guess he did too."[9] Georgia's pleased report that Macmahon "never got slushy" reflects her wariness of romantic encounters—a far cry from the Chatham yearbook's prediction that at twenty-seven a woman's ambition would be "anything in trousers."

Three years Georgia's junior, Arthur was energetic, articulate, and also, according to Anita Pollitzer, "nice looking—desperately good-looking in fact."[10] In spite of the successful avoidance of slush, an attraction had been established between Arthur and Georgia.

Arthur had come to Virginia with a trunkful of books to use for his courses. When he left, at the end of August, there was

some complication concerning the trunk's shipment back to New York. Georgia looked after it for him and wrote to tell him so. The letter included a description of an early walk, a book she'd been reading, and conversations with her sister Claudie. It also contained an admission: Georgia confessed that the trunk's shipment had been an excuse, though a legitimate one, for her to write a letter to Arthur.

Georgia's decision to write first was, in its context, a bold one. For a woman to take the initiative was for her to step outside the code of feminine behavior. Georgia was aware of this, and she felt the need to explain herself: "I just had to tell you about the box—and of course I wanted to say more—but to be perfectly honest— I started not to—then I thought no—that would be playing a game—and games don't interest me like they do most women. I want to write you so I will." [11]

Georgia was aware that she was putting herself at risk. Her fear of rejection was strongly present, and the knowledge that she was treading forbidden paths. In her next letter she expressed relief that Arthur's response had been warm and uncritical, and she added: "If you knew how very much afraid I am to say and do things some times you would think my nerve in doing them inexcusable," [12] and the following week, she said: "I will send you something when I want to . . . and I can— I'm always afraid." [13] She had dared to write him, she said, because her wish to do so outweighed her fear of doing it. This system of delicate emotional counterbalance was vitally important to Georgia. It gave more weight to her own needs than to external controls; it would provide her, recurrently, with internal support for unconventional behavior.

Georgia trusted that Arthur would make sense of her written thoughts and not take exception to her brazen behavior. He did the former and not the latter, much to her fervently expressed relief, and the two began a correspondence, which was friendly, direct, and increasingly intimate.

But her unsolicited letter to Macmahon represented the first step on a path of emotional daring, one that would lead her to take emotional risks, to dare emotional expression, and to honor her own emotional requirements, and all despite the possibilities of criticism and rejection. Georgia's decision to take this path would have far-reaching implications, both in her life and in her art.

• • •

AS THE SUMMER ended, Georgia was once more faced with decisions about her career. In August she had written Anita:

> Talking of 291—and New York— I am afraid I'll not be there. Maybe you can help me decide. I have a position in Columbia College, South Carolina— I don't want it— I want to go back to N.Y. . . . I think I would have time to work down there by myself but nobody will be interested . . . It would probably be good for me to sit down and slave by myself for a year— I haven't decided yet.[14]

Though what Georgia told her friend was true, it was not the entire story: this she told to Arthur.

The year before, Georgia's sister Anita had started nurse's training. Her mother had opposed this, telling Anita that her health would not sustain it. In spite of the warning, Anita set off for St. Luke's Hospital. In September of 1915, she returned to Charlottesville, utterly dejected, with an erratic pulse and a heart condition. She had already spent three weeks in bed, and three more were ordered. Anita hoped to be able to return to nursing in a few months, though it was uncertain that she would ever recover completely. Georgia, deeply sympathetic to her sister, was afraid that their mother would triumphantly remind Anita of her warning.

The risk was one that Georgia refused to take for herself. When her mother similarly warned that Georgia's strength would break down under another strenuous year in New York, Georgia did not believe her, but though she detested the idea of spending the year in South Carolina, she detested even more the possibility of Ida's saying "I told you so."

The decision was a difficult one, and Georgia resisted making it or even discussing it with her mother. The pressure on her rankled: Georgia was twenty-eight years old, too old and too independent to accept this sort of maternal advice readily. Her final decision was not made until September, when she reluctantly chose South Carolina. The O'Keeffe legacy of authority and pragmatism, however, made it possible for Georgia to accept with good grace what she could not change. When she told Arthur of her decision, she dismissed the idea of pity being owed her and ultimately admitted to finding the whole notion funny. She

would get from the experience what she could, and she was already full of curiosity about the possibilities of life in such a remote and isolated situation.

When Georgia wrote to Anita Pollitzer about her decision, her plan seemed to be a careful and self-directed one. This was partly for appearance and partly because she had, by then, made it true. Her choice continued the pattern she began at the Art Students League, when she recognized that social life and serious art were direct competitors.

> I think I will go to South Carolina—for time to do some things I want to as much as anything— It will be nearer freedom to me than New York—you see I have to make a living— I don't know that I will ever be able to do it just expressing myself as I want to—so it seems to me that the best course is the one that leaves my mind freest . . . to work as I please and at the same time makes me some money. If I went to New York I would be lucky if I could make a living—and doing it would take all my time and energy—there would be nothing left that would be just myself for fun—it would be all myself for money—and I loath [*sic*] money.[15]

With a characteristic pragmatism, Georgia accepted without complaint the premise that work was the foundation of real life. She was prepared for both sorts: the work that allowed her to eat and that which allowed her to breathe.

She had chosen against Texas as well as New York. The controversy over the textbooks may have played a part in this decision, but certainly her mother's illness did. Ida's condition was worsening, and the family's center was loosening. Georgia, as the oldest girl, had a responsibility to the family: once Ida realized that she was dying, she had asked Georgia to promise that she would look after Claudia, twelve years her junior. The moment was approaching for Georgia to honor this promise, and South Carolina was not nearby, but it was closer than Texas.

Frank, still inspecting buildings for the government, returned to the house in Charlottesville whenever he could but spent much of his time traveling. The boys had both left home. Francis had gone to Cuba, where he was a successful architect, designing schools for the government. Alexis, having finished at William and Mary, was studying engineering at the University of

Wisconsin. Young Catherine had announced that she wanted to follow Anita into nurse's training. Her mother, ill as she was, was not pleased to hear that: she would have preferred that all O'Keeffe children should go to college. However, Catherine, like the rest of her siblings, was determined to follow her own path. She set off for the Madison General Hospital, where she enrolled in the nurse's training program and was paid the princely sum of six dollars a month. Ida made no claims on her children through guilt and no attempt to keep them at home while she lay ill. A scrupulous honesty obtained: emotional independence worked both ways.

Claudia was still in the local high school. The economic strain on the family continued despite Frank's efforts. That year, meals continued to be offered to students, in a determined attempt to make the household self-supporting. At the end of the summer, after Anita's return, the three older sisters had a warm and companionable time together. Georgia felt tender and supportive toward the devastated Anita, and she did what she could during her sister's convalescence. As for young Ida, who was helping to run the household, Georgia reported to Arthur that she was "the nicest girl in the world." [16]

• • •

COLUMBIA COLLEGE was a women's Methodist school just outside Columbia in College Place, South Carolina. It was a training school for music teachers and was in dire financial straits. Enrollment had dropped drastically, to about three hundred, as a result of the plummeting cotton market, and half of the faculty had left. Georgia was probably offered a position because her lack of degree meant that she would accept a meager salary. Provincial, narrow in scale and scope, economically tottering, and generally demoralized, the school was an odd place for Georgia to choose.

When she arrived at Columbia, the first letter she received, to her delight, was from Arthur. Her reply was full of excitement about her new position, the beauty of the surrounding countryside, and the teaching possibilities. Once Georgia's initial excitement subsided, however, she began to find the environment stifling. "I feel all sick inside," she wrote Anita, "as if I could dry up and blow away right now." [17] The school's deadening commitment to convention and propriety, the absolute lack of interest in art and of intellectual curiosity, made her claustrophobic in a way

she had not felt in Amarillo. A letter to Anita suggested real depression:

> It is going to take such a tremendous effort to keep from stagnating here that I don't know whether I am going to be equal to it or not. I have been painting a lot of canvases . . . white—getting ready to work— I think I am going to have lots of time to work but bless you Anita—one can't work with nothing to express. I never felt such vacancy in my life — Everything is so mediocre— I don't dislike it— I don't like it— It is existing—not living.[18]

Anita was a staunch friend, and her response was immediate and sensible:

> You're tremendously strong, Pat—though you could be weak if you let yourself down one inch—so don't slacken. It won't hurt you to know tame people for a little while— they'll be a rest for you . . . I think you're a great sport and will pull through this . . . Now don't disappoint me.[19]

Georgia's natural inclination to find pleasure in her life reasserted itself, and by getting outdoors for "tramps" and starting to work on her own, she restored her own equilibrium. The combination of the landscape and her solitude had a curious effect on her, however, and though her depression lifted, she found herself in a peculiar state of risk:

> Anita—it has been wonderful weather down here—it would hardly be possible to tell you how much I've enjoyed it— All the little undergrowth in the woods has turned bright—and above—way up high—the pines—singing— It makes me love anybody I love at all—almost a hundred times more— It is wonderful.[20]

Georgia's response to the singing woods, to the bright countryside, was intense, acute, and passionate. Her environment was always of immense importance to her, and in the Carolina landscape she found herself emotionally aroused by the beauty around her. As her letter to Anita makes clear, she was fully conscious of the process.

In the small provincial community of Columbia College, Georgia felt both culturally and temperamentally isolated, and her interior life became, increasingly, both solitary and passion-

ate. The expansion of her emotions found no outlet among the people who surrounded her, and she began to focus her feelings more and more on Arthur Macmahon.

Early in October she wrote Arthur a letter full of her own private excitement and the sensual pleasures she took every day: her delight in a solitary walk taken in the rain, and her wish to explode the sleepy stagnation she found around her. She continued boldly: "Arthur—let me tell you tonight that I like you—will you?"[21] Recklessly she declared that she did not care whether or not he was pleased: she had said it, and that was that. This time, she said, the letter was not so difficult to write: she was feeling daring. It was a feeling that would grow.

Georgia was aware of the process she was undergoing, and of the dynamics between her feelings for the landscape and for Arthur:

> With an abundance of time on my hands—and little
> inclination to work when everything felt so mixed up—and
> some very nice letters from Arthur—I got rather out of gear.
> He is the sort of person who seems to say nice things in the
> very nicest way they could be said—and Anita—I found I
> was going on like a fool—and—nearer being in love with
> him than I wanted to be— It was disgusting—simply
> because I hadn't anything else to work off my energy on
> . . . I know I like him very much—and he likes me as much
> —I think . . . but there is no earthly reason why I should let
> him trail around in my mind like he was trailing.[22]

To Anita, Georgia showed a different side of herself. With her friend, Georgia's inclination was to oppose romantic entanglements. She had sent Anita a letter from an admirer named Hansen, whom she liked and respected but did not love. His feelings for her were obviously stronger, and Anita wrote back in dismay at Georgia's coolness. Georgia's reply was as careful and measured as a grandmother's.

> Don't you think we need to conserve our energies—
> emotions and feelings for what we are going to make the
> big things in our life instead of letting so much run away on
> the little things every day. Self-control is a wonderful thing
> — I think we must even keep ourselves from feeling too

much—often—if we are going to keep sane and see with a clear unprejudiced vision.[23]

This was a strangely cool philosophy for one young woman to offer to another, but it reflected Georgia's austere setting of priorities. Like many of her decisions, this set her outside the feminine tradition: most women of her generation felt that "the big things in our life" were emotional relationships, not work. But her final pronouncement suggests a real resistance toward romantic love:

> I almost want to say—don't mention loving anyone to me— It is a curious thing—don't let it get you Anita if you value your peace of mind—it will eat you up and swallow you whole.[24]

Implicit in Georgia's cool and decorous warning, of course, was its unspoken corollary: her view of love as an overwhelming and irresistible force, one that had the power to change and destroy utterly.

Georgia was taking great pleasure in the countryside, in her work, and in an active intellectual life. Her correspondence with Anita was crucial to her, and Anita was a responsive and contributive participant in their dialogue. The two young women discussed books, concerts, ideas, and the feminist movement, in which Anita was much involved.

Arthur Macmahon was also interested in feminism and had given Georgia *Women as World Builders*, by Floyd Dell. Its premise exactly supported Georgia's position: "The woman who finds her work will find her love . . . the woman who sets her love alone above everything else I would gently dismiss . . . as the courtesan type."[25] Although this sort of political pronouncement was radical at the time, it was consonant with Georgia's background and her role models. On a farm, men and women had their particular spheres of work and responsibility, and the wife's work was as important as the husband's. In an affluent urban household, the wife's role was essentially administrative—there was very little actual labor involved, nor was she vital to the economic unit of the family. The idea of a woman taking a strong and responsible position, which was radical in upper-middle-class urban households, was neither new nor threatening to Georgia; it merely confirmed her instinctive stance.

Through Macmahon and Anita, however, she became aware of the suffrage movement as a political position. That winter she read Olive Schreiner's *Women and Labor*; she attended a speech given by Helen Ring Robinson, a feminist state senator from Colorado, and she wrote away for the suffrage issue of *The Masses*, the radically liberal newspaper. She also subscribed to *The Forerunner*, a lively feminist publication edited by Charlotte Perkins Gilman, a well-known social critic.

It was in *The Forerunner*, in 1915, that O'Keeffe began to read with delight Gilman's beguilingly subversive "The Dress of Women," a long serial essay, cheerful, breezy, and pragmatic. Gilman's comments on women's clothing were funny and tart, and though her posture was radical, her manner was mild.

"The man did not have to please the woman by the small size of his feet," she wrote, "but by the large size of his bank account. His feet were organs of locomotion, hers of sex attraction." She waxed exasperated on the woman's shoe: "It hurts when one first puts it on and essays to 'break it in'—as if one's shoes were wild horses!" She ridiculed the long undivided corset: "This corset is as idiotic as a snug rubber band around a pair of shears." She pointed out the expedience of men's clothing, compared to women's, and argued that the difference was due to the power structure, not physical discrepancies between the genders. Adornment and display were economic strategies for a woman, whose "main line of economic advantage lay in pleasing man." [26]

O'Keeffe found Gilman's tone, full of humor and common sense, deeply appealing, and her arguments equally so. The ideas were not revelations to Georgia—she had dressed as she pleased in Texas—but they supported her own inclinations, and from that period on, she dressed for comfort, movement, and her own private aesthetic code, regardless of fashion.

Feminism was a cause that was ideologically supported by other radical revisionist attitudes of the period—egalitarianism, socialism, atheism, and cubism. Though Georgia did not become a feminist leader and seldom made a public commitment to the cause, the equality of the sexes was a concept for which she felt a profound natural sympathy. She was not an activist, however; her work took priority over feminism, as it did over dancing.

Another interest that would remain an important part of Georgia's art and her life was music. "I like it better than anything else in the world," she told Anita simply. During this period she

was playing the violin for pleasure, and though she no longer drew to music, she still saw the two arts as closely connected.

> It's a wonderful night— I've been . . . wanting to tell
> someone about it . . . I've labored on the violin till all my
> fingers are sore . . . I imagine I could tell about the sky
> tonight if I could only get the noises I want to out of it . . .
> I'm going to try to tell you—about tonight—another way—
> I'm going to try to tell you about the music of it—with
> charcoal—a miserable medium—for things that seem alive
> —and sing.[27]

Stieglitz, "291," and *Camera Work* were all frequently discussed in the letters between Georgia and Anita; art was not central to the relationship with Arthur. Although Georgia had claimed that Arthur was "even interested in the New Art," in fact Arthur's interest was more theoretical than aesthetic. Georgia tentatively suggested that Arthur should read Kandinsky but acknowledged as she did so that the title "would not tempt" him. Ideas were what ravished Arthur Macmahon, not visual experiences. For a corresponding response to her own intense involvement in art, Georgia relied on Anita.

Anita went often to "291," and her attitude to Stieglitz was reverential: "He's a great man, Pat, and it does me good to breathe his air for a while."[28] Georgia, deep in the southern woods and unable to see the exhibitions, sent for issues of *291*, which, with Anita, were her chief connection with the New York art world. Stieglitz and his gallery and magazine were like beacons from a lost civilization, and Georgia found her own wistful recollections of his creative energy intensified by Anita's worshipful posture. In October she wrote:

> Anita—do you know—I believe I would rather have
> Stieglitz like something—anything I had done—than
> anyone else I know of— I have always thought that— If I
> ever make something that satisfies me even ever so little—I
> am going to show it to him to find out if it's any good.[29]

But Georgia was in Columbia precisely to avoid showing her work to other people. She was determined to rid herself of others' influence, even the notion of it, and she was steadily applying herself to this difficult task. She went on:

I am getting a lot of fun out of slaving by myself— The disgusting part is that I so often find myself saying—What would you—or Dorothy—or Mr. Martin or Mr. Dow—or Mr. Bement—or somebody—most anybody—say if they saw it— It is curious—how one works for flattery. Rather it is curious how hard it seems to be for me right now not to cater to someone when I work—rather than just to express myself.[30]

The struggle to free herself, to not "cater to someone," was an intrinsic part of becoming an artist; there was, too, the added complication of being a woman. For this purpose, her removal to South Carolina, among the Methodists, was inspired. She was alone; she had no one to talk to and no one to guide her. "The thinking gets more serious when you wonder and fight and think alone," she wrote Anita.[31] Her intense visual, intellectual, and emotional life gave her a rich source of material for her work, and there was not a single learned male peering over her shoulder, telling her how to transcribe it.

Georgia was approaching the concept of working directly from emotion in her painting. She sent three watercolors to Anita, explaining them in emotive terms. When she sent Anita the letter from Hansen, Georgia explained the picture done in response to it: "That little blue mountain with the green streak across it is what he expresses to me."

Her tone was appealingly self-deprecating. She frequently referred to her work in a cheerfully mocking manner.

If I ever get this darned water color anything like I want it maybe I'll send it to you. Today's is the tenth edition of it and there it stands saying "Am just deliciously ugly and unbalanced."[32]

Anita's responses were immensely important. "Your letters are certainly great," Georgia wrote. "I can't imagine what living would be like without them."[33] More than a good friend, Anita was a valuable and perceptive audience, who recognized the significance of the changes in Georgia's work and was unafraid to state her own responses: "The smaller one . . . struck me as awfully good but *I didn't like it.*"[34]

Anita encouraged Georgia to submit the portraits of both herself and True to the 26th annual exhibition of the New York

Watercolor Club in the fall of 1915. Georgia appears, however, only to have submitted the portrait of True and a picture of hollyhocks; the one of Dorothy was accepted. "Your monotype is very strong and they gave it a good position," Anita wrote. "It's that one of Dorothy with the very red hair."[35] The catalogue of the exhibition, Nov. 6–28, 1915, lists an entry from "Georgia O'Reeffe" from "Columbia College, Columbia, Georgia." The title of the picture is unilluminating: "Color Print."

By the time her work was shown, however, Georgia had gone beyond it. As part of the process of paring down, in mid-October Georgia stopped using colors of any kind. She began working only in charcoal—colors sickened her. She would not return to them until she had said everything she could in black and white: "I believe it was June before I needed blue."[36] Georgia was struggling, too, to establish theoretical as well as technical independence in her work.

> Anita? What is Art anyway? When I think of how hopelessly unable I am to answer that question I cannot help feeling like a farce—pretending to teach anybody anything about it— I won't be able to keep at it long Anita . . . unless I can in some way solve the problem a little— give myself some little answer to it— What are we trying to do—what is the excuse for it all . . . I am really quite enjoying the muddle—and am wondering if I'll get anything out of it and if I do what it will be— I decided I wasn't going to cater to what anyone else might like—why should I?[37]

Anita's response was forthright:

> We're trying to live (& perhaps help other people to live) by saying or feeling—things or people—on canvas or paper— in lines, spaces and color.[38]

Her own position was quite independent:

> At least I'm doing that. Matisse perhaps cares chiefly for color— Picabia for shapes—[Abraham] Walkowitz for line— perhaps I'm wrong—but I should care only for those things in so far as they helped me express my feeling— To me that's the end always— To live on paper what we're living in our hearts and heads, and all the exquisite lines and good

spaces and rippingly good colors are only a way of getting rid of these feelings and making them tangible.[39]

Anita's frank and articulate replies demonstrated her political as well as her aesthetic views. To a feminist, an approach that presumed polarization of the two sexes was a familiar one. By naming male artists who dealt purely with formal concerns and establishing her position as directly antithetical, Anita identified an aesthetic dichotomy between the genders and established a legitimate political position for the female artist to adopt: an unashamedly frank concern with the representation of pure emotion.

The focus on emotion in her work, which had interested Georgia increasingly during the year, coincided with an emotional crescendo in her life. Despite her advice to Anita suggesting that she control her feelings, Georgia found herself giving way with delight in the following month.

Just before Thanksgiving, Georgia heard from Arthur. He had been asked to visit the University of North Carolina at Chapel Hill and the University of Virginia, as part of an effort to promote political awareness among students. He suggested that he spend Thanksgiving weekend with Georgia in Columbia. Arthur had known about the trip beforehand, but aware that Georgia disliked planning ahead, he waited until the last minute with his bombshell, which exploded into her excitement. Georgia's response to Arthur was unabashedly happy: "I'm the gladdest person in the world," [40] but to Anita she was as giddy as a teenager.

> If I told you that I am so glad about something that I'm almost afraid I'm going to die— I wonder if you could imagine how glad I am. I just can't imagine anyone being any more pleased and still able to live. Arthur is coming down to spend Thanksgiving with me . . . Anita—even yet — I can scarcely believe it— Do you really suppose it's true! He even tells me the train he is coming on so it must be.[41]

Georgia's state of high excitement and expectations was a dangerous precursor to any romantic encounter, but the visit entirely lived up to her gorgeous expectations.

Arthur left his parents on Thanksgiving Day and traveled all night on the train, arriving on Friday morning to meet the radiant Georgia. The two had four full days together before Macmahon

boarded the train on Monday night: the visit was a great success. The two spent the time, of course, tramping through the mountains. They went on picnics, took photographs of themselves and each other, and talked and talked and talked. Despite her dislike of planning ahead, "We have made the greatest plans you ever heard of," Georgia wrote with excitement.[42] Looking together toward springtime, they hoped to rent a rustic cottage in the mountains in North Carolina, decorously including Macmahon's mother and brother. The idea of spending time together in the high, clean mountains made them both giddy: "castles in the air," wrote Georgia.

After Macmahon left, Georgia was in a state of beatific ecstasy. "He has been here and gone," she wrote Anita. "We had a wonderful time . . . I feel stunned— I don't seem to be able to collect my wits—the world looks all new to me."[43] Georgia's daze continued, nourished by Arthur's letters. "He has the nicest way of saying things and making you feel he loves you—all the way round—not just in spots."[44]

Arthur's responses make his interest clear, but at each step Georgia seems to have been the initiator in the relationship. It was Georgia who wrote first, Georgia who first mentioned feelings, and it was probably Georgia who initiated the first kiss—to her mingled delight and embarrassment. After Arthur left, she confessed: "I wondered if you had done what I wanted you to last night—and couldn't but laugh— I suppose you did but I can't remember when or where or how? Maybe I did it . . ."[45] She told him cheerfully she was glad that he finally knew the worst of her, her recklessness, her foolishness. She also admitted that given the chance, she might not do again what she had—not that she was sorry, but she worried that he might not want to come again in the spring if she was going to behave this way. In spite of her anxieties, the letter is sustained by a strong sense of her assurance, of risks deliberately taken, of her own needs known. And Arthur was drawn by this impetuous, bold, and unpredictable woman; he put up no resistance.

Georgia told Anita she considered going to New York to spend Christmas with Arthur and found the idea so tempting that she had to put her money away for fear she would give way.

For she was giving way otherwise. Georgia was in love in spite of her stern warning to Anita. Yielding to this experience was headlong and dizzying. Left alone in South Carolina, physi-

cally bereft of her lover but psychologically teeming with the emotions he aroused, she turned to that central and steadying presence in her life: her work. Her attempts to express some of these feelings, and "the world looking all new," were to result in the early "Special" series of charcoal drawings.

Alone in her room, late at night, Georgia began to try. It was not an easy process, and began with false starts.

> Did you ever have something to say and feel as if the whole side of the wall wouldn't be big enough to say it on and then sit down on the floor and try to get it on to a sheet of charcoal paper—and when you had put it down look at it and try to put into words what you have been trying to say with just marks—and then—wonder what it all is anyway — I've been crawling around on the floor till I have cramps in my feet—one creation looks to[o] much like T.C. [Teachers College] the other to[o] much like soft soap— Maybe the fault is with what I'm trying to say.[46]

What she was trying to say was how she felt, which was her own. How she was trying to say it was how other people would like it, how she had been taught. It was night, and around her were silence and darkness. Georgia looked with a strict and unforgiving eye at the attempts that littered her floor. Instead of examining the shapes, or criticizing the techniques, she looked at sources. What she saw was the influence responsible for each work; she identified each picture by the sensibility it was made to please. The acknowledgment had a daunting corollary: If all her work was derivative, how then should she proceed?

It was a moment of great bravery and commitment. At this point O'Keeffe began the laborious task of attempting to work purely from her own consciousness, seeking to eliminate everything from her work except herself. Suffused with the feelings aroused by Arthur Macmahon, Georgia's emotions were strong, rapturous, and easily accessible. With unflinching concentration, O'Keeffe began to draw on her own sensibility.

She did not go home for Christmas that year but stayed at Columbia and worked. On Christmas Day she wrote Arthur with a new brave tenderness: "I want to put my hand on your face and kiss you today—not your lips—it's your forehead—or your hair—that's all."[47] She was in a state of emotional intensity—concentrated, passionate, and high-keyed—that might under

other circumstances have resulted simply in a love affair; her lover being absent, Georgia directed her emotion, undiluted, into her work. It was a pattern that would recur.

The 1915 drawings, with their lyric, tender, rounded forms mark the first appearance of O'Keeffe as a strong, mature, and original artist. Though these are pure abstractions, they show no influence of Picasso, Braque, the analytical painters, or any of O'Keeffe's teachers. Their swelling, biomorphic shapes suggest a sympathy with Dove's approach, for both artists draw on the harmonies of the natural world. Like Dove's, these works avoid the strictly geometrical forms that suggest logic or science: the circles are never perfect, the angles are not right.

Implicit in this deliberately imperfect rendering is a statement of specificity and flux. These are not Platonic ideals of circles; they are abstractions of specific shapes. They do not represent the immutable laws of physics or geometry: these forms swell with an uneven rush, suggesting an awkward, uncontrollable surge, like spring, or a swollen stream.

The early "Special" series makes a strong individual statement, despite the affinity with Dove's work. The forms are purely O'Keeffe's, and they reveal a more voluptuous, sensuous line than Dove's. There is, as Georgia acknowledges, a revealed female consciousness, a tenderness. "Everything round invites a caress," as the French philosopher Gaston Bachelard states simply. This invitation is particularly strongly extended through imperfectly rounded shapes—swellings, mounds, buds—all of which are integral parts of O'Keeffe's vocabulary of design. A frondlike, unfurling shape, curled and layered, suggests a natural process at once delicate and powerful. The concept of unfurling juxtaposes the fragility and tenderness of developing tissue with a gently inexorable force. Movement is portrayed by ripples suggesting the liquid surge of flowing water—a fluid, peaceful form of natural power.

By the end of December, Georgia wrapped up a bundle of her new, strange charcoal drawings and sent them off to Anita. Anita, who had continually encouraged Georgia in her work, saw that the new series deserved a new level of response.

> Astounded and awfully happy were my feelings today
> when I opened the batch of drawings. I tell you I felt them!
> . . . They've gotten past the personal stage into the big sort

of emotions that are common to big people—but it's your version of it . . . Pat—well, they've gotten there as far as I'm concerned and you ought to cry because you're so happy. You've said something![48]

Although Anita did not generally show Georgia's work to anyone without permission, in this case she made an exception.

Pat—I had to do it, I'm glad I did it, it was the only thing to do . . . I walked up to "291"— It was twilight in the front room Pat & thoroughly exquisite. He came in. We spoke. We were feeling alike anyway and I said, "Mr. Stieglitz, would you like to see what I have under my arm." He said "I would. Come in the back room." I went with your feelings and your emotions tied up and showed them to a giant of a man who reacted— I unrolled them— I had them all there—the two you sent . . . before, and those I got today. He looked Pat, and thoroughly absorbed . . . he looked again—the room was quiet— One small light— His hair was mussed— It was a long while before his lips opened— Then he smiled at me & . . . said to me— "You say a woman did these— She's an unusual woman— She's broad-minded, she's bigger than most women, but she's got the sensitive emotions— I'd know she was a woman— Look at that line—" And he kept analyzing, squinting . . . Pat they belonged there . . . They gave those men something—your pieces did . . . Then Stieglitz said, "Are you writing to this girl soon?" I said "yes"— "Well, tell her," he said, "They're the purest, finest sincerest things that have entered 291 in a long while . . . I wouldn't mind showing them in one of these rooms one bit—perhaps I should . . . You keep them . . . For later I may want to see them, & thank you . . . for letting me see them now." Pat I hold your hand . . . You're living Pat in spite of your work at Columbia!!!![49]

Georgia's response to Anita was one of deep gratitude:

There seems to be nothing for me to say except Thank you —very calmly and quietly. I could hardly believe my eyes when I read your letter this afternoon . . . The thing seems to express in a way what I want it to but—it seems rather effeminate—it is essentially a woman's feeling . . . I wasn't

even sure that I had anything worth expressing— There are things we want to say—but saying them is pretty nervy— What reason have I for getting the notion that I want to say something and must say it.[50]

Though Georgia felt uncertainty at expressing a purely female feeling, and a beguiling modesty about her efforts, she had persisted in them. The feelings that moved her to expression are explicitly related to her relationship with Macmahon:

> You say I am *living* in Columbia— Anita—how could I help it—balancing on the edge of loving like I imagine we never love but once . . . something—that I don't want to hurry seems to be growing in my brain—heart—all of me— whatever it is that makes me— I don't know Anita— I can't explain it even to myself.[51]

The connection between Arthur and the work was made explicit. "I said something to you in charcoal," she wrote to him, of the drawings Anita had shown to Stieglitz.[52]

Paradoxically, Georgia's first real expressions as an artist were the result of two strongly antithetical strains in her character. Her resolute asceticism and the strict limiting of her energies to painting had allowed her to develop her great technical skill to a state of virtuosity. In opposition to this austere policy was an irresistible, sudden upsurge of rapture, which provided the rich emotional dynamics that make this such extraordinary work.

12

Mr. Stieglitz: If you remember for a week why you liked my charcoals that Anita Pollitzer showed you and what they said to you—I would like to know if you want to tell me. I don't mind asking—you can do as you please about answering. Of course I know you will do as you please.

I make them just to express myself—things I feel and want to say—haven't words for. You probably know without my saying it that I ask because I wonder if I got over to anyone what I wanted to say.[1]

—GEORGIA O'KEEFFE

GEORGIA'S FIRST LETTER to Stieglitz was ingenuous, beguiling, and rather inarticulate, a request for confirmation of the value of her work.

Stieglitz's response was brisk and immediate.

My dear Miss O'Keeffe:
What am I to say? It is impossible for me to put into words what I saw and felt in your drawings. As a matter of fact I would not make any attempts to do so. I might give you what I received from them if you and I were to meet and talk about life. Possibly then through such a conversation I might make you feel what your drawings gave me.

I do want to tell you that they gave me much joy. They were a real surprise and above all I felt that they were a

genuine expression of yourself. I do not know what you had in mind while doing them. If at all possible I would like to show them, but we will see about that. I do not quite know where I am just at present. The future is rather hazy, but the present is very positive and very delightful.[2]

Stieglitz's tone was encouraging but impersonal, and his refusal to discuss the drawings merely confirmed Georgia's belief that pictures and words were not necessarily interchangeable. She wrote him back:

Mr. Stieglitz— I like what you write me—maybe I don't get your meaning—but I like mine—like you liked your interpretation of my drawings. It was such a surprise to me that you saw them—and I am so glad they surprised you—that they gave you joy . . . I can't tell you how sorry I am that I can't talk to you—what I've been thinking surprises me so—has been such fun—at times has hurt too—that it would be great to tell you. Some of the fields are green—very very green—almost unbelievably green against the dark of the pine woods—and its warm—the air feels warm and soft—and lovely.[3]

Characteristically, in the attempt to discuss what is most important to her, Georgia begins to describe the landscape around her. The visual nourishment she received from it was central to her consciousness, something she felt a strong need to communicate.

To many struggling artists, the most important line of Stieglitz's letter would have been "I would like to show them . . ." In her next letter to Anita, however, Georgia does not even mention this, focusing instead on Stieglitz's direct and powerful commitment to experience, which paralleled her own.

He wrote me one sentence that I thought fine— It just made me ridiculously glad— "The future is hazy—but the present is very positive and very delightful." Anita—he is pretty nice—he must have a pretty fine time living— I just like the inside of him.[4]

With this exchange, the two, O'Keeffe and Stieglitz, began a dialogue that would take on increasing importance in their lives.

As Georgia's relationship with Stieglitz was beginning, her

romance with Arthur Macmahon seemed suddenly threatened. In February, she wrote:

> This afternoon I met a woman who . . . knows Arthur . . . and something she said—makes me—oh—just sort of think —that—why Anita—I can hardly get it into words— I am no more disappointed in him than in myself—but I seem to have just seen my bubble burst—and don't even mind—if it is only a bubble and can burst— I feel a little sick to find that it is a bubble—but if it is—I don't mind its bursting— but to be honest—there is a decided element of humor in it. I cannot but laugh—and Anita I wish I couldn't laugh— It makes me feel as if there is nothing in me at all. Maybe it is because I am so sure that if I told it to him he would someway reassure me.[5]

The charcoal drawings, symbols of her relationship with Macmahon (one of which she called "Maybe a kiss . . ."), now took on a painful poignancy:

> I'm awfully glad those drawings are gone— I like to feel that I am rid of them . . . And I fancy I'll not want to see them again unless I—by some accident—or happenstance— find that my bubble didn't break.[6]

The bubble remained intact, however: Arthur reassured Georgia. It was not the first time this had happened; in October she had written him an oblique account of her meeting with a pretty blond woman whom, she said with meaningful certainty, he would know. She said firmly that she would not tell him the story she had heard about the woman, and waited for Arthur's response. Each time this was forthcoming and satisfying. Although Georgia's boldness may have been unnerving to Macmahon, her gift to him was her extraordinary vitality, her candor, her luminous and joyous response to life. He admitted to her his own anxieties about subsiding into a dreary academic life, though this would have been difficult to do with Georgia. For her part, she recognized that she did not have the temperament for an intellectual, and meekly hoped that he could forgive her that.

The correspondence continued, with its odd mixture of intimacy and distance. Neither Arthur nor Georgia was a regular correspondent, and the exchange of letters was often erratic. The

emotional sustenance, however, that Georgia received from the relationship was evident, continuing, and expanding.

At the beginning of February, Georgia took the next step in a letter to Arthur, one that again directly paralleled and embodied her aesthetic boldness. "Let me tell you what I want so much to," she told Arthur candidly. "I want to love you." Her role as initiator is explicit: she hoped he did not "object to a woman daring to—feel—and say so without being urged in the least."[7]

Throughout the rest of the winter and spring of 1916, Georgia continued with her charcoal drawings. She had reached a state of extraordinary productivity and was working with great intensity.

> I've been working like mad all day—had a great time—
> Anita, it seems I never had such a good time . . . I worked
> till my head all felt tight in the top—then I stopped and
> looked, Anita—and do you know—I really doubt the
> soundness of the mentality of a person who can work so
> hard—and laugh like I did.[8]

Georgia's capacity to laugh at herself was crucial. It protected her from emotional pain, emboldened her, and allowed her to receive pleasure in taking risks. The risks she was taking in her art were important ones, reflected and embodied by the risks she was taking in her emotional life. Both kinds of risks thrilled and energized her. Her exuberance was infectious and highly visible. When she went down the hall to ask another teacher for a cardboard tube in which to mail her drawings, he answered, "For goodness' sake—what's up now . . . I never saw such excitement in anyone's eyes."[9] She wrote Arthur in the same state, asking him if there was "any sense in what I'm liking so much to do— Arthur—I really don't know—and don't much care—that's a lie—but I want to hurry up and live fast—because I want to know—and the only way I can find out is by living."[10]

Georgia had other things on her mind as well as her work: the possibility of going back to Texas. On January 5, she had received a letter from R. B. Cousins, the president of West Texas Normal College, in Canyon, about twenty miles south of Amarillo. Cousins offered her the position of head of the art department. In spite of her great love of the open country, she felt torn at the prospect. "I want to go—and I don't want to go—either

way seems to be Hades— Arthur says he will go out soon but the darn fool puts 'soon' a long way off."[11]

Returning to Texas would mean first returning to Teachers College in New York to take an obligatory course, Dow's "Methods of Teaching." There was more to the situation than a simple job offer. Georgia wrote Arthur that she would explain it, "but it's not a very nice tale—and I'd better not put it on paper."[12] There may have been trouble between Georgia and Columbia College: whatever the situation, it was dispiriting, and she told Arthur she had a hard time finding it funny—her usual remedy for difficulties.

After much indecision, she accepted the Texas offer. At the end of February, Georgia left the Methodists in the lurch (the abrupt departure suggests a possible breach between herself and the college) and went back to New York to enroll in "Pa" Dow's class. She had told Anita that she was two hundred dollars short of the money she needed for her expenses: Anita's generous response was the offer of a place to live. For the rest of the term, Georgia stayed with Anita's uncle Dr. Sigmund Pollitzer and his family, in their house on Sixtieth Street. Aline, the doctor's daughter, took a class at Columbia from Arthur Macmahon. Arthur was one reason Georgia went to New York, and she saw him often—and saw his mother—during her stay. According to other biographers, an interview with Aline Pollitzer revealed that during this period Arthur proposed to Georgia and she rejected his suit. From Georgia's correspondence, however, the situation seems not to have been so simple. Whether or not a proposal was made, Arthur clearly maintained a role of primary importance in Georgia's emotional life.

That spring, as part of her course in teaching, Georgia was an observer at the Horace Mann School in Manhattan. One day she was watching a beguiling little boy in the classroom and finding him so appealing that she wished Arthur could see him. Next, to her astonishment, she found herself wishing that the boy were hers. The thought had never occurred to her before, nor had the next one: the child would not be only hers; there would be a father; it would be both her child and Arthur's. "There had never been anyone else that I would want—or would have for the father of my child."[13] The thoughts were so unexpected, so shocking, and so wildly radical that Georgia was entirely undone. She first felt half blinded, then, certain that

everyone in the class had witnessed her shameless thoughts, she fled from the room. The incident, which she did not share with Macmahon at the time, revealed her deep commitment to him, and his great importance in her emotional life.

Georgia threw herself once again into the turmoil of the art world, going frequently to "291" and other galleries. In April she asked Arthur to go with her to a show at the Bourgeois Gallery. In March she went to see an exhibition of Marsden Hartley's work. Hartley was an American painter Stieglitz had taken on in 1909. A shy, awkward country boy from Maine, Hartley had told Stieglitz that he needed only four dollars a week to live on. Touched by the ingenuous modesty of Hartley's needs, Stieglitz had promised him the money and taken him on as a painter.

The show Georgia saw consisted of oils that Hartley had done in Berlin and were some of his most powerful work. The interlocking semiabstract forms showed strong influence from both the *Blaue Reiter* and the cubist schools. The paintings reflected Hartley's intense emotional involvement with a German officer: they were densely charged with emblems of the military, and the colors were bold and martial. Georgia was becoming increasingly discriminating in terms of her own aesthetic needs, and she felt little sympathy for the cacophonous show. "It was like a brass band in a small closet," she said. Heat and clamor were not what Georgia sought, and Stieglitz, recognizing this, drew out some of Hartley's earlier work: dark, brooding landscapes, which did appeal to her. Stieglitz handed her one of the Maine pictures. "Take it home with you if you wish. If you get tired of it, bring it back."[14] She found she could live with it only three or four days. Hartley's work would always affect her this way: she felt that he began a painting in a state of great excitement but could not sustain his commitment. The incident taught her something of Hartley, of herself, and of Stieglitz. This was the side of Stieglitz Georgia was beginning to know: gentle, thoughtful, and deeply attentive to a real response to a work of art.

During a John Marin show, another incident occurred at "291."[15] Georgia admired Marin's work, and she looked at it while Stieglitz voiced his anxieties about Marin's financial position: just after Stieglitz had sold enough of his work to pay his expenses for the year, Marin had imprudently bought an island off the coast of Maine. O'Keeffe only half listened to Stieglitz's

grievance. On the back of a door hung a small blue crayon draw-ing—an abstraction. Its intimate scale and its clear aesthetic independence made it suddenly accessible to O'Keeffe: concep-tually, this was very close to her own work. It occurred to her that if Marin could make a living selling this eccentric expression of a private aesthetic vision, then she might be able to do the same. Disregarding Stieglitz's complaint, she turned and asked him if this sort of thing could be sold. Stieglitz admitted that it could.

It was an important moment of encouragement for Georgia. Until then she had assumed that her art would be separate from her job; she had unconsciously accepted Eugene Speicher's pre-diction. The notion that the work on which she spent her time and energy might be translatable into currency transformed her view of herself. The work she did might be viewed by the world as real art; she might be paid for the work that was central to her life.

• • •

THE DRAWINGS Anita had left with Stieglitz had remained a pow-erful presence in his mind. He looked at them often, and in May of that year, he decided to exhibit them. He did not notify the artist of his plans. Deliberately waiting until the end of the sea-son, when critics were no longer covering the shows, he hung O'Keeffe's work in conjunction with two other little-known art-ists, Charles Duncan and René Lafferty. Her drawings "created a sensation," Stieglitz said. Among the viewers, "There were two distinct camps—one deeply moved, as though before a revela-tion; the other, consisting of many professional artists, horrified at my showing such work after having presented Matisse and Picasso, Cézanne, Marin, Dove, Hartley."[16] " 'The painters said: we thought you were interested in art' . . . [but] added Stieglitz, 'you should have seen what happened to the faces of women, young women, and middle-aged women when they saw them.' "[17] Despite Stieglitz's intention the show was reviewed, a modest notice in *American Art News*, May 27, 1916.

A small exhibition on to June 18, at the Photo Secession Galleries, 291 Fifth Avenue, consists of drawings by Georgia O'Keeffe, and watercolors and drawings by C. Duncan and oils by Rene Lafferty. Miss O'Keeffe's drawings of various

curious inanimate objects—in one case a conflagration and in another a stalagtite [*sic*] shape—are carefully presented and artistic in quality. Messrs. Duncan and Lafferty's contributions showing some artistic intentions express nothing in particular.[18]

Although the careful language suggest the critic's bafflement by O'Keeffe's work, he accords her a courtesy withheld from her coexhibitors, and it is clear that her work dominated the show.

One of the sensations created by the exhibition involved Georgia herself. She was approached by another student at Teachers College one afternoon. "Are you Virginia O'Keeffe?" the girl asked. "No," said Georgia. "Well, there are drawings by someone named Virginia O'Keeffe hanging at '291.' "

Georgia knew that the show was hers; the realization startled and shocked her. The drawings were intimate visions of hers, highly private, and they had been put on the wall for all the world to stare at. Having her work seen by strangers was excruciating; when Alon Bement had shown some drawings of hers at Teachers College, she wrote Anita: "Anita, those things meant so much when I tried to say them— I object to having [the work] dragged around as a curiosity—it just hurts— I can hardly tell you."[19] Then, too, she felt cheated by the process.

> It is probably a mercenary element in me that objects to showing what I feel and think when I get nothing for it— I could stand to sell it—for ideas that would help me to go on working—or for money—money gives us the things we need to help us say things—but I hate to give it away—just to be laughed at maybe. I guess I never really thought it out definitely to myself even—before I tried to say it to you. It sounds awful doesn't it.[20]

Georgia went at once to investigate the exhibition, and found that her pictures were at "291" and that Stieglitz was not. Seldom in his years of running galleries was Stieglitz absent even for an hour, but the day Georgia arrived he was on jury duty. The rooms were empty of people, and Georgia walked alone among her charcoal drawings. Expecting to confront the combative personality of Stieglitz, she found only his professional accomplishment, his commitment to beauty, his purpose, and her own work in the exquisite space. It was this aspect of him that had drawn

her initially to "291." Whatever rage she felt could not be expressed that day; she left.

When she came back again, Stieglitz was there; this was the occasion of their first real meeting, as he recalled it.

> A girl appeared—thin, in a simple black dress with a Little white collar. She had a sort of Mona Lisa smile. "Who gave you permission to hang these drawings?' she inquired.
>
> "No one," I replied.
>
> Still with a smile, she stated very positively, "You will have to take them down."
>
> "I think you are mistaken," I answered.
>
> "Well, I made the drawings. I am Georgia O'Keeffe."
>
> "You have no more right to withold those pictures," I said, "than to withdraw a child from the world."[21]

In her declaration: "I am Georgia O'Keeffe," Georgia named her source of strength: her identity as a creator. Stieglitz, however, transformed the moment, and denied her power by invoking a still higher one— God, or nature. It was a demonstration by Stieglitz of his own potency, of his capacity to reorder perception, and of his determination to reveal the larger forces that he felt were inherent in all true art.

His commitment to Georgia's work was deep and genuine. He felt responsible for her entrance into the public arena; he also felt it was his duty to impress the artist with the magnitude of what she had done. Taking her into the smaller back room, he asked her how she had come to draw one of the pictures; Georgia explained that the shape had come to her while she had a headache. But when he pursued her with more questions, she withdrew. "Do you think I'm a fool?" she asked, and refused to continue. But Stieglitz was now on his mettle: Georgia interested and aroused him on every level.

For Georgia, the moment was full of ambivalence. She was determined to maintain her dignity and control, but arguing with Stieglitz was difficult under the best of circumstances, and he was now determined that the pictures remain on his walls. Georgia encountered the full force of his very considerable personality, as well as the exhilarating possibility that he understood what she had been trying to say in her work. She found him impossible to resist.

For Stieglitz was charming. He was "easy to look at," as

Georgia said. Physically beguiling, he had strong, regular features, except for a lordly bump on his nose. He had a "very nice" sensitive mouth, a wild thatch of dark hair, and a thick, exuberant mustache. His eyes were the dominant feature, however: dark, large, and penetrating, they revealed brooding depths of profound intensity. Vital and magnetic, he possessed an overwhelmingly strong presence, which, although words were his favorite medium and he talked almost incessantly, was not expressed through language. Many of his comments, written down, seem facile or foolish: it was his energy and his soul that were communicated directly to his friends and admirers, his commitment to the life of the spirit. One of his colleagues wrote later:

> For many years I felt . . . a need to see him again—not to say anything, for conversation with Stieglitz is extremely difficult, as he talks nearly all the time—not even to get any thoughts or ideas from him, for I had my own, and in definite thoughts and ideas he was not rich—but to feel his life, his living being, see where it was carrying him; and in that way, to feel again the freshness, the value of life again.[22]

It was this spirit to which Georgia began to respond—the irresistible quality of Stieglitz, his capacity to charge the moment with freshness, to renew a sense of the value of life.

The balance of power between the two was delicate. Stieglitz was a figure of mythic proportions. Ever since her arrival in New York, Stieglitz had been a giant in the art world, responsible for the most innovative, liberating, and beautiful work Georgia had seen. Aesthetically and intellectually he had been a great and central figure in her life for eight years. Unlike William Merritt Chase, however, Stieglitz was not overwhelming to Georgia. She had by now established herself and was beginning to know her own power. She could sense that she possessed a different kind of strength than Stieglitz's, and that, in this case, she could trust him. Also, he was a handsome man.

• • •

ALFRED STIEGLITZ was born on January 1, 1864, exactly thirteen days before Georgia's mother, Ida. Though both Alfred and Georgia came from European families who made their way successfully in the New World, the two backgrounds were entirely

disparate. Georgia's forebears were restless, determined people who deliberately chose a challenging way of life: rural, agricultural, and primitive, with little promise of material benefits. The life itself was valuable, the quality and the pleasure of it.

Alfred's parents were also adventurers, who ventured to a strange land where they established themselves successfully. But the Stieglitzes came from the German bourgeoisie, which placed great emphasis on material comfort. Order, plenty, and convention were reigning virtues, and the family chose an urban, sophisticated, and protected life.

Alfred's father, Edward Stieglitz, was a German Jew who left Saxony for New York in 1849. Though Edward's father was a farmer, the family belonged to the educated middle class, with a tradition of law, medicine, and community leadership. Edward was sixteen when he arrived, with a certain amount of capital and a great deal of energy and ambition, and by 1857 he was a partner in a dry-goods firm, importing wool. Intelligent and determined, Edward prospered professionally and socially. In 1862 he married seventeen-year-old Hedwig Werner; her family, sophisticated and cosmopolitan, from Offenbach, Germany.

Alfred, their first child, was born in Hoboken. The Stieglitzes bought a three-story brick house there, on Garden Place, for themselves, the three servants, Hedwig's unmarried sister, Rosa, and their children, of whom there would be six.

In many ways the Stieglitz household was more typical of an Anglo-American than a German-Jewish family. Edward, like many of his friends, had given up the practice of Judaism; the strict and clannish ways of the Old World seemed irrelevant and restrictive. Sophisticated, prosperous, and personable, Edward adopted a style of life that would have been inaccessible to him in the European social hierarchy. In America, Edward's tastes ran to "English tweeds, French champagne and Long Island oysters,"[23] He was the only Jewish member of New York's elegant Jockey Club; his equine interests included both racing and riding. He bought his own Thoroughbred mare and learned to ride. In spite of years of lessons, however, he was pronounced by a riding grandchild to have "hard hands."

Having "hard hands" is not uncommon, but it is revealing in terms of both Edward's personality and the male sensibility of his era. A rider with hard hands demands obedience rather than inspiring it; he does not respond to his mount, but requires that

his mount respond to him. The attitude was a pervasive one among upper-class Victorian males.

At home, Edward was the autocrat of the breakfast table, a benign despot. He was an affectionate and attentive parent and husband but was tyrannical regarding his own needs. His emotions took priority, and his anger hung as a constant threat over the household, which he tended to perceive only in terms of its relationship to him. He was enraged if he could hear the housemaid's footsteps upstairs: she was told to work in her stocking feet.

Toward Hedwig, Edward was both tender and authoritarian. Like many men of his era, he viewed women as spiritually superior and intellectually inferior to men. This ingenious philosophy, deeply Victorian, allowed men to love women devotedly and to dominate them utterly, without loss of face or logic. To love someone who was in every way one's inferior would be demeaning; to assume complete authority over an equal would be impossible.

Men were unarguably superior to women physically and economically, and they claimed intellectual superiority as well. This left the spiritual as the only sphere in which women could excel. An argument against women's suffrage glowingly describes women's awesome powers in this realm, as it tries to tempt them to insist on their impotence.

> Why, if our own women could but see . . . what superior grades of beauty and power they fill . . . when they keep their own pure atmosphere of silence and their field of peace, how they make a realm into which the poor bruised fighters . . . their minds scarred with wrong . . . may come in, to be quieted and civilized, and get some touch of the angelic, I think they would be very little apt to disrespect their womanly subordination.[24]

John Ruskin, the artist and critic, was perfectly frank: he "urged woman to regard herself as a household nun."[25] In order that an inviolate male power structure be maintained, spiritual and temporal tasks should be divided. A man should risk the dirt and brutality of the marketplace; the woman should provide a clean, well-lighted place for his return. A wife was the human equivalent of a rosary or religious charm: constant contact with her would restore purity to the continually errant husband.

Natural chastity followed inherent purity. The widespread insistence upon chastity derived from a deeply rooted fear of female sexuality and the consequent demands it made upon men. A woman with no physical needs of her own would place no sexual burden on a man. His sexual performance could not be tested, nor, therefore, could it fail.

Edward and Hedwig settled into a relationship based on these Victorian premises. Edward took responsibility for the material aspects of family life, Hedwig for the spiritual and emotional side. Hedwig was a dutiful, generous, and deeply affectionate woman. She took her role as spiritual protector seriously and devoted her energies to the task of rearing six children.

Alfred was the favorite child, receiving throughout his life a steady stream of adoring attention from both parents. His mother and aunt believed, without much foundation, that he was sickly, and his health was a source of constant concern. His exhaustive preoccupation with his physical condition later in life harked back directly to the intense attention paid to it in his childhood.

Alfred was a thoughtful and responsive child, whose demands upon himself were rigorous. As Sue Davidson Lowe, in her graceful and scholarly *Stieglitz: A Memoir/Biography* points out, Alfred

> strove to match the manly ideal that his father's
> exhortations, if not always his example, conjured up.
> Excellence in every task undertaken. Rigorous probity.
> Physical courage. Unfailing generosity to the needy. Self-
> discipline. Taste. Perseverance. Love of country. Indeed,
> with the conspicuous omission of devotion to God,
> Edward's code was that of an upright Victorian gentleman.
> It was a code that Alfred embraced before he was eight and
> —no matter how elusive strict observance would seem to
> him, or how bizarre some of his interpretations would seem
> to friend, foe or family—never really deserted.[26]

Edward, who had made his way in the world through dedication, determination, and self-discipline, felt strongly that his son should possess these traits, in spite of his affluent environment. His stern and exacting attitude taught Alfred that life was hard. Since Alfred's life was not materially difficult, his hardships were self-imposed. Throughout his life he used the difficulties he encountered as joyful proof of his potency. Nothing valuable was

ever achieved without a struggle, he believed, and in order to create value, he often created struggles.

As the oldest and the favorite, Alfred was the object of his parents' intense love, intense scrutiny, and high expectations—a demanding situation for a child, even one as precocious and capable as Alfred. He set himself physical and psychological tasks in his pursuit of perfection: running laps against the stopwatch, for example, or the strict observance of silence in the presence of adults. He was dedicated to the task of earning his parents' approval and respect. The fact that they gave this freely and lovingly did not lessen Alfred's sense of urgency: paradoxically, it seemed to heighten it. He set himself sterner and sterner goals, and tended to discount his achievements once they were attained.

As one whose behavior was carefully watched, praised, and considered, Alfred took his own thoughts and actions immensely seriously. This resulted in a sense of great competence and effectiveness, which enabled him to assume challenging tasks with impunity. It also gave him a rather melodramatic sense of self-importance.

A family anecdote records the Saturday night ritual, when he was a boy, of rising from the dinner table to take a dime from his allowance and a sandwich from the kitchen outside to an organ-grinder, who set up to play each week at the same hour. One snowy night Hedwig urged him to stay and finish his own meal, but Alfred ignored her, stalking silently from the room. When Hedwig asked, years later, why he had done this, he replied, "But, Mama, I *was* the organ-grinder! Don't you see?"[27] The flamboyant self-dramatization—together with a deep empathy that made it impossible for him to ignore others' needs—would remain a hallmark of Alfred's behavior, eliciting from others exasperation at his exhaustive demands for praise as well as admiration for his real generosity.

The Stieglitzes abandoned the placid, leafy charms of Hoboken for the more worldly delights of Manhattan and in 1871 moved to East Sixtieth Street. The Stieglitz household was immensely civilized, full of rich Victorian textures: plush and velvet, fringe and crystal. Edward was sympathetic to the arts, and the German painter Fedor Encke and the American sculptor Moses Ezekiel were frequent visitors. Edward gave them financial as

well as moral support. Alfred grew up with an awareness of the importance of aesthetics and a respect for the role of the artist.

In the summer of 1872, the Stieglitzes made their first trip to Lake George. Thereafter, they spent a part of each summer there, except for the years when they were in Europe. In 1880 the Stieglitz family rented Crosbyside, the cottage later bought by the Trasks. That summer, Alfred occupied the room that was assigned to Georgia twenty-eight years later.

During adolescence, Alfred became aware of the dissension that lay behind the smooth family facade: his admirable father, whose generosity to his mother was in such public evidence, was in fact mean and parsimonious with her in private. He shouted accusations at her about expenditures in the kitchen, while in the drawing room he supported "an elegantly appointed home, servants, private schooling, music lessons, the best seats at the theatre, the best accommodations at hotels"[28]—all the accoutrements of late-Victorian upper-middle-class affluence. His mother's sobbing rebuttals horrified Alfred, and he sided with her against his bullying, abrasive father. The devastating discord that seemed to accompany money, its possession and its disbursal, gave him a real repulsion to it. In consequence, his attitude as an art dealer was bewilderingly and almost excruciatingly uncommercial. It was a matter of pride for him never to make money the sole basis for a transaction, never to accept the idea that art and money were actually interchangeable. That idea depressed and disgusted him, and people who tried to use money as a source of power enraged him.

Another element of the family dynamics that contributed to Alfred's character was the discovery of his father's moral unreliability. When Alfred was ten, his father broke a promise to him. He had until then believed his father's edicts on honor and principle. The devastating gap between his father's behavior and his pronouncements made Alfred resolve never to make a promise to anyone about anything—a resolution he proudly believed that he kept, in spite of having twice taken marriage vows.

Edward's moral reprehensibility went further, however: a few years later, Alfred discovered that he was making nightly visits to the chambermaid. This polarized Alfred's feelings toward his parents, befouling his father and sanctifying his mother. He was convinced that men, at heart, were base and women

pure. This conclusion colored his responses thereafter; he was instinctively sympathetic to women, often antagonistic to men.

• • •

IN 1879, Alfred enrolled at the City College of New York. Two years later, Edward retired and took the family to Europe. Alfred and his twin brothers, Leopold and Julius, entered the Realgymnasium in Karlsruhe; the rest of the family traveled. In the fall of 1882, Alfred moved to the Polytechnikum in Berlin, to study engineering.

An unsupervised life in a foreign country, among strangers, would be a painful shock to anyone who had received as much loving attention as had Alfred. At home all his efforts were seen as immensely valuable: when he did small errands for his father as a child, he was paid for his efforts in cash. Alfred never lost a vague sense of aggrievement, the feeling that his efforts deserved some sort of extra recognition. He needed tangible and public acclaim for his achievements.

Alfred was lonely, and he did not like engineering. He plodded through his courses, however, until January of 1883, when he saw a camera in a shopwindow. He bought it, took it home, set up his first photograph, and thus began the rest of his life.

Alfred learned mostly through experimentation. He worked alone, photographing the wall outside his window, making minute changes until he had complete technical control. He studied with Professor Hermann Vogel, an early authority in photochemistry, who was exploring the sensitivity of photographic plates.

During the summers, Alfred traveled, taking pictures in the countryside. He developed a style that set him apart from his contemporaries: precise focus, a strongly delineated shape, and unposed subjects.

In the spring of 1885, Alfred abandoned his studies at the Polytechnikum and devoted himself entirely to photography. He had begun to write articles on photography for German magazines, and he entered his first contest the following year. In 1887 —the year Georgia was born—he won his first competition in London. His work began to be reproduced in professional journals, and from then on, he won photographic contests with monotonous regularity.

In the summer of 1888, Alfred's favorite sister, Flora, was married, and Alfred returned to America for the wedding. It was

held at Oaklawn, a big clapboard summer house that Edward had bought on the shore of Lake George. Alfred spent two months there before returning to Germany. A year later Flora was pregnant and wrote him gaily, urging him to come home before she gave birth. Alfred was trying to earn a living, however, and was not there in February 1890 when Flora went into labor. After one hundred hours of trying to deliver a stillborn child, his beloved Flora died. The episode devastated Alfred, who thereafter viewed childbirth as a supremely perilous undertaking.

In the fall of 1890, Alfred reluctantly returned, under pressure from his father to come home and support himself. With two friends, Joseph Obermeyer and Louis Schubart, Alfred took over a photographic developing company. Alfred had reached a state of youthful idealism in a European city where political repression was a very real and visible element. He took a strong stand against the outmoded aristocratic tradition, which he held purely responsible for the poverty he saw around him. On arriving in New York, however, he found the situation infinitely worse. "Everything seemed crass, greedy, filthy, abrasive, selfish. Instead of life, he found a diseased and directionless kinetics, in which the only energizing force was money, its possession and its lack. A regard for quality was scorned, a feel of beauty laughed at."[29]

This response would not change. Twenty years later he was still complaining: "It is ghastly, this combination of bluff, incompetency, and indifference, so prevalent in the U.S."[30] He would continually criticize the crassness and materialism of the society around him. He chose, however, to remain a part of it and to try to counteract its reprehensible aspects. Given his unalterably high standards, his intense commitment to quality and creativity, it was a difficult task, but he would never waver in his determination. His attitude was very much that of the artist-priest described by Kandinsky, his task to assist the public in its spiritual progress, through the medium of the arts.

The new business was only marginally successful, and Alfred soon began photographing again. In 1891 he joined the Society of Amateur Photographers and entered once more the world of aesthetics.

Obermeyer was a friend as well as a partner, and Alfred saw him, and his younger sister, Emmeline, socially. Emmy was nearly ten years Alfred's junior, "amusing, kittenish, uncompli-

cated, gay." Alfred enjoyed her company, and the match was an obvious one. When Joe urged his friend to make a commitment, however, Alfred's tepid response was to suggest a five-year engagement, during which either party could, with honor, withdraw.

But a scandalous incident made negotiations moot: on an evening carriage ride, Emmy either fell asleep with her head on Alfred's shoulder or sat on his lap in the dark. The incident seems hardly the stuff of ruination, but Alfred believed Emmy's reputation to be compromised. He felt it his duty to marry her, and so he did. In November 1893 their wedding formalized the union of quite extraordinarily mismatched temperaments.

Their wedding trip set the tone for the marriage: it was disastrous. Emmy's interests lay in society and possessions, Alfred's in the aesthetic charms of the countryside and in ideas. The honeymoon, "a bewildering diminuendo of pleasures,"[31] made their differences painfully clear. Nowhere did their pleasures and interests coincide.

Alfred's code of honor determined his response to the problems between himself and his wife. For years he attempted to maintain a marriage that was publicly presentable. Alfred supplied Emmy with formalized attention, affection, time, and energy, to satisfy the institutional demands of marriage. As a model for this, Alfred had his own parents' marriage. Far happier than Alfred's, it nonetheless presupposed a vast gap between the two partners, and interests that diverged widely. It also presumed a preponderance of intellect and power held by the husband.

Alfred's own marriage was maintained along those lines. Courtly and generous to a fault toward Emmy, Alfred treated her in public with as much respect as Edward had bestowed on Hedwig. In private he tried to ignore the vast gap between his ideal of Woman and the actual figure of the wife who sat across the breakfast table, whose highest ambitions were sartorial. The cost to Alfred in this attempt was considerable, and during the early 1900s he was increasingly subject to depressions and illness, brought on in part by his marriage.

As Alfred's involvement with the art world increased, the polarity between his and Emmy's views intensified. She complained that his endless discussions were boring; he found her fascination with society incomprehensible. In dutiful compensation he sent her on European jaunts, and he met his friends

without her: their lives became more and more separate. Their only daughter, Kitty, was witness as she grew up to devastating scenes, and the failure of the marriage was known among the family.

Emmy's family owned a prosperous brewing company (later to become Rheingold), and in 1895 Alfred could afford to leave the failing Photochrome Engraving Company. It was his last attempt to earn a living. His economic independence, thanks to Emmy, meant that he could take an unpaid job as coeditor of a magazine, *American Amateur Photographer*. From then on, all his professional energies were devoted to the world of art, and segregated, as far as possible, from the sordid world of commerce.

Alfred's attitude toward Emmy was impeccable. In August of 1916 he wrote to her from New York:

> Dearest Emmy— It is a roaster today. I have been packing all morning. Had to take a second trunk on account of Kitty's things . . . It is about dinner [time] here . . . I'm going to visit Wright who has been ill for weeks and . . . who *must* see me before I go as it is essential owing to the book he is writing, in which "291" is to get a chapter . . . I wonder how you are— Whether you feel a little less blue . . . There is my meal. It is doubly quiet . . . With much love and a big kiss.[32]

Alfred dutifully and impersonally lists his activities, anxiously justifies visits with professional friends, and makes a hesitant, reluctant query as to Emmy's emotional state. That she is "blue" suggests a wistful yearning for something better; the picture limns a pitifully barren marriage.

By 1916, Alfred had been married to Emmeline Obermeyer for twenty-three years. He derived little connubial satisfaction from this arrangement and compensated by flirtations with the young women whom he encountered through his work. His manner was warm, deeply personal, and full of sexual reverberations. Very probably most of his flirtations remained merely that, but just before he met Georgia, Alfred's relationship with Katharine Rhoades reached a romantic flowering. The incident opened the way to further possibilities and left him full of daring.

Stieglitz's intimate style was initially discomfiting to Georgia. When Alfred responded to Georgia, she retreated. When he responded to her work, however, she could not help but approach.

Georgia felt that her soul was delivered, naked and vulnerable, in her drawings; Stieglitz recognized what he saw there.

• • •

DURING THE SPRING and summer of 1916, Georgia continued her correspondence with Alfred Stieglitz. As their relationship progressed, she began to call him Stieglitz, as did his male friends and professional acquaintances. To his family and close friends he called her Georgia; to the world, and to other artists, he called her O'Keeffe.

Georgia tended to resist the use of names in any case. Her world was defined visually, and in her letters, for example, she identified people by visual references rather than by name: "He is a lean dried up little fellow with a moustash . . ."[33] She had four sisters, but referred to each of them impartially in her correspondence as "my sister," sometimes making a further distinction by specifying "one of my sisters." She did refer to Macmahon as Arthur, but Stieglitz was seldom Alfred.

The use of the surname alone suggests closeness among members of the same gender; it is essentially desexualizing. There is nothing in it of intimacy, passion, or sex. This form of naming demonstrates an essential premise of the O'Keeffe-Stieglitz relationship—professional and aesthetic.

In the spring of 1916, Stieglitz took nine photographs of the O'Keeffe drawings exhibited at "291," which he sent to Georgia in Texas. They were simple and documentary in tone, showing the big drawings spaced against the dark walls, and the pleated curtains covering the low cupboards. The friendship had grown while O'Keeffe was in New York, and it continued when she left. Stieglitz was interested in O'Keeffe now as a woman as well as an artist, and he wrote her often. She found herself increasingly involved with him. She wrote Anita:

> I think I have never had more wonderful letters than he has been writing me . . . But his letters Anita—they have been like fine cold water when you are terribly thirsty. I would like you to read them but some way or other—they seem to be just mine."[34]

Stieglitz's correspondence began to take on a tone of musing candor, and he made direct and personal admissions to Georgia. The tenderness that he found in her work encouraged him to

respond in an unaccustomed way. He felt it both possible and safe, with the woman, to reveal his vulnerabilites.

> Your drawings on the walls of 291 would not be so living for me did I not see you in them. Really see . . . The streets are full of soldiers—soldiers to be—and they do not strike me with any pleasure. And yet I feel if I were young I'd join them again rather than be so apart from the world as I am these days.[35]

In a voice quite devoid of self-pity, Stieglitz made thoughtful reference to his personal situation. Irrevocably alone in his marriage, estranged from many of his early associates, Stieglitz was then in a period of painful isolation. In a tone of aching recognition, he wrote her: "these drawings, how I understand them. They are as if I saw a part of myself."[36]

There is in these letters nothing of the deliberately flirtatious style that he adopted with other women. It was O'Keeffe's work that disturbed and drew him, and he felt it gaining strength as time went on. She continued to send him her work. "I have been thinking of your new drawings—and have been telling of them to some of those people enthusiastic about the drawings now on the walls."[37]

By July, his tone begins to take on an exalted emotional plangency.

> Little did I dream that one day [Anita] would bring me drawings that would mean so much to "291" as yours have meant—nor did you dream when you did them that they would—or could—ever mean so much to anyone as they have to "291."[38]

Although Stieglitz refrains from naming himself as the one to whom the work meant so much, clearly it is he who is powerfully moved, who is unable to forget its tender strength.

Six days later he abandoned the impersonal:

> Some of your drawings I'm having framed to protect them. They have meant so much to me that I can't bear the thought that they may be soiled—rubbed.[39]

The association between O'Keeffe's works and a quality of unsullied purity is made early in Steiglitz's mind. He also establishes here his own role as a protector and manager—a role that

came easily to him. In a tone of entitlement, he discusses the treatment of her work. Georgia responds affably. "They are as much yours as mine," she wrote. "It is nice of you to frame what you wanted to— You are a much better keeper than I am." [40] He outlines his plans for the work: framing and further exhibitions.

> Will the pictures lose any of their freedom? I don't like the idea of a frame around them . . . but there is no way out if the drawings are to be protected, and that I insist they must be . . . Quite a few people were disappointed to find your drawings down, but they are coming in the autumn to see them. [41]

His comments on the work itself are now warm, supportive, and personal:

> The one I want most is the one . . . on the left wall . . . The one I considered by far the finest—the most expressive. It's very wonderful . . . none gives me what that one does. [42]

There had begun a mixing of the emotional and the professional: it was inevitable, since what O'Keeffe was doing was so deeply expressive of her emotional life. Stieglitz's responses were not only to the work; Georgia knew this.

13

ON MAY 2, 1916, the landlady appeared at the O'Keeffes' brick house on Wertland Street in Charlottesville. She was there to collect the rent, which was long overdue. Ida and Claudia told her that their father was away and their mother was sick. There was no money. The landlady was implacable: she would not leave, she said, until she saw either Ida or the rent money.

The girls went in to their mother. Ida had been coughing blood and was in the last stages of the disease that the family had traveled two thousand miles to avoid. With her daughters' help she got up from her bed and began the slow and difficult trip to the front door. Her lungs filled with bright arterial blood and she hemorrhaged for the last time. She died before reaching the landlady, who stood waiting by the door. Ida was fifty-two years old.

The family was scattered. Only Claudia, Ida, and the faithful Auntie were at home. Catherine was nursing in Wisconsin, Frank was away working, young Frank was an architect in New York, Alexis was studying in Chicago, and five days before her mother's death Anita had married Robert Young, a Texan studying at the University of Virginia. For Ida Totto O'Keeffe, whose meals in Sun Prairie had been famous for abundance and excellence, whose clean, warm house there had been filled with energy, enthusiasm, and life, it was a sad ending: at her death the house was nearly bare of food and of people.

Georgia left New York at once when she heard the news, taking the overnight train to Virginia. She wrote to Arthur the

next morning: though she ached, and though she could not imagine what she was now to face, she felt calm, convinced that she could meet whatever was to come. She wished that she had not had to tell Arthur what had happened: she did not want other people's emotion in response. She told him that she dreaded the days that would follow this one. Writing from the train, looking out at the countryside, she wrote: "It's a wonderful morning— misty—so very very green— Arthur— I'm very much afraid— I wish you would love me very very much for the next few days."[1]

Ida's body was sent back to the family plot in Madison, where she was buried with her Totto relatives. Aunt Ollie, Aunt Lola, and Catherine were there already; Georgia may have made a brief trip to Wisconsin to attend the burial.[2]

Ida's death had been looming with dreadful inevitability over the household for four years. A surprise to no one, it was deeply felt nevertheless. The death drew the grieving family together, and Georgia wrote of the warm bonds between herself and her sisters: "We seem so much closer now."[3] Yet in spite of the deepened intimacy, grieving was private. Years later, when asked about her mother's death, Catherine had to say only that she had not been there—she had never talked about it with her siblings. It was an O'Keeffe characteristic neither to dwell on pain nor to name its source.

The event was, for Georgia, overwhelming. For six weeks after her mother's death she existed in a grim, empty, and depressive state. When she finally began to recover, after mid-June, she wrote to Arthur that she had been feeling she had no existence. Her loss was so painful that until then, Georgia could not accept it emotionally: "I didn't look at Mama— I can hardly believe she isn't here some where." The reality, however, was insistent and, when Georgia finally accepted it, devastating. One night she slept out on the sleeping porch, waking up in the morning with the sun streaming across her. "Everything looked just like it looked when I used to wake up last summer— I just couldn't stand it . . . I cried good and hard."[4]

Her first letter to Anita Pollitzer from Charlottesville was written two days after the one to Arthur. She had recovered more of her equilibrium, and neither in that letter to Anita nor in subsequent ones did she mention her mother's death or any emotional repercussions—though the extremity of her exhaustion

attested to the latter: "I have spent most of the time in bed—it seems absurd—but I get so tired that I almost feel crazy."[5]

A more somber and ominous indication of her psychological state was revealed by a sudden and unprecedented antipathy. For Georgia the landscape had been a perennial source of nourishment, a metaphorical restorative, reliable, soothing, necessary. In the depths of depression after her arrival in Columbia, South Carolina, for solace she had reminded herself: "I can always live in the woods."[6] After Ida's death there is a sudden change: "It has been wonderful weather here—cool—and rain—so that everything is wonderful heavy dark green—and the green is all so very clean—but I hate it."[7]

Georgia had early established the pattern of private and aesthetic solace, and strength drawn from the rewards of work. She was determined to keep her energies for the big things: for Georgia this meant work. She would not permit her emotions to dominate her life. As she had written Anita: "Self-control is a wonderful thing— I think we must even keep ourselves from feeling too much—often—if we are going to keep sane and see with a clear unprejudiced vision."[8]

Georgia was teaching at the University of Virginia again. Slowly recovering from her mother's death, at the end of June she wrote Arthur: "I feel alive today again—it seems the first time in ages."[9] As she began to return to normalcy she began again to respond to the visual world. When she received from Stieglitz some copies of *Camera Work*, her excitement was so intense that she wrote irrepressibly to Arthur, asking him again to let her tell him that she loved him. She described the beauty of the magazine and then returned to her own emotion. Admitting that her announcements were unsolicited, she suggested that if Macmahon preferred, she could keep her feelings to herself. Her own preference, however, was to share them: "it seems so strange—not to give myself—when I want to . . . Love is great to give— You may give as little in return as you want to—or none at all."[10]

Georgia's youth, energy, and temperament were returning her to a state of exuberance. Intense productivity, alternating with periods of exhaustion, produced a pattern that would recur. In her productive periods Georgia was exhilarated and supremely energetic, filled with ambition and potency. In her enervated

ones she felt incapable and depressed; depression in general accompanied fatigue, and the two together signaled real psychological stress.

In the early summer of that year, Georgia began to work once again, returning to the use of color. The series produced during the summer following her mother's death consists of extremely simple graphic compositions done mostly in blue watercolor. *Blue Lines*, said to be the first of the series, was executed first in charcoal, then in black watercolor, and finally in blue. It is a spare composition, which deeply impressed Stieglitz: linear and calligraphic, it consists of a pair of parallel vertical lines, one interrupted by a switchback. The near-abstract *Tent Door at Night* was also probably done at this time. Next Georgia moved to the embryonic unfurling shapes, loose lyrical plumes, that appear in the earlier series of charcoal drawings. The plume shapes fascinated her: she wrote Anita that one version of this was "the first of a dozen or more you speak of." [11]

When Anita received Georgia's new work, her response was warmly supportive. Stieglitz's reaction (not written to Georgia) was less certain. "A package came from Virginia, a lot of new drawings. Different. I wonder how you will like them. It seemed funny to receive drawings up here. I have been thinking so little of 'art.' Miss O'Keeffe is on her way to Texas. She is without doubt a girl much out of the ordinary." [12]

The blue series, characterized by an exquisite simplicity and purity of line, reflects the strong influence of Dow and his emphasis on the values of Oriental art. In these drawings, however, Georgia has demonstrated her ability to translate an aesthetic concept into her own version of reality, creating work conceptually allied to another tradition but entirely hers.

Blue Lines and the plume series are, like the charcoal series that preceded them, entirely abstract compositions. The shapes are derived from emotional realities, not visual ones. As expressions of subjective states of mind, they are closer to the German *Blaue Reiter* approach to abstraction, which emphasized emotional and spiritual content, than to the more analytical and cerebral French approach, which employed highly specific images of objective reality. Though O'Keeffe had seen the early works of Picasso and Braque, it was Kandinsky's theories and the expressive abstractions of Arthur Dove that served as directional influences on her road to modernism.

• • •

IN EARLY AUGUST 1916, after summer school finished, Georgia left Charlottesville. She set out on a long camping trip with friends, ending up in a mountain cabin, from which she wrote rhapsodically to Macmahon, announcing that she had found her spiritual home: "the only place I know of that I am sure of going back [to]."[13] She had not been working much, she told him: only watercolors, done in blue and green. After the spare and splendid blue series, these seemed, to her, less powerful. She liked one, found the rest middling to poor, and called the whole group "trifling."

At the end of August, Georgia set out for the small town of Canyon, twenty miles south of Amarillo in the Texas Panhandle, where she arrived in the first week of September. Canyon, one quarter the size of Amarillo, was populated by some twenty-five hundred people. It, too, was primarily agricultural and served as a loading station for the cattle driven in from the range. Georgia's new job meant a professional advance, but her attitude toward the college was characteristically irreverent. On her arrival, she wrote Anita: "My first impression was that it is a shame to disfigure anything as wonderful as these plains with anything as little as some of these darned educators."[14]

The new institution was a teachers' training college, which presented itself severely in its *Bulletin:*

> The West Texas State Normal College is not a kindergarten in which infants are to be fed; nor a reform school for delinquents; but . . . a place to which young ladies and gentlemen come with some preparation, and a purpose to get ready for rendering efficiently an important service.[15]

Founded in 1910, the institution prided itself on its facilities. The campus consisted of a square forty-acre tract, "as level as a floor and as pretty as a picture," boasted the *Bulletin*. The original college building had burned down in the spring of 1914, and the year before Georgia arrived, a massive brick and concrete building had been erected. It was solid, vast, and pompous: rectilinear, with vaguely classical trim. "The ventilation, lighting and heating are the most modern," declared the school, and a ninety-thousand-gallon swimming pool was available, alternately, to men and to women.

Georgia was "wrathy" at her first administrative encounter. Her reputation as a dissident had preceded her from Amarillo: "Previous contacts make some of them not like my coming here," she told Stieglitz. "I never felt so much like kicking holes in the world in my life."[16] Once the issue with "educators" was settled, however, Georgia approached the year with anticipation. "My work is going to be great—I think— The building is all new—the best in the state they say—everything looks fine to work with."[17]

She found this time that Texas "doesn't seem far away from the world like it used to."[18] This was due partly to the fact that the trip was now a familiar one, which reduced the psychological distance from the East, and partly to the fact that Georgia herself had now gained considerably in self-assurance. Upon her arrival in Amarillo, she had been uncertain of her own shaky qualifications, but in the intervening years she had achieved professional stature. The world no longer appeared quite so intractable or so disconnected.

When she arrived, it was not only the administration that unsettled Georgia; her room, in another teacher's house, was intolerable. She spent only one difficult night there, harassed by the wallpaper.

> If you had waked up Sunday morning and found pink roses in squares hitting you from all over the walls—pale grey ground—dark green square lines—tails gold—roses *pink* . . . there were pink roses in the centers of the two rugs too — I moved next day."[19]

Georgia moved to one of the only steam-heated houses in town, "the only place . . . where the walls wouldn't drive you to drink."[20] She boarded with the family of the man who ran the town waterworks, spending the next six or seven months there. She had arranged to take rooms in a stylish new bungalow that was being built on Twentieth Street for Douglas Shirley, the physics teacher and college registrar. The house was designed in a geometrical Egyptian style, based on obelisk shapes. When it was finished, Georgia asked for the upstairs room, with a dormer window that looked out across the plains. Mrs. Shirley protested that the room was still unfurnished and curtainless. Georgia, never deterred by other people's protestations, answered serenely that she would take the room without furniture or curtains and asked if she could paint the woodwork black. She was given

the room, but her request to repaint it (which was denied) established her at once in the community as an eccentric; in the story as told, she had asked to paint the entire room black. Her room was, in fact, wallpapered with a silvery white stripe and had white woodwork and furniture. Georgia despised the domestic charm of the decor and countered it with a "painting" she hung on the wall: a piece of black cloth, in a black frame. It was her favorite thing in the room: "It's really great," she wrote a friend.[21]

The role of eccentric was one that bothered Georgia not at all. As always, she stood out from the other women teachers. One of her students remembered Georgia vividly:

> Oh, she wore black. Black, black, black! And her clothing was all like men's clothing. Straight lines, she didn't believe in lace, or jabots in blouses, laces or ruffles or things like that. Everything on straight lines.[22]

It was not only Georgia's clothes (which she made herself) that made her stand out. Her teaching methods were characteristically unorthodox. As head of her department, she had the authority to choose her own texts and methods. She taught design, drawing, costume design, interior decoration, and the teaching of drawing. Georgia's approach was emphatically different from the time-honored tradition of drawing plaster casts of classical sculpture. The beginners' class did

> work in massing and landscape in charcoal and chalk. A study of grasses, flowers and fruits, using a Japanese brush and ink . . . The students study rhythm as found in simple lettering . . . the course includes the illustration of some short story and the binding of these in a booklet . . . the cover being properly decorated and printed.[23]

And Georgia wrote at once to Anita, asking her to send teaching materials: "some photographs of textiles, Greek pottery, and Persian plates."[24]

The importance of decorative patterning, with its subtle and integral relationship to composition, was fundamental to Dow's philosophy of aesthetics. This Georgia adopted wholeheartedly: she used texts on Egyptian decorative art, and a contemporary photograph of the art room shows the walls lined with photographs of the elegant and sophisticated rhythms of Eastern and Middle Eastern design. The only fine-art object visible is a Japa-

nese print. Not surprisingly, Dow's was one of the texts she used: his *Composition* and Wright's *The Creative Will*, among others.[25]

Searching the environment for forms to use in her classes, Georgia discovered shapes that would remain and reverberate in her consciousness.

> You know, this was open country . . . sometimes when there was [sic] large herds brought in around town some cattle would die and . . . those carcasses . . . 'd just lie there and bleach out. I remember she brought a skull in and leg bones and told us how beautiful they were—the sheen on those dried bones, and the look of the bones.[26]

On the prairie, the eye is drawn to any relief from endlessness. The ground beneath one's feet is unrelentingly the same, and an elegant shape is a treasure. As a metaphor—and the move to abstraction in art was very much related to the translation of specifics into metaphor—the bones were quite perfect, symbolizing the good, severe life on the plains. And they were in themselves metaphors and abstractions: there is nothing more central, in every sense, to life than bones. As examples of functional design, they were beautiful: simple, smooth, strong, and economic. Even the colors were right: subtle variations on the theme of pallor. Georgia would not use them in her work for nearly twenty years, but they were a presence, early, in her mind.

Claudia O'Keeffe had joined Georgia and was enrolled at the college. The baby of the family, and twelve years younger than Georgia, Claudie was then seventeen. As she had promised her mother, Georgia now took on full responsibility for her young sister without hesitation: she was the eldest, and responsibility accompanied privilege. This meant an odd rearrangement of their roles, and the fluctuations between their real and adoptive roles made for an eccentric and rather beguiling dynamic. Thereafter the two sisters would continually alternate between tenderly supportive and indignantly competitive attitudes toward each other.

The O'Keeffes made a striking pair:

> [Claudia] was also, like Georgia, what they call "black Irish" —had real black hair, straight long black hair and she pulled it straight back over her head and did a little bun at the back of her neck . . . so she could wear this man's felt hat . . .

She looked very mannish . . . walking along with all that black on and men's shoes. People didn't do that then."[27]

Claudie took as much pleasure in the wild landscape of Texas as Georgia did, and the two young women walked, camped, climbed, and shot together. All the O'Keeffe girls knew how to shoot, and Claudie was particularly good, bringing home wild duck and quail. Georgia's accomplishments were more abstract. She wrote Anita:

Haven't had but about an hour to myself all week. That was yesterday so I got a box of bullets and went out on the plains and threw tin cans into the air and shot them. It's a great sport.[28]

Once again, Georgia was on the wide land. "Arthur—it's great out here—it's like another world." she wrote.[29] Despite social and bureaucratic snarls, the flat, empty countryside itself provided solace. Canyon was a small scattering of houses, and the prairie came right up to the streets.

Tonight I walked into the sunset . . . the whole sky—and there is so much of it out here—was just blazing—and grey-blue clouds were rioting all through the hotness of it . . . The Eastern sky was all grey-blue—bunches of clouds different kinds of clouds—sticking around everywhere and the whole thing—lit up—first in one place—then in another with flashes of lightning—sometimes just sheet lightning—and sometimes sheet lightning with a sharp bright zigzag flashing across it— I walked out past the last house—past the last locust tree—and sat on the fence for a long time— just looking at the lightning—you see there was nothing but sky and flat prairieland—land that seems more like the ocean than anything else I know— There was a wonderful moon—Well I just sat there and had a great time all by myself—not even many night noises—just the wind . . . It is absurd the way I love this country . . . and the SKY— Anita you have never seen SKY—it is wonderful.[30]

About twelve miles from the town lies the Palo Duro Canyon, for which the town was named. Palo Duro is a miniature version of the Grand Canyon, opening suddenly in the wide, flat plains. It was a popular place to climb and picnic: there was a

Palo Duro Club in the early years of the century, and a train from Amarillo went out there three times a week. A student recalled:

> We stayed down there a lot and we were . . . all up and down that canyon . . . It is delightful . . . There was a place on . . . Tom Currie's ranch down there . . . and we kept a stove, a little burner that we could fix fires and we'd cook food in cold cold weather. We dressed in heavy clothes and . . . had picnics. We had gone down there when it was cold and wind and sand was blowing. It didn't seem to hurt any of us.[31]

The landscape above the canyon is vast. The sky is so enormous that if you lean your head back to follow one of the vultures (and there are plenty, sliding luxuriously from one updraft to another) as you swivel to follow his wheeling, you totter, dizzy, at the round blue waste you confront. And the low, blank horizon, emptiness and space without limits, is both exhilarating and frightening. The absolutely flat horizon is inexorable: nothing is hidden. There is, in fact, nothing to hide, there is nothing at all except for this flat endless neat meeting of earth and sky.

The ground around the canyon is chalky cream, and crumbly. Without warning the canyon appears in the prairie, "slits in nothingness."[32] The wind is constant, and the wild wheat leans mildly. The cliffs are neither high nor spectacular; much of them is covered in rough, low, green shrub. But in stripy horizontal patches the earth beneath is revealed—rich, luscious sunset colors, red, ocher, a line of mustard, warm russet pink—all against that dull, dull, almost invisible sagebrush green.

The cliffs plunge down in a triangular sliding scramble, to sprawl haphazardly into the broken gullies at the bottom. As you descend into those vast rumpled shapes, the cliffs rise above you, and the landscape becomes oddly calm, comforting, and peaceful.

The canyon, with its combination of vastness at the top of the bluffs and wild, broken, intimate landscapes inside it, and above all the tumultuous colors of the striated rock, was a feast for Georgia.

> I had been out in the canyon all afternoon—till late at night —wonderful color— I wish I could tell you how big—and with the night the colors deeper and darker . . . Then the

moon rose right up out of the ground after we got out on the plains again—battered a little where he bumped his head—but enormous— There was no wind—it was just big and still—so very big and still . . . a great place to see the night because there is nothing else.[33]

Georgia and Claudia went often to Palo Duro, where the trails leading down to the bottom were cow paths, so steep that the two young women held opposite ends of a stick for balance. Late one day, as they were leaving, they saw "a long line of cattle like black lace against the sunset sky." The vertiginous climbs stayed on in Georgia's mind after she was safe at home. In her dreams, the foot of her bed rose straight upright, tilting her inexorably into a fall. She awoke frightened and exhilarated.

Their excursions continued throughout the winter:

Last Sunday went to the Canyon in a tearing norther— snow flying and bitter cold—it was terrible—but great . . . I spent the weekend at a place in the canyon that they call the country club.[34]

Georgia had sent work from her blue series to Stieglitz and Anita at the end of the summer, and by the time she reached Canyon, she had begun again to use a broad range of color: this was fortunate. The Palo Duro landscape evoked another series of "Specials" (a name given to works that particularly pleased her). These drawings and paintings of the sweeping, fiery views inside the canyon are rich, powerful, and evocative; they demonstrate an exultant freedom of palette. The freedom was, unsurprisingly, emotional as well.

Georgia's letters to Arthur Macmahon continued to be tender and intimate. On the train going out to Texas she had again expressed the wish to "put my hand on your cheek—this time kiss you—then turn my face away right quick."[35] Once she had arrived, he continued to be the object of her intensity, and she wrote often that she wished he were enjoying her new world with her. With remarkable perceptiveness, however, she recognized that she might benefit more by Arthur's absence than she would have by his presence. Describing the glories of a sensational thunderstorm, she added: "it would have been nice to be by you . . . but maybe the loneness . . . gave me a chance to see more and know more what I saw."[36]

In terms of composition, O'Keeffe was making her own way, though involved with modernist concerns. Experimenting with perspective and design, she created landscapes that could be read both as flat patterns and as real space. Some of these compositions are highly complex, and the dense, repetitive color patterns assigned to elements in the sky and in the landscape are reminiscent of the complicated designs—textile and pottery—she used in teaching her students. Her bold use of color and of voluptuous contours, her vertiginous perspective, an assured abstraction of forms, and a sophisticated manipulation of space all demonstrate her emerging capacities as an entirely original worker.

The Palo Duro landscape reminded O'Keeffe of Dow's watercolors of the Grand Canyon, which she had seen in New York. Though she was indebted to him for ideas, she consciously rejected his example, writing dismissively of his inclination to yield to the seductive temptations of prettiness—a fate she avoided assiduously: "I can understand Pa Dow painting his pretty colored canyons—it must have been a great temptation—no wonder he fell." [37]

The year in Canyon was productive. Georgia worked steadily, in sculpture as well as painting and drawing. Sweeping views of the prairies met her when she stepped outside her door, and the visual limitlessness that surrounded her provided metaphorical encouragement for the freedom of her work. The great plains had more than a visual influence on her, however. Georgia was sensitive to sound and was conscious of natural aural rhythms. She explained one of her mountain landscapes by describing the day she had done it: "That day I discovered that by running against the wind with a bunch of pine branches in your hand you could have the pine trees singing right in your ears." [38]

The idea of translating aural phenomena into visual terms had interested her since she experimented with Alon Bement, and she continued to do it throughout her life. The cattle on the plains provided a strong undercurrent of natural music in the windy landscape.

> I wonder if you ever heard a whole lot of cattle lowing—it sounds different here—too—just a ground and sky—and the lowing cattle—you hardly see—either them or the pens . . . I like it—and I don't like it—it's like music— I made up a tune to it this morning. [39]

This music "was loud and sad, particularly haunting at night," full of anxiety and distress. It came from the cows, which were separated for the first time from their calves, before being loaded for the trip to the slaughterhouses. The sound of the cows lowing for their calves day and night haunted her. It remained in her mind, vivid and distinct, like the pallid sheen of the bleached bones, until it was transformed into her work.

The life in Canyon was a full one, aesthetically, physically, and intellectually:

> Anita—really—living is to[o] fine— Last night we had a tremendous thunder storm—and I've never seen such lightening in my life—it was wonderful—the big old man— have I told you about him—he is the biggest I ever saw it seems—tremendous—inside and out—he in his shirt sleeves—black shirt—he is distinctly a working man—and I in my kimono—stood out on the porch for a long time watching the whole sky alive— The lights had gone out— creating disturbance in the house—we were the only ones that went out— I often watch the sunset with him—he is the kind you like to see things with—
>
> I had been reading the Divine Comedy—Longfellow translation—and the tearing storm seemed to be just a part of it all— I was so interested I read almost all night—started to bed—then read over again—all that I had read—it reads even better the second time.[40]

Georgia was reading seriously this year: Ibsen, Dante, and Nietzsche. Arthur had given her a subscription to the *New Republic*, which she enjoyed, and there was also *The Forerunner*, written and edited by Charlotte Perkins Gilman. The feminist publication was serializing the last part of "The Dress of Women," which Georgia recommended ("It is great") and Gilman's feminist utopian novel *Herland*, a cheerfully radical work that challenged patriarchal assumptions across the board and presented an idyllic, man-free society. "She is a smart old girl," Georgia pronounced.[41]

Ibsen, Nietzsche, and Gilman all espoused revolutionary notions of new and radically defined freedoms; Ibsen and Gilman were particularly interested in questions of sexual equality. All three encouraged liberation from traditional beliefs and constrictions, and all granted philosophical permission to develop a personal code of values.

Georgia was also reading widely in aesthetic philosophy, in preparation for a talk she had been asked to give on modern art. That summer, Stieglitz had sent her "five wonderful *Camera Works*." The five would certainly have included the recent issue commemorating "Nine years of public experimenting . . . in the little garret." In this, sixty-odd contributors offered their views on "What 291 Means to Me," praising and celebrating the pioneering spirit of the place and its founder. One of the pieces was written by the building's West Indian elevator operator, who declared that he found "in 291 a spirit which fosters liberty, defines no methods, never pretends to know, never condemns, but always encourages those who are daring."[42] Other contributors to *Camera Work* during this period were Francis Picabia, the French Dadaist; Marius De Zayas, the Mexican caricaturist and essayist; and Paul Strand, the newly emerging photographer whose work embodied the revolutionary principles Stieglitz taught. All the issues contained a steady refrain of aesthetic radicalism, a fierce opposition to the aesthetic establishment, and a continual chant of encouragement to the daring artist.

Georgia responded to the encouragement she was receiving on all sides. She was working boldly and taking real risks in her work. "I've never thought of myself as having a great gift," she said later. "I don't think I have a great gift. It isn't just talent. You have to have something else. You have to have a kind of nerve. It's mostly a lot of nerve, and a lot of very, very hard work."[43]

Imagination is integral to courage: the sensibility that imagines no risks does not knowingly take any, and there is no bravery in a landscape without danger. Georgia's enormously powerful imaginative capabilities resulted in a great capacity for fear of every sort. It was her "kind of nerve," her ability to transcend her fears, of all sorts, that marked her. When she went on a camping trip with friends in the summer of 1916, she wrote:

> I got to the top alone in the moonlight—just as day was beginning to come—it was great—the wind—and the stars and the clouds below—and all the time I was terribly afraid of snakes.[44]

O'Keeffe's priorities were absolutely ordained: the experience was always worth the risk. "I'm frightened all the time," she said years later. "Scared to death. But I've never let it stop me. Never!"[45] It was this determination to proceed that had re-

vealed itself in her bold and unconventional behavior with Arthur Macmahon and had begun to show itself in her work.

The emotional connection with Arthur continued strong, though Georgia was becoming aware of a growing divergence between them. When she arrived in Canyon she told Arthur frankly that she felt "sort of impatient with you for being there" (in New York).[46] Despite Arthur's affinity for the outdoors and for Georgia, he had not managed to come camping with her in the summer, nor did he plan to visit her in Texas. His own priorities were academic; hers were aesthetic.

There was a large area of Georgia's life that she had never shared with Arthur: her work. Anita Pollitzer had been Georgia's sounding board the year before; now Stieglitz supplied her with sustenance. And since, for Georgia, emotion and work were so intimately connected, Stieglitz was becoming more and more a potent presence in her life.

Stieglitz was responding deeply to the things Georgia had been sending him, and he wanted again to give her an exhibition. Although she was pleased by his response, she was ambivalent about showing the work. Faithful to Arthur, she was aware of Stieglitz's intrusions into areas that had been reserved for Macmahon, and by October, she wrote Arthur an odd, semiconfessional letter, trying to alert him to the changing dynamics of the relationships. Stieglitz's letters, she wrote, had come to mean more and more to her. She had been getting them all summer, four and five a week, and sometimes they were so passionate and so intimate she was afraid to open the next one; she felt herself responding to this forceful personality. She also told Arthur that she loved him and that she needed his trust in order to explain herself. Alfred's letters, she says, are strange revelations: "Seeing the inside of him is such a curious—keen—kind of pleasure . . . all day I've wanted to turn quickly to you—[to] like you more because I like other things more."[47] Georgia's letter is full of her anxiety at the strong subversive pull from Stieglitz and her recognition of the implicit threat.

Her feelings of unease increased. Just after Christmas she wrote Arthur a long, brave, and candid letter, in which she revealed deep fears. The first was that of forgetting him, which she found deeply disturbing. Then she spoke about her moment of longing for a child at the Horace Mann School the preceding spring. (Embarrassment overcame her as she wrote him: though

the room was cold, her face was hot.) It was this incident, she told Arthur, which had made her sister Anita's behavior so devastating the year before: poor Anita had become pregnant, and, frightened and indecisive, had first had an abortion, then eloped. To Georgia, full of her own new secret longing for children, Anita's act had seemed a tragic waste.

Georgia's longing for a child was complicated by the presence of Claudie. Georgia had brought Claudie with her, she told Arthur, because she was so fond of her and had worried that the girl would not get on with the rest of the family. Alone with her sister in Texas, Georgia had found the responsibility frightening. When Claudie had trouble with her throat, Georgia had arranged for a tonsillectomy, but during her little sister's operation, fear took Georgia by her own throat. "I almost died I was so scared," she admitted.[48]

Having Claudie with her gave her an understanding of what it was like to take on someone else's life: deeply gratifying but terrifying, and intrusive as well. The experience made Georgia aware of how it would be not only to have a child but to have a dependent spouse. She was determined to have the former and to avoid the latter: "it makes me very sure that I don't want to be in any man's way—and—the little one . . . it seems that I must have it some time."[49] She finished her letter soberly reminding Arthur that she asked nothing of him but that, since the moment in the schoolroom, he had been different to her from all others.

The reason for the letter was her growing sense of intrusion into their relationship by Stieglitz. What she got from Macmahon, she explained, was "a certain kind of cleanness that it seems no-one but you can give me."[50] She found Stieglitz, in his forcefulness and insistent intimacy, frightening. She had found him frightening since the summer, and though things were still stable, she was afraid that she could not keep them so without support from Arthur. She was afraid of her own responses to Stieglitz: it was a cry for help.

• • •

THAT WINTER, Stieglitz had sent her a copy of *Faust*, a text crucial to his own sensibility and deeply connected to his perception of women. Goethe saw "the eternal feminine" as a pure and spiritual, albeit passive, force, an attitude for which Stieglitz felt great sympathy. The gift marked the growing intimacy between them.

Georgia responded to the spiritual struggle of the book with great intensity: "Anita it's simply great . . . I almost lost my mind the day I started it."[51]

In fact, intensity was the keynote of Georgia's years in Canyon. Unlike the period of deliberately solitary stagnation in South Carolina, she engaged herself in all aspects of the life around her, even the academic community. In preparation for the talk on art, she wrote Anita that she had

> been laboring on Aesthetics—Wright—Bell—De Zayas—
> Eddy— All I could find—everywhere—have been slaving
> on it since November . . . Having to get my material into
> shape—Modern Art—to give it in an interesting ¾ of an
> hour to folks who know nothing about any kind of Art—
> well—I worked like the devil—and it was a great success—
> You see—I hadn't talked to the faculty at all and I was
> determined to get them going— They kept me going all
> through the time allotted to the man who was to come after
> me and an hour after it was time to go home—and some of
> them wanted me to talk again next time— It was funny. I
> planned to say things that would make them ask questions
> —really—I had a circus. It was so funny to see them get
> so excited over something they had doubts about the
> value of.[52]

It was characteristic of Georgia's philosophy of commitment for her to take such tremendous trouble over a short talk, and characteristic, too, of her attitude of great respect for other people. There was no hint of condescension toward her pupils or her colleagues, only an interest in arousing their interest.

There were few members of the Canyon community who shared Georgia's beliefs about art and her approach to philosophy. Showing one of the brilliant, liquid, semiabstract Palo Duro landscapes to a baffled Willena Shirley, Georgia explained that it showed how she *felt* about the canyon. Mrs. Shirley replied tartly that if the picture showed how Georgia felt, she must have had a stomachache when she painted it.

In spite of the cheerfully philistine response to her art, Georgia felt herself a participant in the community. There were people on the plains who embraced the sky, the weather, and the landscape exultantly, as Georgia did; this was more important to her than conversation. Georgia often watched the spectacular perfor-

mances in the sky in a state of peaceful shared enjoyment with her first landlord, the "big old man" with a "wonderful white head," who ran the waterworks. And one night, walking on the prairie with a copy of *Faust,* she met a grizzled old farmer driving a load of clover. He looked at the title of her book and then offered her a ride: he had been a schoolteacher for fifteen years. "We had a great time riding in toward the sunset. He was little and dried up and weather-beaten—but he likes living."[53]

Georgia could create her own intellectual landscape, though this was not always satisfactory: "This thinking alone is great but it is puzzling," she wrote Anita.[54] Still, the physical landscape— the wide beauty—was the necessary one. On the plains she felt herself vividly alive and surrounded by vivid life: the pictures from this period reflect this intensity with a corresponding brilliance.

● ● ●

THERE ARE NO surviving letters from Georgia to Arthur Macmahon for six months following her intimate confession of December 1916. Never the leader in their relationship, he may have been entirely unsettled by her revelations, and the correspondence apparently languished as a result. By February, when Anita asked her about him, Georgia replied: "You ask about Arthur? Why Anita—I don't know . . . He is bound to mean a lot to me always. I haven't had much time to think about him— Does that answer you?"[55]

Needless to say, Georgia had ample time to think about Macmahon had she chosen to do so. This time he had not written to reassure her, and to protect herself she had withdrawn from her ardent stance of offered love. Dannenberg was still writing to her too, though the connection between them had become frail as well. It was Stieglitz who was playing the role that had become increasingly important to Georgia. She lived at a level of intellectual and creative excitement, and Stieglitz was her ardent, but absent, respondent.

Anita—he is great . . . Still—I'm glad I can't see him— I'm enjoying his letters so much—learning to know him—the way I did you. And Anita—such wonderful letters— Sometimes he gets so much of himself into them that I can

hardly stand it—its like hearing too much of Ornstein's
Wild Mans Dance—you would lose your mind if you heard
it twice—or like too much light—you shut your eyes and
put one hand over them—then feel round with the other for
something to steady yourself by.[56]

Georgia's appeal—her white skin, her black hair, and her
great, steady eyes—did not go unnoticed in Canyon. At a Christ-
mas party she met a lawyer. He was smitten, she was not, and
the poor man's behavior took on a comic cast. The next time
Georgia went to town, "he followed me around until I was alone
then asked if he could come up." Georgia, who thought they had
nothing in common, said no. Then she saw his stricken face: "I
changed my mind right quick and said he could."

When the lawyer came to call on the schoolteacher, Georgia
was in the midst of preparing her talk on art. She was full of
aesthetic propositions—which were not the sort he had in mind.
Still, he called on her again. By then, Georgia was interested in
their conversation and tried out her ideas on him.

Georgia's landlady suddenly entered the fray, announcing
primly that Miss O'Keeffe could have no more male visitors in
her room. (The *Bulletin* advised the students stiffly that "Young
ladies should receive company only in places prepared for that
purpose, never in their private rooms.") Though Georgia was not
a student, it was not her house. As the landlady was delivering
her ultimatum, the lawyer arrived, and Georgia told him the
news. He suggested a ride in his car, and they set out. "It was a
wonderful lavender sort of moonlight night," Georgia wrote, "we
stopped facing the hills . . . only someway he isn't the kind you
enjoy the outdoors with—he spoils it."

From the lawyer's point of view, of course, it was Georgia
who spoiled it: all she would do was talk about art. He used a
time-honored maneuver. "I was leaning forward," wrote Geor-
gia, "telling some yarn—and bless you—when I sat back straight
—his arm was round me— Jingles—it was funny."[57] The evening
was a failure, each being astonished by the other's failure to in-
terpret perfectly clear signals.

Georgia had, of course, put herself at considerable risk by
agreeing to drive off into the lavender moonlight. The college
took a strong stand on the proprieties. "Purity in women and

chivalry in men are their brightest jewels," the *Bulletin* pronounced. "Conduct that imperils either should be avoided." On the subject of car rides, the rules for students were stringent: "Auto rides at night . . . [are] considered grossly improper—an unpardonable social impropriety."

The interlude with the lawyer was not the only social difficulty that Georgia encountered. She had been known for risqué behavior since the day she was seen sitting on the Shirley front steps with a group of students at lunchtime. Georgia had walked back from the school and committed another kind of social impropriety: in broad daylight, she had taken off not only her shoes but her socks. She then sat brazenly in public with her feet entirely bare. This unsettling scene was observed by passing faculty members, and her reputation was established.

Georgia met Ted Reid, one of the older students at the college, while supervising the painting of sets for a play. Ted was the president of the Dramatics Society, and Ruby Cole (later his wife) was in Georgia's art class. He asked Ruby to ask Georgia if she would help with the sets. Ted, who had spent his adolescence herding cattle, had an abiding love of the Texas landscape. One day he saw Georgia watching a rainstorm and recognized in her face the same excitement he himself felt. The two of them went on long walks on the prairie together, delighting in the landscape and the vast theatrical atmospherics around them.

• • •

WHEN GEORGIA LEFT the University of Virginia summer school the previous August, she had recommended Anita Pollitzer to the head of the faculty there, Mr. Maphis, as a teaching candidate. In January 1917, Anita was offered a job. Georgia encouraged her to take the place but announced her own decision to stay and teach the summer session in Texas, saying that she felt an odd loyalty to the place.

O'Keeffe had continued to send Stieglitz her work, and in November-December of 1916 he put some of her work (including *Blue Lines*) in a group show with Marsden Hartley, Abraham Walkowitz, John Marin, and Stanton Macdonald Wright. Through his efforts, too, one of her pictures, titled *Self-Expression*, was included in a People's Art Guild exhibition, in early 1917. Anita wrote with excitement that she had seen:

the catalogue of the People's Art Guild and you *have* a thing
in it . . . I know its through Stieglitz . . . you're hanging
with Marin—and with Marin means a big fine thing . . .
Heavens I'd like to see it— Tell me about it—or didn't you
know it till now— I call this important and I know I'm
right.[58]

Intercourse between the artist and society is always a matter
of delicate balance. Ideally, the artist works in a state of serene
creative detachment, uninvolved with the question of society's
response and unmoved by the vagaries of popular taste. This
most serene and undisturbed moment comes usually early in the
artist's career, before society pays attention to his work. What
should be idyllic is often marred by penury, however, or by de-
spair at lack of recognition. The perfect balance is difficult to
achieve: once society stops ignoring the artist, it is difficult for the
artist to continue ignoring society. As an emerging artist, Georgia
quite naturally found the moment when her work began to re-
ceive serious attention a heady one.

In the spring of 1917, Alfred Stieglitz gave Georgia O'Keeffe
her first solo exhibition. Opening on April 3, the show contained
the Palo Duro landscapes, the blue watercolors, and one of her
plasticine sculptures, among other works.

When Georgia's teaching term was over in Canyon at the
end of May, she had three weeks at her disposal before the sum-
mer semester began, and was tempted by the idea of a sudden
trip to New York. Not only would she see Stieglitz and her exhi-
bition but she had heard that the building at 291 Fifth Avenue
was to be demolished. She wanted a last look at the space that
had played such a significant role in her artistic development.

There was another reason for Georgia's sudden urge to
travel. There was a man in Texas—probably Ted Reid—who had
become more than a good friend. The two of them shared a love
for the great landscape, and they spent long hours walking on
the plains, day and night, alone with the sky and the wind.[59]
Georgia said candidly that she considered packing up and leaving
with the man, both because of his freedom and because of his
desire for her.[60]

To yield to a man because he wants her is an archetypical
female response, passive and dutiful; it has resulted in a great

many marriages. Georgia felt the mesmerizing pull of this, but she felt, even more strongly, a vehement and instinctive resistance. Though she said she wanted "more than anything" to go away with the Texan, what she did was to ensure that she did not.

Georgia asked Claudie's advice about her wildly impractical plan to go to New York. The trip would cost two hundred dollars, which happened to be exactly all the money Georgia had in the world. Her sister's response might have come from Georgia herself: "If I felt as you do about it," Claudie said, "I'd go."[61] This was on a Sunday. That afternoon Georgia appeared at the Canyon bank manager's house, and persuaded him to open the bank for her. She took out her savings and left the next morning on the early train.

She arrived at "291" unannounced. Stieglitz, who was talking, as always, became aware of "a quiet presence behind him" and turned to find Georgia O'Keeffe. The moment was one of discovery. Georgia's unexpected appearance heightened the magical, otherworldly quality she had for Stieglitz, Besides, the "quiet presence" of Georgia O'Keeffe was by now a remarkable one. There was no longer any question of her standing by unnoticed while more loquacious friends occupied Stieglitz's attention. Her quietness was magnetic: Stieglitz knew now what it concealed.

Georgia was twenty-nine. Her face was no longer girlish but warm and gentle. Her hair hung in a mild loop over her forehead; the white lace of her collar was limp and fragile. Her gaze was direct, thoughtful, and sympathetic, her expression was one of absolute candor, revealing a willingness to be engaged. The hated dimples were still faintly visible; Georgia was still not the beauty she would become. That transformation would occur when her face was further defined and the impeccable skull revealed, the shape of the bones taking elegant and decisive form. Even so, her serene features were informed by such warmth, intelligence, and interior purpose that her appeal was remarkable.

The walls of "291" were bare; Georgia's show had come down. Stieglitz hung it again for her and again took pictures, this time placing Georgia in front of her work. He recorded the woman he saw: her face, direct, smiling, quizzical, faintly reserved; her supple, expressive hands against the rich black and white patterns of her long-sleeved, white-collared black dress;

her hands placed against one of her swirling, unfurling shapes, the fluid curves of the tapering fingers echoed in those of the painting.

The gallery was closing, and O'Keeffe's first one-woman show was the last exhibition to hang at "291." For Alfred Stieglitz and Georgia O'Keeffe it was not the end of anything.

14

*The recent work in oil, watercolor and charcoal of Miss
Georgia O'Keeffe . . . speaks for itself at that jumping-off
place of modern art . . . 291 Fifth Avenue. The work has to
speak for itself, as it is not numbered, catalogued, labeled,
lettered or identified in any way—in fact, it is not even
signed. The interesting but little-known personality of the
artist . . . is perhaps the only real key, and even that would
not open all the chambers of the haunted palace which is a
gifted woman's heart. There is an appeal to sympathy,
intuition, sensibility and faith in certain new ideals to which
her sex aspires . . . Miss O'Keeffe, quite independently of
technical abilities quite out of the common, has found
expression in delicately veiled symbolism for "what every
woman knows" but what women heretofore have kept to
themselves, either instinctively or through a universal
conspiracy of silence.*

—HENRY TYRRELL
Christian Science Monitor,
May 4, 1917

THE APPEARANCE IN THE art world of what was
clearly the direct expression of a female sensibility aroused im-
mediate critical interest. Tyrrell's review, alternating between
chivalry and serious admiration, between objective and subjec-
tive approaches, demonstrates the inherent problems that still
cause difficulties in critical response to O'Keeffe's work. The char-

acterizing of the work as "esoteric," the fact that emotion was a central force in it, the intensely feminine nature of the sensibility that produced it, and the belief that the artist's personality was crucial to an understanding of the work were all elements that would remain controversial in the discussion of her art.

What was clear at once was the emotional impact of the work. Tyrrell continued:

> Whatever her natural temperament may be, the loneliness and privation which her emotional nature must have suffered put their impress on everything she does. Her strange art affects people variously . . . many feel its pathos, some its poignancy, and artists especially wonder at its technical resourcefulness for dealing with what hitherto had been deemed the inexpressible—in visual forms at least.

From the first, the artist's personality is drawn into the discussion, as though the work could be understood only with reference to the sensibility behind it. This is largely true of all abstract art: once the symbols of narrative art are abandoned, without explanatory theories, abstraction runs the risk of being esotericism.

O'Keeffe's abstraction seemed particularly arcane because her imagery was female, drawn from a consciousness that was perfectly accessible to women but not always so to men. And though the female nature of the work was recognized at once, it was not perceived as the underlying element of the alienness that people found. O'Keeffe's imagery was, as Simone de Beauvoir later demonstrated, "Other"; it was apart from the male mainstream. This fact of alienness to the male tradition was responsible for a strand of hostility that would remain part of the complicated skein of response to her work.

Clement Greenberg, for example, writing for *The Nation* in 1946, made the scornful pronouncement: "Her art has very little inherent value . . . [The works] display a concern that has less to do with art than with private worship and the embellishment of private fetishes with secret and arbitrary meanings."[1] There is nothing secret, private, or arbitrary about O'Keeffe's imagery for the woman viewer. The instinctive recognition and response to O'Keeffe's work that women enjoy serves as a measure of the

corresponding depth of alienation from the work that has been felt by some men.

Then, too, there was the emotion—so salient a presence—which made the work so powerful and ultimately so difficult for the critics.

In the nineteenth century, and in the early decades of the twentieth, art critics enjoyed the sentimental and lengthy discussion of the emotive qualities in the narrative paintings they appraised: sadness, tenderness, passion, rage—all were delicious morsels of feeling to be savored voluptuously in print. In 1895, a critic describing a portrait of Lazarus by Elihu Vedder uses the following language:

> In the presence of such a representation in pigment of
> a living soul of such sweetness, such dignity, such tran-
> quil pensiveness, such pathetic and moving serenity,
> such a visible record of mysterious yet not awful
> spiritual experience secretly cherished and intimately
> sustaining . . . [2]

In the twentieth century, however, art criticism began to move away from this tranced subjective approach. As part of the movement toward a rational approach to the world, there would emerge an increasingly strong disaffection with emotion as an element in aesthetic appreciation. As the century progressed, a formalist school of art criticism would evolve, adopting a purely technical and intellectual approach and encouraging the excision of the gentler emotions in the discussion of painting.

Although expressionism would remain a powerful and important element in twentieth-century art, the emotions revealed in it would become increasingly abstract and distant from the observer; equally, the language in which it was discussed would become distant and abstract. Then, too, the emotions most vividly and frequently expressed in the masculine tradition of expressionist art are anger and violence—generally perceived as permissible subjects. One of Greenberg's complaints, for example, concerned O'Keeffe's scurrilous sympathy for the German *Blaue Reiter* and expressionist painters. She used this, according to Greenberg, as "the signal for a new kind of hermetic literature with mystical overtones and a message—pantheism and pan-love and the repudiation of technics and rationalism."[3] Greenberg's resentment of the artists who chose the German over the French

was nothing more than a reflection of his personal preference for intellectual rather than emotional content—as though the world of art could express only one or the other, and as though a qualitative comparison would unarguably place the former above the latter.

But the emotion in O'Keeffe's work—so fundamental that no discussion of her work would be complete without reference to it —was at once joyful, lyrical, and intimate. This dissonance between subject and form was evident from the first critical response to her work. Tyrrell's delicate phrases about "the chambers of the haunted palace" were hardly appropriate to those bold, exultant western images, nor were they adequate to the aesthetically courageous sensibility that produced them.

Similarly, the misconstruing of the content of her works began early. *Blue Lines* is described by Tyrrell in his review as "Two Lives." The confusion may have been aural; since he notes that the works are not titled, he may well have asked for a name and misheard it. In any case, his interpretation, based on his own misunderstanding, created an early foundation for the enduring critical insistence on sexual allusions in O'Keeffe's work.

> "Two Lives," a man's and a woman's, distinct yet indivisibly joined together by mutual attraction, grow out of the earth like graceful saplings, side by side, straight and slender, though their fluid lines undulate in unconscious rhythmic sympathy, as they act and react upon one another . . . But as the man's line broadens or thickens, with worldly growth, the woman's becomes finer as it aspires spiritually upward, until it faints and falls off sharply—not to break, however, but to recover firmness and resume its growth, straightheavenward as before, farther apart from the "other self," and though never wholly sundered, yet never actually joined.

The review begins another pattern: the confusing morass of misinformation about Georgia O'Keeffe, which would grow larger and larger, begins here with her first serious notice in the press. Tyrrell informs the public that the artist, who "is the offspring of an Irish father and a Levantine mother, was born in Virginia and has grown up in the vast provincial solitudes of Texas."

. . .

THE BROWNSTONE that had housed "291" was to be torn down, as part of the great wave of building that was beginning in New York. Rather than move his quarters, Stieglitz decided to close the gallery altogether. He had succeeded at last in convincing the American art world of the merits of both modern art and photography. His obstinacy, however, had prevented him from making his crusade into a successful commercial venture. (Stieglitz's outraged indignation at any suggestion that he was *in business* to *sell* pictures was made possible, at this period, by his unassailable financial position: this was firmly based on his own inheritance and his wife's family's thriving beer business. The fact that his ivory tower was set on such an adamantly bourgeois foundation bothered him—like other contradictions inherent in his philosophy—not at all.)

The Photo-Secession group had long ago disintegrated, when Stieglitz quarreled with leading members Clarence White and Gertrude Kasebier in 1912. Since then, Stieglitz had devoted himself more to exhibiting painting than photography, and a new group of supporters and enthusiasts had emerged. Stieglitz's relationship with Eduard Steichen had deteriorated, owing to increasing strains of competition between the two men on a number of issues. When Steichen had returned from France, he found that he was no longer an equal partner, philosophically, at "291." Paul De Haviland, an energetic supporter, both financially and intellectually; Francis Picabia; Marius De Zayas; and another supporter, the wealthy Agnes Ernst Meyer, had all been members of the "291" group since 1907. In Steichen's absence they had achieved a level of participation that he had previously enjoyed alone, and when he came back in 1915, to discover them as firmly entrenched members of the inner circle, his frustration became apparent. Steichen redesigned the interiors of "291" for the African art show of 1915, making a metaphysical statement about the impact that he felt he should have on the gallery. Steichen was by then a professional who was making his own way in the world, and it was inevitable for him to establish his independence from Stieglitz; nonetheless, the process was painful for them both. When Stieglitz asked his friends and associates to submit their responses to the question "What is 291?" Steich-

en's reply was a list of the gallery's failures, in which he characterized Stieglitz as a "despot."

In that same year, 1915, De Zayas, Meyer, and Picabia also had left the gallery, though on amicable terms. The three of them persuaded Stieglitz to support an offshoot of "291," the Modern Gallery. The Modern would handle the same group of artists, but would do so in a frankly commercial manner. Though Stieglitz agreed to participate in the venture, it meant the loss of his most constant and supportive companionship. The artist Abraham Walkowitz was still a faithful regular, and Marie Rapp, who had been an indefatigable assistant to Stieglitz since 1912, was there as well. But the critical mass had gone from the group. In the fall of 1916, Anita Pollitzer wrote of Stieglitz: "He is so nice—much older than last year though and the fire in him not so keen and crackling—but gosh its there—and burning."[4]

The World War naturally played an important part in Stieglitz's consciousness, its monstrous international carnage dwarfing the significance of any philosophical bickering over aesthetics. As Sue Davidson Lowe reveals, when the war broke out, Stieglitz's companions were a pair of young radicals, opposed to war on ideological grounds and taking a firmly pacifist position. Stieglitz adopted the same attitude, though at the very beginning he entertained the notion that a brief bloodbath would be somehow cleansing and beneficial. Stieglitz was sickened both by the homicidal aggression of his beloved Germany and by the bellicosity of the Allies. The latter was, he believed, motivated by economic as well as humanitarian interests.

In any event, both Stieglitz and the American public lost sympathy for German art, and throughout Europe the modern art movements lost momentum. Public attention was focused on the international political scene, not the aesthetic one.

Stieglitz's role in the world of American art had evolved considerably: beginning with a concern for purely photographic work, he had moved on to European "anti-photographic" art, then more and more toward American art. By 1917, Stieglitz felt that he had made his point to the American public: photography had been accepted as an art form, and radical work by both European and American painters was being shown and collected in the United States. His success was demonstrated by the emergence of other galleries: the Modern, the Montross, and the Dan-

iel, all of which had viewpoints similar to his own and showed the work of artists he had championed.

In 1917 the sense of forceful determination was dissipated. The subscribers to *Camera Work,* who had dwindled to a tiny few, were informed that the June issue would be the last. Stieglitz's mission seemed completed, and no other had yet materialized.

Stieglitz's plan was to close the gallery space and maintain a small office that would house himself, the back issues of *Camera Work,* and any art work that the other galleries had not taken on. Georgia described his plan to establish "a picture library . . . pictures to rent out— He's going to have just one little room 8 × 11 . . . Just a place to sit he says— I don't know. It's all queer. But Anita—everything is queer." [5]

During her visit to New York, Georgia had seen Arthur Macmahon: "I sort of feel that I have gone on past [him]," she told Anita in the same long letter. Arthur did not agree, however, and the two had an awkward and unsatisfactory evening, followed by another, in which they tried unhappily to clarify the situation. Stieglitz, however, was at the center of Georgia's preoccupations and her new life. "It was him I went up to see— Just had to go Anita— There wasn't any way out of it."

Georgia had met, through Stieglitz, a new group of people. She wrote Anita about the Synchromist Stanton Macdonald Wright: "I'd like to give him an airing in the country—green grass —blue sky and water"; and of another new acquaintance:

Met another man I liked— Gaisman—inventor of the Auto-Strop Razor and the Autograph Camera—whatever that is. He took Stieglitz and Strand and me to Sea Gate then to Coney Island Decoration Day— It was a great party and a great day— Dorothy wouldn't go.

But it was Paul Strand who made the greatest impression. She asked Anita:

Did you ever meet Paul Strand? Dorothy and I both fell for him. He showed me lots and lots of prints—photographs— and I almost lost my mind over them—photographs that are as queer in shapes as Picasso drawings . . . I hope you have met him—he is great.

Paul Strand was three years Georgia's junior, a brilliant young photographer from New York. He had been brought to "291" by his teacher, the social-documentary photographer Lewis Hine. On the spot Strand had made up his mind—at seventeen —to become a photographer. The forceful encouragement of Strand's work demonstrated the depth and generosity of Stieglitz as a teacher and mentor: the young man would become generally accepted as one of the great photographers of the twentieth century.

Strand put into practice the principles that Stieglitz taught, making the utmost use of the expressive capabilities possessed by the camera and the photographic process, and at the same time taking a definitive and self-assured leap into abstraction. When Georgia saw his pictures, in the spring of 1917, she was seeing the most advanced work being done in the field. Strand's sharp focus and severe cropping produced bold and original compositions, which are, as Calvin Tomkins notes, "images at rest within the frame—at rest in a space charged with a dense and complex life of its own." [6]

Photography by its nature permits a depth and range of subtlety and chiaroscuro that are unavailable to the painter, and in that sense Strand's work is far less simplified and austere than O'Keeffe's. There were, however, strong parallels between them. Most significant was the use of focus: Strand's close, intimate, and severely discriminating views of ordinary objects transformed them into purely abstract compositions and also into objects of newly perceived interest. This was an approach that O'Keeffe would adopt. Then, too, there was a shared interest in the natural environment and in its specificity. Strand later stated: "I've always had an interest in the things that make a place what it is, which means not exactly like any other place . . . Growing things are part of the quality and the character of a place." [7] Strand's attempt to record the essential character of a place was directly parallel to O'Keeffe's intentions. And in a pattern of aesthetic cross-pollination that worked constantly and powerfully among the Stieglitz group, the two artists twice chose the same remote areas of the countryside as subject matter: the Gaspé peninsula, in Canada, and Santa Fe, New Mexico, and even used the same subjects in those places for their work.

On her way back to Canyon, O'Keeffe wrote warmly to Strand:

And Ive been wanting to tell you again and again how
much I liked your work— I believe Ive been looking at
things and seeing them as I thought you might photograph
them— Isn't that funny—making Strand photographs in
my head. So—I am thanking you for much— I think you
people have made me see—or should I say feel—new colors
— I cannot say them to you but I think Im going to make
them.[8]

But the relationship between Strand and O'Keeffe was based
on more than aesthetics. Paul was a prepossessing young man,
with thick, curly hair, a high forehead, a long, determined chin,
and hooded, piercing eyes. At their first meeting they felt a
strong mutual attraction; Georgia's was made clear by her exu-
berant admission: "I fell for him!"

Georgia's situation was a complicated one. Having fled from
the importunate Texan, in New York she met Stieglitz, who pur-
sued a warm and flirtatious intimacy. Arthur Macmahon was
there as well, still an important part of Georgia's life. And then
Georgia met Paul Strand.

Georgia was at the gallery, looking at Abraham Walkowitz's
new work, when she found Paul's eyes upon her. The look was
unmistakable. "The look in your eyes that startled me . . . I had
just run from eyes [like those] . . . only to find a glimmer of the
same thing in new eyes—so I looked away—wondering—wasn't
there any place to get away from that look—from folks that feel
that way about me."[9]

As with her response to the Texan, however, Georgia's feel-
ings were divided. At first she turned away, but she felt a strong
physical pull toward Paul. When he showed her the prints of his
work, "I loved it—and I love you," Georgia wrote boldly. "I
wanted to put my arms around you and kiss you hard . . .
You've gotten in me—way down to my fingertips—the con-
sciousness of you."[10]

Paul was deeply taken by the beautiful and enigmatic Geor-
gia, whose responses were powerful, deep, and compelling,
whose honesty overwhelmed him. He asked why, then, she had
not put her arms around him as she had wanted. Georgia wrote
back:

In a way I hate to tell you . . . I feel that in a way I am
spoiling—maybe—a person you had made up that gave

you pleasure— Honesty is a mercyless [*sic*] thing. I don't
know whether it is worth while or not— Still I have never
had any choice in the matter—[The reason was that] So
many people had kissed me in such a short time—and I had
liked them all and had let them all—had wanted them all to
—it simply staggered me that I stood there wanting to kiss
someone else—another one I thought . . . What am I
getting to.[11]

The "many people" were probably only two men, Ted Reid
and Arthur Macmahon, but Georgia had been rather shocked by
herself and drew the line firmly at a third— Paul Strand.

Georgia's candor—the acknowledgment of her own warm-
blooded responses—was irresistible. She had to protest Strand's
attempt to place her on a pedestal. "I am not fine," she insisted
stoutly, "nothing fine about me. And I'm not sorry about it
either. I'm only what I am—and I'm free to live the minutes as
they come to me. If you know me at all you must know me as I
am. The night is very still."[12]

Georgia saw herself without apology or excuses and was
aware of inconsistencies. She had made accommodations out of
kindness to men and their feelings: she had let the lawyer come
to call, she had let Arthur state his case and kiss her goodbye,
but she could see that these accommodations satisfied neither the
men nor herself. In the end, she appeared both loose and heart-
less, and she told Strand ruefully that "I seem to like many people
enough to make them miserable— No one enough to make them
happy."[13]

Georgia saw that her attitude set her apart from conventional
women, and she aligned herself with the other gender.

I some way seem to feel what they [men] feel—never
wanting to give all . . . As I see it—to a woman
[commitment] means willingness to give life—not only her
life but other life—to give up life—or give other life—
Nobody I know means that to me—for more than a moment
at a time. I can not help knowing that—the moment does
not fool me— I seem to see way ahead into the years—
always to see folks to[o] clearly—
It's always aloneness—
I wonder if I mind.[14]

Georgia's knowledge of her essential solitude made her clear-eyed and unyielding. She put no effort into superficial intercourse. (This irritated Claudie, who said "walking with [Georgia] is just the same as being alone." [15]) Georgia saw herself as different from most people she knew, but when she met a kindred soul, she connected wholeheartedly, with a wealth of emotion. Paul Strand was such a man.

For the next year she wrote intimate and revealing letters to Strand, telling him of the beauties of the land that surrounded her, of her feelings, of herself. Strand's work made a profound impression on her, and when he sent her some prints, at the end of June, she wrote:

> The little prints—I looked at them a long time . . . your songs—that I see here—are sad—very wonderful music—quieting—music of the man I found . . . I feel that you are going to do much more wonderful things than any of us have seen yet—that you are only just beginning—
>
> The little prints make me conscious of your physical strengths—my weakness—relatively but that in spite of . . . my weakness—I give you something that makes it possible for you to use your strengths. [16]

Her letters are full of tenderness and a barely submerged sexuality: "I'd like to talk to you," she wrote, "nothing in particular— A warm wind—night coming— I'd like to go out on the plains with you and watch it come." [17]

Georgia had not given up Arthur Macmahon, despite her new relationship with Strand and the continuing associations with Reid and Stieglitz. She was confused by the complications of so many men in her life and in June wrote candidly to Arthur: "Maybe this spring I've been too much loved by many different people." [18] Her feeling for him was still strong, however, and she reiterated her old request—that he love her. Still, she admitted that her feeling for him, though wonderful, had dwindled, and she could hardly tell if it existed in reality anymore or only in her mind. Her next letter said simply: "It seems I must either stop caring or touch you when I put out my hand." [19] The following month she wrote him again, poignantly aware of the distance between them, as embodied in her work: "it seems to be getting farther and farther away from you . . . that you probably

wouldn't like it . . . It is too much like me—says things that would make you speechless like my letters."[20]

• • •

BACK IN CANYON, O'Keeffe continued to work in watercolor. Her new work included the "Evening Star" series: bold, rapturous compositions that embodied the daring aesthetic risks O'Keeffe was taking, as well as expressing the vast immensity of the sky and landscape. The endlessness of the sky and land, the lack of limits, was a metaphor encouraging O'Keeffe to pursue her vision, regardless of the conventions. The "Evening Star" pictures demonstrate astonishing courageousness, both in O'Keeffe's use of color and in the transformation of the physical world into abstract design. In this series, as in the 1916 work—the spreading, unfurling plume images and the mountain landscapes—O'Keeffe reveals a masterful control over her medium, combining breathtaking precision with a luminous, melting tenderness and demonstrating a ravishing eye for hue. In this, some of her most important work, O'Keeffe reveals great aesthetic bravery, technical mastery, and a hauntingly original vision: a response to the landscape that has few equals.

• • •

ANITA POLLITZER took Georgia's place that summer, teaching at the University of Virginia. Georgia stayed on in Texas, where she would teach through the summer and start again in the fall term. That summer marked the end of the intense and frequent correspondence between the two young women. Though they would maintain a strong friendship for the next four decades, their mutual need for each other's advice, companionship, and support would never again reach the level of the preceding eighteen months.

Art was becoming less central to Anita's life. She had always been involved in the feminist movement, and in the fall of 1917 she wrote Georgia that she was "working like the Devil for suffrage."[21] Anita chose finally to concentrate her energies upon politics, and the lives of the two women would diverge further as they married and moved into different environments. Nonetheless, the correspondence remains as evidence of a vital and nourishing friendship, which supplied both young women with

constant and reliable support, emotional, philosophical, and aesthetic, during a time of growth for both of them.

Besides Strand and Stieglitz, Georgia had acquired another new correspondent: Stieglitz's niece Elizabeth, his brother Leopold's daughter, a sensitive and perceptive young woman who was a great favorite of her uncle's. Her friendship with Georgia began as Stieglitz's did, through correspondence. "Elizabeth's is particularly wonderful," Georgia wrote of a letter she received in June.[22]

The summer of 1917 was one of great productivity for Georgia, during which she continued her brilliant, lucid work in watercolors. She sent her summer's efforts to Stieglitz in August. "A batch of watercolors came . . . A few wonders. But I'm sure the Colorado stay will have a decided effect upon her further work—will add something very big."[23] "The Colorado stay" was a vacation O'Keeffe had planned, and Stieglitz was, of course, correct in thinking that it would add something very big to O'Keeffe's work—though the repercussions were greater than he expected.

In August her letters slackened. Strand wrote despondently about this to Stieglitz, who replied that Georgia's period of creativity had exhausted her. "She has gone through a very perfect experience—still is in it—and seems to be very tired from all the work."[24] Strand wrote to Georgia asking if illness was the cause. Both he and Stieglitz were wrong about her silence.

"It's someone out here," Georgia explained to Strand: the importunate Texan had once again seized her heart. Part of his appeal was his boldness:

> It seems I have never seen anyone with such damnable
> nerve . . . I've said I won't marry him—again and again—
> still—he's so funny—I don't know . . . right now—I've
> made up my mind that I will—in a year—if we don't
> change our minds—and I know we will change them—or
> I'll change mine . . . I believe I'd like to live with him—for a
> while anyway but I hate the idea of being tied.[25]

Georgia wrote Paul in mid-August from New Mexico, "where the nothingness is several sizes larger than in Texas."[26] She was on her way to Colorado with Claudie, whose turn it was to choose their vacation. That year the rains in Texas had been

heavy, and because of flooding there was no direct train route the two young women could take to Colorado.

" 'We can't go,' my sister said. 'All the bridges are out between Texas and Colorado.'

" 'Let's get tickets the shortest way around then,' I told her. 'If you can't go straight, go crooked.' " [27] They did, traveling first to Silverton, in the southwestern corner of Colorado, where they probably slept at the Grand Imperial Hotel. [28] They traveled through Denver to the town of Ward, near Estes Park, not far from the Wyoming border. There they put up in a log cabin and "seemed to walk on an average twenty miles a day"—their favorite recreation. [29]

Georgia and Claudia stayed in mountain cabins with a small group: "the engineer, and an ex-prize-fighter that I've taken a great notion to . . . a fool and another woman—it was a funny crowd." [30] "Tramping" was the main occupation, though in Ward Georgia painted, among other things, two oils of the church bell —a subject that would continue to appeal to her.

Georgia's delight in the landscape was rich and varied. A description of a moonlit expedition to Stapps Lake demonstrates the commingling in her of aesthetic and romantic response:

The mountains like silver in the moonlight— The black into the pines and into the valleys seemed impossibly black . . . One lake . . . surrounded by bare mountains—bare banks —rocks—a cold bare lake sparkling in the moonlight—
Gosh it was bare—
And I wanted to like some one tremendously—some one that liked what I saw—like I liked it." [31]

On both ends of the roundabout trip, the two sisters stopped off in Santa Fe, New Mexico. The pale, clean, quiet adobe town, the pure, glittering air, and the exhilaration of the high mesa country made the encounter one of great resonance for Georgia. She wrote to Stieglitz that the trip had "virtually washed the slate clean of Canyon— NY—the past." [32]

Willa Cather, who, like O'Keeffe, grew up on the Great Plains of the Midwest, also traveled to Santa Fe.

I go everywhere, I admire all kinds of country . . . But when I strike the open plains, something happens. I'm home. I breathe differently. That love of great spaces, of

rolling open country like the sea—it's the grand passion of my life. I tried for years to get over it. I've stopped trying. It's incurable.[33]

For O'Keeffe, the 1917 encounter was brief. But the land of New Mexico remained—as had the white bones on the high desert and the cries of the penned cattle—deeply settled within her mind. "From then on," she said later, "I was always on my way back."

By mid-September, Georgia was in Canyon again. She had no wish to paint, and when she got out the work she had done in Colorado she pronounced it "so bad that its funny."[34] Paul had faithfully continued the correspondence in spite of the Texan. He now wrote her dolefully of a man he had just met who also claimed a romantic relationship with Georgia. For Georgia, the romantic interludes were not serious (they were probably not sexual, either), and she answered Strand briskly and unsentimentally:

> The man you met was another one—but it doesn't matter about any of them anyway—why talk about it. I feel as though I've just wiped my hand across the table they were on and tumbled them all off. I don't know where they went to—they are all gone for the present anyway. And it's a great feeling that I have of feeling gloriously free.
>
> Some would call it fickle—a ridiculous word. With me its more a feeling of master of myself. I always feel like a sort of slave when I am liking any one very much.[35]

• • •

THE ENTRANCE of the United States into the war had profoundly altered the consciousness of the Canyon community. War was declared in the spring of 1917, three days after the opening of O'Keeffe's exhibition in New York, and at West Texas State Normal College the students filed outside and stood with hands clasped in a great circle around the flag. A chauvinistic, militaristic attitude prevailed: "The West Texas State Normal College is intensively active and aggressively loyal and patriotic," announced the *Bulletin* in 1918. A number of the young men at the college had already signed up for military service. The following spring, the draft was instituted. Those men who were not called up were told by the college that if they wished to enlist, they

could forgo the last months of the term and receive a provisional certificate of graduation.

Georgia's response to the war was ambivalent. Understanding the position the United States had taken in support of the European allies, she still found it difficult to reconcile militarism with fundamental Christian teachings or humanistic behavior. She would always find herself resistant to rising tides of mass emotion, and her sense of real integrity, a philosophical wholeness, denied the possibility of the end's justifying the means.

Paul Strand was undecided about enlisting, on philosophical grounds. Georgia was impatient with his indecision. She supported conscientious objection but recognized that men she respected might disagree with her. Her younger and favorite brother, Alexis, enlisted. Georgia wrote Strand:

> I saw my brother in Chicago— He has enlisted in the officers camp of engineers at Ft. Sheridan—is hoping to be one of the first from there to go to France—and doesn't expect to return if he goes—
>
> A sober—serious—willingness appalling—he has changed much—it makes me stand still and wonder—a sort of awe— He was the sort that used to seem like a large wind when he came into the house.
>
> I understand how it happened— I understand your feeling about it— You are both right— I say I understand you both— Is it true though— Do I understand anything— I do not know.[36]

Georgia counseled her own students to complete their academic terms and graduate before signing up for military service. She was known for the sympathy and commitment she showed her students, and she was concerned that the young men, caught up in a patriotic storm of emotion, were being swept off to a continent they barely knew of, into a conflict they hardly understood.

In the fall of 1917, Georgia, in a state of lassitude and depression, wrote to a friend from Virginia, Anna Barringer.

> I did some better painting last spring and summer than I've done before— It hasn't been shown yet—but probably will be this winter—don't know—don't seem to care . . .
> Stieglitz said he was going to but I haven't heard . . . I

don't seem to care—291 closed you know . . . I haven't
worked for three months now—the longest time in several
years—four—I guess.[37]

Georgia was entering into an emotional state that presaged
physical illness, a recurrent pattern for her. At the end of Octo-
ber, she wrote Strand:

> I guess can't work because everything seems so mixed up—
> so inconsistent— I cannot really be any one thing enough to
> want to say anything about it— Everything seems to be
> whirling or unbalanced— I'm suspended in the air—can't
> get my feet on the ground— I hate all the folks I see every
> day—hate the things I see them doing—the things I see
> them thinking—
>
> I should think going to War would be a great relief from
> this everlasting reading about it—thinking about it—
> hearing talk about it—whether one believed in it or not—it
> is a state that exists and experiencing it in reality seems
> preferable to the way we are all being soaked with it second
> hand—it is everywhere.
>
> I don't know—I don't know anything. There is no-one
> here I can talk to—its all like a bad dream.[38]

Georgia's depression was heightened by an increasing sense
of isolation from the community. Claudia left Canyon in Decem-
ber, to begin student teaching in Spur, Texas. That month, Geor-
gia had a skirmish with a shopkeeper. She asked him to remove
from sale some Christmas cards full of vehemently anti-German
feeling. They were, she wrote Elizabeth, "certainly not in keeping
with any Christmas spirit I ever heard of . . . it seems the whole
town is talking about me— Not patriotic."[39]

Georgia's innate capacity to laugh at her own distress came
partially to her rescue, but the issue was too central and signifi-
cant for her to dismiss. The type of rabid patriotism that she
found herself confronting offended her philosophically. It was in
that year, 1918, that she painted the watercolor *The Flag*. The
picture offers a striking contrast to Albert Bierstadt's famous
American flag, painted fifty years earlier. In that, the red and
white stripes come from the sunset, and brilliant stars blaze from
the evening sky. Bierstadt's painting is a vehement paean to
America, a celebration of a bold and triumphant ideal. O'Keeffe

sets a drooping flag against a starless, darkening sky. The flag flutters limply, stripped of its stars and stripes; its only color, and that of the pole, is blood red.

Though from adolescence Georgia had recognized the differences between herself and other people, her philosophy was fundamentally forgiving and unjudgmental. No matter how angry she became over her differences with people, particularly "educators," she forgave them because they were human. Peaceful coexistence was part of her code, which was essentially humanist. The incident with the shopkeeper, however, and the resultant gossip and ill will, altered her viewpoint. Exposure to hatred and censure from the community because of her philosophical positions made forgiveness less easy. Thereafter Georgia would be more guarded, more critical, and less forgiving.

Georgia's depression deepened, and in January 1918 she contracted a case of the influenza that was sweeping across the country. The infection had settled in her throat, and by the middle of February she notified the college that she would be unable to teach for two or three weeks and asked them to hire a replacement. On February 21, a notice in the newspaper stated that Miss O'Keeffe had been given a medical leave of absence.

Another factor in Georgia's terrible languor may well have been grief. In the fall of 1917, Georgia's mother had been dead just eighteen months. Because of the family's habits of stoicism and silence, Georgia's grief had been largely unexpressed. The "absolute deadness" she felt that fall and winter was partly a slow and painful acceptance of her devastating loss.

The controversy over Georgia's patriotism escalated during her sickness. That year, Ted Reid and two other students were undecided about whether to enlist early; Reid had already signed up with the Air Service Signal Corps. Georgia pointed out that the war would still be going on in a few months and suggested that he stay on and graduate before he went into the service.[40] Her advice seemed to flout the community's "aggressively loyal and patriotic" stance, and public feeling rose against her. Georgia had done something else to arouse public sentiment against her: her friendship with Ted Reid was too intimate to be tolerated. The impropriety of a teacher-student relationship was not to be countenanced, and then there was the fact that the two of them were so visibly unencumbered by questions of decorum, walking about on the prairie in all weather and at all hours. Ted was

visited by a group of faculty ladies, who made a straightforward threat: if he continued to see Georgia, he would not receive a diploma. Ted was certain that if he told Georgia she would create trouble for herself, so without explanation, he stopped seeing her. Each protected the other: Georgia was never told about the ladies' committee; Ted was never told about the disapproval directed at Georgia for her advice.

When Georgia was able to travel, she moved to a friend's farm in southern Texas to recuperate. Leah Harris was an energetic, capable woman who taught home economics at Canyon. Georgia and Claudia had visited her in Waring, near San Antonio, when they returned from the Colorado trip the previous fall. She now invited Georgia to stay with her and her brother. In the spring of 1918, Leah Harris herself was recovering from a bout with tuberculosis, and the two women planned to recuperate together.

Stieglitz was deeply concerned about Georgia's health: the influenza epidemic was a serious threat, which had claimed thousands of lives that year. Georgia was touched by his concern: "the 291 letter made tears come—I felt he had worried so." [41] By April, she was at the Harris farm, and she wrote him more cheerfully. Her recovery went slowly, however, and the letters between Strand and Stieglitz still show deep concern over her health in May, five months after her initial bout of illness.

Stieglitz's domestic life was becoming steadily more difficult. The summer before, he had written to Marie Rapp: "At 1111 [Madison Avenue] all is quiet. The tension is released . . . But the basis is as rotten as ever— It will have to be tackled—like a rotting tooth beyond filling." [42] And to Strand: "Of course my own trouble is purely the family question—the same trouble I've had for so many years— I as yet see no solution. I being as I am." [43] By the following spring, however, a solution started to present itself, and as a preliminary to it he moved out of the connubial bedroom and into his study. He began suggesting to Emmy that their lives could be happier if they were separate.

With his gallery closed, his colleagues setting up projects without him, the philosophical problem of the war looming over him, and his wife remote from his intimate affections, Stieglitz was drawn by the idea of O'Keeffe—distant, mysterious, beautiful, and, as he knew from her letters and paintings, filled with a lucid exultation at life. Letter writing was always a favorite occu-

pation of Stieglitz's; he sometimes wrote twelve or more a day. His letters to Georgia, which had been steady since the spring of 1916, became copious now.

O'Keeffe and Stieglitz came to know each other largely through their letters and their work; it was a curiously disembodied process of approach and understanding, yet there were advantages to it. In spite of her famous claim that words and she were not friends, O'Keeffe as well as Stieglitz was a direct and heartfelt correspondent, communicating the things most central and important to her mind. In bold and elegant handwriting, which grew more similar over the years, they both expressed their most private and complicated thoughts, and the habit of writing to each other frequently and lengthily never left them. Theirs is one of the most complete and revealing correspondences ever collected.

There were disadvantages, such as the risk that they would make each other up in their minds. Letters, as Georgia pointed out, are not at all like talking, and, as she wrote to Elizabeth, "Sometimes I wonder—we use the same ordinary vocabulary of simple words—do we understand one another though— I don't know." [44]

Stieglitz had begun to see O'Keeffe, the creator of haunting, bold, and resonant images, in terms of his favorite symbolic figure: Woman as primeval innocence. That spring, he wrote her: "Of course I am wondering what you have been painting—what it looks like—what you have been full of—the great child pouring out some more of her Woman self on paper—purely—truly— unspoiled." [45]

Stieglitz's preoccupation with the purity and the unspoiled quality of O'Keeffe, her self as a "great child," her magical embodiment of Woman, now began. In the letters of this period he begins to refer to her quality of "whiteness," a metaphysical purity based on her clarity of vision and the lucid wholeness of her mind, which set her apart from other women and, in fact, all other people. "The letter I received today was very quiet—very white," he wrote Strand. [46]

This characterization would prove both beneficial and deeply disruptive to their relationship. On the one hand, it provided Stieglitz with a rationale for a position of absolute and unqualified encouragement toward all her artistic endeavors. On the other hand, the risk in being "Woman" or "great child" is just as great

as the risk in being "Pet": neither has a reality except in the role assigned by the viewer. Both as "Woman" and as "great child," Georgia would be severely proscribed in her behavior: such roles are limiting, no matter how reverential the titles.

Stieglitz's deepening friendship and attraction were demonstrated through his growing sense of responsibility for Georgia. Though she was, in fact, a grown woman, financially and psychologically self-supporting, his attitude took on more and more paternal resonance.

> Women and children, he felt, were like plants, and a man should be like a gardener. He should see that they had the light and soil they needed . . . and water during the drought—above all, that they had space enough to develop to the last leaf and blossom that was in them.[47]

Implicit in the role of gardener is the capacity to give life, to make the distinction between weeds and flowers, to choose which buds shall be allowed to flower. Though with more sensitivity, Stieglitz assumed this decidedly paternalistic role as his father had, and as had most men of his generation.

O'Keeffe herself was not immune to the power of this conventional way of thinking. The role of tended plant was one she initially accepted, particularly since her own strength was then at such a low ebb. In the spring of 1917 she wrote to Elizabeth, who was urging her to return to New York and see Stieglitz. O'Keeffe resisted but somberly acknowledged a feeling of dependence, which already caused some foreboding:

> Just because I want to talk to him, I may go East this spring — I don't know— I can't tell. He is probably more necessary to me than anyone I know, but I do not feel that I have to be near him. In fact I think we are probably better apart. I don't know but I think we are.[48]

Strand and Stieglitz encouraged each other's interest and anxiety over O'Keeffe's situation. Strand, who was indecisive in his personal life, was drawn more and more to Elizabeth, but she was involved with another man. To distract himself, he turned his attention to Georgia and found Stieglitz an enthusiastic cohort. The two men discussed her for hours at a time, worrying about her health and her psychological welfare. Stieglitz had con-

fided to Marie and to Elizabeth that he was falling in love with the young woman with the Mona Lisa smile, who sent him rolls of casually wrapped watercolors that opened to reveal the vivid splendors of the Texas landscape. In love himself with Georgia, and talking to a man who thought he might be, Stieglitz decided to suggest that Georgia leave her job and her friend and come to New York. What finally made the two men decide to act was a situation that seemed clearly to demand old-fashioned male gallantry.

Waring, Texas, was still wild territory in 1918. One night as the two young women were alone in the farmhouse, Leah appeared in Georgia's room, whispering an alarm: a man with a light was stealthily approaching the house. Georgia and Leah ran back into Leah's room, where the two of them lay motionless in bed, Leah holding a pistol at the ready. The marauder crept around to the bedroom window and shone his lantern into the room. Seeing a pistol aimed directly at him, the man fled into the gloom, leaving the two women shaken, giddy, and angry. The visitor was a Dutch farmer named Zeller who lived down the road, and Leah registered a complaint against him.

When Stieglitz and Strand, who were itching for a reason to participate in Georgia's affairs, heard the tale, they decided that chivalry required the intercession of a male protector. After sitting up most of the night in discussion, they decided that Strand should make the trip. Stieglitz gave him the money for the train ticket, and Strand set off for Waring. Soon after he arrived, he plunged fully into the affair of honor.

> In the morning the girls set out for Waring early to phone and sew. I was to go up the road for cream. But it struck me that now was the moment to act—so I started— It takes me a long time before any action can crystallize. So I took the gun and a six-foot whip which I had bought some days previous and hied down the road—and invaded Zeller's property.
>
> When I got to the house he was off in the fields so I waited about 15 minutes. Finally he came riding up on his horse—got off—and we got away from the house so the women folks wouldn't hear. So then I told him he had to go to Waring with me and apologize publicly—informing him

at the same time that I might have a gun and then again I mightn't. It was under my shirt with my hand stuck in on the handle. Very funny.

Anyway he got terribly scared—begged me not to hurt him—a real coward. Didn't want to go to Waring because of enemies—political—there. So said he would gladly come up to the house and wait for the girls. So I marched him up the road ahead of me—he asking me not to shoot him in the back— Too funny. Wanted to know if I was in the Service, but I told him I wasn't answering any questions.

Well, we waited 1½ hours but they didn't come back— When suddenly one of his men galloped up to say that he was wanted down the road to tend a horse that was bleeding to death and he promised to come back at any hour I set if I let him go. So I did, with a warning to be back at 3 p.m. However, when they had gone I felt that they had put one over on me, so after going up the road for cream I decided to go down again and find out whether there was a horse bleeding to death. Made up my mind that I had to go right along and knew that I wouldn't be expected before 3 p.m. after which he might be waiting with a gun himself. So down I went but found that he had gone down to Birney, so told the man to tell him that I expected him to keep the appointment.

Meanwhile the girls got home about 2 o'clock and I had to tell them what happened so they shouldn't undress and go to bed. Finally about 5:30 an auto drew up at the gate and two men came down the path, and turned [out] to be the sheriff and his assistant with a warrant for my arrest on the charge of forced imprisonment—Zeller had sworn it out when he went to Birney. So I laughed and just told the sheriff—who was a good fellow—the facts—and I knew that Zeller had nothing on me. The sheriff wanted very much to clear up the whole mess . . . So it was suggested that we . . . get Zeller to come up and talk things over amicably . . . he sent for Zeller who showed up with a gun at his belt and sore as hell. However I got into him finally and he consented to come in. After that it was all clear sailing. He apologized for coming here that night tho' he claimed his intentions were honorable—and the girls accepted the apology . . .

It must sound all too funny to you—William Hart and the movies—but it is cleared up anyway.[49]

Georgia had started to work again in Waring. That spring, she did a series of brilliant watercolors, fluid, lyrical, and bold. This series includes the nudes and the "Portrait W" series. (The group has been dated 1917, but this date is unlikely. She sent the pictures to Stieglitz in the spring of 1918, probably soon after she did them.)[50] The nudes (probably of Leah Harris), are reminiscent of the Rodin watercolors, in which translucent washes of color define a fluid and recognizable shape.[51] The "Portrait W" pictures are of a local mechanic, Kindred M. Watkins, and they carry the expressive qualities of the medium even further. These "portraits" are purely abstract and are vivid explorations of the sensuous, flowing nature of the watercolor medium.

Georgia was only in relatively good health, suffering intermittently from stomach pains and general malaise. She was considering returning to teach summer school at Canyon, though dreading the prospect.

Debilitating, too, was the fact of Leah's sickness: Georgia found that living with someone chronically ill was a constant drain on her depleted energy. Leah had become psychologically dependent upon Georgia, and, futhermore, there was the dread of consumption: Leah's doctor had told her it was not in a contagious phase, but Georgia did not entirely trust his expertise.

Part of Strand's reason for coming was to help O'Keeffe decide what to do, and this was the topic of much debate. Stieglitz thought she was somehow at risk in Texas and that it was no longer fruitful for her to remain there, but he felt strongly opposed to interference despite his growing emotional attachment to Georgia. In his letters to Strand, his anxiety and his devotion became more and more urgently expressed: "there in my mind there always looms that terrible?— Life— Death— I want her to live— I never wanted anything as much as that. She is the spirit of 291— Not I—that's something I never told you before."[52]

The two men were inviting O'Keeffe to come to New York. Elizabeth had readily agreed that Stieglitz might offer Georgia her studio for temporary quarters. Texas had seen the moment of Georgia's greatest freedom and her greatest productivity. It had also seen her at her lowest ebb, physically and psychologically. The unselfconscious anonymity she had enjoyed in Canyon was

gone; the wide plains there were tainted; and sharing Leah's farm carried with it an emotional burden. Texas was no longer the place for her.

O'Keeffe was aware that Stieglitz's suggestion carried with it emotional implications, and she had wondered from the first if she and Stieglitz were not better apart: "I don't know but I think we are," she had written Elizabeth. She felt drawn to Stieglitz, but she recognized, in her need of him, the risk she ran of losing her independence. Personal isolation was a state she had chosen from the beginning, the better to work. "You wear out the most precious things you have by letting your emotions and feelings run riot," she had written. "I almost want to say—don't mention loving anyone to me . . . don't let it get you Anita if you value your peace of mind—it will eat you up and swallow you whole." [53] The explicit message was the careful avoidance of passion, but implicit within it was the acknowledgment of a passion so powerful that it could overwhelm and obliterate the rest of one's life.

On June 8, Strand sent Stieglitz a telegram: ARRIVE SUNDAY SEVEN THIRTEEN AM TOMORROW.

O'Keeffe had made up her mind.

PART III
1919 - 1928

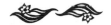

AN ORDERED LIFE:
MANHATTAN
AND
LAKE GEORGE

15

No man cares little about fleshly things. They fill him with a
silence that spreads in rings.

—JOHN ASHBERY

GEORGIA WAS ILL when she arrived in New York.
Feverish and coughing, she was taken from Grand Central Ter-
minal straight to Elizabeth's studio at 114 East Fifty-ninth Street.
The influenza had seriously weakened her: visibly frail, she
would continue to be ill intermittently for months thereafter. On
arrival she was put to bed and into Stieglitz's charge. Convales-
cence was a well-known and beloved country to him since his
childhood excursions through it, tended by his mother and aunt.
Blissfully, he undertook to escort Georgia through it. A week
later she was still spending most of her time in bed: "today nearly
all day."[1] It was some time before Alfred allowed her to venture
outside.

The O'Keeffe whom Stieglitz had known in the letters and
paintings—strong, independent, and courageous—was now
heartbreakingly fragile. This greatly heightened her appeal for
Stieglitz, for it placed him in the role of protector.

Despite Georgia's illness, the days in the studio were not
idle. For Stieglitz and O'Keeffe, who had been corresponding
with great candor and steadily increasing fervor for a year and a
half, these long, intimate daily meetings constituted an intense
psychological consummation. "We have talked over practically

everything," said Stieglitz. "Into one week we have compressed years."[2]

With Georgia delivered into his hands, Stieglitz was beside himself with delight. Arthur Dove, who was farming in Westport, Connecticut, sent down some fresh eggs for the invalid, and Stieglitz wrote him rapturously:

> These last ten days have been very full ones—possibly the fullest I have had in my life . . . Of course the important thing . . . has been O'Keeffe. She is much more extraordinary than even I had believed. In fact I don't believe there ever has been anything like her. Mind and feeling very clear—spontaneous—and uncannily beautiful —absolutely living every pulse-beat.[3]

Stieglitz wrote more fully to Elizabeth, his confidante from the beginning:

> It all seems like a fairy story— Everything connected with it . . . and O.—why I can't believe she is at all— I never realized that what she is could actually exist—absolute Truth— Clarity of Vision to the Highest Degree and a fineness which [is] uncannily balanced . . . There is complete harmony— I feel she is much finer than I am— straighter too . . . She's great— Really.[4]

Although he was in a state of emotional vertigo when he wrote this, Stieglitz would never revise his view. For him O'Keeffe remained always "absolute Truth— Clarity of Vision to the Highest Degree." His language called up those images, created by the pictorialist photographers, of "Woman" in white draperies against murky settings—metaphors for Purity, which Stieglitz found aesthetically offensive but emotionally irresistible.

Stieglitz would also try to maintain the benign tyranny he exercised while nursing her back to health. Their roles as patient and healer echoed a nineteenth-century phenomenon. "The woman patient's dependence on the all-knowing doctor has struck many . . . as an embodiment of the Victorian drama of female submissiveness and male control . . . paradigmatic of Victorian sex roles."[5] Her role as patient stressed Georgia's fragility and her spirituality, which permitted Stieglitz to place her on a reverential pedestal. She could be seen as the Victorian ideal,

pure, unsullied, remote from competition, power, or worldly realities.

The pedestal on which Stieglitz placed her was, in some senses, deserved: O'Keeffe's view of the world was clean and coherent in a way that few people's are. Her vision was exceptionally clear, and she lived by a private and absolute moral logic.

The precision of an abstract moral code, however, is muddied by personal relationships and social obligations. Part of Georgia's moral clarity was due to the fact that since the age of fourteen, when she left Sun Prairie, she had not been a permanent member of any community. The O'Keeffes had always created their own community, carrying their moral certainties with them like tents, from which they proudly flew idiosyncratic banners. The family was composed of solitaries; young Ida wrote: "so much of my life has been spent just with myself and consequently I don't think I act the way the majority of people do."[6]

In spite of her courage and independence, O'Keeffe was not, of course, a goddess, and it was ironic that Stieglitz, who was firmly committed to the notion of personal freedom, aesthetic license, and the independence of women, would direct an old-fashioned combination of reverence and paternalism toward her. Like most, Stieglitz's pedestal was uplifting but would give her little room to move.

• • •

ELIZABETH'S ESTABLISHMENT consisted of two rooms on the top floor of a brownstone. One room, small and dark, was used by Stieglitz for developing and held his photographic equipment: an old white umbrella, to reflect the light, and a dilapidated tripod. The other room, with a skylight and two windows, was sunny and light-filled. In spite of the light, the studio was an unlikely place for Georgia to paint: the colors were wildly distracting—it had lemon-yellow walls and an orange floor. Still, it was cheerful, clean, and spare: "It made me feel good and I liked it," Georgia said.[7] There was very little furniture, and she put her bed under the skylight, so she could look directly up at the starry night. Georgia felt serenely isolated. Stieglitz was her only link with the outside world; she was in New York on new terms and saw no one from her old life. Alone in the hot, sunny rooms, she ignored convention and often dispensed with clothes, painting in solitary silence, in the nude.

As Georgia regained vitality, her image altered for Stieglitz: her spirituality was joined by a solemn, splendid power. Alone in the bare room, O'Keeffe took on the grave, quiet beauty of a sibyl. Stieglitz, who had for months been in love with O'Keeffe's work and with her mind, now fell deeply in love with her physical reality. The "uncannily beautiful" Georgia was no longer remote, inaccessible, and independent; instead, she was his to behold, solitary, cloistered, isolated from the world, dependent on his visits for food and companionship. Alone in the silent rooms he had chosen for her, she was like a captured swan. "I can never quite accustom myself to the idea that I should have the privilege of meaning—being—anything to her . . . It's all intensely beautiful—at times nearly unbearably so—all like the most wonderful music," he wrote.[8]

It is women and kinfolk who are chaperons, steering intercourse through the channels of decorum. In the summer of 1918, Georgia chose to ignore these channels. Her mother was dead, Claudia was in Texas, and Georgia stayed alone in an absent woman's rooms, under the aegis of a married man. When she first arrived, Stieglitz had spoken about Georgia to the Joneses, neighbors in the building, so she would not feel alone at night. At the beginning of July the Joneses went away, leaving Stieglitz kitchen privileges, and complete privacy.

Stieglitz came daily. Often when he came to see her, Georgia was in bed. She was thirty years old, sure of her feelings and unafraid of her sexuality; both were strong. Love she saw as voracious: "It will eat you up and swallow you whole," she had warned Anita Pollitzer.[9] Georgia had counseled distance for her friend; now, deliberately, she chose passion and commitment for herself.

The heat and solitude, the erotic lassitude of the sickbed, the emotional suspense created by the long and intimate correspondence: all contributed to the next step in their relationship. It was certainly here, in the spare, sunlit room, that the two became lovers.

Stieglitz began to translate his fervent feelings into his art. "When I make a photograph, I make love," Stieglitz said simply, and during these light-filled afternoons he began, with a brooding intensity, to record O'Keeffe's taut and elegant voluptuousness. "I have been photographing much, and wonderfully at moments," he wrote Dove.[10]

He wanted head and hands and arms on a pillow—in many different positions. I was asked to move my hands in many different ways—also my head—and I had to turn this way and that. There were nudes that might have been of several different people . . . There were large heads, profiles and what not . . . I was photographed with a kind of heat and excitement.[11]

Stieglitz's loving concentration on O'Keeffe's face and body began a project that would last some fifteen years, comprise nearly three hundred images, and result in some of his greatest work.

Stieglitz watched Georgia with yearning attention, but he wanted the situation between them to develop naturally: "Decisions come spontaneously," he wrote. "In fact there are no decisions."[12] There were, of course, decisions to be made: Georgia was floating in limbo on Fifty-ninth Street and was expected back in Canyon to teach at summer school.

Then one day he asked me if I could do anything I wanted to do for a year, what would it be. I promptly said I would like to have a year to paint. I enjoyed my work teaching, but I would rather just try to paint for a year. He thought for a while and then remarked that he thought he could arrange that.[13]

Stieglitz had made similar arrangements with other artists, advancing money against the sale of work, and already an O'Keeffe picture had been sold from the 1917 exhibition. O'Keeffe chose not to return to Texas and sent her resignation to Canyon. Her belongings were shipped back east to the studio. She was now in love with Stieglitz. This time she chose an emotional landscape over a physical one, but the agreement between them was as much professional as it was personal: as would remain the case throughout their relationship, these factors were subtly and intricately entwined.

With O'Keeffe established in New York, the next decision concerned their personal lives. At first Stieglitz returned dutifully each night to Emmy, but this irregular idyll with Georgia could not continue indefinitely; in fact, it lasted no more than a month. "I do not lack courage—nor decision," Stieglitz wrote Elizabeth.

"But I know many things must be completed before new ones are begun."[14]

Alfred had gone through the anguish of emotional separation from Emmy years before, and their estrangement seemed to him an established fact. After Georgia arrived, he admitted that "The strain is great," but in elucidation he omitted any mention of Emmy, saying only: "There is Kitty—"[15]

Kitty, his daughter, a high-strung and sheltered young woman, had had a governess until the age of fourteen and at twenty was still spending chaste summers at camp. She had been raised primarily by her mother, who had subtly encouraged a distance between the girl and her father. Alfred was an awkward, though loving, parent. He was inconsistent and capricious with Kitty, alternately doting and severe. And oddly, for a man who was so fond of young women, he had never made her into a companion. She was in her teens before she knew exactly what her father did, and she shared little in his interests. Kitty was the captive and unhappy audience of the chill drama of the Stieglitzes' marriage, and she had chosen her mother's side. The emotional gap between himself and his daughter was a source of deep unhappiness to Alfred.

Stieglitz's psychological separation from his wife was soon duplicated by physical reality. On July 3, he escorted Kitty to her camp in New England, and her departure seemed to liberate him. In a fit of apocalyptic bravado, he brought Georgia to his apartment and began to take pictures of her in the small dressing room in which he slept.[16]

Emmy was out when Stieglitz and Georgia arrived at 1111, but she returned to discover her husband and Georgia deep in a photographic session, the white heat of Stieglitz's intensity focused on the grave young woman. Emmy's response was immediate and decisive: she ordered them both out of the house. Stieglitz's version of the story placed him in a position of outraged innocence: "We weren't doing anything," he insisted disingenuously.[17] Emmy could see exactly what they were doing, and that evening when Alfred returned, she presented him with an ultimatum: he was to stop seeing O'Keeffe or stop coming home.

It was, of course, the offer Stieglitz had been waiting for: for banishment, he read freedom. He wrote to Marie Rapp on July 9: "I'm out of 1111— In one hour and fifty minutes the job was

completed. You never saw such a clean job . . . Mrs. S. wasn't home."[18] The next day Emmy broke down and repealed her decree, but it was too late. Stieglitz's chivalrous code would have forbidden him to leave Emmy unasked; the photographic session in his bedroom may have been an unconscious attempt to force her hand. In any case, once given, the command was irreversible. Nothing in the world could now persuade him to return to the gloomy, emotionally barren marriage he had endured for nearly twenty-five years.

Stieglitz's feelings were nonetheless ambivalent. He wrote Dove with traces of injury and complacency: "I was virtually 'kicked' out of home—like I was 'kicked' out of Camera Club 10 years ago— The Club wants me back— Home already regrets."[19] And to Marie Rapp: "I'm really very sorry for Mrs. S. for I know that now she begins to realize what she has thrown away. Squandered. But what can I do? I was certainly patient and persistent."[20]

For all his public bravado, his private feelings at leaving his marriage were painful. The night after Emmy ordered him to leave, he sent her a note, which she kept all her life:

> I shall be home tonight. If you bar the doors as you did last night I shall come in the morning and have my trunk taken. You ordered me to get out yesterday as you said you were closing the flat. But you said there was no immediate hurry . . . if you have changed your mind I can have everything cleared out this week.
>
> I am very sorry that you should see only my "rottenness" and one side—sorrier than I can ever make you understand—as I haven't been able to make you understand for twenty-five years. I have been "guilty" in your eyes for twenty-five years— What chance did you ever give me—or yourself—or our so-called "home"—or Kitty. All you see is right and still it's all wrong. I still maintain I'm the only real friend you have. Time will prove it.[21]

Stieglitz sent his professional belongings to the Anderson Galleries, where Mitchell Kennerly, the head, had agreed to store them. He moved his personal things, including his bed, into Georgia's studio. The two beds stood demurely side by side, separated chastely and absurdly by a blanket hung on a string between them.

No sooner were Alfred and Georgia settled in bohemian bliss than Stieglitz received a summons from his mother to bring Georgia to Oaklawn at Lake George. Alfred's father had died in 1909, and since then Hedwig had ruled the family. She serenely overlooked the improprieties of the situation. Hedwig was not fond of Emmy, having known for years that Alfred's marriage was unhappy. In fact, after a spectacular display of bad temper four years earlier, Emmy had been banned from Oaklawn, though Kitty was still invited for an annual visit. Hedwig was ready to receive the young woman who had made her son happy.

Small, plump, and sweet-faced, swathed in shawls against vagrant lake airs, Hedwig was waiting on the porch to greet them when Georgia and Stieglitz were driven back from the station. She "was dignified—her eyes were dark and wide. She was not tall and not thin—hair parted in the middle and done some way in the back."[22] Hedwig gave Georgia a formal welcome, and thus began a pattern of summer visitations that would continue for nearly fifteen years.

Lake George had been a fixed star in the Stieglitz sky since 1872; in 1886, Edward bought the capacious Victorian house Oaklawn. Edward had been captivated by a huge oak with a trunk so wide that two people, hands clasped, could not encircle it. The twelve-acre property provided all the requisites of summer: tennis court, gazebo, bathhouse, croquet lawn, carriage house, cutting garden, and large vegetable garden. The house was set in a stand of great, high-canopied trees on a steepish slope, in shady proximity to the lake. The three-story dwelling was eccentrically shaped, with gables, bow windows, and an octagonal tower. A rambling porch, which followed the irregular profile of the house on the lake side, was echoed by balconies above on the second floor. Shingled in decorative patterns, gabled, porched, and towered, it was a handsome, capacious, idiosyncratic structure that reflected the vanished realities of the Victorian era: the availability of both unlimited labor and unlimited ease. Hedwig's formidable domestic retinue allowed for as many as twenty family members to stay at Oaklawn together, as a photograph of 1888 reveals.

Inside, the house reflected Hedwig's comfortably bourgeois sensibility. Dim and shadowy, it was full of objects: overstuffed furniture, Oriental rugs, fringed lamps, knickknacks, dark nineteenth-century paintings, tapestries, and allegorical statuary. A

large and assertive plaster cast of Judith became Georgia's particular bête noire, but she found the entire vision appalling and described it as "a well-to-do Mid-Victorian parlor filled with all sorts of horrible atrocities jumbled together."[23]

The stay at the lake was for Georgia a difficult initiation into Alfred's extended and energetically participatory family. The Stieglitz style—intimate, hyperbolic, overwrought—was antithetical to that of the O'Keeffes. Explosions occurred daily, each fully aired and articulated, discussed and examined with great interest and excitement. Selma, Alfred's sister, was a particularly effective participant. Hedwig was the supreme authority, and beneath her, the children chafed and argued. The life of the emotions held full sway at Oaklawn.

Usually there were eighteen or twenty people at the dinner table, all of whom were related. This in itself was strange to Georgia; for more than fifteen years, she had lived in schools, colleges, and boardinghouses, which encouraged her natural inclination for privacy and distance. The sudden plunge into the huge and vocal intimacy of the Stieglitzes was a shock. Then, too, the material splendor of the household weighed her down. There was tea with cakes every afternoon at four o'clock, besides the three huge meals, with "four times as much food as anyone could eat."[24] She was uncomfortable with so many people, who ate so much, said so much, and inflicted their personalities on each other with such insistence.

There were, of course, advantages to being there. Lake George itself was beautiful—vast, shimmering, light-filled. The countryside around the house was peaceful and unspoiled, full of wildflower meadows and quiet dells. There were forest trails winding steeply to the tops of the mountains. The rich texture of the landscape was there, a new set of possibilities, green and lush. Georgia had no responsibilities; there was nothing at all for her to do but walk and swim and paint. Each evening she and Alfred went out in the rowboat onto the lake and watched the dying of the light on the water, reflected in the deep sky above them. Every evening Hedwig waited on the porch for her favorite child to return.

Georgia's presence in Alfred's life endowed him with a new and splendid energy. Revitalized, he found an interest in every activity, and hiked, rowed, swam, and picnicked in the long sum-

mer days. "The days here are the most perfect of all my life . . .
Every moment is complete in itself and full to bursting," he wrote
Strand.[25]

Alfred and Georgia delighted in what they learned about
each other, discovering great underlying compatibilities. "Music
is really heaven's language," Alfred had written the year before,
vividly echoing Georgia's feelings.[26] They discovered the magical
coincidence of the room in Crosbyside/Amitola, shared twenty-
eight years apart. And there were other unknown connections
revealed. One summer Edward Stieglitz had been asked to judge
a painting competition by the art colony across the lake. Edward
narrowed his choices down to two paintings: a landscape and a
portrait by Eugene Speicher of a distinguished, dark-haired
young woman. Unable to decide between them, he asked his son
Alfred for an opinion. "I knew at once which picture," said
Alfred, and chose Georgia.[27]

Everything seemed to heighten the sense of the inevitability
of their union. "We are at least 90% alike," Stieglitz wrote, "she
a purer form of myself— The 10% difference is really perhaps a
too liberal estimate—but the difference is really negligible."[28]
Georgia said simply, "We are very happy here—I was never so
happy in my life."[29]

Their physical passion was insistent and quite visible: Stieg-
litz was both proud and shameless, and in the afternoons he
would rise and lead her blatantly up the stairs. "We'd say we
were going to have a nap," said Georgia. "Then we'd make love.
Afterwards he would take photographs of me."[30]

●　●　●

ONE OF STIEGLITZ's long-held intentions had been to photograph
a subject from birth to death, recording facet after facet of its
response to life. He had started taking pictures of Kitty in her
infancy, but both Emmy and Kitty had protested with such vigor
that he had abandoned the project.

In Georgia he found a model on whom he could concentrate
all his efforts, who understood and supported his art, and whose
collaboration would be absolute. Stieglitz had taken photographs
of other young women during the preceding decade. There were
portraits done of his nieces Flora Straus and Dorothy Schubart,
and of visitors at Lake George. Marie Rapp, at "291," was a fre-
quent model, and the beautiful Katharine Rhoades. Stieglitz had

also taken portraits of artists he represented— Dove, Marin, De-
muth, Hartley, and Picabia were all recorded—all faces he knew,
which interested him. The series of portraits done before 1917
shared similar compositions: a close-up of head and shoulders,
often against a painting, which did not always belong to the
subject.

The indoor pictures are soft-focused. Stieglitz used glass
plates and long exposures; he made his subjects sit motionless,
sometimes for three or four long minutes. Without a brace of
some sort (often used by photographers in the nineteenth cen-
tury), it is difficult to remain immobile for that length of time,
and the subjects often stirred unconsciously, turning hard edges
to gentle ones.

Whether the soft focus was deliberate or not, the dissolving
edges heightened the intensity revealed in the faces of the sitters.
Stieglitz managed to capture a sustained fervor in his subjects
that perfectly reflected his own perception of them. His portraits
have now come to influence our own views of these artists, who
are seen most frequently through his eyes: the gentle, brooding
Arthur Dove, sleek and desperate Charles Demuth, haunted
Marsden Hartley.

Stieglitz's view of Georgia encompassed the various phases
of their relationship. In these first years he saw her as supremely
womanly, ripe, sagacious, and pensive: a woman whose soul was
as important as her body, both of which possessed a subtle and
infinite appeal. The images run a broad gamut of female imagery:
from the wild-eyed, phantasmagoric, Munchian tragedienne, to
the passive, dreamy, collapsing woman, to the strong, squat,
primitive, earthy sexual participant. The delicately rendered
flesh, the smoothness of the skin, the sweetness of the curves,
suggest an almost unendurable tenderness for the subject, but
the images are neither romantic nor sentimentalized. Stieglitz's
relentless eye, now following Strand's example, created rigorous
compositions: cropped, angular, and severe. He established a
vigorous and demanding dynamic between the tactile softness of
the beloved subject and the hard exactness of recording her.

When Stieglitz took the first photographs of Georgia, she
was pleased and flattered; she showed them to her students in
Canyon with delight: "Nothing like that had come into our world
before."[31]

The more intimate series on which Stieglitz now embarked

was a different proposition. With his long hours and long expo-
sures and his critical, demanding eye, Stieglitz took command of
Georgia's time, her body, and her privacy. Exigent, authoritative,
he used her limbs and her energies in the cause of his art. As
Ansel Adams said, "The terms 'shoot' and 'take' . . . represent
an attitude of conquest and appropriation."[32] Moreover, in this
project Stieglitz's art superseded O'Keeffe's: the very nature of
the collaboration required that she be passive. If he was working,
she could not.

Georgia's willingness to collaborate, however, is unsurpris-
ing: the series constitutes and commemorates an act of love.
Then, too, she had a profound respect for his art, in which she
was, she recognized, an important collaborator. As Janet Malcolm
perceptively points out, "the photographs . . . belong among
O'Keeffe's works as well as among Stieglitz's."[33] O'Keeffe's per-
sonality was crucial to these photographs; it was this, as much as
her body, that Stieglitz was recording. In one photograph in par-
ticular, a bold frontal view from waist to knees, he endows her
body with the strength he found in her character. He shows, as
Malcolm says:

> a Leger-like squatness and massiveness: the breasts are
> heavy and pendulous, the pelvis looks broad, the thighs are
> thick . . . it illustrates, fifty years before its time . . . the
> current feminist ideal of woman as large, strong, assertive,
> authentic, unself-conscious, independent of male
> approval.[34]

Stieglitz recorded the O'Keeffe he was coming to know:
grave, silent, meditative, robust, and intense. His view of her
was informed equally by passion and aesthetics. Regardless of
the sentimentality in his words, there is no trace of it in the
photographs, which invariably reflect the demanding eye of the
artist. The photographs began the documentation of a love affair
that existed both between two artists and between two artists and
the art that they produced.

Georgia had not been brought up to think of herself as a
beauty. She was equally resigned to a round Irish face, disfig-
ured, as she thought in her childhood, by a pair of deep and
hated dimples. It was Stieglitz who showed O'Keeffe that she
possessed a remarkable beauty. "I was always amazed to find out
what I looked like. You see, I'd never known what I looked like

or thought about it much. I was amazed to find my face was lean, and structured. I'd always thought it was round."[35]

At thirty, however, Georgia received the knowledge too late for narcissism. In fact, any vanity in Georgia attached to her supple, tapered hands and her thick black hair, both objects of praise. In them she saw beauty, and she let her face look as it might. But her self-image was founded on more fundamental strengths: character, moral integrity, determination, and talent. And it was these strengths that Alfred Stieglitz, master photographer, captured, as well as the more transitory quality of her haunting physical beauty.

16

It was an odd road to be walking, this of painting. Out and out one went, further and further until, at last, one seemed to be on a narrow plank, perfectly alone, over the sea.

—VIRGINIA WOOLF
To the Lighthouse

THE NEW LIFE that Georgia had declared for—one devoted to painting and passion—was gained at some cost, both to herself and to Alfred.

Alfred had left Emmy, hoping for a speedy divorce. In his mind, the marriage had been over for years, and he was eager to formalize this. Emmy felt differently: enraged and humiliated, she saw no reason to grant Alfred his freedom. The divorce would take six years to achieve.

During their final stormy interview in New York, Alfred had promised Emmy that Georgia would not be at Oaklawn when Kitty returned from summer camp. This was easy to promise. Kitty was deeply upset by her parents' split—her father's desertion, as she saw it—so much so that in early August, Alfred left Georgia at Lake George and went to talk to Kitty at camp. "I had a terrible five hours with K. alone . . . I have never seemed so cruel . . . I seemed to be the most selfish brute in the world," Alfred said, then he finished irrepressibly, "—and I knew I wasn't."[1]

Later Emmy came to the camp with Alfred, and the meeting was more successful. "There was a very frank talk—no hysterics —all as peaceful and natural as the surroundings . . . It was the first true meeting of the 3 of us together— Kitty was made very happy— Emmy . . . felt for the first time that she had a true significance in life . . . not a superfluous word—no promises— the straightest of straight lines . . . Kitty and her mother had been brought together on an honest basis."[2]

With the solicitous hope that an understanding had been finally achieved, Stieglitz returned to Lake George. He was anxious about Georgia, left to meet his sister Selma for the first time. "Floating in sprigged chiffon, imperious and kittenish by turns . . . [Selma] embodied everything Georgia deplored in a woman."[3] Moreover, Selma insisted on giving her irascible and undisciplined terrier the free run of the dining room during meals, a notion Georgia firmly resisted. The two women did not become friends, an eventuality Alfred had foreseen. On his way back from seeing Kitty, he wrote Marie: "It seems hardly possible that O. is at Lake George awaiting my return— She alone with the family. And she disliking all families."[4]

It was not true that Georgia disliked "all families." What she disliked was the idea of forced intimacy, and institutionalized relationships. Then, too, the dissolution of her own family had been traumatic. After her mother's death, the grieving, dispirited, decimated household in Charlottesville was terrible to her. The children were scattered, Ida was dead, Frank absent, and the grace and glow of fortune were gone. The very notion of family became painful. Georgia resisted admitting pain or neediness, and her response was to profess a stony isolation—which was inauthentic but served as effective protection.

Stieglitz's own attitude toward his large and complicated family was affectionate and dutiful. It played a central part in his life. Up to the end, Alfred had dinner with Hedwig twice a week and visited her every Sunday. Since his return from Europe in 1888, he had traveled to the family house at Lake George every summer. With his family at the center of his life, it was crucial to Alfred that he reestablish a loving relationship with his daughter. Flush with the heady optimism of his new love for Georgia, he was convinced that he could somehow create a friendship between the two women and transform Kitty's hostility into peaceful acceptance. He had waited to tell Kitty about Georgia,

unaware that Elizabeth had already done so. Kitty took his silence for duplicity, and she brooded.

Believing that the new peace superseded his promise to Emmy, Alfred overlooked it, and Georgia was still at Oaklawn when Kitty arrived from camp. The resulting storm was so devastating that Alfred and Georgia left for New York. A letter from Kitty a week later, hand delivered by a brother-in-law at midnight, demanded Alfred's return to Oaklawn the next morning. Though Alfred obeyed his daughter's order, making the long trip and setting himself to the arduous task of mending the deep rift between them, the damage was irreparable. Kitty believed Alfred had cruelly abandoned her and her mother, and all his efforts to offer another perspective were unavailing. Several drafts of a letter to Kitty from this period show Alfred's concern for her and his recognition of their difficulty in communicating: they hurt each other continually and unintentionally.

The two maintained formally friendly relations, but these were never intimate, though both wished otherwise. A close connection between father and daughter was never reestablished, though a touching letter from Kitty shows her yearnings: "Oh father dear—you can't imagine how I long for frankness—sincerity—from both of you— Even if things are concealed I feel them . . . I am hoping for Easter when I come down that I can get to know you—get to know mother better— I do feel so alone." [5]

Georgia and Alfred's openly illicit alliance had other inevitable repercussions. Georgia, notwithstanding the O'Keeffe tradition of independence, had been brought up to observe the laws of decorum. Frontier self-reliance was different from bohemianism, and Georgia's decision to live blatantly with an older, married man was an affront to her family. She knew quite well that it would offend her aunts and shock her siblings, and so it did. Alexis, visiting her in New York in the fall of 1918, found to his distaste that his sister was living with an elderly married Jewish stranger in two small back rooms, a milk bottle forgotten outside the front door. Deeply disapproving, he told Catherine severely that he "didn't think much of the way Georgia was living." [6]

For Alfred, leaving his wife for the young artist meant enduring the hostility of his beloved daughter. Life without family was unthinkable for him, and he lost a valuable part of it. Georgia, who cherished privacy, independence, and the wide Texas plains, had, in one free-spirited gesture, lost them all. In return,

she acquired Alfred's entire clan as constant and perennial companions, and the high green enclosing skyline of Lake George. Yet such were their feelings of passion and commitment that any cost seemed small.

• • •

IN THAT SAME year, 1918, the O'Keeffe family suffered two further blows. Georgia's father was working in Petersburg, Virginia, in November, when he climbed a roof too steep for the sixty-five-year-old man and fell to his death. His body was sent back to Wisconsin for burial, but not with his wife. The Totto women, fond though they were of Frank in life, were adamant when it came to death. Sweet Aunt Lola and loyal Aunt Ollie would not permit a Catholic to share the Protestant Totto ground in Madison, where Ida and the others lay. Frank joined his parents and his three bachelor brothers in the O'Keeffe plot at Sun Prairie.

A month later, handsome, charming, black-haired Alexis returned from France, where he had been sent as he had hoped. But things had gone badly, and he came home on a stretcher, his heart and lungs damaged by gas.

The warm family core that had sustained Georgia in Sun Prairie—proud, supportive, effective—was extinguished. With her father's death, the last connection to the early, splendid years was lost. The sense of loss she sustained for her parents was deep and painful, and for years Stieglitz warned people not to mention death in her presence: it struck an unbearable chord.

The O'Keeffe children had dispersed; there was no longer any center to hold them. By 1918, they were scattered across the country and, not rich, saw each other seldom. They maintained a strong affectionate current, however, which included Georgia, despite her unconventional behavior.

Georgia had always felt a warm affection for all her siblings except Frank, his mother's first and favorite child and Georgia's closest rival. In their childhood she had consciously tried to outstrip him physically and mentally and, according to her, succeeded. The distance between them increased when Georgia began her relationship with Stieglitz. While at military academy, Frank had become somewhat anti-Semitic, and this created a final barrier between them. Though Frank practiced architecture in New York until 1923 or 1924, Georgia saw him seldom, if at all.

Otherwise, the siblings maintained steady and resilient connections throughout their lives. Superficially erratic, marred by quarrels and grudges, their enduring and fundamental affection did not waver, and in times of stress they turned to one another at once, certain of the love and support they would receive.[7]

· · ·

WHEN GEORGIA decided to stay in New York, she sent to Texas for her things. A barrel arrived, containing her old drawings and paintings. She had liked these well enough in Texas, but now they were part of her past. Discarding was one of Georgia's great talents, and she threw them all out. That night when she and Stieglitz came home, the trash had been put out. It was windy, and the paintings blew wildly all over the dark street.

By moving in with Alfred Georgia declared a new beginning. The hollyhocks of Virginia were consigned to the past, as were the plains of Texas. Georgia was choosing her own life, and as always, she was doing it without regard to convention or to practicality.

Happily and deliberately, Georgia cast in her lot with an impecunious and impetuous older man. Physically, he was an unconventional figure. His dense thicket of hair was in triumphant and continual disarray. He wore his well-made suits haphazardly, and they were crumpled and dejected. His nose, badly broken when he was a baby, was permanently crooked, and one nostril was blocked. He often held a handkerchief between his teeth (the open mouth made breathing easier), letting it dangle rakishly down his chin.

His manner was intense and his eye was wild. Opinionated, stubborn, volatile, eccentric, and self-contradictory, he was a difficult partner: "perhaps . . . I'm just a little Impossible at times," he admitted.[8]

Georgia was crazy about him.

The difference in their ages meant nothing to her. She dwelt purely in the present, and there Alfred was extraordinarily energetic and appealing. She showed her affection openly and physically, unsettling his family by patting Alfred's cheek and asking ingenuously, "Isn't he cute?"[9]

Georgia steered quietly and serenely around his sharp and obdurate corners. Most important, she did not take him entirely seriously. Her capacity for amusement stood her in good stead

during their life together, a fact both of them recognized. "Her Laughter is a great tonic," Alfred wrote.[10] (His Germanic habit of capitalization never left him.) Tyranny functions only if taken seriously, and humor is the first defense against it. Georgia did not believe in her own victimization. Most of Stieglitz's eccentricities she found beguiling, and she recognized the anxiety and the vulnerability that lay behind his need to control an argument or an idea. "When I really knew I was right I could often wear him down. I seldom argued with him though. He was the sort of person who could be destroyed completely if you disagreed with him."[11]

Georgia's capacity to appreciate without judging allowed her to love the best of Alfred. He was brilliant company, charming and inventive: "His mind was quicker than mine," said Georgia, without rancor.[12] He was warm and candid, a tender and devoted lover, a loyal, sensitive, and responsive friend. He was also dedicated to art and work. "The relationship was really very good, because it was built on something more than just emotional needs. Each of us was really interested in what the other was doing."[13] The bond between them was one of passion and tenderness, and their art blossomed.

Although Georgia placed no importance on the discrepancy between their ages, Alfred was privately and painfully aware of it. When he visited Kitty at camp, Stieglitz shared a tent with "the young physical culture instructor . . . a fine-looking fellow—perfectly built—the quintessence of physical strength—youth confidence . . . I did wish—for O'Keeffe's sake—that I had a little of his physique & self-confidence which comes with strong muscles."[14]

O'Keeffe's support of Stieglitz's work was like his of hers: firm, enthusiastic, and constant. In a postscript to a letter of his, she added: "He doesn't tell you the important news at all— So I must add to his letter that he has some new photographs . . . and they are too fine to try to tell about at all— They just make you feel ready to die."[15] Her generous praise was greatly important to him (as was his to her), sustaining and invigorating him and encouraging new work. He was a man of remarkable energy in any case, and Georgia's presence in his life made this even more abundant. "Both G. and I are going at a great pace . . . It's really great to be able to put in 18 hours a day and feel the energy still left of 17 stallions," he wrote modestly.[16]

. . .

IN THE FALL of 1918, Stieglitz had at last become caught up in the fever surrounding the war. "Georgia and I are aching to get into the War together—in some capacity." [17] But their ardor came too late; the war ended in November. They spent much of the fall alone at Lake George, finally returning to New York before winter set in. There were now practical matters that pressed.

The abundant funds from Emmy's family, which had supported so many of his professional endeavors, were now, naturally, no longer available to Alfred. His own inherited income was meager, and he was quite rightly concerned about supporting the woman he had persuaded to quit her job. They had a place to live: Elizabeth was married in the winter of 1918–19 and gave her studio to the couple. Alfred's brother Leopold (called Lee) generously offered to continue paying the rent.

The two small rooms of the studio, perfect for a brief summer idyll, were cramped and inadequate for housekeeping. Just as the early pattern of Stieglitz's taking charge of O'Keeffe was established through her illness, so a culinary pattern was established through the absence of a kitchen at the studio. From the very first, Georgia and Alfred went out to dinner every night, often to Alfred's family, otherwise to a restaurant. Georgia had not cooked when she lived on her own, and she did not cook when she took up with Alfred.

Despite having given up his gallery, Stieglitz maintained an active role in the careers of his artists. From the small room he had kept on the premises of "291," he arranged exhibitions with other galleries, and, with his characterically unbusinesslike approach, he persuaded patrons to put up money for his artists, rewarding them later with paintings. Nothing was specific in these arrangements, no time or price or promised work; they were leaps of faith, and Stieglitz prided himself on carrying them off successfully. One of his backers agreed to advance one thousand dollars in order that the woman from Texas go on painting, and this gave them enough to live on for several months. But the transactional aspects were difficult: the first time one of Georgia's pictures was sold, it took her ten days to recover from the loss.

Georgia was now using oils and painting in rich, highly saturated hues. It was a time of experimentation, and her work from this period varies widely. In both the "Series I" and "Music"

paintings, O'Keeffe used a voluptuous range of rosy pinks and sky blues. The forms are large and centered, and consist of simple, flowing, biomorphic shapes. The "Music" series employs the orificial imagery to which O'Keeffe would return recurrently in her work. It was an idea that fascinated her, and she used it in her most abstract and most realistic work. In the "Music" paintings she created trembling, lyrical, layered archways that give onto a separately defined space. In "Series I" the plumed, unfurling shapes appear again, done in the same lush color range of rose and blue greens. Other abstract works from 1919 are vastly different in mood and vocabulary of form, however. *Red and Orange Streak* and the "Black Spot" series use a geometric rather than biomorphic vocabulary of shapes. Smooth, clean shapes, angular and clearly defined, are set against deeply contrasting backgrounds. Space is defined sometimes through the use of advancing and receding colors, sometimes not at all, the spatial environment left deliberately ambivalent. The colors are densely saturated, often dark and harsh: deep greens and brownish reds. Dynamic tension is created by the high color contrasts, the sophisticated balancing of sharp angles and clean, racing shapes.

That same year, 1919, O'Keeffe began the flower images that were to become so important in her work. Since her schooldays at Chatham, she had used flowers as subjects, but she had thrown out the pink, domestic hollyhocks of Virginia and Texas when she arrived in New York. The first flower pictures she kept were brilliant watercolor studies of scarlet canna lilies. Bold and tender, they capture in melting, flowing color and calligraphic strokes the immediacy, the lines and vitality, of the blossoms.

The three disparate motifs—the luscious, orificial images, the severe geometric abstractions, and the strong bold flower pictures—were all themes that she would return to and develop in her work.

Stieglitz wanted O'Keeffe to continue the black-and-white charcoal series, which he found so strong and self-assured. His attitude was partly due to a real difference of opinion about color. "He had a remarkable color sense, much more subtle than mine," O'Keeffe said candidly.[18] "Mine was obvious and showy in comparison," she said.[19] "I like the spectacular things."[20] It was true that the scarlet lilies shouted, and the rose-and-blue works came perilously close to an overripe gorgeousness, but by now O'Keeffe was beyond intimidation or advice, even from so emi-

nent a personage as Alfred Stieglitz. In a spirit of peaceful coex-
istence, she painted what she needed to paint and let people say
about it what they needed to say. "If I stop to think of what
others—authorities—would say . . . I'd not be able to do any-
thing," she wrote.[21]

It was not only color that caused Stieglitz to complain. His
automatic resistance was to become a pattern: for all his revolu-
tionary spirit, Stieglitz was, initially, deeply opposed to every
innovation Georgia made. "Alfred was always apprehensive
about my new things," she said.[22] Each time she embarked on a
new aesthetic expedition, Stieglitz became agitated. Moreover,
this reactionary caution extended beyond painting. Emmy had
prided herself on her large and varied array of clothes from Paris,
but Georgia, when she put on a dress she liked, would wear it
for two weeks at a time. "He liked that. He always wanted every-
thing around him to look the same," said O'Keeffe.[23] When she
bought a new dress, it was to look exactly like an old one. Stieglitz
held himself to the same strict and reassuring standard: "Alfred
always insisted on wearing a certain kind of tie, a particular type
of sock and underwear and shirt. I used to have to walk all over
town trying to find those special kinds."[24] During all his years in
New York, Alfred used the same tailor, the same custom shoe-
maker, and the same barber, who would come to his house to cut
his hair.

Alfred found himself, like all revolutionaries, finally embed-
ded in the stiffened attitudes of his youth, and, unwittingly, he
began to espouse Sir Casper Purdon's stern pronouncement: "I
dislike unrest." More and more Alfred insisted on established
routines: these would include food, travel, and rhetoric as well as
clothes. He never stopped his fulminations against institutions,
rich people, critics, commercialism, greed, and conservatism, de-
spite the fact that critics, institutions, and rich people became
(partly through his own efforts) increasingly sympathetic to the
art he supported. His success made his defiance obsolete, but he
thrived on the idea of opposition and could not abandon it.

In January 1919, Stieglitz began arranging informal exhibi-
tions in the tiny studio apartment, eager to show off the work
they both had done. Interested viewers included patrons and
artists: Walter Arensberg, Frank Crowninshield, and Leo Stein;
Charles Sheeler and Arthur Davies.

That summer, they stayed on in New York until July, when

Alfred was needed at Lake George: Oaklawn, too expensive to maintain, was to be sold. Alfred, as eldest, would take charge of the transaction. A farm up the hill from the big house had been acquired some thirty years earlier, and that thirty-six-acre property, with a comfortable white clapboard farmhouse and outbuildings, was kept for family use, as was a strip of lakefront land.

Georgia and Alfred would repeat this annual pattern for nearly ten years. The winter months were spent in New York, surrounded by urban bustle and the energy of the art world; the summer months were spent in the Farmhouse, surrounded by a waxing and waning tide of Alfred's relatives and increasing numbers of their own friends.

Paul Strand reentered their lives that summer. After his chivalrous rescue mission to Texas, Strand had put in a stint of work on a farm as a conscientious objector, then enlisted in the army. After his discharge, in August, he came to Lake George at Alfred's invitation.

When they first met, Strand and O'Keeffe had felt a strong mutual attraction. Their relationship, however, was complicated by geography, by Georgia's nascent involvement with Stieglitz, and by Strand's attraction to Elizabeth Stieglitz. Once Georgia had chosen Alfred, she felt awkward at seeing Paul. Alfred, however, was determined to smooth over any unevenness among the three of them.

In August 1918, Stieglitz wrote Strand joyfully, telling him how happy he and O'Keeffe were. "I'm sure G. wishes to be remembered—her 'queer' feeling seems to be gone—you'd be welcome here— I knew she'd get rid of what had gotten between." [25] Whatever had "gotten between" Strand and Georgia was erased, and the three established a firm friendship on a new basis.

Georgia also managed a peaceable acclimation to the Stieglitz family. She felt an affectionate sympathy for some members of the clan, less for others. She was fond of Agnes, Alfred's younger sister, and beguiled by her daughter, Georgia Engelhard, who was nicknamed "Babe," "The Kid," and "Georgia Minor." Georgia Minor had artistic leanings, and Alfred had given her a watercolor show at "291" when she was ten. The summer Georgia met her, in 1919, The Kid was nearly thirteen. Engaging, confident, and irrepressible, she was a special favorite of both Alfred and

Georgia, whom she called "Gok." Georgia Minor modeled for Alfred's photographs and painted with Georgia.

Georgia felt a particular affection for Elizabeth, now married to Donald Davidson. Just as Elizabeth had played an important part in the relationship between Alfred and Georgia, Alfred assumed a similar role in her life. Elizabeth had fallen in love with Donald Davidson, a friend of a student at the Art Students League. Davidson was nearly twenty years older, a gentle, modest, earthy man without material ambitions, who had not been able to complete his education. Elizabeth convinced her family to hire him at Lake George one summer, as a gardener. It was an inauspicious introduction, and when Elizabeth later declared her intention to marry him, the family rose up in outraged opposition. She persisted, however, and Alfred was her ally, providing a mail drop for letters between the two and a staunch encouragement. In the family, he counseled temperance. His brother's indignant disapproval was finally mollified, and the wedding took place without rancor. The two couples, Alfred and Georgia and Elizabeth and Donald, would always feel an affinity based on the secrecy and excitement of their early days. "Alfred came . . . to the conclusion that there really isn't any one at all that really feels anything—really cares anything about us—we two—excepting you two," Georgia wrote Elizabeth.[26]

The rest of Alfred's family was not so easy. For the difficult Selma, Georgia felt, at the start, an amused tolerance:

> Sel has just come up into the room next mine . . . I hear her roaming about restlessly . . . rattles the drawers of her furniture and jangles the beads and moves the chair and drops pins . . . next minute she will have to talk . . . Sel talked about wanting the desk that was in my room . . . all the three weeks she was here—started again yesterday on her arrival— We changed them this morning— Alfred & I . . . and now it looks so nice in my room and the other takes up so much more room in her room—she wants to change back again— So you see—things go on as usual.[27]

The first part of the summer was spent recovering from the strain of the urban winter and drawing sustenance from the countryside. The latter half of the stay resulted in a period of concentrated work for Georgia and Alfred, before their return to New York in the fall.

• • •

STIEGLITZ'S PUBLIC emergence as a pacifist voice during the war had altered his image and his associates. (Sue Davidson Lowe suggests that it was this issue, and not aesthetic differences, that caused the split between Stieglitz and Steichen.) Stieglitz's vociferous support for the pacifist journal *Seven Arts*, started in 1916, had made his position very clear and attracted a new group of friends and associates—many of them now writers instead of artists.

Van Wyck Brooks, Waldo Frank, Theodore Dreiser, H. L. Mencken, Sherwood Anderson, John Dos Passos, Paul Rosenfeld, Lewis Mumford, and Louis Kalonyme were all members of a new group called the Round Table, which met frequently for dinner. As well as a conscientious objection to the war effort, the members shared a generally liberal political view and a strong faith in the individual. "The World can't continue on the present basis. There can be no peace where there is exploitation. No honest effort where there is exploitation. No honest teaching when exploitation is in control of institutions," Alfred wrote.[28] Central to the *Seven Arts* circle were the writings of Walt Whitman and Romain Rolland, both of whom portrayed the poet as a romantic exile from society. Rolland was also a proponent of a form of mysticism. "It's amazing how many really capable people have so little conception of the significance of the psychic in life," Stieglitz wrote.[29] Rolland's philosophy of *unanimisme* comprised "a mystical union of symbols and sensibilities that joined people into a collective group consciousness . . . It was but part of several causes and effects in international thought that gradually linked such disparate persons as Sherwood Anderson, Waldo Frank, Carl Van Vechten, Mabel Dodge, Alain Locke, Gertrude Stein, Alfred Stieglitz, Kenneth Burke, [Jean Toomer] and a host of others who wanted to create a new American idiom."[30]

By the 1920s, the revolutionary spirit in the arts had migrated from the visual arts to literature. There was no new movement in the art world that had generated anything comparable to the tremendous shock of the Armory Show and the great insult to the public made by abstraction. (It is difficult today to believe that a comparable shock will occur again: with that one, the public and critics learned that outrage made fools of them and that it

was safer to voice admiration than indignation, no matter what they saw.)

The public was not yet fully convinced, but it had recognized that abstraction and modernism could no longer be ignored or dismissed. There were increasing numbers of modernist exhibitions put on by galleries and even by museums—those bastions of conservatism. Instead of outrage, Stieglitz, and the dealers who had followed his example, met bafflement and earnest misunderstanding—timid attempts at comprehension. There were rearguard tactics: in 1922, Harry Watrous, president of the National Academy, argued defensively and unconvincingly that the reason "no examples of modernism found their way into the [Academy] show was that no good specimens had been submitted to the jury."[31] But his protests were shrill: in that year alone, modernist works had been shown at the Montross, Daniel, Kingore, Dudensing, Brummer, Weyhe, De Zayas, Hanfstaengle, Société Anonyme, and Anderson galleries. The days on the barricades were over.

In literature, however, the revolution was just beginning. The American scene was viewed as a rich and valuable resource, barely touched by writers. Jean Toomer, who wrote about the black experience, and Sherwood Anderson, writing about the Midwest, were seen as exemplars of a movement toward American authenticity. Waldo Frank, in *Our America*, called for a cultural revolution from an "uprising generation" of American writers, who had yet to use the "buried cultures" of their society.[32] The emphasis on spirituality and intuition, a mystic sense of communion, and the value of a transcendentally American subject matter all appealed tremendously to Alfred Stieglitz, and he gravitated toward literary circles rather than those of the art world.

The Round Table began to meet at a Chinese restaurant on Columbus Circle on Saturday nights. Georgia was the only woman present, and she seldom contributed to the discussions, which grew overheated and violent on occasion. She was interested by them, however: O'Keeffe was a true intellectual, who enjoyed the exploration of ideas. Histrionics and showmanship did not appeal to her, but the ideas did, and in this period she was very much involved in the discussions.

In the fall, 291 Fifth Avenue was torn down, and Alfred lost the tiny, unheated, claustrophobic office—called "the Tomb" or

"the Vault"—he had kept there. He began to invite the world into his private quarters. The two-room studio offered frequent viewings of the two artists' work—often to other artists, such as Dove, Strand, and Marin.

• • •

IN THE SPRING of 1920, Georgia and Alfred learned that 114 East Fifty-ninth Street was to be gutted. They would have to find new quarters in the fall. Lee Stieglitz, a continuing source of financial and moral support to the couple, suggested that they move into his house at 60 East Sixty-fifth Street. Lee's mother-in-law lived with him, and Alfred and Georgia were discreetly allotted rooms on different floors. As an enticement, they were promised an upstairs living room, where they could receive their friends; a darkroom; their own telephone; and new pale-gray paint on the walls. They would have preferred their own establishment, but their finances gave them little choice. And they were allowed as much independence as possible: they would make breakfast for themselves and were still to dine out every night. They moved into the house in December and remained until it was torn down, nearly four years later.

By the spring of 1920, Claudia O'Keeffe had come back from Texas to get her teaching degree at Columbia, as her sister had done. Claudia accepted Georgia's unconventional behavior, and she and Alfred became friends. But Georgia was ill again, which worried Alfred; arriving at Lake George in July, he was still concerned, and she was still poorly. Renovations were being made to the Farmhouse and its outbuildings, and while these were proceeding, Georgia made her first trip to Maine. There she stayed at an inn at York Beach, kept by Bennet and Marnie Schauffler, friends of the Stieglitzes.[33]

Alfred did not accompany her. Georgia's freewheeling approach to travel was not shared by him and in fact marked a deep difference between them. Alfred resisted a change in physical environment just as he resisted a change in painting style. He disliked the risks and discomforts entailed by travel and saw no justification for them. In 1939 he boasted:

> Do you know that in the last twenty-eight years I have been either in Lake George or in New York except for three days in York Harbor, Maine in 1927 and three days in Woods

Hole, Mass., in 1931. I'm a real stick-in-the-mud. The mud
has got me in its grip most passionately. Don't think I like
it.[34]

Of course, he did like it. The passionate grip was Stieglitz's,
not the mud's. But his view was simple: Lake George was perfec-
tion. He was deeply responsive to the beauty of the lake, and his
letters are filled with his grateful admiration for the natural mar-
vels that surrounded him. "There is a great Wind blowing. And
the sky is full of life—and the trees are having a great time— And
the air is cool, the sun not too warm . . ." he wrote Elizabeth.[35]
With perfection in his grasp, he saw no reason to search for it
elsewhere.

For Georgia, however, the trip to Maine was a revelation.
Standing at the edge of the Atlantic Ocean, she felt again the bliss
of a wide flat horizon, the sense of boundlessness and solitude
that she had valued in Texas. The house was set with a cranberry
bog between it and the ocean, with a boardwalk leading to the
wide, clean beach. The house pleased Georgia: nearly empty,
spare and plain, with good, old rugs on the floors. Her own room
looked out onto the ocean and the dawn. It held a big bed and a
fireplace, stacked with birch logs. Georgia spent her days walking
on the long, windy, empty beach, scavenging for odd bits that
she brought back, set in platters of water, and painted. In the
evening she watched for the lighthouse to begin its quiet, com-
forting rhythm across the nighttime sky and the wide, darkening
beach, the deep black water.

The relief and sustenance O'Keeffe felt are apparent in her
description and suggest the yearning she felt for the qualities
inherent in both the ocean and the plains—the long, low, unbro-
ken line of the horizon, and the vast, liberating presence of the
sky. Moreover, the recurrent motif of flowing water in her work
is surprising from someone who lived so firmly inland for most
of her life. Clearly, the nature of water itself, its fluid clarity,
appealed to her. York Beach supplied all this, and Maine re-
mained a source of nourishment and pleasure for her, a necessary
alternative, during those years, to Lake George. It was a recuper-
ative environment, which restored her physically and psycholog-
ically. Georgia visited Maine often in the next decade, to
Stieglitz's bafflement.

The Schauffler establishment was popular among the Stieg-

litz group. Strand, however, did not share Georgia's views: the food was delicious, he said, "but after all the place is anything but attractive, unless one focuses exclusively upon the ocean."[36] This was exactly what Georgia did. It is not surprising that the place held no attraction for Stieglitz, who needed the high green horizon and the warm surround of family.

"Georgia often says let's go to York Beach and live at the ocean," Stieglitz wrote. "I laugh. But I understand. But you know I believe in the follow-through. And there is autumn coming *here* and work to do."[37] For Stieglitz, the wish for the sea was a childish and irresponsible fancy, which would not stand comparison with serious reality. For Georgia, the longing for the ocean was itself a serious reality. The issue lay unresolved between them.

• • •

LIFE ON THE HILL, as the Farmhouse was also called, was not as grand as it had been at Oaklawn. The tennis court was gone, though there was still a croquet lawn. Instead of Hedwig's large staff, local help did most of the work: Ella and Fred Varnum were cook and "coachman" (the carriage horse was thirty-five years old). The large vegetable garden, tended in 1918 by Donald Davidson, thereafter became Georgia's territory. Gardening came naturally to her, and it gave her a real and sustaining occupation outside the intrusive and exhausting family life.

With the entire Stieglitz family in the smaller quarters on the Hill, Georgia was uncomfortably conscious of the lack of privacy. There were a number of farm buildings on the property, and she fixed on an undistinguished, weathered wooden structure, set alone in the meadow. It was the building farthest from the lake and was some distance from the rest of the Hill. While the other renovations were under way, Georgia asked if it could not be fixed up as well. Alfred asked the local contractors, who rejoiced in the names of Mr. Goodness and Mr. Blessing, for an estimate; they named a discouragingly large figure.

The project rested until August, when Elizabeth and Donald Davidson arrived. The enterprise appealed to them, and they and Georgia spent the next weeks energetically at manual labor, replacing the shingles with tar paper, laying a floor, and oiling the rafters.

It was ready in late August. Alfred wrote with excitement: "And Georgia's first picture finished in the shack just before

lunch! A good one!"³⁸ At first it was joint property. "It's great for us to have 'our' shanty," Alfred wrote; he and Georgia had spent the day there. When she finished the painting she found some bits of molding in the trash and made a frame for it, while he constructed a stool "from leavings."³⁹ But the place was Georgia's, and soon he left it to her.

The Shanty, as it came to be called, provided Georgia with a private territory that was vital to her. She drew inspiration for her paintings from long walks through the woods and fields, and often made sketches or notes *in situ*, but she did most of her painting indoors. At the Shanty she could set up her easel and milk-glass palette with the ease and relief of seclusion, achieving the state of solitary concentration necessary to her work. With rare exceptions, she never permitted company while she painted, never showed her pictures, even to Alfred, until they were complete, and never showed her failures. In contrast, Alfred throve on companionship while he worked, and always set up makeshift temporary and public working arrangements in other people's establishments.

One result of Alfred's gregariousness was a constant stream of guests at Lake George. The second summer they had Paul Rosenfeld, who would become a regular visitor, and Charles Duncan, whose work had appeared with Georgia's in her first show at "291."

One night in late September 1920, Georgia came upon Hedwig in the throes of a stroke. She called for help and saved Hedwig's life, by Alfred's account. The old woman recovered, and in a few days, surrounded by nurses, she was taken back to New York. She was the last of the family visitors that year, and Alfred and Georgia were then left alone with their two friends.

The fall of 1920 was a charmed season, tranquil, rich, full of kindness and bounty. "An autumn without a single dramatic sky," Alfred wrote, "just plain loveliness—the loveliness of an ingenue."⁴⁰ Filled with a sense of privacy and liberation in the landscape, freed from convention and disapproving observers, the four of them behaved with blissful spontaneity. "Roamed about in woods during morning. All of us felt 'non-creative.' "⁴¹ They split up the chores, sharing in the cooking, dishwashing, and domestic jobs. Carefully protective of Georgia's time, Alfred did not allow gender to determine tasks. "Lunch just over. Rosenfeld, Duncan and I served Georgia . . . now G. is sweeping

the porch— Duncan scrubbing and polishing the table . . . So you see life is particularly kind to us these days— And we are grateful and won't forget."[42]

It was also a period of tremendous productivity. Alfred announced proudly that "day before yesterday I developed, fixed and washed 72 [photographs]."[43] And Georgia was in a state of great energy, dividing her time between the creative and the practical: "G. has been busy too—canning, cider-pressing, pruning, etc."[44] It was the natural aspect of Lake George, the close contact with the cycles of planting and harvesting, that gave Georgia the greatest pleasure there. Alone in the modest farmhouse, the two of them were filled with productive energy.

> Our days consist of 15 hours . . . We eat in the kitchen—
> And we feel like masters of the world. For we can cook on
> the stove without having to beg permission. We can wash
> our own dishes in sinks. In short we have joined the
> privileged class: the working people . . . Georgia [is]
> cooking—and cooking well . . . I've made some beautiful
> prints. Prints from negatives that I've printed over and over
> again and always failed in getting anything but a good
> photograph instead of a living thing.[45]

Alfred's zealous commitment to the cause of the common man had always been slightly undermined by his bourgeois background and his complete dependence on the working class to clean his house, make his meals, and order his life. Georgia's practical skills solved this problem. The discovery that he and Georgia were nearly self-sufficient was exhilarating, more proof of the magical potency of their relationship.

Georgia was doing creative work as well. "G. is painting apples," Alfred wrote: "She has the apple fever."[46] In choosing these purely domestic subjects for her still lifes, O'Keeffe was commenting on the importance of daily life, domestic gestures. She was expressing the wholeness that lay at the center of things: the apples she pressed for cider were also the objects of her aesthetic attention, equally important facets of her life. The apples were a source of nourishment on every level; beauty and sustenance were shown as equivalents.

In 1920, O'Keeffe produced a series of small domestic still lifes in oil and charcoal. Plums, grapes, pears, alligator pears (avocados), and— over and over again—apples are set, in bowls

or napkins or alone, against white backgrounds suggesting table linen. The rounded, simplified forms are clearly defined and are modeled by subtle shading. The brush strokes are invisible, the surfaces voluptuously smooth. The space is shallow and ambiguous, the fruit surrounded by the white ground. In some a high horizon line suggests the plane of a table. The ambiguous background is reminiscent of Chinese painting, in which a flat unshaded background serves to highlight, isolate, and dramatize the design. It was a device O'Keeffe would use with increasing frequency.

Another influence appears clearly in these paintings — Paul Strand's work, which first suggested to Georgia the power of magnification, the abstract quality of an object when seen as close and simple. The fruits are seen close up; their fullness, wholeness, and the unexpected magnification give them prominence and importance. Though they are clearly recognizable as fruits, the deliberate lack of detail establishes a distance from a purely realistic rendering: there is a quality of clean abstraction, a reduction to essentials. The simplified, interconnecting circular forms are set against solid flat backgrounds, revealing a sophisticated balance of shapes and masses. The colors in the oils are deep, rich, and subtle, and the work reveals a steadily more mature and sophisticated understanding of color harmonies. The voluptuous enjoyment in the handling of the pigment reflects directly the influence of William Merritt Chase, whose manifest delight in the creamy textures of paint was transmitted to his students. "I've painted a little . . . on a canvas filled with white lead till it was really smooth—it was about like I imagine learning to roller skate would be," Georgia wrote the following spring.[47]

As metaphysical statements, the fruits declare a rich satisfaction with the natural world. As visual statements, they make a strong response to the overcrowded domestic environment at Lake George. They defend the clean, the simple, the few. They have emotional content as well; these rounded shapes do indeed "invite a caress." The modest, ordinary fruits are treated with such tenderness, such simplicity and affection, that they serve as statements of gratitude for the physical beauties of the world.

• • •

ALFRED AND GEORGIA were settling into a peaceful and regular life, in spite of its irregular aspects. An implication of a shared

life is the possibility of children. For Georgia, as she had told Macmahon, this was important. Elizabeth had given birth to her first child, Peggy, and she raised the issue to Alfred. Alfred was disinclined, but Elizabeth urged him to consider Georgia: "The thing still stays in my mind—what you said last night about not having a child— Not that I am unable to understand— But the other side— Georgia seems so eager for experience of life."[48] Alfred had suggested that his failure with Kitty should not be repeated with another child, but Elizabeth reasoned gently, "Photography does not cease with a broken or an imperfect plate,"[49] and pointed out briskly that there were other people to consider besides Alfred: "In later years Georgia will have few enough sunbeams."[50] Lastly, she generously offered herself to "act as infant nurse—kindergarten—everything you both have no time for."[51]

Elizabeth's letter arrived when the two had been considering the suggestion: "It came at a particular moment when it was very opportune," wrote Alfred. His response was warm and attentive, but he was dubious from the first.

> We'll see about the suggestion . . . But I'm not convinced that the time has come—or maybe it's gone— The world is such a mess—& all of us are part of that world. Perhaps I lack in a certain kind of courage— Well, we'll see. In the meantime G. is herself such a kid [she was thirty-three]—& developing beautifully. Of course, getting down to the root of everything is the economic question. The World can't continue on the present basis.[52]

For Alfred, the approval of society had always been important: by his own account, it had been the cause of his first marriage. Since he and Georgia could not marry until Emmy granted him a divorce, his decision about having children could legitimately and easily be postponed.

Elizabeth argued in Georgia's favor, urging Alfred to let Georgia "enjoy the pulse of life itself."[53] Georgia's own position was unequivocal. "She wanted children," said Catherine. "[Stieglitz] wouldn't allow it . . . said, 'You'll never be able to paint if you have a child around.' "[54]

His determination that she devote herself to painting may well have played a part in his response, as well as pure self-interest—an unwillingness to share her. For Stieglitz there was

too a far deeper and more important fear that attended the idea of Georgia's pregnancy: the anguish and loss surrounding the death of his favorite sister, Flora, in childbirth. In Alfred's perception, Georgia would always be frail and physically at risk. He watched her solicitously, recording her weight, her menstrual periods, her general well-being or lack thereof. His attitude toward childbirth was instinctive and idiosyncratic, for in general he loved the idea of women's fertility and was delighted when his niece Elizabeth and Marie Rapp had children. It was the terrifying threat that it posed to his beloved Georgia that made the thought of her maternity anathema.

Elizabeth gently continued to press her argument. Alfred said that he was too old; Elizabeth said simply that Georgia was not. The issue went on, a steady undercurrent between Alfred, Georgia, and Elizabeth, until the summer of 1923, when it was decided, devastatingly and conclusively.

17

*With the limited space which the New Republic necessarily
has for such articles, you will see that we must deal with
artists of considerable importance and interest to the public.
It does not seem to us that Miss O'Keeffe falls into that
category.*

—Editor of *The New Republic*
to Herbert Seligmann, August 31, 1921

IN FEBRUARY 1921, Stieglitz exhibited nearly one
hundred fifty photographs. The idea for the show came from
Mitchell Kennerly, a literate, energetic, and generous Englishman
who had been, since 1916, head of the Anderson Art Galleries.

Stieglitz had not exhibited his work since 1913, at "291," and
of the new photographs, only about twenty had been shown
before. The show contained portraits of Waldo Frank, Georgia
Engelhard, Dorothy True, and others; pictures of "291" exhibi-
tions; Lake George and New York scenes; and forty-five images
in the electrifying portrait series of O'Keeffe. Most of these were
identified as O'Keeffe, though one group of prints was discreetly
called "A Woman": eight pictures of hands, three of feet, three
hands and breasts, three torsos, and two "Interpretations."

The exhibition was mobbed by an excited crowd: "all of his
old friends and disciples and many new ones turned out . . . to
see his life work in photography."[1] Several thousand viewers
came in just over two weeks, not only to see the work but to see

Stieglitz—and hear him. "All the photographs were there . . . but greater than the photographs was Alfred, and greater than Alfred was his talk—as copious, continuous and revolutionary as ever."[2] Alfred's exhibition statement was characteristically truculent, didactic, and flamboyant: "I was born in Hoboken. I am an American. Photography is my passion. The search for Truth my obsession."

The cult of personality continued to flourish.

There was great interest in Stieglitz's new work, which showed some of Strand's influence; these images were sharper-focused, cleaner, more abstract, and less narrative than his earlier works. Still in evidence was the extreme beauty of texture and shading that was the hallmark of Stieglitz prints: the rich, luminous lights and shadows, the luscious, velvet blacks, and the great and satisfying depth and subtlety of the whole. Several years later Stieglitz said simply of this work, "This was me at my finest."[3]

As well as admiring this new work, the public was responding to the explicit portraits of O'Keeffe. Her nude body and her recognizable art work in the background set up a complicated and confused reaction. Although the photographs were perceived as works of art, the use of another artist as model—a real person instead of an unknown symbol—made the photographs function on levels that neither Stieglitz nor O'Keeffe had intended.

In some of these works, Georgia's direct gaze is fixed upon the camera, establishing a connection between viewer and subject that, paradoxically, both heightens and denies the erotic nature of the images. Deliberately disturbing, Stieglitz's approach greatly increases the psychological power of the portraits. It also greatly increased their sensationalism, a consequence that Stieglitz certainly did not deliberately plan at the expense of O'Keeffe but that a less provocative personality might have avoided.

In the service of art, O'Keeffe had granted Stieglitz loving dominion over her body and her time. She saw her own role as a collaborator in his aesthetic endeavor. Her own vanity and involvement were secondary, as is suggested by her comment to Elizabeth Davidson about a picture by Alfred: "I only look— about 55 . . ." she wrote ruefully, "but [the photograph] is very fine."[4] The intention of the photographer was not to make her beautiful but to make beautiful photographs. O'Keeffe's own eye

was highly abstract (she hung a painting by Dove on her wall for a year and a half before she noticed that it represented a cow), and she saw the photographs of herself primarily as works of art and abstract images.

For many people, less aesthetically conscientious, the naked breasts and body were explicitly those of Georgia O'Keeffe. The resulting attention was unsettling and unwelcome to her, and it revived again the question of her role: artist or model?

O'Keeffe had worked steadily and productively since her last show at "291," in 1917, but the public's only view of her since then was as a model. Though she recognized Stieglitz's need, both as artist and lover, to record her as he saw her, it was not as she defined herself. If she were to have a public image, it should be as an artist.

Her 1917 exhibition had generated a certain amount of titillated speculation, some of it retrospective. Henry McBride, the critic for the *New York Herald,* referred to it several years later as the exhibition "that occurred . . . shortly after she had burst the shackles. That was the exhibition that made O'Keeffe . . . certainly all the inside world went, and came away and whispered."[5] O'Keeffe, on the plains of the Texas Panhandle, had been innocently unaware of any whispering in New York, but she had unwittingly created a vivid image in the art world there. "The art world did not know that O'Keeffe had formerly had inhibitions, but saw that she was without them in the ['291' show] . . . Even many advanced art lovers felt a distinct moral shiver."[6]

Henry McBride was an urbane, intelligent, and generous critic, sympathetic and admiring toward O'Keeffe's work. His gently satiric tone mocks the conventional view that opposes passion and morality; still, this view existed, as did the notion that passion was, by definition, both sexual and threatening. And though he mocks the titillation, he chronicles and validates it. The "distinct moral shiver" was a phenomenon that was to plague O'Keeffe's work, and the understanding of it, through her career.

The show at the Anderson Galleries "made a stir," McBride wrote later. "There came to notice almost at once . . . some photographs showing every conceivable aspect of O'Keeffe that was a new effort in photography and something new in the way of introducing a budding young artist . . . It put her at once on the map. Everybody knew the name. She became what is known as

a newspaper personality."[7] The nude portraits in 1921 gave a retrospectively erotic tone to the show in 1917, and from then on, O'Keeffe's work would be viewed from that perspective.

It was an ironic occurrence, and one that mirrored the complicated and ambivalent relationship between Stieglitz and O'Keeffe. His demands, as artist and lover, cost her, in some ways, her privacy and her independence. He offered up that most private and inaccessible woman, naked and defenseless, to the public. On the other hand, his behavior presented her with a tremendous fanfare to the public, her own art on view behind her face, powerful and beautiful and proficient, proof that she was successful in both the arenas of art and of womanliness.

During the year of the exhibition, two articles came out about O'Keeffe praising her art and her womanliness. Paul Rosenfeld's "Women, One," in *The Dial*, effuses: "Her art is gloriously female . . . Her great painful and ecstatic climaxes make us at last to know something the man has always wanted to know . . . The organs that differentiate the sex speak. Women, one should judge, always feel, when they feel strongly, through the womb . . . All is ecstasy here, ecstasy of pain as well as ecstasy of fulfilment . . . In her, the ice of polar regions and the heat of tropical springtides meet and mingle."[8]

Rosenfeld's rhapsodies have a paternalistic ring to them, as though O'Keeffe were a newly discovered primitive tribe that could be held up to the civilized world of men as a model of fertility and beauty. O'Keeffe was a sensible woman who had grown up on a farm, and she was indignant at reading in a magazine a discussion of her "great painful and ecstatic climaxes." She wrote Kennerly: "Rosenfelt's [sic] articles have embarrassed me . . . reading [his] article in *The Dial* I was in a fury."[9]

Marsden Hartley, who was at times an inspired painter but never an inspired writer, published an article on modern women painters which included O'Keeffe. His language is more overwrought than Rosenfeld's, and his views sillier.

"With Georgia O'Keeffe one takes a far jump into volcanic crateral ethers, and sees the world of a woman turned inside out and gaping with deep open eyes and fixed mouth at the rather trivial world of living people." He gets worse: "She had seen hell, one might say, and is the Sphinxian sniffer at the value of a secret." In the midst of this nonsense are some sensible thoughts: "The work of Georgia O'Keeffe startles by its actual experience of

life," he says. ". . . All this gives her painting as clean an appearance as it is possible to imagine in painting . . . She is modern by instinct."[10]

Despite its moments of lucidity, the esssay mortified O'Keeffe, as well it might, and she wrote: "I wanted to loose [*sic*] the one for the Hartley book when I had the only copy of it to read—so it couldn't be in the book."[11]

Both Rosenfeld and Hartley meant to praise O'Keeffe. She recognized, however, that by rhapsodizing, they romanticized her and thereby removed her from the realm of actuality. Unintentionally but instinctively they were repeating a Victorian pattern of repression, through their insistence on a dream woman, a model of spirituality to which real women should aspire—thus relinquishing any competitive role in the real world. As a nineteenth-century woman writer observed, a patriarchal society encouraged this pattern, which resulted in an incorporeal ideal:

> The familiar heroines of our books, particularly if described
> by masculine pens, are petite and fragile, with lily fingers
> and taper waists, and they are supposed to subsist on air
> and moonlight, and never to commit the unpardonable sin
> of eating in the presence of a man . . . Evidently, fine
> constitutions, strength of muscle and hearty appetites are
> becoming only in washerwomen and amazons.[12]

O'Keeffe's indignant response echoes the Victorian model precisely: "The things they write sound so strange and far removed from what I feel of myself— They make me seem like some strange unearthly sort of creature floating in the air breathing in clouds for nourishment. When the truth is that I like beefsteak and like it rare at that."[13] Her unflattering self-characterization, a deliberate exaggeration of the difference between her image of herself and a conventional, idealized one, would recur.

While O'Keeffe was reading Rosenfeld's article, Hutchins Hapgood, the critic, came in. "I was in a fury—and he laughed — He thought it very funny that I should mind—telling me they were only writing their own autobiography—that it really wasn't about me at all."[14] Hapgood's sensible and perceptive response granted O'Keeffe a different perspective on the issue and gave her a means of defense against what she described as the "shiver

and . . . queer feeling of being invaded . . . when I read things about myself." [15]

The episode hurt and embarrassed her, and induced a change of attitude. A wary aloofness replaced her earlier ingenuousness, and she determined never to deny what was written about her. Distancing herself from critics and the public was a process that would become crucial for O'Keeffe, one increasingly integral to her character.

By the following summer, she had accepted the process as a part of her life, though a distasteful one:

> I dont like publicity—it embarrasses me—but as most people buy pictures more through their ears than their eyes —one must be written about and talked about or the people who buy through their ears think your work is no good— and wont buy and one must sell to live—so one must be written about and talked about whether one likes it or not— It always seems they say such stupid things. [16]

Georgia was writing in response to a piece in *Vanity Fair* that featured photographs of Georgia and of five other women— Marguerite Zorach, Ilonka Karasz, Lydia Gibson, Eyre de Lanux, and Florence Crane (O'Keeffe and Crane were photographed by Stieglitz)—all of whom were hailed as "Women Painters of America whose work exhibits distinctiveness of style and Marked Individuality." The fulsome text below Georgia's photograph recounts her struggle toward "the new freedom of expression inspired by such men as Stieglitz," and announces solemnly that "her new paintings seem to be revelations of the very essence of Woman as Life Giver."

Georgia commented: "Every time I think of that page in *Vanity Fair* I just want to snort—its only redeeming feature is the line at the bottom . . . of the page." [17] The line, a gratuitous swipe at the six amiable women, reads: "The Female of the Species Achieves a New Deadliness." The artless misogyny was recognized with wry amusement by Georgia. Her snort of disgust for the fatuous praise, and her contemptuous preference for the unearned criticism, reflect her attitude of defiance, which would become increasingly entrenched.

It was painful and infuriating for Georgia to find that the paintings she worked so hard to make clean and spare, in which she so carefully avoided cant and empty bombast, should be dis-

cussed in such nonsensical language. The antithesis between "Deadliness" and "Life Giver" reflects the dualistic notion of the Victorian idealization of Woman. Victorian women were encouraged to aspire to a level of impossible selflessness—"absolute Purity," as Stieglitz reverently intoned. As Virginia Woolf chillingly explains, that ideal, "The Angel of the House," is in fact an agent of destruction. The strict and dualistic code admits no successful middle ground. Implied by the ideal of "Angel" is its opposite. The subtext is severe and threatening: a woman is either a selfless angel or a selfish witch—"a heartless wretch," as O'Keeffe later characterized herself.

Georgia could see that the world would insist on interpreting her actions. Instead of a person, she would be seen as "Woman," and her attribute would be either "Life Giver" or "New Deadliness." Out of exasperation, Georgia chose the latter. She was more contemptuous of assumed piety than she was of wickedness, and besides, the role of monster felt more comfortable than that of angel. Out of sheer perversity, if nothing else, the mask of monster was one Georgia would choose at times to wear.

• • •

BY 1922, Alexis, in Chicago, and Catherine, in Wisconsin, were the only O'Keeffes still in the Midwest. Alexis had recovered sufficiently from his war injuries to work as a recruiter for the army. Catherine, after her graduation from the nurses' training course at Madison General Hospital, had married Raymond Klenert, a banker, and moved to Portage, just north of Sun Prairie. The other siblings were in New York. Young Frank O'Keeffe had married, and Anita and Robert Young had a five-year-old daughter, Eleanor Jane. Ida, who had been teaching in Virginia, had come north to become a nurse like Catherine, and was training at Mount Sinai Hospital. Claudia was studying for her degree at Columbia Teachers College; following in the footsteps of her mother and Aunt Ollie, Georgia had "managed to make that possible" for her younger sister.[18] It was a lean time for Georgia herself, but education took priority.

The four sisters in New York saw each other frequently. Stieglitz was warm and welcoming toward family members; he began a friendly rivalry at the billiard table with Robert Young and established close and affectionate friendships with Ida and Claudia. Both sisters visited Lake George and both were photo-

graphed by Alfred. He liked the energy and enthusiasm of the O'Keeffe women. Claudia's letters are full of the same ebullient self-confidence that characterized her sister. "I am always very busy—entertained by what I'm doing or what I'm going to do—makes me laugh." [19] As well as ebullience, Claudie shared another of Georgia's traits, noting cheerfully: "My spelling is as wretched as ever." [20] And all of them shared a love of the landscape: "How nice it is to get out and feel free! . . . stretch my legs—arms—breathe and be free." [21]

Besides the O'Keeffe sisters, Georgia and Alfred saw the Stieglitzes often, dining frequently at the home of one or another of them. On nights spent alone, Alfred and Georgia, in the full black capes they now both wore, went to local restaurants.

Georgia said later that she had prided herself on never looking like an artist, and it was true that there was nothing about her of the disheveled 1920s bohemian. The photograph of Marguerite Zorach next to Georgia in *Vanity Fair* showed what a typical woman artist looked like: an eccentric in a huge hand-woven sweater, knitted cap, and fingerless gloves. Georgia, next to her, in her neat small black bowler and white scarf, looked nothing like an artist. On the other hand, she looked nothing like anyone else, either, and she began, with the cape, to develop her own strong and dramatic style, which made her, as Peggy Bacon would later say, "conspicuous as a nun." [22]

Georgia was becoming part of the vociferous Stieglitz circle. Many of the writers who had constituted the group in Georgia's first few New York years had moved on, but Sherwood Anderson, Waldo Frank, Hart Crane, Gorham Munson, Paul Rosenfeld, and Jean Toomer were still faithful members. Night after night, people gathered in the upstairs room on Sixty-fifth street, talking until the early hours of the morning. Stieglitz was becoming more and more active in the art world again; after his photographic show he had agreed to help curate a modernist show at the Pennsylvania Academy in Philadelphia. When told that the organizers didn't want "any damn women in the show," Stieglitz replied that in that case they wouldn't have him, either.

It was precisely the sort of encounter at which Alfred excelled. No one would think of trying to call his bluff; his eccentric idealism was too well known. As a consequence, three O'Keeffe works were included in the show. Certainly his championing gave her work a credibility and stature in the art world it would

not otherwise have had. Just as certainly, however, there was a strong element of gender prejudice in the art world, and in order for O'Keeffe to compete on equal terms, some assistance was necessary to establish equality at the start.

In early 1922, Stieglitz, who had been unable to arrange other shows for his artists, persuaded Kennerly to hold an auction of the works of "291" painters. It was called "The Artists' Derby," but its jaunty name was ill-advised. The sales were disappointing, though a small gray barn painting by O'Keeffe fetched the highest price: four hundred dollars. It was the first such group activity Stieglitz had organized since "291" closed, but he had not relinquished his feeling of responsibility toward his artists, and a strong spirit of camaraderie still existed.

By the early twenties, the American modernist movement had expanded. There were now others besides the Stieglitz group, and Joseph Stella, Charles Sheeler, Max Weber, Niles Spencer, Preston Dickinson, William Zorach, Maurice Sterne, Edward Hopper, and Louis Lozowick were all working in the modernist American idiom. Stella, Spencer, Sheeler, Dickinson, Lozowick, and (for a period) Demuth explored the possibilities of machine imagery, using muted palettes and a clean linear style. Cool, immaculate, and emotionless, the work was called Precisionist. The style was clearly related to cubism, based as it was on planar relationships, angular geometric forms, and the manipulation of space.

Precisionism was not the only school. Max Weber practiced his own form of intensely hued cubism. Edward Hopper created a figural realism that harked back to the Ashcan School and combined a purely formal strength with haunting emotional content. O'Keeffe, in choosing flowers and fruits for subject matter, was moving against the modernist tide of cubism and industrial forms, but she was not alone. There was a great deal of experimentation, and the general mood was one of expansion and freedom. O'Keeffe's most immediate circle of acquaintances in the art world, however, was dominated by the artists in Stieglitz's stable, who had successfully assimilated the strengths of cubism into their own idioms.

John Marin was the star of the Stieglitz group; his work was widely respected and commercially successful. O'Keeffe had from her student days admired Marin's highly charged, fragmented style: "Of course, we've never had anyone who could

touch him in watercolor."[23] Later, however, when her own eye had fully matured, she found Marin insubstantial: "There was always something a little soprano about his work."[24]

Marin lived on an island in Maine during the summer and in New Jersey in the winter. He had piercing brown eyes and a peaceful manner, and used "to come over every Saturday afternoon to see Stieglitz. They knew each other so well, they'd never say much. Just [sat] quietly, [Marin] smoking."[25]

Marsden Hartley was in Europe during much of this decade, coming back only briefly, in 1922, when most of his earlier paintings were sold, very successfully, at auction. He and O'Keeffe were never close. There was the issue of the histrionic essay, but in any case they had little in common, either aesthetically or temperamentally. Anxious, needy, and continually aggrieved, Hartley lacked precisely the focus and self-reliance that were so central to O'Keeffe's character.

The American Dadaist movement, which was dominated by expatriate Europeans, was exhausted by the early twenties; postwar hedonism was a poor environment for Dada. O'Keeffe's deliberate removal to the hinterlands had given her very little exposure to it, though she was aware, through *Camera Work*, of its revolutionary and irreverent attitudes. Marcel Duchamp left New York in the early twenties and was never a close friend of O'Keeffe's, though she knew him and appreciated the man himself as a work of art. "One time . . . Duchamp was sitting facing me. I finished my tea, and he got up from his chair and took my teacup with the most extraordinary grace—with a gesture that was so elegant that I've never forgotten it. And I haven't seen anything so elegant since."[26] O'Keeffe's visual memory was remarkable; images remained with her, clear and precise, for years, and her memories of people, particularly artists, were often as brilliant and vivid as snapshots. The sculptor Gaston Lachaise appeared one day and she told him he was beautiful: "He looked so healthy and dark and dreamy against bright dark blue."[27]

The best company was Demuth. "I was fond of Charles Demuth. He was . . . very elegant"[28]; "more amusing than any of the artists I knew."[29] Demuth, from Lancaster, Pennsylvania, had exhibited in Philadelphia and at the Daniel Gallery in New York since 1914. His early watercolors were very similar to Marin's, and probably because of this, Stieglitz did not represent him at first. Demuth broke with the Daniel Gallery in 1921, and from

then on he exhibited with Stieglitz. He was not, however, named as one of the "Seven Americans" in Stieglitz's stable, and the professional relationship between the two men was always slightly ambiguous, though Stieglitz and O'Keeffe liked the artist. "Demuth was one of us," O'Keeffe wrote.[30] Elegant, urbane, and witty, Demuth was excellent company. He was lame and diabetic, and he came to New York for brief sprees—good company and bad habits—before he retreated again to his mother, Lancaster, and good health. He was ravaged increasingly by his illness, to which he finally succumbed in 1935.

Demuth's delicate, luminous watercolors of flowers, his translucent washes, and his delight in biomorphic forms established an aesthetic sympathy between himself and O'Keeffe at once. So strong, in fact, was this affinity that they talked of collaborating on a flower painting, though this never occurred. In 1924 he started a series of poster "portraits" in oils that symbolized members of the Stieglitz circle. It was a mark of their friendship that he did O'Keeffe's first. Though the "portraits" stand as some of his best work in terms of graphics, color, and design, they are esoteric to a degree, and often baffling. The object chosen to represent Arthur Dove, the gentlest of men, was a steel-bladed sickle: a beautiful abstract curve, and symbolic of farming, but equally of ruthless killing. It was hardly an appropriate metaphor for a man whose instincts were slow, warm, and nourishing.

O'Keeffe is symbolized in Demuth's "portrait" by an apple, two pears, and a squash lying on a table: fruits of the land and objects that she herself chose as subjects for paintings. Her name is written from bottom to top, with a sunburst around it, against a flat white background: well enough. But the dry and rusty leaves of a tropical houseplant (a sansevieria, commonly called, as Barbara Haskell points out, a snake plant) take pride of place in the composition, and though the sinuous lines that define them are reminiscent of O'Keeffe's wavelike abstractions, it seems still a curious choice.

Demuth's friendship and respect for O'Keeffe was demonstrated in his will: he left her all his oil paintings. O'Keeffe respected his bravery in the face of his physical frailty and pain; his determined elegance; his wit; and the sensuous beauty of his work. As she herself grew surer of her aesthetic needs, however, she found something lacking in Demuth's work, a central pas-

sion. Seeing an exhibition of his in 1929, she wrote: "Very fine—
Only maybe I begin to feel that I want to know that the center of
the earth is burning—melting hot."[31]

It was Arthur Dove for whom Georgia felt the greatest sym-
pathy and friendship. She had been profoundly influenced by
the first Dove reproduction she had seen, around 1915, in Jerome
Eddy's *Cubists and Post-Impressionism.* Dove's response to her
work was similarly sympathetic: "That girl is doing without effort
what all we moderns have been trying to do."[32] O'Keeffe's affin-
ity with him was both aesthetic and temperamental: "Dove had
an earthy, simple quality that led directly to abstraction. I loved
his things. I always wished I'd bought the ones I wanted, but
Stieglitz always told me to wait."[33] Dove farmed in Westport with
his wife and son until 1919, when his life was transformed, much
as Stieglitz's had been. Dove left wife, son, and farm, with much
pain and scandal, but without much choice. He had fallen sump-
tuously in love with another artist, Helen "Reds" Torr, who left
her husband to live the rest of her life with Dove. The two of
them spent much of the next five difficult years on a boat, moving
next to the Dove family's bankrupt farm in upstate New York.
Their lives provided a number of parallels with Stieglitz and
O'Keeffe's: founded under similar painful and stormy circum-
stances, both marriages were true partnerships. The Doves
"shared a dedication to art, a love of hard work . . . and a real
humility that allowed them to take great pleasure in existence, no
matter how strenuous or straitened their circumstances . . . Their
feelings for each other were warm and supportive . . . They
seemed to feel no threat from each other as artists, and expressed
only admiration and praise for each other's work."[34] Dove's ap-
proach to painting echoed O'Keeffe's: "There is no such thing
as abstraction: it is extraction, gravitation toward a certain direc-
tion, and minding your own business."[35] Dove and Reds took
great pleasure in the life they led: it was clean and close to the
bone.

Though O'Keeffe was the only woman artist who rose to
such prominence from Stieglitz's circle, she was not the only
woman in it. Marion Beckett, one of the "Three Graces" at "291,"
showed now with Montross. She was still part of the circle, how-
ever: a stylized portrait of Georgia by Beckett was the lead paint-
ing in her 1925 show, which included portraits of Katharine
Rhoades and Alfred Stieglitz as well. Her painting of Georgia

illustrated a newspaper interview with O'Keeffe in the *New York Sun*, December 5, 1923. Katharine Rhoades, another of "the Graces," was still a close friend of Alfred's and very much in evidence. Florine Stettheimer was a *faux naïf* painter from a rich New York family. She and her sister Ettie were also members of the Stieglitz social circle, though Florine never exhibited with Alfred. Georgia liked Florine's flair and eccentricity: "Whenever Florine finished a painting she'd invite people in for tea." [36]

In February 1922, Stieglitz became a founder of a loosely structured literary magazine called *MSS*. Paul Strand agreed to be the editor for the December issue, which was to be devoted to the old, delicious question "Can a Photograph Have the Significance of Art?" Georgia agreed to write an article for it and to design the cover. Her design turns the three-letter name into a huge bold decorative pattern that dominates the top half of the page.

That summer, Georgia and Alfred were at Lake George by July. As usual, they began by recuperating. "Georgia hasn't started painting. Her chiefest ambition is to gain ten pounds." [37] But ten days later she had begun working, and Alfred reported "a corking pastel." [38]

The summer was a terrible one for Alfred: he was watching his mother approach death. Hedwig, covered with shawls and surrounded by nurses, was failing rapidly. Alfred himself was fifty-eight, and the world around him seemed in decline: "Our place going to pieces. The old horse of 37 . . . being kept alive by the 70-year-old coachman. I, full of the feeling of today, all about me disintegration—slow but sure: dying chestnut trees—the pines doomed too—diseased . . . the world in a great mess." [39]

Alfred's first response to this was to start another series of portraits, of Georgia Engelhard. A number of these are nude, the young adolescent body breathtakingly white and pristine. In one, Georgia Minor sits poised in an open window, a handful of apples in her lap; in another, without coquetry, she holds one breast in her hand: the pictures are lyric celebrations of young flesh.

Alfred's delight in young women was unabashed and direct, and so energetic that his adolescent nieces were forbidden to have private chats with Uncle Alfred. His attitude, however, was so direct, so lacking in prurience, and so obviously informed with warmth and affection that the girls themselves, unthreatened, felt only warmth and affection in return.

Alfred had another model that summer. In 1920, Paul Strand had begun a relationship with the painter Rebecca Salsbury, whom he then married. The daughter of Nate Salsbury, the flamboyant manager of Buffalo Bill's Wild West Show, Beck had become an energetic member of the Stieglitz circle, helping with the organization of *MSS*. Febrile, freckled, dark, and striking, she greatly appealed in looks and manner to Stieglitz, who began taking pictures of her in 1921.

At the beginning of the summer of 1922, Beck came for a brief visit alone; she would return with Paul late in August. During her first stay, Beck took a room at a nearby inn but spent her days at the Hill. Enthusiastic and high-spirited, Beck charmed everyone, including old Fred the coachman. She was beautiful in the same way Georgia was: strong-boned and clean-limbed, long-haired and lithe. Tramping in the hills, she wore men's trousers, and lying in the sun she wore nothing at all. Alfred did a portrait series of her, placing her smooth limbs against the pale texture of grass and straw or half submerged in the lake. Georgia commented on their activities obliquely, mentioning merely that Beck could stay in the icy waters of the lake longer than anyone else.

At midsummer, after Beck's departure, Alfred turned away from tangible subjects and began his photographs of clouds and sky. This project would evolve into his "Equivalents," a series that constituted one of his great works, at once deeply abstract and specifically representational, richly textured with light and shadow, and, as always, full of emotional resonance. "Georgia says they're like photographs of a breath," he wrote Elizabeth.[40]

Though behavior on the Hill seemed clean, sane, and healthy to its occupants, the view from the outside was different. Rumors circulated in the decorous community about the plein-air nude photography. A plainclothes policeman, set to watch for further depravity, stood awkwardly about the fields and lanes. At the end of the summer, Beck and Paul went for an innocent skinny dip in the lake, only to be apprehended by a stalwart representative of the law. They were fined ten dollars each for their disgraceful behavior, to forestall further damage to the fabric of society.

At first blush, the incident was absurd: a married couple's bathing habits seemed entirely unrelated to the larger good of the community. Nonetheless, the policeman's prim reprimand had merit. He had been called, not because of Paul and Beck's swim-

ming, but because of Alfred and Beck's photographic sessions, and although those appeared altogether innocent, they were not.

O'Keeffe was accustomed to being the center of Alfred's erotic interest, but gradually it became clear that his affection for women was too copious to be contained. That summer, Georgia watched Alfred spend his days recording the nude beauty of other women: a dangerous occupation. She knew herself the sort of concentration and intensity it required, and although she believed his interest in other women did not diminish his interest in her, still his energy was visibly directed elsewhere. It was a subtle issue, for his energy was equally elsewhere if he was photographing the barn; and her energy was elsewhere if she painted in solitude. Yet there was a significant difference. Alfred's candid statement, "When I make a photograph, I make love," rendered things no easier.

It was ironic that the ludicrous encounter by the lake should snare the wrong man, on the wrong occasion. But Alfred felt himself deeply responsible and paid the Strands' fines: it was he who had encouraged them, he said. And it was Alfred, in the end, who was responsible for the air of license that pervaded the house in the name of art. Alfred's belief that art transcended all other concerns resulted in his feeling entirely outside the law.

The summer passed, however, without tension. A letter from Georgia to a friend of the Stieglitzes displays her high spirits: "Good morning Sime! You are a cut[e] old boy . . . This sneezy page is written to you to ask you if you do not want to board the train and come up here—you may stay as long as you can stand my food— The leaves have barely turned the least little bit." [41]

The summer was finally a productive one for Georgia as well as Stieglitz. By October, Alfred reported: "Georgia painting. Feels well. Cooks well . . . some *deeleeshus* food . . . We may open a restaurant." [42] She suffered from mild eye strain but was working hard. "I insist she paint," Alfred boasted to Beck. "Says I'm a worse slave driver than ever. Well I don't mind if I am. There are results quite worth while. A few Wonders since you left. And not apples—landscapes." [43]

O'Keeffe was finally turning to the Lake George countryside in her work. It did not bring out her best efforts; the high, claustrophic horizon, the deep, impenetrable green, the sense of enclosure and narrowness, all inhibited her. "The days have been

warm and still . . . the green so near and close—all about one—
and the lake and mountains hazy out there," she wrote after-
ward.[44] Years later she knew: "It is lovely country with many
trees but it is not for me."[45] The landscapes from this period are
dark, stylized, and semiabstract, simple flattened masses of color.
It was not a countryside that encouraged expansion. "The people
up there live such little, pretty lives, and the scenery is such little,
pretty scenery," she explained, pointing to a genteel, streamlined
lake scene; ". . . that's the way I felt when I painted this."[46]

Her feelings toward the lake itself had always been ambiva-
lent. During her second summer there, she and Alfred had been
out rowing during a high wind, and a nearby canoe with two
young boys in it tipped over. Alfred put Georgia ashore and
rowed back to help the boys. He saved one, but the other
drowned in front of him. It was a devastating incident. Alfred
responded to it as though Georgia had fallen from a horse: "Geor-
gia and I were on the lake several hours this morning. I knew it
was best to get her right out on it."[47] The death struck an omi-
nous note in the holiday surroundings and established the lake
as a presence not entirely benign.

As well as the larger landscapes, O'Keeffe persisted with the
still lifes of natural subjects, continuing the clean, strong series of
plants. "O'Keeffe is busily painting. Primarily small things. Very
rich in color. Oils and pastels," wrote Stieglitz.[48] She may have
been experimenting with the mixing of media: one day she an-
nounced mysteriously that she needed sealing wax for one of her
pictures. She and Alfred walked to the village to buy it, but she
would not explain, and Alfred was not permitted to see the unfin-
ished picture.[49] The trial seems not to have been successful, as
there is no record of surviving mixed-media work.

O'Keeffe also did *Cos Cob*, a close-up, stylized oil of skunk
cabbage, which incorporated the swirling, unfurling forms of the
early 1915–16 images with the biomorphic forms of the actual
plant, establishing a strong visual rhythm through the dynamics
of opposition: dark and light, curved and linear.

It was probably in this summer that Georgia painted her only
animal portrait: the beguiling *Cow*, stylized, simplified, and
nearly cartoonlike in its sleek and curvilinear outline. The head is
shown close up, the tongue curled out, the eyes rolling as the
heifer reaches longingly for an apple just out of reach. In its
instinctive sympathy for natural form, its unselfconscious ab-

straction of shape, the work is very reminiscent of Arthur Dove's. It is also, like some of his work, nearly comic in its quality of playful caricature. This comic element was rare in O'Keeffe's work, but another painting tentatively dated to that year revealed the same gentle humor. *The Little House*, with its neat, rounded, stylized clouds, its lollipop trees, and its demure white pointed-roofed cottage, looks like an illustration for a children's story.

Altogether, the work was increasingly confident. O'Keeffe was advancing in a number of directions, continuing to experiment, continuing to draw inspiration from natural forms, and "doing the most beautiful things," as Alfred wrote.[50] By the end of the summer, Stieglitz had decided that it was time for another exhibition of O'Keeffe's work.

18

ALRED STIEGLITZ
PRESENTS
ONE HUNDRED PICTURES
OIL, WATER-COLORS
PASTELS, DRAWINGS
BY
GEORGIA O'KEEFFE
AMERICAN

O'KEEFFE'S FIRST LARGE solo exhibition, in 1923, was held under the obliging auspices of Mitchell Kennerly, at the Anderson Galleries, on Park Avenue at Fifty-ninth Street. The show ran from January 29 to February 10, and it was jammed: some five hundred people came each day. The whispering that had gone on about her "uninhibited" work in 1917, and the remarkable photographs of the artist exhibited in 1921, made the event border on the sensational. The frankly curious came to be shocked, and the art lovers to admire.

No checklist was kept, but judging from the list of the pictures sold and from the critics' comments, the exhibition included examples of everything O'Keeffe had done since 1916. Close to twenty pieces were sold, many to family members and friends. Leopold Stieglitz, Anita Young, Beck Strand, George Engelhard (Georgia Minor's father), Katharine Rhoades, Paul Rosenfeld, Sherwood Anderson, and Arthur Dove (in a trade, for one of his pictures) all made material commitments to O'Keeffe's professional skill.

Duncan Phillips, the patron and collector, who supported Stieglitz's artists, bought *The Shanty*. This was a deliberately drab oil of her studio at Lake George. Her own preference for brilliant colors was well known, but she did not like being characterized as feminine because of it. "Among the artists at that time it was disgraceful to think of anything pretty . . . People felt that painting had to have a sort of dirty look. I felt I could make a dirty painting too, so I did."[1] It amused her that this was the first painting of hers bought by Phillips.

Henry McBride's review of the exhibition was deeply perceptive and warmly congratulatory. He refers to the early charcoal series of abstract, emotional, introverted drawings, and points out the risk of self-involvement that lay in her development:

> If all those vapors had not been shattered by an electrical bolt from the blue, O'Keeffe would have undoubtedly suffocated from the fumes of self. There would have been no O'Keeffe. In definitely unbosoming her soul she not only finds her own release but advances the cause of art in her country. And the curious and instructive part of the history is that O'Keeffe after venturing with bare feet upon naked sword blades into the land of abstract truth now finds herself a moralist. She is a sort of modern Margaret Fuller sneered at by Nathaniel Hawthorne for a too-great tolerance of sin and finally prayed to by all the super-respectable women of the country for receits [sic] that would keep them from the madhouse. O'Keeffe's next great test, probably, will be in the same genre. She will be besieged by all her sisters for advice—which will be a supreme danger for her. She is, after all, an artist, and owes more to art than morality. My own advice to her—and I being more moralist than artist can afford advice is, immediately after the show, to get herself to a nunnery.[2]

McBride recognizes O'Keeffe's aesthetic progress, from the esoteric and rarefied nature of the early drawings to the larger and bolder world expressed in the abstract paintings of the Texas landscape, for example, and in the serene domestic still lifes, which express a tranquil and integrated view of the world.

With the reference to Margaret Fuller, McBride acknowledges the risk of subversion through popularity. Fuller was a nineteenth-century feminist writer who urged women to develop

the masculine side of their nature. Initially viewed as a scandalous revolutionary, McBride presents her as a figure who ironically became a role model for highly respectable conventional women.

McBride recognizes the same potential pattern developing in O'Keeffe's work: initially viewed as shocking, it was also, and increasingly, popular. Subversion of the artist through popularity is subtle. Human nature responds with pleasure to praise, and it is difficult to ignore kind words. Nonetheless, the artist must pursue a solitary and revisionist vision, maintaining her own interior silence. Once she listens to the voice of the public, the artist has lost her own.

McBride's "nunnery" was close to what O'Keeffe had chosen, years earlier, herself: a small Methodist women's college in South Carolina. Not precisely a nunnery, but an environment that had allowed her to develop in solitude. The need for solitude and interior focus was one she found far more crucial than "success":

> Whether you succeed or not is irrelevant, there is no such thing. Making your unknown known is the important thing —and keeping the unknown always beyond you. Catching, crystalizing your simpler clearer vision of life—only to see it turn stale compared to what you vaguely feel ahead—that you must always keep working to grasp.[3]

"The outstanding fact is that she is unafraid," McBride goes on. "She is interested but not frightened at what you will say . . . It represents a great stride, particularly for an American. The result is a calmness . . . There is a great deal of clear, precise, unworried painting."[4]

O'Keeffe responded to McBride's review with pleasure:

> Your notice pleased me immensely—and made me laugh—I thought it very funny—I was particularly pleased—that with three women to write about you put me first. My particular kind of vanity doesn't mind not being noticed at all . . . and I don't even mind being called names—but I don't like to be second.[5]

In spite of Georgia's insistence on being first, the rest of the letter consists of high praise for the work of another artist—John

Marin. One aspect of O'Keeffe's calmness was her consistent gen-
erosity to other painters. With very few exceptions, she was sel-
dom critical of other artists: she felt no threat from them. If she
did not like an artist's work, it was outside her sensibility, and
she had nothing to say of it. If she did like work, she was positive
and supportive. "I must add that I don't mind if Marin comes
first," she finishes rather mischievously, "because he is a man—
its a different class."[6]

O'Keeffe's account of her struggle to achieve the calmness
McBride describes was recounted in her own contribution to the
catalogue. O'Keeffe's modest, ingenuous statement begins with
a rather devastating indictment of a patriarchal system that re-
stricts the activities of a young woman. The list of forbidden
activities all relate to gender, and the result is a suffocating sense
of repression and constriction.

> I grew up pretty much as everybody else grows up and one
> day seven years ago found myself saying to myself—I can't
> live where I want to—I can't go where I want to—I can't do
> what I want to—I can't even say what I want to— School
> and things that painters have taught me even keep me from
> painting as I want to. I decided I was a very stupid fool not
> at least to paint as I wanted to and say what I wanted to
> when I painted, as that seemed to be the only thing I could
> do that didn't concern anybody but myself—that was
> nobody's business but my own . . . I say that I do not want
> to have this exhibition because, among other reasons, there
> are so many exhibitions that it seems ridiculous for me to
> add to the mess, but I guess I'm lying. I probably do want
> to see my things hang on a wall as other things hang so as
> to be able to place them in my mind in relation to other
> things I have seen done. And I presume, if I must be
> honest, that I am also interested in what anybody else has
> to say about them and also in what they don't say because
> that means something to me too.[7]

Her candid and welcoming attitude demonstrates her readi-
ness for a dialogue with the public and the critics. In light of
McBride's observation, however, that too much attention from
other women, or indeed from the public in general, could prove
destructive, it is interesting to note Stieglitz's shrewd handling of
the artist and her work. He had shown the first O'Keeffes, in

1917, when Georgia was a thousand miles away. He did not show her work again to the public until she had produced one hundred pictures, all solid examples of a style that was increasingly certain and mature. O'Keeffe was then thirty-six years old, sure of herself as a person and an artist.

In the spring of 1923, Stieglitz had another exhibition of his own work: portraits of Georgia and other subjects, pictures of Lake George, and "Music—A Sequence of Ten Cloud Photographs." The new work was acclaimed widely, and the Boston Museum of Fine Arts asked for some prints for their collections, at last acknowledging photography as a fine art.

Alfred had sustained a terrible emotional blow in November, when Hedwig died. "The winter had been very hard on him— The nerves seemed tied up so tight that they wouldn't unwind," Georgia wrote.[8] There were physical causes too; when they arrived at Lake George, she wrote: "The spring has been terrible and when we got here he was just a little heap of misery— sleepless—with eyes—ears—nose—arm—feet—ankles—intestines—all taking their turn at deviling him . . . It was rather difficult—in a way he is amazingly tough but at the same time is the most sensitive thing I have ever seen."[9]

Besides his bereavement, Alfred was distressed by the relationship with his daughter. He and Kitty had made an uneasy peace, though she still refused to meet Georgia. Alfred had been disinvited from her graduation from Smith College in 1921. Her uncle Lee advised against her taking a job, for reasons of health, and instead, Kitty married Milton Sprague Stearns in the summer of 1922. The following June she gave birth to a son, and days afterward she collapsed with a severe postpartum reaction, dementia praecox, which led to a permanent loss of her sanity.

Alfred reacted with grief and self-blame: "I certainly failed in so many ways in spite of all my endeavour to protect and help her prepare herself for life. I realize with every new day what a child I have been & still am— Absurdly so. It sometimes disgusts me with myself."[10] Kitty's doctors did not support Alfred's feelings of guilt. Her condition was diagnosed as schizophrenic and not related to her father's behavior. At first Kitty's recovery seemed probable, but hope slowly lessened. Most painful for Alfred was the knowledge that his presence threw his daughter into a frenzy of rage and despair. After a few visits he was forbidden to return, and in fact he was never permitted to see her again.

Kitty's tragedy as well as the loss of his favorite sister in childbirth significantly affected Alfred's attitude toward Georgia's becoming pregnant; his opposition became adamant and final.

The question of Georgia's maternity is central to their relationship and involves the many layers of it. Georgia had written candidly to Catherine. "She would have liked children," Catherine said, "but her husband wouldn't allow it . . . He said she wouldn't be able to paint if she was puttering around with babies." [11]

Ironically, Stieglitz's attitude mirrored that of the domineering and chauvinistic nineteenth-century husband who forbade his wife a career, insisting instead on the devotion of her energies to the domestic sphere. Both attitudes were paternalistic, and both presumed that the responsibility for women's bodies and their lives belonged to their husbands.

Georgia submitted to Alfred's injunction. Women have been known to conceive in spite of a husband's objections, but to become pregnant surreptitiously would have been difficult with Stieglitz as a partner. He was fascinated with female lunar cycles —he wrote Beck Strand: "I knew you had the Curse . . . Georgia wondered if I kept tabs on all of the women I knew" [12]—which seemed to him mysteriously arcane, demonstrations of women's otherworldly natures. Priding himself on his sympathy and understanding, he was always conscious of Georgia's progress through the menstrual cycle. "The Curse" was an important factor in their household; travel plans revolved around it, days off from painting were scheduled because of it, and moods and tempers were assigned to its influence, all in a manner that was intended to be tender and reassuring but that implied some measure of control.

Pregnancy was an issue that did not allow a compromise, and Alfred's wishes, finally, took precedence over Georgia's.

• • •

THAT SUMMER, 1923, Stieglitz and O'Keeffe arrived at Lake George in late June. Beck Strand came up once at the beginning of the summer and again at the end of August. Alfred urged her to come on behalf of Georgia: "It would be nice for her to have you here." [13]

During Beck's second stay, the photographic sessions began again. This time, something occurred between Alfred and Beck

that deepened and complicated their relationship: apparently a romantic interlude.[14] That fall he wrote Beck tenderly: "It seems ages since the summer! And all it signified. I'll never forget it. Much was very wonderful even if very painful."[15]

Alfred's overflowing love for women was similar to his love of his ideas: both were natural, crucial, and ardent needs, and both would cause him trouble more than once. Alfred labored under the naive belief that motivation determined effects. Since his motives were always pure, he firmly believed that he would cause no pain. This misguided innocence never left him, sustaining him through his many infatuations.

Alfred's correspondence with Beck in October suggests that Paul Strand was having an affair with another woman. Alfred was as warmly protective as though he were Beck's legal guardian and as though there were no irony in his position. "I'm glad you felt you mustn't address the woman. It would have been the worst thing to do. It's all too horrible. Only I know *how* terrible. Poor, poor girl. Completely innocent. I wonder does *he* do what is really best in the long run?"[16] The relationships of Georgia, Paul, Alfred, and Beck had become intricately entwined, Alfred's romance with Beck echoing Georgia's earlier encounter with Paul. An urge for symmetry may have influenced Alfred; the same urge of unconscious or deliberate retribution, reflecting Alfred and Beck's liaison, may have influenced Paul.

Georgia was aware of Stieglitz's flirtations—the beautiful Katharine Rhoades was at Lake George as well that summer—but she neither challenged nor accused. Any rage and pain she felt was silent, private, and serious. She did not believe in asking people to change; she kept her own counsel and took her own steps. Shortly after Beck's arrival, at the beginning of September, Georgia suddenly went to Maine, where she stayed for nearly a month. She left just before the Davidsons arrived, writing a letter of explanation to Elizabeth:

> It's no use to say anything—I've just gone and done it . . .
> The feeling that you would be with him for two weeks
> made me feel easier about leaving . . . you don't really
> mind my coming—I assure you it is much pleasanter for
> you than my staying there would have been.[17]

The last sentence sounds a somber note: Georgia's acknowledgment of her own unpleasantness signified her acceptance of

the mask of monster and the accompanying feelings of shame and defeat. Just as she took responsibility for no one's happiness but her own, so she blamed no one for her misery or her unpleasantness. Rather than demand that her own needs be met, she fled the field and saw herself "a heartless wretch."

Georgia's unhappiness was evident. "[The mail] brought a very beautiful letter from Georgia. Rather sad. But very beautiful. There is no doubt if any woman should be close to me it's Georgia — For she is truly beautiful at the root."[18] Alfred's musing over closeness suggests its opposite—the distance between them.

For Georgia, besides the issue of Beck, there was also the growing realization that she would never bear children—an idea that takes on reality slowly and painfully for a woman, bringing with it sudden, intermittent, and devastating moments of anguish.

There was also the steady presence of visitors. Freed this summer from the company of the incessant and overweening Stieglitz family, for whom she no longer felt such an amused tolerance, Georgia was now baffled and exhausted by Alfred's insistence on a constant stream of guests instead of blessed and available privacy. And even though Hedwig was gone, Georgia was not the head of the household and had little control over it. "She says she still feels like a visitor here," wrote Alfred.[19]

There had been a host of visitors: Anita Pollitzer for a brief stay, the Seligmanns, the Schaufflers from Maine, Paul Rosenfeld, the Davidsons, Beck Strand, and, for ten weeks, Marie Rapp Boursault and her two-year-old daughter. Both Alfred and Georgia were taken with little Yvonne; nonetheless, the long visit was exhausting.[20]

"I don't know why people disturb me so much—they make me feel like a hobbled horse," Georgia wrote.[21] It was not solipsism that prompted this comment; Georgia was highly conscious of other people around her and could not ignore them to pursue her own ends.

Alfred was convinced that earnest discussion would cure the problem: "We had some real Talks . . . They showed her some things in a new light. She listened and heard. And I was much clearer. The days of adolescence are over & the relationship reestablished finely [sic] free . . . It is all working out."[22]

Always optimistic—he loved her—Alfred would write this sunny phrase again and again. Alfred's need was for people;

Georgia's was for solitude. The difference was fundamental and absolute, and neither he nor she would alter. For the next several years she would endure sociability until she could do so no longer, and then she would flee.

In November, after Georgia had returned, Ida O'Keeffe came to stay at the Hill for two weeks. "She was a delight to have," Stieglitz said. "For she really released Georgia much . . . Laughed, slept 12 hours a day . . . was in the woods a lot."[23] Ida took out Fred's rifle and brought back a squirrel, which was skinned and cooked. The energetic and exuberant Ida represented the family and the strong real world in which Georgia had grown up. Georgia relaxed in Ida's warm and positive presence.

Ida's response to Alfred was warm, affectionate, and irreverent. When later he sent her a photograph he had taken at Lake George, she wrote back sternly:

> The picture came and I do not like it. Will you please tear
> up the negative. There is nothing beautiful about that
> terrible looking picture— If orders are not obeyed you will
> find yourself in the hands of the law. If anyone ever saw
> that [picture] you would lose your good reputation with the
> camera completely, so for your own good you better take
> my advice. I do not like to write to an old uncle in this
> manner but you have been away from civilisation for so
> many months that I know you are working along the wrong
> line.[24]

Alfred reveled in Ida's enthusiasm and well-being: "Never saw anything quite so healthy—so balanced."[25] Georgia, in unspoken comparison with her sister, continued poorly, with one minor ailment after another plaguing her health.

Despite her problems, Georgia had begun painting while she was at York Beach in September. "She did a few very fine things in Maine. In a way it's a shame she had to choose coming to me than remaining there to paint," wrote Alfred,[26] unwittingly articulating the choice that Georgia, increasingly, faced.

Her productivity continued when she returned to Lake George. "G has been painting strenuously . . . in 5 days she completed 3 canvases. A larger one and two smaller ones, All A1," he reported proudly.[27] Contrasting her own work with Stieglitz's, O'Keeffe called his "very wonderful—way off the earth," her own "very much on the ground." For the time being

she was wary of abstract paintings. "I suppose the reason I got down to an effort to be objective is that I didn't like the interpretations of my other things."[28] All but three of the paintings she exhibited from that season were clearly representational. There were two Lake George and four York Beach pictures; the rest were trees and still lifes: sunflowers, calla lilies, alligator pears, figs, and other fruits. Leaves were also subjects: jagged irregular shapes. Often these have slits, tears, and openings in them, demonstrating the continuing fascination with orifices begun in the trembling arches of *Music Pink and Blue II* of 1919. One small work (done the following year), of dried oak leaves with elliptical holes in them, creates a magical pattern of interlocking openings, layered one on top of the other, smooth and mysterious.

The season ended well. On one of their last days at the Hill, late in November, something happened that Stieglitz had been dreaming about for years. "There has been a blizzard. Knee-high snow. Maddeningly beautiful. Georgia had a great time in it . . . We tramped through the snow to the Post Office yesterday . . . so beautiful . . . trees, hills, bushes white laden down with fresh snow red berries peeping out . . . & Georgia never was happier. It was really glorious."[29]

For Stieglitz, the color white had a particular resonance, representing an immaculate purity of spirit, and essential goodness. From the beginning he had seen O'Keeffe as "white." The real vision of her tangible presence in the "Maddeningly beautiful" white countryside, "never . . . happier," was a moment of epiphany and exaltation for Alfred, vindicating and confirming their life together, their surroundings, the choices they had made. The sensation of joy was mutual: that winter, Georgia wrote Catherine simply, "the living is extraordinary."[30]

• • •

GEORGIA CONTINUED to maintain a strong connection with her midwestern background. In early February 1924, she wrote her sister Catherine, who had given birth to a daughter, Catherine Klenert:

I had your letter this morning. The news of you and your baby—your way of living is nice to have. I like to feel that at least one member of the family lived what might be called a normal life— No one in New York can even approach being

a normal human being so that wipes out four of us at one swoop. You can be glad that you live in a little town where you can look out and see a tree.[31]

Francis had moved to Havana, and the four O'Keeffes who were guilty of living in New York were Georgia, Ida, Claudia, and Anita. Catherine's modest and independent choice of life style was one that Georgia would continue to admire. Her sister's life in the small Wisconsin town, with steady husband and beguiling daughter, gave Georgia a sense of reassuring continuity and furnished a comforting link with her childhood.

Georgia's own news bespoke a very different style of living:

I may have another exhibition this year— Am not sure yet —don't much care—but I've done well enough to be talked about and written about more and more.[32]

A month later, Alfred Stieglitz again decided to present the work of Georgia O'Keeffe, American, at the Anderson Galleries. This time there were only fifty-one paintings by Georgia, and Alfred had his own exhibition, in the smaller of the two rooms. The response was not as tumultuous as it had been at the previous O'Keeffe show, but still critics and public came. O'Keeffe was now an established persona in the art world. The preceding October, an article in the Canyon, Texas, newspaper suggested that the local residents had had second thoughts about their eccentric teacher. "Among the twenty best modern artists in America . . . Miss O'Keeffe will be remembered by many as having been connected with this institution for two years, and her many friends here realized at the time that she was a woman of genius."[33] Royal Cortissoz, the deeply self-impressed *eminence grise* of the art world, was not so nimble. The loftily condescending review of her first show was impudently reprinted in the announcement of the 1924 show: "Miss O'Keeffe's tints are often beautiful. It seems a pity that a sensuous glow like hers shouldn't be governed by some pictorial purpose. There is much pretty talk among modernists about the virtues of 'abstract' art. The painting itself, as on this occasion, leads nowhere."[34]

O'Keeffe was the subject of an excellent and lucid article by Paul Strand, in which he discusses "the fact that, without self-consciousness or mannerism, the most personal and subtle perceptions of women are embodied for the first time in plastic

terms" and goes on to explain the importance of color in her paintings. Instead of insisting on the purely personal nature of her work, Strand grants O'Keeffe "a deeply personal language, a communicable aesthetic symbology expressive of the social significance of her world . . . it is this very inter-relationship between social evolution and aesthetic forms, which gives the latter that vitality and livingness we call Art."[35]

Not only was Strand's article clear and intelligent; it remarks on the validity of O'Keeffe's work as an expression of the larger, legitimate world, instead of seeing it as critics tended often to do, as representative of an arcane and hermetic system of female symbology. This would be a continuing problem concerning response to her oeuvre: after the excitement of finding a woman's expression in paint, those people who saw the work as restricted to female issues, and without merit in larger terms, would continue to find it unsatisfying.

In early 1924, Catherine wrote to Georgia, asking her advice on commercial art. Advertisements of the period encouraged the amateur artist to become a professional, and it seemed to Catherine an easy and appealing way of making extra money.

Georgia did not encourage Catherine, however, for philosophical reasons. Georgia was intensely aware of the risks of commercialism to the artist—it was an issue on which Stieglitz was vehement. When John Marin's father suggested to Stieglitz that Marin paint commercially part time in order to subsidize his noncommercial work, Stieglitz is said to have replied, "That, sir, is like suggesting that your daughter be a virgin in the mornings and a prostitute in the afternoons."

Georgia's advice to her sister was a good deal gentler, but her views were similar:

When you ask me about commercial art I wonder if you know what you are talking about . . . A large proportion of the people who think they want to be Artists of one kind or another finally become commercial artists—and the work that they send out into the world is a prostitution of some really creative phase of Art. It is the surest way of making a living. Very few real artists make money enough to live on out of really creative work. It is the person who makes something similar to the real thing that has been talked about— People have heard it talked about—few of them

ever see the real thing but they take up with interest the
thing that has been commercialized because they have
heard of it . . . There are very few artists of any kind who
are not commercialized in one way or another . . . I feel you
can't know much of anything about commercial Art— You
are not mixed in with the hash of the world like I am— You
can be glad that you will probably even die without its
meaning much of anything to you. You see I tried
commercial Art—fashions— I was a failure . . . And I tried
doing other foolish forms of commercial Art— I could make
a living at it—that is— I could exist on it—but it wasn't
worth the price— Always thinking for a foolish idea for a
foolish place didn't appeal to me for a steady diet—so I
gambled on this foolish business of painting— And here I
am at it.[36]

The issue of commercialism was a complicated one. Because
of changing technology, it had become possible by the turn of the
century to reproduce works of art for the general public. This
resulted, on the one hand, in the art poster movement, which
included among its distinguished members Degas, Toulouse-
Lautrec, and Mucha. These artists were delighted at the dissemi-
nation of their work and believed that society would only benefit
from the easy availability of serious art. As the century pro-
gressed, however, commercial considerations took increasing
precedence over aesthetic ones. Stieglitz adopted a fiercely elitist
position on the subject. His belief was that widespread circula-
tions of serious art would trivialize and vulgarize it.

O'Keeffe had tried commercial art herself since moving back
to New York in 1918. A large silk company, Cheney Brothers,
had commissioned O'Keeffe canvases for an advertising cam-
paign, probably between 1918 and 1923. Stieglitz had told her
that in permitting the reproduction of her work for advertising
purposes, "she would make it possible for thousands of people
to do 'similar' work, who did not really get the spirit or know
what they were doing."[37]

Stieglitz carried this exclusionary attitude to a radical ex-
treme. Though he saw himself as a high priest of art, he had no
intention of distributing the sacrament to the multitudes. His
attitude was based on the negative power of withholding, and he
took great pride and perverse satisfaction in preventing people

from seeing or buying serious art. Despite his belief that society should support artists by buying their art, Stieglitz's biographies are full of his triumphant refusals to sell it.

Besides the issue of commercialism, O'Keeffe was going through the consideration of other aesthetic problems during this period. In October she wrote Sherwood Anderson, who was a good friend and frequent correspondent at this time: [38]

> I've been thinking of what you say about form . . . I feel that a real living form is the natural result of the individuals effort to create the living thing out of the adventure of his spirit into the unknown . . . and from that experience comes the desire to make the unknown known— By unknown I mean the thing that means so much to the person that he wants to put it down—clarify—something he feels but does not clearly understand . . . Making the unknown known . . . if you stop to think of form as form you are lost.[39]

The duty is to the experience, as Philip Larkin has said. O'Keeffe's position continued to be one of passionate concentration on the experience, with a determined disregard of art theory —simply minding your own business, as Dove had said.

> If I stop to think of what others—authorities—would say of my form I'd not be able to do anything . . . I seem to feel incensed that you don't treat the thing that is yourself as the simple fact of yourself—there it is—just you—no great excitement about it—a very simple fact—the only thing you have—keep it as clear as you can.[40]

That spring, Stieglitz was becoming interested once again in exhibitions. While N. E. Montross was sick, Alfred was asked to take the dealer's place in his gallery during a Marin exhibition. He sold a picture for an excellent price (higher than the one Montross was asking). The incident reassured him of his capability and revived his interest in a gallery of his own. He asked Kennerly to reserve room for a large exhibition of works by Stieglitz artists in the following year. He also began to consider taking a permanent exhibition room on the premises of the Anderson Galleries. Domestic circumstances were also changing: Alfred's brother Lee could no longer negotiate the stairs in his house on

Sixty-fifth Street. He sold the building, and Alfred and Georgia had to find new quarters by June.

On their arrival at the lake, Georgia wrote Anderson a long letter, which vibrated with enthusiasm.

> Stieglitz and I are alone again on the hill at the lake—we are more alone than before because old Fred who has been on the place for 38 years—died this winter— For the first time we are really masters of the house and so far we have managed wonderfully— Stieglitz of course was much worried that we couldn't get along— I didn't worry at all because I knew we would get along— As a matter of fact— I couldn't for the life of me see why we shouldn't get along —if we couldn't manage one way we could another. Of course I haven't always had Fred—and Stieglitz has— That is probably why he worried and I didn't.[41]

In this letter Georgia adopts a teasing, affectionate tone toward Stieglitz, one that demonstrated her tolerant acceptance of his foibles as well as her very real devotion to him. The spring had been hard for both of them:

> It seems we have been moving all winter— Stieglitz has to do everything in his mind so many times before he does it in reality that it keeps the process of anything like moving going on for a long time. It really isn't the moving with him. It is the many things within himself that he focuses on the idea of moving— He has to go over them again and again— trying to understand what it is that he is and why—in relation to the world—and what the world is and where it is all going to and what is it all about—and the poor little thing is looking for a place in it—and doesn't see any place where he thinks he fits.[42]

But Georgia was so elated at being alone in the country that Alfred's plight could not dampen her spirits. One of her great gifts was her sense of delighted amusement with life:

> Well—I don't know whether I fit or not but I do know that if I don't cook the dinner we won't have any and when it is eaten if I don't wash the dishes— Well Stieglitz always tries but he is so absent-minded he throws the left-over scraps

. . . back into the bread box and wipes the dishes and puts them back into the draining rack as though they were still wet . . . I have to laugh— He tries to help because he has a theory about doing things for yourself— But it isn't really worth putting his mind on it— He just doesn't know how— His material for working hasn't come yet and he walks around like a forlorn lost creature— I am very busy— because I know things have to be done—just the ordinary drudgery that goes with living— I've never had any theories about liking to do it—or wanting to do it—or that I ought to do it—but when it's here to be done and no one else to do it—I can do it—and I don't mind.[43]

Georgia's approach was cheerful, sensible, and practical: "if we couldn't manage one way we would another." It was antithetical to that of Alfred, who worried about everything: he had bottled water sent from New York City to the lake one summer as a precaution during a drought.

Georgia was elated that the kitchen was now hers: Ella Varnum, the cook (whom she called "the Dragon"), had left when her husband died. And besides the solitude, there was the countryside: Georgia's real and heartfelt response to the landscape was evident. She took great delight in the garden, which was now entirely her province: "Georgia is excited because her potatoes & Co. are up and doing," Alfred wrote Beck.[44]

And Georgia wrote Anderson:

I rather like it after that nightmare of New York. Here at least the lilacs are in full bloom—and the grass is tall and soft and wavy everywhere—the mountains are a fine green . . . and best of all—we are alone.[45]

It was in this year, 1924, that O'Keeffe painted the brilliant "Corn" series. These powerful images of young sweet-corn plants present the subject as seen from directly overhead, providing a plummeting, vertiginous view of the circling layers of the central shaft below. The disorienting angle, the strong abstract patterns of dark and light, the bold use of contrasting greens, and the recurrent biomorphic, uncurling, frondlike forms combine to make a dramatic and exhilarating statement.

The solitude threw Georgia and Alfred's relationship into sharp relief.

Stieglitz misses people—but I don't think he even cares
much about that . . . He is a forlorn little soul— I do what I
can—but I have to keep some of myself or I wouldn't have
anything left to give. Giving is difficult—almost to[o]
difficult. Do not think from what I write that I am blue— I
am having one of my few great days of the year when there
is no one around and I can really breathe . . . Being alone is
good for Stieglitz too . . . He reads a little . . . and pokes
around—a funny little soft grey creature.[46]

Georgia's tenderness toward Alfred takes on a poignant
note: he was sixty years old that year, and she thirty-seven. The
contrast was becoming more pronounced, and Georgia's feelings
began to take on a maternal tone. In spite of his dominating ways,
she saw Alfred as often helpless and dependent; that spring he
had suffered a devastating kidney attack, which immobilized him
for several weeks.

With remarkable insight, Georgia recognized the real threat
to her autonomy implied by Alfred's dependence: "I have to keep
some of myself or I wouldn't have anything left to give. Giving is
difficult—almost to[o] difficult."

Despite its early promise of solitude, Lake George that sum-
mer was again filled with a stream of visitors. The Davidsons and
their older daughter, Peggy, Paul Rosenfeld, Carl Zigrosser (an
art dealer), Arnold Ronnebeck (a German artist and writer), Ida
O'Keeffe, Beck, Katharine Rhoades, and, at the end of the sum-
mer, Lee and Lizzie Stieglitz. The idea of selling the Hill had
engendered an alternative plan of running it as a profitable farm,
with the Davidsons in year-round residence. Lee and Lizzie came
to investigate, and Lee found it so agreeable that he decided to
make Lake George his summer headquarters—causing the Da-
vidsons to abandon all thought of living there. All this signaled
an upsurge of interest in the place by the Stieglitz family mem-
bers, which sent Georgia into despair. She suggested more than
once to Stieglitz that they build their own house—a plan he re-
fused to consider. In spite of his reluctance to travel, Stieglitz was
domestically far more footloose than Georgia was. He was per-
fectly content with temporary, makeshift, and communal ar-
rangements, for living and for working. This approach was
anathema to Georgia, who wanted a precise definition of the
space that was hers and absolute control over it. It was, as much

as anything, a question of responsibility: Alfred was happy to let others take responsibility for his domestic circumstances, since he saw himself, personally, as helpless. It was a blessing to be under someone else's roof. For Georgia, who took serious and complete responsibility for her own life, it was a waste of energy having other people around.

Physically, Georgia began to demonstrate signs of distress, and Alfred's letters refer to a recurrent malaise. "Georgia is feeling somewhat better," he wrote in July. "She was very miserable all last week . . . I feel so damned useless— I do hope she is finally mending."[47]

Georgia, Beck, and Katharine Rhoades were all at Lake George in August, demonstrating Alfred's flair for dangerous emotional scenarios as well as his ingenuous conviction that all the ladies he loved would love each other.

Alfred had continued with his nude series of Beck, testing her ability to stay in cold Lake George. One of the finished pictures showed Beck's round breasts, seen from above, barely submerged in the water—a print which Alfred called the "Water Lilies."[48]

Alfred found the atmosphere somewhat strained. "It has been a very difficult week," he wrote Elizabeth. "But there has been some clearing up . . . Nothing has been said except finally between G. and myself . . . I & my women folk seem to be on a working basis."[49] The tension was considerable. Whatever was said finally between Georgia and Alfred, her unhappiness was evident to all. Later he wrote: "Beckalina, mia carissima . . . You really had nothing to do with the, let's call it unrest—inner—of G.—as I see it. But we won't go into that. You have too much sense—there is today—& tomorrow—& we—you & I—& we & others—work & jobs,"[50] he finished obscurely, suggesting his own interconnecting web of obligations, which ultimately prevented the affair (of whatever sort) with Beck. What had occurred between them was over. Beck was pregnant when he wrote that letter (she later miscarried), which may have triggered a change in their relationship. In any case, Stieglitz's tone toward Beck becomes increasingly paternal, tender in a nostalgic and sentimental way.

Georgia's visible distress that August demonstrated her increasing difficulty in balancing her own needs against those of Stieglitz. Her suppressed anguish was revealed through unex-

pected comments: "I wish you could see the place here—there is something so perfect about the mountains and the lake and the trees— Sometimes I just want to tear it all to pieces—it seems so perfect." [51]

Alfred's demands on Georgia were constant and twofold, directed at her both as artist and as wife (though they were not yet married). He valued the concept of Georgia's independence, and at the start of their relationship he had reveled in it. "It was great to have you see O'Keeffe lecturing me," he had written Elizabeth in 1918. [52] His exhilaration at O'Keeffe's forcefulness was real, but he had a low tolerance for real disagreement. Georgia commented on this:

> [His hearers] were often speechless. If they crossed him in any way, his power to destroy was as great as his power to build . . . I have experienced both and survived, but I think I only crossed him when I had to—to survive. [53]

Alfred had always gotten his own way; his need to win was always greater than anyone else's. "He was the leader or he didn't play. It was his game and we all played along or left the game." [54] His father's temper and benevolent despotism hung before Alfred like a guiding star. He believed his motives were altruistic and his actions therefore incontrovertible. His conviction brooked no opposition, and as Georgia observed, he "was the sort of person who could be destroyed completely if you disagreed with him." [55]

On a personal, domestic level, there was another side to the issue. Besides his ferociousness, there was Alfred's physical frailty, his evident dependence, and his great tenderness—all of which made it difficult for O'Keeffe to resist him. His loving solicitude toward her was manifest. He wrote anxiously of her attitude and her feelings, her illnesses and her mental condition. Beck, intending a visit, received a suggestion that she stay in a nearby inn, The Pines, instead of at the Hill. "I don't want Georgia to be in the kitchen more than an hour a day. I feel that is sufficient for meals," he announced. [56] This was characteristic of Alfred, demonstrating a very real concern as well as a tenuous grasp of culinary realities: one hour a day is hardly enough to prepare, cook, and clean up after three meals, even if only for the two of them.

For Georgia, there was no level on which she could resist

Alfred without accepting the role of heartless wretch. Direct confrontation would be considered unwomanly, so that even if Georgia could withstand the violence of Alfred's response, an attempt to challenge him would be accompanied by a feeling of defeat. She would "fail" as a woman, through her hostile and combative behavior. Moreover, giving her own needs precedence over his was even more unwomanly behavior and would contribute further to a feeling of failure. The conflict was a diabolical one, for whether Georgia won or lost as a contestant, she lost as a woman.

In spite of these somber undercurrents, there was a vital, loving bond that connected the two; they were each other's source of happiness and creative productivity, and were deeply aware of this. "I feel like a little plant that he has watered and weeded and dug around," Georgia wrote a friend.[57] Certainly O'Keeffe's paintings from these years—the serene and radiant flowers, fruits, and plants—demonstrate a crucial aspect of her relationship with Stieglitz: a sense of vivid, overflowing mutual tenderness.

• • •

IN OCTOBER, Ida O'Keeffe returned. Again, her presence was a delight to both Georgia and Alfred. "The days rush by like mad," Alfred wrote Elizabeth, "there is harmony . . . And much laughter and rare good humor."[58]

As always, when a young woman appealed to him, Alfred struck up a flirtation. The one with Ida was not serious, but it was energetic and full of suggestive behavior. Alfred called himself the "Old Crow Feather" and sent Ida a sleek example of one in a letter (it is still in the letter at the Beinecke Library). He nicknamed Ida "Red Apple." His letters to her are full of references to kisses, slaps, giggles, and teasing innuendo. He mentions Ida's "Soft Spots" and her "Black Ferns" and the vices and virtues concealed by her nightgown. One night he tiptoed in to peek at her on the sleeping porch, a scene that he described voluptuously in a letter to her. He wanted to photograph her naked back, and in case Ida had missed the sexual symbolism of "Crow Feather" and "Red Apple," Alfred took a photograph of a gleaming and luscious apple, a stiff black crow's feather sunk deep into its core.

Ida responded to all this with utter irreverence. She made fun of Alfred's innuendos and flatly refused to pose in the nude.

Ida read his palm one night and announced that Alfred was an incurable flirt and a terrible fraud. Far from taking a romantic interest in Alfred, she was involved with two other men, one of whom was Paul Rosenfeld. Clearly Ida was not a sexual competitor but an ally of Georgia's. Georgia observed the antics of Ida and Alfred with amusement and pleasure. She described Alfred meeting Ida's train: Ida "told me laughing that he jumped around like a little dog wanting to play— They have great times." [59]

Ida represented a tangible link to the comforting reality of Georgia's own family and her childhood. The younger sister maintained a steady correspondence with Aunt Ollie and Aunt Lola, and she sent snippets of homely family gossip to Georgia and Alfred: "[the aunts] had been busy picking fruit, making jelly and preserves . . . Alexis is contemplating matrimony. The aunts approve of the girl." [60] Ida planned a trip to Havana to visit the "Cuba relations," Francis and his wife, who had lost a baby in April. [61] In New York, there was "Sickness in the Young family . . . Eleanor Jane had her adenoids removed . . . Anita had an eye tooth extracted . . . She has her old spell on for trimming up her family." [62] The stream of quiet domestic news was a comforting counterbalance to the febrile intensity of Georgia's world.

In early June of 1924, Alfred had been granted an interlocutory divorce decree, and his divorce became final in September. Alfred wanted to marry, hoping that this would legitimize his situation in Kitty's eyes.

There were other considerations: though Alfred claimed to enjoy the bohemian liaison, his inclinations were more decorous than he liked to admit. By his own admission, his first marriage had taken place because of public opinion. Legal questions of taxes and inheritance played a part; and there was the unarguable fact that he and Georgia loved each other.

For Georgia marriage had little appeal. Certainly Kitty was not the focus of desperation and anguish for her that she was for Alfred. Financial considerations were unimportant to her. "I've always been able to earn enough money to live on," she said. [63] Georgia's financial situation was closely entwined with Alfred's in any case, as long as he represented her work. The marriage would mean a lifelong connection to the large Stieglitz family, which had proved so threatening and difficult for her. And though she would have to accept the responsibilities of kinship, she would reap none of the maternal rewards of marriage: on this

Alfred was still adamant. To Georgia marriage represented chiefly the diminishment, real or implied, of her independence.

Georgia took a resolute stand on one issue: she refused to change her name. She was now thirty-seven years old and had been exhibiting professionally in New York since 1916 as Georgia O'Keeffe. To change now to Mrs. Stieglitz would be a symbolic regression and a denial of her professional independence. And as O'Brien points out in *Willa Cather*, the connection

> between naming and the search for identity is particularly strong in a patriarchal society. Women's inability to trace a matrilineal inheritance through their last names signifies their impotence to name, or define, the self. In controlling her own name, then, Cather was appropriating the traditionally male power of self-definition.[64]

In Georgia's case, her maternal heritage was represented by her given name, her paternal by her surname: she was the product of the two, and her name was crucial to her identity. The issue was complicated by the fact that Stieglitz was already a famous name in the world of art, and her adoption of Alfred's name would be tantamount to admission of professional collaboration, or the superimposition of his aesthetic vision over hers. "I had a hard time hanging onto it," O'Keeffe said later, "but I wasn't going to give it up. Why should I take on someone else's famous name?"[65]

Four months after the divorce decree was finalized, Alfred and Georgia were married. It was not a sentimental occasion: Georgia wrote to Catherine matter-of-factly that they were marrying because of Kitty. Years later, asked by an interviewer about the marriage, she answered, "What does it matter? I know I didn't want to."

There were no ceremonial preliminaries. In fact, on the evening before the wedding, Ida took Alfred to a musical called *High Stakes*, where he fell asleep. The next day, December 11, Alfred and Georgia went out to John Marin's house in Cliffside Park, New Jersey. With Marin and George Herbert Engelhard as witnesses, the two were married before a justice of the peace. There was no reception and no festivities; the couple went directly back to Manhattan. Marin drove them to the ferry, and on the way he turned to speak to them in the back seat. He ran into a grocery wagon, skidded across the street, and ended up nosed into a

telephone pole. The car was moving slowly, and no one was hurt. It was hardly an auspicious beginning, however, and afterward Georgia remarked enigmatically that she felt as though she had lost a limb. It was impossible to tell whether she referred to the accident or her wedding.

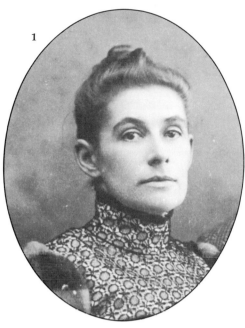

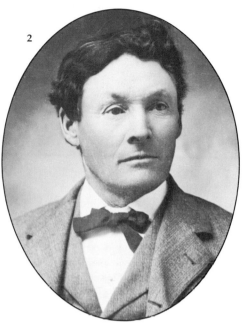

1. Ida Totto O'Keeffe, 1898.

2. Francis Calyxtus O'Keeffe.

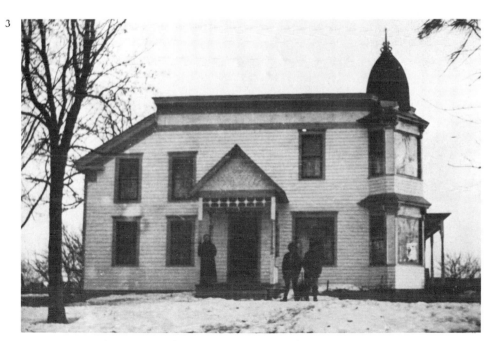

3. The eccentric farmhouse built by Frank O'Keeffe, Sun Prairie.

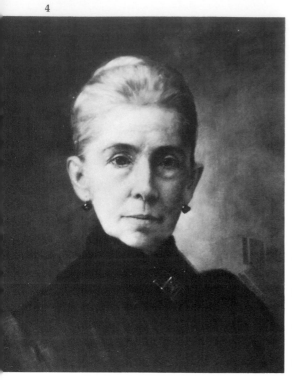

4. Isabella Wyckoff Totto, Georgia's grandmother.

5. "My Auntie" (Eliza Jane Wyckoff Varney, Georgia's great-aunt) by Georgia O'Keeffe, ca. 1905.

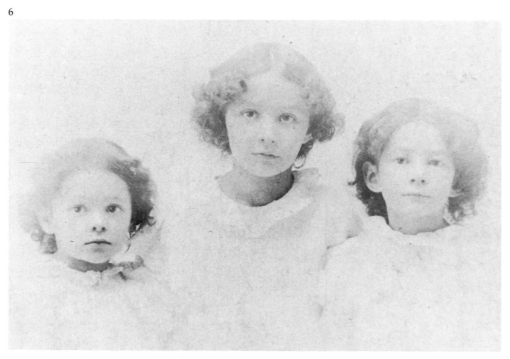

6. Ida, Georgia, and Anita, ca. 1893.

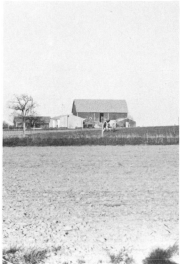

7. The main street of Sun Prairie at the turn of the century.

8. The O'Keeffe barn, from across its fields.

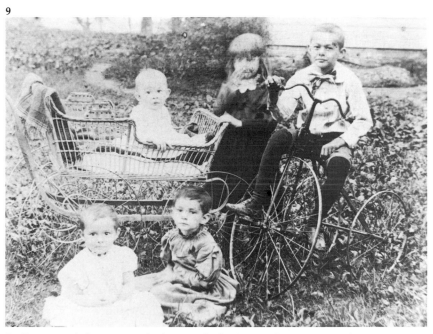

9. From top left, counterclockwise: Catherine in the carriage, Ida and Anita on the ground, Francis, Jr., on a tricycle, and Georgia in motion—"probably giving orders," explained Catherine.

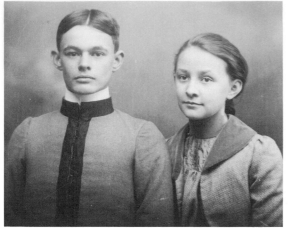

10. Francis, Jr., and Georgia, while Francis was attending the military academy, ca. 1901.

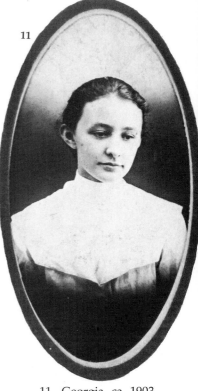

11. Georgia, ca. 1903.

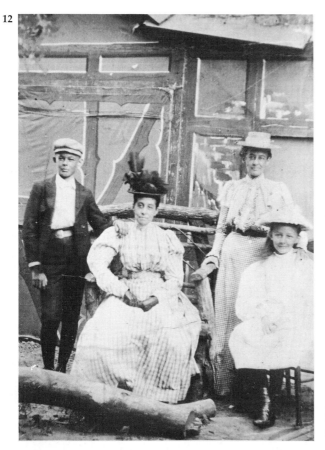

12. A holiday outing: Francis, Jr., Aunt Ollie and Aunt Lola Totto, and Georgia.

13. ". . . the south would be so warm and comfortable . . ." Wheatlands, the spacious homestead in Williamsburg, Virginia.

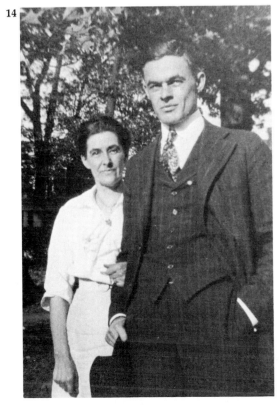

14. Ida and her favorite child, Francis, Jr.

15. Georgia and a young man, in Jamestown, Virginia, ca. 1910.

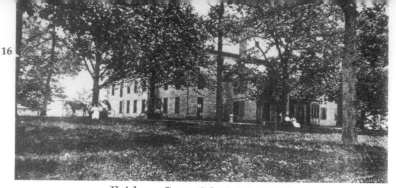

16

Friday, June 2d, 8:00, P. M.

PROGRAM.

Exhibition of Physical Training.

Wands. Dumb Bells. Indian Clubs. Fourth Division
Emerson College System.
Junior and Senior Students Physical Culture

Piano. Rondo in E Flat Major. Chopin.
Miss Reba Turner.

Dramatic As You Like It. Shakespeare.
17 Scene, Oliver's house. Duke Frederick's court. The Forest of Arden.

Monday, June 5th, 10:00, A. M.

Class Day.

Prayer.

Address by President of Class of 1905. Miss Christine McRae.

Class History, Miss Lucile Foster.

Class Prophesy, Miss Georgia Totto O'Keeffe.

Class Poem, Miss Earnestine Frank.

Class Will, Miss Susan Soaper Young.

Planting of Tree.

Bonfire.

16. Chatham Episcopal Academy in the year of Georgia's graduation, 1905.

17. Commencement festivities, Chatham Episcopal Academy, 1905. Georgia had no speaking part, but took part; she is at far right, holding a child's hand and grinning.

18

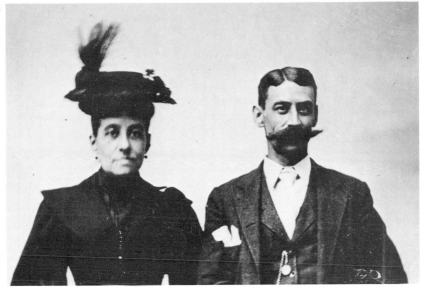

18. The indomitable Aunt Ollie and her brother Uncle Charly Totto, with whom Georgia stayed in Chicago while studying at the Art Institute in 1905–1906.

20

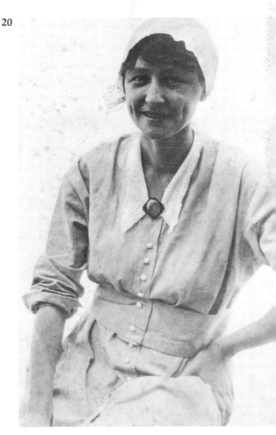

19

19. The narrow, cramped house in Charlottesville; the South no longer so warm and comfortable.

20. Georgia, ca. 1912.

21. William Merritt Chase, the brilliant stylist—Georgia's teacher at the Art Students' League in New York, 1907–1908.

22. Arthur Wesley Dow, who taught at Teachers College. Georgia found his approach to art liberating, though she found him in person too mild; she called him ''Pa'' Dow and warned against eating too many sugar plums.

23

23. Anita Pollitzer, Georgia's lively and enthusiastic classmate at Columbia Teachers College, New York.

24

24. *Lady with Red Hair*, by Georgia O'Keeffe. Possibly a portrait of Dorothy True, who was the third member of Georgia's triumvirate of friends at Teachers College in 1914–1915.

25

26

25. "The Little Galleries of the Photo-Secession," on the top floor of 291 Fifth Avenue, where Alfred Stieglitz began showing avant-garde work to Americans.

26. An exhibition at "291" in 1914, at once stimulating, provoking, and mischievous: works by Picasso and Braque, an African mask and a large, handsome wasps' nest.

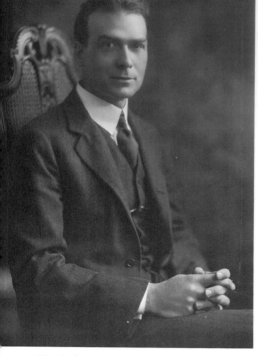

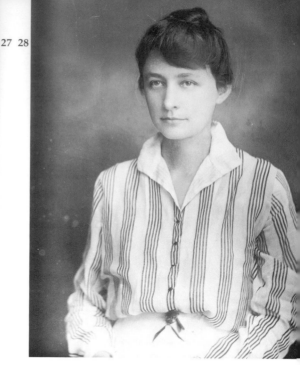

27. Arthur Macmahon, a brilliant young political scientist who taught summer school at the University of Virginia. Anita Pollitzer pronounced him "desperately good-looking."

28. Georgia in the summer of 1915, when she taught at the University of Virginia and met Arthur.

29. "We had a wonderful time . . . the world seems all new to me." Arthur and Georgia in the mountains, Thanksgiving weekend, 1915.

30. Georgia, photographed by
Arthur Macmahon,
Thanksgiving weekend, 1915.

31. "I said something to you
with charcoal," Georgia wrote
to Arthur.

32. R. B. Cousins presiding over the West Texas Normal College, ca. 1917.

33

33. The art room, West Texas Normal College, in 1919. On the walls are the teaching aids that Georgia asked Anita to send her from New York: "some photographs of textiles, Greek pottery and Persian plates," and, at rear, Japanese prints.

34

34. Palo Duro Canyon: small, vertiginous, and vividly colored.

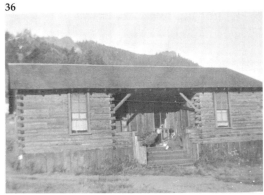

35. Georgia "tramping" in the Colorado mountains, 1917.

36. Georgia on her cabin porch, Estes Park, Colorado, 1917.

37. Paul Strand, by Alfred Stieglitz, ca. 1917: "I . . . fell for him," Georgia wrote Anita.

38. Georgia in Texas: "The openness. The dry landscape. The beauty of that wild world . . ."

39. The young Alfred Stieglitz. "Your drawings . . . would not be so living for me did I not see you in them . . . how I understand them. They are as if I saw a part of myself," he wrote Georgia from New York.

40

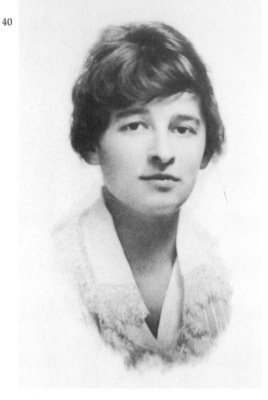

40. Catherine Blanche O'Keeffe, ca. 1913.

41

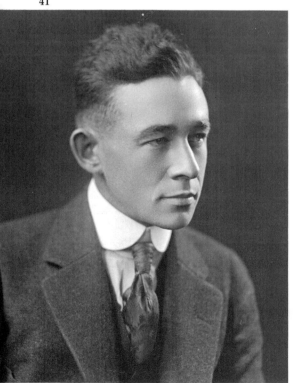

41. Alexis Wyckoff O'Keeffe, Georgia's favorite brother.

42

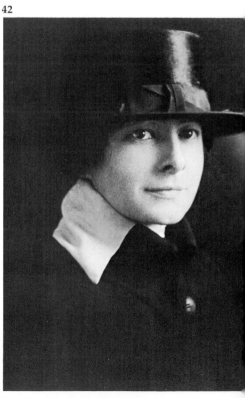

42. Ida Ten Eyck O'Keeffe, ca. 1918.

19

The magnifying glass takes the world as though it were quite new . . . a fresh eye before a new object. The botanist's magnifying glass is youth recaptured. It gives . . . back the enlarging gaze of a child.

—GASTON BACHELARD,
The Poetics of Space

IT WAS PRECISELY "the enlarging gaze of a child," deliberate, thoughtful, and unconventional, that O'Keeffe turned onto the diminutive objects she chose to magnify in her work. Her celebration of flowers was an expression of her feeling for the world around her, a reminder, bold and insistent, of a force besides that of speed and noise and machinery. Here was something else: ravishingly lovely, silent, breathtaking, and surprising.

The earliest recorded enlarged flower images seem to date from around 1919. Two oils of red cannas from that year, 17 by 22 inches, began the series in which O'Keeffe explored this secret inner space. One of these works is geometrical, angular, and symmetrical, the other rounded, tender, and flowing.[1]

In 1922 she painted *Canna Red and Orange*, 20 by 16 inches, and the voluptuous, stylized skunk cabbage, *Cos Cob*, the same size. It was in 1924 that the works became significantly larger, and in September of that year Alfred mentions "rare large can-

vases."[2] These were 48 by 30 inches, and in 1925 the dramatically enlarged works created a stir on exhibition.

Like many incidents in O'Keeffe's life, the origins of the enlarged flowers are not obscure but rather overdocumented. If Alfred's reference to the "rare large canvases" marks their first appearance, Georgia began to paint the enlarged flowers when Ida was at Lake George, filling the house with wildflowers.[3]

By O'Keeffe's account, however, the inspiration for the large paintings began with two things: a small still life by Fantin-Latour, and the mood of speed and technological advance then current in New York. It was the dynamic tension between the two—the quiet, yielding, fragile beauty of the flower, and the massive, rapid, mechanistic current—that created the impulse.

> That was in the 20s, and everything was going so fast.
> Nobody had time to reflect . . . There was a cup and saucer,
> a spoon and a flower. Well, the flower was perfectly
> beautiful. It was exquisite, but it was so small you really
> could not appreciate it for itself. So then and there I decided
> to paint that flower in all its beauty. If I could paint that
> flower in a huge scale, then you could not ignore its
> beauty.[4]

The Fantin-Latour flower, small, subtle, and exquisite, was the product of an earlier time and a quieter sensibility. "I realized that were I to paint the same flowers so small, no one would look at them because I was unknown. So I thought I'll make them big like the huge buildings going up. People will be startled—they'll *have* to look at them—and they did."[5]

The forces of speed and technology produced diametrically opposed aesthetic responses. The Italian futurists (whose art was based on a fascistic and misogynistic creed) tried to interpret the forces of technology. Their work was geometric, full of sharp angles, hard surfaces, great distances, and a sense of explosive violence. In contrast, O'Keeffe's work, a counterresponse to technology, was soft, voluptuous, and intimate. Full of rapturous colors and yielding surfaces, it furnishes a sense of astonishing discovery: the heart of the flower lies as a dark, mysterious core at the charged center of these paintings. Though the work is explicitly feminine, it is convincingly and triumphantly powerful, a combination that had not before existed.

The great flowers echo O'Keeffe's childhood fascination with

the miniature world of the dollhouse. It was there that she had learned of the magical transformation that occurred with a shift of focus. "When you take a flower in your hand and really look at it, it's your world for the moment. I wanted to give that world to someone else."[6] Size confers importance, and the implications of this magnitude were startling: the voluptuous amplitude of the flowers proclaimed the enormous significance that the modest objects held for O'Keeffe. (She gave flowers professional precedence over people, and while she was painting a flower she honored its existence, refusing to see people until the bloom had faded.)

Besides the celebration of color and texture, the flower paintings demonstrate a sophisticated manipulation of form and space. The unexpected size of the flower suggests an altered world, an unexplored universe in which the laws of physics are unpredictable. This adventurous approach would continue to manifest itself, in other ways, in O'Keeffe's work. Her preference for ambiguous backgrounds, for example, composed of flat fields of color and undifferentiated distance, would infuse many of her paintings with an element of surrealism, a deliberately unpredictable and undeterminable world governed by a serene internal logic that was hers alone.

Her own understanding of these subtle manipulations is demonstrated in a letter she wrote some years later, in which she gently chided viewers for their insistence on conventional approaches to scale and distance. In earlier still-life paintings, a flower was usually shown smaller than it actually was, to suggest a reasonable distance from the viewer. That distance, however, is only a matter of form: it is no more logical to see a flower from five feet than from six inches. As O'Keeffe points out to a critic who described a flower as "enlarged": "I want to call your attention to the fact that the Jimson weed . . . is not an enlarged flower." She had painted it actual size on the canvas, which is precisely what the viewer does not expect. "I wonder," she goes on quite sensibly, "why you never mind that I paint the mountains small—as an idea I would think it would be quite as reasonable."[7]

As before, Stieglitz was unsettled by the new work. "Stieglitz came in while I was painting and he laughed. 'I wonder what you think you're going to do with that,' he said. 'Oh, I'm just painting it,' I said."[8] Stieglitz's anxiety surfaced each time

O'Keeffe struck out in a different direction: a gentle deprecation was the rule, coupled with anxious caution. His attitude toward Georgia's work was in fact salubrious: since O'Keeffe could not rely on Stieglitz for psychological support, she had to achieve each new step on her own, through a sense of inner conviction.

During the exhibition of the large flowers, Stieglitz found more and more occasion to bring out his own photographs and to discuss his relationship with O'Keeffe: their aesthetic connection, their emotional background. He was not overtly jealous—Stieglitz truly supported her work—but still, there was something disturbing to Alfred about the huge beautiful shapes, the vivid colors, the yielding contours, and the excited crowds of people coming to view them.

O'Keeffe's flower images inevitably suggest comparisons with those radical compositions of Paul Strand's—bold, cropped close-ups—that O'Keeffe had first seen in 1917. Certainly Strand's imaginative approach had made a strong impression on her. "I believe Ive been looking at things and seeing them as I thought you might photograph them," she wrote him in 1917. "Isn't that funny—making Strand photographs for myself in my head."[9] Though it was seven years later that she began her huge and dazzling canvases, O'Keeffe had been painting smaller, cropped close-ups of flowers since 1919—just two years after she was "making Strand photographs" for herself in her head.

Strand's influence seems to have been unconscious, or at least unacknowledged: "I don't think photography had a thing to do with it," she stated firmly.[10] It was characteristic of O'Keeffe to deny or minimize influences from other sources. "School and things that painters have taught me even keep me from painting as I want to," she wrote.[11] At great cost, she had freed herself from the thrall of convention and teachers, and it was only natural that she would guard her victory closely.

• • •

IRONICALLY, O'KEEFFE'S choice of flowers as subject matter resulted in her entanglement in both a patriarchal myth of the nineteenth century and the flamboyant Freudian associations of the twentieth. Neither connection was intentional; O'Keeffe's choice of subject matter was entirely personal.

In the nineteenth century, women's close symbolic association with flowers was used in paintings as a means of locating

the female role in the domestic sphere rather than in the world of intellect and commerce. Flowers represented an innocent soul, pure and decorative, that aptly corresponded to the feminine ideal. This relationship was depicted in abundance by nineteenth-century painting. Jules Michelet, a French writer, announced that a young girl's education could be accomplished merely through her studying a flower, which embodied a domestic purity and beauty: "For woman a flower is a whole, whole world, pure, innocent, peace-making . . . they speak so low, these flowers, that we can hardly hear them. They are the earth's silent children." [12]

Paradoxically, in the newly Freudianized New York world of the twenties, flowers became the antithesis of this ideal of innocence; they were now seen to represent sensual and erotic feelings. In bohemian circles, the radical theories of Freud were welcomed in a spirit of boisterous permissiveness. Attempts at amateur psychoanalysis generated parlor games of free association and dream interpretation, in which inner meanings were deciphered according to the "Freudian formula." This sort of response was widespread and popular. It was embraced particularly by people whose sexual lives lay outside conventional norms, who felt liberated by the idea that sexual urges were the unruly powers that underlay the solemn struts and decorous arches of society.

Edmund Wilson, for example, whose lucid commentary was so influential in explaining the twentieth century to itself, carried on an active subterranean sexual life with prostitutes and was also an avid shoe fetishist. His own enthusiastic response to Freud's thesis of sexuality is evident in the following extract from his diary. It was written in the summer of 1924, before he could have seen one of O'Keeffe's giant flowers:

> The auratum lilies [were] having orgasms in the vase on the mantelpiece—straining back their great gilded red-flecked flesh-like white petals while their pistils emitted semen and the stamens smeared it with their brick-dust pollen. Inside the petals were stiffening white fringes like the entrance to a vagina. All the time they gave off a heavy, sweet odor. [13]

The sexuality of O'Keeffe's flowers was at once declared as fact by critics and public alike, but as Wilson's passage demonstrates, much of the eros was in the eye of the beholder. If the

actual flowers themselves, sitting quietly on the mantelpiece, were perceived by critics as pornographic, then O'Keeffe's paintings had very little chance of escaping that characterization, no matter what her intentions were. The accusation of sexuality was one that offended and surprised O'Keeffe. She relentlessly denied it, but her denials led her neatly into the Freudian trap. In this, the accused is always guilty as charged, and denial means only the refusal to acknowledge the guilt. The hotter and more insistent the denial, the more ineluctable the charge. There was nothing O'Keeffe could say that would effectively silence the suggestive questions or prevent the flat assertions as to her own motivation.

Sexual connotations would continue to be ascribed to the work, but some of the viewers recognized their own participation in the process. As Lewis Mumford, another thoughtful and intelligent critic, wrote:

> Yesterday O'Keeffe's exhibition opened . . . the show is strong: one long, loud blast of sex, sex in youth, sex in adolescence, sex in maturity, sex as gaudy as "Ten Nights in a Whorehouse," and sex as pure as the vigils of the vestal virgins, sex bulging, sex tumescent, sex deflated. After this description you'd better not visit the show: inevitably you'll be a little disappointed. For perhaps only half the sex is on the walls; the rest is probably in me.[14]

In view of both Wilson's and Mumford's self-supplied erotic vision, O'Keeffe's denial carries both weight and dignity: " . . . when you took time to really notice my flower you hung all your own associations with flowers on my flower, and you write about my flower as if I think and see what you think and see of the flower—and I don't."[15]

The vulval imagery in O'Keeffe's flowers has been much discussed, but in fact it is something for which botany should take the responsibility. Flowers do bear structural similarities to human reproductive organs, and this has more to do with the process of reproduction, both horticultural and human, than with the suppressed or expressed sexuality of an artist who paints the image of a flower.

O'Keeffe's flowers were images drawn from a female perspective, which made them both new and suspect. Phallic imagery is so much a part of European art that it has become

invisible. That these images—the battle and hunting scenes in which men hold spears, swords, lances, pennants, and flags; the portraits of men holding scepters, pens, and paintbrushes—were not retrospectively barraged with Freudian explication meant merely that they were part of a masculine, patriarchal tradition and therefore were perceived as the norm; it does not mean that the imagery is not phallic.

Similar parallels can be drawn in the abstract art of O'Keeffe's contemporaries. Many of Arthur Dove's works are phallic, most specifically his *Penetration* of 1924. His paintings were not, however, claimed as evidence of rampant sexuality, since they were part of a male-oriented continuum. Then, too, it was hardly a victory for a male critic to discover that a male artist had feelings of sexuality, but a certain prurient element of triumphant accusation accompanied the identification of sexuality in a woman's work. In fact, the claims of the critics have about them a trace of the smutty glee of pornography—the attitude that enlarges, dramatizes, and overexamines sex, which was just what the critics claimed O'Keeffe's paintings were doing.

The sexuality in O'Keeffe's paintings is inextricably related to her integrated view of life. Sexuality was a central force, celebrated but not separated from the rest. O'Keeffe expressed a natural sexuality, one inherent in flowers, landscapes, food, and relationships. It was not prudishness that prompted O'Keeffe's denial of the critics' claims. She felt that to dwell on human sexuality, to isolate it from the other currents that flow through life, would trivialize and vulgarize the current that she tried to express. Years later, when a film interviewer asked her about the vulval character of her flowers, O'Keeffe snapped at her to turn off the microphone: she refused to talk about "such rubbish." [16]

In any event, the controversy demonstrates the infinitely plastic nature of a natural symbol. It was society itself that determined the radical change in perception, transforming flowers from a chaste to an erotic symbol. O'Keeffe intended her flowers to represent neither explicitly. Flowers did in fact exist in nature as O'Keeffe painted them: lush, enfolding, layered, and secretly chambered. The viewer decides for himself how to see them: for Michelet they were emanations of innocence; for Wilson, pure sexuality.

The large flowers appeared first in the "Seven Americans" show that Stieglitz put on at the Anderson Galleries in March

1925. The seven artists whose work was shown were Marin, Dove, Demuth, Hartley, O'Keeffe, Stieglitz, and Strand, and the show opened to mixed reviews. O'Keeffe and Stieglitz were the stars, and O'Keeffe "outblazes the other painters," according to Edmund Wilson. He found her new work "charged by her personal current," full of color and brilliance, statements of a remarkable spirit, embracing, courageous, and bountiful.[17]

The "Seven Americans" show placed O'Keeffe's work next to that of her peers for the first time since 1916. She was in more exalted company now: that of the best American moderns. It was an appropriate moment for this conjunction, since, regardless of her claims, she had been experimenting with some of the forms and concerns that preoccupied the Stieglitz circle.

O'Keeffe preferred to minimize the aesthetic crosscurrents that operated between herself and Stieglitz, though she readily admitted that a spirit of amiable competition reigned. The two of them competed at times for subjects, and once, she acknowledged, he beat her to an image—a door at Lake George. Certainly the severely classical lines of the black-and-white doorway appear both in a Stieglitz photograph and in an elegant O'Keeffe painting. There are other pictures she does not mention, however, which demonstrate just as close a sympathy.

Stieglitz's *Dying Chestnut Tree* of 1919 shows a stark trunk branching into a trifurcated silhouette that dominates the sky, in deep relief against the clouds; the mountains curve gently below. O'Keeffe's *Autumn Trees—the Chestnut Red* of 1924 takes a nearly identical form—possibly the same tree—and sets it similarly, dark against the pale sky. The two images are virtually identical, only her curving mountain horizon is higher. The powerful trinity of the upright form, which obliterates most of the pallid infinity behind it, prefigures the cross series O'Keeffe would do later —but Stieglitz's photograph, precisely and specifically, prefigures her tree.

Another interaction is revealed in O'Keeffe's *A Celebration* of 1924. This makes specific reference to Stieglitz's work: the image is a shifting mass of cloud formations against the sky. The picture demonstrates the great differences between their styles: in Stieglitz's hands, clouds are evanescent, subtle, and fragile. O'Keeffe's strength lies in the serene solidity she imparted to her forms, and the same subject, translated into oil paint, becomes heavy and lumpish.

Besides her experiments with Stieglitz's formal structure and his subject matter, O'Keeffe did a series of buildings that reveal a sympathy for John Marin's work. The "Flagpole" paintings, with their casual laws of physics, their illogical perspectives, and the whimsical, energetic atmosphere of wind and sky, suggest a familiarity with the fragmented, idiosyncratic cubist approach of Marin.

Regardless of these early experiments, O'Keeffe followed no one, continuing to find her own way. Although influences on her work are discernible, they are ideas that have been deeply assimilated, not superficial similarities of style or technique.

Though O'Keeffe's claim of an aesthetic self-creation was not entirely defensible, she was not the only one who made it. Her originality was widely recognized in the art world. "There is no imitation of Europe here," said Brancusi, looking at her paintings. "It is a force, a liberating free force." [18]

O'Keeffe continued for several years to produce the vivid and rapturous flower paintings, expressive of the tender, lyrical side of her life, the warm and vital aspect of her relationship with Stieglitz. There was, however, in some of her work the suggestion of another element. Since her first summer in Lake George in 1918, O'Keeffe had taken individual trees and leaves as subjects for her paintings. While some of these are peaceful and lyrical in mood, others, such as *Birch and Pine Tree Nos. 1 and 2* of 1925 or *Portrait of a Day—Third Day* of 1924, deliver a message of confinement and anxiety. The imagery in these works—a single white birch tree against an oppressive dark green surround, or one pale leaf against a deep ominous ground—expresses a sense of isolation and anguish.

• • •

IN JUNE 1925, Alfred and Georgia made their way to the Hill at Lake George. Lee and Lizzie had just built a bungalow—Red Top —on the property and were there for the summer. So, for six weeks, were their small granddaughters, Peggy and Sue Davidson.

Sue Davidson Lowe's later memories of Georgia present her as a benignly mysterious figure, but the child's first encounter with O'Keeffe was traumatic. Sue, who was then nearly three years old, made a polite curtsy, held out her hand as she had been told, and said, "How do you do, Aunt Georgia." Georgia's

response was sudden and irrational fury: she slapped the little girl in the face and commanded fiercely, "Don't ever call me 'Aunt.' "[19]

The summers at Lake George were becoming increasingly difficult for Georgia. The Stieglitz family was back in full force. That year, besides Lee and Lizzie, there was Alfred's melodramatic sister Selma, whose emotional storms resulted in daily shouting matches at the table that left the rest of the family in a state of alternating anxiety and exhaustion. The two little Davidson girls, besides being restless and unpredictable, were tangible reminders of the children Georgia would never have.

In addition to the tension engendered in Georgia by the constant presence of other people, she was in physical distress again that summer. She suffered an allergic reaction to a vaccination, and both legs swelled painfully. Alfred's brother Lee, who was a doctor, came majestically down the hill to treat her: he ordered her confined to bed, with her legs bound. The constrictive Victorian treatment was worse than the symptoms, but Georgia managed slowly to recover; it took her nine weeks.

Lunch and dinner were communal meals at the farmhouse. Red Top had no kitchen, and Lizzie had brought her cook, so Georgia was relieved of domestic responsibilities, but the luxury of this was offset by the rigidity of the schedule, and by the banality of the meals themselves. Sue's recollections show that Georgia's response to this was less than tactful.

> I am mesmerized by the routine she had perfected for circumventing the salads ordered by my grandmother, whose . . . menus are depressingly uninteresting. While each of us is served, on a bed of helpless lettuce and coated with a gruel of anemic pink . . . either a blob of tomato aspic or a cluster of avocado and grapefruit wedges, Georgia receives an empty bowl. Into it she tears fresh lettuce and watercress she has gathered from the brook; wonder of wonders, she adds onions and garlic, items strictly prohibited in Stieglitz households; a few deft tossings with oil and vinegar and she is done. Then, in haughty silence, she rises to take her fragrantly polluted creation to the porch overlooking the lake. Often she does not return for dessert.[20]

Lee's wife, Lizzie, enraged Georgia, simply by the meekness of her manner and by her constant humble capitulation to the criticisms heaped upon her by her husband and sisters-in-law. The very presence of such a victimized, self-deprecating wife aroused Georgia's antipathy. Lizzie appeared to have no needs of her own, no wishes, and no pride. Certainly the comparison between the two would threaten to place the mask of monster once again on Georgia's face: for the two women's concepts of the role of "wife" were so antithetical that they could hardly mean the same thing. Either Lizzie failed miserably at the role, or Georgia did.

The Stieglitzes were not the only residents at the Hill that summer: Frances O'Brien, a friend of Georgia's from her student days in New York, visited, as did Jean Toomer, and Paul Rosenfeld was there for the whole summer. Rosenfeld was an amiable presence, quiet at table, though he and Alfred talked tirelessly alone. Rosenfeld had proposed marriage to Ida, who at first turned him down. She then had second thoughts and wrote to Alfred, wistfully wondering where Paul was, and asking Alfred to send her greetings. But Alfred decided to oppose the relationship. He felt that Paul, who was working hard, needed quiet and concentration, not emotional turmoil. Alfred refused to tell Ida where Paul was, and he delivered none of her messages. Ida's hints for an invitation to Lake George were ignored. At the end of the summer, Alfred announced gleefully what he had done. His maneuverings were successful, and the separation put an end to the relationship.

20

*A flower or a shell stands out from the usual disorder that
characterizes most perceptible things. They are privileged
forms that are more intelligible for the eye, even though more
mysterious for the mind, than all the others we see
indistinctly.*

—PAUL VALÉRY,
Les Coquillages

WHEN ALFRED AND GEORGIA moved out of Lee's
house in the spring of 1925, they had taken a studio on East Fifty-
eighth Street. They gave this up that summer, before leaving for
Lake George. They planned to take a suite in the fall in the thirty-
four-story Shelton Hotel, on Lexington Avenue at Forty-eighth
Street. When Georgia inquired at the hotel, where they had
stayed before, she was told that no suites were available. With
the monarch's calm certainty that her command was someone
else's wish, she ignored this response. In November, Alfred and
Georgia moved into the hotel; they would live there ten years.

"I am living very high up in the world this year," Georgia
wrote Catherine, "on the 28th floor— It is very grand looking out
over the city."[1] Suite 3003 (inexplicably on the twenty-eighth
floor) was modest. "We have two rooms here," Georgia wrote.
"The bedroom is tiny— Just room for the beds and a path to the
bathroom and a bureau—but it faces north—east and south so
we have lots of sun and air. The sitting room is large enough for

our purposes—and has a good light so I can work if I want to—faces north and south."[2] The walls were painted pale gray, the furniture covered in off-white, and there were no curtains. It provided the essentials: air, light, and an absence of distractions. With this move Georgia established her priorities and firmly excluded herself from domestic responsibilities. The housekeeping was done by the hotel, and Georgia and Alfred had breakfast and dinner at the cafeteria. This was on the sixteenth floor, and had a terrace and a fireplace. In warm weather, meals were outdoors, overlooking the city, and in the winter people sat before the blazing fire. Entertaining was simple: an extra room was easily obtained, and meals from the cafeteria required no thought or planning. The Shelton provided all the amenities of a household without the responsibilities, "So for the present we are very comfortable as far as living goes," Georgia wrote Ida.[3]

Aesthetically the situation was ideal. The building was the first set-back skyscraper in the city, and it towered over the rest of the buildings, offering expansive vistas in all directions. Though the impersonal technology of a skyscraper seemed antipathetic to Georgia's character, the site offered her the sense of boundless space and distance that she needed. The East River could be seen below, and beyond her windows was the continual drama of the sky—clouds, wind, fog, rain, and sunrise.

As well as moving house, during the fall of 1925 Alfred took on once again the responsibilities of a gallery. In December he opened Room 303 in the Anderson Galleries building. This was officially called the Intimate Gallery; unofficially it was the Room. This, too, was modest: one twelve-by-twenty-foot chamber. The walls were covered in black velvet, which was changed at once. "We have covered the black walls with white unbleached cheesecloth— It seems light and free and the room much larger— We are . . . going to begin having small exhibitions of the men."[4]

The Stieglitz stable was now specified: the Room would handle the works of "Seven Americans: John Marin, Georgia O'Keeffe, Arthur G. Dove, Marsden Hartley, Paul Strand, Alfred Stieglitz and Number Seven"—the unknown quantity. Alfred printed a brochure in which he attempted the difficult task of distinguishing his venture from the infamous concept of a commercial gallery. The Room was "not a business . . . but a Direct Point of Contact between Public and Artist."

For Stieglitz it was crucial to differentiate between "true" and

"commercial" art, between selling paintings and permitting the public to take sustenance from the works: the actual exchange of money was painful for him. One means of making the distinction was to revert to the equation of art and religion, which had been current a decade earlier.

Alfred's sacramental attitude was deliberate and specific. The brochure announced: "Hours of Silence: Mondays, Wednesdays, Fridays, 10–12 AM," during which time an opportunity for "communion" with the pictures was promised. During the first exhibition—John Marin's—Alfred said mysteriously that "Perhaps the pictures were a new Christ, for certainly in America they would be crucified."[5] During the O'Keeffe exhibition a month later, he pointed at one of the paintings and said, "I might say that this is the beginning of a new religion."[6] And Alfred left the Room always unlocked, like a chapel. He believed that an honor system would obtain, and in fact there were no thefts.

The small, light room had only the paintings, a table that held a crystal ball, and a highly charged atmosphere: equal parts sacrament and violence. Stieglitz maintained the flow of vehement, disputative, magical discourse. The writer and critic Herbert Seligmann was so struck by Stieglitz's energy and intensity that he came in daily and began writing down the talk verbatim. His notes were later published, as *Alfred Stieglitz Talking*. Stieglitz was as mystical and baffling as an Oriental sage—a comparison he welcomed. He was philosophically eclectic and took an interest in astrology and numerology. The choice of Suite 3003 at the Shelton had pleased him, since it serendipitously echoed the gallery's number, Room 303.

During the first months after the opening of the Room, Georgia spent much of her time there, sitting quietly, hands folded. She watched people with interest, amusement, and—during her own exhibition—anxiety. "With the excitement my food doesn't like me—for days," she wrote a friend.[7] Her celebrity did not alter her view of herself or her work, and she continued to insist on the real humility she had urged on Sherwood Anderson.

[Someone] said to her that her work was marvellous, he could not find words to express what he felt. "Oh, no," said O'Keeffe. "It's just ordinary. I think each painting very fine just after I've done it. But that wears off. It's just part of my daily life."[8]

Georgia's close involvement with the Room meant a commingling of roles. Her position there was domestic as well as professional: she saw herself as Alfred's wife, partner, and collaborator. During Marin's exhibition, she asked the artist how he had come to produce three particularly good watercolors on the same day.

"What did you have for breakfast that day?" she enquired.

"Why, what has that to do with it?" Marin smiled.

"Well, if you had an intelligent wife, like myself, for example," retorted O'Keeffe, "she'd remember what you had for breakfast that day and give it to you occasionally."[9]

As well as O'Keeffe's good-humored view of her own role, the incident reflects her belief in the importance of physical and mental harmony. Unlike Stieglitz, whose meager breakfast of cocoa and zwieback lasted him until dinner, O'Keeffe believed that the body deserved respect and dignity: a balanced diet, plenty of exercise, and natural foods. This pragmatism was one element that differentiated her from the men—the theoreticians —in the Stieglitz circle.

Now that she was an exhibiting artist and Stieglitz's wife, she was a more threatening figure to the other artists. "At first the men didn't want me around. They couldn't take a woman artist seriously. I would listen to them talk and I thought, my they are dreamy. I felt much more prosaic, but I knew I could paint as well as some of them who were sitting around talking."[10] Georgia's competitive instincts were discreet but active, and she resented the gender prejudice she felt.

Georgia established her own competence in a number of areas. Stieglitz's photographs had shown her to be a beauty, so she was successful in the most traditional female role. On a purely practical level, she helped with the physical drudgery of running the gallery. She carried paintings and hung all the exhibitions. She was, in fact, matchless at hanging paintings, with a flawless eye that all the artists respected. Most important, as a painter she was becoming increasingly formidable: her early watercolors, her bold flowers, and now her paintings of New York, demonstrated her growing strength and importance.

During her exhibition, in February, O'Keeffe went to Washington to address the National Women's Party, at Anita Pollitz-

er's invitation. From the time of her first association with Anita, O'Keeffe had been aware and supportive of feminist issues, and her letters to Anita made clear a thorough understanding of them. The feminist periodical *The Forerunner*, to which she subscribed in 1915, was highly radical in its outlook and examined the sexist nature of a patriarchal society in a great variety of its manifestations. O'Keeffe took the cause of feminism seriously, but she was neither angry nor confrontational; her form of activism was largely private. She recognized an innate difference between the genders and a difference between the male and the female experience. The year before, she had written to Mabel Dodge Luhan, a sometime writer on the arts:

> Last summer when I read what you wrote about Katherine Cornell I told Stieglitz that I wished you had seen my work —that I thought you could write something about me that the men cant— What I want written I do not know— I have no definite idea of what it should be—but a woman who has lived many things and who sees lines and colors as an expression of living—might say something that a man cant — I feel that there is something unexplored about woman that only a woman can explore— Men have done all they can do about it. [11]

O'Keeffe's speech in Washington was well received: lucidly and firmly, she spoke of the need for women to become independent and to take responsibility for themselves and their lives. While Georgia was delivering this message of self-reliance, Alfred, in New York, was struck by his own emotional dependency.

Stieglitz saw Georgia off at Pennsylvania Station, and the unaccustomed situation—her departure and his solitude—touched off feelings of fragility and loss.

> He had then walked through the streets of New York alone, as he had not done in years, and the streets and the city became unreal, and disappeared, and everything took on the aspect of O'Keeffe's whiteness. He had felt her as white, himself gray by comparison, and no one could ever be for him the white thing O'Keeffe was. That was what was in her work in Room 303 and O'Keeffe's absence intensified that feeling of her whiteness. [12]

Alfred was reminded of the feelings of humility and awe he had experienced in the beginning of their relationship: "I feel she is much finer than I am—straighter too," he had written to Elizabeth.[13] And to Paul Strand: "She is the Spirit of 291—Not I— That's something I never told you before."[14]

O'Keeffe's first show at the Room, February 11–March 11, 1926, was composed of fifty recent paintings, among them *New York with Moon*, her first urban landscape. She had approached the new subject slowly, producing this sole painting of the city during her first year in the Shelton. There had been "Things that I thought I wanted to paint but now that I am here it seems that all I can do is look at it."[15] Alfred's reaction to the new theme was, predictably, apprehensive, but he was reassured by the acclaim the paintings received.

The New York pictures represented an important achievement for O'Keeffe. "When I wanted to paint New York, the men thought I'd lost my mind. But I did it anyway," she said proudly.[16] After drawing on natural forms for imagery, and specifically forms that were associated with women, she triumphed in meeting the men on their own ground and succeeding with a subject that was specifically urban, man-made, and technological.

O'Keeffe approached the austere world of steel and glass, of grids and angles and geometry, and transformed it into a world governed by her own internal laws of physics. In most of these paintings, atmospherics play a part fully as important as the severe geometry of the buildings. Light, sky, and weather determine the nature of these black monoliths; the paintings represent a triumph of aesthetic balance between evanescence and adamance.

Several years earlier, Georgia had met the journalist Blanche Matthias, who wrote for the *Chicago Evening Post*. Matthias had asked to meet O'Keeffe after seeing Stieglitz's photographs of her. The encounter was not a success; O'Keeffe was wary of journalists, and she acted distant. She eventually warmed to the other woman, however, and later wrote her: "You felt afraid of me last spring— Well I was rather formidable— I'm feeling better now— You might not be afraid of me now— It's New Year's Eve — I greet you."[17]

Matthias was just O'Keeffe's age, a beautiful woman, articulate and perceptive. The friendship between the two was cemented by the article Matthias wrote during O'Keeffe's show in

1926. A quiet and intelligent piece, it addresses O'Keeffe's feminism as well as her art. Apart from her abortive experience in Texas, O'Keeffe was not a political activist. Her philosophy of personal responsibility meant living her views and creating in her own life the environment in which she believed. As Matthias saw it, however, O'Keeffe's attitude was socially subversive.

> Without hesitation I say that women like O'Keeffe are dangerous to this world of affairs, especially dangerous when they are artists. The purity of woman may indeed become a virtue when she learns to express herself fearlessly in art and action. Let her add wisdom to her capacity for love and face life with the courage which her sublimest ideals demand, then look sharp, you worlds, who see in flag-waving an excuse for murder, and in power, your privilege to abuse. The O'Keeffes are coming![18]

Matthias understood the wholeness of O'Keeffe's approach: "Her sense of order is everywhere . . . She moves in one piece," wrote the journalist. She articulated the mythic quality of O'Keeffe's looks, character, and achievements:

> She is like the flickering flame of a candle, steady, serene, softly brilliant . . . This woman who lives fearlessly, reasons logically, who is modest, unassertive and spiritually beautiful and who, because she dares paint as she feels, has become not only of the most magical artists of our time but one of the most stimulatingly powerful.[19]

O'Keeffe responded with warmth and enthusiasm to the article. "I think it is one of the best things that have been done on me—and want very much to thank you . . . the spirit of it is really fine."[20]

O'Keeffe was finding much for which to be grateful at that moment: "Really very fine things are happening in The Room . . . Since the 291 exhibitions I haven't had anything so sympathetically cared for— Being Stieglitz's own place the things seem to feel at home."[21] Opening the new gallery had galvanized Stieglitz, and he was operating at full throttle, engaged, energetic, and effective. Watching him organize, create, and orchestrate, O'Keeffe was full of admiration and gratitude. He was, for her, at the center of things.

Stieglitz always seems more remarkable—and he brings remarkable things out of the people he comes in contact with. I feel like a little plant that he has watered and weeded and dug around—and he seems to have been able to grow himself—without any one watering or weeding or digging him— I don't quite understand it.[22]

Though O'Keeffe used the natural metaphor of plant and gardener to express her tenderness and gratitude for Stieglitz in her writing, she also used a deliberately artificial metaphor—an urban landscape—to express the same feeling. A nighttime skyscraper scene shows a neon sign vivid against the darkness, spelling out Alfred's name in a brilliant message of affection.

The winter in New York was a period of creativity and expansion for both Alfred and Georgia. "We are very busy—and I guess I am particularly busy with myself—it must be so just now," Georgia wrote Blanche.[23] Matthias was sick, and Georgia's response was characteristically generous but unsentimental. Georgia believed people could help each other in limited ways. She gave no advice. Warmth and affectionate support alone could be given—real help had to come from within. "You seem rather troubled in your mind . . . these days," she wrote Ida when her sister was unhappy. "I wish I could help you—but I don't see how I can. I think it is all something that you have to work out for your self . . . It is good you are in the country."[24] To Matthias, Georgia wrote: "I hope you are caring for your self—giving your self a chance— Something in you must quiet down so that you can get well— I wish I could help you— I am learning something myself— I don't know exactly what it is—but if I did—if I could put it clearly into form it would cure you— That is worthy of a laugh but I am sure it is true."[25]

Georgia's learning process was thoughtful and self-directed. That summer she wrote to Waldo Frank:

I am one of the intuitives—or subjectives—or whatever you call the type of person who comes to quick and positive decisions—and then sometimes—when it interests me— have to work for days or weeks or months to find out why I came to those decisions . . . So my opinions I always count as of no value—real value—for anyone but myself . . . Dont think that I really underrate my way of thinking . . . I have just wits enough to know that if you really sift to the

bottom any more reasonable approach to life . . . it really isn't any more rational than mine.[26]

Stieglitz's monologues made her chary of "analysis" as such, and Georgia shrewdly recognized that the most rational minds reached decisions intuitively and then backed them up with rational arguments. She was, like many women, more aware of her intuitive life than many men, but unlike many women, she refused to accept inferior status because of it.

• • •

IN JUNE, Alfred entered Mount Sinai Hospital, suffering from another kidney attack. "It has been very painful for him and the poor little thing is quite wore out . . . He has had a hard time," Georgia wrote Anderson.[27] By the end of the month he was well enough to return to Lake George, and they had the place to themselves at the beginning of the summer. Lee and Lizzie were in Europe until August, and had thoughtfully sent their cook up to the Hill. Georgia had decided at the last moment to take on a student, a young woman from Texas. She stayed with them initially but soon moved to a local inn, the Pines. Alfred approved of her, pronouncing her "Very healthy in every way."[28]

The summer began well. At the end of July, Alfred wrote Elizabeth, "Georgia is in great shape," and she had begun to paint. By early August, Frances O'Brien, Ida O'Keeffe (who had also taken up painting), and Eva Herrmann, the daughter of a friend of Alfred's, were all staying at the Hill. By mid-August there were undercurrents of anxiety. Georgia was turning more and more solitary and had taken to getting up before daylight for a two-hour walk.

"Georgia worries me much," Alfred wrote Seligmann. "She has lost much weight here . . . Psychic conditions. I'm hoping to have her build up. But there is always a worry . . . Of course she has been exercising much and eating nothing."[30] Frances O'Brien and Ida left, and two days later Lee, Lizzie, and the small Davidson girls arrived for two weeks. Two days after that, Georgia was gone. Her sudden departure was painful and unexpected for Alfred: "Georgia has gone to York Beach. She has suddenly decided. She has lost 15 pounds and was terribly nervous . . . It's too bad. Please don't mention it to anyone—either her going or her being run down. It's no one's business."[31]

This time, in his anxiety, Alfred followed Georgia to Maine. It was one of the three times in twenty-eight years that he altered his habitual route between Lake George and Manhattan.

> Caught a miserable cold . . . But I don't regret the trip there . . . I *had* to see Georgia for her and my own sake. And miserable as I am in bed here now I was really more miserable before going. I feel much better— Georgia is certainly an extraordinary woman.[32]

In spite of Alfred's propitiatory trip to York Beach, Georgia refused to return to Lake George with him. There was no peace for her there: Alfred had offered the Farmhouse to a nephew for his honeymoon, and Selma's arrival still threatened. Alfred's tone was chastened:

> I've been alone—it's no longer a secret—for weeks . . . So I've had a lot of time to ponder over much . . . Getting much that had gotten tangled up straight within myself. Georgia returns tomorrow. I know her stay in Maine was a sorely needed one. I hope she has gained in weight. I know she is again released as far as spirit is concerned.[33]

Georgia did not, however, return the next day, telegraphing another postponement. "Georgia will show up as she knows the House will be empty," Alfred wrote confidently.[34] The house was not quite empty, however: Selma was there, complaining bitterly, when Georgia arrived. Alfred and Georgia had only a brief period alone after Selma finally left.

From Georgia's four weeks in Maine the haunting shell series was produced. She may have begun the works at York Beach, but she continued them at the lake. "Georgia is painting— All her things are in a minor key," Alfred wrote that fall.[35] These ruminations on the theme of the shell range from the highly representational to the purely abstract. Most powerful are the clamshells, open and closed: small works, monumental images. In these, the clamshell's seam is centered in the narrow perpendicular space. The sense of monumentality is achieved by the space given to the shell within the rectangle: the smooth enigmatic curves dominate, filling it entirely except for the corners.

Closed Clam Shell presents the shell's narrow, subtle line of closure down the center—denial, prohibition, and exclusion— while the smooth gray-white halves meet neatly, mirroring each

other—containment, completion, and wholeness—the closed and coupled self.

Open Clam Shell reveals something more. Again the narrow perpendicular space is filled by the long, slanting shape that reflects itself. But in this image the silent interior appears: here are muted pearly layers within, curved and subtle. At the heart of the interior is another opening, mysterious, dark, and opaque.

As with the earlier orificial images, the shells reveal a fascination with the idea of openness and closedness, accessibility and exclusion. The austerity of the palette, however—muted whites and grays—and the severity of the forms—restrained curves, long straight lines—suggest a reduction, a controlled retreat from the ardent, trembling pinks and blues of the "Music" archways. Moreover, the earlier, ecstatic "Music" openings had no means of closure: they are perpetually accessible. The shells are quite other: their openness is no more likely than their closedness.

It is possible to argue the vulval nature of these images—they are, it is true, interior chambers lined with soft and intimate surfaces. More central to their meaning, however, seems to be their essential qualities of openness and closedness. The cool inevitability of a closed shell, the quiet suspense of a barely opened one, are qualities far more compelling than a purely sexual interpretation would permit. Shells represent something deep and essential, something abstract, shapely, and significant, as do bones. In fact, shells are exoskeletons, the counterparts of bones, in function as in form.

Whether or not the series was meant to parallel O'Keeffe's swift and absolute removal from Alfred—her insistent solitude and distance—the quiet shells made a potent statement. Numinous, serene, and dignified, they are compelling and mysterious images, enormously powerful, which resonate with a sense of privacy, intimacy, and inner strength. If she was becoming increasingly aware of the threat posed by Alfred's presence in her life, she was beginning to perceive her own strengths in response to that threat.

• • •

THE ROOM opened the 1926–27 season with an exhibition of John Marin. His work hung from early November to early December, and during it a young matron wandered into the Room for the first time. Struck by the energy of a watercolor, she asked about

it, but Stieglitz gave her a short shrift. "It has been acquired," he said coolly, and turned to someone else. Snubbed, the woman left, but the Marins stayed in her mind. She returned but was disappointed to find another show hanging. The new work (O'Keeffe's) made no impression on her, but she was struck this time by Stieglitz, by his face and his intensity as he talked to another woman.

> The young woman is questioning the man about the meaning of a particular picture. "Do you ask what the wind means?" he replies. "You might as well ask what life means" . . . The voice rivets my attention. I notice the man's face for the first time. The lips are finely drawn . . . the eyes are deep-set, dark, piercing . . . All my life I have been waiting for someone to answer my own questions. Now a stranger, Mr. Stieglitz—makes the first satisfying statement I have heard about art . . . The encounter seems absurdly slight, yet within a split second an inner music soars.[36]

The young matron was Dorothy Norman, a pretty, dark-eyed, dark-haired woman from a sheltered, middle-class Jewish background. After graduating from Smith College, she married the wealthy Edward Norman in 1925, and she and her husband moved from Philadelphia to New York. Idealistic and ardent, she volunteered to work with the ACLU.

It was unlikely that O'Keeffe was present during Norman's first visits: she was coming infrequently to the gallery now. The novelty of the viewers, of the paintings, and of Alfred in his element had worn off. There was also the problem of Alfred's need to talk about O'Keeffe the person, while O'Keeffe the work hung on the walls. Alfred's personal revelations were sometimes embarrassing. The season was successful professionally, however, and marked Georgia's first significant income from the sale of her paintings. During her exhibition, six paintings were sold, for a total of seventeen thousand dollars.

Summer 1927 at Lake George followed the usual pattern: early solitude and peace gave way to congregation, tension, and anxiety. Alone with Alfred, Georgia attended to domestic chores that she enjoyed. "There comes Georgia with the sprinkling can and a big grin," Alfred wrote Elizabeth.[37] The atmosphere changed as the houses filled up; after Lee and Lizzie's arrival,

Georgia had an attack of rheumatism which kept her from painting. And in August something more alarming occurred: a lump was discovered in Georgia's breast. She was admitted to Mount Sinai Hospital, where the tumor was removed. It was benign, but the operation was debilitating, and recovery took her some months. The operation had a positive aspect: O'Keeffe painted the powerful and mysterious *Black Abstraction*, based on the visual sensation of going under the anaesthetic. Lying on a stretcher, she saw a brilliant light—the operating lamp—overhead. She wanted to remain conscious as long as possible, and heard the doctor washing his hands. As the anaesthetic took effect the light began to whirl and recede, withdrawing into blackness. She lifted her arm up; it dropped. The light became smaller and smaller; she was gone.

Recuperating at the Hill, Georgia found herself under the watchful and restrictive eye of Lee, who forbade strenuous exercise. This year, Georgia had allies, though: Georgia Minor was back, as were Davidson, and Selma's son, William Schubart, and his family.

Donald Davidson, Georgia Minor, and young Dorothy Schubart were all Georgia's allies, rebels against the rest of the family. They laughed behind Stieglitz' back and often met after dinner at the Shanty, for a clandestine tipple. (Both Alfred and Lizzie were teetotalers.) A more dramatic act of insurgency was the kidnapping of the hated plaster bust of Judith. This high-Victorian object had survived the move from Oaklawn to the Hill. Pompous, fussy, and inauthentic, it became an object of loathing for Georgia. One night it was spirited away and buried somewhere on the property, so deeply and cleanly that it was never discovered. This has been reported as the work of Georgia and various accomplices, but Dorothy Schubart asserts that the conspirators numbered a select two: Georgia O'Keeffe and herself. Now she alone holds the secret of its location.

Georgia's feelings of hostility toward the Stieglitz household were more and more evident. "I was hard on that family, but they were hard on me," Georgia said later.[38] It was not only the family that affected her that year; the effects of the surgery were traumatic. In September, Alfred wrote Beck: "She's better yet isn't. There is a bit of painting but not much enthusiasm."[39] And the two of them had managed only seventeen days alone together

during their five months at the lake. "The summer was a difficult one," Alfred admitted.[40]

Georgia considered staying on alone at Lake George in October, but it was difficult for her to leave Alfred, whose love, dependence, and displeasure were all so strong and so compellingly voiced. He was anxious to return to the Room, and in the end Georgia went with him.

• • •

IN NOVEMBER Dorothy Norman reappeared at the Room, for her first significant exchange with Stieglitz.

> I go into the Room once more. Stieglitz is alone, looking far into space. He asks if I am married, if the marriage is emotionally satisfying . . . "Yes, I'm in love with my husband and we have a new baby." "Is your sexual relationship good?" Talking about such matters is of vital importance, in spite of my inability to be totally honest. Stieglitz inquires, "Do you have enough milk to nurse your child?" Gently, impersonally, he barely brushes my coat with the tip of a finger over one of my breasts, and as swiftly removes it. "No." Our eyes do not meet.[41]

By her own account, Norman's husband was sexually insensitive, and Alfred's "impersonal" caress of her breast made a deep impression on her. She became obsessed by seeing Stieglitz: "Try as I will not to go to the Room, I go . . . I make valiant efforts to space my visits. I can wait three days before returning . . . I am so excited and filled with such curiosity that I can barely move, barely speak."[42]

A more experienced woman would have recognized this as simple and blatant flirtation; Ida would have smacked Alfred's hand. Norman was only twenty years old, however, and determinedly idealistic: she persuaded herself that her excitement arose from modern art. She wrote Alfred a breathless and self-consciously charming letter, in which she asked permission to spend more time with him.

> I know it is awfully young of me to do this. But . . . I have a very difficult time keeping away from 303! . . . I love the

work you're doing so, I feel so jolly about everything all the way thru' me that I *have* to write and thank you for it.

. . . I would love to help you with what you are doing . . . and . . . if you do want any help—I'm just aching to give it. I love what you're doing. I *feel* it." [43]

Unsurprisingly, Stieglitz was beguiled and flattered by Norman's adulation. When she offered more specific services—to "answer the phone, shut the door—hang the pictures"—he granted her permission to spend her days at the Room. She mentioned shyly her wish to write about him and took notes of his conversation. She soon decided that one article would not suffice: an entire book would be necessary to capture the essence of Alfred Stieglitz.

Alfred wanted all his friends to like each other, but the meeting between O'Keeffe and Norman was not a success. Though Norman viewed O'Keeffe with wide-eyed reverence, O'Keeffe saw in Norman a spoiled rich girl, playing at social causes. She was brisk and dismissive with the younger woman: besides her obvious infatuation with Georgia's husband, Norman was the antithesis of an independent woman. Offering to shut the door of Alfred's gallery was not the sort of contribution O'Keeffe admired. She asked Norman why she didn't work for the Women's party and "drop all other 'nonsense.' " By her own account, Georgia was intolerant of Norman from the first.

> I never did like her, from the very beginning. She struck me as a person with a mouth full of hot mush, and why didn't she swallow it or spit it out? She was one of those people who adored Stieglitz, and I am sorry to say he was very foolish about her. [44]

• • •

IN THE FALL of 1927, the artist Gifford Beal and a small group of patrons opened the Opportunity Gallery in the Art Center, at 65 East 56th Street. The gallery was a nonprofit enterprise that offered free exhibition space to new artists and gave the public an opportunity to see fresh work. The director was Alon Bement, O'Keeffe's old teacher, but each exhibition was selected by a different artist. The jurymen of the first season were an illustrious group: Walter Pach, John Sloan, Georgia O'Keeffe, Rockwell

Kent, Robert Henri, Charles Demuth, and the lesser-known Allen Lewis.

The exhibition chosen by O'Keeffe opened in mid-December. Among others, it contained work by her sister Ida and five paintings by Helen Torr, who was married to Arthur Dove.

O'Keeffe and Torr had both had pictures illustrated in *A Primer of Modern Art,* by Sheldon Cheney, in 1924, and Georgia had subsequently written Dove to tell him how much she liked Reds' drawing. Cheney linked the two artists: "I find something coming into the work of certain Americans—particularly Georgia O'Keeffe and Helen Torr—which is emotionally very moving."[45] Torr's work is subtle and small-scaled, somewhat reminiscent of Dove's, though it is not derivative. It reflects a deep sympathy for biomorphic forms and for natural imagery. The Doves were a mutually supportive couple; unsurprisingly, Dove liked Torr's work best in the show, his wife noted in her diary.

Henry McBride, however, who gave the show "a fine notice" in the *Sun,*[46] wrote Georgia: "I liked your sister's things best in the Opportunity Show."[47]

Ida had begun painting in earnest during the summer of 1925, while she was nursing an elderly gentleman in Norfolk, Connecticut. She felt a familial urge and wrote Georgia: "All of these beautiful flowers here give me a wild desire to paint,"[48] adding confidently, to Alfred: "Have the feeling that I can do it."[49] It was not Ida's first attempt; she had taken classes at the University of Virginia summer school, with Anita, before Georgia had, and had continued painting intermittently. Ida took painting seriously: she had paid her rent by selling her work during her five months in New York.

Ida asked Alfred and Georgia to help her order materials, and she found a local artist, a Mr. Tuttle, to give her lessons. When her materials arrived, her patient was too ill for her to leave for lessons, so she launched into painting without them. Fruits and flowers were her subjects: she chose a row of sociable green figs, she wrote, and a lone iris. Ida's enthusiasm informed her days, and she wrote Alfred: "Now that I am lost completely in paint and colors the days are all too short. At night I even dream of colors."[50] The process itself enraptured her: "When I paint I am not in this world at all. It affects me worse than music."[51] The following summer, when Ida visited Lake George, she painted constantly, and Alfred wrote enthusiastically of the results: "Ida

O'Keeffe . . . has become a passionate painter and has incredible talent."[52]

It was a measure of Georgia's professional generosity that, far from feeling competitive with either Torr or her sister, she encouraged their work in such a strong and tangible manner.

The winter of 1927–28 marked a general decline in the art market. For O'Keeffe, however, it was a banner year: it marked the highest price ever brought by O'Keeffe, by a woman artist, or by a living American artist.

The annual O'Keeffe show at the Room ran from January 9 to February 27, 1928. It opened without her: on December 30 she underwent another operation. Cancer was again suspected, but again a benign cyst was removed.[53] The process was debilitating, and ten days later O'Keeffe was still in the hospital.

Her show was composed of recent work, among which were seven shell paintings. O'Keeffe had continued with flower subjects and skyscrapers, and she had begun, as well, to reminisce about the wide skies of the west. Henry McBride's review gave a clear idea of what her work was like and what it was about: "She is in love with lines," he wrote, "with simple, smooth surfaces that change so slowly in tone that it sometimes appears as though a whole earth would be required to make them go all the way around."[54]

He singled out for praise the Shelton Tower paintings; an astonishing western landscape, *Red Hills and Sun;* and *Dark Iris No. 1,* an enlarged flower painting, which in its somber luminosity was far more powerful than the innocent pinks and blues of previous works. McBride's comments had amused O'Keeffe in earlier years, as he poked gentle fun at ladies and intellectuals, but by 1928 O'Keeffe felt that his criticism had been so important to her that she wrote to thank him: "What you have done has helped make a place in the world for what I do—not through what you write about me but through what you have written about all the workers . . . And I am glad you accept my small thank you."[55]

O'Keeffe had heard McBride making conventional complaints about a newspaperman's salary, and besides the letter, she made a gesture that could be read as either calculating or naive. McBride recognized the gesture as one of remarkable innocence:

A lady, right out of the blue, and therefore most indubitably an angel, drops manna to the value of two hundred dollars in my direction . . . It was noble and beautiful of you to do it, my dear O'Keeffe, but I wasn't sure it was noble of me to accept—and I wanted to be noble too . . . Also, I insist I'm not really hard-up and have about all that it is good for me to have . . . I decided that it was an action typical of your usual beautiful self (but innocent! you and Alfred are both a pair of innocents . . .).[56]

• • •

NOT MENTIONED in McBride's review was the new flower series. O'Keeffe had seen some creamy calla lilies in a Lake George florist's window: "I started thinking about them because people either liked or disliked them intensely, while I had no feeling about them at all."[57] O'Keeffe began to explore the furled, waxy shapes, with their clean, sculptural quality.

A series of six small lily panels hung together at her exhibition. When an unknown man asked their price, Stieglitz tried to snub him by naming an insultingly high sum: twenty-five thousand dollars. To Alfred's astonishment, the man agreed without demur to pay it. The buyer was an American who lived in Paris, and upon Alfred's strict questioning, he proved to have an aesthetic sensibility that measured up to Stieglitz's stringent requirements. He promised to hang all the pictures together, in his own house, and never to sell them in his lifetime. Stieglitz took his role of guardian very seriously and wrote admonitory letters to buyers, in which he reminded them of their trust. "Pardon my intrusion," he had written a new collector the year before. "I don't know you. I don't know your circumstances. But I do know you are about to be entrusted with one of the greatest works of art of our time and you are assuming a great responsibility."[58]

The roaring twenties were in full cry. In the mood of febrile gaiety that prevailed, the high price of the lilies, coupled with O'Keeffe's quietly eccentric persona, was news. Against the background of bobbed and shingled short-skirted flappers, O'Keeffe stood out dramatically. One article called her a "prim ex-country schoolmistress who actually does her hair up in a knot."[59] For the public, O'Keeffe's image had changed—this was a far cry from the nude photographs exhibited by Stieglitz.

That spring, O'Keeffe was overtired and on edge. The surgery had left her weakened and exhausted. Moreover, the nonsensical publicity irritated her, as did the continuing presence of Dorothy Norman at the Room.

Norman by now was attending to managerial and secretarial work for Stieglitz. Her daily presence there—unpaid, ardent—had not gone unnoticed by friends and family. Norman was not universally admired; the writer Anaïs Nin found her self-centered and rigid, "intellectual, but cold as a human being." [60] The relationship between Stieglitz and Norman was doting, intimate, and highly visible, and some members of the Stieglitz family found Norman's adulation a downright embarrassment. "My God, how she listened, how thirsty she was to learn, how willing to take on any task or errand, even anticipating its need," wrote Sue Davidson Lowe. [61] Not only was Norman eager and intelligent; she was beautiful, with the kind of looks that always attracted Alfred, as Lowe points out. She had "the dark eyes and hair, sensitive mouth, expressive hands and pale complexion of his mother." [62]

Catherine Klenert and her six-year-old daughter, Catherine, came to New York for a visit that spring. They stayed with Anita, and afterward Georgia wrote: "It was fine to see you. Only when I think of what a poor excuse of a person I was when you saw me I feel I ought to be shot for letting myself get so tired." [63] By late April, "I had had all the winter I could stand," she wrote a friend, "so I took to Maine for a little over two weeks." [64]

Needless to say, Maine was no less wintry than New York, but at least there she was alone, and freed from the claustrophobic tensions that surrounded her in the city. In New York there were too many people, too many demands, not enough sky, and too much of Dorothy Norman.

• • •

ALFRED AND GEORGIA moved to Lake George at the beginning of May, a few days after Georgia's return from Maine. Stieglitz had slipped on a wet floor and wrenched his back, then had torn a ligament in his finger: he was nearly helpless during the move up. When they arrived, Georgia's state of mind was somber. She wrote Henry McBride:

> I try to remind myself I am here—in the country—that
> there are things one always does here—but I feel in a sort of

daze— I don't seem to remember that I am here—and it is most difficult to remember how to wind up the machinery necessary for living here . . . I look around and wonder what one might paint— Nothing but green—mountains—lake—green . . . and Stieglitz sick.[65]

Conditions were improved at the Hill that year. Margaret Prosser, a sympathetic French Canadian who had worked at Oak-lawn as a teenager, was full-time housekeeper, relieving Georgia of domestic pressures. Lee and Lizzie had built a kitchen for Red Top and no longer arrived twice daily to share meals. But for Georgia the improvements made little difference. Her depression worsened, and barely two weeks after her arrival she had fled again to York Beach.

I am in Maine—have slept and slept and slept—till now when I wake at six in the morning I am ready to get up . . . It has rained most of the time since I am here—but I have spent much time out doors any way—am having a great time . . . I am quite a normal human being here—it is quiet —wonderful food—busy people who leave me alone—and the ocean.[66]

At the beginning of June, unwilling to face the summer at Lake George, Georgia proposed a trip back to Wisconsin to visit her family. Alfred invoked his ill health: "I sometimes wish I had a few ailments instead of the many so that I might be able to take a few months off and accompany O'Keeffe to 'her' America. I know that is what she craves for. I wonder can it ever be."[67] Two weeks later the conflict had deepened: "I oftentimes—most times —feel like a criminal . . . in being the cause of keeping Georgia from where she really naturally belongs."[68]

Physical freedom and psychological independence are closely entwined. Georgia's yearning for travel threatened Alfred, suggesting an inevitable divergence of paths. Alfred preferred to see the issue in aesthetic terms, asserting that Georgia's trip was a demonstration of her needs as an artist, not as a woman. Between the two of them there was little communication on the subject—all that was clear was her unhappiness. The issue of Dorothy Norman was not discussed, though it was known to their friends. Elizabeth Davidson was again Alfred's confidante, and when he wrote that things were going well between himself

and Georgia, she wrote him: "It was so good to hear that there is again understanding—togetherness." Tactfully avoiding names, she goes on: "I hope nothing will be infected from the outside— to disturb the new peace," and makes a specific comparison between Alfred's past infatuation for Beck and his current one for Norman: Elizabeth hopes that "even in the case of a stupidity— Beck or such—it should not go deep." [69]

To escape all this, in mid-July Georgia boarded a train, solitary and independent. Her cash tucked prudently into a money belt, she set off to see Aunt Ollie, Aunt Lola, and her sister Catherine, halfway across the country. [70]

Back in Madison, Georgia was supported and enfolded by her past. She was again among people who took responsibility for themselves and took pride in their dignity. Instead of the shouting matches at the dining table at Lake George, the evenings in Wisconsin were long and quiet. Georgia listened to the slow stories of kin and took part in domestic rituals: shelling peas, husking sweet corn, picking the dark grapes that hung from the arbor over Aunt Ollie's porch.

During the weeks in Wisconsin, Georgia ruminated on her situation and her anger. (Though Catherine knew that the trouble was Alfred and another woman, the sisters never discussed it.) When Georgia arrived finally at the decision to return to Alfred, she announced to Catherine that she wanted to paint a barn. Georgia had painted several barns at Lake George, but the ones in Wisconsin—handsome, solid, stately—embodied the strength and reality of her own past. The painting would be a reminder to Stieglitz that she represented something vital and enduring. "The barn is a very healthy part of me—there should be more of it— It is something I know too—it is my childhood," she wrote the following year. [71]

Catherine drove her sister along the narrow farm roads until they found a barn that Georgia liked. It was a classic example, deep red, with a stone foundation and high peaked roof; the barn had a silo at one side of the massive hayloft and a long one-story cattle barn attached to the other. A white five-bar fence enclosed its small barnyard. Catherine asked the farmer, Charlie Boylan, for permission to paint it, then sat in the front seat while Georgia got out her oils in the back. "She gave me a board, and brush, and paint, and said, 'Catherine, you can paint one for yourself

and I'll paint mine.' "[72] When the two sisters had finished their paintings, Georgia held hers up. Her barn, highly realistic, dominates her canvas, the high-pitched roof nearly touching the edge. Massive and comforting, the barn makes a simple statement about the strength of the land and the life on it.

Georgia looked at Catherine's painting: small, naive, and utterly unselfconscious, a red barn set in a field of dreamy wheat. "I like yours better than mine," said Georgia. "I really like it better than mine."[73] Georgia's response was characteristic: generous, direct, and genuine. She felt no jealousy at Catherine's work, only a warm sympathy. Her comment addressed the spirit of the work, not the technical ability, and the spirit was one she recognized.

"She was really quite surprised at my barn," said Catherine with modest pride.[74] Like Georgia and Ida, Catherine had the family gift: "First time I'd had a paint brush in my hand," Catherine said of the attempt. But when she asked Georgia for criticism and advice, Georgia only smiled. "Find out for yourself," she said, opening the world of painting for her sister to explore.

• • •

GEORGIA RETURNED to Alfred in mid-August; he seemed older and frailer than she remembered. The separation deepened the tenderness they felt for each other, and when the Hill emptied— early that year—they spent a blissfully quiet time together until mid-September. But the peace was short-lived: just as Alfred's finger finally healed and he felt himself whole again, he had a heart attack.

The episode and its implications were frightening to both Alfred and Georgia: he was sixty-four years old. Alfred was confined to bed for three weeks, and Georgia sent for Ida. The two sisters attended the painstaking diet and medications prescribed. Georgia's time with her family and her cheerful sense of practicality had restored her good humor, and she wrote Ettie Stettheimer: "strained spinach, peas, beans, squash, ground lamb and beef—strained this—five drops of that—a teaspoon in a third of a glass of water . . . I almost feel as though I'm not doing all these wonderful things myself . . . Don't be sorry for me— I'm busy —and learning a great deal."[75] Alfred bemoaned his helplessness

and asked her to add, from him: "I am disgusted with myself—
much disgusted."

By mid-November they returned to the Shelton. It was to be
the last season of the Room: like 291 Fifth Avenue, the Anderson
Galleries building was to be torn down the following June. The
winter was a quiet one: "We do not go out nights and do not
have guests so it is much easier than other years— I thrive on it,"
Georgia wrote Catherine.[76]

Catherine, having discovered the pleasures of painting, was
pursuing her new avocation with serene energy, great delight,
and Georgia's encouragement. Georgia had given her sister
brushes and paints in Wisconsin, and sent her more from New
York. Catherine sent her paintings to Georgia for comments. The
second shipment arrived around Christmas: large images of flow-
ers.

Though Catherine did not remember seeing Georgia's own
large flower paintings, her visit to New York the previous spring
makes the question problematical.[77] Whether or not Catherine's
work was influenced by her sister, Georgia's response to it was
warm and positive: "I think your painting[s] fine—so does every-
one I show them to."[78] The feeling of companionship and shared
endeavor was reflected in the letter written to Catherine when
Georgia's red barn painting was sold: "I thought it would interest
you as it was partly your work."[79]

As well as praise, Georgia gave some rare advice to her sister,
illuminating her own approach to painting:

> All I have to say is this— Making an object look like what
> you see is not as important as making the whole square you
> paint it on feel like what you feel about the object . . . If
> that doesn't mean anything to you don't worry about it—
> Just go ahead with what you are doing—you are doing
> wonderfully— Try to make the stems of your flowers—and
> the background back of the whole thing as wonderful as
> your flower— Or you might try to paint something else—
> why don't you try some winter landscapes. You don't have
> to sit out in the field to do it—you can remember it—
> Anyway—I think you are grand . . . You just go ahead
> working . . . You are one of my nicest thoughts.[80]

Alfred's response to the work was similarly enthusiastic:

I must tell you how amazingly and delightfully I think you have developed as a painter. It is quite incredible. And still I am not a bit surprised—it seems to be in the family—a certain rich gift of expression—and a rare sense of color. My congratulations.[81]

PART IV

1929 - 1946

A FAIR DIVISION:
NEW YORK
AND
NEW MEXICO

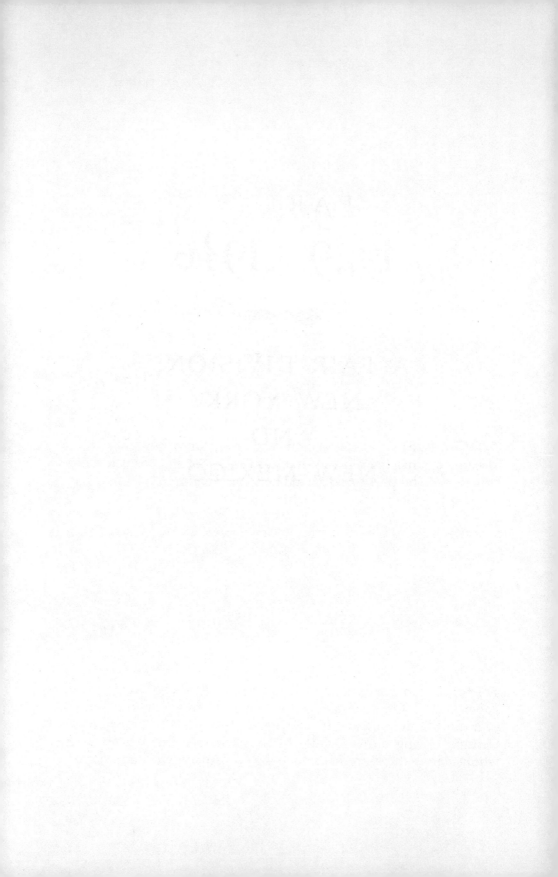

21

*In New Mexico . . . there existed a world in which life held
intensity, an intensity drawn from an impulse to survive,
and a mystical faith that mediated that survival.*

— JULIE SCHIMMEL,
Art in New Mexico

GEORGIA'S 1929 EXHIBITION, from February 4 to
March 17, consisted of thirty-five canvases, not all of which were
new work. The past season had been a meager one: "Georgia has
painted relatively little." Stieglitz admitted. "Mainly very small
canvases."[1]

O'Keeffe continued to paint flowers, the New York skyline,
and leaf studies. Increasingly evident in the leaf studies was a
tendency toward an image of brokenness. The silhouettes of the
leaves during this period are imperfect, jagged, and torn; they
are quite unlike the surreal and abstract perfection of the earlier
natural forms.

Alfred worried about the paucity of O'Keeffe's output, both
on her account and on the gallery's. From 1925 to 1929 he had
shown his own stable, while giving occasional exhibitions to out-
siders: Gaston Lachaise, Oscar Bluemner, Francis Picabia, and
Peggy Bacon. O'Keeffe was the heartbeat of the operation, how-
ever, and he wrote gloomily: "Maybe it's our last [season]. With
Georgia having done so little I can't quite see the Season as a
whole. Her exhibitions were usually the Anchors of the year."[2]

The response to the exhibition was generally positive, though, and the mysterious owner of the calla lilies bought four paintings (one of which was the red Wisconsin barn, for four thousand dollars).

Though Georgia appeared at the gallery in a flaming scarlet cape, her mood was somber, and her response to the work was saturnine. "It was mostly all dead for me," she wrote Ettie Stettheimer.[3] After the show came down, she wrote Henry McBride in a tone of wry self-deprecation: "The encouraging note that I want to add is that I hope not to have an exhibition again for a long long time. Even if you have a cold, maybe that will make you feel a little better."[4]

Louise March, a German exchange student at Smith College, came into the Room one day and was struck by the O'Keeffes. Stieglitz was taken by the gentle and intelligent young woman, and he invited her to come back and meet Georgia. March was an appealing figure, small and composed. Georgia liked an article Louise had written about modern art in Berlin, and she liked Louise. She invited her to come and stay with them at the Shelton, and when Louise later moved to New York, it was through Georgia that she found work: she took over the running of the Opportunity Gallery from Alon Bement.

Louise March was a frequent visitor at the Shelton that winter, and she observed Georgia's unhappiness. Tension ran high, and arguments between Stieglitz and O'Keeffe were common. "A small thing would set it off. They would tell me to go ahead to the cafeteria, and say they'd be right there. They wouldn't come, and an hour later I'd go back, and she'd be in tears."[5]

Georgia was finding the design of her life increasingly claustrophobic. It was Alfred who decreed the daily pattern, just as he had with Emmy, just as his father had with his mother. It was Alfred whose needs—social, emotional, and physical—took precedence. The case for this was strong; Alfred had woven his social and professional lives together. He could insist on the necessity of his constant availability—at meals, in the evenings, on vacations—to all the people who laid claims on his energy. "[He] loved having people around the house all the time," Georgia said later, "and I'd have to take three weeks off to do a painting. And that's no way to be a painter."[6]

Alfred decided where they lived and where they traveled.

There were only two locations he would tolerate: New York in the winter and Lake George in the summer; it was as simple as that. O'Keeffe began to recognize that neither place, for her, was nourishing, vital, or, finally, tolerable.

At the start of their relationship, Stieglitz assumed that O'Keeffe's needs and interests were identical to his, and this was nearly true in those early days. Georgia found the endless discussions of art and philosophy interesting, and she saw Alfred's family as an exotic foreign tribe. Now Georgia was through talking about art, and she was no longer amused by the Stieglitzes. It was the time in her life for work.

Life in New York was distracting and a constant drain on her energy. "The city's very hard," she said simply.[7] The country at Lake George, with its suffocating verdancy and enforced communality, was just as bad. She saw nothing ahead but noisy, crowded city alternating with crowded, noisy country, a fixed and endless pattern. What she needed was "busy people who leave me alone," the long, unbroken line of horizon, and an endless quantity of "sky . . . the best part of any place."[8]

Alfred's intentions were always benevolent. Far from wishing Georgia stifled, he wanted her free and happy. She was central to his life, a fixed constellation around which the rest of his sky revolved. But however celestial, her place was fixed by him; it was his sky.

Stieglitz perceived Georgia as "finer" than himself—"straighter." This adulatory respect was good for the soul perhaps, but not for the relationship. Initially, Georgia had seen Stieglitz as powerful, fearless, virile, her access into an enchanted world of love and art. He had reveled in this view, but eleven years later, Stieglitz knew that she no longer perceived him thus. She had nursed him through kidney attacks and had steadied him when he tottered. She no longer stood breathless and silent when he spoke; in fact, she took his speeches with a grain of salt. Moreover, it was increasingly the income from O'Keeffe's paintings that supported their life together. Alfred knew that O'Keeffe now saw him as human: flawed, garrulous, aging.

This did not diminish Georgia's affection; she loved him without qualification, but also without idealization. "I believe it was the work that kept me with him," she wrote, "though I loved him as a human being. I could see his strengths and weaknesses.

I put up with what seemed to me a good deal of contradictory nonsense because of what seemed clear and bright and wonderful."[9]

For Alfred, however, the changing image was painful. It was natural for him to wish for someone to see his "whiteness," someone who would feel astonishment and adulation at the thought of him, see him as strong and forceful, effective and marvelous, someone who would grow silent at his presence, in a reverential manner O'Keeffe would never again adopt. As it happened, during the winter of 1928–29 there was someone at the gallery who was eager to do just that.

"I listen to Stieglitz, read about him, watch him function, look at his photographs, talk with him, and begin to fathom that he represents an approach to life I have been seeking . . . but had not found . . . Like some great force of nature," wrote Dorothy Norman in her memoir.[10] "Stieglitz—much older than I— has a youthfulness, vigor, and sense of fullness about life unlike anyone I have ever known. His experience and wisdom are qualities of a mature man, but not of a father. I have no daughterly feelings towards him."[11]

The temptation he felt to teach himself to the rapturous young woman, to see himself, his "youthfulness, vigor . . . experience and wisdom," reflected in her shining eyes, proved irresistible to Stieglitz.

One day I enter the Room and find only Stieglitz, who motions me to sit far away from him. He smiles. "Out of danger." I had thought he was teasing when he said this before, but now he sounds as if he meant it. A tense silence. We look at each other intently, deeply. I hesitate to speak. I'm so young, my words will sound absurd. I whisper across the space. "I want to say something to you." "Say it." The voice is gentle, encouraging. I remain miserably silent. "Say it," he repeats. "I can't." "Say it." A huge effort; I feel almost strangled. "I love you." His face softens, his eyes glisten. His voice grows even more tender, his expression more intimate. "I know—come here." He reaches out his hand. "We do," he says, and brings a new world into existence. He adds, "I've wanted to do this for a long time." He kisses me as I have never dreamed a kiss could be.[12]

Alfred had blissfully yielded to temptation once again.

In her book, Norman made abundantly clear the precise nature of her relationship with Stieglitz:

> The love of this sensitive, passionate man arouses me to perfect fulfillment. To have a complete erotic experience again and again is breathtaking, almost frightening in its intensity . . . I felt bewildered on being first aroused by Stieglitz. Nothing else had brought me alive in the same way. The miraculous frenzy of awakening, of being fulfilled.[13]

Stieglitz, seeing himself reflected magically in Norman's eyes, wrote her: "Yes you love me. And I love you. And I know it is no crime. Not before God. Not before right thinking Men and Women."[14] Despite his fervent avowal of innocence, Stieglitz did not mention his crimeless passion to O'Keeffe—who was surely a right-thinking woman.

• • •

BY THE SPRING of 1929, life was closing in on Georgia. Alfred's behavior, foolish or criminal, was painful to watch, but she made no accusations. Her instinct was not to alter other people's behavior but to modify her own, and she had developed a characteristic response to pain. "You must not let the things you cannot help destroy you," she advised a friend. "I am sure that Work is the thing in life . . . Do save your strength and energy for creating— don't spend it on problems and situations you can't help."[15]

Even for Georgia, however, work was impossible under these circumstances: the emotional landscape was excruciating, and Georgia set out to find a new physical one. "If I can keep my courage and leave Stieglitz I plan to go West," she wrote Blanche Matthias. "It is always such a struggle for me to leave him."[16]

Georgia's need to leave was necessary for survival, but Alfred saw it as a direct threat to himself. He was opposed, as always, to the idea of her traveling, and this time the conflict between them became intense. Everything in Alfred resisted Georgia's departure: his own need for her presence, his fear of aging, of her defiance, of losing her forever. The real threat, however, was not Georgia's independence but his own guilt. He knew that Norman's presence was becoming increasingly important to him, but as long as this was not mentioned, as long as

Georgia stayed with him, as long as the semblance of normality was preserved, he could insist on his innocence.

Had Georgia cast blame, Alfred would have turned on her that vehement, irrefutable stream of volubility, maintaining his guiltlessness and demanding her agreement. "He could always outtalk you," as she said.[17] Georgia used her own methods— silence and action. She made neither accusations nor complaints; she said only that she wanted to leave. She did not need to break the silence, and Alfred did not dare to.

Georgia, brought up on a farm, was an emotional pragmatist. Alfred, raised in a sheltered environment where hardship was artificially induced, was a sentimentalist. Altruistic, idealistic, and naive, he had a benevolent self-image. He could not admit that his behavior might wound Georgia, whom he cherished, whose presence was central to his life, and whose "whiteness" still awed and dazzled him. He used everything in his power— rage, authority, neediness—to convince himself and her that she should stay with him, that this was her duty, her need, and her wish.

The struggle was the same one O'Keeffe had battled with years before, in South Carolina: this time she was trying to achieve emotional instead of aesthetic independence. In each case, absolute concentration on her interior voice was required, and the determined dismissal of other influences. However difficult psychologically her aesthetic liberation had been, there was no moral stigma attached to it, and it affected no one but herself: certainly it gave no one else pain.

This was not true of the emotional liberation. Though O'Keeffe was largely indifferent to social conventions, she was deeply committed to a private morality. One aspect of this was a great value placed on charity in the original sense: *humanitas*, or *caritas*—the generous and loving treatment of the individual. To insist selfishly on her own needs over those of someone she loved was painful; to watch her own actions give pain was excruciating. Georgia was grimly aware of the injury she inflicted on Alfred by leaving, and she knew how her behavior diverged from that of the loving and supporting wife. She was deliberately choosing her own survival, though it meant injury to others. From then on, she acknowledged this, neither excusing nor defending herself, and she referred to herself thereafter in letters as "a heartless wretch." Explaining the title of a pastel she did of two smooth

and impenetrable black stones, *My Heart*, O'Keeffe said, "I thought they looked hard."[18]

The struggle for emotional independence was by far the more difficult one. "When they argued, he did the talking. She wouldn't combat him in words, but in feeling," said Louise March.[19] Georgia maintained her silent insistence, however, and at last Alfred acknowledged defeat and agreed to her leaving. "The difficulty in getting out here was enormous, but I came," she said later.[20] The act itself was crucial to her: "I think I only crossed him when I had to—to survive."[21]

• • •

SINCE THE late nineteenth century, artists had been drawn to the area around Santa Fe, New Mexico, by the pellucid light, the invigorating air, and the irresistible presence of the Indians, quiet and self-contained. Early settlers had not competed for the hot and arid southwestern lands as they had for the fertile plains of the Midwest. While most of the Wisconsin Indians had been reduced to poverty-stricken outcasts in the farming community, those of the Southwest had retained control of their lands, their environment, and their lives.

The mystical nature of the landscape and the people who lived there had a transforming effect on the art produced there. "While other Western art emphasized drama, adventure and activity, New Mexican pictures share an emphasis on atmosphere and character rather than action."[22] The quality of the light and the harsh, vivid colors were demanding and stimulating. Marsden Hartley, who had gone there in 1918, wrote Stieglitz: "This country is very beautiful and also difficult . . . it is not a country of light on things. It is a country of things in light, therefore it is a country of form, with a new presentation of light as problem."[23]

Since her first visit there in 1917, Santa Fe had never left O'Keeffe's consciousness. Reminders of New Mexico occurred periodically and unexpectedly. In 1925, Stieglitz mentioned in a letter the pull of the Southwest on Georgia's mind: "She dreams of the plains—of real spaces."[24] A month later there was a romantic apparition at Lake George: "Night before last a strange young artist from Santa Fe appeared unannounced. He had come in a Ford all by himself from Santa Fe—slept under stars at night . . . He stayed here thirty-six hours."[25] That same year, Georgia saw an essay she liked by Mabel Dodge Luhan, who lived in New

Mexico. Georgia wrote Luhan, whom she barely knew, about the possibility of an article on her paintings. The letter ended: "Kiss the sky for me—You laugh—but I loved the sky out there."[26]

During the summer of 1926, Paul and Beck Strand visited Taos, where they stayed with Luhan. Presciently, Paul wrote Stieglitz that he wished Georgia would come out: she "would do extraordinary things."[27] Paul Rosenfeld went to New Mexico as well, and in the fall of 1927, at Lake George, he and Georgia discussed their recollections. That year, O'Keeffe painted the vivid and powerful western landscape *Red Hills with Sun*. In this composition the radiant sun is partly concealed by the strange bare hills, lying in vivid folds against the sky. The atmosphere is electrifying and, with the use of the clarion scarlet, makes a dramatic shift from the black-and-white New York landscapes, the muted shells, and the domestic flowers that made up the rest of that year's work.

One of the reasons that New Mexico loomed so large in the eastern consciousness was the flamboyant presence there of Mabel Ganson Evans Dodge Sterne Luhan. Mabel was a rich and frequently married woman from Buffalo, who collected people and created situations. With her second husband, the architect Edwin Dodge, she established the Villa Curonia in Florence, where an illustrious group of guests stayed, Gertrude Stein and Alice B. Toklas among them.

Mabel's third husband, the artist Maurice Sterne, first urged her to come to New Mexico in 1917. Arriving in Santa Fe, Mabel went at once to Taos, where she was smitten by the landscape, the Indians, and the atmosphere. She rented a large adobe house and threw herself into the affairs of the Indian pueblo. Mabel's response to the Southwest was more ardent than Maurice had bargained for: she fell in love not only with the countryside but with one of its inhabitants. Within the year Mabel was separated from her third husband and had established a new life with the Pueblo Indian Tony Lujan.

Mabel bought the first land she had ever owned, on the edge of the pueblo, and with Tony's help she built an elaborate and beautiful adobe house, Los Gallos. She sent for her furniture from Florence and moved in. Tony moved in with her, and in due course they married, though, with characteristic eccentricity, Mabel anglicized her own name to Luhan, while Tony's remained Lujan. Once installed at Los Gallos, Mabel began singing the

praises of Taos to friends and illustrious strangers. It was Mabel who persuaded D. H. Lawrence to come to New Mexico: she "willed" his coming, sending a long letter on parchment, which assured him solemnly that only he could interpret the culture there. Lawrence succumbed to her blandishments and arrived in the early twenties. He found her a forceful woman, "Heavy with . . . energy like a small bison."[28]

Another vivid member of the Taos community was the Honorable Dorothy Eugenie Brett, whom Georgia met in New York in the fall of 1928. Brett was an engaging and unpredictable Englishwoman, who had studied art at the Slade School in London. Lawrence had invited her to join him and his wife, Frieda, in a sort of utopian commune he planned in New Mexico. Brett accepted, and though the utopia did not materialize, the three stayed on together in the magical landscape. In exchange for the manuscript of *Sons and Lovers*, Mabel gave Frieda the 180-acre Kiowa Ranch, and when the Lawrences returned to Europe, Brett stayed on there alone. Brett was kinder describing Mabel than Lawrence was—the two women were lifelong friends—but she, too, saw a taurine quality: "She is short, square, a small black bull . . . a small powerful woman with a beautiful voice and beautiful eyes."[29]

D. H. Lawrence painted as well as wrote, and in the winter of 1928–29 there was talk of a show of his pictures at the Room. Both Stieglitz and O'Keeffe admired Lawrence's writing (Stieglitz had supported the effort to distribute *Lady Chatterley's Lover* in America). He could not, though, "see" Lawrence's paintings in the Room—a final and implacable judgment. At Mabel's urging, Brett came to New York in November 1928 with her own paintings, and one agonizing afternoon she spread them out for Stieglitz to judge.

Brett was a *faux naïf* artist, and her later works are brilliantly colored primitive representations of Indian ceremonies, dense with rhythmic line and pattern. Stieglitz could not "see" her work in the Room, either, but he referred her to another dealer—Frank Rehn—who, to everyone's relief, said he would giver her a show. Stieglitz and O'Keeffe had both taken a liking to the shy, unpredictable Englishwoman, who was deaf and carried a large ear trumpet named Toby. That winter, Brett stayed initially with Mabel Luhan, in her apartment at One Fifth Avenue. Brett and Mabel had a close and complicated relationship, marked by fre-

quent disagreements. When Mabel's invitation to One Fifth was revoked because of one of these, Brett moved to the Shelton, where she saw O'Keeffe and Stieglitz often. Brett was enchanted by them both:

> The famous breakfasts began . . . Stieglitz with his silver hair like an aureole round his head; his serene face; lovely, shapely lips; strange dark eyes . . . slight and small . . . composed and dignified. Georgia, her pure profile against the dark wood of the panelling, calm, clear, her sleek black hair drawn swiftly back into a tight knot at the nape of her neck; the strong white hands, touching and lifting everything, even the boiled eggs as if they were living things—sensitive, slow-moving hands.[30]

That winter, Mabel Luhan had given Georgia an open invitation to visit her in Taos, and after Brett left New York to return to New Mexico in the spring, the pull of New Mexico became stronger and stronger. When Georgia first decided to travel, she considered Europe, but the bare red hills and the southwestern sky were by now a powerful part of her consciousness, and they proved stronger than the remote charms of the Continent. On April 27, Georgia set off with Beck Strand for the spare and vivid landscape of Santa Fe.

• • •

IN 1929, Santa Fe was a small town in the hills, dominated by the Indian pueblos, the colonial Spanish presence, and the Catholic Church. It was the oldest American capital and one of the oldest European settlements; its character had remained unchanged for several centuries. The adobe buildings were low and modest, the streets narrow and dusty. In the quiet shady square at the center of town a stone shaft stood, marking the end of the Santa Fe Trail. Indians in blankets spread out their wares daily on the sidewalk; they were regarded with reverential awe. "It is as if [the tourists] felt that the Indians had some key, some integrity, some harmony with nature which they, the white Americans, had lost."[31] This attitude was a far cry from the one that prevailed in Wisconsin: "You may not think much of Indians up there," Georgia wrote Catherine in Portage, "but we have certainly had a great time with them here."[32] In Santa Fe the Indians' power

was manifest and magnetic, and the splendid landscape proclaimed its own strength.

Beck's reasons for traveling to New Mexico were complicated and personal, as were Georgia's. In spite of a strong bond between them, the Strands' marriage was under strain. Beck, who desperately wanted a child, had been trying for several years to conceive, and had miscarried at least once. Beck was insecure and unsure of herself in any case, and the increasing anguish of infertility, as well as the temperamental differences between her and Paul, had established a painful pattern. "How could I ever have left you—all your tenderness," she wrote Paul just after her departure, "but it is just as well I am going, that row the last night was pretty awful and I know I was behind it all— But I can't help it."[33]

The two women traveled across the country by train, stopping in Chicago to see Alexis, Betty, and their new baby, Barbara June. It was an easy trip, and Beck wrote: "even little Stieglitz could stand a trip like this."[34] She reported that "Georgia is very well and content," but went on: "I hope she will remain so."[35] As they approached New Mexico, Georgia's pleasure in the landscape was increasingly evident, and her spirits lifted.

On arrival in Santa Fe, on April 30, the two women went first to the Hotel de Vargas. This proved seedy, and they moved to La Posada, where they each had "a nice single room with running water at $2.50 a day."[36] They plunged at once into the local activities, planning to attend the Corn Dance the next night at San Felipe Pueblo and the Indian relay races and games three days later, in Taos. They had not told Mabel they were coming, and planned to surprise her and Brett at the Indian ceremonies. Their privacy would be lost once Mabel saw them, and Beck— very fond of Georgia and somewhat awed by her—regretted it. Mabel was at the Corn Dance, as expected. Also as expected, "as soon as the dance was over Mabel began working on us and has, as I felt she would, offered us the same studio you and I had," Beck wrote Paul.[37] Beck and Georgia had planned to go to Taos anyway, and Mabel's powers of persuasion were potent. She was not only powerful, she was charming; her house was beautiful and well run, and the combination was hard to resist. Beck and Georgia agreed to leave for Taos two days early. They spent the next four months in Los Gallos, on the edge of the high, flat, sage-covered plain.

The narrow dirt road to Taos from Santa Fe passed through the canyon of the Rio Grande, winding dangerously along the riverbank. Emerging from the confinement of the canyon, the great high mesa stretches out beyond, seven thousand feet up, ringed by mountains that rise another six thousand feet. "Coming out of the canyon," Lawrence wrote, "is an unforgettable experience, with all the deep mountains sitting mysteriously around and so much sky." [38] Taos lies in the southeastern corner of the plain. It is made up of three villages: Rancho de Taos, where the old adobe mission church stands; San Fernando de Taos, the village itself; and San Geronimo de Taos, the five-hundred-year-old Indian pueblo, layers of adobe dwellings, sturdy, economical, and serene.

In the late twenties, Taos was a very small town indeed, entirely dominated by the Indians. Brett remembered it with affection:

> Women with baskets of flowers and vegetables on their heads—offerings to the Church—would walk along, their backs straight as poles. And wagons filled with Indian men and women going down to shop. Occasionally a burro with packets of wood on each side of it. Few and far between were the cars. The rhythm of life was slow in those lovely days—the roads muddy, the avenue of cottonwoods untouched, the roads after a storm a quagmire. [39]

For Georgia, the experience of being high in the mountains, beneath that sky, among those small, modest, earth-formed buildings, was overwhelming. Her heart lifted like a bird. She wrote Catherine: "I am West again and it is as fine as I remembered it—maybe finer— There is nothing to say about it except the fact that for me it is the only place." [40] The difference between the vivid glowing landscape of New Mexico and the somber green enclosure of Lake George was at once apparent to her: "Lake George is not really painting country. Out here, half your work is done for you." [41] In fact, the new landscape suited Georgia exactly: "The climate here is very fine . . . The people are interesting— I have the finest studio I have ever had— There is very little that doesn't seem quite perfect." [42]

The Big House, the main building at Los Gallos, was a three-story adobe house, with carved wooden gates opening from the street into a flagged courtyard. Georgia and Beck stayed there, in

one of the four guest bedrooms, for nearly three weeks before moving to Casa Rosita, the Pink House, the cottage where both the Strands and the Lawrences had stayed. Lawrence described it:

> We have got a pretty adobe house with furniture made in the village and Mexican and Navajo rugs and some lovely pots. It stands just at the edge of the Indian reservation: in front, the so-called desert, rather like a moor covered with whitish sagebrush . . . Some five miles away the mountains rise . . . on the North the sacred mountain of the Indians sits massive on the plain.[43]

Meals were eaten at the Big House, which lay across an alfalfa field from the cottage. The property was scattered with smaller buildings, and Georgia's studio was nearby. It was round, with a high ceiling, a fireplace, and north windows that looked out over sage-filled plains toward the Taos mountains. Georgia described it:

> Taos is a high, wide, sage-covered plain. In the evening, with the sun at your back, it looks like an ocean, like water. The color up there is different . . . the blue-green of the sage and the mountains, the wildflowers in bloom. It's a different kind of color from any I'd ever seen—there's nothing like that in north Texas or even in Colorado. And it's not just the color that attracted me, either. The world is so wide up there, so big.[44]

Georgia's physical and emotional state had been fragile when she left, and Beck sent solicitous reports back East. "Georgia has made remarkable progress," Beck wrote. "She looks so well already—all the tension gone and a real serenity flowing. Tell Stieglitz this, and that she has not had a single ache or pain or physical distress since we arrived . . . She is a new woman."[45]

The day after her arrival in Taos, the new woman boldly began a perilous undertaking, evidence of her new independence. With Beck and Tony Lujan as instructors, Georgia set out to learn how to drive. At first Beck reported approvingly that Georgia "really did very well, and was not at all timid."[46] Georgia's approach was undeniably bold: less than a week after the first lesson, Beck announced excitedly that she and Georgia had bought a black Ford sedan with a steel-blue interior for $678.

After discussion, the car was named "Hello! . . . the good old American greeting; Georgia and I both seem terribly *American* with all those other people here."[47] (A number of Mabel's guests were European.) After Georgia clipped a gatepost, Tony refused to drive with her, and the task of teaching fell entirely to Beck. After nearly two weeks of lessons, Beck found Georgia still easily rattled and distracted, and decided she had not much instinct for driving after all. By the end of the month, however, Georgia was finally at ease driving alone and was already looking forward to buying a more powerful car. Georgia herself had seen only the excitement of the project. "The bridges here are only wide enough for angels to fly over so they give me great difficulty . . . It is lively I assure you," she wrote cheerfully to Paul Strand.[48]

Beck and Georgia spent much of their time in the open, walking, riding, and camping in the high dry air, under the strong New Mexican sun, surrounded by the great open sky. Beck was an excellent companion for Georgia, energetic and responsive, and the two shared a delight in their surroundings. Georgia's descriptions of her time there focus on constant travel: a four-day horseback trip to visit Brett at the Kiowa Ranch, forty miles away; a trip to an Indian dance; three or four days at Marie Garland's ranch, the H & M, at Alcalde; a long car trip to the Grand Canyon, the Painted Desert, and Navajo country. This gypsyish life would have been anathema to Stieglitz, who depended for his peace of mind on knowing exactly where he would be each day, each night, and, more important, knowing exactly where Georgia was.

Georgia was well aware of this: "Mabel always wanted to get [Stieglitz] out here. He never came. I wouldn't let him. He had the sort of mind that wouldn't have let me drive five miles to the market by myself."[49]

Georgia's wanderlust was given free rein. She was entirely unconcerned with material considerations—where she slept or how long she stayed. For her, the summer was a continual visual feasting on the great spectacle of the Southwest.

Some of the evenings were quiet; Beck reported that they lived like "two old-fashioned girls in the country—sewing at night around the fire, playing solitaire, chatting."[50] On other evenings there were entertainments at the Big House. Tony brought Indians in to dance and sing; Mabel brought Anglos in to eat and talk. The Taos community was full of artists, writers, and eccentrics. John Marin was there in June, and the critic Hutchins Hap-

good and his family spent the summer. Willard "Spud" Johnson, a journalist, was a sometime secretary of Mabel's. There was Witter "Hal" Bynner, a poet from the East; Daniel Catton Rich came through, a midwestern tourist with a lucid and perceptive mind, who would become an influential museum curator. John Collier, commissioner of Indian affairs, and his son Charles were there; the local artists Cady Wells and Russell Vernon Hunter; Henwar Rodakiewicz, the filmmaker; the Mexican artist Miguel Covarrubias and the photographer Ansel Adams turned up: all of them became friends of Georgia's. There was a constant stream of visitors; like any great hostess, Mabel gathered people to her like a magnet, each attracted partly by her, partly by the collective glow of the whole.

On her arrival that spring, Georgia was much taken by her energetic, charismatic, and deeply generous hostess. Mabel had given her a new world. And "Mabel was very nice. She charmed everyone. Her silence made you defer to her. They were *knowing* silences. They affirmed the deepest thing in you. You *wanted* to be near Mabel," wrote a friend.[51] Mabel's energy, her intensity, her silences, and her power all drew Georgia to her. The courageous and eccentric example Mabel had set was deeply appealing to Georgia. Mabel had left the East, left her husband, and left the conventional world to cleave to a new, spare, bright existence; she seemed to Georgia to have a deep inner life.

Brett was a gallant and adventurous figure. Having received little support, financial or psychological, from her aristocratic English parents, she had first chosen the uncertain life of an artist, then thrown in her lot with the unreliable D. H. Lawrence and his wife, Frieda, traveling four thousand miles to the Taos mountains. There she lived for much of the rest of her life in rural poverty in a small wooden cabin, tending horses, fishing, painting, writing, and squabbling with Mabel. In spite of her deafness, Brett saw herself not as handicapped but as rather rakish. She spoke proudly of her "rough Western ways," and she wore a big high-crowned sombrero, loose dungaree pants, and a pair of tooled western boots in which she dashingly concealed a long knife. Georgia liked Brett and liked visiting her on the Kiowa Ranch; she was encouraging about Brett's painting and her writing.

Mabel and Brett were not the only unusual women in the community; in fact, the area was remarkable for the number of strong and independent women who had chosen to lead their

lives there. Many of these were single, or much married, and largely indifferent to eastern mores. (Some of these women were lesbian; one aspect of Taos's unconventionality was an early tolerance of homosexuals, both male and female.) That Georgia was spending the summer there without her husband did not brand her as a monster.

Unconventional behavior on a smaller scale was accepted too. New Mexico was a sensual feast of heat, color, and air, and nude sunbathing was a local practice. D. H. Lawrence viewed this as a kind of spiritual surrender to the sun. Georgia's motivation was more homespun: she loved "that sun that burns through to your bones."[52] Beck announced: "Georgia and I get into our skins and out of our clothes right after breakfast, put down a blanket and lie in the warm healing sun."[53] With Brett, Georgia clambered about the Kiowa Ranch, then, after bathing naked in the irrigation ditches, they lay drinking in the heat of the sun through their skins. And one day late in the summer Georgia and Beck, in bathing suits, washed the Ford with the hose. They could find no sponges, and it was Georgia's idea to use sanitary napkins instead. Finishing the car, they took off their bathing suits and turned the hose on each other. Georgia wrote gleefully about these schoolgirlish capers to Mabel, who was away, mentioning that there was no one else she could tell.

Georgia and Beck were full of high spirits. One day they drove "Hello" out into the sage, stripped off their clothes, and walked around naked in the sunlight. Pleased with their daring, they recounted this to John Marin at the breakfast table. Marin, who was rather sedate, remarked repressively, "You WOULD." This made Beck laugh: "Really it is too terrible how untamed and wild we are." His stuffiness made him an irresistible target, and the two began "all sorts of antics and prickings and stickings of poor Marin."[54] One night Georgia began teasing him and said wickedly, "You little bit of a thing, I could put you in my pocket." Marin was indignant at this, whereupon Georgia announced, "Yes, and if you don't look out I'll kiss you!" Beck joined in, and threatened, "Yes, we'll both kiss you." Marin "braced himself in his deep chair and looked most worried and bristly, so with an eloquent look at each other we made a dive at him, one on each side of the chair, and while he threw up both arms to ward off whatever was coming, we planted, each of us, a peck somewhere

around the neighborhood of his head of hair . . . he had to laugh himself."[55]

One evening the two women dressed up for dinner in fancy hats and clothes and makeup: "giggling and roaring we walked through the pasture in answer to the dinner bell and when we went in created quite a sensation," wrote Beck.[56] Another night Beck and Georgia went dancing with the artist Andrew Dasburg and another friend, Bob Smith. The dance was at the town hall, and most exclusive: "Gents 25c—Ladies free." Dasburg did not dance, so Smith stepped out alternately with the two women, carrying on until midnight, when Georgia and Beck "had a spin together . . . it really was great," Beck reported.[57]

Beck was delighted with Georgia's continuing improvement in health and mind: Georgia was driving, dancing, "eating like a man," and even "smoking a cigarette every once in a while."

> Georgia . . . certainly belongs to this world and so many of the things she gets into in New York have dropped away out here as they are not really part of her real self. She eats everything, is indefatigable, plays solitaire, loafs, chats, laughs a lot and has no theories about anything but just goes along as things come . . . Of course, the newness is still present and eventually, when she gets in her stride in her work and becomes more concentrated, she may possibly take on some of the old irritation, but I don't think so.[58]

Georgia throve on all of it: the land, the sky, and the freedom. "The daylight is coming," Georgia wrote Henry McBride. "I am going up on the roof and watch it come—we do such things here without being thought crazy—it is nice—isn't it."[59]

· · ·

BOTH BECK and Georgia had come to New Mexico to paint. They worked separately but peaceably, giving each other encouragement, companionship, and ideas.

Beck was uncertain of her ability and felt intimidated by Georgia's presence. "I get frightened when I see the vastness of what is to be worked with but I'll do the best I can. I know I'll be discouraged if I see what Georgia does so I shall try not to until I go," she wrote Paul.[60] Georgia, however, was encouraging and supportive. Beck reported:

I had a very wonderful talk with her two nights ago . . .
We were sewing before the fire. We got into a discussion of
personal problems and how the person himself has to take
the step, and that led to what I was doing with pastels and
she said many things about how to clarify what you wanted
to do, that were very helpful. She said my world was a
powerful one and a beautiful one but that there were holes
and empty places that she could tell me how to improve but
would not because after all it is to be done through feeling
and that she could not add. Anyhow, when I start again,
I shall do better.[61]

The assistance was mutual, however. Georgia encouraged
Beck to begin work, but it was Beck who recognized as subjects
some of the things for which Georgia would become famous.
Beck was intensively responsive to the natural world, and her eye
sought out the same shapes and colors that Georgia's did. It was
Beck who first painted the artificial roses, the sky, and perhaps
the Penitente cross. "The paintings I am doing now . . . are some
white artificial roses I got in the department store," she wrote
Paul in May; "they are really quite beautiful. Pure, clear white,
and a nice shape."[62] Georgia began painting the artificial white
flowers later that summer, and continued to use them for years
thereafter. Besides the flowers, Beck addressed herself at once to
the New Mexico sky, without any reference to the landscape
below. On June 11 she wrote: "I finished a pastel that is GOOD,
Georgia says it is the best one I have done . . . The moon and
fleecy clouds," and her next attempt was the moon and one star
in a dark sky.[63] Later in the summer, Georgia would do her own
rendering of the gorgeous New Mexico night, *The Lawrence Tree*,
and the sky would increasingly figure in her paintings thereafter.
Shortly after their arrival, in mid-May, the two women walked
out to the Penitente cross behind Mabel's, but it was Beck who
began work on a picture of the black cross in early June, while
Georgia was addressing herself to the Indian pueblo.[64]

Georgia's response to Beck's first attempt in oils was at once
encouraging and rather crushing: "Georgia liked it but also re-
marked that she could work on it and make it a *grand* painting."[65]
Her comment reveals a strong interest and identification with
Beck's work. (Beck's first oil is not identified, but if it was the

Penitente cross, then Georgia did indeed make of it "a *grand* painting.")

Handicapped by a sense of inferiority, Beck wrote wistfully to Paul that perhaps she was not smart enough to keep up with Mabel and Georgia. Anxiety bred resentment, and she pointed out, with a trace of spite:

> [In three weeks Georgia] has painted only three things:
> A fairly big one of trees, a lady santo, and one of Mabel's
> porcelain roosters . . . only slight in content . . . I do much,
> much more than she does, both in work and outside
> things.[66]

The two fell out over a letter that was to be mailed and was not, and Beck wrote crossly: "She knew I was sore but you know how stubborn she gets when she is made to feel in the wrong . . . Georgia is extremely self-centered and thinks mostly of herself." The friendship was fundamentally sound, however, and in the same letter Beck continued, "We are both having a good time —lots of laughs and fun."[67]

* * *

THAT SUMMER, Mabel returned to Buffalo for a hysterectomy. Georgia and Beck stayed on at Los Gallos. By then they had made their own friends, and in any case, they were well looked after by Tony.

Tony Lujan was an impressive man, tall, handsome, and taciturn. "His white sheet was spotless, his long braids were beautifully arranged, intertwined with a white ribbon that made an exquisite pattern. He was well built, though on the portly side, and had an enormous chest. He stood out from the rest [of the Indians] like a proud cock amongst a flock of meek chickens."[68] Mabel was rich and self-indulgent, gregarious and loquacious; Tony was silent, illiterate, independent, primitive. She was deeply committed to society and spent much of her time planning dinners; he was deeply committed to farming and spent much of his time with his animals (he called his small herd of horses "a family"). In spite of the obvious incompatibilities, there was nonetheless a deep and powerful connection between them. Tony's strength was not threatened by Mabel's money, and de-

spite all odds, their unlikely marriage worked well and lasted the rest of their lives.

By all accounts, Tony was tactful, generous, and kind. He was amused by the Anglo visitors, and when he heard that Ida's nickname for Stieglitz was "Crow Feather," he began to call Georgia "Mrs. Crow Feather." Besides a sense of humor, he shared with Georgia a strong affinity for the natural world.

> One day I was out riding with Tony Lujan. The plum trees were in blossom and there were wild roses everywhere— the colors were just magnificent. I said, "Tony, I just don't think you like it around here as much as I do." He was silent for a long time and then he grunted and said, "That's why I here." [69]

He was a sympathetic companion, "one of the most remarkable people I have ever met," she wrote Catherine.[70] To Mabel, Georgia made a more heartfelt comment: "I want to tell you . . . that next to my Stieglitz I have found nothing finer than your Tony . . . your Tony is a rare—rare person."[71]

Tony took Georgia through the Indian country by car and by horse, revealing the landscape and providing access to the reservations and the pueblo. The two of them went camping together, once as far as Mesa Verde, in Colorado. Tony and four other Indians took Georgia and Beck on a four-day trip to a celebration at Las Vegas, New Mexico. Georgia was moved by the ceremonies: "The boys danced two nights . . . I quite lost my head over the perfect thing John is . . . His dance was so beautiful—so terribly alive—he enjoyed it so—the human thing that happened to them all—the change from almost stolid indifference to that great aliveness," she wrote.[72]

The Indian dances were a source of fascination for the Anglo tourists. D. H. Lawrence, seeing the San Geronimo dance, wrote:

> Never shall I forget watching the dancers, the men with the fox-skin swaying down from their buttocks, file out at San Geronimo, and the women with seed-rattles following. The long, streaming, glistening black hair of the men . . . Never shall I forget the utter absorption of the dance, so quiet, so steadily, timelessly, rhythmic, and silent, with the ceaseless down-tread, always to the earth's center . . . Never shall I

forget the deep singing of the men at the drum, swelling
and sinking, the deepest sound I have heard in all my life.[73]

Religious intensity, both Indian and Christian, was an im-
portant part of the New Mexico landscape. The Catholic Church,
established four centuries earlier by the Spanish colonialists, was
integral to the community. The mysterious Penitentes were active
there—members of a Catholic sect which arrived with the early
Spaniards. During the rest of the year the Penitentes functioned
much like any other Catholics, but at Easter, rites of flagellation
and crucifixion were performed. Originally, the crucifixions were
done with nails, but in the milder twentieth century, thongs were
used to bind hands and feet to the cross. Even so, death some-
times resulted from the excruciating ordeal. The merciless physi-
cal trials were readily accepted by the indigenous Indians, whose
own rituals contained similar duress. The small Penitente
churches—*moradas*—were a part of the landscape, as were the
austere black crosses that stood in the hills. "I saw the crosses
so often . . . like a thin dark veil of the Catholic Church spread
over the New Mexico landscape," Georgia wrote.[74]

Georgia began slowly but worked with increasing intensity
that summer. Six days after her arrival in Taos, she started to
paint. The great sky, the wide horizon, and the absence of any
constrictive presence were liberating. She found herself in a new
world, and she wrote Mabel in Buffalo: "I don't know whether
you know how important these days are for me or not but I feel
it is so. They seem to be like the loud ring of a hammer striking
something hard."[75]

She was feeling her way into her new world. Her first three
attempts were of trees, the wooden "lady santo," and Mabel's
porcelain rooster. Her next painting seems to have been the
painting of Taos pueblo, on which she began work in early June.
The Indians did not welcome Anglos recording their lives and
houses, and Georgia had to pay fees for her sessions there, "so
much for so many times on the same painting and so much for
each new one."[76]

In August, Ida O'Keeffe arrived. Georgia had recommended
her to Mabel as a nurse, and Ida accompanied Mabel on her trip
back and presided over her recuperation. Georgia had asked both
Beck and Ida to write Alfred cheering letters. Assuring him that
Georgia was happy and productive, Ida wrote: "Georgia has been

making some big pictures. Did one up at Brett's yesterday of a pine tree and millions of stars. She is sitting under the tree looking up to paint it, quite a knotty dry-looking tree."[77] The "pine tree and millions of stars" is the lyrical *The Lawrence Tree*, one of O'Keeffe's favorite paintings.[78] Georgia described it later: "There was a wonderful big pine tree in front of the house, with a carpenter's bench under it. I used to lie on the bench and look up, and eventually there was nothing to do but paint that tree."[79]

If for Georgia the summer was one of exhilaration, for Alfred it was one of fear. Beck wrote him from Santa Fe in May, describing Georgia as having acquired "a strength that has come from finding what she knew she needed."[80] Alfred hinted complacently that the whole idea had been his, but his last comment reveals his true feelings:

> As for Georgia, Georgia is always a different person when she is free—with none of the ordinary responsibilities—and in a congenial surroundings (country & life) and when she really feels stimulated & well. That's why I felt a trip to Europe stupid—but I said nothing until others did— I knew the Southwest—just where she is—was *the* thing for her— I saw the inevitability of just what has happened . . . Of course I'm very glad. Tomorrow it's three weeks that you two left.[81]

Alfred tried to match Georgia's exploits with his own: he splurged, buying an elegant new Victrola, and he, too, learned to drive. At first he kept up his spirits, and in June, from Lake George, he wrote Seligmann: "Georgia continues to have a very gorgeous time, and as I see this I realize fully how silly (criminally so) were she to come here this summer."[82] Later in the month, however, to Elizabeth, he admitted to unhappiness. "I have been going through a kind of crisis with myself since [arriving] here," he wrote.[83]

Georgia had originally planned to be back at Lake George by July 1 but was not ready to return then. At this, Alfred felt he had reached a gloomy and arid plateau: "A miracle had happened. I believe I'm finally actually beyond all Hurt . . . I certainly went through Hell itself for two weeks."[84]

Three weeks later he wrote rapturously of a spiritual reunion:

I had a marvellous wire from Georgia this morning— She feels as I feel— Exactly. It all seems as if I were in a trance— She will stay in Taos & paint awhile & will come soon if I promise honestly to take care of myself— Of course you know what I am—and what she is—and what we are together— She feels a greater & more wonderful togetherness—the first coming together in purity on a much higher plane![85]

But in a week he had plummeted again, increasingly forlorn and frantic, fearful that Georgia would never return. His letters to her were full of misery, and aching with neediness. As though the letters were not enough, he sent her photographs, symbols of all the pain he was feeling. The 1929 "Equivalents" are dark and ominous, muffled suns behind thick ridged blankets of clouds. "That's death riding high in the sky," he said of the photographs later. "All these things have death in them . . . ever since I realized O'Keeffe couldn't stay with me."[86]

In late July he felt again that he had reached a breakthrough.

I had the toughest day & night yet, up 40 hours writing—& writing— But sent no letters nor telegraphs—couldn't. Georgia was fortunately out of reach. But four wonderful letters from her came . . . my Vision is Clear once more— I know what separated us—it is The Room! It came first—& I believed G. understood the Room was another form of her . . . I know she'll feel very happy. And that is all I really want.[87]

The correspondence between Georgia and Alfred was copious. They wrote nearly daily, often more than once, and during their shared life exchanged more than eighteen hundred letters and telegrams. Despite the volume, their communication was less than perfect. Since a central issue between them—Dorothy Norman—was never discussed, the dialogue that summer was oblique and ambiguous. Georgia's abstract epistolary style, in any case, tended to avoid specifics, and this particular issue was one that Stieglitz himself was not prepared to raise. Nearly four months after her departure, Alfred still did not acknowledge why Georgia had left, what it was that troubled her, or what the matter was between them.

While Alfred groped anxiously for motives and causes, Georgia, freed from the turmoil of the city and from the daily sight of Alfred's foolishness, began slowly to move toward a new, calmer perspective on her situation. Part of this came from an unexpected source. Georgia and Mabel had carried on a warm and personal correspondence since Mabel's departure. In these letters Georgia acknowledged her own situation, uncharacteristically: "I feel like snuggling up to you and crying about it all," she wrote. "I very much need what this summer is giving me." [88]

Tony Lujan had divorced his Indian wife when Mabel divorced Maurice Sterne. Unlike Sterne, Lujan's ex-spouse still lived nearby. Throughout his marriage to Mabel, Tony maintained a part of his life that was purely Indian. Periodically, he left without explanation for the pueblo, resisting Mabel's attempts to pursue or prevent him; this drove Mabel frantic with jealousy. That summer, writing to Georgia from her hospital bed in Buffalo, Mabel was so distraught at Tony's infidelities—real or imagined—that she considered leaving him. Tony's misery at Mabel's departure was visible and touching, and Georgia could see that Mabel's possessiveness threatened to destroy her marriage. "I rather imagine the twists and turns your imagination is taking while you are there alone," she wrote Mabel. [89] Parallels between Mabel's situation and her own gave Georgia a new perspective on her marriage:

> I am sure that you are the center for him as I am the center for Stieglitz, and he for me . . . Something you are—and something Tony is—is helping me much with something between Stieglitz and myself—it is smoothing away many things for me— Tony just being what he is—seems to pull out of me the best things that are in me— And a lot of surface things—that hurt one's vanity—and that the world looks at . . . just become so much nothing— For the thing you have—hardly anyone can see because hardly anyone knows it— What worries you is that the World sees— Well —let it go to Hell. [90]

Georgia was determined to understand and accept Stieglitz's position, adopting an attitude that would be supportive for Alfred and liberating for herself:

I know that many people—men and women—love Stieglitz
—and need the thing he has to give— I feel that I have two
jobs—my own work—and helping him to function in his
own way— And by helping him I sometimes mean—I don't
want to get in his way— That is why I came out here . . . I
feel that you haven't any more right to keep Tony utterly
unto yourself than I have to keep Stieglitz—if Tony
happens to go out to women with his body—it is the same
thing when one goes out for a spiritual debauch . . . even if
he goes out and sleeps with a woman it is a little thing.[91]

Georgia's final piece of advice sounded an ominous note of
warning, a reminder of the risks that accompanied too great a
demand: "For God's sake—don't try to squeeze all the life out of
him— I know from experience that it isn't a pleasant sensation—
and you will not like what is left."[92]

The pressure from Alfred mounted steadily. "I have been
having telegrams from Stieglitz all day today," Georgia wrote
Mabel. "I am about decided to go back to Stieglitz next week . . .
He seems to be in a bad state and I feel I have little choice in the
matter. I can't tell you how it grieves me."[93] Paul Strand was
staying with Stieglitz at the Hill in July, and the two of them
spent an agonizing week together. Paul wanted to join Beck in
New Mexico, but she had not agreed to this. "Common suffering
does bring souls closely together," wrote Alfred.[94]

In August, Elizabeth wrote Alfred anxiously: "No word from
you—it does worry me . . . I don't want you to be so alone . . .
I know you only write when things lift—when there is a little
peace and sunshine—so there is no peace and sunshine."[95]

Alfred may have written Elizabeth only when things lifted,
but when things closed down around him he wrote Georgia very
readily. "I had fifteen letters from Stieglitz last night," Georgia
wrote; "it made me very sad."[96] His letters became increasingly
insistent, and by mid-July, she began despondently to reconcile
herself to making an early return. She had not told him before,
but she finally made a clean breast of her worst sins. She con-
fessed to her riding trips, her driving, and her "new closed-in
Ford," and waited with trepidation for his response. But Alfred
was in no position to judge her. While waiting for the mail at
Lake George, he had impulsively chartered a small airplane and

was taken high across the lake, a far more reckless exploit than any of Georgia's. Landing, he received her letter. "After his ride there was nothing for him to say about the Ford except that it was good—that he was glad I had done it," Georgia wrote Mabel.[97]

The situation was known among their friends. Henry Mc-Bride wrote to Georgia in September: "Are you still down there leaping from cliff to cliff, from mountaintop to mountaintop? . . . Things have come to such a pass that the movements of Georgia O'Keeffe are generally known, like those of Colonel Lindbergh." He had read about her doings, he told her jauntily. "Such things as there were about Georgia O'Keeffe . . . ! All a revelation to me! I got the idea she was a hard, managing type of female, the kind that stops at nothing, the kind that burns up her children in the kitchen stove for the sake of the insurance. I got quite alarmed for Alfred. And then almost immediately there came the news that Alfred had taken to flying." McBride's gentle teasing underscored his affectionate sympathy for O'Keeffe, and he finished: "But I do sincerely hope you and John Marin are going to cool down a bit before you return to New York . . . Otherwise it's going to be demned [sic] hard on us critics."[98]

It was a measure of Alfred's affection that he supported Georgia's purchase of a car, and it confirmed her underlying belief in his real support of her. But Stieglitz's firm theoretical support of O'Keeffe was paralleled by an equally strong unconscious opposition. The dynamics of a strong and loving couple are complicated and contradictory: "The relationship was really very good, because it was based on something more than just emotional needs . . . Of course, you do your best to destroy each other without knowing it," said Georgia perceptively.[99] Far from being an indictment, the comment merely acknowledges the latent fear that exists on both sides of any close and demanding relationship—which is the fear of the dissolution of self, the threat of destruction that lies beneath a powerful love. It was a tribute to their abiding affection that they insisted on maintaining the relationship rather than acknowledging the inexorable pulls toward its destruction.

Georgia saw that it was her responsibility to resist those destructive forces from both herself and Alfred. She had not opposed Alfred's control of her life, because of its kindly patriarchal

guise: his rules seemed like a token of his affection or, more difficult to resist, an indication of his need. Either way, she now saw, he had prevented her from leading her own life. "I think I would never have minded Stieglitz being anything he happened to be if he hadn't kept me so persistently off my track," she wrote Mabel.[100]

Georgia recognized that her attitude must be reciprocal and that in asking Stieglitz to let her live her own life, she must let Stieglitz live his. She determined not to cripple him with jealousy, not to "choke the life out of him." This was a lucid and admirable decision; jealousy, however, is not so neatly set aside, nor is the alteration of a ten-year pattern of deference so easily achieved.

As Georgia found her way to this rigorous and generous attitude, Alfred floundered, swinging back and forth between elation and despair. Part of the reason for this was Georgia's obliqueness and his own stubborn timidity: it was difficult to deal with a problem when it was never named or acknowledged. Alfred's misery, however, was due in some measure to his own actions in another sphere. Moving parallel to his feelings of loss and passion toward Georgia was an entirely antithetical thread.

Alfred's first airplane flight had been unplanned, but when he took another, longer one, all the way to New York, he set his affairs in order in case of a fatal crash. The arrangements he made with Elizabeth revealed a subterranean current. "I intend flying tomorrow . . . I am authorizing your mother to send all mail etc. for me to you. I know you'll certainly place it where it belongs. Under no condition do I want Georgia to have anything to do with it."[101]

Elizabeth was again Alfred's confidante, as she had been in 1918, during his illicit involvement with O'Keeffe. Now he planned to entrust his niece with his most dangerous property. "The N[orman] letters are all packed up. I'll entrust them to your mother to send to you in case of accident."[102]

Elizabeth wrote back reassuringly: "Don't forget to register Mrs. N's letters to us, when you feel the time has come— We will keep them for you carefully—till you have worked your way through this tangle.[103]

Characteristically, Alfred saw no inherent discrepancy in the two coexisting threads, Dorothy and Georgia, and in the same letter he wrote: "The week has been a terror—6 days without a

word—finally yesterday a telegram saying she'd be back in Taos by last night—who knows? . . . I wrote 12 letters & didn't mail them til after the telegram came." [104]

Georgia was traveling steadily in late August, riding to Brett's ranch on horseback, driving to Santo Domingo for the Indian dance, and on to Marie Garland's ranch in Alcalde, via the small town of Abiquiu ("very beautiful"). In a group, with Henwar Rodakiewicz and Marie Garland, his wife, Spud Johnson, and Charles Collier, Georgia went to the Grand Canyon and Navaho country, in an old Rolls-Royce and a Packard. "We drove with the tops of the cars down most of the time—greased faces and peeling noses—and everybody loved it." [105] Back at Taos, Georgia found the Luhan household diminished and disarrayed: Mabel had gone to the sanitarium in Albuquerque, and Tony had joined her; everyone was leaving. The moment had arrived at last. "I began to pack," said Georgia. "I was ready to leave—in every way." [106] She wrote Mabel:

> I knew that if I stayed here long enough the day would come when I would feel right about going—as I feel this morning. I knew I would have to go back to my Stieglitz— but I didn't want to go till I was ready and today I am ready —and want to go. [107]

Alfred wrote ecstatically to Elizabeth:

> At 6:00 Georgia arrives! . . . Miracles have happened . . . All too incredible to be told. I know it is all a reality— And very perfect. My aim will be to keep it perfect. I'll do more than my share . . . I have learned a lot—& shall apply what I have learned. [108]

The long and difficult separation ended on August 25, and the reunion fulfilled every expectation. "Well, 72 hours are gone," Alfred wrote Elizabeth in a tone of blissful celebration. "Georgia is very very happy. And you know what I am when she feels that way. The miracle has happened." Helplessly, he added a postscript: "Georgia is very beautiful." [109] Georgia's mood was transcendent: "She is radiant," Alfred wrote five days later. "Everyone is delighted with Georgia . . . our relationship is sounder than before." [110]

Georgia's ecstasy was equal to her husband's.

It is wonderful to be back with my funny little Stieglitz [she wrote Mabel]. He is grand—so grand that I dont seem to be able to see family about or anything else— I just seem to think—to know—that he is the grandest thing in the world —and wonder how I ever was able to stay away from him so long. It all seems perfect— I feel I must wake up and find it a dream— It just doesn't seem humanly possible that things can be this way— He is so nice—and I am so glad to be back with him again . . . He seems to me the most beautiful thing I ever knew.[111]

As for their relationship, Georgia felt: "many things that had been accumulating inside of me for years were arranging themselves—and rearranging themselves— The same thing had been happening to Stieglitz—and as we meet . . . it seems the most perfect thing that has ever happened to me."[112]

Each was impressed by the other's new skills. Georgia was delighted at Alfred's flying, and: "Imagine my astonishment to find him learning to drive a car," she wrote Mabel.[113] But though Alfred was triumphant at his achievement, driving never was easy for him, and after an encounter with a belligerent water pipe sticking up on the lawn, he gave it up forever. Of the two, it was Georgia who exploited the great possibilities of the automobile.

She had left her first Ford in Taos, where Brett sold it for her that fall. At Lake George, Georgia bought a new Ford and prepared for her driver's test. Unlike New Mexico, New York State required licenses. Georgia lay awake with nerves all the night before her test, but "much to my surprise . . . the car didn't hop or skip or anything,"[114] and she passed with flying colors. Once legitimized, she determined to learn to drive in traffic:

Am driving ten miles every day to the nearest uncomfortable town with our favorite taxi man during the busiest hours and I drive up and down the main street— around corners—turn around . . . When I wake up in the night—a feeling of gloom comes over me and I decide to sell my second Ford— In the morning my stubbornness starts me off driving again—and in the dark hours of the night I despair again— That is the way I am— However . . . Driving a bit in the little town here will make N.Y. much easier, and if I am going to drive at all I want to be able to drive anywhere.[115]

Charles Collier arrived from Taos and spent two weeks at the Hill. Georgia "had a fever to go" to York Beach, and the three of them drove there together in the Ford. Alfred's readiness to make the trip was a token of his new mood of acceptance, and far from feeling jealous of the young man who had spent the summer with his wife in the West, Alfred found Charles "a delight."

But everything was a delight that fall. "The weather has been beautiful," Georgia wrote. "[We talk] and talk—getting acquainted—really acquainted is a never ending process—we are still at it—as hard as though we had just met this morning for the first time." [116]

Georgia was working hard but slowly, feeling her way with the new material. In spite of its allure, New Mexico was a difficult subject. John Marin, faced with the problem of painting it, at Mabel's breakfast table had made the flat pronouncement: "None of us can do it, it's impossible." [117] It would take Georgia some time to work her way clear to her own vision of New Mexico.

"I am working—you will be pleased to know how slowly," she wrote Brett in the fall. "Worked over two old ones that I started in New Mexico, and have only two new ones—they need to be painted over entirely . . . That is all—and I have been working almost every day." [118] The New Mexican influence was strong but not yet assimilated. "My painting is queer," she wrote Brett, "but I feel sure it will come in time." [119] She produced one canvas that she liked: "It is all pink and lovely—really nice I think" (probably *Pink Abstraction* of that year). [120] And there was one that excited her: "I have a new painting that raised the roof off the house about ten feet— Red and orange— I was three days painting it and ill for three days afterward from my excitement— But it is a knockout—even if I say so myself— Not that I think a knockout important— Not at all—it just is that way." [121]

Alfred, full of joyful energy, began to photograph O'Keeffe, something he had not done since the early twenties. One image of this year shows Georgia standing against her new black Ford. Her hair is drawn back, taut and severe, from her face, her black dress shows only a pale V at her throat. One hand is set proudly on her hip, and her back is straight as a Spanish dancer's. The image is one of great pride and strength; the presence of the car, and its implications of mobility and distance, is inexorable. But the face, though aloof, is beautiful. Clearly the subject is beloved, and her strength is carefully rendered, admired, and cherished.

In late October, Alfred wrote that "Georgia and I would really like to stay here all winter—perhaps come to town for 3–4 weeks."[122] The Room had closed, and there was no specific reason for Alfred's presence in New York. Yet to relinquish the urban life entirely would have been difficult—in fact, impossible —for Alfred, and in the end they decided against it.

"Somehow I feel—so does G.—that we should keep the city contact to a fuller extent than just a visit— So within three weeks we'll be New Yorkers once more— Maybe a new Room (or Rooms)—maybe heaven knows what."[123]

22

*Mountains are giant, restful, absorbent. You can heave your
spirit into a mountain and the mountain will keep it, folded
. . . the mountains are home.*

—ANNIE DILLARD,
Pilgrim at Tinker Creek

ALFRED AND GEORGIA were both in good spirits, full
of plans and vitality, when they came down to the city in the fall
of 1929. Georgia, wrote Alfred, was "very fit . . . much too good
for an old duffer like myself—although," he added modestly, "I
must confess I'm not as much of a duffer as I was. Not by a long
shot."[1]

The preceding spring, the Room had closed for good. Alfred
had plans for another exhibition space, which were supported by
the Strands and Dorothy Norman. In October, Beck drafted a
letter asking for financial backers and sent it to Alfred for ap-
proval. Alfred found it barely acceptable. "You have no idea how
it goes against my grain to have anyone called upon to give
money 'for me' in days like these," he wrote Beck.[2]

Alfred planned to play a less central role in the new gallery
—"I wanted the 'young ones' to keep up the activities"[3]—but the
new gallery was just as much Alfred's as his others had been.
From his comments Paul Strand inferred that "the young ones"
(including him) had not been keeping up the activities before. He
took umbrage at the implication that he had not contributed suf-

346

ficiently to the Room, and the incident left its mark on the relationship between Strand and Stieglitz. Strand explained his diminished involvement with Stieglitz as an ideological rift: he felt more and more a need for social content in his work, an approach Stieglitz had never supported. "He was one of Alfred's children," Georgia said, "and he grew up. It seems when this happens it's usually necessary to turn against the parents."[4] Strand's abdication was made easier by Dorothy Norman, who began to spend more of her time and energies at the gallery. Her relationship with Stieglitz continued to be close and emotional.

The Strands and Norman found financial backing and premises for the gallery. An American Place opened in December of 1929 at 509 Madison Avenue, in a new skyscraper at Fifty-third Street. As the stock market plummeted, Alfred offered to let his backers renege on their promises. None did.

The exhibition space at Suite 1710 was small and exquisite, like all Stieglitz's galleries. The main room was about eighteen by thirty feet, with ten-foot-high ceilings and three big windows looking west. At the far end of the room were openings into two others: Alfred's small study on the left and another, smaller exhibition space on the right. Just inside the front entrance was a cubicle that became Alfred's first real darkroom.

O'Keeffe chose the colors: gray and white, as always. The smooth cement floor was glossy gray, and the walls and ceilings were white (later the walls were painted a pearl gray). The window shades rolled up instead of down and left a stripe of light aimed at the ceiling. Floodlights banked along the ceiling beams were blue-bulbed, according to Alfred's theory that this most closely replicated daylight. The gallery space had an enchanted quality, austere, light-filled, quiet. The pictures seemed to float on the pale walls, and the atmosphere was serene and meditative.

Down the street was the Museum of Modern Art, which opened that November. Its second exhibition consisted of works by nineteen contemporary American artists. Georgia agreed to lend her work, in spite of Alfred's disapproval. Alfred was deeply suspicious of all institutions and saw no reason to make an exception for this one. He particularly disliked the idea of the wealthy board members, who were presided over by Mrs. John D. Rockefeller, Jr. Like all his opinions, Alfred's views on rich people were ambivalent. There are numerous stories of his refusing to sell

paintings to people whose money offended him, but he was not insensible to its appeal; ultimately, his enterprise depended upon it. For Georgia, who was entirely secure in her own self-sufficiency, the idea of money was less powerful. It was Georgia's theory that Dorothy Norman's real attraction for Alfred was her money: "I think if it hadn't been for the money, he would never have noticed her."[5]

Whatever the attraction was, Dorothy Norman was more frequently at the Place than she had been at the Room. Alfred increasingly depended on her for secretarial and administrative tasks, and she took over more of the functional aspects of the gallery—except for the hanging of the shows, always and solely Georgia's domain.

It was a difficult time for O'Keeffe. On January 7, 1930, her favorite brother, Alexis, died of complications from his war injuries. Georgia wrote to his widow, Betty:

> The only thing that makes it all seem right is your feeling that you would do it all over again even if you knew . . .
> Your letter is very fine—it makes me cry every time I read it
> —not on account of Alexis—but on your account . . . I was sorry to see Alexis marry—I felt it would make trouble for you . . . I can not even say to myself as I sit here looking out at the city—that the things that have hurt me most have been worth most to me. If I could say that for myself I might feel better about you and your sorrow—but I can't. A great sorrow is a great experience—a life without it seems a pale colorless thing to me—but I can not help feeling that a great joy is more to my liking.[6]

• • •

GEORGIA'S EXHIBITION opened in early February. Alfred was, as always, anxious about her new work. He expected few sales, explaining: "Her things are a bit too daring this year."[7] Excitement preceded the show: "the O'Keeffe craze in the art circles . . . has attained the fury of a spinning tornado," according to one New York columnist.[8] The Canyon newspaper, *The Prairie*, noted the "craze" with pride and produced some imaginative variations on the O'Keeffe myth: she had gotten her start by sending "a few charcoal drawings of flowers to a friend, with instructions to look at and burn them . . . She was recently paid

$25,000 for five drawings of lilies . . . She has also published a book on art."[9]

The exhibition consisted of twenty-seven paintings, nineteen of which were from New Mexico. As well as the pictures mentioned by Beck—the "lady santo" (*The Wooden Virgin*), one of trees, and one of Mabel's porcelain roosters—there were an Indian kachina doll; an abstraction from an Indian headdress; *The Lawrence Tree*; four stark Penitente crosses; three smooth sculptural fragments of Ranchos Church; and one Taos Indian pueblo. There were as yet only two paintings of the hills, the subject that would play such a large part in her later work.

The new paintings showed the influence of the Southwest; the colors in *Kachina Doll* and in *At the Rodeo, New Mexico*, the Indian headdress abstraction, are harsh and the contrasts bold.

The pictures reveal a readiness for change and a sense of experimentation. Something O'Keeffe had acquired from photography, to her great enrichment, was a sense of optical freedom. This allowed her to manipulate space, to present things at close or long range in a manner unknown before the introduction of photography. Faces, for example, could be seen with much greater intimacy and detail by the camera than courtesy and the paintbrush would permit. O'Keeffe incorporated the ideas of magnification and cropping into her work, using them first on her flowers. In the New Mexico paintings she further explored the possibilities of optical manipulation, freely cropping the shoulder of the Ranchos Church from its body and capturing the image of a tree from below—as a photographer might. *At the Rodeo* is based on a small circular ornament on an Indian headdress, magnified to the point of abstraction, as though by a telescopic lens.

The interdependence among the Stieglitz group is demonstrated with particular clarity by the images of the Ranchos Church. Paul Strand's 1931 photographs almost exactly follow O'Keeffe's 1929 painting. The point of view is identical, and the only difference lies in the cropping of the right-hand wing: O'Keeffe shows the complete wing, while Strand abbreviates it.

There were three tree paintings, two of which were nocturnal and infused with a sense of mystery and poetry. In the lyrical *The Lawrence Tree* the pine is seen from underneath, dark and beguiling, with the points of light shining precise and intense, through and around the dense foliage, illuminating the warm, blue night

sky. The choice of perspective and the glittering nighttime setting are unexpected, and a dizzying exhilaration pervades the composition.

Apart from the New York skyscrapers, O'Keeffe painted buildings rarely, and those she chose most often embodied an affinity with the landscape, a spiritual attitude stated in physical terms: barns, churches, and the Pueblo houses. Deeply appealing to her were the smooth, modest, literally earthy adobe buildings. Just as they were physically linked to the surrounding landscape by the material from which they were made—local earth—they were linked philosophically to the landscape by the Indian's harmonious coexistence with earth and heaven. The completeness of this notion engaged O'Keeffe, its wholeness and economy, as well as its spare, smooth beauty.

Most significant about the church and the cross series was the combination of visual spareness with emotional splendor. The simple forms and smooth surfaces make for a sense of cleanliness and purity; this is conjoined with an unexpected richness of depth, feeling, and scope through subtle shadings and a sensuous application of color.

The crosses are some of O'Keeffe's most powerful works, most particularly *Black Cross, New Mexico*. Shortly after arriving in Taos, she and Beck had gone for a walk one evening. They had gone past the *morada*, toward a cross in the hills. They were told it was a *Penitente* cross, but the name meant nothing. It was a large one, large enough to hold a man, with a small cross on either side. The cross was dark and forbidding against the glowing evening sky. It was not exactly against Taos mountain, but Georgia painted it so: the two images seemed to belong together, representing one aspect of the country.

This monumental painting McBride called "the great 'Parsifal' cross." Its black trifurcated silhouette echoes both Stieglitz's and O'Keeffe's own *Chestnut Tree* of 1919. Great formal strength is achieved through the stark and simple cruciform that dominates and nearly obliterates the sky and the background. Behind the inexorable black geometry of the cross is a surge of voluptuous turbulence: the distant ripple of red hills. The juxtaposition of the two opposing forces—order and passion—is presented in brilliant and powerful terms, and demonstrates O'Keeffe's own conviction that "the center of the earth is burning—melting hot."

The critic from the *New York Times*, Edward Alden Jewell,

wrote two columns of praise about the exhibition. Henry Mc-Bride's opening lines were characteristically droll: "Georgia O'Keeffe went to Taos, New Mexico, to visit Mabel Dodge . . . Naturally something would come from such a contact. But not what you would think . . . Georgia O'Keeffe got religion. What Mabel Dodge got I have not yet heard." His view of the work was quite serious, however, and he recognized the extent to which religion infused the new work: eight of the paintings were of religious objects or buildings. "It is intellectually thrilling to find Miss O'Keeffe adopting so quickly the Spanish idea that where life manifests itself in greatest ebullience there too is death most formidable." [10]

• • •

IN THE LATE 1920s, with the start of the Depression, a shift occurred in both the political and the aesthetic arenas. The period of expansive internationalism was over; a nationalistic mood began to prevail, and social and economic problems to dominate the national consciousness. In the art world, this meant a movement away from European theories of abstraction and toward more representational art. An attitude of introspection and national self-examination became current. The problems of society, ignored during the ebullient twenties, were now given a painful prominence; artists and writers began to address political, cultural, and social issues. America's particular landscapes, urban and moribund as well as rural and bucolic, were examined by its artists: Charles Burchfield and Edward Hopper, Grant Wood, Thomas Hart Benton and John Steuart Curry. This attitude of specificity and particularity conflicted with O'Keeffe's view, always abstract and metaphoric. (A decade later, seeing a Curry mural, O'Keeffe wrote: "Just the thought of it makes me tired." [11])

In the spring of 1930, in a rare political gesture, O'Keeffe took part in a public debate with Michael Gold, the outspoken editor of the liberal and populist *New Masses.* Gold took O'Keeffe to task for not making political statements in her art. He declared that the proper study of mankind—the artist—was man. The one true issue was humanitarian, he said, and art should reflect only the struggle of the oppressed classes and the travails of the poor, in a specific and representational way.

O'Keeffe took a view both larger and smaller: she pointed out first that women are, themselves, an oppressed class. (Eight

years later, Virginia Woolf would use exactly the same argument in her famous feminist manifesto *Three Guineas*. Woolf quoted a similar complaint—that women took no political action against Nazism or Fascism—and declared that women's situation was such that they must confront the dictator at home before they could seek him out abroad.[12])

Gold sneered; he was interested only in working-class women's oppression—in short, only in economic oppression. O'Keeffe stepped into a larger arena and explained that the repression of women is also a humanitarian issue, and one that can be expressed through art. She made it clear that the expression, however, did not need to be the pedestrian limning of specific downtrodden women. The proper study of womankind is woman, but not in a manner that ignores the fundamental tenets of art itself. "The subject matter of a painting should never obscure its form and color, which are its real thematic contents . . . So I have no difficulty in contending that my paintings of a flower may be just as much a product of this age as a cartoon about the freedom of women—or the working class—or anything else."[13]

The disagreement between them was fundamental: O'Keeffe held that art is, itself, a moral structure, and that by adhering to its principles the artist upholds those of a universal moral system. To prove this, she used the example of her own struggle as a painter. In freeing herself from male influences and achieving an independent status, which allowed her to paint as she properly should, according to the strictures of art, she was submitting herself to a rigorously demanding system, for art incorporates a stern conscience that, once acknowledged, is not casually discarded in other arenas. As an admiring artist had written her in 1927:

> My heart finds in your pictures a deep satisfaction . . . this comes from . . . a fearless clarity of vision . . . perfect purity of purpose . . . This amazing psychic balance comes from a courageous self-acceptance, without which no real and lasting art is possible. With this to stand on, you have dared, and loved, to paint what seems to me the organs of the spiritual universe . . . you do what is your own, and I believe that your own is significant to painting and to our time.[14]

Gold refused to see the merit of this argument. He held that art as a social force was unequivocally subservient to politics, and thus aesthetic concerns should be secondary to political thought.

Quite as impressive (and more beguiling) as O'Keeffe's lucid reasoning was her lack of ire. While Gold blustered, she listened, calm and unthreatened. When he turned offensive, she smiled and suggested that he was upsetting himself unnecessarily. A reporter saw Gold as fussed, awkward, and intimidated, O'Keeffe as mild, self-possessed, and friendly. The two of them, in fact, embodied their own arguments: while Gold took things personally and specifically, O'Keeffe's position was lucid, calm, and abstract, and in terms of personal response, far more "humanitarian"—that is to say, friendly—than Gold's blustering antagonism. In the end she announced that she would take him to see her exhibition, and then home to meet Stieglitz for dinner and more talk.

The encounter revealed the strange quality of O'Keeffe's tenderness—a glowing but impersonal warmth—manifested in both herself and her work.

• • •

IN APRIL 1930, Georgia went alone to Maine. As always, the tranquil spareness of the landscape revived her. She wrote Brett:

> It's cold as blazes. Each day a different soft color—
> Yesterday a brilliant dark blue—a wild west wind blowing
> the top of the high surf that had rolled in from the day
> before . . . I love it—at night . . . stars—and a thin new
> moon— I walk out there alone on the beach for at least two
> hours every day . . . I have painted these two days—queer
> little centerless paintings—and my open fire—lying on the
> floor looking into it makes me feel almost as satisfied and
> quiet as lying out naked in the Taos sun. And so it goes—
> for a heartless wretch like me.[15]

Mabel invited her to Taos again, but Georgia had not yet decided to go back to the Southwest: "I have no plans except that in a few moments I dress myself and get out on the beach for an hour—then to paint."[16]

That spring, Georgia had introduced Alfred to "the last person that I had talked much about from out there . . . he liked him

like I do," she wrote Mabel.[17] Georgia wanted very strongly for the two halves of her life to fit together, and Alfred's approval was important. "It made everything seem very perfect for me," Georgia wrote of Alfred's response, "because he hadn't seemed to have much faith in the people I had liked out there except Tony . . . I like the people that I like very much to like one another—it makes me feel good."[18] To Brett she wrote: "I know Stieglitz thinks much of you, he said at supper that that was one reason why he was satisfied for me to go out there again."[19]

Georgia's decision was still strongly dependent on Alfred's reaction, and this year he gave the trip his blessing: "I couldn't decide until Stieglitz decided—it came quietly—naturally—like the flow of all the winter has been— It is what I want to do for my work—and I have been so very well after the summer out there . . . It is almost as though Stieglitz makes me a present of myself in the way he feels about it," she wrote Brett.[20] But Georgia was still not certain of her plan until late May, when she finally made the decision to leave in mid-June.

Georgia went to Lake George in early May to plant the garden and to open the house for Alfred. Georgia Engelhard was there with her, a favorite companion, and Alfred came up for a weekend. "He is so nice," she wrote Mabel, "I really think I am probably very dumb to go away and leave him again . . ."[21]

Early spring in the Adirondacks is a brown, bleak time, and green plants are rare. One of the earliest to appear is the strange, retiring jack-in-the-pulpit, which rises fresh and vivid from the sere brown leaves on the forest floor. By the springhouses in the woods, Georgia found a patch of jacks. They were the dark-veined variety, with dramatic purple-green stripes on the inner leaves that surround the smooth central shaft. Georgia was reminded of her high school art lessons, and saw the jacks as subjects for her work. She did a series of six paintings of them.

The jack series is a powerful celebration of the strong thrust of spring and of the dark secret tower enfolded in green. The shapes are those that had interested O'Keeffe from her earliest days as an artist: the long clean sweep of the rising stem, the swirling curves of the protective leaves, and the rounded dark bulb shape of the jack, which reads alternatively as either an opening or a solid shaft. The pictures are triumphs of abstract composition, full of a formal strength, a remarkable monumen-

tality, and a resonance from an emotional communion with natural forms—a continuing motif in O'Keeffe's work.

Because of the phallic shape of the jack itself, the paintings have been viewed as overtly sexual. Challenged on all sides to confess to their erotic nature, O'Keeffe refused this categorically. For her abstract eye, the rising stem and the furling leaves created a strong and speaking pattern: it was that she attempted to record. The rampant sexuality of which the paintings are accused is not in the eye of every beholder—not, in any case, in hers. Like the flowers, however, the jack paintings reveal the strong current of sexuality that infuses all living forms, animal and vegetable.

· · ·

MABEL'S INVITATION the second year was more moderate. She wanted more privacy herself that summer, and Georgia stayed at first in the studio and took her meals alone at a small hotel. The arrangement suited Georgia very well, for her view of Mabel had altered. Despite Mabel's thoughtful silences, despite her capacity for perception and charm, there was a fretful childishness about her that undermined any serious endeavor and most of her friendships. Mabel was deeply self-indulgent and spent most of her time and energy on superficial things: gossip, social life, and petty feuds. The bickering that went on among Mabel, D. H. Lawrence, Frieda Lawrence, and Brett was famous. It included (after Lawrence's death) a plot to steal his ashes: Frieda foiled this by mixing them with cement and making them into a concrete slab. In response, Mabel and Brett boycotted the memorial ceremony.

Georgia had not seen Mabel's pettiness during her first summer in Taos. As a new arrival, she received temporary immunity, and Mabel was only there for a month before leaving for her surgery. Georgia's gratitude for the experience of being in Taos conferred on her hostess an aura of benevolence. "You see—I am always feeling that I owe you very wonderful days."[23] At the end of the summer, however, the household was in an uproar because of Mabel's silly, malicious behavior: "She and Ida parted . . . Mrs. Hapgood gone—insulted . . . everyone aquiver."[24] Back in the East, Ida told Georgia stories of Mabel's spite and gossip, corroborated and embellished by Brett.

That summer, while Georgia had written enthusiastic letters from Taos to Mabel in the hospital, Mabel had felt excluded from the activity. Already anxious and jealous about Tony's behavior, she was not reassured by Georgia's rapturous praise of her husband, nor by hearing about their camping together under the stars. Her jealousy turned from Tony's Indian wife to Georgia, and her attitude became increasingly hostile. "Mabel had periods of minding and periods of not minding," Georgia said later, adding, "She really knew there was nothing to mind."[25] The rift was formally healed, but there were no more overnight camping trips for Georgia and Tony.

That year, Mabel's pique was capricious. Even without meals, Georgia soon found life at Los Gallos too socially demanding, and she moved on to a hotel. Mabel took offense and demanded that she come back. Georgia explained that she could not work and socialize both, but promised to call when she took a break. When she did call Mabel, she was rebuffed. Mabel said she had peyote singers coming that night, and too many people already: Georgia would not be welcome. Tony appeared in the evening to escort Georgia to dinner. When Georgia explained what had happened, "Tony came in and sat down in the rocking chair. 'I go to a lot of trouble, get peyote singers,' he said. 'She no invite my friend. I not go.' And he didn't," Georgia related. "He sat there all evening, rocking in the corner."[26] It was a typical Taos story, full of huff and counterhuff, the sort of behavior that prevails in any isolated community.

"Mabel was always perfectly awful to Brett, who never heard anything she didn't want to hear," said Georgia.[27] Brett was used to Mabel's high-handed treatment, and she gave as good as she got. Mabel once wrote Brett, complaining bitterly that Brett had eaten all her chocolates; Brett wrote promptly back, threatening to call the police the next time she saw Mabel speeding. "But they'd always get back together again," said Georgia.[28]

Georgia identified the problem in Taos: "There were not that many interesting people. They'd have terrible fights, and not speak to each other for days, but then they'd get bored and make up."[29] Mabel's wealth, her international background, her Indian marriage, her writing, and her personality gave her an overwhelmingly important position in the small community. The local paper called her the "Undisputed intellectual high priestess of Taos . . . absorbing, witty, sensational, frank and gay. She is all

of that and something more."[30] Georgia supplied the missing quality: "Mabel was pretty mean," she said. "She had the ability to paralyze a room. She would invite a lot of people and seat them around in a circle and they'd be so intimidated that nobody would say anything, and then the next day Mabel would go on about how everyone in Taos was so stupid."[31]

Georgia herself could not resist bedeviling Mabel: "I enjoyed worrying her, I must admit. One of my favorite ways . . . was to leave her house after a party and pretend I'd forgotten to say goodbye to Tony, and then come back, and say goodbye to Tony."[32] Mabel was the sort of target Georgia found hard to resist: a patently silly woman.[33]

The feuds and bickerings in Taos were not what she wanted, and the summer of 1930 was the last summer Georgia spent in "Mabeltown." Afterward she wrote Brett:

One thing that gets me about . . . the Taos country—it is so beautiful—and so poisonous—the only way to live in it is to strictly mind your own business . . . and use your ears as little as possible—and keep the proportion of what one sees as it is in nature—much country—desert and mountain— and relatively keep the human being as about the size of a pin point— That was my feeling about my summer—most of the human side of it isn't worth thinking about—and as one chooses between the country and the human being the country becomes much more wonderful.[34]

• • •

WHEN GEORGIA arrived at Lake George in September 1930, Alfred was warm and welcoming. "When ever I come back to Stieglitz I always marvel to see again how nice he is," she wrote Beck. "There is something about being with Stieglitz that makes up for landscape."[35] This year Alfred was cheerful and productive, "mounting prints at a great rate." He had been flying again, and invited her up in the air. "He took me flying—it is quite a sight from the sky— I sat in a cold sweat—he perfectly unconscious— He is pretty smart."[36] Alfred no longer felt frightened and dependent on Georgia. He was turning toward other activities, just as she had: flying and Dorothy Norman were his pursuits.

That fall, Norman was expecting her second child. While Georgia and Alfred remained at Lake George, Georgia was pain-

fully aware of the daily letters and telephone calls that had become a pattern between Stieglitz and Norman, and of Alfred's distress over the approach of the dangerous event. The baby arrived safely, and by December Norman was back on her daily schedule at the gallery. If Georgia hoped that motherhood would reduce Norman's faithful attendance at the Place, she was disappointed. That winter, Norman was even more in evidence, doting, consciously virtuous, devoted to Alfred's needs. She had taken up photography with Alfred though he had always refused students in the past. The two spent hours together, absorbed in her education. Stieglitz lent her his Graflex, and when she took some portraits of him, he offered to develop and print them for her.

Georgia cultivated her independence. She continued to be the hostess at Shelton dining room dinners, but she refused to be a full partner in Alfred's maze of social and familial obligations. She began leading her own social life. "Stieglitz never does such things," she replied that winter to an invitation from the writer Carl Van Vechten, "but I will if I can."[36] (Van Vechten's uproarious parties were famous for being "silly"; at one of them the host wore a bathing suit.)

Georgia's response to unhappiness, her own or others', was always the same, and in answer to a dismal letter from Brett she wrote: "The vision ahead may seem a bit bleak but my feeling about life is a curious kind of triumphant feeling about—seeing it bleak—knowing it so and walking into it fearlessly because one has no choice—enjoying ones's consciousness."[37]

Emotion, she felt, should be used as a creative force but the work should be "colored . . . by love rather than—other things": pain, rage, and hatred were not large enough emotions to use.

O'Keeffe believed that work was the antidote for unhappiness, that in fact it was the only way to real happiness and fulfillment. This was to be tested as she watched Alfred's attention turn more and more intensely toward the young and compliant Mrs. Norman.

The situation was trying, and by spring Georgia was anxious and on edge. Her letters to her friends contain no complaints about Stieglitz; her unhappiness is evident only obliquely. That spring she wrote Brett: "Everything is too much like Spring in feeling. Everything perfect for working except the sharp interest in it in one's center . . . I was in Boston for three days—enjoyed

the Museums but Oh!!— You had better dig into the work. It is all that is, really."[38]

This year, Alfred was not so supportive about her leaving, and Georgia was far more decisive about her plans. He asked Georgia to stay longer than she had planned and help him sort out paintings that were in storage. Alfred was beginning to do business with Edith Gregor Halpert, the energetic founder of the Downtown Gallery. Some of the works were to go there, some to An American Place, and some back to the artists. Georgia scheduled five strenuous days at the warehouse, after which she left as planned. Alfred felt exhausted and somewhat ill-used; for solace he turned to Dorothy Norman. He had begun to photograph her, and found her a willing model.

In April, O'Keeffe went out to New Mexico, to the H & M Ranch in Alcalde—a small town some forty miles southwest of Taos—where Marie Garland rented cottages to her friends.[39] Garland was another of the robust and independent women of the area. A colorful personality, she had been a great beauty and was still, in her sixties, a charming and interesting woman. Very much a part of the Taos circle, she was "a much-married lady, statuesque and generous . . . [who] writes a little poetry, preserves a siren youth, and offers Delphic hospitality to artists, writers, and mystics."[40] Garland and her husband Henwar Rodakiewicz had come on Georgia's first trip to the Grand Canyon, in 1929, after which O'Keeffe had stayed on with Marie. Marie was a great cook and hostess, and the parties at her house were legendary. The party after a performance of Spud Johnson's play about Mabel Luhan ended in a free-for-all, and in the morning Georgia picked her way across the broken glass on the floor.

The summer of 1931 was one of Georgia's best. She stayed alone at the house in Alcalde and had a model A Ford, with large high windows and enough room to fit a 30-by-40-inch canvas. The front seats swiveled, and she could sit in the back and put her canvas on the reversed front seat to paint. She drove all over the countryside, painting the landscape. For eight of her ten weeks there she drove "almost daily out from Alcalde toward a place called Abiquiu—painting and painting. I think I never had a better time painting—and never worked more steadily and never loved the country more."[41]

She had found Abiquiu "very beautiful" when she first

passed through it in 1929; in 1931 she returned to the landscape that would nourish and sustain her for the rest of her life. "It was the shapes that fascinated me," she said, "the shapes of the hills."[42]

• • •

THE SMALL sheepherding village of Abiquiu lies along the banks of the Chama River, in Rio Arriba County. The landscape there is not spectacular: the Chama is a modest tributary of the Rio Grande, and it wanders peacefully through scrubby bottomland, pale chalky hills rising haphazardly around it. Cottonwoods line the river, their generous shapes making a cloudy outline along the narrow stream. Water is an erratic presence in New Mexico: many of the streambeds are dry for months on end, merely wide meandering paths. The soil in them is fine and dry, like talcum powder.

The tiny Hispanic community is centuries old. It was an Indian pueblo before the Spaniards came, a stronghold of the Penitente sect afterward. When the Spaniards arrived in New Mexico, they found a familiar landscape, fierce and dry. They brought from the arid Iberian plains a sophisticated system of water allotment: to this day, each parcel of land is part of the complicated irrigation system, with certain rights at certain times to the precious commodity.

The soil is poor, and so are the people. Farming has for centuries been managed through the *partido* system. Traders owned the animals (mostly goats), which they loaned to the "sharecropper" herders, who took the risk of raising and fattening the animals for market.

The countryside, choppy and broken, is ideal for goats but little else. It is a lean, bleached, wild place, uneven, full of bluffs and steep canyons. In spite of its aridity, its spareness, there is an overriding softness to it because of the fine sandy soil. The shapes of the hills and the bluffs are gentle, rounded, smooth, and the sense of the dry, powdery soil prevails. About ten miles north of Abiquiu the landscape begins to alter. The low irregular ridges, covered with scrub, give way to smooth, strange red hills and high pink cliffs. The landscape opens up, and great vistas stretch out to distant purple mountains.

It is not gentle country. The place demands solitude, an intense attention to the land. It is too large for human needs, at-

tachments, talk; the landscape stands a silent and irrefutable reminder of things on a different scale.

The cliffs and the distance provide great sustenance for the spirit: vast, intense, absorbent. The view sweeps one into its folds like sleep. There is a risk, however, of becoming absorbed, passive, obedient to the larger power that surrounds. It threatens as those great plains, uncivilized, primeval, threatened the early settlers. To take hold in this landscape, to produce, to concentrate, to stake out territory, is remarkably difficult.

O'Keeffe grew up with great spaces, and the long sweep of horizon was what she craved. The sense of limitlessness offered her liberation. It allowed her sense of self to expand infinitely, independent yet attached to something larger than the self. As Willa Cather's biographer pointed out, for a strong woman the plains signified transcendence, not obliteration.[43] It was a supreme sense of transcendence that O'Keeffe found in the vast sweep of the New Mexican views, the brilliant clarity of the colors, the sense of freedom and solitude. It would remain thereafter the central source of elemental strength.

• • •

ON GEORGIA'S return to the lake in 1929, she had found the landscape welcoming, but in 1931 she wrote: "Here I feel smothered with green."[44] She came back early, in the third week of July, with the feeling that Stieglitz needed her. It became painfully clear that he did not. If the summer was liberating for Georgia, it was equally so for Alfred. He had, at sixty-seven, again violated his sacred routine. The first time he had done this had been for a visit to his daughter, in a moment of her extremity; the second visit was made to Georgia, in her extremity. This last was a visit to Dorothy Norman, and the extremity was his own. On July 7, three weeks after his arrival at Lake George, he left for Woods Hole, on Cape Cod.

"Stieglitz is eager for me to be with him at Lake George and see where he lives, photographs and prints in the summer. Since I cannot leave Edward and the children, [Alfred] comes to Woods Hole," Norman wrote ingenuously.[45] At the beginning of July, she and her forbearing husband received Alfred in their large summer house. There he stayed for several days, photographing Dorothy nude in a wildflower meadow, before the two of them took an overnight trip to Boston.

Like Stieglitz, Norman was a romantic. "I want to hurt or tear apart nothing. Nor does Stieglitz," she wrote.[46] Her self-image was one of kindness and generosity, and it did not allow her to admit that her behavior might be damaging to others. Norman professed bewilderment at her husband's sudden jealousy and wondered artlessly, "Does our love really interfere with the rest of our lives? With the lives of those closest to us? Or does it contribute?"[47] She pointed out the thoughtful benevolence of herself and Alfred: "We never think of breaking up our marriages. We are nourished by and nourish them."[48] Her attitude was at once passive and melodramatic: "I am swept along by a strong double tide . . . I was a small child, unknowing. I am a larger child . . . Life has called to me . . . I shall spend the rest of my life paying the price for life."[49] That others might also have to pay the price for her being "a larger child" did not seem to occur to her.

Alfred, too, was busy ignoring the realities of his situation. Back at Lake George, he shared his infatuation with his guests, the ever-present Paul Rosenfeld among them. Even the housekeeper, Margaret Prosser, was informed of Norman's attractions: "The full-hipped Child-Woman with soul-brimming eyes . . . the essence of the Female Spirit."[50] The desperately skewed logic of infatuation convinced him that his involvement with Norman was a benefit to everyone around him, including Georgia.

Georgia may well have disagreed with this theory, but she kept her thoughts to herself. In her letters she was resolutely cheerful, describing the parts of her life on which she concentrated: the pleasure she took in the landscape and her work. "We walk and I feel like the top of the world," she wrote Beck from Lake George. "My paintings hang on the wall and look funny to me— What I do here is very different [she had painted landscapes in New Mexico but at Lake George was working from the bones and skulls]—but that was my intention . . . So—all put together—it seems a pretty good life."[51] The following month she wrote calmly: "the summer . . . has been a bit fantastic to say the least . . . I feel fine—really very gay—in spite of family life which at present is a bit thick— I find that nothing disarms them like laughing at them— And so it goes . . . I may stay up here after Stieglitz goes to town . . . probably will."[52]

Despite Georgia's determined good humor, concentrating on work and excluding Alfred's infatuation from her mind was ex-

hausting and disheartening. Her temper was precarious, and Alfred's family was at times an excruciating irritation. She had insulated the Shanty against the heat and spent her days there in solitude. Children were strictly forbidden to go near it. One hot summer day, Sue and Peggy Davidson, dressed as Indian scouts, in fringed chintz leggings, crept up to spy on the dangerous territory. Peering carefully over the windowsill, they saw Georgia sitting peacefully before her easel in the nude. Georgia's rage was monumental and immediate: "She was as magnificent and awesome as a goddess," wrote Sue Lowe. The scouts retired in confusion and terror; shortly afterward Georgia left for Maine, "for a smell of the salt air and a week on the beach— It is the only thing aside from the desert." [53] But the trip to the beach gave her solace only as long as she was there: she returned to Lake George just before Alfred departed once again for Woods Hole. In spite of the excruciating knowledge that lay between them, Georgia maintained her silence.

Georgia had become freer and more independent in her attitude toward the house at Lake George. She had taken out a piece of the porch roof to give Alfred more light for his printing, and she next removed a wall of her room, expanding it by the size of the closet next to it. She painted the floor deep green and put down a New Mexican rug. She made the changes without consulting the rest of the family, who found her behavior cavalier. The Farmhouse had been Georgia's domestic responsibility for nearly a decade, however, and she was now assuming a right of eminent domain. She could not imagine anyone truly objecting to increased light and enlarged spaces. More important, she had reached a point at which she was taking charge of her environment as well as her life.

Her feelings were not being treated by her husband with consideration, regardless of Alfred's claim that his love for Dorothy Norman enriched his marriage. Georgia's mother had taught her the first lesson of emotional self-reliance, and now, from her husband, she was learning it a second time, more painfully: no one was responsible for her happiness but herself. it is unsurprising that she was so casual in her treatment of the Farmhouse.

That fall, Georgia accompanied Alfred to New York in October, but after hanging the first show of the season—Marin's—at the Place, she returned alone to Lake George to paint. This year she was beginning to be able to use the elements of New Mexico

more freely and intensely, and the work was going well. In July, Alfred had written: "Some of her paintings I think show a great step forward in many ways." [54]

Now that O'Keeffe could drive herself to the city at will, leaving any day at dawn and arriving by lunch, she felt free and independent. "Yes—I drive to New York—and in New York— right up to the door of the Shelton at six o'clock when the traffic is thickest—have done it five times—it is 220 miles—yes—I am proud of it— So that is that," she wrote to Brett. [55] Based in Lake George, she concentrated on her painting, leaving Alfred to concentrate on Norman.

O'Keeffe's life was becoming increasingly divided between the green and the sere, marriage and work, city and country, East and West. Her happiness was inextricably entwined, however, into both halves, and she refused to give up either half for the other. The pain of Alfred's infatuation over Dorothy Norman was outweighed by the value of her marriage, and her work took on a transcendent importance, overriding both pain and marriage. "It is all that is, really."

23

*I have wanted to paint the desert and I haven't known how
. . . So I brought home the bleached bones as my symbols of
the desert. To me they are as beautiful as anything I know
. . . The bones seem to cut sharply to the center of something
that is keenly alive on the desert even tho' it is vast and
empty and untouchable—and knows no kindness with all its
beauty.*

—EXHIBITION CATALOGUE,
An American Place, January 1939

THE BONES HAD BEEN in Georgia's mind since she
first saw them a decade earlier on the plains of Texas. On the
high mesa—as on the Wisconsin prairie—there is no middle
ground, nothing to arrest the eye between the ground at one's
feet and the long, steady line of the horizon. The gray-green sage
and piñon pine form a vague, cloudy, intermittent cover over the
reddish soil. There is no relief, no hard shapes interrupt the neb-
ulous flow of muddy green and reddish brown, except those of
stones and bones. These are scarce but not exotic: they are a part
of the landscape, like shells at the beach.

O'Keeffe was not the first woman painter to discover the
shapely appeal of bones. In 1873 the Philadelphia portrait painter
Cecilia Beaux produced a careful study of the female human pel-
vis for an anatomy class. Two years later, for a geological survey,
Beaux drew a set of paleontological specimens, including the

skulls of an ass and a camel. On her own, for the pleasure of it, Beaux drew all the parts of the human skull.

In the pre-Freudian era, Beaux found nothing morbid in the smooth curves, only a glorious abstract form. Nor was she accused of celebrating death, though this was largely because the pictures were not presented as finished works of art. The pelvis and the paleontological specimens were assignments, the human skull was done for herself, and all were executed in pencil and wash, the traditional medium for scientific illustration.

Though Beaux herself did not pursue bones as subjects, her exultation at their formal beauty was as strong as O'Keeffe's: "How marvelous was the sphenoid . . . Double-winged it was, almost glittering in its translucence," she wrote.[1] Moreover, conscious of the similarities of form, function, texture, and beauty, Beaux made the direct and intuitive association between bone and shell. She declared that the bone seemed "to be the armor of some creature whose destiny it should be to float like the nautilus in a tropical ocean."[2]

· · ·

O'KEEFFE SAID that she began bringing back bones after her first summer in New Mexico, 1929. Her dates are not always precise, however, and the bones were probably first brought east in 1931.[3] The first bone picture—*Thigh Bone with Black Stripe*—seems to have been done in 1930 or 1931.[4] It was in 1931 that O'Keeffe wrote Henry McBride from Alcalde:

> I see that [at] the end of my studio is a large pile of bones—
> a horses head—a cows head—long bones—short bones—
> all sorts of funny little bones and big ones too— A beautiful
> rams head has the center of the table . . . What will I do
> with those bones . . . When I leave the landscape it seems I
> am going to work with these funny things . . . but maybe I
> will not.[5]

That year, at Lake George, O'Keeffe painted the splendid and monumental *Cow's Skull—Red, White and Blue*—a skull against a blue ground, a red stripe on either side of it. When the idea came to her for the first skull painting, she gave the housekeeper the day off. She said there was something she wanted to do and she needed solitude. Margaret Prosser returned at the end of the day, to find the palette clean, the paints put away, the

easel tidy, and the painting finished, its presence calm and powerful in the room. (Prosser had a more tangible relationship with the painting: the blue ground in *Cow's Skull* is said to be the blue pajamas of her son Frankie: the skull was propped against them in a chair.)

In *Cow's Skull—Red, White and Blue,* the short-horned skull is placed in the top and center of the canvas. The image is centered and frontal; this and the three strict vertical lines that lie on either side and behind the skull establish a severe and formal symmetry. The strictness of these lines, the symmetry of the design, and the inexorability of the cold white bone create an atmosphere of austerity, emphasized by the severe contrast between the pale skull and the black pole behind it.

There are, however, equally strong forces opposing that austerity. The symmetry, for one thing, is not complete. The skull itself is uneven, the bone around the nostril having on one side been eaten away. The severity of the design is counterbalanced by the flaming scarlet bands on either side of the canvas and also by the rush of blue strokes that flow diagonally toward the central black pole. The opposing forces are part of a familiar O'Keeffe dynamic: severity and passion, a powerful order competing with violent flux.

The image of the skull itself, potent, immutable, and unprecedented, achieves a remarkable monumentality. There is a great and immutable power in the hard white bone, and O'Keeffe saw it as a symbol of a strong land.[6]

In the bones she had found her last great image: the smooth osseous shapes that she transformed into icons. Her steady gaze and absolute attention effected a transformation, from the small and ordinary to the monumental. Enlarged, physically and psychologically, the objects take on resonant and mythic overtones. As well as death, they represent an interior strength, tranquil, remote, and enduring. Their pearly white forms—voluptuous, harmonious—gleam against flat fields of color, sometimes against the red New Mexican hills themselves.

The idea of bones conjures up something smooth and burnished, but in fact, bones on the desert are dry, rough and porous, gray around the corners, scratchy and bumpy. It is O'Keeffe's brush that polishes these white fluent shapes, transforming them into objects that gleam with significance, certainty, and great beauty.

• • •

IN LATE DECEMBER 1931, O'Keeffe's exhibition went up, domi-
nated by the bone paintings. They caused an uproar, as had the
magnified flowers. Henry McBride, reliably, understood the
bones very well.

> Looking at these original works purely from the painting
> angle they are of Miss O'Keeffe's best, and for my part I
> imagine that she saw these ghostly relics merely as elegant
> shapes charged with solemn mystery. Like the plant forms
> and shells . . . that she so inordinately admires, these bones
> to her are part of nature's marvelous handiwork, to be taken
> at face value and reverenced for their intrinsic form.[7]

Other critics, however, insisted on Freudian interpretations.
Death, despair, and destruction were all proposed as subliminal
messages. A "splendid salutation of the dead," one critic called
it.[8]

As they had on the flower paintings, O'Keeffe and the critics
disagreed. O'Keeffe insisted that she chose the objects for their
shapes and for their metaphorical significance, but she took that
to be life on the desert, not death. We must accept O'Keeffe's
clear assertion that she did not consciously associate bones with
death; only she can have known. There are, however, uncon-
scious forces, less clear but equally powerful, that shape actions.
In 1930 and 1931, O'Keeffe was making a difficult emotional
choice about leaving her husband, about accepting his infidelity,
about her own response to that infidelity, and about how she
would lead her own life. It was a time when she was scraping
down her life to its sparest, hardest essence, when she was re-
moving the soft tendrils of emotion, cutting out the tender core
of vulnerability. That was the moment in which she chose to
paint the bones.

Regardless of their confusion, critics as well as the public
were moved by the strange pictures: they were like no others.
For once, even Stieglitz had liked the new work at first sight.
When Georgia drove the new paintings down to New York from
Lake George, she wrote: "Stieglitz was . . . much surprised at the
paintings—liked them much—which surprised me because I had
thought them a bit too weird for him."[9]

There was, as some critics suggested, a connection between

O'Keeffe's new works and the Surrealist movement. Certainly she began using elements that were part of the Surrealist vocabulary: the illogical suspension of objects in pellucid space, the use of a magical perspective, the arbitrary juxtaposition of near and far, and the elimination of detail in order to create an aura of strangeness and mystery.

However, the connection was coincidental. Though it is possible that O'Keffee saw some Surrealist works, she produced these paintings before the exhibition in 1936 that largely introduced the movement to New York. More important, O'Keeffe and the Surrealists had little in common philosophically. The Surrealist movement deliberately fostered an atmosphere of the arcane, the esoteric, the inexplicable. Self-consciously obscure, often violent and erotic in their imagery, the Surrealists emphasized a psychoanalytic approach, relying on chance and the subconscious to produce images that were intended to be resonant and profound. O'Keeffe painted objects that were ordinary, things picked up off the ground: shells, flowers, bones. On the high New Mexican desert, the bones were not esoteric, though critics often chose to see them so. As Freud pointed out, "Sometimes a cigar is simply a cigar," and for O'Keeffe, the bones were simply beautiful objects that represented her world, just as shells and flowers had represented other landscapes. "I don't think of their being bones . . . it is my way of saying something about this country which I feel I can say better that way than in trying to reproduce a piece of it. It's a country that's very exciting . . . How can you put down an equivalent of that kind of a world?" [10] There was a fundamental lack of self-consciousness about O'Keeffe that distinguished her work from the Surrealists', even when the work seemed to overlap. Her intent was clarity; theirs mystery.

In fact, O'Keeffe had never been a committed member of any aesthetic movement. She was a modernist—one of the group of Americans experimenting with abstraction and postimpressionist concerns in the first quarter of this century. However, she never became a member of the other groups that formed around her: Precisionists, Regionalists, or Surrealists. Stieglitz always worked with groups and liked the idea of communal effort, but O'Keeffe felt that her work was a private endeavor. "Stieglitz liked the idea of a group," she said. "I didn't." [11]

Alfred's sympathy for the idea of groups did not extend to

institutions. He generally disliked museums and was ferocious in his disapproval of government work projects for artists. He insisted that bureaucratic restrictions governing message, image, and hours would prevent the artist from operating as a free agent.

It was painful, therefore, for him to find that O'Keeffe had deliberately involved herself in a project that smacked of bureaucracy, plutocracy, and public works. Equally enraging was the fact that she was doing it for subsistence-level wages.

The Rockefeller Center project in New York was a vast and ponderous skyscraper complex, which was intended to make a variety of public statements about the arts in America, the importance of the common people, and the benefits of technology. Diego Rivera, the Mexican Communist artist, was commissioned to paint murals for the interiors of Radio City Music Hall. After managerial unease—Rivera was highly controversial—the artist was removed from the project.

The Museum of Modern Art, without an active role in the Music Hall project, announced a competition that alluded directly to it. Sixty-five American artists, O'Keeffe among them, were invited to submit plans for a mural design. The requirements specified a cartoon for three panels, and one large completed panel, seven feet high by four feet wide. The best entries would be exhibited at the museum in May. The competition was announced only six weeks before the deadline for the submissions. The public nature of the mural project meant that in many of the entries, political concerns superseded aesthetic ones. This, combined with the early deadline, resulted in a generally low standard of excellence, and the competition was not regarded as a success.

O'Keeffe's entry had no political overtones. It was a long horizontal composition, containing familiar O'Keeffe themes. A Manhattan skyline had plumes of smoke drifting through the nighttime sky; a large low moon appeared in one panel, and as an example of her newly achieved freedom to manipulate scale, space, and perspective, large roses hung in the sky in another.

Donald Deskey was the designer of the Music Hall interiors. His intent was to make the theater into a public gallery of contemporary art, decorated by first-rate modern artists. In the spring of 1932, he approached O'Keeffe, offering her fifteen hundred dollars to paint a mural for the ladies' powder room. The room was eighteen by twenty feet, with eight round mirrors, three feet six

inches in diameter, set into the walls. The fee was less than half what O'Keeffe received for a good oil painting, but it was the maximum permitted each artist.

O'Keeffe had wanted to work in a large public space for several years. "I have such a desire to paint something for a particular place—and paint it *big*," she wrote Blanche Matthias in 1929.[12] She agreed to Deskey's proposal, in spite of the small fee, and planned to fill the room with big flowers—probably from the mural design for the Modern.

When Stieglitz heard what she had done he was enraged. He confronted Deskey, declaring that as O'Keeffe's agent, he was revoking the contract. Deskey explained that the contract was between himself and O'Keeffe. Stieglitz then suggested that O'Keeffe would waive the fee entirely, on the condition that she receive five thousand dollars for expenses. Deskey repeated his position: the contract was between himself and O'Keeffe.

Stieglitz returned to O'Keeffe and launched an attack on her. He felt she was publicly betraying him, as an agent and as a husband, as a commercial and a philosophical partner. O'Keeffe's private negotiation of the contract made him look redundant and feel foolish. Her acceptance of a small fee nullified all his efforts to create a strong market for her work; her support of a commercial building project, erected by rich people and decorated en masse, was deeply antipathetic to him. And finally, commercial considerations aside, there was the question of marital loyalty: Stieglitz expected his wife to support him in the public arena even if she disagreed with him privately.

The confrontation was part of a continuing dynamic. O'Keeffe was acting as an independent person and artist, at some cost to the marriage. Her cool exclusion of Stieglitz from the Music Hall negotiations made a statement that he found subversive and threatening. The case for Stieglitz as the betrayed husband was strong, defensible, and easily articulated. The unspoken subtext, of course, was Stieglitz's public betrayal of O'Keeffe with Dorothy Norman.

• • •

IN FEBRUARY 1932, Stieglitz exhibited one hundred twenty–odd photographs at An American Place. It was a forty-year retrospective, and it included his New York buildings, the O'Keeffe portraits since 1922, and portraits of the new beloved face, Dorothy

Norman. Referring to the exhibition in her letters, O'Keeffe maintained a smooth and impenetrable veneer: "The Place is the most beautiful now that it has been at all," she wrote Brett; "as you walk down the length of each wall and look at each print it is as though a breath is caught."[13]

The photographs of Norman are very different from those of O'Keeffe, revealing Steiglitz's view of his very different subjects. The O'Keeffe photographs project strength as well as beauty. The lines and angles of the subject's bones and limbs form powerful matrices, formal designs of potency. Photographed against her own work as well as against blank walls, Georgia very much occupies the space around her, and she takes imposing command of the territory, physical and psychological. The sense of purpose, integrity, and passion are quite as important as O'Keeffe's haunting, unconventional beauty.

By contrast, Dorothy Norman's beauty is soft, youthful, and passive. Nearly twenty years younger than O'Keeffe, Norman had regular features, dark hair, and large dark eyes in a pale oval face. In Stieglitz's photographs, her smooth, unlined face is very close; in some, the entire frame is taken up by her features. The face in these photographs exists only for the photographer; the only background elements are light and shadow; there is no sense of a real environment. The face is a beautiful, mild object set in anonymous space. It is shown frowning thoughtfully or smiling, compliant, and willing. The contours in the face are rounded and soft, with no strong hard lines, no angles. No work is shown that relates to her, and little sense given of a surrounding life. There is little suggestion of psychological presence, nor does she create her own private reality. The thoughtful frown seems self-conscious: as Janet Malcolm observed, she appears "a handsome young woman with a perpetual extremely pained expression."[14]

For Stieglitz, this mild passivity was reassuring. Norman was in her late twenties, a married woman with two children, but she was seen both by herself and by Stieglitz as girlish and innocent: he called her a "Child-Woman"; in her own writing she called herself "a larger child."

If the point of Alfred's infatuation had not been made by the photographic exhibition, it was made by his tutelage of Dorothy Norman as a photographer. If not made by that, it was made by Norman's newly visible association with the gallery. By the spring of 1932, the initial three-year rent guarantee had run out.

Norman persuaded Stieglitz that the precariousness of the economy warranted a more inclusive search for supporters. She suggested they broaden their base from the small coterie of loyal backers. She wrote letters to every conceivable patron and made a plea in the newspapers for more funds. The result was Stieglitz's acceptance of her as a business partner, in practice if not in theory: the new gallery lease was in her name, and from that time on, a percentage of artists' proceeds went to the Dorothy Norman Rent Fund for the gallery. Norman was now part of every facet of Stieglitz's life: she was his photographic model, his professional associate, and his creative protégée. As a cumulative public statement, it was difficult to ignore.

• • •

IN MAY 1932, Georgia traveled to Lake George, planning to proceed to New Mexico at the beginning of June. Just before she was to leave, Alfred spent a weekend with her there to say goodbye. A day after his return to New York, however, he received a telegram from Georgia: she would not be going west. Staying at the Hill, she would not have to share Alfred's days with Norman, and if Georgia was at Lake George, Alfred would not go to Woods Hole. Georgia's ambivalence was revealed in a letter she wrote to Russell Vernon Hunter in the spring.

> You are wise—so wise—in staying in your own country
> that you know and love— I am divided between my man
> and a life with him—and something of the outdoors—of
> your world—that is in my blood—and that I know I will
> never get rid of— I have to get along with my divided self
> the best way I can— So give my greetings to the sun and
> the sky—and the wind—and the dry never ending land.[15]

Besides the unacknowledged threat of Woods Hole, there was a logistical consideration: Georgia was very much involved with the practical arrangements for the Radio City project, and that summer she went down to New York four times, twice staying a week.

O'Keeffe was at the lake, with Georgia Engelhard, when Alfred arrived for the summer, toward the end of June. He brought with him the usual influx of guests. Paul Rosenfeld and the critic Ralph Flint were there, as well as a group of reverential disciples, who referred to Stieglitz as "the Master." Perhaps en-

couraged by this deference, Alfred had conceived of an ill-fated and astonishingly naive plan. He asked his friends to talk to Georgia privately and try to persuade her of two errors in her ways. He wanted to convince her that her participation in the infamous Radio City project meant aesthetic prostitution for her and public ignominy for him. He wanted also to persuade Georgia to adopt a more sympathetic attitude toward Dorothy Norman: it seemed to him that Georgia was being willfully unkind in refusing the friendship of the younger woman. And since his infatuation was never discussed by Alfred and Georgia, he could adopt a tone of righteous indignation about the issue, pretending that his position was blameless and Georgia's inappropriate and unwarranted. There was a precedent for his monumental naïveté: the first time Alfred had seen Emmy after leaving her, he had asked her to dinner with himself and O'Keeffe, believing that the two women would become friends.

Paul Rosenfeld wisely refused to participate in the nonsensical effort, but the other men, singly and in groups, dutifully brought up the awkward topics, offering their "independent" opinions to O'Keeffe and even to Georgia Minor, hoping that the younger Georgia might influence the older. A sense of humor might have saved the situation, but no one dared see the plan as silly. Instead, the disciples stalked their quarry across the countryside, anxious, invariably unsuccessful, and bathed in gloom: they were called "the Sunshine Boys."

The domestic atmosphere did nothing to lighten the moods of the Sunshine Boys; between the Master and Georgia there was a strong current of tension, interrupted frequently by quarrels. Georgia wrote Brett: "Everyone dislikes the Idea of Radio City—but I feel that has nothing to do with my wanting to paint a room—so there we are all in a squabble—everyone getting on everyone else's nerves."[16]

By August, Georgia's nerves had had enough. She set off for Canada, up the Saint Lawrence River to the Gaspé peninsula. Paul Strand had taken a trip there in 1929, and his report and pictures had interested O'Keeffe. She traveled with Georgia Engelhard, who was now almost twenty-six, energetic, enthusiastic, and quite as adventurous as O'Keeffe. She was an excellent companion: the two women shared a taste for onions and bootleg liquor, as well as a healthy scorn for the imbroglios at Lake George. "She is wonderful," Georgia wrote, "really lots of fun in

every way."[17] Clear-eyed and boldhearted, Georgia Minor had responded to a severe fear of heights by becoming a well-known mountaineer. O'Keeffe had "ragged her" into learning to drive, and the young Georgia had, with Alfred's encouragement, become a competent photographer. With O'Keeffe's coaching, she had become an interesting painter.

The two women set out in Georgia's Ford through the bleak, invigorating countryside. The landscape was very different from that of either New Mexico or New York. Along the Saint Lawrence there was open, rolling, and rugged farmland. The rich, newly plowed fields and the sense of strong agricultural life, strongly reminiscent of her Wisconsin childhood, exhilarated Georgia.

> That was a wonderful trip . . . The soil there was a marvelous deep black after it had been turned over, and there were beautiful blossoming potato flowers—very lush.[18]

On the Gaspé, too, Georgia found the mismatching of houses and barns that was prevalent in the Midwest.

> The southern side of the St. Lawrence River was lined with hideous houses and beautiful barns. The barns looked old, as if they belonged to the land, while the houses looked like bad accidents. [19]

The coast itself was very rocky and very wild, with high cliffs rising straight out of the sea and wild forest coming right down to the water.

The Gaspé had been settled by the French, and French was still the common language. This pleased Georgia, since she could not speak it and was therefore absolved of the obligation to talk to anyone. After the intensely social climate of Taos, she found the involuntary silence a great relief, and because of this she told Hunter that the Gaspé was better for painting even than New Mexico. "The Southwest is not the only place on the map," Stieglitz wrote Seligmann, rather gleefully.[20]

The Catholic Church was much in evidence, and crosses stood in the northern landscape as they had in New Mexico. On the Gaspé, however, they stood by the shore awaiting the fishermen's return from the sea, symbols of hope and supplication. In contrast to the heavy and unforgiving Penitente crosses, which

represented exigence and pain, the French crosses were slim and cheerful, hung with decorations and full of optimism.

> In New Mexico the crosses interest me because they represent what the Spanish felt about Catholicism—dark, somber—and I painted them that way. On the Gaspé, the cross was Catholicism as the French saw it—gay, witty.[21]

The two women painted steadily, staying in farmhouses along the way and once in an empty hut. Georgia Engelhard was one of the few people with whom O'Keeffe painted. Georgia Minor's work had received early encouragement: in 1914, Stieglitz had shown her paintings at "291." When she was a teenager, she and Georgia gave a joint exhibition of their work in the little white house with the weather vane at Lake George. The show was open exclusively to the family, admission was ten cents, and all proceeds went to the Red Cross.

Engelhard's pictures, not surprisingly, show O'Keeffe's influence: a simplification of shapes; shining, luminous surfaces; and a certain radiance about her colors, a muted internal brilliance, particularly in her whites. Engelhard had an elegant sense of composition quite her own, however. A large decorative three-paneled screen by her, depicting deer climbing through mountains, reveals a strong sense of stylized pattern and subtle, rich color harmonies.

The two women returned in early September, loaded with their work. O'Keeffe's paintings from the Gaspé are dark and somber: full of muted greens, deep browns, blacks, and the vivid white of the barns. The barns were something she had long known and understood: she produced strong and solid forms, at once abstract and specific, secure in their potency, connected to the land and dominating it, outlined against a wide, pale sky.

The other paintings from this trip—crosses and landscapes —are not as successful and though she found the travel invigorating and exactly suited to her needs at the time, the climate of the Gaspé was finally too bleak for her. It was cold there even in August, and Georgia had become addicted to the steady, searing New Mexican sun.

The Georgias made several forays into Canada that Prohibition year, returning once with a contraband cargo. Much to their chagrin, they were stopped at the border, relieved of their liquid booty, and fined. Georgia said nothing about the incident to Stieg-

litz, who disapproved of drinking and was in any case no longer a sympathetic ally. A letter to Georgia from the United States Customs Bureau aroused Alfred's curiosity, however. He opened the letter and found damning evidence: a receipt for the fine. A ferocious scene ensued. Georgia's outrage at his invasion of her privacy (opening her mail) was equaled by Alfred's outrage at her contempt for the law. The parallel between this and the nude-bathing arrest reveals the changes that had taken place between them. Instead of closing ranks against a ponderous bureaucracy, Alfred and Georgia instinctively took opposite sides on the topic, and each accused the other of moral turpitude. The response was symptomatic of their relationship at the time: resentful, challenging, and dangerous.

That fall, O'Keeffe spent much of her time alone at the lake, working on her designs for Radio City. Stieglitz was in New York, embarked on a project of his own: Dorothy Norman had shown him a sheaf of poems. Norman hesitated at first to reveal the work to Stieglitz, thinking it was "too young." Alfred, however, was impressed by the artlessness of her stream-of-consciousness pieces, which were thoughts on love and religion. A firm supporter of intuitive expression, he liked her ingenuous style. He wrote to publishers on her behalf, suggesting at least to one that his discovery of Norman the poet was the equivalent of his discovery of O'Keeffe the painter. In the event, he failed to persuade any publishers, and he took on the task of publication himself. *Dualities* was published by An American Place in 1933.

Dorothy Norman undertook a similar project. Alfred's seventieth birthday would occur on January 1, 1934, and Norman, planning to commemorate this and to celebrate Alfred's achievements, approached editors and solicited contributions from friends and supporters. When *America and Alfred Stieglitz* was published by Doubleday in 1934, it contained a collection of essays in praise of Alfred by his friends and admirers. Among the many contributors were Waldo Frank, Sherwood Anderson, Jean Toomer, Gertrude Stein, and other writers, as well as the artists Dove, Marin, Hartley, Demuth, and Dorothy Brett. An essay by one of Stieglitz's best-known artists—his wife—is conspicuously absent.

"I don't like to be second or third or fourth," Georgia had written Henry McBride a decade earlier, "I like being first—if I'm noticed at all—that's why I get on with Stieglitz—with him I feel

first." [22] Georgia no longer felt first, and the displacement was excruciating. She could not tolerate even being in the same room with Norman, and once, escorted to a party where Norman had already arrived, she turned around at the door and left.

She was finding the tensions that surrounded her increasingly difficult to ignore, though she knew no other method of dealing with them. Georgia's response to adversity was to challenge it; one rainy day she wrote: "I may go out and walk in it, for spite." It was a courageous approach to life, but one that was beginning to lose its efficacy.

• • •

BY OCTOBER, strain was increasing from another source: the Radio City project. On the train back to Lake George from New York, Georgia wrote Beck about "the struggle with the young men who have to struggle with every one from Mr. Rockefeller and Mr. Roxy to the stone mason— I am a bit worn," she wrote, and "loosing [*sic*] interest tonight—but don't tell anyone— I will be feeling better in the morning." [23]

The Music Hall was behind in its construction schedule, but though the construction was delayed, the opening date was not, and the artists had less and less time in which to work. They could not begin until the plaster on the walls was fully dry. O'Keeffe was to work on canvas laid down on plaster, and she was concerned about the canvas being applied to the complex curves in the corners of the ladies' powder room. Deskey assured her that the canvas was being properly attached by professionals and that the plaster would be dry before the application took place.

On November 16, six weeks before the building was to open to the public, the powder room was finally ready for Georgia to work on it. Deskey escorted O'Keeffe and an assistant to the pristine room. O'Keeffe sat down on a box in a corner of the room to consider her task before beginning. As she looked around the room, part of the canvas came away from the wall in one corner. She pointed this out to Deskey; he assured her it could be fixed. O'Keeffe went out to lunch, and came back to find more canvas loosening.

Though other biographers describe an emotional scene, Deskey remembers nothing dramatic about it, and O'Keeffe's own account is low-keyed and straightforward. "I came to town to

start on that job but the plaster is wet—not ready for the canvas —so I've told them I am not going to do it—they say I am—so there we are. I am in a sulk because I want to do it but I cant if the plaster isn't dry . . . it causes much disturbance about this part of town."[24]

O'Keeffe announced her refusal and walked off the job. Stieglitz was delighted, and the next day he called Deskey and announced that O'Keeffe was having a nervous breakdown and would be unable to complete the project. With characteristic pugnacity, he threatened to sue Radio City if O'Keeffe was not released from her contract. Deskey released O'Keeffe and gave the commission to the Japanese-American artist Yasuo Kuniyoshi.

In her lettters, Georgia's tone was calm about the Radio City debacle. "I think I'll go back to the country tomorrow and let someone else paint the room on the wet plaster," she wrote Hunter, adding whimsically, "I think I'll . . . paint the kitchen wall."[25] But the calm and the whimsy were deceptive; in fact desperation was approaching, but O'Keeffe could neither write nor speak this; she had no language for it.

This was a public failure for O'Keeffe, perhaps her first. It was not a tangible or critical failure, but one of nerve. It was fear, not wet plaster, that stopped her from continuing the project. Surely she could simply have stipulated that her work could not be viewed until she declared it ready; moreover, if she had set to work at once with an assistant, the job would probably have been completed in six weeks. The wet plaster was an excuse to obey her husband, and to avoid risk. The project had taken on terrifying proportions, the risks were overpowering, and her nerve was gone.

She had never before mentioned fear of public failure. The public exhibition of her work was an interesting process to her, but her self-esteem as an artist depended upon pleasing neither the public nor the critics. This attitude required a strong ego and a firm conviction, which she had always had. "I never cared anything at all what other people thought," she said of her work years later. "I was just doing what I wanted to do."[26] Her response to her very first show at "291" revealed an essential aloofness from public and critical response. "The show was no pleasure to me. There was a certain satisfaction, but no pleasure."[27] Her feelings thereafter continued to be ambivalent: she was interested that the public found her work interesting, but she

painted for herself. Of the critics, she wrote: "I wonder that I've been able to walk down the street so unaware of the printed word about me— It is as if I have a strange oily skin of some sort that words don't get through."[28]

This year was different. In letters about the Music Hall project, for the first time she reveals a serious fear of failure. Her expression of it was casual, but the anxiety was real: "It seems a bit funny when you have had an absurd idea in your head for years to suddenly find yourself about to try it out in public and see if it will work," she wrote to Beck.[29] To Brett she was more revealing: "No-one in my world wants me to do it but I want to do it . . . I want to try it— I must admit that experimenting so publicly is a bit precarious in every way," she wrote, adding, "my kind of work is maybe a bit tender for what it has to stand up to in that kind of world."[30]

The source of her anxiety was evident: Stieglitz's antagonism to the whole idea and his hostility toward her. At the end of the summer, when his attempts at dissuasion had failed, he had announced publicly his support of the project. O'Keeffe, however, knew his true feelings about it very well. "My Gawd won't I get Hell if I cant make a go of it."[31]

Georgia's fear of Stieglitz's "Hell" exactly paralleled her fear of her mother's "I told you so," which kept her from returning to New York in 1915. Each time, the threat of humiliation at the hands of a powerful loved one proved too strong for her, and in each case, she reluctantly gave way.

Stieglitz's objection to the Radio City commission was ostensibly a moral one, but the real issue was personal: Stieglitz's affections were now directed elsewhere. The withdrawal of love is a terrible act for a moral person, and the accompanying guilt is devastating. To legitimize his cruelty, the cooling lover seeks just cause. Stieglitz railed vituperatively about O'Keeffe, shocking his friends with his violence and vehemence. His antagonism was a part of that searching for just cause, that triumphant hostility with which a former lover justifies his coldness, vindicating his withdrawal and proving his innocence. His rage was devastating to his wife.

For both Stieglitz and O'Keeffe, their art was crucial to themselves, to their personas and their self-images. Stieglitz had always gloried in O'Keeffe's work. He had seen it, quite properly, as the expression of herself, that central core of identity which he

honored and cherished. His adamant and violent rejection of O'Keeffe's plan, and his hostility toward her projected work, was a violent rejection of herself.

O'Keeffe had lost Stieglitz's support—emotional, professional, and psychological—and without it, her own confidence withered. She lost a central nerve, integral to her aesthetic life. She had failed publicly and drastically as a wife; she could not risk, as well, failing publicly and drastically as an artist.

24

*It is debilitating to be any woman in a society where women
are warned that if they do not behave like angels they must be
monsters . . . patriarchal socialization literally makes women
sick, both physically and mentally.*

—GILBERT AND GUBAR,
The Madwoman in the Attic

DAYS AFTER O'KEEFFE'S withdrawal from the Radio
City project, the psychological effects of her decision began to
appear. Her symptoms were physical: shortness of breath, pains
in the chest, and difficulty in speaking. Alfred at once called Lee,
who diagnosed shock and prescribed bed rest. This seemed effec-
tive, and in a few days Georgia was well enough to take the train
back to Lake George, where she set to work preparing her paint-
ings for the winter exhibition. The improvement was only tem-
porary. By the tenth of December, Georgia was back in New
York, feeling worse. Added to the former symptoms were blind-
ing headaches, chronic fatigue, and sudden weeping spells. Lee
called in specialists, who offered an array of diagnoses: heart
trouble, kidney ailments, and menopause. (It was not meno-
pause.[1]) Alfred made his own ironic choice: "Heart!!" he wrote
Seligmann.[2] Bed rest and a bland diet were generally agreed
upon, and Lee paid house calls twice a day. At first Alfred stayed
at home with Georgia; then he resumed his daily hours at the
Place, and she was alone.

Georgia's condition worsened: she could not eat or sleep and was taken by long bouts of weeping. Four days before Christmas, she moved in with her sister Anita and her family, in their large apartment on Park Avenue. Alfred prepared her paintings and the gallery for her exhibition without her. He confessed to Seligmann in mid-January: "Georgia has me worried more than I like to admit."[3] He had cause to worry: she had developed neurotic symptoms—hypersensitivity to noise and a morbid fear of water. She was terrified of the crowded streets and began to doubt her sanity.

Female illnesses occupy an important psychological niche in the dynamics of the patriarchal society, as Gilbert and Gubar point out in *The Madwoman in the Attic*. Freud named the disease hysteria after the Greek word for womb, because the overwhelming number of victims of that disorder were female. Consequently, the disease was believed to be caused by the female reproductive system. Anorexia, agoraphobia, and rheumatoid arthritis, by a wide margin, claim more women than men, and it is Gilbert and Gubar's convincing thesis that these ailments have been caused by the crippling psychological restrictions of a rigid and dominating patriarchy. By means of ridicule, intimidation, and absolute prohibition, women were consistently constrained from making independent contributions to the cultural world.[4]

O'Keeffe was not constrained from creative efforts, but just as strenuous were the restrictions placed upon her independence. For ten years, out of love, she had led Stieglitz's life with him. She received his love and his encouragement for her work. His love was now directed elsewhere, and those devastating forces of ridicule, intimidation, and prohibition were directed at her work.

Illness was an important element in O'Keeffe's life, the physical state reflecting and paralleling the psychological one. Her first year in Chicago, at the gloomy and intimidating Institute of Art, was ended by a bout of typhoid. Her second stay in Chicago, spent at exhausting and psychologically debilitating work, resulted in a severe and providential case of measles, which threatened Georgia's eyesight and prevented her from continuing the work. After her mother's death, in 1916, Georgia lapsed into a period of numbing fatigue that nearly incapacitated her. Her serious bout with influenza, in the winter of 1917–18, followed hard

on the heels of her devastating confrontation with the chauvinistic attitudes of the community in Canyon, Texas.

In New York, sickness seemed to be a part of O'Keeffe's life: "Is there, after all, a connection between genius and ill-health?" asked a journalist in 1922. "Miss O'Keeffe has known a great deal of illness."[5] Stieglitz's protective solicitude encouraged the perception of O'Keeffe as dangerously frail. In 1918 a patron asked him to recommend an art teacher: "O'Keeffe would be A1," he wrote, "but I feel she ought not to use her throat this year and above all chance all [kinds of] weather."[6]

Stieglitz's anxiety was justified. For the first ten years of her life with Stieglitz, O'Keeffe was plagued by recurring illnesses: odd, unrelated ailments. A cold would keep her in bed for a week, and a vaccination kept her there for six weeks, with swollen, painful legs. Grippe and influenza were periodic occurrences throughout the winter. In 1921 she suffered from eye problems; in 1927 at Lake George, a sudden midsummer bout of arthritis—coinciding with the arrival of Stieglitz family members—kept her from painting.

Alfred's extreme hypochondria, the propitiatory bottles of disinfectant he carried, his fear of other people's germs and bacteria, both mirrored and encouraged O'Keeffe's sicknesses. Alfred, however, reveled in all this, while O'Keeffe was grieved by it. The symbiotic nature of their sickness and well-being was recognized by their friends: when Ida heard one summer that Georgia was sick, she wrote cheerfully: "Well I know how it is—if one of you cuts your finger you are both sick."[7] Two years later, Henry McBride wrote:

> I wasn't too much alarmed by your tale of Alfred's illness and the disorders of the menage, for I concluded long ago that both of you depend physically upon the other and that such an arrangement is the real secret of longevity. You will have scares but they will only be scares. You will be long in the land, both.[8]

Georgia commented later, wryly: "Alfred once admitted that he was happiest when I was ill in bed because then he knew where I was and what I was doing."[9] Women's illnesses were perceived by a patriarchal society as the result of ill-advised involvement with "dangerous" (creative or subversive) activities—"Is there . . . a connection between genius and ill-health?"—or

as the natural result of a giving and sacrificial nature. Illness also served as an opportunity for men to enforce restrictions on women's activities, as Georgia's comment makes clear. The masculine approach to healing often turned the process into an exercise in domination and subjection.[10] Protective and paternalistic restrictions—enforced rest and inactivity—were common responses to female illness. When Georgia's leg swelled after her vaccination, Lee ordered her confined to bed, with her legs tightly bound. If the physical symptoms were brought on by feelings of repression and restriction, the treatments reinforced the causes.

Although O'Keeffe chose, herself, not to complete the Music Hall project, it was a choice she made under overwhelming pressure from Stieglitz. In fact, her sense of his involvement was so great that forty years later, she still maintained that Alfred had sabotaged the project. Half seriously, she claimed that he had somehow contrived to make the canvas peel away from the wall.

It was a dilemma for which there was no correct solution. If she chose the part of a good wife, she surrendered her independence and her sense of herself as an artist. If she chose independence and acted in public defiance of a husband she loved, then she sacrificed both her marriage and her perception of herself as a good woman.

Her own emotional commitment to Stieglitz outweighed her commitment to her work. To Betty O'Keeffe, her brother's widow, she had written: "All this happening to you makes me feel how utterly empty all my living would be without my Stieglitz."[11] In the end, O'Keeffe chose the part of a good wife and betrayed herself. She had lost her sense of direction and of confidence; she had allowed Stieglitz to invade and control her aesthetic life, as he had taken charge of all other aspects of her life. She had delivered herself up to him, leaving herself no central core. If his behavior was destructive, hers was self-destructive, and she recognized her defeat at her own hands.

On February 1, O'Keeffe was admitted to Doctors Hospital in New York, where she was treated for psychoneurosis.

• • •

CATHERINE O'KEEFFE KLENERT had continued with her painting since she began it in the summer of 1928. She was astonishingly talented as a painter, proceeding with rapid, intuitive skill and a complete lack of self-consciousness. Catherine benefited from liv-

ing in a small community and from being a famous artist's sister: within a year, notice was taken of her paintings, and an article entitled "Portage Housewife Self-Taught Artist" appeared in the *Milwaukee Journal*. A year afterward Catherine's work was given a full-scale exhibition: sixteen of her paintings hung in the Springfield Art Museum, in Missouri, to general acclaim. "Never in our lives have we seen such unusual colors," wrote one reviewer. "They are modernistic things to the nth degree." [12] "They are the height of finesse and subtlety," announced another. [13] Her success was not only critical: she promptly sold two paintings, to a man who told her he would rather have her poppies than a new overcoat.

Georgia's responses to Catherine's work continued to be encouraging and enthusiastic. "Maybe when I go back to town you will send me some of your paintings again," she wrote. "I am glad you keep at it and would like to see others." [14] In October 1931, Catherine sent a new batch of paintings to Georgia, including some of the enlarged flowers, and asked her sister's advice about an exhibition in New York. Georgia's answer was warm and direct.

> I think you have improved in a surprising way. The thing
> that I think would happen if you showed them in New York
> is that they would say that you are very much influenced by
> me. I think it is not so much that you are influenced by me
> as that we are alike. I kept out your best morning glory. I
> will take it with me to the city . . . Alfred may decide to
> show it and maybe one of your milk weeds in a mixed
> show. I will let you know . . . Your work is so clean and so
> pure I dislike the idea of it going to another gallery. I wish
> that we could give you a small show but I very much doubt
> it. You see Alfred doesn't like taking on a new person
> because he feels he hasn't the energy to follow the thing up
> —that to develop a painter is what seems worthwhile to
> him and that it is a matter of years and years—The purity of
> the thing you do makes me so very conscious of the fact
> that I live in the market place—and I feel the market place
> marks me quite sorely. Alfred liked your things like [those
> of] Ida—he liked them very much. I hope so much that you
> keep on working—working a lot. My love to you all. [15]

An agent took on the business of arranging exhibitions of Catherine's work, with considerable success. Catherine showed again at the Springfield museum, at the State Historical Museum in Madison, at the Milwaukee Art Institute, and at the Walden Gallery in Chicago. Though the press made much of the family connection, Catherine showed her work as Catherine Klenert and said proudly that she had not seen her famous sister's paintings before she began to paint her own.

Ida had also been exhibiting her work. After starting to paint seriously in 1925, she had followed in Georgia's footsteps, getting a degree in art from Columbia Teachers College and taking summer art courses at the University of Virginia. Not wishing to trade on her famous sister's name, Ida exhibited initially under the name Ida Ten Eyck. Georgia was not involved with her work as she was with Catherine's, though she encouraged Ida as well.

In July, four of Catherine's paintings were shown informally at the Delphic Studios on East Fifty-seventh Street in New York. And despite Georgia's advice, on February 27, Catherine had a one-woman show there. The Delphic took on both sisters' work, Catherine's and Ida's, and promoted the family connection. Not only was the relationship with Georgia made clear, but naive still life paintings by both grandmothers, Isabella Dunham Wyckoff and Mary Catherine O'Keeffe, were exhibited, suggesting a strong artistic heritage.

Critical response to Catherine's work in New York was positive though cool. The *Post* noted: "At first, because of the enlarged flower forms and intense color, one is reminded of Miss O'Keeffe, but the individuality of the exhibiting artist asserts itself. Her work has a personal sense of design and a highly personal palette." [16] "There is, as might be anticipated, a remarkable color sense," said the *Times*, but "Georgia remains supreme." [17]

The critics' responses made clear the difficulty of viewing Catherine's paintings without the larger oeuvre of her famous sister looming over them. Her work, however, should be seen on its own terms, and as such, it is significant. As the product of a completely self-taught artist, produced in three years' time, the paintings are quite astonishing. Her technical skill, her sense of color, and her emotive capacity are impressive from any point of view. Whether or not she would have developed aesthetically

and philosophically had her career continued is a matter for speculation.

Catherine's paintings are similar to Georgia's in formal terms; they are close, magnified examinations of flowers. The blossoms are centered on the canvases, and both their size and the richness of the colors insist on their importance. In spite of the stylistic resemblances, Catherine's best work is not derivative of her sister's, however, and would not be mistaken for Georgia's. *Red Poppy, Sunflowers,* and *Blue Morning Glory* are perhaps the best of Catherine's extant paintings. These share a gentleness, a velvety softness of texture, and a complexity of line—irregular and organic—which differentiate the paintings from Georgia's harder, cleaner, more abstract work and mark them as distinctly Catherine's. The work of both sisters has a richly emotive quality, a sense of vivid and sensuous color, and a purity that sets them apart from that of other painters.

When Catherine's show went up at the Delphic Studios, Georgia was in the hospital. She was in a hypersensitive state, thin, frightened, weeping, and unstable: a far cry from the serene, competent, and generous queen remembered by Catherine. Georgia's self-confidence was at its lowest ebb. She had seen herself replaced by Dorothy Norman in Stieglitz's affections, his photographic prints, and his professional activities. She had failed in a professional commitment, and she had failed herself. She was now faced with the work of a younger sister, who had endured none of the tribulations O'Keeffe had, whose flower pictures reaped where Georgia's had sown, and whose work was, Georgia herself acknowledged, purer, in a way, less besmirched by the emotions, ambitions, and rivalries that affected O'Keeffe's world.

Georgia's response to the exhibition reflected her state of mind and equilibrium. All her anxieties focused on her distant sister. Georgia's rage was monumental and intense: she wrote Catherine, threatening to tear her paintings to pieces. The Delphic show "was death against me," Catherine said.[18] She was devastated, having known nothing of Georgia's illness; for her, the enraged letter was a bolt from the blue. Her beloved queen had turned suddenly executioner, merciless and implacable.

It was a painful episode: the two sisters did not communicate for four years, and Catherine never painted again.

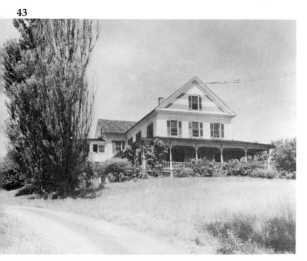

43. The Farmhouse, or The Hill, where the entire Stieglitz family stayed during the summers at Lake George.

44

44. *Corn, Dark I*, by Georgia O'Keeffe: delight in the fertility and richness of Lake George, during the early years.

45

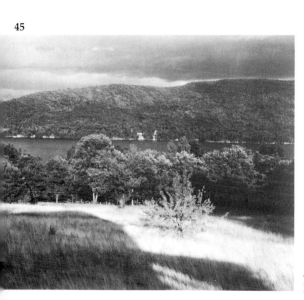

45. *View of the Lake:* a romantic, lush, enclosing landscape.

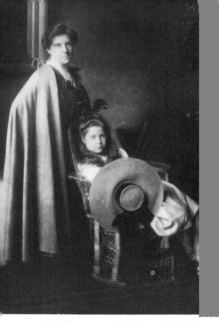

46. Emmy and Kitty: Alfred's wife and daughter, meticulously dressed and posed.

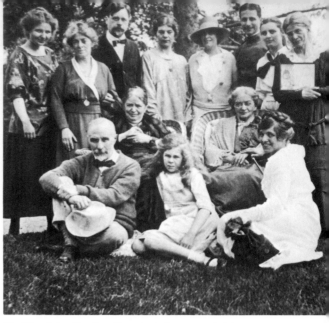

47. The Stieglitz family, 1918: large, voluble, and daunting. Elizabeth is standing at extreme left, Selma is wearing hat, Hedwig is in left-hand chair, and Georgia Engelhard is at her feet.

49

48. Kitty and Alfred, by Alfred: a portrait of silence and distance.

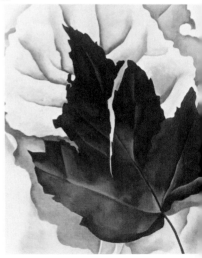

49. *Pattern of Leaves*, ca. 1923. Vulnerability, the jagged tear down the center, begins to appear in the Lake George pictures.

50

50. Elizabeth Stieglitz, Alfred's niece, a close friend and confidante to both Alfred and Georgia. A teetotaller and nonsmoker, Alfred posed her with a beer, a pipe, a cigarette, and a wide smile.

51

51. Rebecca Salsbury (Beck Strand), ca. 1922. An intimate member of the circle: Alfred's model, Georgia's painting companion, and Paul's wife.

52

52. Georgia and Ida at Lake George, 1924?: Ida's visit brought "much laughter and rare good humor," wrote Alfred

53

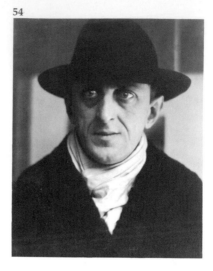

54

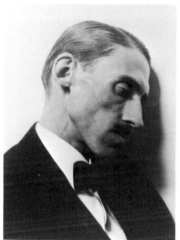

55

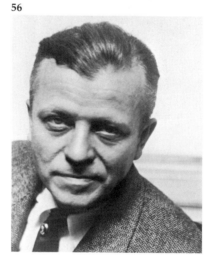

56

57

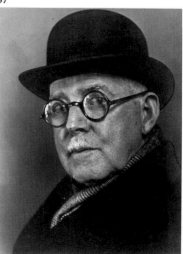

53. The Stieglitz stable of artists: John Marin, 1922.

54. Marsden Hartley, ca. 1915.

55. Charles Demuth, 1922.

56. Arthur Dove, 1915.

57. Henry McBride, 1933: the critic whose intelligence, perceptiveness, and sympathy helped launch O'Keeffe's work, and whose humor provided the basis for a long and affectionate friendship with O'Keeffe.

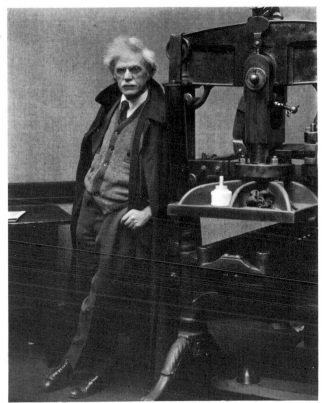

58. Alfred Stieglitz at Lake George, by Paul Strand, 1920.

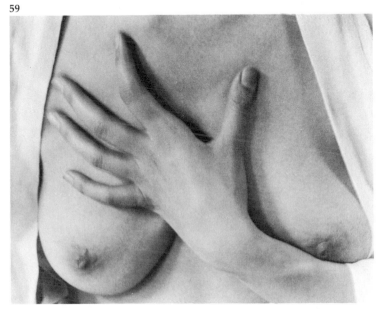

59. From the series of nudes by Stieglitz of O'Keeffe, 1919.
His presentation of O'Keeffe was confusing. Was she artist or
model?

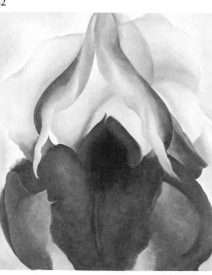

60. Dorothy Norman, whose entrance into
Stieglitz's life created domestic and professional
strain between Alfred and Georgia.

61. *The Lady of the Lilies: Georgia O'Keeffe,* by Miguel
Covarrubias. Georgia's response to both private and
public turmoil was an attitude of cool
invulnerability.

61

62. *Black Iris III,* 1926; the heart is shown
as hidden, dark, and fragile.

63

63. The ladies of Taos: Mabel Dodge Luhan, Frieda Lawrence, and Dorothy Brett.

64

64. Tony Lujan, Georgia's friend and guide through her newfound land.

65

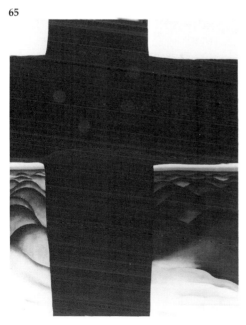

65. *Black Cross, New Mexico,* 1929, Georgia's rendering of the order and passion she found in the New Mexico landscape.

66

66. "Equivalent," 1930, Alfred's response to Georgia's departure for New Mexico. "That's death riding high in the sky . . . ever since I knew Georgia couldn't stay with me."

67. Betty O'Keeffe, Alexis's wife, ca. 1930.

68. Alexis O'Keeffe, ca. 1930.

69. Jean Toomer, in 1925, when Georgia first met him: ". . . so silent, so beautiful looking, his skin so dark and smooth and gleaming, his eyes so strange and risen looking," wrote his first wife, Margery Latimer.

70. Marjorie Content Toomer, Georgia's gentle friend and Jean's second wife.

71. Georgia in the doorway of the one-room schoolhouse at Sun Prairie, ca. 1942.

72. A soiree at Mabel Dodge Luhan's in New York: Thornton Wilder discussing James Joyce's *Finnegan's Wake*, January 12, 1940. Georgia O'Keeffe is at center; Dorothy Norman, behind her, to the right, casts a troubled look at O'Keeffe.

73. O'Keeffe and ten others are honored by the Women's National Press Club, February 1946. Woman of the Year is Dr. Lise Meitner, the atomic scientist, first row, center. O'Keeffe, in severe black, stands behind, second from left.

74

74. Georgia by Ansel Adams, taken during his visit to
Ghost Ranch in 1937.

75

75. By Ansel Adams, 1937: Georgia triumphant, with her
booty.

76

76. By Ansel Adams, 1937: preparations for *plein-air* painting.

77. Georgia and Alfred at Lake George, during the forties. As Alfred's health failed, he depended more and more upon his wife.

78. *Grey Hills*, 1942: Georgia's response to the landscape was still one of tenderness.

79. Anita's world: Mrs. Robert Young and the Duchess of Windsor at the races at Gulfstream Park, Florida, in the early fifties.

80. Maria Chabot, Georgia's energetic friend, companion, and helper, in the garden at Abiquiu, mid–1940s.

81

81. The house at Ghost Ranch, early 1950s, photographed by Marjorie Content Toomer, who is visible in the window's reflection.

82

82. One of Georgia's chow dogs, photographed by Marjorie Content Toomer.

83

84

83 and 84. Georgia in the kitchen at Ghost Ranch—a life of quiet domesticity.

85

85. Georgia, in the lush and fertile garden at Abiquiu.

86. Georgia, in the wide landscape with her dogs, in the mid–sixties.

87. The stark and sun-bleached patio at Abiquiu, which so fascinated O'Keeffe.

88. Georgia on the roof at Ghost Ranch: a life of increasing isolation.

89. Juan Hamilton, her assistant, in 1979, who described himself as "somewhat handsome."

90. An exhibition in Texas of Hamilton's work: attention focused on O'Keeffe.

91

91. Three sisters in New Mexico: Catherine, Georgia, and Claudia O'Keeffe in 1976, with Jingo the chow in front.

92

93

94

92. Ray Krueger, grandson of Catherine O'Keeffe Klenert.
93. Catherine Krueger, daughter of Catherine O'Keeffe Klenert.
94. June O'Keeffe Sebring, daughter of Alexis Wyckoff O'Keeffe.

• • •

GEORGIA'S OWN SHOW, "Paintings New & Some Old," went up on January 7, 1933. Her work from the previous season was neither copious nor strong enough to stand alone, and Stieglitz hung some twenty-odd canvases, dating from 1927 to 1932. Included in it were *White Flower One* and *White Flower Two*, derived from the ill-fated designs for the Music Hall. The work made a strong statement in terms of O'Keeffe's past achievement, but not in terms of her most recent work. Her presence in the art world was, by now, well enough established for the critics to permit her a fallow year. Henry McBride referred to her state in his review: "An illness to Miss O'Keeffe is almost unthinkable . . . she has always seemed so unearthly and so unphysical as to be quite without the range of the slings and arrows that attack us lesser mortals."[19]

Georgia was at first allowed only one visitor in the hospital, her sister Anita.[20] Alfred's presence was upsetting to her, and he was permitted only one ten-minute visit each week. Gradually Georgia began to gain weight and to walk a little in the hallways. Alfred brought her photographs of her exhibition, which was thronged with people. Despite the crowds, however, the economic climate was dour, and not one painting was sold.

The economic situation added to Alfred's general feeling of anxiety, but the heart of it was his terror about Georgia. He feared that his wife was slipping into the same madness that had claimed his daughter. "Georgia's illness is critical," he wrote Strand hopelessly; "it's all pretty terrible."[21] Anxious, guilty, and desperate, he threw himself into a frenzy of activity at the Place. He turned the small exhibition room into a storage area and emptied his warehouse space, bringing to the Place the paintings and photographs he had stored for over a decade. In a sweeping gesture, he decided to dispose of his collection of works by other photographers between 1894 and 1911. Melodramatically, he announced his plans to throw them out onto the street with the trash. (This did not, of course, occur. Carl Zigrosser, head of the Weyhe Gallery, notified the Metropolitan Museum of Stieglitz's plan. The museum sent a wagon to collect Stieglitz's "refuse.")

By the second week in March, Georgia managed twice to make her way to the gallery while her paintings were still hang-

ing. "Couldn't stay but a few moments—but I got there— Doing such little things [is] so strangely difficult for me but much easier every day it seems."[22] The letter to Beck is in a hand quite unlike her normal firm and original handwriting. Only in the letters from 1918, during her breakdown in Texas, was her writing so frail and tentative.

She was getting better, though. She saw a few friends now and was amused at her own predicament: "I am much better— and very funny—getting over whatever I have is a very strange performance— I'll not go into it—but you would certainly laugh."[23]

On March 18, her work came down. Stieglitz's group rallied around him, and Elizabeth Davidson, Dove and Reds, and Cary Ross, the new helper at the gallery, spent the day taking down O'Keeffe and hanging the Dove show. Dorothy Norman did not appear. Alfred's grief and guilt at Georgia's condition had reminded him of the real center of his emotional life and had displaced his infatuation with Norman. Their romantic involvement diminished, although Norman remained a staunch supporter and assistant at the gallery.

On March 24, Georgia left the hospital. Reds had given her the name of a hotel in Bermuda, and with an old friend, Marjorie Content, and her daughter, Sue Loeb, she set off to recuperate in the sun.

Stieglitz and O'Keeffe had known Marjorie Content since the late teens, when she was married to Harold Loeb, editor of the literary magazine *Broom*. Marjorie was a beautiful woman, black-haired and dark-eyed, with a gentle manner and an independent soul. She knew the Southwest and had worked for the Bureau of Indian Affairs, taking photographs of the Apache tribes in Arizona. "I like Margery [sic] very much," Georgia wrote Beck, "and a place where the sun shines and it is warm—where no one will ask me how I feel and no one I know will be around seems very good to think of."[24]

Warmth, languor, and solitude were just what Georgia needed. "It is warm and slow and the sea such a lovely clear greenish blue," she wrote Beck, "I have done little but sit— However the sitting is good."[25] Reviving, she stayed on alone after Marjorie and Sue left; Georgia moved to the Cambridge Hotel, in Somerset. "Feel much more like a human being—begin to tan—and walk about a little."[26]

She returned to New York in May. "Everything seemed a bit too moldy out in Bermuda— The idea of islands got a bit on my nerves too— I seem to like the solid earth," she wrote Marjorie.[27] She spent a day and a half in New York, in bed, then moved to Lake George, where she relapsed once again into inactivity: "I am feeling very good when I don't do much of anything . . . lie in the sun a great deal."[28]

Georgia was improving. She had gained weight: all her pants were too small, she told Marjorie cheerfully, and she had taken to wearing Alfred's. The doctor was adamant about her staying quietly in Lake George, however, and would not hear of her going out west before the end of July, and maybe not then. Her progress was largely physical; underneath it was an anguish that pervaded her days.

> I got out the Ford and drove to town for the mail yesterday — I was terrified to try— I seem to have such a strange kind of weakness that I can't explain even to myself—it is as though a very important part of me that I know no words for is so weak that it almost keeps all the rest of me from functioning.[29]

Georgia Engelhard was in Lake George with her, and Stieglitz arrived on June 16; it was the first time the husband and wife had lived under the same roof since the previous December. Alfred was devastated by Georgia's condition: "O'Keeffe in bed. Very low in every way," he wrote Seligmann.[30] To Dove he wrote despairingly that he felt like a murderer and he feared that Georgia would never paint again.

Georgia seemed to have no reserves and no defenses.

She had adopted a stray white cat; Alfred disliked cats, and when he arrived at Lake George he sternly ordered the cat sent on its way. Georgia's response was, horrifyingly, a flood of tears. Alfred at once relented, appalled far more by her fragility than by the interloper.

"She needs all the care anyone can need . . . I feel pretty blue . . . I am really absolutely alone these days—have been since many months," Stieglitz wrote forlornly to Brett. "I must stay on my feet yet because of G. everything is uncertain. It is impossible to plan or look ahead."[31]

Listless and enervated, Georgia lived as an invalid. She stayed in bed all morning; later she drove, in her new Ford con-

vertible, to flat ground and went for brief solitary ambles. By August, she was feeling better and could stand the Stieglitz family without resorting to drugs: when they first arrived she had had to take as much heart medicine as she had at her worst, in the winter. She was still without energy:

> I just sit in my effortless soup and wait for myself. I do not mean that I make no effort to do things that seem difficult. It seems I never made such efforts to do things in all my life put together—it is that all the little daily doings are such an effort— Edward Stieglitz drove me . . . only about fifty miles . . . and I was barely able to get out of bed the next day— And the worst of my fatigue is a suffering in my nerves that is much worse than physical pain— I don't really get tired physically.[32]

Alfred wrote Seligmann somberly: "I see no 'light' for the autumn or winter as far as she is concerned," and he added a touching acknowledgment of his own sense of inadequacy: "It's a tough situation. And somehow I feel I have never been quite big enough for 'my job'—That's the truth."[33] Alfred's "job" had been not only to maintain his independence beside a strong and independent woman but also to provide her with the support she needed—a paradoxical task required of any relationship, difficult in direct proportion to the strength and independence of the two partners.

For the rest of her life, O'Keeffe insisted on making clear her own self-sufficiency. Years later, in her nineties, O'Keeffe commanded a writer not to mention either her marriage or her husband in an essay on her work. Her reluctance to acknowledge the importance of Stieglitz's support increased after the Radio City incident and her subsequent collapse. This revealed both O'Keeffe's real dependence on Stieglitz and her capacity to survive without him. Her recovery from that devastation would be an achievement entirely her own.

Georgia stayed on at the Hill after Alfred returned to New York. "It is wonderful to be alone—it seems I have never enjoyed anything so much."[34] She spent all fall there, with Margaret Prosser and with her cats (she had acquired a second). She had not painted since the preceding fall. "I have not worked at all . . . Nothing seems worth being put down— I seem to have nothing to say— It appalls me but that is the way it is," she wrote

Hunter.[35] That same month, Ansel Adams wrote Stieglitz, asking to borrow work for a joint Stieglitz-O'Keeffe exhibition in the gallery he was running in California. Stieglitz, in a state of anguished anxiety, identified the work with the artist and despaired of losing both. "What you ask is absolutely impossible," he wrote Adams. "The O'Keeffes are needed here. I dare not risk them out. She is not painting. May never paint again."[36]

Her surreal, abnormal state contrasted vividly with her earlier life. "As I remember myself it seems that there was a spring in me—now I feel more like just a dead weight— As I move about now I don't feel my heart stop every once in a while as I did with any extra effort for so long—maybe the spring will come back, as many fears have slipped away."[37]

That fall, Beck's marriage was beginning to founder. Georgia, hearing talk, asked Beck gently if she should dispel the rumors. When Beck replied, in some distress, that the rumors were true, Georgia gave her own formula for dealing with unhappiness.

> Try not to take it too seriously—or maybe I mean take it more seriously—imagine it is two years from now—and in the meantime dont do anything foolish. Only time will make you feel better—and don't talk about it to people if you dont want to . . . Why should you be expected to explain your personal life to anyone— It is rather difficult to even explain it to oneself . . . don't look ahead or behind and maybe you can enjoy the "now" and not feel a bit disturbed . . . And don't worry about what you are going to do with your life—you can manage.[38]

• • •

IN LATE NOVEMBER, Georgia heard from Jean Toomer. The writer had been a friend of both O'Keeffe's and Stieglitz's since the early twenties, when he published his novel *Cane* and was hailed as a leader of the Black Renaissance. Herbert Seligmann, then secretary of the NAACP, had brought him to meet and have dinner with Georgia and Alfred. Georgia, whose experience with blacks had been limited, was uneasy at the prospect of having dinner with a black man. Out of awkwardness more than prejudice, she planned to meet him at the gallery but plead a headache at dinnertime. Upon meeting him, however, she changed her mind.

Alfred, too, liked Toomer immediately. Toomer was intensely intuitive, a characteristic that Alfred admired deeply, and both men valued feeling more than intellect.

In the mid-twenties, Toomer had become a follower of the Russian mystic George Gurdjieff.[39] A leader in the movement now, Toomer led "awareness sessions." His presence introduced an eccentric and mysterious element to any group: antilogical, oblique, and unsettling. He was intrinsically gentle, not confrontational, and the combination intrigued Stieglitz. Toomer, like many in Stieglitz's circle, looked to the older man for support and encouragement in his endeavors, and often sent his writing to Alfred for comments. The two corresponded regularly throughout the twenties.

In the summer of 1931, Toomer led a session of exercises in Portage, Wisconsin. In his group was the novelist Margery Latimer, an intense, beautiful young woman who was a friend of Catherine Klenert's. Latimer had encouraged Catherine to paint and had written an admiring piece on her work for the Milwaukee Institute of Art. Georgia had met Margery while she was in Portage in the summer of 1928; the two became friends. Her letters, which sound like Georgia's, reveal the affinity between them: "I don't have the energy for it [working]," Margery wrote Georgia. "Now I feel weak and boneless . . . But I want to forget everything and plunge into writing the way I used to, like a bird swooping and gathering everything in its claws."[40]

Of Catherine's work, Margery wrote: "I loved the sunflowers your sister painted and the larkspur—it was the strangest color I have ever seen—like some evenings that are purple and the color stood out and was all full and breathing against the canvas. She said she felt so queer when she got through and she didn't know how she ever did it."[41] Margery's response to Georgia's paintings was strong and immediate: "Reading over your list of paintings made me suddenly taste your world in my throat."[42]

Toomer and Latimer were drawn to one another. "Jean was so silent, so beautiful looking, his skin so dark and smooth and gleaming, his eyes so strange and risen looking, as though he had risen from all that he was," Margery wrote.[43] They married in the fall of 1931, and the following year they had a child. Margery was a Christian Scientist, and despite her serious heart condition, the birth took place at home. The delivery was difficult and Margery barely conscious when it was over. She held her

baby, smiled, and lapsed into a coma. No doctor was called, and twelve hours later Margery died.

The following year, Toomer planned to publish a memorial volume of Margery's letters. He had asked Georgia, among her other friends, to lend him any letters she might have. Georgia wrote from Lake George, explaining that she kept very few letters but she thought she had a remarkable one from Margery in New York, where she promised to look.

Georgia went to New York around the end of November. She did not stay with Alfred but rented a room for herself at the Shelton, where she stayed for a week, resting a great deal and making steady progress. She was strong enough to visit Florine Stettheimer and see the Brancusi exhibition. The outing tired Georgia, but the crucial thing was, as she wrote Strand, that "I could again walk the street a little without fear of losing my mind." [44]

"It will be nice to see you," she had written Toomer from Lake George, and so it proved to be. Unexpectedly, Georgia invited him back with her to Lake George, where he had visited in 1925. Since her trips to the Southwest began, Georgia had been, increasingly, socially independent of Alfred, and she had always had her own men friends. Louise March remembered one man whom Georgia would meet at the subway station in the evenings and walk home with, just for the pleasure of the shared walk and conversation. It was not a flirtation: though sexuality was a part of her character, flirtatiousness was not.

For his part, Alfred was achingly eager for Georgia to revive, and he viewed her invitation to Toomer as a sign of progress. Alfred wrote Toomer at Lake George: "Georgia has no idea how much she worries me not only now but has worried me all these years." [45] His anxiety was justified: for the first week of Toomer's visit, Georgia spent most of her time wrapped in a blanket: "I caught cold in the town and rushed back up here to enjoy it by myself," she wrote Beck. [46]

Toomer's presence was comforting. Alone in the white farmhouse, set in the winter landscape, the summer houses closed and shuttered against the fierce cold, the wide lake below frozen deeply, the two of them sheltered against each other. Toomer's quiet industry rested Georgia: he spent his day working and left her alone. When she was ready, he was there. "He is nice to have about— Is working on a novel—but we say a few words a day to

one another and get on very well," she wrote Beck,[47] and to Marjorie Content she wrote: "You must meet him—you will like him I think."[48]

Toomer visited from early December until the day before New Year's. He wrote a series of warm, chatty letters to Stieglitz, dense and single-spaced, mostly about his work. In the first of them, he said that Georgia "keeps to her bed . . . in good spirits."[49] Three letters later, there was a change. On December 21, he wrote:

> I am amazed at the way Georgia has just suddenly come out of that condition into this condition, this aliveness. For the first ten days I was sort of in the house by myself . . . Now it is inhabited by someone else, by an extraordinary person whom hitherto I've hardly more than peeped at from the outside (and how she can keep people outside!) whom now, however, I'm beginning to see and feel—if not to understand! We've had several long talks about all sorts of things and I'm impressed by the way she has of remaining always herself. Now and again she likes to tell me that she hasn't a mind—but I don't think she thinks she fools me. What she hasn't is a mind filled with a lot of rot . . . I hope you come up for Xmas.[50]

Toomer's own eccentric appeal had something to do with Georgia's emergence from her shell. One night he picked up a tray and began thumping out an Indian rhythm on the bottom of it. Georgia wrote Marjorie: "I got the shivers all over, through the roots of my hair."[51]

Stieglitz did come up for four days at Christmas, from the twenty-third to the twenty-sixth, then left the two alone again in the winter landscape. Outside, it snowed steadily; indoors, there was quiet. "Very little talk— I have finally arrived at that—the not talking seems to give a real quiet that seems to make the whole house feel good . . . We only talk at night and even then often just sit and read. The snow falls very thick and fast—real winter snow . . . The world here is very lovely white it is all white— It seems so quiet and nice," she wrote Paul Strand.[52]

On December 30, Toomer wrote Stieglitz a brief farewell letter. Compared to the earlier letters, it was short and rather awkward. Unlike them, it was double-spaced, so that what was not said took up more room than what was said. "It has been won-

derful here in every way," he wrote, and though he had planned
to return to New York and see Stieglitz, he now announced a
change. "I thought I might return to New York but now I see I
must go back . . . to the middle west. I wanted to see you again
. . . Perhaps later in a month or so . . . a good birthday and a
splendid continuation of the form."[53]

In the four days between Alfred's departure and Toomer's,
the relationship between Jean and Georgia had deepened and
strengthened. When Toomer left, on New Year's Day, O'Keeffe
began to write to him warm, tender, thoughtful letters that re-
vealed both what the interlude had meant to her and why the
relationship would not continue.

> I seem to have come out of my daze into another world
> today—feeling very good—as tho there is nothing the
> matter with me any more. Thank you.[54]

Toomer's calm and meditative gaze, his tenderness and
warmth, had restored Georgia to a condition in which she again
was aware of her own value, her own worth as a person. It was
a great gift.

> You seem to have given me a strangely beautiful feeling of
> balance that makes the days seem very precious to me— I
> seem to have come to life in such a quiet surprising fashion
> —as though I am not sick anymore— Everything in me
> begins to move and I feel like a really positive thing again.[55]

Her own emotional response was direct and unadorned:

> I miss you . . . so many things seem to have turned over in
> me that it seems a very long time [since you left]—and even
> though I miss you I am glad to be alone. I like the feeling
> that you are very busy with your own affairs—and that you
> wear the red scarf— I like doing that to every one who sees
> you.[56]

The episode with Toomer demonstrated to Georgia her own
need for emotional fulfillment. She wrote Toomer:

> My Kitten Cat is lovelier than ever— Maybe I love her too
> much— Maybe it is something in me that I *have* to spend on
> something alive that is beautiful to me. I am quite amused
> with my love— For her—and I like her being so sure that I

like her—her certainty is one of the nicest things about her.[57]

Georgia was forty-six when she acknowledged her need for a reciprocated love. In the preceding few years she had attempted to concentrate on work and to insulate herself from the idea that love was central to her happiness. Her breakdown, and the interlude with Toomer, revealed to her the error of that attitude.

Despite the shared affection between Toomer and O'Keeffe, she felt strongly that their separation was inevitable. "Everything is very nice—only I miss you. It also seems that I never felt more ready and willing to be alone."[58] She recognized that Toomer's driving quality, despite his gentleness and sympathy, was for control, much like Alfred's. His calm, mystical approach was very different in style from Alfred's direct, aggressive personality, but nevertheless it tended in the same direction. After reading some of his work, Georgia wrote him:

> The thing that seems to make you want to write—and *be* as you are—is for me—of a quality that I quite wish to stand apart from because I care so much about it—and possibly even fear it—unless I could do something with that very large ego of yours—either make it so much larger that it would cease to exist—or so small that it wouldn't be noticeable. You do not need it in the obvious form as you have it—because you really *are* . . . I say good night to you from a far off distance as one does to ones God— That sounds funny but I feel a bit that way about the thing in you that makes you be—the sharp clear line in you.[59]

The following day she had a dream that reflected clearly her feeling that they should continue on separate paths:

> I waked this morning with a dream about you just disappearing— As I seemed to be waking you were leaning over me as you sat on the side of my bed the way you did the night I went to sleep . . . in the dining room— I was warm and just rousing myself with the feeling of you bending over me—when someone came for you . . . seemed to be in my room upstairs—doors opening and closing in the hall . . . whispers—a woman's slight laugh— a space of time—then I seemed to wake and realize that the noises—undoubtedly meant that you had been in bed with

her—and in my half sleep it seemed that she had come for
you as though it was her right— I was neither surprised nor
hurt that you were gone or that I heard you with her . . .
And I waked to my room here . . . with a sharp
consciousness of the difference between us. The center of
you seems to me to be built with your mind—clear—
beautiful—relentless—with a deep warm humanness that I
think I can see and understand but *have not*—so maybe I
neither see nor understand even though I think I do— I
understand enough to feel I do not wish to touch it unless I
can accept it completely, because it is so humanly beautiful
and beyond me at the moment. I dread touching it in any
way but with complete acceptance.[60]

Georgia was feeling her way toward a perception of her own
real needs for strength and sanity. Central to that was a firm
belief in her work and value, both as a person and as an artist.

My center does not come from my mind—it feels in me like
a plot of warm moist well-tilled earth with the sun shining
hot on it—nothing with a spark of possibility of growth
seeded in it at the moment. It seems I would rather feel it
starkly empty than let anything be planted that can not be
tended to the fullest possibility of its growth. What that
means I do not know, but I do know that the demands of
my plot of earth are relentless if anything is to grow in it—
worthy of its quality. Maybe the quality that we have in
common is relentlessness—maybe the thing that attracts me
to you separates me from you—a kind of beauty that
circumstance has developed in you—and that I have not felt
the need of till now. I can not reach it in a minute.[61]

O'Keeffe's unflinching approach to her own needs demon-
strated her arrival at a new plateau of self-sufficiency. A deep
honesty informed her assessment, and she saw herself without
guile or excuses, recognizing her strengths—the quality of her
plot of earth—and her weaknesses: her lack of Toomer's "deep
warm humanness." Toomer responded with a deeply perceptive
letter, in which he noted a certain "unconscious stinginess" in
her. He had observed that she asked nothing of other people and
accounted for this in two ways. One was that she herself had a
"rich inner supply to draw upon," and the other was that her

refusal to take anything meant that she would never be obligated in return.[62] His assessment was accurate as far as it went: the inability to ask other people for anything was a direct result of Ida's cool astringency, and Georgia's attitude was founded early in self-defense.

Characteristically, Georgia's recognition of her own needs placed the responsibility for her well-being on herself. She blamed no one else for her difficulties and acknowledged her vulnerabilities.

> If the past year or two has taught me anything it is that my plot of earth must be tended with absurd care— By myself first—and if second by someone else, it must be with absolute trust—their thinking carefully and knowing what they do— It seems it would be very difficult for me to live if it were wrecked again just now.[63]

The implication that O'Keeffe could not go on living unless her needs were met referred to a very real threat. Through the submergence of these needs, she had come terrifyingly close to the loss of her sanity.

• • •

THE RELATIONSHIP between O'Keeffe and Toomer clearly had erotic overtones: "I like knowing the feel of your maleness," Georgia wrote him,[64] and, even more specifically, "I wish so hotly to feel you hold me very very tight—and warm to you."[65] The relationship may not, however, have been a sexual one. Ambiguities abound in the letters, and even her wish for him to hold her tight continues: "closer than you have—maybe—closer than you can— I couldn't be different than I was when you were here." Her words suggest a real temperamental gap between them, a difference that was not temporary, something that prevented the relationship from advancing. On January 4, Toomer sent his "Greetings to . . . the bundling-bed."[66] A bundling board is a nineteenth-century device: a padded board laid down the center of a double bed, so that, in the event of the need to share one, an unmarried couple could do so virtuously. Its function is that of Tristan's sword: symbolic and physical enforcer of chastity; enforced chastity clearly played some part in their encounter.

On January 10, writing to him about her dream of the other

woman, Georgia referred to the events that took place on the night before Toomer left. Her comments suggest something that might, in fact, have precipitated his leaving—something that may have been a sexual invitation on his part and a rejection on hers: an attempt to move close to each other, which was unsuccessful:

> The morning you left I only told you half of my difficulties of the night before. We can not really meet without a real battle with one another and each one within the self—if I see at all. You have other things to think of now.[67]

Whatever the nature of their relationship, it was a close and tender one that served a valuable restorative function for Georgia, reassuring her of her own value and warmth and of the fact that she was alive.

> What you give me makes me feel more able to stand up alone—and I would like to feel able to stand up alone before I put out my hand to anyone— Maybe what you give me at this time and in this way is the most precious thing I can receive from you.[68]

25

*Today is all bare and bright, bare limbs and bright sky and I
thought there is a way to face the truth we actually know far
inside us, our nakedness, our peril, and let it invigorate
every cell. There is a way of becoming so alive that anything
on earth that happens is a privilege.*

—MARGERY LATIMER,
October 23, 1928

BY EARLY 1934, Georgia was on the mend. A week after
Toomer left her she began to paint, for the first time since the fall
of 1932. "It will undoubtedly take quite a period of fumbling
before I start on a new path," she wrote him, "but Im [sic] started
—and seem to settle down to it every day as tho' it is the only
thing to do."[1]

Toward the end of January, Georgia made two trips into New
York. In anticipation, she was thrown into "the most ridiculous
panic" and climbed back into bed for the rest of the day, but "I'm
going anyway," she wrote Toomer.[2] She took a quick trip to look
through work for exhibition—and went next for twelve days, for
the hanging and opening of her show. It was exhausting but
salutary: Georgia felt "as tho' I was smashed to bits so many
times . . . though I really stand it very much better each time,"
she wrote Toomer.[3]

The show was a retrospective, as there was no new work.
"Georgia O'Keeffe at an American Place: 44 Selected Paintings,

1915–1927" ran from January 29 through March 17. Alfred had chosen the works carefully, omitting most of the flower paintings and the New York landscapes. Beginning with two "very pure and beautiful" abstractions from 1915—probably *Blue Lines* and one from the plumed "Blue" series—the show included the clamshells, the jack-in-the-pulpit series, and a number of abstractions. Lewis Mumford, writing for *The New Yorker*, saw the works as those "in which she has concentrated and celebrated almost every phase of the erotic experience." Beyond the erotic, he noted that "the directness of transcription from feeling to symbol gives the best of these canvases a special and distinguished place of their own to which few contemporaries, however talented, have access. These pictures are not derivations, they are sources."[4] The Metropolitan Museum made its formal declaration of O'Keeffe's merit by buying *Black Flower and Blue Iris*.

O'Keeffe herself felt little connection to the exhibition. "I feel so far removed from my work when I go to see it . . . I can imagine denying I had ever done it," she said in an interview,[5] and was unconvinced of its success: "I do not particularly enjoy thinking of [my show]— There are paintings of so many things that may be unpaintable."[6] One of them recorded her response to Toomer when he first visited Lake George, nearly a decade earlier. "The feeling that a person gives me that I can not say in words comes in colors and shapes," she wrote him. "I never told you—or any one else—but there is a painting I made from something of you the first time you were here— I hunted for it and hung it . . . It is rather disturbing to take the best of the work you have done from the people you have loved and hang it that way and go away and leave it— Makes me feel strangely raw and torn."[7] (The painting is most likely the 1925 *Birch and Pine Trees— Pink*.) In New York, Georgia approached an understanding with Alfred. She was coming to terms with herself and with her affection for him, and Alfred was learning to accept the realities of Georgia's needs. "There were talks that seemed almost to kill me —and surprisingly strong sweet beautiful things seemed to come from them," she wrote Toomer.[8] If the talks were painful, the leavetaking was, as well: "The days with A. were very dear to me in a way— It was very difficult to leave him but I knew I could not stay."[9]

Georgia went back to Lake George, where the temperature was below zero much of the time. She walked on the frozen lake.

"It is lovely," she wrote, "feels so big and wide—a wonderful feeling while I am out there— The bitter cold and wind [are] even part of what I like—only when I get back to the house I am alone again."[10]

"If I liked the country it would be quite perfect but I don't like this kind of country," she had written Hunter the year before.[11] At the end of February she left, alone this time, for Bermuda. "I am tired of cold and wind and snow and being alone," she wrote Toomer. "[I] want to lie in hot sun and be loved—and laugh—and not think—be just a woman— I rather imagine just a woman doesn't have to think much—it is this dull business of being a person that gets one all out of shape."[12] She knew the trip to Bermuda was not a permanent solution. "You must know that my coming out here to these toy like islands on the glassy green sea is only an evasion."[13]

What was permanent was a sense of deep and necessary commitment to her own needs as an artist, which must take precedence over her other roles, as wife, lover, friend. She wrote a poignant acknowledgment of this: "I am moving it seems—more and more toward a kind of aloneness—not because I wish it but because there seems no other way."[14]

In Bermuda, Georgia stayed in a house belonging to Marie Garland, with people she had met the year before. She had a big clean light room, with a high four-poster bed and a fireplace. "Sun and a summer feeling are good for a change," she wrote Beck, ". . . flowers and birds—all the pretty things—light and lovely and nothing."[15] She began to draw the twisted banyan trees and did a series of velvety black charcoal studies of banana flowers, their rounded forms rich, voluptuous, and mysterious.[16]

Her sense of well-being returned. "God how I sleep," she wrote Toomer. "It is really good to sleep again."[17] At the end of April she called for a steamship booking, but there was no berth for her on the date she wanted. Queen Georgia replied serenely that she must go anyway. "Long pause on the telephone—and then the voice says—I will see—and I say to myself—Of course I will get it."[18] And she did; her luck had returned.

Toomer was in New York when she returned from Bermuda. He and Marjorie Content had met, through a mutual friend. "I think you will like him," Georgia had told Marjorie, and she was right. The attraction between Jean and Marjorie was immediate, and Georgia's response was generous: "I like it very much that

you and Margery have started what I feel you have— I like it for both of you because I feel deeply fond of both of you," she wrote Toomer. "I thought—it would be pleasant to ride with you in the spring instead of the cold winter . . . but it is all right as it is— For both of us it is very right as it is." [19]

Georgia's returning health was evident. "I seem to be feeling very good in both my body and my mind," she wrote Toomer. "Many things seem clear to me that were disturbing for a long time before I got really sick. They seem to come clear in such a strangely quiet way—something seems to take form in me without my knowing why or how—everything is alright." [20] With Georgia's returning strength and clarity came the determination to go west, starting early and staying until the weather turned cool.

Mabel Luhan had felt remorseful at her behavior toward Georgia. She made several peace offerings and repeatedly invited her to Taos. Georgia would not enter into the pattern of fight and forgiveness that Brett and Mabel enjoyed, and she wrote a frank reply, pacific but aloof:

> You know— I like you Mabel but some times you just seem
> so funny to me . . . I always think . . . of the way you were
> the last two times I was there—and I rather think you
> probably would not enjoy me any more now than you did
> then . . . remember that I like you even when you have
> seemed horrid— I think the reason you seem funny to me
> when you behave badly is that I always feel you are
> mistaken— And being as clever as you are it seems amusing
> when you make mistakes—and it seemed that I saw you
> make such funny ones . . . Greet the sky for me when you
> look out the window. [21]

Georgia had no intention of staying with Mabel, and to Beck she confided that she did not even want to go back to Marie Garland's. She needed to husband her energy, and a gossipy and sociable community dissipated it. As one local resident wrote, "The lure of sociability in Santa Fe is a dangerous thing . . . A person attempting serious work in Santa Fe must guard against his genius for friendship." [22] Georgia moved away from the gregarious society that she had at first found so appealing. She was, as she had said, moving toward less talk, fewer friends—a kind of aloneness.

• • •

IN JUNE, Georgia left for the Southwest, establishing a pattern of her own—a counterpart to Alfred's fixed routine—one that did not vary for more than a decade. This year, she went with Alfred's blessing. He was still worried about her lack of vitality. "Hope the stay there will restore her health and confidence," Alfred wrote optimistically to Brett. "Of course I miss her. I'm asking no-one to the Hill. So it will be ready for G. without notice." [23]

Georgia took the train to Chicago, where she met with Marjorie Content, and the two of them drove in Marjorie's old Packard out to Alcalde. They took a cottage at the H & M Ranch, where Toomer was to join them in July. Marjorie had her own interests, and the two women spent their days separately. Georgia was using charcoal again, and she produced the strong and rhythmic *Eagle Claw and Bean Necklace,* in which the smooth, rounded dark bean shapes contrast vividly with the spiky talons of the eagle claw. The composition consists of curves, circled and layered in upon themselves, forming a strong, coherent, and fiercely protective whole.

That summer, O'Keeffe spent much of her time drinking in the views, the light on the hills, the shapes and the colors. She seldom looked at a view without wanting to get further into it, and she drove, rode, and walked as far into the landscape as she could get. The roads were dirt, and there was no way of telling, from a crossroad, if the dusty track you crossed would vanish in a riverbank after half a mile or continue, bumping and sliding, into new and unexplored vistas in the next state. Georgia made early starts and drove all day through the wild countryside, stopping to paint when she found the right place. She drove once tantalizingly above a series of painted mesas but could not find a way to reach them.

Charles Collier first told Georgia about the landscape around Ghost Ranch, some twelve miles north of Abiquiu. "Charles told me there was a place I hadn't seen yet, a place that he thought I'd like . . . he drove me out." [24] Though they rode around the high mesas, they could not get onto the ranch, Georgia was contemptuous at the idea of a dude ranch, but she was determined to find the landscape. She went back alone, and when she saw a truck with GR on its side at a grocery store, she accosted the

driver, who told her to turn at the steer's skull—if it was there (it was often stolen). The skull was in place, and she drove up the rutted dirt track, across a plank bridge, and found a loose semi-circle of bungalows set at the base of a mesa.

Ghost Ranch is at the eastern edge of the Jemez mountain range, in what is known to geologists as the Abiquiu Quadrangle. There are a few places as spectacular on the North American continent, but not many. Geologically it is rather complicated; visually it is breathtaking. The high, flat bottomland is broken irregularly by vast cliffs and low hills in astonishing colors. The rock formations are Mesozoic—roughly between one and two hundred million years old. The cliffs and hills stand like a geological model, each layer a demonstration of earthly possibility.

The narrow top layer of the high cliffs, the Dakota formation, is sandstone, gray shale, and coal. It is sedimentary, the result of an ancient stream and swamp that lay high on top of it, around a hundred million years ago. Below this lies the Morrison formation—gray, green, and purple mudstones—also deposited by swamp and stream. Next is the Todilto formation, gray gypsum cliffs, precipitated from a vast lake that once covered the area. Then comes the Entrada layer—the wide, spreading, beautiful pink sandstone cliffs. Between two and four hundred feet thick, this sandstone is eolian—blown there by the wind. The last and oldest formation is the Chinle, some two hundred million years old, composed of high mounds of red, green, gray, chocolate, and purple siltstone in a fine powder, also eolian. The colors in the landscape derive mostly from iron oxide, a wildly generous element, which produces a riotous collection of dark and brilliant reds, blues, yellows, greens, and purples.

Once blown or settled solidly in place, the cliffs and hills were then worn slowly away. Again, the process was done by wind and water—the modest Chama and its tributaries. The shapes in the landscape are formed by fluent forces, wind and water. There was no violent unpheaval here, there are no jagged edges or hurled boulders. The formations reflect and mimic the forces that shaped them; the cliffs are collapsing, soft, fluid, voluptuous. Soft runoffs of pink sandstone lie in deep piling waves beneath the high bluffs; the rounded mounds of red siltstone, striped unevenly with purple, stand smooth and perfect as though poured through an hourglass.

In the clear air, distances are deceptive, and no matter where

you stand the pink cliffs seem closer than they are. The sheer face of exposed earth is disturbing: this is the real mother earth, not as gentle as one had hoped, but much more powerful than one had expected.

It is a landscape difficult to describe with any hope of credibility; the colors are wildly garish, the shapes unlikely. It ought, in fact, to be extravagantly tasteless, vulgar, and unbelievable. It is saved from this by its scale, which is vast and monumental, and the fact that the sky, which is even vaster and more infinite than the landscape, presides serenely over it.

It is a landscape that O'Keeffe adopted on sight. She drove up to the door of Ghost Ranch and asked if she could have a room. Told that one would be available the following day, she went back to Alcalde and packed her things. During her first night at the ranch, a guest's child had appendicitis, and the whole family moved out, vacating one of the cottages. O'Keeffe moved in, returning to Marjorie and Jean only to witness their wedding in September.

"Ghost Ranch" was a translation of the Spanish Rancho de los Brujos. The latter has a slightly more sinister connotation: male witches are specifically malevolent, unlike ghosts, which are often innocuous. During the period of Spanish rule, the area around Abiquiu was an Indian pueblo with a lawless reputation. Its distance and its unruliness placed it on the outskirts of Spanish authority, a place of exile for miscreants from Santa Fe and Taos.

Near the end of the nineteenth century, the two Archuleta brothers settled on property north of Abiquiu, on the Piedra Lumbre (Shining Stone) Land Grant, the title of which had come from the king of Spain. At the base of the high mesas, they built an adobe house and channeled water out of Yeso Canyon for themselves and their livestock. One brother took the cattle to the market in Santa Fe and returned with the proceeds in gold. The other brother, Juan Ignacio, accused him of keeping part of the gold. His brother denied it; there was a terrible scene, and Juan Ignacio killed his brother. He buried the corpse on the hillside and told the widow he would kill her baby if she told what had happened. Here the story departs from the rational and enters into the territory of dream and myth. Ignacio threatened to sacrifice the baby to the grand master of evil spirits, Vivaron, a thirty-

foot-long serpentlike creature. The wife felt it prudent to leave, with her baby, in the middle of the night.

Sixty years later, the widow's daughter told the story to Arthur Pack, who then owned the ranch. Vivaron, of course, was dismissed as a mythological creature fabricated by the Hispano-Indian inhabitants, until, in 1935, the complete skeleton of a prehistoric creature—a phytosaur—was found in the vicinity. It was thirty feet long, and resembled a serpent.[25]

When two neighbors were hanged for cattle rustling, Juan Ignacio left the area. According to a history of the ranch by Arthur Pack, the place was next owned by a woman from Boston, who started the San Gabriel dude ranch in Alcalde, and married a cowboy, who won Ghost Ranch in a card game. The San Gabriel Ranch went bankrupt in 1929, and the couple divorced. Ghost Ranch went to the wife, who sold it to Pack in 1933.

Arthur Pack was a literate and intelligent man. A conservationist from the East, he first saw Ghost Ranch in 1928, when he came out to photograph mountain lions for the magazine he edited, *Nature*. In 1929 he brought his family out to stay at the San Gabriel Ranch, and four years later they moved to New Mexico for good, with a tutor for their children. Pack bought the 21,000-acre Ghost Ranch and began to convert it to a dude ranch, hiring Amarante Archuleta, Juan Ignacio's oldest son. On the other side of the mesas from the rest of the compound, facing the long, dark, low Pedernal Mountain on one side, and the pink cliffs on the other, Pack built a rambling adobe house for himself and his family. He named it Rancho de los Burros—a mild wordplay on Rancho de los Brujos.

Ghost Ranch was an exotic mix of Spartan and Lucullan elements. It was not cheap: in the depths of the Depression, Pack charged a stiff eighty bucks a week for life in splendid isolation. The ranch was three hours from Española over the rutted dirt roads, and the nearest telegram and telephones were thirty-five miles away, so Pack bought a small airplane. The rooms were tiny and austere, at night kerosene lanterns were used, but the food was good, and the landscape was as luxurious as anywhere in the world.

At Ghost Ranch, O'Keeffe had found what she needed. The singing sky, the radiant cliffs, and the oblique profile of the Pedernal all spoke to her, and the message was one she wanted to

hear. It was her landscape. From then on she spent the best part of almost every year there, in the literal if not the metaphorical sense; after Stieglitz died she moved there, in both senses of the word, for good.

• • •

GEORGIA NOW established her own annual pattern, as firm and undeviating as Alfred's. In the spring she went to Lake George and opened the house for Alfred, then she set off for the summer in the Southwest to work. She returned to Alfred at Lake George in the fall and spent the winter with him in New York.

It was not ideal. The two missed each other painfully during the summer-long separations. Alfred could not help but feel abandoned; Georgia could not help but feel anxiety over his frailty and guilt at her absences. Nor was the arrangement entirely equitable—Stieglitz had not changed his life an iota for Georgia. It was still Georgia who altered her movements according to his needs—staying at Lake George and living half the year in New York. But there was no perfect formula: Alfred was too old to make the long, disorienting trek to the Southwest; Georgia could not spend the whole year in the East; and they loved each other.

Alfred's support was once again firm and unequivocal. When Georgia returned from Ghost Ranch in the fall of 1934, she complained at the constrictions of the rooms at the Shelton and the problems of interruptions by chambermaids. Alfred at once wrote a stern letter to his landlord at 509 Madison Avenue, reminding him of Georgia's importance as a painter, her long illness, and the publicity that would soon arise from publication of Dorothy Norman's book. Alfred felt that all this justified his request: a free studio at 509 for Georgia. He was indignant at the landlord's refusal.

The relationship between Stieglitz and Norman had become less threatening. It continued to be close, and O'Keeffe was still made uncomfortable by the younger woman. Matters were made no better by Stieglitz's putting the wrong letters in envelopes addressed to Dorothy and Georgia one summer. Georgia opened hers in the dining room at Ghost Ranch, began to read it, and left the room. But the moment of real crisis was over, and Georgia had triumphed. "If he sleeps with another woman, it is a little thing," she had told Mabel Luhan, and now she could confirm it.

Georgia's marriage, and the love between herself and her husband, were intact. "I don't really know what happened," she said years later, "but I feel he was very foolish about her." [26]

As Georgia regained her confidence, she lost her anxiety in Norman's presence. At the end of the decade, Mabel Luhan held a literary evening—Thornton Wilder discoursing on *Finnegans Wake*—attended by both women. A photograph shows O'Keeffe and Norman sitting one row apart. O'Keeffe is in front.

O'Keeffe's show opened at An American Place on January 27, 1935. It was again a retrospective: twenty-eight paintings, dating from 1919 to 1934. Though there were still not enough recent paintings to make a show, she was beginning to find her way. Eight of the works were from the previous year: the series of banana flowers done in Bermuda and six New Mexico pictures, of which three were of the red hills.

In the new gallery Stieglitz was continuing to experiment outside his immediate circle. He gave two husband-and-wife shows in the early thirties. In 1932 he presented work by Paul and Rebecca Salsbury Strand (he included Beck's work in a group show again in 1936). In both 1932 and 1933 he exhibited the work of Arthur Dove and Helen Torr.

The Strand show contained photographs by Paul and paintings on glass by Beck. Beck's work (little of which is extant) was *faux naïf* and included many flower still lifes. A Strand pastel of the mid-thirties, *Moon and Clouds*, reveals a strong sense of design, an instinctive sympathy for natural forms, and a tendency toward the smooth, abstract, rounded shapes that appear in O'Keeffe's work. It also presents the magnified image that had become such a part of the Stieglitz group vocabulary.

Dove and Torr shared an artistic vocabulary of flowing, biomorphic forms. Much of Helen Torr's work was small-scaled and subtle, still lifes based on natural shapes. "I thought they were very good," wrote O'Keeffe later of her paintings. "I think she is a person who would have flowered considerably if she had been given attention." [27] O'Keeffe liked Torr, and in 1931, while she and Dove were living on a boat, Georgia invited Reds to stay as her guest at the Shelton. "I had a suite—bed room, sitting room, & bath— Grand. Took a bath," wrote Reds happily. [28]

In 1935, Dove and Torr were living in upstate New York. That spring, they prepared for another joint exhibition with Stieglitz. The two of them spent a week building crates, carefully fram-

ing and packing the results of a year's work. At the end of the week, just before the shipment was sent, Torr recorded in her diary:

> A letter from Stieglitz, saying he thought we didn't realize there was not room to show my things— [The] room I had used [was] for storage now. Also, [he] thought I should have a show somewhere else of new and old things where there might be a chance to sell a thing or two.
> Rather a drop.[29]

Torr wrote to O'Keeffe, telling her what had happened. O'Keeffe at once bought six of Dove's watercolors from the show. The gesture was direct and generous; it also distinguished O'Keeffe's role from Stieglitz's. But the drop was a bad one: Torr did not find a new gallery, and her work was not exhibited again during her lifetime.

In the summer of 1935, Georgia stayed at Ghost Ranch for a full six months, from June to November. It was a productive season, and her show the following winter, from January 7 to February 27, was composed entirely of New Mexican pictures. O'Keeffe was still feeling her way: five of the paintings were modest still lifes—turkey feathers, pottery, and a kachina; five were landscapes; five were flowers; and two revealed her continuing preoccupation with bones, *Rib—Piece of Jawbone with Tooth* and *Ram's Head, White Hollyhock—Hills*. The surreal juxtaposition of skull and horizon was one she would continue to explore.

It was in 1936 that O'Keeffe finally realized her wish to do a large painting "for a particular place." She received a commission for a flower painting from Elizabeth Arden Beauty Salons. Georgia painted huge radiant jimson blossoms, and this time she had Stieglitz's enthusiastic support for the project, owing partly to the fact that he himself had set the price, a whopping ten thousand dollars. (Stieglitz disapproved of the Museum of Modern Art because of its rich trustees, but it bothered him not at all to hang O'Keeffe's painting in the rarefied air of an exercise salon for wealthy women.)

The winters in New York had become less difficult for Georgia. She was now quite independent of Stieglitz socially. His increasing frailty meant a lessening of his hectic schedule, and her annual New York stint was finite: there was blue sky at the end

of it. Moreover, Georgia had achieved a new authority and took increasing charge over both her life and Stieglitz's.

The canvas for the Arden project was 6 by 7½ feet, and to work on it Georgia needed more space than she had in the small rooms at the Shelton. She rented a penthouse studio at 405 East 54th Street, and by early April, they were "no longer inmates at the Shelton," Stieglitz wrote Ansel Adams. He made proprietorship clear: "She has a penthouse studio!"[30] The apartment was Georgia's; the lease and the telephone were in her name. Alfred had, at first, resisted the difficult wind of change sweeping through his familiar surroundings: the apartment was too luxurious, he said, and too far from An American Place. What he was really resisting was Georgia's assumption of control, but he was no longer the benevolent despot in charge of O'Keeffe's life. O'Keeffe said serenely that she was going in any case, and would he like his things moved as well?

The apartment, overlooking the East River, was light and airy, "so grandly spacious and light that I feel queer," Stieglitz wrote.[31] Outside the curtainless windows was a terrace rimmed with a box hedge. O'Keeffe painted the walls white, and the floors were a polished dark brown. The furniture was minimal and severe: simple shapes covered in black. The only color was in the Navajo rugs and in the flowers that Georgia brought in. Flowers, skulls, shells, and bones were part of a continually changing series of still lifes.

When Dove came to see the new apartment, Stieglitz led him into his own bedroom. (Georgia and Alfred had had separate bedrooms at Lake George for a number of years. Their twin beds shared the same room at the Shelton, but in the new apartment their rooms were separate.) Alfred gestured at a steamer trunk, unopened. He had not yet unpacked, he declared defiantly, as though this gesture would hold the terrible change at bay. But Georgia was undeterred, in her decision and in her affection for him; she had found her balance. Stieglitz continued to have large groups in for dinners on Saturday nights, but Georgia no longer felt the need to participate. She hired a cook-housekeeper, and designed an expandable table to accommodate the crowd. Georgia often spent the evening sewing quietly in a corner, her mind on her own matters.

26

From where I stood it seemed I could see all over this world
. . . and I like the feel of the wind against me when I get up
high.

—GEORGIA O'KEEFFE

THE NEW BOND between Alfred and Georgia was strong, sure, and affectionate. Georgia shared her life at Ghost Ranch as fully as possible, writing him copious and daily letters that described her friends and experiences and made clear her affection and availability.

In 1937 she wrote: "You sound lonely—and I wonder should I go to the lake and have two or three weeks with you before you go to town— I will if you say so— Wire me and I will pick right up and start."[1] As her accessibility to him increased, Stieglitz's anxiety lessened. He was saddened by the fact that Georgia would leave him every spring, but he now felt confident that she would return to him each fall.

When Georgia had arrived that summer at the ranch, unannounced, there was no available room. She waited, as she had with the Shelton and the steamship company. Finally Arthur Pack mentioned the little house he had built. It was now empty, for his wife had eloped with their children's tutor, and Pack left his house, with its painful associations, moving back to the main

compound. O'Keeffe moved at once into the house that would be at the center of her life until the end of it.

Georgia was ready to settle down in New Mexico. Three years earlier she had written Beck: "I also think I want to keep house [in New Mexico]—what an idea!"[2] Her life in the Southwest had taken on increasing importance, and she was ready to make a commitment to it. She painted two oils that proclaimed her pride and pleasure in her new circumstances. *My Backyard* shows a vast, sweeping landscape, and *The House I Live In* is a quiet rendering of the building, with the oblique silhouette of the Pedernal rising beyond it.

The house is set on a very flat plain of red earth, covered with wiry grass and set with clumps of twisted cedars. To the west the ground rises gently in low curves; to the north it is flat, right to the foot of the radiant cliffs. To the south lie the low purple silhouettes of the Jemez Mountains. In the center of these lies the long, slant-topped Pedernal, thickly dotted with trees except for one bare flank—"in the shape of a leaping deer."

Low and humble, the one-story adobe is shaped like a square horseshoe. It is set around a central patio, which faces the Pedernal. The patio, filled with roses in Pack's time, was gradually overgrown with wild silver-green sage in O'Keeffe's. Big sections of tree trunks were set about it as seats, and all around the edge, under the overhanging roof, were ledges and boards covered with the smooth rocks she collected. Animal skulls hung along the edge of the roof, and there was a sense of casual organic clutter.

Leaning against a wall was the inevitable southwestern ladder of unpeeled wood. In a place with so much sky, roofs are important. The flat adobe ones are used as rooms, at once private and open, a magical space. Ladders are stairways: "Ladders are wonderful things—very important in the world," O'Keeffe said later.[3]

Despite her longing for solitude, and the distance between her house and the compound, O'Keeffe was drawn into the life of Ghost Ranch. An isolated outpost creates a sense of community, and Georgia liked Pack and his new wife, Phoebe Finley, the daughter of a former partner.

Georgia also liked the people who worked for Pack, and spent time as happily with the ranch workers as she did with the guests. One night the Pack children put on a play, with their

governess (hired this time instead of a tutor). "I only looked on with Pete, one of the ranch hands—half Indian and half . . . French . . . he sat by me most of the evening."[4] When one of the ranch hands hurt his foot, Georgia and Pete went to tell the family.

> They were so distressed—a very old man—quite blind and thin but very alive in his way of moving about and gesticulating— Pete was so quiet and gentle with him— The house very poor but neat and orderly— I was interested in it all—it was quite beautiful—but sad—the old man was so worried.[5]

And down by the Chama River lived an ancient Navajo Indian named Juan de Dios, so old he had been a slave to a Spanish family; his hero was Abraham Lincoln, who had set him free. The old man owned an elderly steer, also named Juan. When Juan the steer died, Juan the Indian gave O'Keeffe the animal's skull, knowing her predilection for bones. Georgia made a drawing of the skull and gave it to Pack: it became the emblem of Ghost Ranch, and graces their letterhead to this day.

Georgia respected the Indians and Hispanics, their dignity and privacy. She sympathized with the New Mexico Indians, who had received shabby treatment from the federal government. Her interest, however, was quiet, nonvocal, and nonpolitical. Her philosophy was much like theirs: she tended to her own affairs.

Although Georgia thought initially that dude ranchers were a lower form of life, she discovered that many of the Ghost Ranch guests were interesting and enterprising people. They were drawn, as she was, to the exhilarating country. Among the visitors were Leopold Stokowski, Charles and Anne Lindbergh, and Maggie and Robert Wood Johnson, of the Johnson & Johnson family. Ansel Adams came there, and David McAlpin, who was establishing a photography department at the Museum of Modern Art. In New York, McAlpin had introduced O'Keeffe and Stieglitz to a young woman from Philadelphia, Margaret Adams Bok. Shortly thereafter Peggie Bok married Henwar Rodakiewicz, now divorced from Marie Garland. Georgia liked Peggie at once and invited her to visit Ghost Ranch the following summer; Peggie and Henwar celebrated their wedding anniversary there. Gerald Heard the writer was a visitor one summer (Georgia painted

a tree around which he had danced), and Aldous Huxley and his wife stayed in Taos with Frieda Lawrence and her new Italian husband, Angelino Ravagli (D. H. Lawrence had died in Europe in 1930).

Frieda was a favorite of Georgia's:

> She was very special. I can remember very clearly the first time I saw her, standing in a doorway there, with her hair all frizzy, wearing a cheap red calico dress that looked as though she'd wiped the frying pan with it. She was not thin and not young, but there was something wonderful about her . . . She was very beautiful. Oh, Frieda would come into this house with that huge voice of hers. "Georgia!" Her voice would fill the house. She stayed top of the heap. I really liked her.[6]

In July 1937, Georgia took a camping trip to Colorado and Arizona with Ansel Adams, Dave McAlpin, and Orville Cox, who worked at Ghost Ranch. Adams stayed with Georgia at Ghost Ranch that summer and took a series of pictures of her. These show a relaxed, companionable woman, at ease with herself and with her surroundings. Among these was the famous photograph of O'Keeffe smiling at Cox, in a rare moment of near flirtation. People often thought, understandably, that the man in the hat was O'Keeffe's husband; O'Keeffe identified both men, characteristically, by role rather than by name. "That was not my husband," she said, "that was the wrangler." (Cox was in fact an expert on local archaeology and Indian culture, and he arranged trips for Ghost Ranch guests.)

That summer, O'Keeffe wrote Stieglitz a series of letters that give a vivid sense of the life she led at Ghost Ranch.

> I was up early—painted all day—out in the car from 7 till 11 —then the rest of the day indoors—and there it hangs on the wall looking at me—and I don't know what it looks like but I think I'll paint it again tomorrow—just some red hills — At 5:30 I went out and walked—just over the queer colored land—such ups and downs—so much variety in such a small space . . . Maggie Johnson was at the house for supper—back from their pack trip . . . I've been up on the roof watching the moon come up—the sky very dark— the moon large and lopsided—and very soft—a strange

white light creeping across the far away to the dark sky—
the cliffs all black—it was weird and strangely beautiful.

That summer, Peggie and Henwar were there:

Last night after supper and into the moonlight we all
walked up back of the main ranch house—one of my
favorite places—up over the hills and low cliffs—the sunset
over the far away plains—cliffs—and the blue mountain—
so very beautiful— They loved it—we walked up till we
were all hot—then it began to rain a little—just enough to
cool you but not really wet you— It was bright moonlight as
we came down— When we got over to this house—
everyone seemed so pleased to be here—it is so still—so
alone—so open all around— I love the way they love it— I
feel it almost a personal flattery that they like it as I do. Felix
and I went in the kitchen and fixed some iced fruit juice . . .
then climbed to the roof with it where the others were—
getting it up the ladder was quite an adventure but we got
there— Henwar had taken up a load of blankets—we all sat
there in a row . . . When I came into my room with a small
lantern . . . it vaguely lighted the white room and through
the very big window I could see the cliffs in the moonlight
—bright—with the windmill wheel shining bright in front
of them—it was wonderful . . . They go tomorrow— I will
be glad for the time we have had together—but am very
ready to be getting to work. I have never had a finer time
with so many people at once—sort of sparkling and alive
and quiet all at the same time. You would have liked it too
and been a nice part of it.[8]

The letters reveal a sense of peaceful appreciation for the life
she was living. Open, responsive, and generous, she was de-
lighted to share it with her friends.

The life there was not all gaiety. The Packs had been given a
baby antelope, which had grown into an intimidating creature.
In August, Georgia wrote: "We had much excitement this morn-
ing. My antelope friend appeared and stalked all around the
house keeping us all at a safe distance. He is very beautiful—but
I do not wish to meet him empty-handed."[9] Antelopes in rut are
aggressive, and Georgia's "friend" was quite dangerous. The
Packs' governess did meet him empty-handed and was gored to

death. The antelope was shot, and the skull given, predictably, to Georgia, who later painted it.

Danger played a real part in O'Keeffe's life in New Mexico. She had always struggled with her fears. An early letter to Stieglitz from Charlottesville recounts a solitary nocturnal hike: "I got to the top alone in the moonlight—just as day was beginning to come—it was great—the wind—and the stars and the clouds below—and all the time I was terrribly afraid of snakes."[10,11] To Henry McBride, years later, she wrote from Alcalde: "It galls me that I haven't the courage to sleep out there in the hills alone—but I haven't."[12] She wrote Beck that she broke out "in a cold sweat" when Alfred took her up in the airplane with him, and when she spent the fall of 1930 alone with Margaret Prosser, she wrote that Margaret's

> drunken husband . . . furnishes considerable drama and human interest . . . sometimes even contributes a bit of fear. And then I say firmly to myself—I'll not have a drunken man disturb my world, and [I] keep my boots on so that in case he comes I can jump over the front porch rail and run—and that way I feel safe— I always have to laugh that boots make me feel safe.[13]

Asked years later if she felt fear often, O'Keeffe replied, "I'm frightened all the time. Scared to death. But I've never let it stop me. Never!"[14]

∙ ∙ ∙

WHEN SHE WAS working, Georgia rose at six and was off by six-thirty. She would bring a painting back to work on it further indoors. Her paintings began by being straightforward and representational, done from life. Later, as she worked over them in her studio, they took on the emotional resonance that gave them their power. In her 1931 show, she felt the work had not made this transition, and she wrote to Brett:

> My show looked well but the two most important phases of it—the landscapes and the bones were both in a very objective stage of development— I hadn't worked on the landscapes at all after I brought them in from outdoors—so that memory or dream thing I do that for me comes nearer reality than my objective kind of work—was quite lacking.[15]

As the decade progressed, the "memory or dream thing" became more fluid and powerful. As she had told Catherine, Georgia painted how she felt about what she saw. She continued to paint the large flower images, leaf forms, and small objects from her new surroundings: turkey feathers, the local artificial flowers, pottery, a horseshoe. But the landscape was becoming more and more important, and through her work she began to learn and possess it.

In the paintings of the red hills and the landscape around Ghost Ranch, details were smoothed away and the rich fluid rhythms of the soft earth were emphasized. In the best of these paintings, O'Keeffe struck an exquisite balance between a purely representational rendering and dreamlike abstraction. These paintings took on that heightened sense of reality, the emotionally charged presence, that gave her greatest work such strength.

"These hills look so soft. Such good earth. I have wanted, sometimes, to take off all my clothes and lie back against these hills," she said later.[16] (The red hills are not, in fact, good earth, but badlands; iron oxide dust, dry and sere. Georgia's eye was no longer that of the farmer's daughter but that of the artist.)

Despite their barrenness, O'Keeffe saw in the contours of the red hills a warmth and tenderness. In an exhibition catalogue she wrote: "A red hill doesn't touch everyone's heart as it touches mine and I suppose there is no reason why it should."[17] Her work had begun to reflect the touching quality of these red hills, to present the soft collapsing contours tenderly and gently. A direct analogy is made between earth and the human body—smooth, rounded, warm-colored. In the gentle rising slopes and the passive recumbence, the reference is made more specifically to the female body. It was a reference of which O'Keeffe was well aware: "I did a painting," she said of a 1945 work, "just the arms of two red hills reaching out to the sky and holding it."[18]

As well as with the landscape, O'Keeffe's preoccupation with bones intensified, and she experimented further with the smooth dreamy shapes. In the mid-thirties she had begun a series of skulls against the sky and horizon: mules, steers, horses, mule deer, and antelope. In *From the Faraway Nearby* of 1937, one of the most powerful of this series, a majestic forest of pristine white antlers rises from a bleached eyeless skull, the whole set against a crystalline sky and the distant hills. (The skull boasts too many antlers; as a paleontologist noted, "the second [lower] pair of

antlers is . . . the work of the artist, not evolution."[19] The deliberate specificity of the skull, with its missing teeth and the corrugated wrinkles at the base of the antlers, contrasts with the abstract sweep of the snowy hills in the distance. The whole sets up the reverberations of beauty, intimacy, and haunting distance that characterize O'Keeffe's work, her presence, and her temperament.

Often the skulls, with their benevolent, arching horns, are placed frontally in her paintings, centered against the sky and over the distant horizon, as the crosses had been. If the dark and rigid man-made crosses represented a harsh and punitive force that dominated the landscape, the skulls—bright, shining, and arched—represented a different kind of order: benevolent, ageless, overarching—part of a natural structure that was quite separate from man.

Though generalizations are perilous, it is possible to divide O'Keeffe's work into two broad categories, in which water and its absence play dominating roles. From the very beginning of her career, the presence of water, innately and absolutely sensuous, was important in O'Keeffe's work. The undulating line of wave patterns, the rich unfurling growth of juicy green tendrils, the long flat horizon of Lake George, the vast and dominating presence of the ocean at York Beach, all serve as testimonials to the importance, for O'Keeffe, of the qualities of water. She found it a source of balm and energy. The infinite flux of water, its clean surge, its smooth liquid ripple, was central to her sensibility.

During O'Keeffe's nervous breakdown in 1933, her perception of the nature of water was radically altered. While she was in the hospital, water took on a peculiar horror, threatening and terrifying, as did Stieglitz. The yielding, soothing, beneficent element, intimacy and sensuality, had betrayed her. Thereafter, most of the landscapes she painted were arid.

• • •

RELIEVED OF the obligation to spend the summer there, Georgia took a pleasure in her brief stays at Lake George. Sue Lowe provides a graceful and vivid picture of her at the lake in this period:

> I see her on cool mornings or evenings hugging her
> slenderness in a near blanket-size shawl or a too-large
> rough cardigan. Even with the strap of an undershirt

invading the wide neckline, she brings an unaffected elegance to everything she wears, including the most ordinary housedress. Her predominant white is often enlivened with a bright sash; her homespun skirt, after her first trips to the Southwest, is sometimes a throbbing Navajo red . . . Her carriage—head high, nape cupped in the coil of black hair that she covers from time to time with a triangle of vivid cotton—lends the austerity of her profile the proud look of a ship's figurehead . . . Her walk along the dusty roads is purposeful and smooth, her footfalls silenced in canvas espadrilles. She strides across the heat-hazed meadows of noon, through seas of wildflowers and sour grasses. Sometimes she stoops to pluck a single flower, sometimes to build an armful of blossoms . . . I see her usually walking alone, at a distance, but sometimes she is arm-in-arm with Alfred, her sleek head inclined toward his unruly thatch of grey. They talk in low conspiratorial tones or are silent; occasionally a pause in stride is filled with an expository gesture or a burst of giggles. Often I see her under one of the gnarled apple trees . . . Arms wrapped about knees, skirt drawn to ankles, she sits in motionless contemplation.[20]

O'Keeffe was drawn to the beauty of Lake George, but for her the place was always under siege:

I love all those things so much it almost makes me feel I must stay here. Then [a friend of Stieglitz's] calls tonight . . . he and that German doctor and some Dutch girl will be here tomorrow. A[lfred] . . . gets on a prickly edge ready to meet them— He seems to become all different at the thought of having someone to talk to—so I don't feel pleased any more to be here . . . now there will be talk— steady talk I suppose—and it all bores me so— No one will say anything except how awful the world is—and I know all those things they will say and don't see any sense in saying them— I would rather walk through the woods . . . or just look at the sky.[21]

As the threat of war in Europe approached, Stieglitz became gloomy and apprehensive; Georgia held herself aloof from the

maelstrom of political discussions. Her view of the world was clear-eyed and practical, if not optimistic:

> I think that the average human being can not see the different sides to different situations so when another man disagrees with him he will step on him if he can—or even kill—the stronger will not give the weaker a right to his own way of being and doing if he can help it— It isn't a pretty picture but the human being behaves pretty much that way.[22]

• • •

O'KEEFFE WAS no longer a member of the avant-garde but was acquiring stature in the larger world and accumulating laurels there. In 1935 she was cited for excellence in her field by the New York League of Business and Professional Women, and in May 1938, O'Keeffe received her first honorary degree: a doctorate of fine arts, from the College of William and Mary, in Williamsburg. Anita, Ida, and Claudia all came to the ceremony, at which eight O'Keeffe paintings were exhibited. The college's president announced proudly that Williamsburg had presided over the maturation of O'Keeffe's "talents for vision and craftsmanship."[23] The college itself could claim little credit for this, however: not only did Georgia not attend it; women were not even admitted as students when Georgia had lived there.

To the ceremony O'Keeffe wore a plain skirt and blouse and her inevitable flat-heeled shoes. Furthermore, though she expressed her thanks, she refused to give a speech. This was a disappointment to the officials, who wished for pomp.

Georgia had always resisted pomp, and like Thoreau, she was wary of occasions that required new clothes. Instead of avoiding the occasions, however, she simply wore everyday clothes. O'Keeffe's attitude toward clothes had always been individualistic, though this became more pronounced with age. Ever since reading Charlotte Perkins Gilman in 1915, O'Keeffe had chosen her clothes for practicality and freedom of movement, as well as for her private aesthetic pleasure. High heels and cosmetics were anathema. Simple and severe, her clothes were often monochromatic, black or white, and idiosyncratic as to line. From childhood she had known how to sew, as did most young women of modest means, and she made her own clothes for years. When

Beck sent her a jacket and skirt, she wrote: "I dyed them both black and I feel perfect— I have made two summer dresses—all by hand . . . a good feeling . . . almost as good as an animal with fur on it." [24]

In spite of her deliberate avoidance of conventional feminine beauty (when Elizabeth Arden insisted on having O'Keeffe made up, just to show her the potential, O'Keeffe rushed home to wash her face), O'Keeffe had a mesmeric appeal of her own. She had become a beauty, with dark, deep-set, ruminative eyes, high cheekbones, and a generous, sensitive mouth. Beyond bone structure, however, was her arresting presence. She possessed the sense of physical certainty, the interior conviction traditionally assigned to men. Though her beauty was feminine, her manner—neither coy nor artificial—had about it a directness and self-containment that was expected of men, not women. This strength and conviction became part of the aura of potency, of strangeness, that had begun to take shape around O'Keeffe.

• • •

DURING THE THIRTIES, Stieglitz had continued to show occasional work by artists outside his own stable. In 1936, he showed Beck's work again, and that season he took on a new photographer: the bearded, grinning westerner Ansel Adams. Two years later he exhibited another—a gentle, reticent Yale medical school student, Eliot Porter. He showed, as well, the work of Stanton Mac-Donald Wright, George Grosz, and William Einstein.

Einstein, a distant cousin of Stieglitz's, who had moved back to New York from Paris in 1932, began to help Stieglitz at the Place. He was small, quick, and appealing, and both Stieglitz and O'Keeffe took to him. Stieglitz hoped to make Einstein his successor at the gallery, and he gave the younger man a show in 1936. Einstein became a close friend of Georgia's, and it was he who first urged her to write about her work. Though she "could hardly bear to look at his paintings," [25] Einstein was the only person with whom Georgia liked to talk about art, and he became a confidante as well.

In the spring of 1938, Stieglitz had another heart attack, followed by a bout of pneumonia. O'Keeffe took him up to Lake George, where she stayed until August. The stay was not an easy one: the hired nurse hurt her leg getting off the train, and Georgia had two invalids on her hands. Moreover, she herself had "a

lame arm [bursitis]—a bad nose." What she needed, she told Einstein, was "a dry open space all by myself." Alfred's attempts at emotional blackmail had begun anew after his second heart attack. She wrote Einstein:

> Alfred remarked—"None of your particular friends will be out there this year—what will you do?"—my answer—"Be by myself—which I like—or make some new friends." Alfred's answer in a very sad voice, "Yes I know." [26]

She had planned a trip to Yosemite with Ansel Adams, but Stieglitz's condition had unsettled her. She wrote Einstein:

> This morning I don't feel much like it—sitting here in this damp place—comfortable—
> But Oh My God!
> Im too tired to even write straight. [27]

The scrawled phrase was a rare cry for help, but Georgia did not elucidate: the rest of the letter to Einstein was professional talk.

Georgia did leave Lake George for New Mexico in August, when Stieglitz felt better, and she stayed out west until November. In September, she went on the trip to Yosemite with Ansel Adams and Dave McAlpin, a beguiling man who had been "a treasure" in O'Keeffe's life "because the Art world was just a foreign country to him . . . I thought that was fine." [28] Adams was an enthusiastic and irrepressible photographer, whose good nature and love of the high country endeared him to both O'Keeffe and Stieglitz; his vision of that country, imbued with a mystical clarity, impressed them as an artist's.

O'Keeffe had never been to Yosemite, a longtime favorite of Adams's. The group went by horseback on a seventeen-day trip through the lakes and meadows of the mountaintops. Seeing Georgia move through the high, wild landscape made Adams see it afresh. "To see O'Keeffe in Yosemite is a revelation," Adams wrote Stieglitz; "for a while I was in a daze. Her mood and the mood of the place—not a conflict, but a strange, new mixture for me. She actually stirred me up to photograph Yosemite all over again . . . She says very little, but she looks, and once in a while something is said that sums everything up in a crystal, inevitable clarity." [29]

O'Keeffe and Adams remained lifelong friends, but they dif-

fered fundamentally over the role of the artist. After their earlier trip, Adams sent both her and McAlpin prints of some of the photographs he had taken. O'Keeffe wrote him a furious letter: McAlpin was perfectly capable of paying for prints, she said, and by giving away his work Adams was betraying all artists and devaluing his own work.

Adams disagreed: "I think O'Keeffe is a perfectly grand person," he wrote McAlpin. "One of the best—but I think she is completely haywire in that point . . . That attitude does more harm to the cause than good. I think Stieglitz started it and others have misinterpreted it. You are generous with their type [artist] and they should be generous with yours [patron]." [30]

Adams was not quite right. Stieglitz played a part in O'Keeffe's attitude, but there were earlier influences. William Merritt Chase had taught his students at the Art Students League to place high value on their own work. Even earlier, however, was Ida's influence: the cool withholding and the pride.

O'Keeffe very seldom gave her work away, and the few times she did she seemed to regret it. One large and beautiful painting, *Pelvis with Shadows and the Moon* of 1943, was a gift to Frank Lloyd Wright, with affection and appreciation of him as an artist. Years later, a representative from Taliesin, Wright's foundation for the arts, expressed Mrs. Wright's continuing thanks for the painting. O'Keeffe replied hopefully, "She can always give it back, you know." [31] The Wright painting was too well known to get back, but most of O'Keeffe's "gifts" turned out to be long-term loans. After Anita Pollitzer's death, O'Keeffe wrote at once to her relatives, asking for the return of paintings O'Keeffe had given Anita some forty years earlier. Nor was this an isolated incident. The work was a part of herself; it cost her something. Giving it away trivialized her effort and devalued the work.

O'Keeffe did not take part in business transactions, and when her friend Maggie Johnson asked to buy a morning glory painting, Georgia sent her to Alfred. Alfred wrote Maggie a sprightly letter, explaining that he knew that what the Johnsons wanted more than anything was a child. They could not have that, he went on kindly, but what they could have was the O'Keeffe, for fifteen thousand dollars. (The Johnsons adopted a daughter instead.)

O'Keeffe's feeling about commercial projects changed briefly

during this period. In 1937, Steuben Glass invited twenty-seven artists to design works in crystal. Among them were Matisse, Noguchi, Dali, and O'Keeffe: an august and international gathering. O'Keeffe accepted, and Stieglitz did not protest: not only was it a corporate commission, but the work would be made in multiples and available to the public. The quality of workmanship was very high at Steuben, and O'Keeffe liked the idea of crystal. She designed a jimsonweed blossom to be etched on a circular bowl: subtly asymmetrical, lyrical, and very simple.

In the summer of 1938, O'Keeffe took on another commission, which was less successful. She was offered a trip to Hawaii by the N. W. Ayer advertising agency, in exchange for two new paintings that the Dole Company could use for promotion; O'Keeffe agreed. Margaret Prosser came down to New York to look after Stieglitz, and in early February 1939, Georgia took a train across the country and a boat to Honolulu.

Dole's great pineapple fields were "all sharp and silvery, stretching for miles off to the beautiful irregular mountains."[32] O'Keeffe asked to stay nearby, where the fieldworkers stayed. The request violated the strict class distinctions that governed the island and was denied. It was an inauspicious beginning. The Ayer representative brought her a peace offering: a pineapple, but O'Keeffe called the tame piece of fruit "manhandled" and would have nothing to do with it.

O'Keeffe moved to the Kona Inn on Maui, where she met a neighbor, Richard Pritzlaff. Pritzlaff was an eccentric and disputatious character who raised Arabian horses and Chow dogs in the hills northwest of Abiquiu. The friendship flourished, but the Dole project did not.

The paintings O'Keeffe produced in Hawaii are oddly sterile. The abundant greenery, the spiked and jagged botanical specimens, and the rock formations made poor subjects for her. The Hawaiian work is harsh, dry, and angular. Dole might have overlooked the aesthetics, but they could not overlook the promotional aspects: O'Keeffe gave them paintings of ginger and papaya trees, but not one painting of their principal product. When the company, with some indignation, requested one after her return to New York, O'Keeffe began to develop signs of nervous strain. Dole shipped her a small pineapple plant for her private examination, and she did at last produce the spiky and forbidding *Pineapple Blossom*, but no one was satisfied.

Perhaps because of this, in June of that year, 1939, Georgia was bedeviled by headaches and sinus trouble. She lost twelve pounds and could not sleep. The doctor finally ordered her to bed for six weeks, and she was still in New York at the end of July, seeing him three times a week and, she wrote Henry Mc-Bride, dutifully "following his printed page of when and what and how much to do of everything till I feel all doctors should hang and we might just as well die when it is such a dull life trying to get healthy . . . As far as I can make out there isn't much the matter with me except that I was tired, and had been too tired too long." [33] Her only pleasure lay in her orders to get up at six and go walking; she tried all the streets from Tenth to Eighty-sixth. To Einstein she explained her problem simply: "It's my handsome set of nerves." [34] Her nerves were exigent: she did not paint between July and October, and did not go to New Mexico that year. Her absence was due partly to Stieglitz's illness in the late summer: by the time she had recovered, he needed care. The declaration of war in Europe was devastating to him, and his heart turned troublesome. Georgia missed her trip, and in October she wrote a friend in New Mexico: "I wish so much to go that I almost wish I had never been there." [35]

The following summer, O'Keeffe invited Einstein to stay with her at Ghost Ranch. "I believe it is the first place in America where [he] has felt rather happy to be," she wrote Dove proudly, and described the diminutive Einstein "hauling manure for the patio . . . riding a horse—looking tall in boots and a big stetson hat—both boots and hat left here by others . . . He thinks he is too new to wear a red handkerchief around his neck." [36]

That fall, Georgia bought her first property: the small house at Ghost Ranch, with eight acres. At once she began to make changes: she enlarged windows and knocked out a wall to create a studio. The furnishings, however, remained minimal, as did the colors: black and white, for the most part. "I prefer to live in a room as bare as possible," she had written in 1922.[37] In the breakfast room, facing the sunrise, there was a built-in couch of adobe, set with cushions; daybeds stood in other rooms. As decoration, there were animal skulls, bones, rocks, and oddities: a small crosscut saw hung over one of the fireplaces; the big brass urn from "291" stood next to it. White muslin curtains hung at the windows. The dining room held the slab-legged plywood table that she designed; in the studio was a large worktable.

There was a sense of order and cleanliness and, except for the ubiquitous bones and stones, no clutter. It was a house that exactly fit its surroundings and its owner.

One of Georgia's friends from this world was the artist Cady Wells, a personable young man from Boston. Born in 1904, he studied music before moving in 1932 to New Mexico, where he began to paint with Andrew Dasburg. Like O'Keeffe, he was concerned with the contours of the landscape around him, and his compositions reveal a sophisticated manipulation of space and perspective, through the use of pattern and line. O'Keeffe liked his work, and when it was shown at the Durlacher Brothers Gallery in New York, in 1944, O'Keeffe wrote modestly in a foreword: "I am glad you are showing Cady's painting at the same time that Stieglitz is showing mine because I think we are the two best painters working in our part of the country."[38] Despite his sophistication, however, Wells's work lacked the passion that O'Keeffe required in art. When earlier, he asked for her comments on a painting, she wrote:

> It was very careful—and very handsomely completed . . .
> in such a careful fashion that I felt it a bit smothered— Cady
> —forgive me—I do not wish to be unkind—but it was the
> sort of thing that if it had been free would have been big
> . . . [It] seemed to have every thing but real life in it and
> maybe you fooled yourself a bit because it was so handsome
> . . . I wanted to write you after I saw it but it was difficult
> for me. The painting was so good that I wished it had just
> that extra quality that would make it breathe— And I saw
> no reason why I should write you that till you ask me.[39]

Wells wrote back offering to strangle her, but O'Keeffe took no offense.

> No—I'm not annoyed with you—and I don't care anything
> about your manners one way or another— Your letter
> seems very normal and I like it that you are angry tho
> making you angry . . . was not my wish or intention— I
> knew when I wrote that I was hurting the artist in you and I
> like it that you kick back and spit at me . . . I like the artist
> standing up for himself . . . Believing in what one does
> ones self is really more important that having other people
> pat you on the back . . . And as long as you make perfectly

clear . . . that you don't care what I think anyway—I can't imagine why you want to choke me—why bother.

O'Keeffe's gentle response ended on a sad note: "I am glad you had such a good winter— Maybe it will please you while you are thinking unpleasant things about me to think to yourself that my winter has not been so good— You can say to yourself glee-fully—serves her right!"[40]

Their friendship survived this passage and a more difficult one that occurred in the winter of 1938. O'Keeffe wrote Wells that Stieglitz thought he would show Wells's work; she discussed framing, shipping, sale prices, and publicity. Wells packed the work and sent it to New York, where Stieglitz turned it down flat. It was for Wells, as it had been for Torr, "rather a drop."

It was probably after this incident that Georgia wrote him: "Your image slips often across my thinking—as you sat beside me at dinner—walking through the hall downstairs—the soft tan coat—as you sat at the foot of Alfred's bed—and I wished you had known him when he was younger . . . I wish always as I think of you that you looked better—wish to put out my hand to you—but what can I do. So much seems so futile."[41]

The relationship was marked by periods of affection and re-jection: it was close and volatile. The two shared an affinity with the landscape that was unique, and with Wells, O'Keeffe ac-knowledged an emotional connection rare for her, one that verged on dependency.

Cady— It is Monday night—and I must write you as you did not come because I have thought so much about you . . . I really did not think you would come but I hoped you would— I wanted to walk through my world here with you —up to the cliffs—and through the red hills . . . Tonight— at sunset I walked alone out through the red hills— I thought of you—wished you were with me but I get a keen sort of exhilaration from being alone . . . I climbed quite high—a place swept clean where the wind blows between two hills too high to climb . . . but from where I stood it seemed I could see all over this world— When the sun is gone the color is so fine—and I like the feel of the wind against me when I get up high . . . I really don't know why I should so much wish you to walk with me through what is just outside my door—unless it is that I think it almost the

best thing to do that I know of out here—it is so bare—with a sort of ages old feeling of death on it—still it is warm and soft and I love it with my skin—and I never want any one out here—it is almost always alone— I wanted you to walk through it with me . . . I did not realize till this afternoon when I counted up the days on my fingers that you must be leaving either today or tomorrow— It was very good to see you— I have really become very fond of you.[42]

Her affection for him was strong and explicit: "Remember when your spirit shivers or feels closed in that I love you widely," she wrote, "like the country."[43] Like lovers or siblings, Georgia and Cady bickered: "You and I don't quite seem to get along," she wrote him once.[44] Despite the emotional temperature of the relationship, it is very unlikely that the friendship was erotic. Wells was nearly twenty years younger than O'Keeffe; possibly more important, he was not interested in romantic relationships with women.

Georgia was not always an easy friend, and Arthur Pack came in for a dose of fury from time to time. Georgia wrote Wells:

I gave him one of my best trimmings— I had been mad at him long enough to have it all very clear in my mind and in fine order and I spared him nothing— I drew all the blood I wanted to and wiped my knife clean on what was left of him. He didn't have a leg to stand on— In a way it was pretty awful but it was what I thought and felt and I hammered it in one nail after another.[45]

Phoebe Pack liked Georgia but found her "the hardest person to get along with she had ever known."[46] Once Georgia saw a cake in the Ghost Ranch kitchen and announced that she would like to give it to her housekeeper, for her birthday. Phoebe refused—it was part of the guests' dinner—and Georgia left in high dudgeon. Georgia's rages were like flash floods, rapid, brief, and devastating. The Packs were kindly people, and after Georgia had "wiped [her] knife clean" on Arthur, they responded in their own manner:

Next day five youngsters from the ranch were sent over on burros with an extra burro loaded with vegetables:
 carrots
 16 beets

2 cauliflower
2 cabbages
3 large head of lettuce—
I had to laugh— Well—I guess that is all right now—[47]

• • •

THROUGHOUT THE DECADE of the thirties, O'Keeffe was becoming increasingly well established in the national cultural arena. In January 1937 she was included in a show of five modern painters at the University of Minneapolis Art Gallery, and in 1938 she received the degree at William and Mary. In 1939 she was chosen simply as one of the twelve most outstanding women of the previous fifty years. And her painting *Sunset—Long Island* was chosen to represent New York State at the World's Fair.

During the teens and twenties, O'Keeffe's work had been part of the rarefied world of the avant-garde. By the thirties, popular taste had caught up with the Stieglitz circle. This was a mark of its success but a source of frustration for Stieglitz the elitist. O'Keeffe's art, powerful, tender, and rapturously colorful, had seized the imagination of the public. Her work reached far beyond the small inner circle of the New York cognoscenti who had first admired it: a thousand people a week came to see her show in 1937.

She had always enjoyed critical support, which had been nearly undivided since Royal Cortissoz had changed from his first Olympian condescension to his later ponderous admiration of her. Henry McBride at the *New York Sun*, Lewis Mumford at *The New Yorker*, and Paul Rosenfeld in various magazines had all been powerful and articulate champions of her work. Once established, however, her position opened her up to a more vituperative sort of personal attack than is generally leveled at beginners.

In March 1938, George L. K. Morris directed a confused and mean-spirited accusation at O'Keeffe. Morris, himself a painter, delivered his taunts in the pages of *Partisan Review*. "I could have foretold, Miss O'Keeffe, that this would happen to you," he began portentously. His chief complaint concerned the absence of technical skill: "the art of painting itself, the necessary technical equipment, did not come naturally to your fingers . . . You felt that everything you touched was sensational . . . whereas in reality there was only the sign-painter's slimy technique."[48] The complaint about O'Keeffe's technique is a curious one. As Mc-

Bride pointed out, her paintings appeared "to be wished upon the canvas . . . the mechanics have been so successfully concealed."[49]

The true object of Morris's rage, though not articulated, seems to be O'Keeffe's imagery, which embodies a courageous tenderness. Morris's own cool, analytical abstractions, carefully and rationally constructed, were the forerunners of the art that would emerge as a dominant force in the American art world.

As the twentieth century progressed, the art it produced could be roughly divided into two groups: cool or enraged. It was not O'Keeffe's courageous willingness to paint her own emotions but rather the emotions she chose to paint that set her apart from the male-oriented world of contemporary art. Tenderness and rapture played no part in this development; quite outside the mainstream were O'Keeffe's vivid, dream-colored compositions, which embodied these unfashionable emotions.

27

FOUR YEARS AFTER her furious attack on Catherine, Georgia wrote her younger sister, saying frankly that she was sorry. It was "a real nice letter," remembered Catherine.[1] Georgia invited her sister to Ghost Ranch and asked if Catherine was still painting. Catherine accepted her sister's apology and her invitation, but painting, for her, was over.

Catherine had no ambitions in the world of art: she had simply tried to set down what she felt about a moment. This unselfconscious ingenuousness had been what Georgia most admired about her sister's work, and it had been destroyed. The power and authority of the beloved older sister was enormous, and for Catherine, painting had become charged with tension and threat. Georgia's grace in apology, however, was matched by Catherine's generosity in forgiveness. The two sisters resumed their closeness, and the incident was closed.

• • •

BEFORE IDA became a nurse, she taught art in Virginia for a number of years, and in 1927 she returned to art as a profession. Attending Columbia Teachers College she received a Master of Arts degree in 1932. That summer she spent in Tennessee, painting and looking for a teaching job. The following summer (she had inherited the family wanderlust) she was at Deer Isle, Maine, and by 1938 she had left New York for good. She spent the summer in the Ozark Mountains in Missouri and went on to San Antonio in the fall. She settled finally in Whittier, California, where she spent the rest of her life.

434

Ida had begun to exhibit her work in 1927, in Georgia's show at the Opportunity Gallery. She had a one-woman show in the spring of 1932 in Portage, at the Springfield Art Museum in Missouri in 1933, and at the Delphic Studios in New York in 1933 and 1937. In 1940 she showed monotypes at the Sachs Auditorium, in New York, and her still life *My Table* won the De Forest prize at the National Association of Women Painters exhibition.

Ida's work shows little similarity to that of her sisters, and, unlike them, she did not succeed in achieving a unique and personal style.[2] She was more technically sophisticated than Catherine but lacked the profound lyrical and emotional commitment that characterized both Catherine's and Georgia's painting.

In 1939, Claudia, too, left New York. With a friend, Hildegarde Hohane, she moved to California, where she bought land in Beverly Hills and started a kindergarten. "An exclusive school for the children of Particular Parents," her brochure proclaimed. "It sounds a bit snooty to me," said Georgia at once; "sounds very snooty to me."[3] Despite her brisk criticism, Georgia supported the enterprise both psychologically and materially. She lent Claudie two thousand dollars and requested a mortgage on the property. "I don't see what else we can do about it. I would really like to have some form of security," she said reasonably.[4] The loan was not used as psychological leverage: "It is your affair —and I wish you luck," she wrote.[5] Nor did she want Claudie to feel penurious. "You say you are trying to keep expenses down. My advice to you is not to be stingy—I think it will not pay."[6]

By the mid-thirties, O'Keeffe paintings were selling for upwards of five thousand dollars, and though sales were unpredictable, they were fairly steady. When Georgia began to enjoy a reliable and comfortable income, she undertook family financial responsibilities frequently, without complaint or resentment, carrying on the tradition that had enabled her to complete her own education with Aunt Ollie's help. As Ida grew older and needed financial assistance, Georgia provided it. "Just have the bills sent to me," she wrote Claudia.[7] Her brother Francis had moved to Cuba (and dropped the second *f* in O'Keeffe). When he was fifteen, Georgia invited her nephew, young Francis, to stay with her in Abiquiu for five weeks. He turned up again four years later, in trouble, and Georgia paid off all his debts and gave him an allowance to get him back on his feet. When Alexis's son Bobby needed special schooling, Georgia paid the tuition.

Regardless of age, familial relationships do not alter, and Claudia was always Georgia's youngest sister. Until Claudie died, at age eighty-five, Georgia gave her advice about financial transactions, eating habits, exercise, and life in general, whether Claudia wanted it or not. Around 1940, Georgia began to have trouble with her eyesight. Anita, with similar problems, had gone to Mrs. Bates, the wife of an eye doctor who prescribed ocular exercises instead of glasses. Aldous Huxley had written a book about the dramatic change the Bates Method had made for him, and Georgia tried it herself. The idea appealed to her—reliance on the self rather than on mechanical aids—and she performed the exercises religiously. Though Claudie had not complained of eye trouble, Georgia wrote, "I would look into it if I were you."[8] Georgia also recommended a general exercise program—the Mensendieck system, which she was following. "It would [be] . . . good for the shapes of both you [and Hildegarde]," she told Claudie firmly, "Now don't put it off—and if you can't start now don't fail to start in June."[9]

During the early forties, Georgia became increasingly interested in the benefits of diet and exercise. She was a friend of Adelle Davis, the nutritionist, and through another friend, Caroline Fesler, Georgia met Dr. Ida Rolf, the founder of Rolfing, a program of muscle manipulation. "I still get up at six and go walking in the morning—breathing as deeply as I can," she told Claudie, with an older sister's serene assumption that her opinions are always welcome and tact is superfluous "—it would do you good—get your stomach in shape."[10] "You do as I say even if you don't want to," she told Claudie starchily. "I know it is best."[11] Beneath the bossiness was an undercurrent of affectionate solicitude: "Dear Claudie," Georgia wrote, "I keep wondering how you are. Drop me a word and let me know. I am so sorry that your trip was so unfortunate. Let me hear how you are."[12]

Georgia had begun inviting friends and family to stay at Ghost Ranch before she had even begun to rent the house there. Beck Strand, who was living in Taos then, was one of the first, in the summer of 1936. Peggie Bok (now Kiskadden) was a frequent visitor as was Anita Pollitzer. During the forties, Louise March came every year, and though Georgia was a welcoming hostess, she drew her own firm lines. One year she wrote:

If you come plan to spend a few days with me but Louise—
I can not ask your children— Couldn't you leave them with
your friend . . . There are some forms of discomfort I do
not give myself— I'll be glad to have you. It is the time
when working is good and children around the house—
well they are children around the house and at that time I
can not have it— Don't tell me yours are different—and
don't be hurt— I would love to have you. [13]

Claudie was the most frequent family visitor, and after Georgia bought her house, her letters to Claudie are full of invitations: "When are you coming?" is the recurrent question. "Can't you come now—right now—today? for a few weeks— I am sure it would be good for you. Do try." [14] Georgia's attitude was based on her beguiling conviction that the life at Ghost Ranch had no peer. Material possessions meant little to Georgia: it was visual splendor and empty space that lifted her up. Sharing those was the most generous act she could imagine.

Georgia's favorite brother, Alexis (then called "Tex"), had been badly damaged by gassing in the Argonne during World War I. Before the war, he had worked as an architect with Francis in New York; after it, he first worked as a recruiter for the army, then had gone back to engineering (he'd been an army engineer), building roads in Wisconsin. It was there that he met Elizabeth Jones, from Oak Park, Illinois, who was studying at the university in Madison. Tex was sensitive, sympathetic, and good-natured, and he had the O'Keeffe good looks: curly black hair, brilliant blue-green eyes, and an unexpected auburn mustache. Betty left college to marry him in 1927.

They moved to Chicago, where they had their first child, Barbara June, the following year. Tex started his own import-export business and applied for a patent on a packaging design. He was determined to succeed at his new venture no matter what the cost; it killed him. He died in early January of 1930, at the age of thirty-eight, leaving his pregnant widow with a one-and-a-half-year-old daughter. In March, John Robert O'Keeffe was born. "I am glad . . . ," Georgia wrote Betty. "It is the only O'Keeffe boy." [15]

June inherited something of her father's looks: "When I look at you I see my brother looking out at me," Georgia told her

later.[16] O'Keeffe children of that generation were scarce: Georgia, Ida, and Claudia had none, and Catherine, Anita, and Francis had only one each. When Tex died, Anita offered to adopt June; Betty politely declined. The family stayed in Chicago for seven years, then moved to Beverly Hills, near Ida and Claudia. Her husband's sisters were formidable, but Betty had a strong sense of family and wanted her children to grow up among relatives. Claudia had become a successful schoolteacher, and Ida, in nearby Whittier, worked as a draftsman for Douglas Aircraft during World War II. Both women had houses and gardens, and both welcomed their brother's children. June and Bobby grew up around their independent and outspoken aunts, with a strong sense of belonging to the O'Keeffe tribe. When June went to Vassar, in 1946, she came to know her two eastern aunts.

Anita's life style had become increasingly grand—a far cry from the bone-spare days of Charlottesville. Robert Young was a shrewd financier, who had made a great deal of money on the railroads and was on his way to amassing a considerable fortune. He advised Anita's sisters on their financial affairs and bought paintings by Georgia for his wife. By the thirties, the Youngs were spending their winters in Palm Beach and their summers in Newport, where they first rented the Vincent Astor "cottage" and later bought their own enormous house, Fairholme. The zenith of their social achievement was a close friendship with the Duke and Duchess of Windsor, for whom, it is said, they built an entire wing on their house at Palm Beach. Their daughter, Eleanor Jane, called Cookie, had a glamorous coming-out season: she was a debutante of the year and was presented at the Court of St. James's. She then followed her mother's example and eloped. Her marriage was brief and unsuccessful, and it ended in annulment. Worse was to come: in 1941, Eleanor died in an airplane crash, at the age of twenty-three.

June, seeing her aunts Georgia and Anita in New York, found them a study in contrasts. Anita took her niece to the hairdresser; Georgia to the health food store. Anita advised her to take care of her skin; Georgia to take vitamins. Anita told her to lose weight; Georgia to gain it. Anita told her to wear high heels; Georgia to wear flat ones. Anita took her to dinner and taught her how to use the Russian service; Georgia took her to Chinatown and taught her how to use a Chinese teacup. Georgia had her own, unconventional vanities, however: while Anita

would tell June to wear a hat to shade her face, Georgia told her to wear a scarf to protect her hair. Sunburned hair was anathema.

The O'Keeffe style was cool. "There was no kissing, no touching, no hugging," said June. Nevertheless, the feeling of warmth and of unquestioned support obtained, a constant subterranean current.

Continuing the family connection to the next generation, Georgia invited Catherine's daughter to Ghost Ranch. Young Catherine made her first visit to her aunt Georgia at the age of sixteen, taking the train by herself from Wisconsin. The visit to the small, spare house in the wide land was a revelation for the young girl, who was mesmerized by the extraordinary world of her extraordinary aunt. Georgia was kind but brisk, and her ideas seemed wildly eccentric: she told her niece to take off her glasses and use her eyes, and to take off her clothes and lie in the sun. "The sun's good for you," Georgia told her, and her matter-of-fact attitude robbed the idea of shock.

No one was exempt from Georgia's temper. One morning her aunt asked Catherine to drive over to pick up the mail, and though Catherine was not yet dressed, she did as she was told. When she returned, Georgia was standing by the garage with a group of people. To avoid appearing before strangers in pajamas, Catherine drove the car across the dry ground in front of the house.

The ecosystem is fragile in the high mesa country. There are no rains for months, and those that come sink directly into the ground. It is said that the wheel ruts of the original covered wagons are still visible along the Santa Fe Trail. Outraged by Catherine's cavalier treatment of the land, Georgia told her niece fiercely, "*No one* drives on this ground." Catherine retired to her room in tears, but Georgia proved as kind as she was fierce. "Later she came and she was sorry," said Catherine, and "then everything was all right." [17] For Georgia as well as Catherine, the visit was a success: "It is young Catherine Klenert that I have here," she wrote Claudia. "She is lovely." [18]

Georgia was close to her various sisters in various ways. Anita was the nearest in age and had been a companion from the start. As they grew older, Georgia and Anita shared an economic freedom and a social mobility; each gained a certain stature in the eyes of the world. Georgia admired Ida for her high spirits and

independence, and for Claudia, the youngest, she never lost her sense of affectionate solicitude. It was for her sister Catherine that Georgia seemed to have the most respect. Catherine had lived out the pioneer promise of the Sun Prairie beginnings. Her life in the small town of Portage, with her husband, her daughter, and her garden, seemed to Georgia a real one, and she admired Catherine's modest, realistic goals and pleasures. "I like to think how smart you people are to be living where you are instead of here," Georgia wrote.[19] Catherine's life was based on pragmatic, small-town values: responsibility, self-reliance, stability, and honesty, all of which Georgia honored. "She thought Catherine was the only one who had made a success of her life," said a friend. Georgia felt more than respect for Catherine: though she offered everyone else a handshake, Georgia put her arm around Catherine. As she wrote her sister, "You are one of my nicest thoughts."[20]

• • •

BY THE END of the thirties, the center of Georgia's life was no longer in New York. The winters spent there were obligations, performed out of love. She had no emotional commitment to anything in the city except Alfred, and the world there gave her little sustenance. Often Georgia spent weekends with Esther Johnson, whose brother-in-law Robert she had met at Ghost Ranch. Esther was from New England; she was small, thin, and restrained, and she wore flat shoes and no makeup. Her husband, Seward, was one of the Johnson & Johnson family corporation, and enormously rich, but they lived simply on the big, old-fashioned Cedar Lane Farm in Oldwick, New Jersey. They bred prize-winning Holstein cattle from two herds, called "Milk" and "Honey"; they also bought O'Keeffe's *White Barns, Red Doors* of 1932. Georgia liked Esther more than almost anyone else in New York, but even Esther's frequent company could not make up for the eastern landscape. "I have been getting out in the country around New York quite often," she wrote Hunter. "I don't think much of this kind of country but it is pleasant to get away from the city."[21] A 1941 painting, *From a New Jersey Weekend, No. 1,* is gray and somber and depicts two looming gravestones that dominate the canvas, flanked by black skeletal trees. The blank gray surfaces, the bare trees, and the high horizon contribute to a sense of stifling confinement.

In October 1942, Georgia and Alfred moved from the penthouse on the East River to a smaller apartment at 59 East Fifty-fourth Street. The penthouse had been cold, and during the war taxis were scarce: the trek from the river to the Madison Avenue gallery was hard for Alfred, who was frailer each year. The new apartment was only a block away from the Place, and Alfred's room had its own heater. "He is very pleased with the change," Georgia wrote Claudie. "I am not so pleased but I don't really care."[22]

Georgia's commitment to Alfred was loyal and absolute, though he was no longer the companion he had been in her early years of discovery and accomplishment. He was now a responsibility. She had always looked after his clothes, mending the holes in his pockets, exiling his sweaters when they became too disreputable, and tracking down the very particular kinds of underwear, socks, and shirts on which Alfred insisted. She now took him to the tailor's and the shoe store. All his clothes had to be reproduced exactly, and even when identical replacements were found, Alfred complained that they would look too new for years. The famous loden cape, Alfred's trademark, came from Germany. When it finally wore out it was replaced by a duplicate, which Louise March brought back for him. Georgia took care of Alfred while she was with him in the winter, and she left him in the strong and affectionate hands of Margaret Prosser in the summer. She had hired a housekeeper when they moved to the penthouse, and from then on there was always someone to look after Alfred: a Swedish woman first, then a Finn. If he returned to New York before Georgia did in the fall, friends came and stayed with him: Peggie Kiskadden, and a friend from New Mexico, Maria Chabot.

As O'Keeffe's life in New York was growing smaller and dimmer, her life in the Southwest increased in vigor and complexity. During her first summer at Ghost Ranch, O'Keeffe hired a local girl to live at the ranch with her, to cook and clean. The girl was pregnant, and as the summer progressed she became very pregnant. Discussions of the issue was difficult, as the girl flatly denied her condition. When she reached her term, O'Keeffe offered to drive her to the hospital, and the girl at first refused. There was no husband, she said, so there could be no baby. In spite of this unanswerable logic, O'Keeffe took her to the hospital and waited during the delivery. Three days later the girl was

ready to leave, but when O'Keeffe arrived to pick her up, she found her alone. O'Keeffe's request for a baby produced the same response: there was no husband, and there could be no baby. Pressed, the girl admitted that in fact there might have been a baby, but she was ready to go back to work, alone. O'Keeffe dismissed this idea roundly. She demanded the baby from the hospital and took mother and child back to the ranch. She sent to New York for a book on child care and spent the summer helping to look after the infant. Because of the awkward lack of a father, the baby was a secret. His clothes were hung out on the line at dawn and brought in before a passerby might see them. Georgia referred to him as "our baby" and adjusted her schedule to fit his. "There wasn't a finer baby in the region than we had that summer," she boasted later.[23]

At the end of the summer, Georgia made a determined assault on the mother, to find the identity of the father. When his name was finally produced, Georgia wrote the young man a brisk letter, announcing that he had a baby at her ranch and requesting his presence on the following Sunday. No father appeared, whereupon Georgia put baby and mother into the car and drove off in search of him. They found the young man in a logging camp in Colorado. He was pleased to be found: as requested, he had driven to Ghost Ranch—almost. At the last minute his nerve had failed him, and he had bashfully retreated, driving all the way back to Colorado.

Having presented the young man with his son, Georgia now announced the wedding. She invited relatives, arranged for a church, and engaged a priest. The baby slept peacefully, in a packing box lined with shelf paper, until, at the last minute, Georgia brought him in for the ceremony. The young family she had insisted on founding kept in touch with her for years. Georgia later told a friend proudly, "I drove over a thousand miles to get that baby married."[24]

Despite the excitement, producing a baby and organizing a wedding was not something Georgia hoped to do each summer, and she looked next for someone to help her whose private life would be less demanding. At the end of that summer, she met Maria Chabot at lunch at Mary Cabot Wheelwright's ranch. Wheelwright was from Boston, a wealthy, intelligent, and effective woman. She was profoundly interested in her adopted re-

gion of Santa Fe and founded a museum devoted to the indigenous Indian culture.

When she met O'Keeffe in 1940, Maria Chabot was twenty-seven, dark-haired, with striking features and a strong physical presence—"a tall handsome young woman," Georgia called her.[25] Chabot came from San Antonio, of an English diplomatic family that had served in Mexico. She went to school until she was fifteen, after which she earned money herself to pay for tutoring in the classics. She later studied at Oxford and at the university in Mexico City. (An early encounter between Chabot and O'Keeffe occurred in a Hispanic village. Stepping into a house to ask for directions, Maria saw on the wall the reproduction of a brilliant purple petunia painting: Georgia's.)

Georgia took to Maria at once and invited her back to tea at Ghost Ranch. The two women shared a number of characteristics: both were strong, opinionated, and forceful; both were self-sufficient and used to living alone. They were devoted to the southwestern landscape; both were aesthetically sophisticated, visually and aurally, and they shared similar musical tastes. Educated, capable, and fiercely independent, Chabot was an ideal companion for O'Keeffe, who needed someone to run the practical side of her household so that she could devote her energies to painting.

Chabot had no income and wanted to become a writer. O'Keeffe offered her room and board in exchange for taking care of the mechanics of their daily life. Chabot would write and O'Keeffe would paint, Chabot would look after the household and O'Keeffe would pay for it. The first season, 1941, was not a great success—Georgia's style was imperious—but the following winter O'Keeffe sent Chabot a railroad ticket to New York. Maria accepted the peace offering, and the two of them went together to hear every single performance of Beethoven's Ninth Symphony conducted by Bruno Walter. Chabot was willing to try a second summer with O'Keeffe: "I liked what she was doing." The second season was better, and thereafter the two women spent several months a year in each other's company for nearly a decade.

"Maria got off yesterday and I did feel out of breath," O'Keeffe wrote a friend from New York. "She was only here ten days but it seemed as if she had been here all winter—we did so

many things so fast."[26] One year Georgia sent her alone to see her annual exhibition, acknowledging both Maria's participation in the life that produced the paintings and her intellectual and aesthetic capacity for appreciation of the work. And on one visit, Maria and another friend, the collector Caroline Fesler, made the selections for one wall of O'Keeffe's next show. O'Keeffe hung the wall as they suggested: a great honor.

The friendship between O'Keeffe and Chabot was not quite one between equals, however. O'Keeffe, as always, felt a serene assurance that her own needs took priority. Her status as Chabot's senior and her employer are reflected in the comment: "I rather think that the reason she comes to me summers in spite of family and friends objecting is that I have left her free with her own affairs—only making suggestions at times and only being insistent that she go my way when her way may disrupt my life and leads to nothing worthwhile for her."[27]

The Chabot-O'Keeffe relationship was a tempestuous one. Their friendship was determined in part by their isolation in the wild, high mesa country: a solitary figure in an empty landscape becomes charged with meaning. "I . . . seldom see anyone but the young woman who lives with me and keeps my world going," O'Keeffe wrote.[28] Jealousy entered into the relationship: during the war, when gasoline was in short supply, a boyfriend drove nearly a hundred miles to see Maria. He was turned away at the door by Georgia, who refused, out of sheer contrariness, to let him see her. Chabot once said: "We lived so closely and so innocently that we needed each other's energy."[29] "Innocent" was the word: they were as close as siblings, and equally charged with affection and competition. When O'Keeffe invited Chabot to Chicago for the opening of her 1943 show, the two women shared a hotel room. "So we could fight better," Chabot said. Fight they did, but the other side of the relationship was equally strong. Leaving New Mexico one fall, O'Keeffe wrote Chabot: "I want to thank you for the many, many things you thought of for me— your real kindness—and freshness—you made so many things so easy for me."[30]

O'Keeffe's high-handed refusal to let Maria see her boyfriend was surely motivated by the monarch's imperial logic: since she herself had no romantic element in her life in New Mexico, it seemed fair that Maria should not either. For in spite of Georgia's independence, her heedlessness of convention, and her deliber-

ate removal from her husband, she seems not to have been drawn to sexual adventures. Maria lived with Georgia a part of each year for a decade, and was close to Georgia for the next forty years of their lives. She was an integral part of the small community in which Georgia had stayed since 1929. Maria would certainly have been aware of any such adventures that Georgia undertook in New Mexico, then or later. When she was asked, years afterward, if there had been any, she found the idea preposterous. Living with O'Keeffe, she knew very well how Georgia's energy was spent: on her work. Georgia's nature was more ascetic than libertine. Her sensualism—of which there was a great deal—was expressed through her painting.

This pattern was not new but was begun in the fall of 1915, when Georgia found herself falling in love with the absent Arthur Macmahon. In his absence, Georgia transmuted her own headlong and importunate passion into her work and produced her first great series of drawings. This pattern of the absent lover continued: Georgia wrote tender and intimate letters to Arthur for nearly a year after she had deliberately moved two thousand miles away from him. She admitted that she was probably better off without him, in terms of experiencing the excitement of Texas. She was probably right: instead of addressing her ardor to the man in person, she expressed it in brilliant and original watercolors. When she met Paul Strand, the same dynamic continued. Georgia's letters to Paul are full of references to emotion and caresses, though she had met him only briefly in the spring of 1917 and did not see him again until the spring of 1918. To him she acknowledged her resistance to emotional commitments and recognized the probable results of this—"a kind of aloneness." When she began her correspondence with Alfred Stieglitz, Georgia admitted that she thought they were probably better apart than together. This did not refer to their ability to get along but to her own ability to work best alone, at a remove from the beloved. Although she lived steadily with Stieglitz from 1918 to 1929, even during those years she left him periodically and fled alone to Maine in order to recover her sense of self, of purpose, of concentration. The years in New Mexico were not a break but a continuation of a long-established pattern of distance, of deliberate separation from the person she loved.

• • •

MARIA TRIED at first to raise vegetables at Ghost Ranch, in a small fenced corral. The venture was not a success. The soil was thin and dry; rabbits came after the lettuce, and rattlesnakes came after the rabbits. The failed attempt marked the beginning, however, of O'Keeffe's reconnection with the soil. Partly for pragmatic reasons, partly for the pleasure it gave her, for the rest of her life Georgia was to maintain some kind of garden.

In 1943, as a war effort, Maria farmed fifteen rented acres in Abiquiu, growing beans in the dry, sandy soil. O'Keeffe's attitude toward the war was one of concern but not connection. She had felt a deep emotional commitment to the First World War, to no avail. When the Second World War began, Alfred and his friends were made so voluble and so heated by the subject that O'Keeffe withdrew. Her correspondence contains few references to the war, and most of those concern practical matters. When Claudie wrote her a worried letter, Georgia answered: "Of course one can not tell what the war will do anywhere or to anything so I guess all one can do is go about one's business." [31] And later: "Yes—the war is bad and will undoubtedly be worse. I do not look forward to it— Every body and every thing went so crazy with the last one—I suppose it will all get that way again." [32]

The war affected Georgia's life in practical terms, and in New Mexico she lived close to the land in a manner that harked back to the days in Sun Prairie. "When there is no meat we eat beans," she wrote Claudie cheerfully. The problem of subsistence was a challenge, not a hardship. In the austere landscape, self-sufficiency seemed both appropriate and appealing. It amused her to find wild edible plants: one of these was an herb locally called chimaja, for which O'Keeffe competed with the antelopes:

> I loved walking in the low sun—evening light through the red and purple earth—bending or kneeling often to pick the small fragrant leaves—you cook it fresh with eggs—or put it dried, in soup— And it amused me to be hunting something the Antelope likes so well . . . It entertains me too—to find something to eat—growing wild out in that bare place. [33]

It was during these years that O'Keeffe began again the patterns of canning, bread baking, and vegetable raising that she

had known as a child, and which she continued in her household for the rest of her life.

Chabot was O'Keeffe's favorite camping companion, and the two of them spent weeks at a time in the wild hill country. They brought their provisions with them—once it was "twenty pounds of good venison," which had to be put on top of the car at night to keep it from the animals. They ate at sunset, wrapping a piece of bacon around a chunk of venison and cooking it over the open fire. Later Maria read out loud in the firelight. The two of them went often to what O'Keeffe called the Black Place, a region of dark bare hills some hundred and fifty miles north of Abiquiu, which looked "like a mile of elephants." [34]

O'Keeffe's life in the hills was ruled by her own needs, and society's rules often went by the board. One Thanksgiving, O'Keeffe and Chabot had invited two men from Española to Thanksgiving dinner. Georgia began cooking the turkey the day before, but she had no culinary sage and seasoned the bird with the wild herb: a mistake. When the turkey was roasted it was rank and terrible. Late that night, O'Keeffe washed the stinking carcass out, to no avail.

Alone in the nighttime kitchen the two women faced domestic catastrophe: the reeking, dripping bird, and the impending arrival of the expectant guests, who now seemed intruders. Georgia and Maria took wild flight: they packed the car and set off at midnight through the cold night to the Black Place. There they had to clear the snow from the frozen ground before they put down their sleeping bags, and even then the cold was intense. Maria kept a fire burning all the next day to warm the earth where they were going to sleep. It was so cold Georgia had to stand on a rug, and wear gloves, while she painted.

Certainly the midnight flight was bad manners, but the point of living in that wild landscape was the freedom to respond to it in kind. And in the subtle and continual conflict between work and the world, again and again Georgia chose work. The conflict was never finally resolved. Georgia took pleasure in her friends, enjoyed their company, and acknowledged some of the demands of society. Work, however, was an imperative. Solitude was the constant, society the deviation.

• • •

THE COUNTRY here is really fantastically beautiful," she wrote Claudie from Ghost Ranch. "It has such a clean untouched feeling— I never get over being surprised that I am here—that I have a house and that I can stay." [35]

The house at Ghost Ranch was where O'Keeffe's heart lifted, but as a place to live it was difficult: the mechanics of running it were complicated, inconvenient, and exhausting. During the war, gasoline and tires were in short supply, and merely getting to the house was difficult. The land was too dry and poor to grow vegetables, and there were no nearby sources of food. Maintenance was problematical: simply calling a plumber was arduous. O'Keeffe had no telephone, and a trip had to be made over the rutted dirt roads to Española to make a call. Even the car trip depended upon the weather: rain storms and flash floods filled up the arroyos and turned them into torrents that could not be crossed by cars for several days. Before she bought the house at Ghost Ranch, O'Keeffe had explored the countryside, looking for another house that would make living easier. She looked first in Barranca, then in and around the old village of Abiquiu.

When she first saw the house at Abiquiu it was a ruin. An adobe wall, broken in places, enclosed it and the garden. Georgia climbed boldly in and walked around: there was a large patio with a door in its long wall. It was the door which drew her.

Besides the beautiful and enigmatic door, O'Keeffe discovered that the house had its own well, and much-coveted water rights. The sprawling house dated to the early nineteenth century and parts of it possibly to 1740. From 1804 until 1902, a distinguished local figure, General José María Chavez lived there. The property was still in the Chavez family when O'Keeffe first saw it. It was for sale, but for a price she found exorbitant: six thousand dollars. Later the owner reduced the price, but by then O'Keeffe was not interested. She was buying the house at Ghost Ranch—for a similar price, but that house was in good condition, and came with eight acres. Chavez subsequently died, leaving the house to his son, who sold it to the Catholic Church for a dollar. The church had no use for it, and the property became a local co-operative as stabling for pigs and cattle. O'Keeffe, still fascinated by the door in the patio wall and increasingly in need of arable land, then reconsidered. She began to press the Church to sell the property to her. It was an unheard of notion, but Georgia had seen something she wanted. In the end the Church

yielded to the irresistible force. On the last day of December 1945, the derelict building and three acres were sold to O'Keeffe. The Church made a handsome profit on the transaction, increasing its investment by ten times: the property reportedly changed hands for the sum of ten dollars, cash money.

When O'Keeffe bought it, the buildings were falling down. The roofs had caved in, and the old adobe was sliding into flattening heaps of mud. A complete renovation was necessary, and O'Keeffe asked Chabot if she would take it on. In that same year, Mary Wheelwright had given her ranch, Los Luceros, to Chabot: Wheelwright's intended heir had died, and she had no children. The big ranch was in the Rio Grande Valley between Taos and Santa Fe and was one of the oldest in the area. Chabot took on the responsibility of the ranch with relish (included with the land were two O'Keeffe paintings) and spent the next twenty years farming the property herself, working ten hours a day on a tractor.

In spite of her new enterprise, Chabot agreed to oversee the renovation of the Abiquiu house. The project was large and complicated, and it took nearly four years to complete. The adobe bricks had to be manufactured by hand, the roof restored, seven fireplaces built, and plumbing and electricity installed. Building supplies were in short supply, since at the same time, the top-secret military installations were being built nearby at Los Alamos. Georgia asked her brother Francis to use his influence as an architect to obtain nails for her project.

Maria Chabot took as much pleasure in the process of restoration as Georgia did. Conscious of the materials, the process, and the feeling of the place, it was Chabot who set the paving tiles in front of the magical patio door.

What had been the stable, or carriage house, was farthest from the street, on top of the bluffs. Here Maria planned the studio. This would overlook the long sweep north, across the Chama River, and east, down the valley, along the road to Española. Chabot paced off the distances, laying out the rooms. She decided where to put the walls and fireplaces. She found an old book on ethnic architecture and duplicated a Hopi fireplace for Georgia's bedroom: the Indian fireplaces are small half- or quarter-round ones that throw fierce heat into the room. The roof was made with vigas, the peeled cedar logs that form the ceiling in every traditional adobe house. Above those she used stripped

willow withes. She was deeply conscious of the presence of the house: "I wanted it to feel like a nest," she said.

The bricks were made on the property, so that the house was made from Georgia's land, part of the earth she owned. It was not an easy process: adobe is a temperamental medium, requiring both determination and intuition. "I wanted to make it my house but I'll tell you the dirt resists you," O'Keeffe said. "It is very hard to make the earth your own."[36]

The bricks are made from a mixture of clay, sand, straw, and water. The right kind of earth must be found near a source of water, and the mixture must be right: too much sand, and the bricks dissolve; too much clay, and they split. The adobe makers dig a shallow hole, run water into it, throw in straw, and mix the mud with feet or hooves. The mixture is then shoveled into flat boxes and left in the sun. The men make the 8-by-14-inch bricks into walls, carefully forming an interlocking pattern of strength. On the exterior walls there is a thin coat of cement stucco, to resist the weather. The interior walls, however, are traditional. Chabot had the dark gray adobe for the final coat brought in from Las Vegas, New Mexico, 110 miles away. This smooth finish is traditionally applied by women. The fact that her house was finished by women's hands pleased O'Keeffe, as did the process.

> This morning the women started the smooth coat of plaster — It was a bright clear day and is quite wonderful—women on scaffolds against the sky . . . men mixing a vast pile of mud for the women to plaster with. It is really beautiful to see and the mud surface made with the hand makes one want to touch with the hand—and there it is soft against the sky.[27]

28

THROUGHOUT THE 1940S, O'Keeffe's work was shown each year at An American Place, and each year the exhibition attracted crowds. Her reputation was growing steadily. She was fully established as a significant presence in the art world, and she received formal acknowledgment of this. In 1942, she was awarded a second honorary degree, this one from the University of Wisconsin. In 1943, Lloyd Goodrich, from the Whitney Museum of American Art, requested her permission and cooperation in making a scholarly record of her work for the museum's archives. In 1946, she received an accolade from the Women's National Press Club, as one of ten women who had achieved distinction in their fields. Three years later, she was elected to membership of the National Institute of Arts and Letters.

When Alexis died, in 1930, Georgia had written his widow, Betty: "I can promise nothing—a painter's life at best is precarious—and it costs me a great deal to live."[1] O'Keeffe's financial position was precarious during the twenties and early thirties, but she was never in the desperate straits of Dove and Hartley. Despite the Depression, O'Keeffe's works sold increasingly well. She and Marin were the primary supporters of the Rent Fund for the gallery, to which all Stieglitz's artists contributed. She often bought works by other artists (Dove in particular), and by 1936 she had felt financially stable enough to sign the new apartment lease in her own name. It was a precarious situation: the sales of her paintings were always erratic, and Stieglitz had always been equally proud of both selling and refusing to sell her work. For her part, all O'Keeffe cared about was making enough money to

allow her to paint for another year. She was more pragmatic than Stieglitz but was hardly a saleswoman. Writing to her collector friend Caroline Fesler, O'Keeffe said delicately of a painting Fesler wanted: "Would it seem alright to you at $5000—or shall we talk of it when you come?"[2] Later she wrote: "I feel quite diffident about making the suggestions."[3]

Despite Alfred's intractability and her own indifference, her paintings were never sold cheaply or haphazardly. Their erratic and short supply, coupled with the invariably high prices, made the market in her work a remarkably stable one. Many of the best paintings stayed unsold, and their value increased steadily.

Though Stieglitz's arrangements with artists generally precluded their selling through other dealers, exceptions were made, and O'Keeffe's expanding independence during the late thirties and the forties liberated her increasingly from his control. Starting in 1935, her work appeared regularly in group shows at Edith Halpert's Downtown Gallery. In 1937, when a portfolio of twelve color reproductions of O'Keeffe's work was published, Halpert gave the artist a one-woman exhibition, courtesy of An American Place.

Though the critics were generally respectful of O'Keeffe's work, as they tend to be of an established artist in midcareer, this was not invariably the case. Besides the petulant letter by George L. K. Morris in 1938, criticizing O'Keeffe's lack of technique, in 1946 there was a disapproving article by Clement Greenberg in *The Nation*. Greenberg claimed that O'Keeffe's only *virtue* was her technique. "The deftness and precision of her brush . . . exert[s] a certain inevitable charm . . . Otherwise her art has very little inherent value."[4] Greenberg's claim so enraged Stieglitz that in the last month of his life he exerted himself to write a furious response. The art world is nothing if not political, and Stieglitz, who had always been controversial, was losing his supporters and his power. There was a new generation of critics, who did not hold the Stieglitz circle in any great esteem, who resented the insularity and irrationality of Stieglitz's reign, and who saw things a new way. It was inevitable that the Stieglitz painters would be criticized, if for nothing else, for the fact that they were, by now, no longer the avant but the old guard.

Still, most of O'Keeffe's reviews had continued positive since the beginning of her career. Those critics who were not won over by the work at least recognized and respected it. Marya Mannes,

in 1928, had found herself "somehow repelled by the bodiless-ness of" O'Keeffe's work, but acknowledged the "frequent, un-precedented beauty" of it.[5]

In 1943, O'Keeffe was given her first major retrospective ex-hibition. It was held at the Art Institute of Chicago, the first such show there to be given a woman. It was organized by Daniel Catton Rich, the director of fine arts at the institute, who had met her in Taos a decade earlier. Rich was a perceptive and sensitive scholar, who greatly respected O'Keeffe's work. He accepted Stieglitz's terms for the exhibition, the first of which was that the institute buy a major painting from it. Rich chose a great work: the *Parsifal* cross of 1929, black geometry against the rich red hills. The second condition was that O'Keeffe be permitted to hang her exhibition herself. Her initial request was that the institute re-paint the galleries in which the work was to be shown. This apparently imperious demand was in fact quite reasonable: the walls in question were a pale violet.

Rich's essay for the exhibition catalogue was the first long scholarly piece on the artist and her work. It contained the bio-graphical structure of the O'Keeffe myth as it would be retold again and again, in articles and essays. Rich perceived the great strengths of O'Keeffe's work—her capacity to render emotion in abstract terms, her astonishing gift of color, and her deep and extraordinary connection with nature. The essay, lucid, elegant, and scholarly, made a strong intellectual statement in support of O'Keeffe's art. The exhibition, in an institution of great eminence, and the calm appraisal of Rich's catalogue removed O'Keeffe's work from the somewhat esoteric environment that Stieglitz had created for his artists.

In 1944, O'Keeffe again was involved in an exhibition, this time of Stieglitz's private collection of modern American and Eu-ropean art. The show, at the Philadelphia Museum of Art, was called "History of an American—Alfred Stieglitz: '291' and After," and was done in conjunction with Carl Zigrosser and Henry Clifford. It gave an impressive view of the breadth and depth of Stieglitz's aesthetic perception. Instead of being seen in Stieglitz's own small space, in Stieglitz's own testy presence, the work was shown in the serene and capacious halls of the Phila-delphia Museum, with all the attendant implications of majesty, posterity, and immortality. Stieglitz's stature in the field of Amer-ican art, his remarkable eye and prescient viewpoint, were newly

revealed to the public, and his importance took on newly enlarged dimensions, as did those of his artists.

A second major achievement for O'Keeffe was her 1946 retrospective at the Museum of Modern Art in New York. This exhibition was mounted by James Johnson Sweeney, an eminent figure in the art world. For a catalogue essay, O'Keeffe sent Sweeney a collection of clippings about herself, though she made a casual disclaimer: "Don't take those clippings very seriously— I've never denied anything they wrote so it isn't always true— I always thought it didn't matter much—maybe I even really enjoyed usually feeling quite different about myself—than people often seemed to see me."[6] Unfortunately, Sweeney, a perceptive writer, wrote no essay at all for the show.

O'Keeffe's was the first major exhibition the museum had ever given to a woman artist and was a high-water mark for her. In spite of the prestige, O'Keeffe did not allow the exhibition to inflate her perception of herself or her art; this had been established twenty years earlier:

> [A visitor] had said to O'Keeffe that her work was
> marvelous, he could not find words to express what he felt.
> "Oh, no," said O'Keeffe, "it's just ordinary. I think each
> painting very fine just after I've done it. But that wears off.
> It's just part of my daily life.[7]

Three years later she explained to Mitchell Kennerly:

> I see my little world as something that I am in—something
> that I play in. It is inevitable to me. But I never get over
> being surprised that it means something to anyone else.[8]

O'Keeffe had maintained from the first an absolute separation in her own mind between her work and the world's response to it. This separation allowed her a quiet bemusement at that response, but the one crucial assessment of the work was hers, and that was the only standard by which she judged it.

About the exhibition she wrote to Sweeney:

> I must say to you again that I am very pleased and flattered
> that you wish to do the show for me. It makes me feel
> rather inadequate and wish that I were better. Stieglitz's
> efforts for me have often made me feel that way too— The

annoying thing about it is that I can not honestly say to myself that I could not have been better.

However—we need not go into that. But I do wish to say that if for any reason you wish to change your mind feel assured that it will be alright with me— For myself I feel no need of the showing. As I sit out here in my dry lonely country I feel even less need for all those things that go with the city. And while I am in the city I am always wanting to come back here . . . When I say that for myself I do not need what showing at the Museum shows mean— I should add that I think that what I have done is something rather unique in my time and that I am one of the few who gives our country any voice of its own— I claim no credit—it is only that I have seen with my own eye and that I couldn't help seeing with my own eye— It may not be painting but it is something—and even if it is not something I do not feel bothered— I do not know why.[9]

What was, what had always been, primary for O'Keeffe was the painting itself. Exhibitions and critics were interesting, praise was flattering, but all was secondary to the work.

• • •

DURING THE LATE thirties and throughout the forties, O'Keeffe produced some of her greatest landscapes. As she well knew, it took her some time to work through the purely objective phase of recording a landscape, and many of the early landscapes of New Mexico have an unrealized quality to them. The least successful of these are ploddingly realistic, without the "dream thing" she did to the paintings after she had recorded the scene. By the middle of the thirties, however, she had achieved a deep intuitive response to the countryside, and the paintings began to resonate.

During this period, O'Keeffe was painting at her peak, interpreting, again and again, the blissful, rapturous slopes and shapes and colors around her. She used favorite locations over and over: the high pink cliffs outside her house at Ghost Ranch, composed of layers of windblown sandstone; the strange pale columns at the nearby White Place, a sixty-million-year-old formation of white volcanic ash, eroded by wind and water; and the dark hills at the Black Place, soft mounds of deep-gray gypsum.

O'Keeffe paints a dream landscape, voluptuous, tender, vast. Her renderings of the soft red hills, the pallid stone cascades of the White Place, and the slow, dark turmoil of the Black Place all contain a splendid, fluid grandeur.

To the eye, the pink cliff-structure stresses horizontal striation. This suggests heaviness, density, a packing down of substance: these are shapes determined through oppression. In O'Keeffe's paintings, however, oppression is rarely evident. What she chooses to emphasize are the fluid forces—wind and water. She imparts to the dry stone formations the melting, lapsing, falling characteristics of waterfalls. The pink cliffs are banked with soft runoffs, which lie in deep piling drifts beneath them. At the White Place, the slim folds of rock stand in tall, soft pleats like a monumental skirt.

The pink cliffs, the White Place, and the Black Place continue a recurrent theme. As early as 1919, O'Keeffe had used the image of a fissure in the center of the painting, a narrow crack of vulnerability that splits the composition centrally. Starting with the abstractions, the fissure appeared in the torn leaf paintings, the clamshells, the New York streets, the jack-in-the-pulpits, the corn, the skulls, the dry waterfalls in the pink cliffs, and the dry, dark hills.[10]

Sara Whittaker Peters, an O'Keeffe scholar, has made a convincing argument for reading many of O'Keeffe's still lifes as self-portraits. O'Keeffe herself acknowledged that *Shell and Shingle* was a picture of herself, and certainly on some level the paintings must be read as references to her state of mind. Despite the image O'Keeffe presented to the world, that of an indomitable woman, her paintings project a very different persona. The leaf pictures of the twenties show a fragile presence, torn and broken, often overpowered by surrounding elements; the birch tree paintings of the same period disclose a pale, slim body, oppressed by the overwhelming presence of larger, darker trees and undergrowth. The New York pictures often contain a small white presence—a street light—dwarfed and frail among the looming black buildings. The narrow black fissure cleaves the bone in the skull paintings, asserting vulnerability, and in the Black Place series the line becomes a jagged lightning streak, leading deeper into those rounded dark hills. A line of helpless accessibility splits all these objects, hard or soft, from top to bottom.

East River from the Shelton of 1928 shows a white compote

containing a hidden, rounded fruit, the brave green leaves of which hang beyond the pink rim of the dish. This is placed on a windowsill overlooking the East River, a gray, smoky industrial landscape in the background. As a self-portrait—the small, concealed fruit above the cityscape—the work makes a vivid commentary on O'Keeffe's life in the city, and the painting takes on a witty and ingenuous charm. In all these still lifes, a fragile and vulnerable persona, sometimes cheerful, sometimes threatened, is manifested.

Besides the landscapes, in the late thirties O'Keeffe continued to use bones as subjects. Initially she had placed the bones in a closed interior space or in the abstract limbo of an empty color field. "They were my symbols of the desert," Georgia said,[11] ". . . my way of saying something about this country which I feel I can say better that way than in trying to reproduce a piece of it. It's a country that's very exciting . . . How can you put down the equivalent of that kind of a world?"[12]

As the decade wore on, O'Keeffe began to find a way of incorporating with the landscape the bones that she saw as its equivalent. In the mid-thirties she painted the "Skull" series, and later she set the bones of the body in splendid juxtaposition to the landscape, the gentle curves of the hills echoing the rounded contours of the bones. In *Red Hills and Bones* of 1941, a long thighbone and a set of vertebrae lie in the foreground against a background of hot rust-red hills. The narrow, jagged spaces between the vertebrae are echoed by the irregular creases in the hillside. The formal repetition, the tonal similarities, the long, sleek silhouettes, and the smooth, smooth textures all insist on the deep affinity between the two entities.

During this period, O'Keeffe experimented in using the elements of her old environment set against those of her new one. Single objects, large flowers and shells, are placed against the red hills. *Red Hills and White Flower* of 1937 and *White Shell with Red* of 1938 both set a highly magnified white object, frontally centered, in a background of flaming red. The white objects—the nautilus shell, the rippling jimsonweed—are utterly clean and rendered with spectacular purity, so that the contrast between them and the hot dry hills is dazzling. Despite the technical brilliance of these paintings, there is a psychological dissonance about them that renders them unsatisfying. O'Keeffe came to recognize this herself: she had always collected shells until she moved to New

Mexico. There in the arid landscape she found the hard, brilliant aquatic shapes anomalous, and she gave away her collection. The rigid, tightly furled, pearly structures do not achieve the same resonance against the alien desert hills as do the soft, dry, porous bones.

In February 1940, Georgia took a sailing trip in the Bahamas with Robert and Maggie Johnson. From this, O'Keeffe painted the elegant *Brown Sails, Wing and Wing*. In this the dark sails dominate the canvas, slicing the pale sky in a pattern of natural geometry; the bold, clean, angular composition brings it closer to the Precisionist movement than any of her other paintings.

In the late thirties, O'Keeffe began to experiment with stones, setting the smooth, rounded shapes large in the canvas space, against a flat field. *Red and Pink Rocks* of 1938 places two gently curved shapes, one on top of the other, against a pale background. In this composition, O'Keeffe explored the problem of the clean, ovoid shapes within the rectangle of the canvas, establishing a tension between the rounded forms inside it and the square right angles of the painting itself. This tension makes reference to the shape of the canvas, using it as a compositional element intead of as a window on the image. The stones take on a sleek inevitability through the hypnotic evenness of their texture and curve. The painting is an exemplar of O'Keeffe's elegant manipulation of the idea of abstraction: the perfectly smooth elliptical stones are at once highly specific and purely abstract. The fascination with the closed circle against a flat field of color would lead to another series in the early forties.

In the summer of 1943, O'Keeffe found a perfect pelvis bone. She had collected pelvises for years; they were scattered in casual bone piles at her houses. "One day I held one up against the sky and saw the blue through that hole," she said.[13] To Louise March she wrote:

> I am having a very good summer. A cows pelvis is my last effort and one of my best. Maybe you remember a pile of them in the portal last fall—they have been lying there for two or three years—I always knowing that I would do something about them one day.[14]

Though O'Keeffe's art progresses through different stages, there are certain elements that remain constant: the long, lyrical

line that Henry McBride pointed out, the matchlessly smooth texture, an essential simplicity, a reliance on biomorphic forms. Another constant was O'Keeffe's use of scale and distance.

Starting with the domestic still lifes of the early twenties—the fruit, glasses, and crockery series—O'Keeffe had placed small objects in the foregrounds of her paintings, close up and highly magnified. This format she had used to great effect with the leaves and enlarged flowers she continued to paint. In the late twenties she introduced another element. In *East River from the Shelton* the small, close-up compote lies large in the foreground, before a distant vista in the deep background: there is no middle ground. In this she made use of a format that juxtaposed near and far, and in which scale played a significant part.

The lack of middle ground is a device that O'Keeffe used recurrently. It figures in all her major series: the bones, the skulls, the flowers and shells against the landscapes, and the pelvises. This format makes obvious reference to two sources, only one of which O'Keeffe acknowledged readily: Chinese art and the camera. It was the former to which O'Keeffe admitted an indebtedness. Chinese paintings manipulate scale and perspective according to decorative demands, placing near and distant figures on the same flat field, with no psychological assistance from a middle ground to produce the transition. The use of a highly magnified object in the foreground came, however, directly from photography and is seen in the early Strand work. Strand's enlarged and abstracted images of the picket fence, the kitchen bowls, and the porch railing were all examples of the transformation of a recognizable object into an abstract form through the simple use of magnification and placement. Stieglitz's portraits of O'Keeffe, starting in 1917, continued to exploit the possibilities of this process: his outsize images of her hands, face, throat, huge in the picture space, are direct precursors of O'Keeffe's hugely magnified paintings of flowers, crosses, and skulls.

This imaginative manipulation of scale was psychologically important in O'Keeffe's work. It allowed her to offer a visually insignificant object as one of great psychological significance; this presentation insisted on a new assessment. The format, in its banishment of the middle ground, proclaimed the dream quality of the images. Middle ground establishes reality; the size of things as they recede makes order of a landscape. Without that ordered progression, all rules of reality and perspective are sus-

pended, and the viewer accepts and understands the dream nature of what is seen.

As well as the near-far juxtaposition, the pelvis series reveals another recurrent theme. Ever since the fragile, abstract archways of the late teens, O'Keeffe's work had contained orificial imagery. "I like empty spaces," she said simply. "Holes can be very expressive."[15] The paintings of windows and doorways, of closed and open shells, and of pierced leaves are all variations on this theme, which reached its apotheosis in the pelvis series, executed mostly between 1943 and 1947. In her 1943 exhibition, seven out of nineteen paintings were pelvis pictures. The series was O'Keeffe's last that combined equal parts of passion and austerity, but the passion that informs them is itself austere. It is less physical then metaphysical, a spiritual rather than a bodily ecstasy.

The modest domestic still lifes of the early twenties, the flowers, and the New York landscapes had all dealt with specific and tangible subjects, real and physical, though stylized. The bone and skull paintings had begun to explore further and to present highly specific and realistic objects in a visibly nonrealistic setting. The pelvis series, through both formal and psychological means, made a departure from the tangible, daily world. In these there is a new, meditative focus on larger verities, a transcendence of the smaller concerns of daily life.

These paintings are based on the image of the pelvis bone set against the sky. The ovoid shape is central, dominant, and empty, and around and behind it lies a flat color field. The form of the pelvis, severe and stark, is at once abstract and realistic. The ringing, singing shapes of these bones are clean, rounded, and smooth. They combine echoes of both birth and infinity; the glittering sky beyond the bones holds a breathtaking clarity, deep and endless. The palette in the first pictures is austerely limited to blue and white, and the shape to one smooth and simple curve. The series contains a purity and lucidity unrivaled in O'Keeffe's work.

> It is a kind of thing that I do that makes me feel I am going off into space—in a way that I like—and that frightens me a little because it is so unlike what anyone else is doing— I always feel that sometime I may fall off the edge.[16]

• • •

IN HIS PRIME, Stieglitz had always exercised absolute control over the artists he represented. The showing of their works anywhere but in his own space was largely prohibited. He had once reluctantly agreed to a John Marin retrospective at the Museum of Modern Art, but in general he felt it was a bad idea to encourage museum enterprises. He refused to permit the Modern to exhibit his own work in 1937, on the grounds that he hated "the exhibition passion as evidenced in our country." [17] He had agreed to the 1943 exhibition of O'Keeffe at the Art Institute of Chicago on the grounds that the work would be seen by an audience unable to see it in New York. But in 1946, when the Museum of Modern Art proposed a show of her work, Alfred was deeply opposed. The museum was only a few blocks from An American Place, and Stieglitz felt that anyone wishing to see O'Keeffe's work could do so right at his gallery. O'Keeffe took the radical view that the exhibition would be a serious and worthwhile endeavor and, instead of eclipsing the Place, would affirm its position. (In fact, a retrospective at the Museum of Modern Art was then arguably the pinnacle of an American artist's career.) At last Alfred gave his reluctant consent.

The exhibition commemorated simultaneously the rise of O'Keeffe and the decline of Stieglitz. With his accedence to the MOMA show, his era of benign tyranny was over. From now on, his artists' works would be exhibited by strangers, hung and lit according to other people's standards, and shown to audiences that he could not screen. Georgia, who knew that Alfred would perceive the exhibition primarily as "The Triumph of the Museum over Alfred Stieglitz," asked Anita Pollitzer to have dinner with him on the night of the opening, "as he will be so sad."

To Henry McBride she wrote:

> I see Alfred as an old man that I am very fond of—growing older—so that sometimes it shocks and startles me when he looks particularly pale and tired— Aside from my fondness for him personally I feel that he has been very important to something that has made my world for me— I like it that I can make him feel that I have hold of his hand to steady him as he goes on. [18]

McBride, a strong and vital voice in the art world when O'Keeffe had started out, was growing older himself. She told him:

> as I see you it is a somewhat similar feeling—only I am not so close— I like you to know that I appreciate you . . . You give to me much more than I can possibly give to you—just by being what you have been.[19]

In 1946, Alfred was eighty-two years old. His strength had been failing for several years, though his mental and intellectual stamina remained intact. Once, after a heart attack, Peggie was with him in New York. A hired nurse suddenly appeared in Peggie's room. "He wants me to tell him all about my love life!" she announced, outraged. As Peggie explained, Alfred was simply interested in people.

On June 5, Georgia flew to New Mexico. Before she left, Alfred had begun writing her so that his letters would welcome her there.

> And this to be mailed to Abiquiu! Number 1 of 1946 . . . I greet you on your coming once more to your own country. I hope it will be very good to you. You have earned that. A kiss. I'm with you wherever you are. And you ever with me.[20]

On the following day he wrote a heartfelt response to her show at the Modern:

> Incredible Georgia—and how beautiful your pictures are at the Modern . . . Oh Georgia—we are a team.[21]

The next letter was written just before she left:

> It is very hard for me to realize that within a few hours you will have left . . . But there is no choice. You need what "Your Place" will give you. Yes you need that sorely. And I'll be with you, Cape and all. And you'll be with me here.[22]

O'Keeffe, too, wrote letters before she departed, leaving them in places where he would find them one by one. "Found your letters and notes gradually," he wrote. "Ever surprised. And ever delighted."[23]

Stieglitz had not been well that spring. He had suffered recurrently from angina, and he postponed his trip to Lake George

until he felt stronger. By early July he felt well enough to schedule his departure for the eighth. On the sixth he went in to the Place. Beaumont and Nancy Newhall, dropping in for a visit, found him there, lying on his cot. He told them in whispers that he had lain there since he had felt a sharp pain in his chest. Nonetheless, he wanted to chat. He told the Newhalls that it was a fine day, and that he had "placed" an O'Keeffe painting. He asked them to read aloud to him James Thrall Soby's review of Georgia's exhibition at the Museum of Modern Art. The review was full of praise, which pleased Stieglitz particularly since Soby had never liked O'Keeffe's work before: the current exhibition convinced him. Stieglitz lay on the cot listening to the tribute to Georgia's work, moving one arm up and down in a slow, repetitive wave.

Despite the pain in his chest, it was, for Stieglitz, a fine day, a very fine day. The work that, besides his own, was most central to his career, to his life, and to his heart was spread out, vivid and dreamlike, on the pure white walls of the Museum of Modern Art, for the whole world to see. His faith had been vindicated: the critics saw in the work what he had seen, and the promise he had recognized in those 1916 drawings had been fulfilled. Georgia's work seemed to be all around him: in the museum, in the accolade by Soby, and in his morning's transaction—"placing" one of her paintings. He was surrounded by the triumph of her art. He himself was on the wane, but through his love and support he had helped Georgia to achieve her success.

Stieglitz was taken home by his nurse-companion. After lunch the Newhalls went to his apartment to see him again: he was worse. The doctor had been there and was coming back. Now Stieglitz was lying in bed, and an existential anguish had set in. "What they do to me! What they ask of me!" he whispered wearily over and over. "You have no idea!"[24]

Alfred was in bed for four days. His doctor reached Georgia and urged her to return from New Mexico: she did not. Years of emotional blackmail from Alfred had left her wary and resistant; in any case, she was stubborn. Instead of returning herself, she arranged for Donald Davidson to come in and spend the nights with Alfred, and the handyman at the Place, Andrew Droth, to take Davidson's place in the daytime.

Alfred was reassuring, and he wrote Georgia bravely: "Nearly all right. Nothing for you to worry about."[25] The next day, feeling better, he wrote: "I am sitting in your room. At your

desk . . . Your letter one of 3 . . . Read it first. As I always read your letters first. Kiss—another kiss. Tomorrow I'll go to the Place for a while."[26]

But Alfred had made his last trip to the Place. That morning, Davidson had had to leave early, before Andrew arrived. When Andrew came, at noon, he found Alfred unconscious, lying in the corridor, halfway between Georgia's room and his own. His pen had rolled from his hand and lay beside him. The next day, O'Keeffe, shopping in Española, received a telegram: Stieglitz had suffered a massive stroke and had been taken to Doctors Hospital. Without going back for luggage, O'Keeffe drove directly to the airport at Albuquerque, where she took the next plane to New York. She was with Alfred in the hospital room when he died, in the early morning hours on July 13.

With Georgia at Doctors Hospital was Dorothy Norman. Though Norman's daily presence at the gallery had diminished, she had maintained an administrative role there, and she still felt a deep and abiding affection for Alfred. The two women, Dorothy and Georgia, took turns at the long vigil in what was, according to Norman, a spirit of reconciliation, but which was more likely, for Georgia, one of armed neutrality.

The funeral was held at Frank Campbell's, an Upper East Side establishment that was too elegant for O'Keeffe's taste. After a determined search, she found what she wanted and had it delivered to Campbell's: a plain pine coffin. It was lined with pink satin, which she tore out. That night, alone, she sewed into the coffin a new lining of pure white linen.

At the funeral on Sunday the casket was closed, and covered in black muslin. Georgia was composed, dignified, and remote, visibly and utterly alone. Alfred had requested that his funeral be without service, eulogy, or music. The mourners filed silently past the coffin. Afterward, "with a majesty I shall never forget," wrote Sue Lowe, Georgia drove off alone in the black limousine to the crematorium.

The Monday after the funeral, Georgia called Dorothy. For years she had watched in silence while the younger woman took her place, in public and in private. With Alfred's death, she could now sever their connection finally and absolutely. She told Dorothy that she could leave her things at the gallery for the rest of the summer, but in the fall Georgia wanted Dorothy gone, and she wanted complete control of the gallery herself. Dorothy de-

murred, pointing out that Alfred had turned over the running of much of the gallery to her, and that the Rent Fund was still in her name. Georgia said with certainty that Stieglitz had let Dorothy take charge of these things only because he and his family always liked making things difficult. She wanted, she reiterated, complete control.

Then, fueled by nearly two decades of rage and humiliation, and tortured by her own sense of bereavement, anguish, and guilt at leaving Alfred so frequently and determinedly and at not returning earlier, Georgia unleashed her rage at Dorothy at last. She informed Dorothy that her relationship with Stieglitz was "absolutely disgusting." Dorothy, who had always felt that her relationship with Alfred somehow differed from an ordinary adulterous affair, seemed shocked and confused by Georgia's implacability. She "made a few heartbroken responses, and then was quiet under this malignant whipping." [27]

Many of Alfred's friends, who had seen Dorothy's steady support of him, who had seen him decline, who had seen Georgia's determined departure from him each year, saw Georgia's behavior as reprehensible: Adams called her "psychopathic." Georgia was accustomed to the mask of the monster. She did not defend herself; she explained her own side to no one. Years later she confessed her sense of anguished guilt at not coming back sooner, but at the time she said nothing. She let no one into her own private world. When David McAlpin called, she sent word that she did not want to see or talk to anyone, and the woman looking after O'Keeffe told Nancy Newhall that Georgia was not well. In private, Georgia nursed her bereavement, her loss, her guilt, her sorrow. What the world had seen was her rage.

Later Georgia took Alfred's ashes to Lake George, where, alone, she buried them among the roots of an old tree at the edge of the water. "I put him where he could hear the Lake," she wrote.[28] She refused to tell which tree and which roots she had chosen. When Lee Stieglitz later asked her the location, to ensure that a new water pump would not displace the ashes, Georgia still would not disclose the location. The irrepressible Georgia Minor, hearing that the pump may indeed have been set among the ashes, devised an epitaph for her uncle: "Alfred, though dead, is dynamic still."

• • •

GEORGIA HAD BEEN prepared for Alfred's death for a number of years. Her life had expanded and moved beyond the close-knit and interdependent relationship of their early years together. As she had risen, Alfred, twenty-three years older, had inevitably declined. Her commitment to him had been steady and consistent, acknowledging the changing needs of both of them. Her concern for him was outweighed only by her own requirements for emotional survival. The relationship had been one of immense tenderness, support, and respect, in spite of the tensions between creative temperaments, the vast difference in ages and backgrounds, and the inevitable strains of married life.

Their union, if not entirely conventional, was entirely successful. In the end, marriages are judged empirically, and by that measure this marriage was complete: the forces that bound O'Keeffe and Stieglitz together were deep and lasting, far stronger than those that drew them apart.

PART V

1947 - 1972

A PEACEFUL LIFE:
THE LAND
OF
SHINING STONE

29

A house ought to fit its inhabitants as the dress fits the body,
or the body fits the soul.

—CHARLOTTE PERKINS GILMAN

 STIEGLITZ'S SHORT WILL had been drawn up in 1937, and it named Georgia O'Keeffe his primary heir and sole executrix. His estate contained some eight hundred fifty paintings, watercolors, drawings, and sculptures. There were hundreds of photographs, and some fifty thousand letters. It took O'Keeffe three years, from 1946 to 1949, to settle the estate. One of her tasks during this period was to help organize two Stieglitz exhibitions—one of his own work and one of his collection. The shows opened together in 1947 at the Museum of Modern Art in New York and later traveled to the Art Institute of Chicago.

Over the years, Alfred had acquired works in lieu of commissions; others had been bought at auction because Alfred felt they were going too cheaply; some were bought outright. The collection was wide-ranging and eclectic, and the task of division and allotment of the Stieglitz Collection was enormous. Everything had to be assessed and sorted and sold or given away. "It was all very interesting," O'Keeffe wrote Peggie Kiskadden, "taking inventory of my period in most difficult fashion—and it is good if one really can weather it—one has to make so many decisions—

there is no way to be right."[1] To assist her in the decisions, in 1947 O'Keeffe took on the services of a young woman named Doris Bry. Bry was twenty-six, well educated, and knowledgeable in the field of photography. She was also reliable, meticulous, and scholarly. Two other advisers on whom O'Keeffe depended greatly were Daniel Catton Rich, for the disposition of the artwork, and the son of Alfred's sister Selma, William Howard Schubart.

Schubart was a competent, effective businessman and banker, who handled O'Keeffe's business affairs until his death in 1953. (O'Keeffe had been advised by her brother-in-law Robert Young, but she was said to have become disaffected by his enchantment with the Duke and Duchess of Windsor and removed her business to someone whose view of society was closer to her own.)

O'Keeffe liked Schubart and his wife, Dorothy. One of O'Keeffe's very few portraits is of Dorothy, in charcoal. Since Schubart often worked on Saturdays, he complained once to O'Keeffe that the only day he could see her exhibitions at the Place was Sunday morning, when it wasn't open. She offered to open it for him if he would come in a top hat, white tie, and tails, riding in a hansom cab. Schubart accepted the challenge at once, and on the following Sunday the two of them proceeded regally across the quiet streets by horse and carriage to a very select showing at the Place. Their friendship contained an element of *tendresse*, and the tone of O'Keeffe's letters to Schubart are affectionate and intimate.[2]

Stieglitz had made no provisions for his enormous collection before his death. O'Keeffe was opposed to amassing possessions and had always warned Stieglitz that if he left it to her she would give it to museums. Since she did not think one museum would accept the entire collection, she divided it among seven. The largest group of works went to the National Gallery of Art in Washington, the Metropolitan Museum in New York, and the Art Institute of Chicago. Smaller groups went to the Boston Museum of Fine Arts, the Philadelphia Museum of Art, the San Francisco Museum of Modern Art, and Fisk University. The staggeringly voluminous Stieglitz archive went to the Beinecke Library at Yale University. A photographic record was made of all of Stieglitz's prints, and a master set of the prints was given to the National Gallery.

The unexpected choice of Fisk University was the result of

O'Keeffe's long-standing friendship with the novelist-critic-photographer Carl Van Vechten. O'Keeffe had met Van Vechten in the twenties; he was a hugely energetic and unconventional man, with a wide circle of friends in the black community. During the thirties he had tried to photograph every black person who was successful in the fields of art, entertainment, letters, and sports. He was a friend of the president of Fisk, Charles Johnson. O'Keeffe shared Van Vechten's respect and sympathy for black writers and artists. One summer, Beaufort Delaney, a young black artist who had shown his work at the Vendome Gallery, had come into the Place asking for part-time work so that he could support his painting. O'Keeffe found him very appealing, "dark—clean—really beautiful" (she did a charcoal portrait of his face[3]), and sent him to Louise March, who was then living in the country. "I would take him in a minute if my place were not so far away," she wrote.[4]

By her own account, it was Van Vechten's intention to leave his music collection to Fisk that influenced her, but certainly her relationship with Jean Toomer affected O'Keeffe's decision to leave part of Stieglitz's collection to the black college in Tennessee.

To house the works, the college converted a gymnasium with the help of a New York architect, whose views were not those of O'Keeffe. In the late fall of 1949 she and Doris Bry went to Tennessee to oversee the installation. O'Keeffe was deeply disappointed by the design of the space and the lighting. "It was a fine space for pictures but everything they had changed . . . was wrong," she wrote Daniel Rich.[5] The task of rectifying the errors was large and tedious, but the process was an enlightening one. Staying in a black community was a new experience for O'Keeffe.

> There was a very black girl—who asked me the startling question—Why do you associate the idea of purity with white and not with black—she was very quick with her intuitions—and clear with her thinking—so right down on the earth like a truth— I find myself constantly wondering what she would think and say about what goes on around me—as if it is a test . . . I had no idea of the many things color of the skin can mean and do—it is sad . . . Yes—Fisk was an experience in snootiness—inertia and what you will —a kind of eagerness that made one want to cry.[6]

Unfortunately, the gift to Fisk was not as successful as O'Keeffe had hoped. The premises were poorly maintained, and the works were in danger of deterioration. When it became apparent that the university lacked the funds for the maintenance and insurance of the collection, O'Keefe reclaimed it for restoration, though eventually it was returned to Fisk.

The gifts of Stieglitz's works to the other museums were less problematical, but they reflected O'Keeffe's determination to ensure proper maintenance and respect for them. Besides this, her position reflected the insular elitism of the Stieglitz reign. The terms by which she gave the works are usually restrictive and have made it difficult for the works to be loaned to other institutions and, in some cases, even to be seen except by scholars. The attitude of reserve amounting to distrust was partly the result of Stieglitz's aversion to museums and the undeserving world in general. O'Keeffe, never in sympathy with this viewpoint before, began after his death to adopt elements of it. This was due to two factors: her own isolated life in the Southwest and the unwelcome publicity to which she was increasingly subjected.

Carl Van Vechten and another of O'Keeffe's friends, Lincoln Kirstein, were both influential in her decision to give the enormous Stieglitz archive to the Beinecke Library. Through Van Vechten she met the curator of the Collection of American Literature there, Donald Gallup, and discussed the possibility of the gift with him. As she acknowledged, Yale itself had meant nothing to Alfred Stieglitz, but Gertrude Stein's papers there were an inducement— Stieglitz had published some of Stein's early writing. She liked "the order and intimacy" of the collection at Yale;[7] she also obviously liked the modest and scholarly Gallup. The decision was made and enacted with dispatch: the first meeting between Gallup and O'Keeffe took place in early 1949, and the first boxes were shipped to New Haven in the fall of that year.

Stieglitz had been a prolific letter writer, particularly during the summers. At Lake George, he would sometimes write a dozen or more letters a day. Some of his letters to Georgia, written serially throughout a day or over several days, ran to fifty or sixty pages. He and his correspondents—friends, family, and colleagues—were remarkably careful to preserve the letters, and an astonishing amount of correspondence survives: the Stieglitz circle may very well be the best-documented one in the world.

O'Keeffe took her responsibilities as executrix seriously. She

asked his correspondents to donate their Stieglitz letters to Yale, and family and friends responded. O'Keeffe dutifully sent unopened material that might have offended her—Alfred's letters to Katharine Rhoades, for example. When Georgia found that Doris Bry had violated the privacy between Alfred and Katharine and had read the letters before forwarding them, she was enraged: "I felt like slapping her face," she said.[8]

Alfred's letters to Rhoades, to Emmy, and to Kitty were all placed under a restrictive clause, as were the nearly nineteen hundred letters exchanged by Alfred and Georgia. Clearly O'Keeffe felt ambivalent about the correspondence: if she had wanted no one to see the letters, she could have burned them. She chose instead to place them in one of the safest repositories in the world, designed purely for scholarly access to manuscripts, and to restrict their availability until 1976, thirty years after Stieglitz's death. The inaccessibility of the letters and their inscrutable presence at the library contributed to the aura of mystery, romance, and secrecy that began to surround O'Keeffe.

• • •

COINCIDENTALLY WITH the settling of the Stieglitz estate, the Abiquiu house was finally finished, and in 1949, Georgia moved out to New Mexico for good.

The house in Abiquiu was the realization of a dream. Twenty years earlier, Georgia had told Alfred of her ideal house.

> She wanted to build a house in which there would be no wood, and [that would have] the only furniture she could endure—kitchen furniture. The kitchen furniture, to carry out her idea, would have to be made as sensitively as O'Keeffe made her paintings. Then, if such a house were designed and built by O'Keeffe, the women seeing it would all immediately say to their architects, "Build me a little O'Keeffe house."[9]

"I prefer to live in a room as bare as possible," she wrote in 1922,[10] and this preference still held. O'Keeffe gave credit for this to Stieglitz. At a time when other galleries were dark, velvet-walled, draped with brocade, set with ornate couches, and full of gilt-framed paintings, " '291' hardly had anything in it, you know. There was one chair in a corner," she said later. "I'm sure that did something to me. Also my interest in Chinese and Japa-

nese art."[11] (Only O'Keeffe, however, was permitted to make inferences concerning her sources. When a friend remarked later that her house reminded him of a monastery in Kyoto, she rounded on him. "This is entirely my own," she snapped, "there is nothing Japanese about it."[12])

In Abiquiu, O'Keeffe came close to her domestic ideal of "a little O'Keeffe house." The compound is composed of two buildings, separated by an outer patio—but not the famous patio. That patio is an internal one, a private space entirely surrounded by the larger of the two buildings. It "is quite wonderful in itself. You're in a square box; you see the sky over you, the ground beneath . . . there's a plot of sage, and the only other thing in the patio is a well with a large round top. It's wonderful at night —with the stars framed by the walls."[13]

Inside, the rooms are simple but not bleak. Compared to the cold high-tech interiors in style during the 1970s and 1980s, these rooms are in fact oddly cozy, in spite of their austerity. They are clean and simple, but it is an old-fashioned cleanliness, a comforting simplicity, one that accepts imperfections. The adobe is soft and yielding, and there are no sharp angles, no perfect lines. The scale is small and the spaces protective. It is a deeply restful place.

One building (the old pig stable), set boldly on the edge of the bluffs and overlooking the Chama valley, contains O'Keeffe's studio, bedroom, and bath. The walls of the studio are white, and the floor is covered with white wall-to-wall carpeting. The furniture is nearly invisible: a small white-covered daybed, a large plywood worktable, file cabinets, a simple white slipcovered chair, and one sleek tubular chair. A set of long, low shelves set along the interior wall is curtained with white muslin, and the same white muslin hangs casually at each side of the window. More evident than furniture is empty space. "I like to have things as sparse as possible. If you have an empty wall you can think on it better—I like a space to think in. If you call what I do thinking," she added.[14]

The other house is set back from the bluffs, behind the studio. Here are the social rooms: kitchen, pantry, living and dining rooms, three more bedrooms, and an odd clutter of smaller spaces—a roofless room, and an "Indian room," where the Indians were said to have come to trade with the Hispanic residents

of the house. O'Keeffe liked to eat dinner there, with the door open onto the garden.

The kitchen and pantry are full of texture and color. Wooden shelves in the pantry are lined with canned food and dried herbs in big glass jars. A window overlooks a further patio, and the walls are painted white halfway up, with the smooth, rich brown of adobe above. The kitchen is simple and businesslike, with a small rectangular table in the center, and modest appliances.

The dining room contains a simple plywood table with the odd X-shaped base that O'Keeffe designed, which supported her dining tables in New York and Ghost Ranch. In both dining and living rooms, the walls are adobe, dark and comforting. These rooms are interior chambers, facing south toward the flourishing garden, away from the wide valley view. They are dark, cool, and protected, and provide a strong sense of shelter.

Most of the south wall in the living room is plate-glass window, giving onto the garden. Below the window is an adobe ledge, covered with rocks and oddments, and before it is a glass-topped table, which O'Keeffe liked "because it looks as if it almost didn't exist."[15] Bookshelves are built into the adobe walls, and along the west wall, instead of unendurable furniture, is a long built-in settee, a smooth flow of adobe covered with adobe-colored cushions. This is interrupted partway down its length by a glass-topped panel, which contains an interior compartment. Within this, like a piece of jewelry, is coiled a perfect, beautiful rattlesnake skeleton. A primitive mask hangs on the long empty wall, and a Calder mobile flickers in one corner.

All these rooms have an intense feeling of personality, a concentration of sensibility so strong that one guest remarked that she felt as though she were visiting a shrine.

"I gave away everything of value before moving out here in 1949," O'Keeffe said proudly. "The books too. All I kept were the Museum of Modern Art catalogues . . . for reference. I don't want to own any new things."[16] Though Margaret Prosser had offered to move out to New Mexico with her in 1949, O'Keeffe declined the offer. "She was one of those pople who always talk about the past, and I didn't want to hear that."[17]

In the late forties, Georgia had written a will in which she left the house at Abiquiu to Maria Chabot, acknowledging their friendship and Maria's proprietary involvement in the house.

When Georgia moved out to New Mexico, however, the close relationship between the two women began to falter. Maria was running Los Luceros now and was no longer available to work for Georgia (though she was still willing to go on the arduous camping trips: "I was the only one who would"[18]). They were both too independent to stay together year-round, and in any case, the renovation project had put a strain on the friendship. There had never been a clear agreement about payment, and in the end Chabot reckoned that she received less than a dollar an hour for her three years of painstaking work. (She also received a pelvis painting, but Georgia later retrieved that.)

"Maria, who really built this house, became attached to me as a result, and was very jealous. I told her eventually that she'd have to leave and not come back," she said years later.[19] The incident of Maria's boyfriend being turned away, and the will, however, suggest that jealousy and attachment were not exclusively Chabot's. Just as Chabot had been dependent on O'Keeffe for employment, room, and board, so O'Keeffe had been dependent upon Chabot for companionship and practical assistance. "It was hard for her and bad for me, to have that power," Chabot said. Maria did go away, though not because of Georgia's order: she married and moved to the Orient. The friendship between the two continued at that more peaceable distance. The mutual affection was real and enduring: as Maria, who had been the object of some of Georgia's fiercest attacks, said of her, "She was no more bad than she was good."

"I don't want to know about the private lives of the people who work for me," O'Keeffe said later of Chabot.[20] This lofty claim of disinterest was nonsense, as the story of the mysterious baby demonstrated. The imperious dismissal of Chabot was indicative of a new development in O'Keeffe's character.

Georgia's comment was, to quote Georgia herself, "pretty snooty." It relegated the Oxford-educated Chabot to inferior status and characterized her close friend as merely one of "the people who work for me." But the dismissal was an aspect of Georgia's move to the Southwest. Moving, for Georgia, had always been a metaphor for liberation. Her grandparents' intrepid journeys to Wisconsin, her parents' brave move to the South, her own journeys to Chicago, to New York, to Texas, and back to New York, had all been deliberate explorations of new territory. "I don't want many things in my life," O'Keeffe said later. "I've

moved a lot, and always I've left things behind."[21] Just as she had thrown away much of her work from Texas when she arrived in New York in 1918, so when she moved to the Southwest in 1949 she again divested herself—of relationships as well as belongings. "I feel about my friends in N.Y. that I have left them all shut up in an odd pen that they cant get out of," she wrote Schubart.[22] Stieglitz's death had marked, for O'Keeffe, the end of a tender and passionate part of her life. She would be less accessible to people, less inclined to start new relationships. Close and intimate friendships, those in which she had an emotional stake, would from now on be fewer. These carry risk as well as reward, and O'Keeffe, who was sixty-two in 1949, was ready to stop taking emotional risks.

The move away from intimacy was gradual, and not without pain for Georgia herself. Peggie Kiskadden visited her at Ghost Ranch in 1950, and Georgia's subsequent letter reveals the poignancy that resulted from the intermingling of her two worlds and the grief she felt at losing one:

> Peggie Dear:
> Since you left I have wanted to write you and tell you what a very real pleasure your visit was to me. It made me feel that I had been at home again—at home with many things that have meant home in my life but are not quite a part of what is my life as I live it now— A tear drops as I write it to you—as I knew tears were coming when you left and I could say nothing— The long time we went over Alfreds work the day before you went made it seem that he had been here too— He always seems oddly present here at the ranch— I was always so aware of him here for so many years— I wrote to him from this table so many many times —so he is always here—and when you were in Abiquiu he seemed vaguely present—as you drove out of the gate—it was as if that thing he had been in my life for so long was going again—driving off into the dawn.[23]

• • •

IN 1943, O'Keeffe had begun painting two great series: the pelvises and the Black Place, and though she painted relatively little during the second half of the decade, she continued to work on these themes.

In the Black Place paintings O'Keeffe produced some of her most powerful work, using a rich and subtle palette of grays, gray-greens, blacks, and whites. In some of these, over the melting, collapsing formation of the soft hills is superimposed a bold and vigorous pattern of broad, jagged, dark forms, a lightning strip that ricochets down the yielding center of the hills. As in the earlier pink and blue music and leaf paintings, a central, vertical fissure is prominent. In the Black Place paintings, however, O'Keeffe has gone beyond the intimate and personal presence of the earlier works. The majestic Black Place paintings attain a great, somber crescendo of strength and mystery. Monumental in scope, the works have a dark and thunderous presence that is at once luminous, haunting, and devastating: they are as powerful as anything O'Keefe painted.

The Black Place is the last series in which a fluid, liquid quality dominates. It is also her last great series. Though she painted individual works thereafter that deserved attention, that were even great, she found no more subjects for series that would provide the same sense of rich visual and psychological gratification that the earlier series had: the flowers, the shells, the New York cityscapes, the crosses, skulls, and pelvises, and the red hills.

In 1946, the year of Stieglitz's death, O'Keeffe produced few paintings, and of those, many were stark and wintry. Characteristic were *A Black Bird with Snow-Covered Red Hills* and *Bare Tree Trunks with Snow*. The first is one of the very few O'Keeffe paintings that contain a living creature. The crow, however, is eyeless and stylized, and the sleek black curling silhouette approaches a sentimental prettiness. The painting of tree trunks is a bold, vivid semiabstraction, strong dark shapes against a brilliant white background.

Another series begun in the early forties was that of the ubiquitous cottonwood trees that line the riverbeds of Abiquiu. This is not one of her successful series. The images are cloudy and undefined; they lack the clarity and the smooth, pure lines that so vividly characterize O'Keeffe's best work. The palette, dominated by the pale greenish yellow of the leaves, lacks the visual splendor and the strength of the other New Mexican landscapes.

Besides the leafing cottonwoods, O'Keeffe addressed herself to another tree series: blasted stumps, twisted, sere, and dead,

set against a background of dry red hills. O'Keeffe continued, too, intermittently, to paint magnified flowers. The ones from this period are harsh, arid, and inaccessible. The sense of voluptuous tenderness present in the earlier flowers is gone.

It was also in the mid-forties that O'Keeffe began the formal, stately "In the Patio" series, in which she immortalized the famous patio and the door that had so mesmerized her when she first saw it. "I bought the place because it had that door in the patio . . . I had no peace until I bought the house," O'Keeffe said in 1962. "I'm always trying to paint that door—I never quite get it. It's a curse—the way I feel about that door."[24] Between 1946 and 1960 she produced nearly twenty renditions of this scene. *Patio I*, done in 1946 (probably before Stieglitz's death[25]) shows the doorway open and the central orifice accessible. Thereafter, in the series, the doorway is closed.

The pictures celebrate the austere rectangle of the door and its relationship to the rest of the long adobe wall; sometimes an element of the surrounding environment is included—a piece of sky, huge fluffy weightless flakes of snow, or the line of square flagstone steps that lead past it. Working on a particular theme and producing variations on it was not, of course, new to O'Keeffe. "I have a single-track mind," she said. "I work on an idea for a long time. It's like getting acquainted with a person, and I don't get acquainted easily."[26] The patio door so fascinated O'Keeffe that she ventured into Stieglitz's territory to record it. In the late 1950s she took photographs of it, which she made into postcards—one sent to Carl Van Vechten is dated 1959. Her eye as a photographer is, unsurprisingly, the same as her eye as a painter, and the photograph reveals the same austerity of composition, the same beautiful balance of simple shapes, lights and darks, lines and masses, that appears in her paintings.

In the "Patio" series, there are no flowing biomorphic rhythms; in fact, there is an almost total absence of curves. The shapes are sharp-angled and geometrical. In some of the early works in the series, the pictures are representational and volumetric, but as the series progresses the paintings become increasingly abstract. In the later paintings, the composition is entirely flat. There is no sense of depth or space—no fore-, middle-, or background—merely the surface of the canvas, the picture plane itself. Detail, volume, and texture are excised. Stylized in the extreme, the paintings are reductivist and minimal, simplified to

a point that denies the real world of tangible objects, existing in a pure state of color and shape. The presence of a strong and effective emotion that had earlier been so prevalent in O'Keeffe's oeuvre is absent from these stark and ascetic compositions. Her other architectural images contain a strong sense of emotional charge: the New York pictures, for example, are full of atmospheric eddies, which suggest imminent change. The "Patio" series, by contrast, is austere, enigmatic, and immutable. The strength of these paintings is purely formal and intellectual; they are static rather than dynamic and contain no emotional resonance.

The move to New Mexico in 1949 meant, in terms of O'Keeffe's work, release and liberation. The small adobe houses twelve miles apart in the wide landscape she called the Faraway were now her only homes, and she no longer had to fight for her time spent there. Caught no more in the struggle between East and West, duty and need, guilt and liberation, she was free to live the life she had chosen, and this had its consequences on her work.

Turbulence had been the impetus of O'Keeffe's greatest work. Her early passion for Arthur Macmahon had given rise to her first great series of abstractions. The rich, voluptuous flowers, the half-closed shells, the sensuous red hill, and the arching, ethereal skulls had all reflected the passion she shared with Stieglitz, its rapture and torment. But rapture and torment both diminish with the years, and as Stieglitz's life moved toward its closing, and as O'Keeffe herself grew older, the turbulence between them lessened, the relationship quieted and deepened. When finally Stieglitz died and O'Keeffe moved to New Mexico, the turbulence ceased altogether, and its loss was evident in her painting. As she turned away from intimacy in her life, so she did in her work.

"Try to paint how you feel about what you see," Georgia had written to Catherine twenty years earlier. When she wrote that advice, passion was the driving force in O'Keeffe's work. After her move to the Southwest, a different sensibility began to dominate the paintings. They were informed by a sense of calm and stillness. Though most of O'Keeffe's landscapes are devoid of motion, its possibility is present, for example, in the still lifes of leaves or fruit, and many of the early abstract works are full of rippling fluidity.

In the "Patio" series, however, done during the decade of

the fifties, these images of a silent, ancient, sun-striped dooryard prohibit the very notion of movement. Soundless, immutable, and absolute, they emanate a sense of calm, but no emotion. Georgia had written years earlier of her wish to "know that the center of the earth is burning—melting hot." But after Stieglitz's death, this was not the earth she painted. From then on, her earth was barren, sere, and impassive.

• • •

FOR THE FIRST four years after Stieglitz's death, O'Keeffe and Marin together tried to maintain the Place, but it was uphill work. Demuth had died a decade earlier, and Dove a few months after Stieglitz. The circle was shrinking, and in any case, without Alfred to run it, An American Place was hardly the same. Still, Georgia considered finding someone to run the gallery for her and keeping it open from a distance.

In October 1950, O'Keeffe put on a show of her work there. It was the first exhibition of new work since her annual show at the Place in 1946. During the years of settling Stieglitz's estate, she had come briefly to New Mexico in the summers and had painted little. The exhibition comprised thirty-one pictures, from 1946 to 1950. In it were eight paintings from the "Patio" series, nine of trees, and various landscapes, flowers, and horns.

From the art world she received a response very close to indifference: one paragraph in the *New York Times* noted briefly that she was "an enigmatic and solitary figure in American art."[27] Younger than most of the members of her own circle, she had outlived the era of her peers and her supporters. Stieglitz's period of greatest influence was thirty years in the past. Stieglitz, Dove, and Demuth were dead, McBride had retired, and the art world had changed. Though in a letter to Schubart she was not decided about keeping the gallery open, by the time the show went up she had made up her mind. The list of paintings included the brief announcement: "This is the last exhibition to be held at An American Place."

By the early fifties, the loose and impersonal paintings of the Abstract Expressionists, with their disruptive and disrupted images of violence, had seized the imagination of the critics and the public. The Action and Gesture painters used an atmosphere of furious activity to project their messages. They rejected the esoteric symbolism of the Surrealists in favor of a deliberately non-

imagistic art, in which no subject was recognizable: the violence of the brush strokes themselves furnished the energy. The Abstract Expressionist school could not have been more antithetical, in its intentions, its methods, or its pictorial vocabulary, to O'Keeffe's smooth, simplified images and invisible brush strokes.

But O'Keeffe was not disturbed by failure, either in her own or in others' eyes. "For myself I am never satisfied—never really — I almost always fail," she wrote equally to Schubart.[28] O'Keeffe's concerns were not, as they had never been, financial. She told Schubart casually: "I don't have to save money for anyone—I don't suppose it much matters if I am that much behind."[29]

Regardless of success or failure, the drive to paint was constant: "The painting is like a thread that runs through all the reasons for the other things that make one's life."[30] She continued to paint, as she always had done, partly precisely because she did fail so often. "Maybe that is part of what keeps one working."[31]

Out of style and out of step, she addressed herself to the elements of the New Mexican landscape, continuing to record the sere red hills, the dead and twisted trees, the rising shapes of horns and antlers, and the silent, empty patio: the images and feelings most central to her life.

30

She has become braver as she has aged, less interested in the
opinions of those she does not cherish, and has come to realize
that she has little to lose, little, any longer to risk.

—CAROLYN HEILBRUN,
Writing a Woman's Life

WHEN O'KEEFFE HAD announced to him in 1950 her
plan to show her recent work, Schubart's response was anxious.
Georgia answered him:

> I have your letter telling me of your fears about my having a
> show—that it may not be good etc. Don't think I haven't
> thought that over—and that I think I have material for a
> very good show—it may be even rather startling . . . I have
> two houses and there are paintings in both of them—within
> a few days I will get the paintings all in one room in one
> house and see how I look— I was willing to have a show
> just on what I have here in Abiquiu—so I feel pretty secure
> about that— I have always been willing to bet on myself
> you know—and been willing to stand on what I am and can
> do even when the world isn't much with me— Alfred was
> always a little timid about my changes in my work— I
> always had to be willing to stand alone— I don't even mind
> if I don't win—but for some unaccountable reason I expect
> to win . . . I don't even care much about the approbation of

the Art world—its politics stink— I don't see that it matters too much— I'll be living out here in the sticks anyway— What is the difference whether I win or lose— I am a very small moment in time.[1]

Georgia's claim of disinterest in the New York art world was genuine. When she closed down An American Place in the fall of 1950, she planned to carry on without a gallery to represent her. Without Alfred, the center of the art world was missing for her. One year she wrote a friend that she was working on a large painting in New Mexico, but as Alfred was no longer there to see it, she would not bother to ship it back east. Once physically removed from New York, she found herself increasingly estranged from it.

O'Keeffe's initial plan was to hire her assistant, Doris Bry, as her agent in New York for her work and her affairs. "I think she understands my feeling and will try to follow it," she wrote Schubart.[2] O'Keeffe liked and trusted Bry, though she maintained a firm delineation between personal affairs and professional ones. "Certainly talk with Doris about anything you want to," she wrote Schubart, "ask her anything you want to—only don't let her worm anything about my finances out of you."[3]

In the event, O'Keeffe changed her mind about a gallery. Shortly after the closing of An American Place, she agreed to show her work with Edith Halpert, an enterprising woman who had taken on several artists from the Stieglitz stable. The Russian-born Halpert, who had been married for a time to the artist Samuel Halpert, was dark, heavyset, and forceful. She had opened the Downtown Gallery in the mid-1920s, and from the start it had been devoted to the American scene. Unlike Stieglitz, Halpert was interested in naive American art, and offered works by Edward Hicks and anonymous *fraktur* artists as well as by modernists.

The move to the Downtown was a natural one for O'Keeffe. Halpert was among the few dealers Stieglitz favored, and during the thirties he lent work by his artists to her shows. When he died, Halpert took on Marin and O'Keeffe, as well as the Dove and Demuth estates. During the fifties, Halpert's distinguished stable included Charles Sheeler, Yasuo Kuniyoshi, Ben Shahn, and Stuart Davis. O'Keeffe had been exhibiting in group shows at the Downtown Gallery since 1935. From then on, her work

appeared in almost every group show of contemporary American painting held by Halpert. And in 1937, when a portfolio of twelve color reproductions of O'Keeffe's work was published, the Downtown gave her a one-woman exhibition, courtesy of An American Place. The arrangement with Halpert seemed to suit Georgia's needs: she could live and work in New Mexico and have her work shown competently in New York by someone who understood it. This left her blessedly free to devote her time and energy to her real life in the Southwest.

Georgia's commitment to Abiquiu had begun the year before she moved into her house there: it was in 1948 that she established her garden. This was a large and flourishing operation, an old-fashioned mixture of flowers and vegetables. "I have a garden this year," she wrote enthusiastically to Henry McBride. "The vegetables are really surprising. There are lots of startling poppies along beside the lettuce—all different every morning—so delicate—and gay— My onion patch is round and about 15 feet across—a rose in the middle of it— Oh—the garden would surprise you and I think you would like it very much."[4]

The garden was in five sections, divided by narrow paths and connected by narrow bridges. Each spring, truckloads of manure arrived, last year's residue was plowed under, and the planting began. It was an organic operation, and no chemicals or poisons were used. Marigolds were set among the vegetables to repel insects, and one year when a plague of grasshoppers appeared, a flock of turkeys was bought to counter the attack.

The garden, more than anything, was a statement of Georgia's commitment to her new life. Vital and flourishing in the dry white landscape, it manifested the energy and care that O'Keeffe put into it. She devoted herself to the tasks of gardening, making recipes for compost, ordering seeds, and planting and weeding. Water was allotted once a week, and the whole garden was flooded like a rice paddy.

> On Sunday morning—early—the water comes in to irrigate —creeping over it all till it is all a lake—divided into many sections with raised paths to walk on to control the water. I don't know how I ever got anything so good. I might add that the good people of the town have water for their needs on week days— I can have it on Sundays because I am an outsider—and a heathen anyway.[5]

O'Keeffe's self-characterization was quite legitimate. Abiquiu was a small village, insular, self-sufficient, and homogeneous. Among the closely knit Hispanic Catholics, who had been there for generations, the presence of an Anglo woman was highly visible, alien, and intrusive. The villagers were initially resentful of her: the Catholic church had planned to build a parochial school and convent on the Chavez land, a far more prestigious project for the village than the arrival of this lone and eccentric Anglo.

Mitigating factors worked in O'Keeffe's favor. To begin with, jobs were scarce in Abiquiu, and the use of local labor for the restoration of O'Keeffe's house had been much appreciated. Moreover, once established there, she inaugurated a tactful and considerate employment policy. Georgia split up the household duties, hiring as many people as possible rather than one or two full time. (Many members of the Martinez family worked for O'Keeffe.) A strict employer, she could be absolute and unforgiving. When one long-term and well-liked employee was found to be charging his groceries on her account, he was banished forever: there were no second chances. She treated the villagers with respect, however, and she appreciated good work. Of the man who brought her firewood she wrote: "I pay him—and then because the wood is good I give him a loaf of bread I've made myself."[6] She was sympathetic, if not familiar, with the people who worked for her, and established relationships with them based on affection and trust. When Dorothea Martinez, her longtime housekeeper, lost her father, Georgia wrote Claudia, "She was upset . . . Why don't you write her a note— It would please her very much."[7]

In spite of O'Keeffe's "heathen" proclivities, she had always felt a sympathy toward Catholicism, which dominated the life of Abiquiu. Though not a participant, she was an appreciative observer of the religious rituals:

Christmas eve is very pretty here with many candles in paper sacks outlining roofs and walls—and *luminarios*—fires of pitch wood that flares very brightly in front of all the houses where people can afford it—each one has nine or ten fires in a row—it makes the little village very pretty and smell very good as the pitch wood burns . . . Some fifteen or twenty people came in and sat by the fires indoors for

awhile—drinks and talk—after that Mass and then to other houses for possale [*posole*] a sort of hominy stew with pork.[8]

Abiquiu was a Penitente center, and at Easter week the activity was intense and moving.

> I have never experienced anything like this week—the Church overpowers the little group of houses—and there is so much praying—so much parading—with sad doleful singing—tunes that seem to come from a long long old experience—every day feels like Sunday— I've just been up on the roof listening— The old fellows who were important handed down the word that they should sing so that the hills would ring back the song to them—the songs are short and get their strength from being repeated again and again as the procession comes down from the hills and goes to the church . . . It is oddly moving with the faintest touch of green just coming—and the long dark mesa back of it all.[9]

The current of Indian life, as well as that of her Hispanic neighbors, continued to absorb her.

> I've gone to two all night dances . . . the blessing of the home—the other . . . a Navajo ceremony that has to do with curing the sick and also something to do with a kind of adoration of fire . . . I would say that some 1200 people gathered out there in the night—built big fires . . . teams of 20 and 30 came in and danced and sang all night—they all bring food and eat among the fires—evening and morning —the singing and dancing amid the green—the smoke— the fires and the stars— It is quite wonderful.[10]

During the year of her victory garden, Maria Chabot had returned each day from the fields with new stories of the local inhabitants, which had fascinated Georgia. Now living among them, O'Keeffe found them "very gentle and immensely polite . . . I'd never want to move into a new village."[11]

O'Keeffe felt a responsibility to her community and made tangible contributions to it. She built a gymnasium so the young boys could play indoors. She paid for clean drinking water to be piped in, when all the water but hers was found to be polluted. She loaned her car to the village baseball team for transportation to games, and once a month she sent the children in her car to

the movies in Española. She made a large contribution to the Rio Grande Youth Foundation, to help needy children through school. She gave fifty thousand dollars for a new building for the Abiquiu Elementary School, stipulating that it be constructed in the traditional manner—flat-roofed and of adobe. She requested permission to buy the steep and rocky land directly south of her property, promising that the land would be terraced, planted with fruit trees, and left open. Though the property was communal, part of the original land grant, all the villagers but one took her at her word and voted to let O'Keeffe buy the ravine. (Simon Martinez voted against it: "She means what she says now," he warned, "but one day it will be fenced off." He was overruled, but he was right: the land is now fenced and private.)

O'Keeffe took an interest in the village children. She wrote Anita Pollitzer about "three small boys who just now came in and stayed over an hour—among other things, they painted their spinning toys—red, green and violet." [12] And young Vidal Martinez (son of the dissident) remembered that "The high point of Christmas, when we were little, was going to Miss O'Keeffe's." She received the children with ceremony and handed each a little bag full of nuts and fruit (never candy).

When Vidal saw Miss O'Keeffe on one of her solitary walks, he changed his course in order to encounter her. She was full of odd, interesting questions: "She would hold out a rock, and ask 'What do you see?' " She challenged and encouraged the children; she urged them, always, to complete their education. Often she did more than urge, financing college for a number of local teenagers: Mike Martinez, Vidal's brother, was one of these. [13]

One of O'Keeffe's favorites among her neighbors was young Jackie Suazo, whose half-brother, Napoleon Garcia, was O'Keeffe's gardener. Jackie was a handsome child, quick and beguiling, with bright, dark eyes. In the late forties, O'Keeffe had taken a liking to the boy and begun taking him with her on camping expeditions. She taught him to paint; he spent more and more time at her house and was finally given a bedroom there. O'Keeffe lost her heart to him: he was charming and unreliable, with an unerring knack for trouble. At the age of twenty, in 1955, he was incorrigible, and still charming.

Is Jackie my friend? I call him my darling and tell him my idea of a darling is someone who is a nuisance—he has

been the horror of the community— I hope he doesn't
become a jail bird—[14]

Though O'Keeffe hoped that Jackie would go on to art
school, his interest in painting was largely determined by
O'Keeffe. His works are derivative—cattle skulls, close flowers in
a distant landscape—and in the end he refused to pursue an
artistic career. Neither this nor the three jail sentences that
O'Keeffe believed he had served ended the relationship:
O'Keeffe's critical judgment seemed to be suspended in Jackie's
case. With him she was forgiving and uncritical, and nothing he
did seemed to offend her. The two remained close, and for years
after leaving home Suazo sent Georgia Mother's Day cards in-
scribed "To my second mother." Though, late in O'Keeffe's life,
she quarreled with Suazo over money and stopped seeing him,
O'Keeffe never closed him out of her feelings. Her connection to
Jackie was more like kinship than friendship, and in her will she
left him thirty thousand dollars.

• • •

THROUGHOUT THE FIFTIES, O'Keeffe established a comfortable
and domestic life in her two houses. She maintained her long-
standing friendships through lengthy and frequent visits from
friends and family during the summer months. Both Catherine
and Claudia came periodically to New Mexico. Catherine, often
with her daughter, Catherine Krueger, and her two grandchil-
dren, visited for weeks at a time; Claudia came alone for the
whole summer. Louise March, Anita Pollitzer, Frances O'Brien,
Peggie Kiskadden, Dan Rich, and others often brought their fam-
ilies for visits with Georgia.

Concurrent with the settled and hospitable routine of enter-
taining, O'Keeffe established a pattern of travel. She had seldom
in her life spent an entire year in the same place, though since
she had lived with Stieglitz her travels had been brief and spo-
radic, and had not included Alfred: "He was a bad traveller. He
couldn't do it simply, and he was such a worrier."[15] Though
O'Keeffe had considered going to Paris with him, his caution
would have curtailed all her impulses. "I couldn't imagine being
in a place where I couldn't talk . . . Stieglitz would have said
everything I wanted to do was impossible . . . I couldn't have
proved that it wasn't."[16] Now that she had all the time she

wanted in Abiquiu, she could afford to wander abroad at her leisure. For the next thirty–odd years, until she was ninety-six, she took a trip outside the United States roughly every other year.

Financially, she enjoyed increasing sufficiency, though her attitude toward money was an idiosyncratic blend of the practical and the haphazard. In 1952, when Schubart pointed out mildly that she was spending a rather large proportion of her available money, she replied: "Yes I do—and the odd thing is that I have the idea that I would be satisfied with so much less." [17] Although her pleasures were simple ones, great simplicity is an expensive taste. A clean house, a well-tended garden, immaculate clothes, delicious meals, and the air of quiet serenity that comes from a well-run household; and then beautiful music, an excellent car, and foreign travel—none of these come free. She could afford them, however. She was comfortably off. Her paintings continued to sell for good prices, and she had always had excellent help in managing her capital. As she pointed out to Schubart: "in spite of my bad ways [my] capital has increased almost 100,000 since 1950." [18]

In March 1951, O'Keeffe went to Mexico, driving down with Spud Johnson, in convoy with the photographer Eliot Porter and his wife, Aline, the painter. "I wanted to see the murals the boys have been doing." [19] ("The boys" were Orozco, Rivera, Siqueiros, and Covarrubias.) O'Keeffe stayed with Miguel and Rose Covarrubias, friends from New York. Struck by Orozco's color, she saw him as "the great painter," whose work was infused with "a feeling of violence and revolution— They are all that way . . . You feel it as part of their lives." [20]

In 1953, at the age of sixty-five, O'Keeffe went to Europe for the first time. Her midwestern composure and her refusal to be impressed is reminiscent of Henry James's American tourists. She traveled to Paris and then toured the rest of France, which she found beautiful, "but," she added composedly, "I like our country." [21] She saw Mont Saint Victoire, the mountain Cézanne immortalized, and wondered mildly how the innocuous peak had managed to cause such a commotion. Offered an introduction to Picasso, she declined, on the grounds that they would not be able to speak to each other.

O'Keeffe continued on to Spain, where she saw the Prado. She had always like Goya's work, "as much as any occidental

artist," and at the Prado she enjoyed it immensely, so much so that she returned the next year. This time she stayed in Spain for ten weeks, with a few days in Tangiers. "I was very excited by the Prado, which made me think there must have been something the matter with me." [22] In 1922 she had declared, "I do not like pictures and I do not like exhibitions of pictures." [23] This, of course, was an overstatement. O'Keeffe always enjoyed some pictures—those of Rodin, Van Gogh, Brancusi, Pissarro, and her perennial favorites, the Chinese. As a rule, however, she did not enjoy going to exhibitions of other people's work. "I always destroy pictures . . . I'm very critical. I don't seem to have the kind of pleasure I know a lot of other people have in pictures. I just can't look at a picture and get pleasure out of it like they can." [24]

This response—her "destructive eye" as she called it—had played an important part in O'Keeffe's creative life. After an early period of absorption of other people's art, a painter must achieve a personal vision, forsaking all others. This personal vision is hard won and must be jealously guarded. Aesthetic insularism is crucial to a creative identity. As O'Keeffe lost the passionate involvement with her own art and her own place, she became more receptive to the work of other artists. The old pattern in her life with Stieglitz had been determined first by him and then by work. Now O'Keeffe ordered her own life; she traveled more and, according to the available records, she worked less.

Claudia closed down her school in 1954 and afterward began to spend her summers at Abiquiu, often staying there while Georgia was at the ranch. The arrangement was peculiar but well suited to their personalities: the relationship was affectionate and loyal at its root, but bickering roiled the surface. Georgia would ask Claudia to come for a month, but the two would quarrel after a week and Claudia would leave in a huff, sometimes for whichever house Georgia was not residing in, sometimes for California. "I'm leaving because we fight like cats and dogs," she announced to one visitor. The bickering did not alter the affection, however, and the pattern of warm invitations and thin-skinned aggrievement continued between them.

Georgia had at first done the work in the garden herself, then she had hired boys and men from the village to help her. As the years went by, Claudia assumed increasing responsibility for it. She took proprietary satisfaction in growing nearly all the vegetables for the household, year round. Georgia gave her credit,

telling an interviewer proudly: "My sister Claudia grew a two-pound tomato last year."[25] There were rows of squash and corn and tomatoes, lettuce and peppers, and pole beans climbed up a tree. There were raspberries, apples for applesauce, peaches and pears. What was not eaten in the summer was put up for the winter, just as had been done in the kitchen at Sun Prairie sixty years earlier.

The purpose of the garden was just as much aesthetic as it was nutritional. "I have been working," Georgia wrote Anita Pollitzer, "or trying to work my garden into a kind of permanent shape—so that if I live for twenty-five years it will be pleasant to walk about in by the time I am too old to do anything else. It will probably take the 25 years because I don't know too much about doing it and good things are some times a long time growing."[26] One artist friend said: "I always thrilled to see her garden. It was like a storybook garden in a wasteland . . . It looked like a Persian miniature, with its high adobe walls; inside it was cool and shady, dappled with sun and hot spots, and full of a vivid mix of flowers and vegetables."[27] The final form, with its stone paths and narrow bridges, was reminiscent of Japan. As Georgia had hoped, twenty years later, she *was* walking in it, and she found that its design held out strongly in the black and white of the wintry landscape.

The appeal of a garden is subtle and pervasive, and O'Keeffe was very conscious of its potent charm and the risks this involved: "I have to go up to the ranch, you see, or I'd spend all my time working in the garden."[28]

Georgia's domestic world could at last include full-time pets. She had owned cats since 1933, when the visiting critic Elizabeth McCausland had found a stray white kitten—the cherished Long Tail—wandering at Lake George and presented him to Georgia. After she established her own house in New Mexico, Georgia kept a cat there in the summer, leaving it with a friend for the rest of the year. In 1951 she acquired a dog. "I have a dog that would amuse you," she wrote Claudia, "a large black French Poodle—really very sweet and polite."[29] Two years later the poodle was gone, but that Christmas she received two handsome "blue" Chow puppies, gifts from Richard Pritzlaff, the neighbor she had met in Hawaii. Bo and Chia "astonish and amuse me," O'Keeffe wrote a friend, "they seem to belong to adobe—a snowy world."[30] From that time on, O'Keeffe kept Chows, which

she called "little people." Eight years later she wrote that Bo and Chia "are maybe my best friends here—I enjoy them very much — The male lies on my window seat now with his legs stretched straight out behind him—looking like a fine big cattapillar. They sleep in my room at night and in the day time are always just outside the door."[31] Bo was her favorite: "big with a strong smooth coat . . . in Abiquiu he was the town boss . . . He had some bad scars from the fights that made him the town boss. He would run through a flock of chickens as though they were not there."[32] Bo (or Bobo, or Beau, as she alternatively called him) had a reputation for fierceness, but this was primarily directed at dogs. Life with him was full of excitement:

> Charles was here today . . . his dog got out of the car and Bobo got hold of his skin on his back and [he] hung in midair for ever so long—Charles and I both kicking him— Charles' dog howling—it was terrible . . . Bobo was hanging on him—till Charles pinched his nose so he couldn't breathe—then he let loose— Oh we had a time.[33]

The dogs were central to her life, creatures she loved and whose wishes she respected. She stopped going out on painting trips in her car one summer, as it was too hot for her dog and she could not bear to leave him; she could not put in a new heater at the ranch, she told an interviewer, because the only place the heater could go was where the dog slept, and she could not put the dog out of her place. Chows have thick, fine coats, and O'Keeffe conceived the idea of saving the hair the dogs shed in the spring and making it into cloth. Louise March, who was running an arts and crafts center, had the hair woven into a warm shawl for O'Keeffe.

When Bo finally died, after being hit by a truck, she buried him under a cedar tree at the White Place and grieved. "I like to think that probably he goes running and leaping through the White Hills alone in the night," she wrote.[34]

• • •

IN 1956, O'KEEFFE took a trip to Peru, which she found superior to France, reluctantly admitting a possible superiority to America. "The colors there are almost unbelievable . . . marvelous purples, violent colors. And the Andes are sparkling—they freeze at night, and in the morning they glitter. I think it's the most beau-

tiful country I've ever seen."[35] She traveled to Peru with a young woman from Abiquiu, Betty Pilkington. (The Pilkingtons ran the local gas station, and Betty was O'Keeffe's secretary and companion for a number of years. O'Keeffe sent her to college in Santa Fe.)

O'Keeffe's travels became increasingly ambitious, and in 1959 she went around the world, beginning in the Orient. She saw Rome after the Middle East, and found that it suffered by comparison:

> There is nothing there in man's scale. The cherubs on the
> walls in the Vatican—dreadful. Those big naked things.
> Bigger than a man. Everything in Rome was like that to me
> —extraordinarily vulgar . . . as if being huge made them
> good . . . [In] the Middle East . . . everything is made to
> man's measure . . . though the palaces were large, they
> were made up of small units where you felt you belonged.[36]

One of the consequences of O'Keeffe's global trip was an increased interest in the view from above. She had found her first flights on commercial airlines exhilarating. She wrote Maria Chabot:

> It is breathtaking as one rises up over the world one has
> been living in . . . and looks down at it stretching away and
> away. The Rio Grande—the mountains—then the pattern
> of rivers . . . Then little lakes . . . then . . . Amarillo
> country . . . a fascinating restrained pattern of different
> greens and cooler browns . . . It is very handsome way off
> into the level distance, fantastically handsome . . . The
> world all simplified and beautiful and clear-cut in patterns
> like time and history will simplify and straighten out these
> times of ours— What one sees from the air is so simple and
> so beautiful I cannot help feeling that it would do
> something wonderful for the human race—rid it of much
> smallness and pettishness if more people flew.[37]

The experience of flight contributed to a slow and significant transformation in O'Keeffe's point of view. The physical remove echoed and validated a psychological one: she was beginning to move away from her subjects.

The use of scale and perspective is central to O'Keeffe's work. Early in her career, magnification of the subject had played

a crucial part: by means of it she had transformed ordinary flowers into breathtakingly dramatic subjects, informed with emotion and passion. Toward the end of her career this process was inverted, and she began to take a distant, telescopic view of her subjects. The distance implied was a philosophical one, and the work of her later years is infused with a sense of benign removal. O'Keeffe's paintings took on, increasingly, an aspect of calm, transcendent stillness, and a metaphysical mood replaced the romantic. The shapes she used were less flowing, more formal and precise, more crystalline and stylized. The line became calligraphic rather than sensuous. Emotion diminished and finally ceased altogether.

The sky had figured importantly in O'Keeffe's earlier work. *Red Hills and Sky* of 1945 achieves its strength from the fragile balance between the earth and the sky; it is "just the arms of two red hills reaching out to the sky and holding it." The same tension is achieved in the pelvis series, whose paintings portray a psychological dialogue between bone and infinity, the relation between tangible and intangible, very near and very far.

In 1955, in two big canvases, *From the Plains, I and II*, O'Keeffe gave the sky even greater prominence. The paintings derive from the lowing sound of the cattle she remembered from Texas. Highly abstract, the image is virtually all orange sky, with jagged lightning streaks and a suggestion of red horizon line along the bottom of the canvas.

Another painting in which the sky figures powerfully is the beguiling *Ladder to the Moon* of 1958. In this a luminous wooden ladder hangs magically in the evening sky, leaning lightly to one side, halfway between a high, half-visible moon and the low, noble black silhouette of the Pedernal. The images are all of transition: the ladder itself implies passage from one level to another; the moon is cut neatly in half by the bold slicing light, halfway between full and new; and the evening sky is in flux, still pale along the line of horizon, shading into deep azure night at the top of the canvas. It is not difficult to read this painting as a self-portrait: the light, hopeful form of the ladder, balanced, serene, and radiant, is poised between the vanishing glow of earthly day and the rich blue night of the heavens; O'Keeffe was seventy-one when she painted it. Elegant and mysterious, *Ladder to the Moon* is among the most appealing of O'Keeffe's paintings.

When O'Keeffe herself moved into the sky, however, she

acquired a sense of calm removal from her subject. In the late 1950s, O'Keeffe began the "Rivers Seen from Air" series, first in charcoal, then in paint. These meandering silhouettes against murky backgrounds are vague and undefined, and have little power compared with her great series. Like the cottonwood trees, the rivers seen from the sky lack the clean, sweeping shapes and the smooth, sure lines that in the rest of her work so gratify the sensibilities. Despite the fact that the rivers themselves are liquid, the pictures of them are dry and aloof. Because of the directly perpendicular angle of vision, there is no visible flow or motion, no hint of yield or current. Her paintings from the air, both of the air and of the earth, lack the tension and power that derive from the contrast of the two elements. The sense of great struggle emanates from the strenuous juxtaposition of opposing elements: earth and ether, the immediate and the distant. There is something bloodless and disinterested in the "Rivers Seen from Air" paintings. The works are not compelling; distance alone is simply distance.

O'Keeffe's travels gave her a wider knowledge of the world, which was bracing and exhilarating for her personally. In Greece, for example, she was thrilled when she recognized in the sweaters knitted by women on the street the same rough pattern that appeared on the robes of sculptures centuries old.

The effect of travel on her work was not so salutary. It was an exchange of breadth for depth. A sense of rootedness and understanding had always been crucial to her. She had never felt the strong sense of connection that would have enabled her to paint the Lake George landscape, and it had taken her several years in New Mexico to learn how to paint that countryside. During a brief stay in a strange country, she could not hope to achieve the intimate understanding necessary for her painting.

On her travels she continued to do sketches—thumbnail pencil drawings—but if she did paintings from them she did not feel they were successful, and they have never been shown or reproduced. She knew that what she was doing was risky, and she admitted candidly that she had "no business" to paint other countries.

31

*Time and trouble will tame an advanced young woman, but
an advanced old woman is uncontrollable by any earthly
force.*

—DOROTHY L. SAYERS

DURING THE 1950S O'KEEFFE showed her work in the
Downtown Gallery, which was now uptown, in a brownstone on
East Fifty-first Street. Throughout the decade she had only three
one-woman shows, and of these, only one was of recent work.
This may have been due merely to the meagerness of O'Keeffe's
output during the period, but it may also have been a reflection
of the attitude of public and critics. During the ascendancy of the
Abstract Expressionists, the response to O'Keeffe's work had be-
come markedly tepid.

By the late fifties, the currents of American art had again
begun to change, and the color-field painters had come into
prominence. Unlike the Abstract Expressionists' work, here the
dominant mood was calm tranquillity, and the images were
formed by large, quiet masses of intense and homogeneous color.
Instead of the violence of the hand's motor activity, the subtle
capacities of the perceptive eye were brought into play. The use
of dense, luminous color as a discrete force, one that created its
own sensations and emotions, was explored by Barnett Newman,
Mark Rothko, and Clyfford Still.

Though O'Keeffe had been completely out of step with the Abstract Expressionists of the preceding decade, by the end of the fifties her work was unexpectedly fashionable again. Moreover, her place in the history of American art was becoming established. In 1958, when O'Keeffe was seventy years old, the Metropolitan Museum in New York put on an exhibition, "Fourteen American Masters," which surveyed the history of American painting. O'Keeffe's work was given an entire room. "I am quite pleased," she wrote Claudia,[1] as well she should have been.

In the same year, Edith Halpert put on an exhibition of fifty-three of O'Keeffe's early watercolors, from 1916 to 1917. The bold, saturated colors, the simplified shapes, and the atmosphere of dreamlike intensity in these created a strong parallel to the work of the color-field artists. When critics suggested that O'Keeffe had simply been trying to fall into step with recent art, Halpert gleefully told them to look at the dates.

In the fall of 1960, O'Keeffe was given a one-woman exhibition by Daniel Catton Rich, who had moved from the Art Institute of Chicago to the Worcester Museum of Art in Massachusetts. Among the forty-three works shown, Rich included sixteen of O'Keeffe's new paintings—patios, cottonwoods, and rivers seen from the air—and he wrote another articulate essay on the power and importance of her work, praising her lucidity, her elegance, her renunciations. O'Keeffe, characteristically, treated the event as though it were her due. She pressured Rich to buy a painting for the Worcester Museum (he didn't), and at the last moment asked him to change the opening date, so that she could take a trip to Japan.

The relationship between Rich and O'Keeffe, based on mutual respect and affection, remained firm, but that between Halpert and O'Keeffe was foundering. In the spring of 1961, Halpert gave O'Keeffe the last exhibition of her work at the Downtown Gallery. It would have been hard for anyone to follow Stieglitz as O'Keeffe's dealer. Halpert's eye was good, but her approach was far more commercial than Stieglitz's, and the days of "marrying" the perfect and deserving owner to the right painting were over. Halpert was a tough and assertive saleswoman, who did not turn down potential buyers simply because they were rich. The difference in sensibility was great, and since both were strong-willed women, unwilling to capitulate, their parting was inevitable.

In 1963, two years after O'Keeffe left Edith Halpert, Doris

Bry became the agent for her pictures. Both O'Keeffe and Stieglitz had always been loath to part with O'Keeffe paintings. In 1926, Herbert Seligmann wrote: "The pictures . . . were like children to himself and O'Keeffe. He had had a terrible time getting O'Keeffe accustomed to the idea that she must let them go out into the world . . . When O'Keeffe's first picture was taken away it had taken her ten days to get over it."[2] Consequently, a large quantity of O'Keeffe's paintings, including some of the best, were still unsold in the fifties. They were stored in the Manhattan Storage Company, at Third Avenue and Eightieth Street. Interested buyers approached Bry, who regarded O'Keeffe's work with the protective zeal O'Keeffe and Stieglitz always felt.

The best paintings had always been deliberately withheld from the market, and this tradition continued. Bry sold little or nothing to dealers, and never an important painting. Often she wrote sales contracts with clauses that ensured the paintings would not end up on the open market. Many were shown only to museums or to people who said they planned to give them to museums.

If the prospective client seemed to be worthwhile, Bry then took the initiates on a ritual journey to the warehouse. There is about a warehouse a certain reverse chic, the work reposing in a dim, cavernous realm, visibly under lock and key. The private trips to the warehouse were quintessentially privileged. It was another element in the growing O'Keeffe mystique, contributing to the aura of hermeticism that surrounded her: her isolated life in the distant desert, her lack of a commercial gallery, her general rejection of the New York art world, and the elitism attending the purchase of one of her paintings.

●　●　●

DURING THE SIXTIES, O'Keeffe continued her travels. On her first trip to the Orient, in 1959, she announced that when she arrived in Japan she felt quite at home at once. She returned a year later. These around-the-world trips involving a series of long flights made O'Keeffe increasingly conscious of the view from an airplane window. Aloft in 1960, O'Keeffe wrote: "Now the sun is bright over what looks like a vast field of snow stretching all the way to the horizon . . . It is odd to look out on this field of snow or white cotton— It looks almost solid enough to walk on."[3]

The image remained in her mind, and within a few years she

began a series based on it. Done between 1963 and 1965, these "Sky Above Cloud" paintings are enormous, the largest canvas being 96 by 288 inches. Sandy Seth, the daughter of O'Keeffe's good friends Oliver and Jean Seth, lived with O'Keeffe during the summer of the first painting; excitement and concentration attended the project. The enormous canvas, too big for the studio, was put in the unheated garage. Driven by the purely pragmatic imperative of completing the work before the cold set in, O'Keeffe worked all day and every day all summer, and had the painting finished before the fall.

> I had two 10-foot tables with a board between to be high enough to reach the top of the canvas. First I stood on the tables. Then I sat on a chair on the tables. After that I sat on the tables. Then I moved the tables and stood on a plank and after that I sat on the floor to reach the bottom.[4]

In each painting the sky is seen from an airplane, reflecting a sense of limitless space: a vast horizon, below which is a passive sea of floating clouds. The sky above the horizon is a clear pale pink, rising into a pale translucent blue; the clouds are solid white against a dense aquamarine. The great size of the canvas, the flat and distant horizon, the orderly pattern of receding clouds, and the pale, serene colors all contribute to a sense of mystical tranquillity, a calm and meditative view of infinity.

The presence of tranquillity was steadily more evident in her work. In the early sixties, O'Keeffe painted a series of "Roads in Winter." She began with a camera, as she had on the magical patio door. The road that winds up through Abiquiu comes along a series of low switchbacks, twisting among the gentle hills: this is the view from O'Keeffe's bedroom. Trying to photograph its clean and simple shape, she had to tilt the camera into an awkward position to get the angles in, and when she developed the picture she liked the framing. The winter road drawings and paintings are pure and clean and well shaped, smooth, calm, and distant. A sense of emotional connection to the earth is absent, and the slope of land and twist of roadbed are seen in purely graphic terms: landscape as calligraphy.

In the early sixties, O'Keeffe was invited on a voyage down the Colorado River organized by the photographer Eliot Porter. Porter, O'Keeffe, Doris Bry, the photographer Todd Webb (a friend since the mid-forties), Tish Frank (a friend from Santa Fe

who was Mabel Luhan's granddaughter), Porter's son and daughter-in-law, and a half-dozen others made the ten-day trip. Eliot Porter had always seen Georgia in black and white, but on the river she wore a bright red dress and looked very beautiful. The group floated nearly two hundred miles through the wilderness. "We slept every night in the sand—one night in a real sandstorm—another it poured rain most of the night—but I saw wonderful things and think it was very good—very fine, indeed," she wrote.[5]

O'Keeffe felt a strong affinity with the Colorado River landscape. She particularly liked a place called Music Temple, which had strange echoes and, at the distant top, a blue hole of sky. The river was being dammed in Glen Canyon as part of an energy project, and when this was completed, O'Keeffe went back periodically with the sensitive, thoughtful Tish Frank. The two stayed on a houseboat, sharing long, peaceful days on the calm water, Frank reading while O'Keeffe drew and painted.

On the Colorado River trip, O'Keeffe collected her favorite things: bones and stones. One night, on his way to the campfire, Eliot Porter picked up a stone. It was the quintessential rock, smooth and flat, black and flawless. O'Keeffe asked him boldly to give it to her, but Porter, though he was not collecting stones, refused. Back at home, the Porters hatched a diabolical scheme: they invited O'Keeffe to a dinner party and left the coveted object on the coffee table. All the family pretended not to watch as Georgia, as expected, tucked it into her own pocket. "We got it back later," said Aline Porter, smiling: they were all delighted at Georgia's presumption. In the end they gave it to her, and later she told *Life* photographer John Loengard it was her favorite rock. He photographed its mysterious black oval on her wrinkled palm.

O'Keeffe took rocks seriously, and on another river trip, she started everyone collecting them by her example. Finally the raft operator announced that the rocks would all have to be thrown overboard, as they made the rafts ride too low in the water. Everyone looked at O'Keeffe, who had started it. She smiled. "I'm not throwing mine anywhere," she announced. Everyone else dutifully threw their collections into the river, while Queen Georgia looked serenely on.

The dark, burnished Glen Canyon rocks fascinated her, and in the sixties and early seventies she painted a series of their smooth black ovals centered against a deep-blue sky. The dark

ellipses are large and magnified, and powerful, and their shaded forms dominate the canvas. The rounded, oversized shapes create strong visual reverberations of an earlier series, the dark ovals of the stones echoing, obversely, the blue ellipses of the sky of the pelvis series. The rock series signifies the end of the orificial imagery that had so engaged O'Keeffe's imagination, and the series lacks the strength and tension of the earlier ones. The oval shape in the pelvis series is negative space, it is an opening, a window to the sky; in the rock series of twenty years later, the oval is positive space, it is finite and unyielding, polished, closed.

• • •

DURING THE EARLY sixties, O'Keeffe was briefly involved with another enterprising young woman dealer. Terry Dintenfass was a protégée of Halpert and eventually acquired the estates of both Dove and Sheeler. She received an imperious telegram from O'Keeffe at Christmastime: COME AND SEE ME. Such was her mystique, by then, in the art world that Dintenfass dropped everything and flew at once to New Mexico. For a period Dintenfass brought her own customers to the vault with Bry, but the tripartite liaison made for inevitable complications, and in 1965, O'Keeffe established Bry as her sole agent.

Doris Bry did an admirable job. Dedicated, studious, competent, and intelligent, she monitored all the O'Keeffe transactions that she could. She made long visits to New Mexico, carefully going over the work O'Keeffe was doing, then returning to New York to carry out the artist's instructions. By arrangement with the New York auction gallery Park-Bernet, Bry was called whenever an O'Keeffe came on the market. She obliged the gallery by providing information as to provenance and dates, and also gave, unasked, her judgment as to the value of the painting. Often representing the artist, on occasion representing a client, Bry bid on many of the O'Keeffe paintings that appeared on the market. This was not an attempt to support the market value of the works artificially but the reflection of O'Keeffe's wish to repossess the better examples of her work. During the fifties, sixties, and early seventies, when O'Keeffe paintings were undervalued, Bry bought back a good many of them. Besides shepherding the work through the marketplace, Bry undertook a careful documentation of the entire oeuvre, determining the correct dates of execution and keeping track of provenance and con-

dition, a continuation of work begun by the Whitney Museum. In 1952 she published a modest article on O'Keeffe in the *Journal of the American Association of University Women,* and in 1965 she wrote a small beautifully produced book called *Alfred Stieglitz: Photographer.* Bry's relationship with O'Keeffe was a complicated one, though not uncommon. O'Keeffe's magnetism and the power of her work was such that Bry deliberately eschewed other associations to devote herself to the artist and her art. Working out of her apartment, Bry guarded O'Keeffe from all possible assaults: economic, social, and art historical.

Doris Bry is a tall woman, now slightly stooped, with short gray hair. She speaks slowly and carefully, and wears a small, perpetual frown and an air of meditative caution. Her protective loyalty to O'Keeffe was already established in the fifties. Diana Schubart Heller remembered coming in to the Place to see O'Keeffe's cloudy cottonwood paintings. Heller did not like the new paintings and said so; she remembered Doris's response as disapproving and somewhat shocked. By the early seventies, Bry's protective responses were highly developed and automatic. When a writer approached her with the possibility of doing a project on O'Keeffe, Bry's action was immediate and adamant. There was no point in writing *to* O'Keeffe, she asserted, since O'Keeffe sent all her mail, unopened, to Bry. And there was no point in writing *about* O'Keeffe, since she, Bry, was doing so.

The attitude of stern discouragement was partly legitimate: after a major retrospective in 1970, O'Keeffe began to receive nuisance telephone calls and an intrusive quantity of mail, to the extent that her privacy was seriously threatened. The element of possessiveness, however, which had figured in the friendship with Maria Chabot, was to become a recurrent thread in the relationships that surrounded O'Keeffe.

• • •

ANITA POLLITZER and O'Keeffe had remained good friends over the years, exchanging affectionate if sporadic letters and visiting each other infrequently. Pollitzer retired from the chairmanship of the National Women's Party in 1949. In November 1950 she published an article in the *Saturday Review.* The short biographical essay, entitled "That's Georgia!," drew on Pollitzer's long friendship with O'Keeffe. In felicitous language, Pollitzer described O'Keeffe as a young woman at art school. "There was something

insatiable about her—as direct as an arrow, and hugely indepen-
dent."[6] It was one of the first articles to present O'Keeffe as a
formidable and hermetic desert dweller. "A solitary person . . .
unbelievably strong . . . People figure very slightly in her
world," Pollitzer wrote.

On seeing the article, O'Keeffe commented: "You seem to be
on the way to becoming an authority on me."[7] Shortly thereafter,
the plan for Pollitzer to write a full-length biography of O'Keeffe
was conceived. Pollitzer, working on it in the mid-fifties, sent
Georgia a draft of a prefatory note that cited Georgia as the first
American woman to break through to the top rank of artists and
one without aesthetic influence or precedent. "Don't forget Mary
Cassatt!" Georgia wrote, countering Anita's hyperbole. "I am not
sure that your new paragraph will hold water— We probably all
derive from something—with some it is more obvious than with
others—so much so that we can not escape a language of line
that has been growing in meaning since the beginning of line."[8]
In the final draft of the preface, Mary Cassatt was mentioned,
though relegated to the European arena: the exchange demon-
strated the strong collaborative spirit between the two women.

Preparing the book, Pollitzer, at O'Keeffe's recommendation,
interviewed her friends and associates, among them William Ein-
stein and Daniel Catton Rich. For the biography, O'Keeffe gave
Pollitzer permission to reproduce paintings, to publish their cor-
respondence, and to read the Stieglitz-O'Keeffe letters and pub-
lish some of them.

In 1959, Anita sent the first draft of the manuscript to Doris
Bry, who responded with a long, careful, and detailed letter that
sounded an ominous note. In Bry's view, the strong points of the
manuscript were its subject, material, and research. The weak
points, she felt, were the writing and the structure: a fairly damn-
ing assessment.

Pollitzer worked on the text for nearly another decade, and
early in 1968 she sent the final revision to O'Keeffe. In February,
O'Keeffe wrote her a long and thoughtful response. It was gentle,
affectionate, and, ultimately, crushing:

> I read your manuscript some time ago and it has lain on my
> table—probably because you are an old friend and I do not
> like to say to you what I would say to someone else.
> I made notes as I read it the first time. I looked it over

again and could have made many more—but that does not
meet the situation. You have written your dream picture of
me—and that is what it is. It is a very sentimental way you
like to imagine me—and I am not that way at all. We are
such different kinds of people that it reads as if we spoke
different languages and didn't understand one another at
all. You write of the legends others have made up about me
—but when I read your manuscript, it seems as much a
myth as all the others.

I really believe that to call this my biography when it
has so little to do with me is impossible—and I cannot have
my name exploited to further it. I find it quite impossible to
say yes to you for it, as my biography. I cannot approve it,
directly or indirectly, in any way.

You speak of friendship, but it is not the act of a friend
to insist on publishing what you call my biography when I
feel so deeply that it is unacceptable.

I appreciate the time, thought, work and effort that you
have put into your manuscript, but with the way I feel
about it, I wish you would give up the idea of publishing it.
The best solution I can think of is that I offer to buy the
manuscript and your notes for what we would agree to as a
reasonable compensation. I know that money cannot pay
for your feeling about your work—but I would like you to
consider what I suggest. It would be a clean ending to this
unfortunate situation and you could go on with your
interests in other directions.[9]

Pollitzer was an intelligent and articulate woman, but it
would have been hard for anyone to write objectively about Geor-
gia while she was alive. Anita had succumbed, intermittently, to
a sort of sentimental rhapsody: she described Georgia at twenty
as "a shy beauty," for example. Throughout the book, Pollitzer's
view was rose-tinted, and her tone one of respectful admiration
for her friend. Far from flattering O'Keeffe, this sounded a note
of terrible discordance. O'Keeffe later told Anita's nephew: "She
liked her picture of me, and it wasn't like me at all."[10]

The incident was a deeply painful one for all concerned. "It
has been very hard to say no to Anita," Georgia wrote. "I was
very upset about it, but there was nothing else I could do."[11]

Pollitzer herself was horribly disappointed by Georgia's re-

sponse, and unfortunately the incident was not resolved in Anita's lifetime. In the same year that Georgia refused her consent to the project, Pollitzer lapsed into an early senility; she died in 1975.

The episode established a precedent for an aura of biographical murkiness around O'Keeffe. It was the inception of a cloud of denial, restriction, and obstruction that would persist. Moreover, O'Keeffe appeared cold, calculating, and thoughtless in this incident, a woman who would not hesitate to put her own professional aims ahead of her friendships. In actual fact, she had allowed her friendship to take precedence over her judgment. She had unwisely encouraged a good friend, who was not a professional writer and who had no training in that field, to undertake an endeavor both difficult and important. As Pollitzer herself had said of her first meeting with O'Keeffe: "Her presence seemed to lift us up to an immediate adulthood in our own art not only because her own work was exceptional but because the standards she set for herself were exacting." [12]

The standards O'Keeffe set for herelf were both exacting and unyielding. In the case of a collaborative effort such as an authorized biography, she could not lower the standards for Anita without lowering them for herself. This was something she was not equipped to do; both she and Anita suffered as a consequence.

After Anita Pollitzer's death, her relatives received a letter requesting that the O'Keeffe painting given to Anita years earlier be returned. Anita's nephew William is a gentle and courteous man, and he dutifully followed instructions and sent the painting back.

It was not the first time that O'Keeffe had adopted this position of proprietary intransigence; there are a number of similar stories, in which people brought her paintings to be authenticated or examined, only to find O'Keeffe deciding to claim her own right to them. "I'm not giving it back," she would say flatly, and such was her conviction that no one ever took further action. To be fair, it was only gifts, or paintings that had slipped through the normal channels, about which she took this position.

O'Keeffe was known for not giving away her paintings. This attitude was due not to a lack of generosity but to a larger philosophy. She had invested her entire life in her creative work, and she could not afford to devalue her efforts. She did give her work

on occasion to her very close friends: Anita Pollitzer, Frances O'Brien, and Maria Chabot all received paintings, and O'Keeffe took them all back in the end. Friends who bought pictures had better luck. When Peggie Kiskadden told Georgia that she wanted a painting, O'Keeffe offered to give her one. "But I could tell that that wouldn't be the right way to do it"; Kiskadden insisted on paying. She spent a full day making a selection from the storage room at Abiquiu, and finally selected a New Mexican tree painting. O'Keeffe gave her plenty of time to pay for it but not much of a reduction in the price. When Jean and Oliver Seth decided to buy one of her paintings, she invited them up to look. "What had you thought of paying?" she asked. When they named a figure, O'Keeffe replied cheerfully that she had been thinking of ten or fifteen percent more. Donald Gallup, too, bought from her, carefully choosing and slowly paying for a painting of the Ghost Ranch house. When June Sebring's husband, Frank, wrote Georgia that he would like to buy a drawing, she wrote back, friendly but cautionary: "I can not give them to you."[13] She told him the price—one thousand dollars—and suggested that he come and look, and she would see what she could do. What she did was to make the picture available to his modest means, and he bought *Antelope's Horns*, as a surprise for June, for Christmas.

• • •

AS RECOGNITION OF O'Keeffe's distinction increased, she continued to receive honorary degrees, awards, medals, and fellowships. O'Keeffe took acclaim in her stride. In 1962 the American Academy of Arts and Letters elected her to membership. She wrote Beck: "I hear that it is an honor so I go—as my fare is paid —wonders never cease."[14] In that same year she was awarded the Brandeis University Creative Arts Award. In 1966 she was made a member of the American Academy of Arts and Sciences, and a large retrospective of her work was put on at the Amon Carter Museum in Fort Worth and the Museum of Fine Arts in Houston. A few years later she was approached by Lloyd Goodrich regarding a major retrospective at the Whitney Museum in 1970. Doris Bry was invited to be co-curator, and she worked closely with him on the exhibition; O'Keeffe hung the show herself.

The Whitney retrospective was extraordinarily successful.

The other artists in the Stieglitz circle had been nearly a genera-
tion older than she; because of this identification with an earlier
group, and because of her longevity, O'Keeffe had outlived her
own aesthetic obsolescence. There is a period, inevitably, during
which every artist's work looks dated, when the period of novelty
is over and before it achieves historical placement. O'Keeffe's
work had languished in the public view during the fifties but had
subsequently made the transition from outmoded to classic. It
had come back into fashion during her lifetime.

The intense sense of communion with nature, the lyrical
forms, the rich colors, the mystical overtones, all struck chords of
great resonance for the generation of the sixties. Furthermore, as
the feminist movement of that period gained momentum,
O'Keeffe was adopted by it as an iconic figure.

Feminism was something O'Keeffe had supported steadily
throughout her life. By 1929, *The New Yorker* described her as "an
ardent feminist."[15] She wrote to the sculptor Malvina Hoffman:
"It is the only cause I get much interested in outside my own
work."[16] In 1944, O'Keeffe sent a lucid and impressive letter to
Eleanor Roosevelt, gently chiding her for opposing the Equal
Rights Amendment. "It seems to me very important to the idea
of true democracy—to my country—and to the world eventually
—that all men and women stand equal under the sky— I wish
that you could be with us in this fight."[17]

O'Keeffe had always been deeply conscious of the subtle and
far-reaching consequences of growing up female in an androcen-
tric society. "I often wonder what would have happened to me if
I had been a man instead of a woman," she wrote Betty O'Keeffe
in 1930.[18] She saw individual independence as the single most
crucial issue for women. Just as she had asked Dorothy Norman
why she didn't join the Women's Party and drop all the other
nonsense, she felt women should struggle for their own libera-
tion before crusading for other social issues. She had placed its
significance above the workers' movement in the thirties, and in
the seventies she found sexism comparable, in its subtlety and
pervasiveness, to racism. "I think it's pretty funny that women
have always been treated like Negroes in this country and they
don't even know it," she said.[19]

In her personal life, O'Keeffe encouraged women profession-
als. She consistently consulted women doctors—Mrs. Bates for
her eyes, Dr. Ida Rolf for her massages, Dr. Connie Friess as her

physician. When William Howard Schubart died, in 1953, she employed as her financial adviser Ruth Foshay, and later Diana Heller, Schubart's daughter.

For the feminists of the sixties and seventies, O'Keeffe's life of independence served as an exemplar of feminist behavior. The problems she faced were common to all women in the arts, though her solutions were pioneering and courageous. Her character seemed to embody those virtues—independence, strength, and dedication—that the movement extolled. It was hardly surprising that the women's movement adopted O'Keeffe as a heroine; one group produced a feminist version of Leonardo's *Last Supper*, with O'Keeffe in Christ's place at the table.

Nonetheless, it was precisely the qualities the feminists admired that resulted in O'Keeffe's disavowing any allegiance with the feminist movement in later years, just as she disavowed any dependence on other artists or aesthetic movements. O'Keeffe had struggled alone for her independence; it had both cost and gained her a great deal. The battles she had fought had been personal and solitary, and she refused to dilute her achievement in the reservoir of group activity—which the feminists of the seventies promoted. When Gloria Steinem, the elegant doyenne of the women's movement, appeared at the Abiquiu house with a bouquet of roses, O'Keeffe refused to see her. And when she received a request for an interview by a writer on women artists, she said impatiently, "A silly topic. Write about women. Or write about artists. I don't see how they're connected. Personally, the only people who ever helped me were men."[20] For the feminist extremists she felt nothing but contempt. Her innate sense of dignity made a nonsense of feminist guerrilla tactics: "How can they ever gain anything, jumping around like that?"[21]

O'Keeffe said often that she liked men more than women, but this was patently untrue. She clearly did not dislike the entire gender: she herself was a woman, and one well known for her self-respect. She did like men more than a particular sort of woman: the conventionally "feminine" type, whose behavior seemed dominated by and dependent upon male expectations. Moreover, her stated preference was not borne out by the evidence: O'Keeffe's greatest friends were women. Anita Pollitzer, Blanche Matthias, Beck Strand, Frances O'Brien, Maria Chabot, Marjorie Content Toomer, Esther Johnson, Louise Trigg (a high-hearted friend from Texas, who lived in Santa Fe and whose first

husband was a cousin of Robert Young's), Tish Frank, Jean Seth, and Peggie Kiskadden were at all times members of the inner circle, not to mention her sisters. And for thirty years, O'Keeffe's companions and assistants were women: intelligent, strong, and independent. O'Keeffe enjoyed their company and valued their assistance, if she professed to scorn their gender.

O'Keeffe's patronizing attitude was a curious one—a sort of identification with the oppressor that allied her with men rather than with her own gender. Her supercilious pronouncement that the only people who had helped her were men, for example, was due more to the fact that the only people who had had the power to help were men, rather than to anything else. This was only one of the many ways O'Keeffe ignored and broke down sexual stereotypes. Her androgynous looks and sexually independent manner set her outside the norms of conventional feminine behavior. Writing in the early years to Arthur Macmahon, she had commented ingenuously that she wished sometimes he were a girl. Other women were attracted to her; Frida Kahlo, the Mexican artist—an avowed bisexual—boasted that she had flirted with O'Keeffe on meeting her in New York. Moreover, O'Keeffe's relationships with women were often close and tempestuous: all this has given rise to speculation about bisexual activity. It is not beyond the bounds of possibility, but both Maria Chabot and Jerrie Newsom flatly and absolutely refuted the suggestion that O'Keeffe ever had sexual relationships with women.

• • •

GEORGIA WAS attentive to every aspect of her environment, and food was an important part of her world. As one friend said of cooking, "It was one way to present yourself to her," and she remembered people by the dishes they could make. She respected a good cook and appreciated excellence. After she had eaten his roast chicken stuffed with truffles, she offered a friend of Spud Johnson's a thousand dollars a month to come and cook for her. One gentle young artist, David McIntosh, who lived near Abiquiu, became friends with her after he successfully made her an excellent salad. It was done at her request: she explained that this was the test of a good cook.

Jerrie Newsom was cook, housekeeper, and companion to O'Keeffe from 1966 to 1974, with some gaps. Newsom is an energetic and sympathetic Hispanic woman, small and quick, with

bright black eyes, a good smile, and a sense of humor. Like Chabot and like O'Keeffe, she is an independent soul, and her relationship with O'Keeffe was warm, close, and often tempestuous.

When Newsom went to O'Keeffe and asked for work, Georgia had her make a sponge cake, then hired her on the spot. Jerrie worked mostly at Ghost Ranch, picking up O'Keeffe in Abiquiu on Sunday night and spending the week with her at the ranch. Local women refused to stay at Ghost Ranch—the stories of the murders gave it a sinister reputation in Abiquiu. To Jerrie, who was from the village of Tres Piedras, the local stories meant nothing.

Jerrie found O'Keeffe an exigent employer: "When she'd holler you'd have to run." [22] About some things she was frugal to a degree: "She made us wash out the Baggies and hang them on the line," said Jerrie. "She never kept money in her purse. If she had a dime, that was a lot." In other areas she seemed unconcerned about cost: O'Keeffe kept her old Ford for years, replacing it with a Volkswagen bus, similarly modest; in the seventies, however, she bought a glamorous white Lincoln Continental and later a Mercedes-Benz. "Jerrie," said O'Keeffe, "it hurts me to spend one penny, but when it comes to thousands, I don't seem to care." She refused categorically to take a participatory interest in her capital. When a newly appointed investment adviser was assigned to her account, he phoned her to make recommendations. O'Keeffe heard him out and replied, "Young man, I don't expect you to ask my advice on these matters. Do you expect me to call you up and ask what I should paint?"

O'Keeffe was unpredictable though generous about gifts. At Christmas, Jerrie received a fat check, and her husband was given, each year, an identical pair of red wool socks from the Johnny Appleseed catalogue. When Jerrie's thick black hair began to gray early, she lamented to O'Keeffe.

"How much would it cost a month to dye it?" O'Keeffe asked.

"Twelve dollars," said Newsom.

"Well, I'll raise you twelve dollars a month," said O'Keeffe.

Jerrie knew her own mind, and she had her own eccentricities. "I called her Mrs. O'Keeffe," said Jerrie. "I called her Mrs. O'Keeffe, and Miss O'Keeffe, and sometimes I called her Georgia, because I thought that was so cute for me to call her Georgia. She didn't care!" Jerrie felt the same amusement at the world that her

employer did, and was similarly sure of herself. Georgia took care to let no one in the studio when she was painting, but Jerrie took no offense. "I didn't care. I wasn't going to learn how to paint," said Newsom.

Deeply fond of each other and similarly temperamental, O'Keeffe and Newsom fought periodically. Newsom left often, and once she stayed away for two years. "One time I got mad and told her I was leaving. She said, No you're not. She chased me around the piñon trees until she was tired," said Newsom. "Then I left. She let me cool off, and three days later she called up and pretended to cry. 'Jerrie, I'm sorry,' she said. We both started to laugh. 'Come on, Jerrie,' she said. 'Here I come,' I said. She'd make you laugh. She'd make you cry too."

Though O'Keeffe might lose her temper at Newsom, she insisted on other people's respect for her. When the two women traveled together, O'Keeffe introduced Newsom as a friend. "I'd sit at the table and have champagne and turkey. All that people knew was that I was 'Mrs. Newsom.' " Once Georgia and Jerrie flew to Dallas to see a Chow dog show. Georgia bought Jerrie a first-class ticket; she herself flew tourist class.

At Ghost Ranch, Jerrie went on walks with O'Keeffe up into the pink hills. Fifty years earlier, Georgia had said, "You know how you walk along a country road and notice a little tuft of grass, and the next time you pass that way you stop to see how it is getting along and how much it has grown?"[23] Her sense of connection was still strong and unconventional. She and Jerrie "used to put rock corrals around little tiny piñon trees so people wouldn't step on them," Jerrie said, and they made dams with stones to protect the trails from flooding. "She called dirt 'earth,'" Jerrie said. "That's what she called it."

Newsom learned to cook the nutritious dishes that O'Keeffe liked and to bake the special bread she ate: "Wheat had to be ground at the house for it, and there were sunflower seeds. I didn't know what all went into that bread, but it was delicious." Jerrie made the only candy O'Keeffe would eat, from apricots and powdered milk. Lacking O'Keeffe's convictions about sugar, Jerrie made clandestine trips to the local store to buy candy.

"I know where you went, Jerrie," O'Keeffe would announce.

"Miss O'Keeffe, I went to make a long-distance telephone call. I used the pay phone at the store," Jerrie would say severely.

"I know what you did. You went to buy poison."

On most days, Jerrie fixed homemade bread, cheese, and fruit for O'Keeffe's lunch. If O'Keeffe went off for the day, she took the lunch with her. Once, however, when the two women were in Santa Fe, Georgia experimented with the forbidden. "She made me take her to get a hot dog and sauerkraut, but she wouldn't eat it there. She made me drive out of Santa Fe before she'd eat it."

O'Keeffe's rules for her own behavior were strict. She refused any sort of drugs, including aspirin. Her cure for a headache was to wrap her head up warmly. She hated and feared colds, which were severe trials for her. Guests who arrived with a cold were banished to their rooms or sometimes asked to leave altogether. Her judgments were eccentric: she did not suggest that Jerrie stop smoking but admonished her not to frown. "You'll get wrinkles," said Georgia, who possessed the best-known wrinkles in the country.

Besides cooking and housekeeping, Jerrie came to do much of the driving. She took O'Keeffe into Santa Fe once a week to get her hair done at La Fonda, and once a month for her massage. Both these small vanities were kept secret from the world (the departure for the massage was made at five in the morning).

O'Keeffe's sense of herself and her looks had not altered: she knew very well that she was a handsome woman. She dressed in a way that she liked, one that suited her. She wore black when she was photographed, but she habitually wore other colors: one of her favorite dresses was a wraparound full-skirted turquoise-and-white pin-striped cotton. She wore this so long that Jerrie finally told her she was taking it away from her. "Jerrie, that's my treasure," O'Keeffe complained. "What are you going to do with it?"

"Probably burn it," Jerrie replied.

Though O'Keeffe did not wear makeup, she was very conscious of presenting herself well. She arranged her own image to her liking just as she arranged her environment to her liking. O'Keeffe had always been proud of her hair, and its length and thickness were still a source of particular pride when she was in her seventies and eighties. People often arrived at the house to find her with her hair flowing down her back. It was at once put up, with protestations of surprise, but this happened often enough to suggest that it was deliberate and that the glimpses were planned by a woman still proud of her looks. David Mc-

Intosh came into the Abiquiu house one morning to find her in a blue-and-white kimono, the early light on her, and her pewter-colored hair falling down to her waist: he thought her very beautiful.

As she grew older, Georgia compensated for age; when her hair turned thin and white, she wrapped her head in filmy white linen, like a French nun. Her choice of clothes was often dramatic —besides her deep-black dresses and Spanish hats, she wore silk Oriental robes in opulent colors. Her great dignity and physical authority conferred on the clothes a sense of appropriateness, and they looked not like costumes but like robes of state.

"If she was vain about anything it was her hands," said one friend. Georgia's hands were beautiful, but they were also valuable: they were her tools. At an exhibition opening in New York, when an admirer put a hand out, O'Keeffe smiled and shook her head. "Oh, I'm not shaking hands." Nor did she clap hard at concerts, or lift heavy things: Georgia's hands were as well and carefully kept as her brushes and palette.

Sometime around 1971, O'Keeffe began to lose her central vision, as had her grandfather and namesake, George Victor Totto. O'Keeffe was eighty-four years old. "I'd been to town and was going home. And I thought to myself, well the sun is shining, but it looks so grey. I thought, that's a little funny, but I didn't pay any attention to it . . . But the third day, that was enough. When I began working at it, I found that I wasn't seeing . . . things were beginning to be dull for me."[24] When she realized what was happening, O'Keeffe called up Peggie Kiskadden in California and announced, "My world is blurred." Peggie went to her at once. With her help and others', O'Keeffe went to a number of eye specialists in New Mexico and California, but all gave the same discouraging prognosis. Macular degeneration involves that part of the retina responsible for acute vision. Central vision deteriorates and is lost, though peripheral vision, which is black-and-white, is retained for a period. According to one medical theory, the slow degeneration in the eye is accompanied by a corresponding one in the brain, which leads eventually to senility.

Of all their senses, humans are disproportionately dependent upon sight. And though most people depend on sight to make order of their lives, few people depend upon it, as O'Keeffe did, for splendor. It was a monstrous irony for O'Keeffe to lose

her vision. She had once told Louise March that her only fear of death was the loss of color. Now color had become uncertain, and line was gone almost altogether.

Her response was characteristically pragmatic. "I think I have a peculiar kind of eye trouble, and there is nothing to do about it," she said. "That's what the people that think they know tell me. So I just make up my mind . . . when you get so that you can't see, you come to it gradually. And if you didn't come to it gradually, I guess you'd just kill yourself when you couldn't see."[25] However painful the task, O'Keeffe adjusted to the idea of a new life.

David McIntosh was a walking companion of O'Keeffe's, and during the early 1970s he saw her begin, with reluctance, to recognize her limitations. Clambering along an icy arroyo in the fading light of a winter afternoon, McIntosh offered his arm to the octogenarian—an unprecedented gesture. "That offends me," O'Keeffe said with disdain, and drew regally away. McIntosh withdrew his arm, and the two walked on. The rocks were slippery, and the light continued to fade. After a time, O'Keeffe asked coolly, her head high, "David, would you give me your arm?"[26]

Later, when O'Keeffe could no longer negotiate the steep, sandy trails at the ranch, Jerrie walked slowly around the courtyard at Abiquiu with her for exercise. "Ten times each day. She'd move a pebble after every time around."

When Maria Chabot heard about O'Keeffe's failing eyesight, she went to her at Ghost Ranch. "I took her out into the patio and put my hands on her shoulders. I stood her looking out at the Pedernal. 'Can you see that?' I asked.

" 'No,' said Georgia, 'but I know it's there.' "[27]

• • •

VIRGINIA ROBERTSON is a small, attractive woman, intelligent and articulate. In the summer of 1971 she arrived at Abiquiu to work as O'Keeffe's secretary. Her daughter Gail had suddenly decided to get married, and Virginia had taken over Gail's job temporarily as a favor to O'Keeffe. Virginia Robertson and Georgia O'Keeffe discovered a mutual compatibility, and the arrangement lasted. "I've never known anyone like that," Robertson said of her. "It wasn't just that she was famous or important; it was something in herself."[28] For the next several years, Virginia Robertson lived

at the ranch or at Abiquiu during the week and went home to Albuquerque on the weekends. Among other things, the two women shared a love of music—Robertson's husband had been director of the conservatory at Oberlin College—and one of their great pleasures was listening to classical records in the evenings, sitting together in the patio under the black, blazing sky.

It was Robertson who found a scrap of O'Keeffe's writing on the back of an envelope: "I saw the crosses so often—and often in unexpected places—like a thin dark veil of the Catholic Church spread over the New Mexican landscape." William Einstein had years before encouraged O'Keeffe to write about her paintings, and the scrap had been written in the thirties, about her first seasons in New Mexico. Struck by the vivid prose, Robertson encouraged O'Keeffe to expand upon it. With Robertson's help, O'Keeffe began to write her autobiographical book, *Georgia O'Keeffe*. It was a laborious task of dictating, transcribing, rereading, and editing. O'Keeffe was meticulous about her writing, working over and over the text as though it were the smooth surface of a painting.

O'Keeffe was becoming increasingly philanthropic in a quiet way. She gave a substantial amount to charity each year. As well as the contributions she made in Abiquiu, there were others. In 1972 she agreed to allow the Santa Fe Chamber Music Festival to use her work on posters; she also made substantial cash contributions to the festival. In gratitude, performances were given at the house in Abiquiu or at the home of Louise Trigg, who was a founding director of the festival.

In the second year that Robertson worked for her, O'Keeffe began to revise her will; she wanted to establish a foundation and trust for her paintings. O'Keeffe's vulnerability was increasingly apparent, and Robertson found herself in a position of steadily expanding influence. O'Keeffe relied on her more and more for the handling of daily matters. Liking and trusting Robertson, she planned to place her in charge of the foundation and to write her into the will. Robertson knew the value of the estate, she understood O'Keeffe's dependent status, and she could see the political intrigue that might develop. Reluctant to become involved in such a complicated situation, she announced her decision to leave.

Robertson made her announcement at the end of the week,

on the Thursday before Labor Day, 1973. O'Keeffe was visibly distressed by the declaration; she had come to depend upon Robertson for her friendship as well as her help. Asking if there was nothing she could do to make Robertson change her mind, O'Keeffe made an offer to increase her salary and to build her a house nearby. Robertson, who had had a hip replacement, pleaded ill health and remained firm. "My mind was made up, and I said no," she said.

Later that night, after dinner, the two women sat out in the patio, listening to music. O'Keeffe asked Robertson again if there was anything she could do to persuade her to stay. "I said no, that I was very sorry. I could see that she was upset," said Robertson. There was a silence, and then O'Keeffe said quietly, "Well, no one is ever going to leave me again."

● ● ●

ON FRIDAY, a young man from Ghost Ranch appeared at the back door. He wanted to know if there were any odd jobs for him. Jerrie called O'Keeffe, who told the young man to come back the next day.

The young man was not really looking for work. For him O'Keeffe was, as she was for many of his generation, the embodiment of an ethic, a moral beacon. He was not the first aesthetic supplicant to throw himself at her feet. Ever since the show at the Whitney Museum, a steady stream of often ragged but deeply respectful young people—artists, writers, musicians, and drifters—had appeared in Abiquiu with gifts to offer: food, a song, their own work, or simply an admiring eye. One young woman gave O'Keeffe a set of recipes; on the back of each was a drawing. Moved by the intimacy of the paintings, the admirers expected a corresponding intimacy in the person.

"So many letters," said O'Keeffe. "Why do all these people care about me? They write, 'I admire you greatly. I do not wish to invade your privacy but I am a painter and I will be in Abiquiu on Thursday and please answer this letter because this is the only reason I am making the trip.' How many letters like that can you answer?"[29] Often O'Keeffe gave generously of her time and energy; many people were told to come for an hour and stayed for a meal or a night. There were, too, stories of her capricious behavior: once, when Louise Trigg (also small, handsome, and

white-haired) was with her at Abiquiu, Georgia ordered her friend to introduce herself as Georgia O'Keeffe to some admiring and credulous arrivals.

Often the visitors hoped, in her steady, focused presence, to find a sense of direction. Typical of these restless and uncommitted, but enterprising, admirers was a young woman who wrote to O'Keeffe "from the atelier of Soleri in Arizona where I was working . . . I arrived in Abiquiu with a friend and my six-month-old child." O'Keeffe warmly received the visitor, who afterward made her a dress. The next time "I stopped by to see her . . . I was teaching on the Navajo reservation and came over for a visit. I brought my cello with me to play a piece I'd made up especially for her."[30] To pay tribute was the purpose of the visit; to bask in the presence and to receive a mystical benison was the hope.

These supplicants hoped for a validation of themselves; they hoped that breathing in the presence of the power that was innate and manifest in O'Keeffe and in her work would result in a magical transference and that the essence of that power might be shared or at least understood. By then O'Keeffe had taken on a mythic quality, standing for more than herself alone. Her own great physical beauty, the great beauty and power of her work, and the courageous independence of her history all combined to produce an image that fascinated and attracted a stream of admirers.

As she grew older, O'Keeffe increasingly possessed a central and innate strength, to which people were drawn; neither they nor she could help it. "Women," wrote Isak Dinesen, "when they are old enough to have done with the business of being women, and can let loose their strength, may be the most powerful creatures in the world." Even if O'Keeffe had not been a famous artist, the examples set by her mother, her grandmother Totto, and her aunts Lola and Ollie made the persona of the powerful older woman a natural one for her to assume. O'Keeffe's power was complex, however. Besides the fascinating personal potency, large sums of money began to figure in the complicated equation of personality. Power and money have an irresistible drawing force, and whether or not people acknowledge it, they cannot ignore it. Once these elements enter into a relationship, simplicity is lost. The relationships around O'Keeffe began, inevitably, to

reflect these complications, and to manifest the presence of jealousy, resentment, adulation, defensiveness, and possessiveness.

It was everyone's dream to be the person in whom O'Keeffe took an interest, the person who would be taken into her life, the person who would be allowed to share in her innate, extraordinary, transcendent power.

PART VI

1973 - 1986

WITHDRAWAL:
THE DYING
OF
THE LIGHT

32

THE YOUNG MAN AT O'Keeffe's back door was tall, with large, wary brown eyes and long, thick, dark hair in a ponytail. He was twenty-six years old, and his luck was down.

John Bruce Hamilton was born in Dallas, Texas, just before Christmas in 1946. Much of his childhood was spent in Latin America, where the boy received the nickname Juan. His father, Allen Hamilton, was a lay worker in the Presbyterian Church, who taught for years at the Evangelical Seminary in Costa Rica. The Hamiltons moved about a great deal, returning to the United States in 1960 and settling in the New York area. After high school, Juan went to Hastings College, in Nebraska. Hastings, a small, strict school, founded by the United Presbyterian Church, requires the study of Christianity and forbids the use of alcohol. Hamilton graduated with a degree in studio art in 1968. He was a conscientious objector to the war in Vietnam, and attended the Claremont graduate school, in California, studying sculpture under Henry Takemoto. After one semester, he dropped out in order to marry, and he and his wife, who was from a military family, moved to Vermont. There Hamilton built a cabin on her family's land, made pots, and raised vegetables. Two years later, the marriage ended in divorce.

Like many of his generation in this period, Hamilton was restless, troubled, and uncommitted. Neither art nor commerce held him in its sway. He was unsure of his talent and of his need to make art; unwilling to devote himself to a job or to a government he did not respect; unable to find a place for himself in the world. By the spring of 1972 he was driving aimlessly around the

country: "One day . . . in San Francisco, the next in Mendocino. Then Seattle would beckon . . . Three months into this odyssey, [his] dog disappeared, his clothes were stolen, and his truck broke down." [1]

Defeated, Juan went to live with his parents, in New Jersey. He had no job, no wife, no car, and no prospects. A family friend offered to arrange a job for him in the kitchen at the Ghost Ranch in Abiquiu, New Mexico. Hamilton took it.

In 1955, Arthur Pack had given Ghost Ranch to the Presbyterian Church. O'Keeffe, initially displeased, had come to accept Presbyterians as she had come to accept dudes, and by the 1960s, an amicable relationship existed between herself and the ranch. It was being run as a conference center, though it rented rooms to outsiders. O'Keeffe depended on the ranch for neighborly gestures and often called the office for people to do odd jobs for her. When the headquarters building burned down, O'Keeffe promptly contributed fifty thousand dollars to a replacement fund.

Hamilton worked at the ranch for about eight months, doing scut work in the large, bleak modern kitchen. Georgia O'Keeffe was a potent presence beyond a ridge of mesas. Hamilton was drawn to the idea of her, and twice he went to O'Keeffe's house in the hope of meeting her.

The first time he was accompanied by a friend. Catherine Klenert remembered letting him come in to fix the kitchen sink. Georgia looked clearly and deliberately through him. "I might as well have been a rock," Juan complained (though here he was wrong: O'Keeffe paid close attention to rocks). "She didn't say hello. She didn't look at me. It was like I wasn't there." [2] O'Keeffe had always admired "the Indian eye that passes over you without lingering . . . passes over you as though you don't exist." Moreover, she used it herself: "the same way I used to look at the Presbyterians who bought Ghost Ranch so they wouldn't become friendly." [3]

The second time Hamilton saw O'Keeffe, he helped unpack a wood-burning stove for her. He was with Jim Hall, the director of Ghost Ranch, who said affably to O'Keeffe, "Juan here used to collect antique stoves." "Well," she snapped, "this stove is *not* an antique." [4]

The third time Hamilton went to O'Keeffe's back door, she kept the screen closed between them. He asked for work; she

said she had none. Hamilton turned and walked away, but O'Keeffe remembered that she had a painting to crate. "Wait a minute," she called. "Do you know how to pack a painting?"

Hamilton started out at O'Keeffe's Ghost Ranch house doing odd jobs—clipping hedges, crating paintings, driving people to the airport. When O'Keeffe realized that he was educated, she asked him to type the letters that had begun piling up after Virginia Robertson's departure. O'Keeffe was not quick to forge friendships, however, and for months she made it clear through her manner that their relationship was professional, not personal: she largely ignored him and could never remember his name. As the two spent more and more time together, however, O'Keeffe softened toward Hamilton. For one thing, he was good company: he was articulate and educated, and he cared about art. Then there was the way he looked: tall and lanky, with regular features, thick black hair, and dark liquid eyes. O'Keeffe admired good looks in anyone, and most particularly in young men. His dense dark mustache and large dark eyes even gave him a resemblance to Alfred Stieglitz. The similarity, however, was a superficial one, owing largely to the enshrouding mustache. In photographs, Stieglitz's eyes reveal a focused intensity; Hamilton's, a look of troubled anxiety.

Then, too, there was the evident fact that O'Keeffe needed a companion. As her failing eyesight diminished her independence, Juan took her on her walks. He could drive her around the countryside, and he could help with her correspondence. Temperamentally there was a sympathy between them; his slight acerbity pleased her. Hamilton was not worshipful of O'Keeffe. His own character contained a streak of her laconic midwestern practicality. When they walked one day on the high rocky ground near Ghost Ranch, O'Keeffe told him to be careful. If he broke a leg, she said, she would have a hard time getting him home. Instead of reassuring the elderly woman that he would not break his leg, Hamilton said mildly, "Well, you'd just have to work at it." [5] And there was a playfulness about him that made O'Keeffe laugh: one day he introduced her to an interviewer as Mrs. Stieglitz, something no one had dared to do for half a century.

Though O'Keeffe had not decided at once to be Hamilton's friend, she *had* decided to keep him from leaving. He arrived on Labor Day weekend of 1973. When Calvin Tomkins, from *The New Yorker*, arrived to interview O'Keeffe three weeks later, she

had already begun to take steps to ensure that Hamilton would stay. She said candidly that she was urging him to build a kiln at Ghost Ranch, for reasons of her own: she would be able to stay there all year round if Hamilton was there.[6]

Jerrie Newsom was intensely aware of the changes that took place as the relationship became more intimate. Hamilton began to spend more time in the house and finally to have meals with O'Keeffe—a large step up from being yardboy. Friction between Newsom and Hamilton was inevitable, and increasingly evident. O'Keeffe was neat and methodical in the house—doors had to be entirely open or entirely closed, for example, and nothing was out of place. Hamilton was neither neat nor methodical, and his presence introduced a masculine disorder—beer cans, for example—that irritated Jerrie. Hamilton was aware of the antipathy between them and announced to O'Keeffe one morning that he'd had a dream that Jerrie was pulling his hair. "She believed in dreams," Jerrie said. Georgia turned at once to Newsom and asked, "Jerrie, don't you like Juan?"

The strain was partly attributable to ethnic issues: Juan's dark coloring, his fluent Spanish, and, above all, his menial role had seemed to place him on the same level as Newsom and the other local Hispanic help. His education and background made it gradually apparent that he was capable of a social mobility and political power that was not available to them. Under these circumstances his metamorphosis was difficult for Jerrie, and Juan's behavior made it no easier.

Hamilton himself was under pressure for ethnic reasons. When he began working full time for O'Keeffe, he moved out of the Ghost Ranch compound. Before he moved into her house, he lived in a trailer near Abiquiu. The local Hispanics were strongly territorial and unwelcoming to Anglos. Juan drank at their bars and flirted with their girls; the villagers thought poorly of this. They also felt a certain possessiveness of O'Keeffe, and they resented this dark, good-looking young man who had waltzed so casually into her life and who so clearly was taking on economic and emotional importance. "There was a feeling of, 'Why not me?' " said one resident. Both jealous and protective, they made their feelings brutally clear. A coarse announcement was painted on the adobe wall of O'Keeffe's house, explicitly stating a sexual relationship between Hamilton and O'Keeffe. And Hamilton

came home one night to find his dog's head nailed to the door of his trailer.

Hamilton's life was in disarray. There was no peace in it, no certainty, no legitimacy, and no sense of purpose. He lived on the edge of a chasm; he was near chaos, disaster, and despair. O'Keeffe was his mainstay; the work he did for her was visibly necessary and important. She encouraged him to start on his own work; she gave a center to his life.

In January 1974, Hamilton and O'Keeffe went to Morocco together. For the first time, the night before they both left, he slept at the ranch. He let the bathtub overflow and flooded the bathroom. The chaotic mess, and the fact of their traveling together, made the situation finally untenable for Newsom. When the two returned, Jerrie quit for the last time. "Miss O'Keeffe," Jerrie said resolutely, "I am not going to look after your help." This time, O'Keeffe let her go. It was the first of many choices Georgia would make between the young man and old friends.

Juan Hamilton moved in with Georgia O'Keeffe. It was exhilarating and expansive to live in the famous house and to share the famous life. Hamilton was diffident and respectful of O'Keeffe, grateful for her encouragement in his work and admiring of hers. He assisted with her book, *Georgia O'Keeffe*, taking over where Virginia Robertson had left off, and helping to select the illustrations. On a more domestic level, he took walks with O'Keeffe, made appointments for her, drove her to keep them, answered the telephone, and cut up the meat on her plate. Sharing her day was often exciting, challenging, and rewarding; it was also hard work, sometimes tedious, sometimes draining.

O'Keeffe was not easy to live with. An attendant part of her charisma and intensity made her oddly exhausting to the people who worked for her. Her friends acknowledged that as she grew older, O'Keeffe became more determined to have her days run according to her plans. "It was something you accepted about O'Keeffe," said a friend. "You knew that if you wanted to see her, you saw her on her terms." O'Keeffe's autocratic behavior was not simple selfishness; it was based on the premise of a cause larger than herself—her work. For her, this took precedence over everything else, and as she did not spare herself, she did not spare others. There was also the tendency, noted since the days at Chatham Hall, to get other people to do what she wanted a

tendency that was irresistible to someone possessing such magnetism and power.

Virginia Robertson lived with her five days a week for several years. Often, if they were not working on the book, the two women would sit quietly through the long afternoons and talk together. Robertson, deeply fond of O'Keeffe, found the work interesting and O'Keeffe remarkable. Nonetheless, at the end of each week, Robertson was exhausted. Her daughter had had the same experience. "By Thursday night I'd be thinking, I'm not going to last . . . And on Sunday night I'd feel so drained at the thought of going back. But I loved her!"[7]

O'Keeffe did not make things easier for Robertson. On Friday at lunch, just before Robertson was to leave, O'Keeffe might say, "Oh, Mrs. Robertson, there's just one more thing—do you think you could do one more letter?" Then, later in the afternoon, she might say, "Oh, look, it's getting dark. You can't drive home in this. Why don't you stay on and go home after breakfast tomorrow." Robertson did so several times, until she realized this would happen as often as she let it, and she put a stop to it.

O'Keeffe's ingenuous ploy revealed her rather touching plight. She had, even before she was widowed, chosen self-imposed solitude and had deliberately avoided relationships that threatened to impinge on her work and her privacy. She bickered even with her sister Claudia, her most frequent and most welcome visitor. Now, her eyesight failing, she was ready to admit a need but could not articulate it. Ida's daughter could not ask for friendship. O'Keeffe paid Robertson for her time and could only ask her to stay to write letters.

The situation that had been difficult for Robertson was no less difficult for Hamilton. Though at first the days spent with O'Keeffe were a series of pleasurable discoveries, he found that the commitment was more than he had bargained for. She made demands that she felt were reasonable; he felt they were not. As Maria Chabot, Jerrie Newsom, and others had learned, O'Keeffe expected the same response from all her employees: "When she hollered you'd have to run." To his friends, Hamilton complained that O'Keeffe ignored his own schedule, summoning him peremptorily while he was working. Implied by this was an assumption that she would never have tolerated herself: that any of her work—even paperwork—took precedence over his. Jan Sultan, who gave both Hamilton and O'Keeffe their Rolf mas-

sages, became a drinking friend of Hamilton's. Sultan remembered hearing "his struggles . . . whether he could stay on and put up with the demands of this old lady, who would call when he was working on his art and say 'come' and he had to come."[8] Hamilton found himself at O'Keeffe's house eight to twelve hours a day, six days a week. And it was more than a simple demand on his time: besides her insistent command of his life, Juan was becoming increasingly dependent on O'Keeffe, psychologically and financially.

During Tomkins's visit, Hamilton discussed his reluctance to build a kiln because he didn't know whether his talent was sufficient for the commitment. O'Keeffe encouraged him to start. "Work encourages work," she said serenely; it had always been true for her. Her assurances were important to him, and he began. Moreover, when he started again to make his smooth, asymmetrical pots, O'Keeffe tried her own hand at it. It seemed a logical step, since her eyesight would not permit the control she wanted for painting, and she began to use the tactile, malleable medium. Hamilton's role was that of guide and teacher, though she never did master it. It was heartening and strengthening for him, and her admiration for his work was like a blessing. "But I haven't yet made a breathtaking pot, one that makes the clay speak," she said. Pointing to one of Hamilton's she said, "I think *this* is a breathtaking pot."[9]

As time went on, Hamilton's self-assurance increased. More and more responsibility was placed on his shoulders. When the mail arrived, he read out the letters to Georgia, and as Virginia Robertson had, he gave his own recommendations for the replies. Because of his association with O'Keeffe, Hamilton acquired vicarious stature, and his own power increased as O'Keeffe's physically failed. Her eyesight weakened and her limbs began to falter: Hamilton necessarily controlled access to her. Some of her friends, including her financial adviser, Diana Schubart Heller, found that they could no longer reach O'Keeffe by telephone. They were told that O'Keeffe was out, or napping, or busy. Calls were not returned. Letters, too, were controlled by Hamilton, who could choose what he would read to her. People in the art world, recognizing that Hamilton was now a crucial factor in reaching O'Keeffe, began to accord him the respect they would give O'Keeffe herself.

Juan had little money when he arrived at O'Keeffe's, but a

year later he was able to buy from Jerrie Newsom's brother-in-law a house in the nearby town of Barranca with a splendid and panoramic view. The transaction was presumably facilitated by a loan from O'Keeffe; the will O'Keeffe wrote in 1979 contained a specific forgiveness of all debts owed her by Hamilton.

"I was a broken man when I came to her. She said later I reminded her of a wilted leaf. I was embarrassed to be asking her for work, and I expected her to say no."[10] The words are Hamilton's own, and they are curious ones. They proclaim a rather touching lack of self-confidence, but there is an oddly boastful ring to them. There is in them a faint flavor of the revival meeting, like the born-again Christian or the reformed alcoholic, who savors his own degradation before the moment of revelation and ascendance.

It is not surprising that a "broken man" would feel drawn to someone whose power and assurance were so unassailable. Hamilton was at first an acolyte at O'Keeffe's altar. He felt deep respect for her and gratitude for her support. But their relationship was not one between equals, and Hamilton's rise to power did not alter that. No matter how much power he achieved in the outside world, it was vicarious, borrowed from a woman nearly six decades his senior, a woman whose talent and fame and, most important, absolute sense of assurance set her apart from him forever.

Gratitude is not a solid base for friendship. The beggar may thank his benefactor, but he feels rage as well as appreciation. And Hamilton did not always receive support from O'Keeffe. She praised his pottery—up to a point, ". . . then I mentioned an exhibition and she laughed at me. She said, 'You have some very nice things, but you don't have a body of work.' She could be extremely encouraging, but she could also deflate you, cut the legs right out from under you."[11]

Hamilton was not equipped to deal well with this; he had little resilience and little self-assurance as his description of himself as a "broken man" made clear. His background had been a difficult one—the family had moved continuously. Hamilton himself blamed his problems on the nurses who attended his birth. Born three days before Christmas, he claimed that "The nurses in the hospital all wanted to be out shopping. They gave my mother a hard time. I always associate that beginning with my rough life."[12] One aspect of Hamilton's temperament was his

tendency to view himself as a victim. Wary, anxious, and inse-
cure, he used his considerable charm and his good looks to offset
his uncertainty.

Hamilton was unquestionably deeply fond of O'Keeffe;
friends commented on the strong and evident bond between
them. As O'Keeffe grew older and frailer and more dependent, it
became easier for him to take control. The more money and
power Hamilton received, the more complicated his position be-
came.

Hamilton did not hesitate, however, to exploit his power in
the matter of his own work. Bry's policy had been strictly exclu-
sionary of dealers, and O'Keeffe's paintings came rarely onto the
open market. In the late seventies, Gerald Peters, an enterprising
young man in Santa Fe, and Robert Miller, a New York dealer
(whose wife's sister was married to Esther Johnson's son), ap-
proached Hamilton about handling works by O'Keeffe. Hamilton
suggested that they show his pots. The galleries dutifully ex-
hibited Juan Hamilton pots; they were simultaneously permitted
to handle O'Keeffe paintings. In 1980, Janie C. Lee, a dealer in
Houston, showed Hamilton's pots. An article on the show re-
vealed the dynamics behind it. Titled "Georgia O'Keeffe Satisfies
the Crowd That Idolizes Her," the piece is mostly about O'Keeffe
and the excitement generated in Houston by her appearance at
the Hamilton opening. "I thought his work was beautiful," said
Lee. "We communicated and then I spent five wonderful days at
Miss O'Keeffe's home." In that same year, a donation of $100,000
was made by O'Keeffe to the Museum of New Mexico in Santa
Fe. Part of it was to be used to purchase work by Juan Hamilton.

Though Hamilton's works were bought on occasion by mu-
seums, including the Metropolitan in New York, there is a mur-
kiness surrounding their reception in the art world. For one
thing, pottery has always been classified as a decorative art, not
a fine art—an inferior status. Moreover, Hamilton's pots are in-
extricably linked to O'Keeffe's name and the attendant implica-
tions. Collectors Joseph Hirshhorn and Joan Mondale are
frequently cited as owners of the pots, but according to a friend
of O'Keeffe's, purchases were not always entirely voluntary.
When Hirshhorn came out to celebrate O'Keeffe's birthday,
which he did annually, she had a Hamilton pot placed on his
chair at the table, so that Hirshhorn had to pick it up and hold it.
"You should buy that," O'Keeffe told him. Opinions of Hamil-

ton's work are not high in the upper echelons of the art world. "They're beautiful," said one curator associated with the Whitney Museum, "but they're not important." Even more crushing is the assessment of one of the grander contemporary dealers, Irving Blum of the Blum-Helman Gallery. "They look like art," said Blum, "but they smell like decor."

• • •

O'KEEFFE'S ARRANGEMENT with Doris Bry was very straightforward: Bry sold O'Keeffe and Stieglitz material for a flat commission of twenty-five percent. It was around 1965 that she became exclusive agent of O'Keeffe's work, and according to Bry, at that time she was named as O'Keeffe's sole executrix. It was Bry's idea that O'Keeffe designate a number of paintings in her will and specify the institutions that were to receive them, so that if both she and O'Keeffe died, the paintings would go to the chosen recipients.

Peggie Kiskadden's son, Derek Bok, had become the president of Harvard University, and in 1972, negotiations were begun to establish an O'Keeffe bequest to Harvard. Bry, who had been associated with O'Keeffe for more than twenty-five years, discussed with her the disposition of her property after her death. According to Bry, "At this time, Miss O'Keeffe, at my insistence, abandoned the notion that she could discharge me at will; she told me I was her 'exclusive agent' and said that the agency would continue for her life. At her request, the Harvard University agreement was to be worded to reflect and ensure all of that . . . Thus, by 1973, with the commitments made by Miss O'Keeffe—embodied, I believed, in her will and . . . the Harvard Agreement—I thought I had finally achieved the security I needed."[13] An early version of a trust agreement did, in fact, provide for an annuity for Bry, but the Harvard Agreement did not. It was ironic that 1973, the year of Juan Hamilton's arrival in O'Keeffe's life, was the year in which Bry finally felt she had achieved security with O'Keeffe.

When Bry first started working for O'Keeffe, it was crucial that she spend most of her time in New York. By having an East Coast representative, O'Keeffe could stay undisturbed in New Mexico. Twenty years later, the situation had changed. Transportation and communication had radically improved, so that many transactions could be taken care of from New Mexico and

O'Keeffe could travel more easily. She, on the other hand, had declined, and needed more daily attention than Bry, in New York, could supply.

Hamilton's presence in New Mexico became a threat to Bry's presence in New York. As she herself pointed out, it would be easy for Hamilton to make it seem to O'Keeffe that Bry's responsibilities were not being carried out properly. Innuendo, tone, and context are crucial factors in dealing with a blind person. Jerrie Newsom was conscious of a subtle offensive being waged by Hamilton, who jeered at the absent Doris to O'Keeffe.

Moreover, O'Keeffe herself was becoming increasingly attached to Hamilton. In 1980, Hamilton married Anna Marie Prohoroff Erskine, a twenty-six-year-old divorceé from Arizona whom Hamilton met while she worked in an art gallery in Phoenix. By all accounts, Anna Marie is a strong and stable woman, self-possessed and mature. O'Keeffe's approval was not immediate, however. As Hamilton admitted, though O'Keeffe recognized rationally that he needed a woman his own age, this was hard for her to accept emotionally. The first meeting between the two women "was not a success," and for a time O'Keeffe referred to Anna Marie as "that poor thing."

Certainly there was a romantic attachment between O'Keeffe and Hamilton, one that linked the wilted leaf and the indomitable nonagenarian, the beautiful young man and the ailing old lady. The warmth and tenderness between them was direct and unequivocal, and often they held hands in a casual, reassuring manner. Just as certainly, however, the attachment was not sexual. O'Keeffe had always had a penchant for young men, though Peggie Kiskadden said absolutely, "She never had affairs. There was only Stieglitz."[14] After the encounter with Toomer, there is no evidence to the contrary. Still, O'Keeffe had often fallen in a kind of love with young men, and younger men had figured importantly in her life. There were Ted Reid, in Texas, and Paul Strand, both slightly younger, and later Cady Wells, Jackie Suazo, and William Einstein, all substantially younger. And in the late 1940s, Georgia made out a will leaving property to two charming younger men of whom she was very fond, Henwar Rodakiewicz and Magnus Swenson Harding. "He brought out her maternal side," said Kiskadden of the handsome Harding.

O'Keeffe admired handsome creatures—men, women, and dogs. As with her Chows, she liked the look of young men, she

liked their energy and their suppleness and their spirit. As she grew older, she became frankly flirtatious. One young man saw O'Keeffe standing on the street in Santa Fe, leaning against a wall and watching him. As he passed, she said simply, "Hello, young man": a tribute to youth and beauty. A photographer friend remembered Georgia making clear her attraction to the young man who was his assistant. She liked the attention, she liked the fun of flirting, but the flirtations were innocent. The young man on the street became a close friend, but that was all. Jerrie Newsom, when asked, was shocked at the suggestion of Georgia's sexual liaisons. "Not ever," she said, "not ever."

By the time she was in her eighties and Hamilton nearly six decades her junior, a physical relationship was not a realistic possibility. Still, there did exist between them an intensely loving and highly charged bond, and as the years went on and O'Keeffe became frailer, her dependency on him increased. She watched him constantly, and asked for him if he left the room. "She is definitely in love with him," one visitor wrote in 1980, "and I think that he must love her, in a way." [15] For O'Keeffe, her eyesight fading and her body failing, Hamilton was more and more her link with the rest of the world, with the life she had known. For Hamilton, O'Keeffe was both a beloved friend and a continual responsibility, one who weighed him down with emotional needs and practical duties. With an aged parent, this relationship is to be expected: the commingling of love and resentment, duty and tenderness. Between O'Keeffe and Hamilton, however, there was nothing so simple or clear-cut, and it is hard to imagine that the relationship was not confused by money, dependency, and, finally, greed.

O'Keeffe had not hesitated to take advantage of Hamilton's dependent position when he first arrived. Offering him an irresistible combination of money, working space, encouragement, and the charismatic thrill of her friendship, O'Keeffe had ensured, as she had told Virginia Robertson, that no one would ever leave her again. Robertson, Chabot, and others, more independent, had in the end refused her offers and withdrawn from her powerful aura, but Hamilton had not. The consequences, for both Hamilton and O'Keeffe, were mixed.

Hamilton himself was not easy to live with, and his temper was volatile. After an exhibition of O'Keeffe's work at the Governor's Gallery in Santa Fe in 1975, Hamilton and another young

man went down with a truck to pick up the paintings. They found the pictures laid face down on a worktable. The original "American Place" labels on the backing, with Stieglitz's elegant flowing handwriting, had been carelessly covered by the recent, and relatively insignificant, Santa Fe Labels. Hamilton's response was instantaneous and overwrought. He lunged across the table for the curator and knocked his glasses off. Though the accidental labeling was unfortunate, the response seemed extreme.

It was around 1977 that Doris Bry realized that Hamilton was intruding on her territory. Two paintings had been sold by Hamilton and O'Keeffe without her knowledge or participation. As sole agent, she ought to have received a commission on the transaction. Justifiably outraged, she protested. O'Keeffe, however, would not be crossed, not even by someone who had worked for her for thirty years. She was adamant, and her response to Bry's complaint, transmitted to her by Hamilton, was one of cold hostility. The controversy ended with a devastating move by O'Keeffe: she terminated the relationship and demanded the return of all works by her and Stieglitz.

Bry refused at first, and in May 1977, O'Keeffe took legal action, suing Bry in federal district court in New York to recover all her material. The works were placed in legally neutral territory, and Bry filed a counterclaim for breach of contract. She attempted to prove that her agreement with O'Keeffe was a lifetime arrangement and did not permit termination. Bry also sued Hamilton in New York State Supreme Court for "malicious interference" in her relationship with O'Keeffe and asked for nearly thirteen million dollars in damages.

The lawsuit and the countersuit, with their attendant implications of rage, betrayal, and altered alliances, threw the relationship between O'Keeffe and Hamilton into a new light. Speculation arose as to a possible marriage between them, on which neither would comment. (When Jean Seth called Georgia to ask about it, Georgia dismissed it: "I hope Juan hasn't heard this; it will spoil his Christmas!") *People* magazine arranged an interview and a photograph, for which Hamilton posed like a starlet. Wearing a large hat, he leaned against the wall, legs crossed at the ankle, one hand coyly behind his neck. He encouraged the implications: "There is prejudice against us because she is an older woman and I'm young and somewhat handsome."[16] He went on to say: "If I had been a young woman and she an

older man I doubt anyone would have cared much." [17] The analogy is a curious one. Instead of using the more obvious comparison, "If I had been an older man and she a young woman," he maintained the junior, dependent role, switched his own gender, and placed O'Keeffe in the senior, commanding role, making her male.

In any case, a romantic attachment between two people some sixty years apart is neither biologically nor emotionally normal. A young woman devoting herself to an elderly man is not uncommon, but the gentleman in question generally makes up financially for what he lacks in constitution. Hamilton's use of this simile is interesting, for O'Keeffe's finances were to complicate the other elements in their relationship. Despite Hamilton's sober protestations of friendship and pure affection, O'Keeffe's towering stature and her steadily increasing wealth were factors that cannot be ignored. It is difficult to imagine a thirty-year-old man maintaining such a demanding relationship with an unknown and impoverished old woman, no matter how interesting her personality.

Doris Bry finally and bitterly settled both her lawsuits. The one against Hamilton was settled in 1982, the one against O'Keeffe in 1985. The judge dismissed most of her claims. Bry herself was responsible for substantial delays in her depositions, and the contractual agreement between herself and O'Keeffe that she had promised was never produced. Apparently, O'Keeffe, who had never intended any such rigid arrangement as a lifetime agreement, had never created one, much to Bry's dismay. Hamilton, who had long ago established power over O'Keeffe's private life, now reigned supreme over her professional life.

One of Georgia's closest and most enduring friendships—with her sister Claudia—was threatened and two other relationships were eventually destroyed by Hamilton's presence. To Georgia's old friends, the relationship with the handsome young man seemed unnatural and discomfiting. Georgia's family and old friends seemed to present a threat to Juan. The changing dynamics between O'Keeffe and Hamilton were demonstrated when the situation came to a head and Claudia called Juan "a gigolo." Peggie Kiskadden, who was there, clapped her hands and began to sing. Claudia joined in, and the two sang the show tune "Just a Gigolo," to their own great delight. Georgia and Juan, however, were not amused. According to Louise Trigg,

Claudia later announced that she would have him arrested. And Peggie Kiskadden, after an episode of spectacular rudeness on Juan's part, turned at last to Georgia. "I can't come back if he is allowed to talk to me like that," she said with dignity, and waited for Georgia to rebuke her employee and defend her friend.

But Georgia said nothing to her sister and nothing to her friend. Claudia and Peggie had visited often and lengthily, particularly since the onset of Georgia's eye problems, but no one could be there as often as Juan: O'Keeffe could not afford to lose him. The balance of power had shifted subtly and irrevocably, and it became increasingly clear that Juan was in the ascendancy and that his behavior would be tolerated and ignored by Georgia, no matter how offensive it was to other people. The incident ended Georgia's friendship of some forty years with Kiskadden, to both women's regret. Georgia later mentioned wistfully to a friend that she wondered if Peggie missed her as much as she missed Peggie. (Kiskadden remained a presence in Georgia's life: she appeared in her dreams.)

Another casualty was the relationship with Frances O'Brien, of some fifty years standing. O'Brien and Kiskadden both supported Bry in her suit against Hamilton, and O'Keeffe, whose judgments were clear and absolute, would not maintain alliances with both sides. A letter from Abiquiu abruptly demanded the return of the paintings O'Keeffe had given O'Brien years before.

There were still, however, people O'Keeffe continued to see, whom Hamilton liked and who liked him. Todd Webb, Ansel Adams, Eliot Porter, Louise Trigg, Jean and Oliver Seth, and a number of others found no obstruction to their friendships. Those friends that Hamilton liked found him a great boon in Georgia's life. They were witness to the affection between the two and to the constant and undeniable support and assistance Hamilton gave Georgia. Moreover, Hamilton is, by any standards, charming. It is his great strength: most people who meet him like him. Those friends of Georgia's who posed no threat to Juan, and whom he liked, liked him a great deal. They found him to be responsible, affectionate, and conscientious, and they became his staunch allies. As with a new marriage, the relationship between O'Keeffe and Hamilton took precedence. Some old relationships survived, some did not.

In the summer of 1976, Hamilton flew to New York to work on O'Keeffe's book. He hired a young man named John Poling to

do some construction work on his own house and to build paint-
ing crates for O'Keeffe. Poling was twenty-three years old, a stu-
dent at the University of New Mexico who was earning money at
odd construction work on the side. Before Hamilton left for New
York, he hired Poling to paint the trim on O'Keeffe's house at
Ghost Ranch. While Hamilton was away, O'Keeffe called Poling
inside, and he began doing some of the things Hamilton had
done: reading her mail to her and typing her letters. "At first, I
used to bring my own lunch," Poling said. "Pretty soon, I was
having lunch with her."[18] One day she asked him to help her
with an idea she had.

While staying with Esther Johnson in New Jersey one week-
end, at Juan's suggestion O'Keeffe had begun painting again. She
started in watercolor, doing simple, colorful abstractions that re-
called her work from the mid-teens. Poling was asked to help
with a more ambitious work: a large oil. He repainted a primed
canvas white, then the two of them worked together. "We drew
out the basic design in charcoal," he said. "I would hold a yard-
stick and move it around. She'd stand back." O'Keeffe told Poling
when he had achieved the right angle, and he drew the line in
charcoal. He mixed the paint, putting blotches of color on the
canvas for her to choose from. "Her vision was sort of blurring
all over, but there were little holes in it where she could see
through." Once she had chosen the color, he applied it according
to her instructions. "I got such a charge out of it," Poling said. "I
loved the brilliant blue and how it looked with the orange." The
painting, a patio door, took nearly five days to complete. After-
ward O'Keeffe said, "I should give you something for this," and
she wrote her name on a postcard, which she handed him.

Between sessions at the painting, the two talked, or Poling
drove her on errands or visits. He fell under the powerful
O'Keeffe spell. "There was nothing else I wanted to do," he said.
"I was more interested in spending time with her than anything
else. It was just so neat to hang out with someone like that—just
to hear her laugh."

When Hamilton came back, Poling picked him up at the air-
port in Albuquerque. At once, tensions arose. Like a jealous hus-
band, Hamilton questioned Poling closely about his work at the
ranch. Poling "felt guilty for having been that close to her. He
was asking me more and more about what I'd been doing. Finally
he said, 'You've been eating with her, haven't you?' "

Hamilton's instincts were powerfully territorial. He knew very well how a friendship could arise between O'Keeffe and a young man doing odd jobs around the house. Poling was sent off forthwith, though he was called for again when O'Keeffe decided to try another canvas. This one, which has often been reproduced, was *From a Day with Juan*. The image is an abstract geometrical shape, gray against blue, reminiscent of the rising Washington Monument against the sky. For this, Poling was paid five dollars an hour as a studio assistant. As before, O'Keeffe directed while he laid the paint on the canvas.

When Poling saw the painting reproduced in *Artnews*, without any mention of assistance, he was disturbed, and he attempted to talk to O'Keeffe and Hamilton about the incident. Twice he tried, and each interview went badly. The first time, he saw Georgia alone in the courtyard. The dogs were barking, and she thought that he wanted money or recognition and ordered him to leave. On the second try, Poling saw Juan, and things went no better. "I don't know what went on between you and Georgia," Hamilton said accusingly, as though this were the crucial issue, and the painting irrelevant.

Poling finally went to the local newspaper. O'Keeffe, fierce and self-protective, defended her work against what she saw as an invasion of privacy and a devaluation of her efforts. Her growing blindness was still something she tried not to acknowledge, and she tried to keep it from the world at large. Admission that she could not apply the paint on her own canvases was humiliating, and she angrily tried to dismiss the entire episode. "I don't think it's anyone's business," she said loftily, and went on to announce, with a brutal lack of tact, "Mr. Poling was the equivalent of a palette knife." [19]

Hamilton's argument made less sense. "Does a translator have to give credit to his secretary?" he asked, implying that the answer was no. [20] The question of a writer giving credit to a translator would be more to the point, and the answer, in that case, is yes.

O'Keeffe's response was understandable, Hamilton's was less so. It was his fear of being supplanted that seemed to make him tetchy and suspicious. Hamilton's insecurities evidently were not appeased by his growing power. The complications of his relationship with the frail, fierce, rich, vulnerable O'Keeffe continued. He found ways of dealing with his insecurities. They

were not ones generally considered beneficial, but they were time-honored ways.

The moral climate of Santa Fe in the 1970s and early 1980s was composed of freewheeling western independence and an eastern hippie-style spirit. The combination made for a widespread availability of drugs: cocaine and marijuana were the staples, though others were easily available in a wide variety. Given Hamilton's generation and his background, it would have been surprising if he had never taken drugs during this period; no such eccentricity has been suggested. Hamilton himself publicly acknowledged a drinking problem. The substances in question unloose restraints, usually imposed by reason and affection, upon behavior.

With O'Keeffe, Hamilton had become a man of substance and acclaim. O'Keeffe believed him to be an artist; so he now believed himself to be one. Museum directors considered his conversation valuable; his bank balance bespoke security. Yet all his standing and esteem was vicarious, and the knowledge of his borrowed power aroused his insecurities. He admitted his anxieties to friends. "He was afraid that people only liked him because of O'Keeffe, that no one liked him for himself," said one friend. His relationships with other people had become clouded and complicated, just as his bond with O'Keeffe had been, by her power and money. These factors do not prevent friendship, but they prevent its clarity. And Hamilton felt the implications were intolerable: his reality, as a person and an artist, was dependent on O'Keeffe. His dependency and her power continued to affect their relationship as her physical frailty increased.

On the surface, however, the shared life between O'Keeffe and Hamilton was productive and positive. Despite her age, O'Keeffe continued to carry on professional activities. Juan had helped her in important ways in the publication of her autobiographical *Georgia O'Keeffe*, which came out in 1976, and with his assistance and encouragement, she cooperated with a New York filmmaker, Perry Miller Adato, on a documentary that was released for her ninetieth birthday in 1977. There were more interviews granted to periodicals (though these were more often popular than art magazines), and she seemed more accessible to the world. Juan was given credit for these changes; he made it easier for her to travel and to execute her intentions. Clearly, he added to her life; clearly, he provided her with mobility, comfort,

and assurance. Taking a trip without him in 1976, she wrote: "I might add that I miss the feeling of security you give me but I seem to manage to get along in my own casual fashion."[21]

In 1977, she had first met an attractive young scholar of photography, Sarah Greenough, who was then working on the Stieglitz Collection at the Metropolitan Museum. The following year, Greenough was awarded a Kress fellowship to catalogue and organize the Stieglitz material at the National Gallery of Art in Washington and subsequently, in 1983, to mount an exhibition of the work and write the catalogue for it. Greenough went often to Abiquiu to work with O'Keeffe and Hamilton on the Stieglitz exhibition, for which Hamilton was made co-curator. His participation reveals the extent to which his private life as an artist was invaded by his public life with O'Keeffe. It had become impossible to separate his life from hers anymore, and his work as her delegate to the outside world involved traveling and diplomatic activities as well as answering her mail. Besides, there was a glamour and swank to be found in the upper echelons of the art world, a rarefied atmosphere highly accessible to the emissary of Georgia O'Keeffe, though not necessarily to a humble potter on his own from New Mexico.

In 1978, Hamilton was given power of attorney over O'Keeffe's affairs, a practical necessity because of her failing eyesight. It was described by one lawyer as being "as broad a Power of Attorney as I have ever seen drawn and executed in the State of New Mexico."[22] This document gave Hamilton complete control over every imaginable transaction, including permission to make charitable donations, and it gave him access to all of O'Keeffe's assets.

In 1979, O'Keeffe wrote another will, which superseded the Harvard Agreement. In this she directed that the house in Abiquiu should go to the National Park Service or the National Trust for Historic Preservation. There were a number of small bequests to the people who were then working for her, thirty thousand dollars to Jackie Suazo, forgiveness of a debt to a local couple, and forgiveness of any debts to Hamilton. Hamilton was named executor, if he survived O'Keeffe and qualified. Then he was given his choice of any six oil paintings and fifteen works on paper—not to be chosen from works otherwise allocated. He was also to get the Ghost Ranch property. The bequests to charitable institutions, begun with Doris Bry in the mid-sixties, were firmly

stated. She specifically designated fifty-two paintings, the best in her estate, to go to eight major museums: the Art Institute of Chicago, the Boston Museum of Fine Arts, the Brooklyn Museum, the Cleveland Museum, the Metropolitan Museum in New York, the Museum of Modern Art in New York, the National Gallery of Art in Washington, and the Philadelphia Museum of Art. All other works of art were to be given to charitable institutions. These were to be selected by Hamilton, and were to include the University of New Mexico. The Museum of Fine Arts, Museum of New Mexico, was specifically named as a recipient. All other property was left to Hamilton. The will was dutifully read aloud to the nearly blind woman; the proceedings were witnessed by O'Keeffe's friends Louise Trigg and Jean and Oliver Seth. Both Trigg and the Seths were good friends and supporters of Juan's, and both had a long-standing relationship with O'Keeffe. Louise's family was from Amarillo and had known Georgia in the mid-teens. Jean Seth was a local art dealer, who had once given a show of Ida's work. Oliver's father, O. C. Seth, had been Georgia's lawyer when she bought the Abiquiu and Ghost Ranch houses. Oliver Seth was a distinguished lawyer and a federal judge, a man highly respected and esteemed by the legal community in Santa Fe. His signature on a document would, simply by its presence, increase its credibility.

In earlier wills, O'Keeffe had named family members as legatees. The will drawn up in the late forties left her houses to friends, and most of the rest of her property was to be divided between O'Keeffe's siblings and their issue. During the 1970s, however, the wills she had made directed more property to the public than to family, and in the 1979 will, no family members at all were named as heirs. Few people, however, would have thought of questioning her decision regarding her property. She was still clearly vital and lucid.

The change in her property planning had little bearing on Georgia's family relationships. These were still strong and affectionate, though the ranks were diminishing. Claudia's close friend Hildegarde Hohane had died in 1958, and Anita Young's husband, Robert, had shot himself in the billiard room of the Palm Beach mansion in January of that same year. Georgia had comforted both sisters, inviting Claudie to New Mexico after spending ten days with Anita in Florida, "one of the saddest times of my life." [28] Ida, who had so delighted Georgia with her

high spirits in the early years, had died in 1961. Georgia was saddened by her sister's death but disappointed by her life: "In some odd ways it is a wasted life," she had written Claudie.[24]

In the next two decades, visits among the four remaining sisters continued to be frequent. One year Georgia stayed with Catherine in Portage, Wisconsin, near Sun Prairie. The two sisters pulled up unannounced in a grand and gleaming car outside the modest O'Keeffe farmhouse. The family who lived there had never heard of Georgia O'Keeffe but hospitably allowed the two women to wander through the house. "Do you still hang ham in the attic?" Georgia asked. (In 1976, the farmhouse burned to the ground, and Sun Prairie suddenly decided to recognize its famous artist. The town planned to name a park after her and invited her to come to the ceremony and to donate one of her paintings to the historical society. O'Keeffe regretted both invitations, and the park was named after someone else.)

Both Catherine and Claudia came to stay with Georgia nearly every year, and Georgia periodically went east to visit Anita, either in her "acres of velvet" at the Ritz Towers or at her Palm Beach house. While Jerrie Newsom was working for Georgia, Catherine often brought along her daughter, Catherine, who now had four children. In the fall of 1976, Catherine and Claudia came out together to stay with Georgia. Ever since the late 1950s, when Georgia had had a telephone installed in her house, the sisters maintained their closeness by telephone when it became more difficult to maintain it physically. Georgia continued to feel protective and nearly maternal toward her younger sisters. She called them often, and when Claudia suffered a seizure in the mid-seventies, Georgia kept in close and constant touch; when Catherine contracted a painful and debilitating case of shingles (which Georgia had had in 1969), Georgia telephoned every night for a progress report and recommended homeopathic remedies.

Georgia's grandnephew Ray Krueger had made his first long visit to her for two weeks in 1960. Ray was Catherine Klenert's grandson, born in 1947. Intelligent and independent, he had inherited the clean, open-faced O'Keeffe looks. He and his great-aunt shared a liberal political view, and during his visit they talked about the civil rights movement, Ralph Nader, and Common Cause. Ray found Georgia broad-minded, responsive, and warm.

Georgia, continuing the family tradition of tuition assistance,

had sent Ray's older sister, Georgia Krueger, to the University of Arizona. When she offered, a few years later, to send Ray to Harvard, she met resistance. Georgia specified Harvard, and Ray, who had inherited a generous dose of the O'Keeffe independence of spirit, chose to make his own way at the University of Wisconsin. By 1979, he had finished graduate school and was a practicing lawyer. He found himself working on a case in the Southwest and paid a weekend visit to Georgia.

The weekend was a significant one for Krueger. Quiet, intimate, and relaxed, it created a bond between the aging woman and the young man. "We spent the weekend talking," Ray said. "There was a real rapport." Georgia responded warmly to her sister's grandson; she found a strong young man, assured, articulate, and with the quality of steady midwestern integrity that Georgia both possessed and admired. The two spent some time at Ghost Ranch; in the evening they walked together in the shadow of the majestic rose-colored cliffs. The next day they went back to Abiquiu, the steady dialogue between them continuing.

In the late afternoon, when Ray was ready to leave, Georgia asked him to come and stand before her studio door in the strong, raking light, so that she could receive the clearest image of his face. "It felt very strange, to stand there in the sunlight while she looked and looked at my face. Then she said she wanted to know it, to know my face, and she put her hands out and moved them across my face, touching my features, gently and slowly." [25]

The connections of kin were crucial to Georgia. "It's a boy," Georgia had written Betty O'Keeffe of her second child in 1930. "I'm so glad. It is the only O'Keeffe boy." The steady, continuing flow of the family was important to her. O'Keeffes were physically a formal family, and the intimate experience of her grandnephew's face—the laying of her hands upon his flesh—was a significant moment for both Ray and Georgia, one that embodied and extended the tender and compelling bond of kinship.

When Ray left his great-aunt that afternoon, he drove to the top of the first curve in the road, then stopped his car and turned to look back. Several hundred yards away, Georgia was standing watching him. "She couldn't have seen me," he said, "she was mostly blind by then. But she was looking at me. We looked at each other without moving." He, too, felt the potent sense of connection, the family current.

If the weekend with Ray Krueger meant a sense of funda-

mental reassurance for O'Keeffe, it must have given Juan Hamilton a very different sensation. Georgia had told Juan that she wanted him to meet Ray, but Hamilton did not appear at all during the weekend. By then he was a constant presence at her house, so his absence was remarkable. Georgia mentioned him often to Ray; she could not understand why he did not come. Ray could not understand why it mattered. For Juan, the appearance of another handsome young man, this one a blood relation, must have been threatening in a more serious way than that of the painting assistant, John Poling. His attitude toward the O'Keeffe family had always been ambivalent; it was to become increasingly intransigent.

While O'Keeffe valued her privacy and responded fiercely to attempts to violate it, she did not fear intrusion as much as resent it. Her response to the public was becoming increasingly acerbic. To strangers and even to friends she could be imperious, abrupt, and dismissive. The world's intrusions were unwelcome, and she had lost patience. She retreated more and more into a closed and exclusive atmosphere in which Hamilton was her only fixed and trusted ally. With Hamilton, a different attitude apparently obtained: fear seemed to enter into his sense of privacy. The domestic employees, for example, during the last years were all required to sign agreements in which they swore secrecy, promising not to write or talk about their experiences in the O'Keeffe household.

The 1978 power of attorney and the 1979 will had changed Hamilton's status: he was now an official representative of O'Keeffe and heir to part of her fortune. His position brought increasing anxiety, however: any doubts he had had before about his own ability and his own worth were more troubling as the stakes rose. Claudia was anxious about his presence in her sister's life: she witnessed fierce fights between them and heard Hamilton threatening to leave Georgia if she did not yield. There were times when Hamilton took out his feelings on the frail, imperious woman who so dominated his life and for whom affection was so closely intertwined with resentment. Georgia herself was no stranger to temper and had vented her anger on her companions. But as she declined physically, the struggle was no longer an equal one.

Between 1979 and 1982, the decline was visible. Sarah Greenough, who worked with her during that period, noticed that

though O'Keeffe was still alert, her sight deteriorated badly and she had markedly less energy. By 1982, Georgia was ninety-five, frail, nearly blind, and quite deaf. She was increasingly dependent on Juan for the mechanics of living; she was also in a kind of love with him. Increasingly, the scenes between herself and Juan ended with her capitulation. The balance of power was shifting: Georgia was no longer always the queen.

Hamilton had conceived a plan for a centennial exhibition of O'Keeffe's work, to open at the National Gallery. Sarah Greenough, an impressive scholar, took part in this project as well. Expanding her expertise into O'Keeffe's domain, she took on the task of editing a large selection of O'Keeffe letters for the catalogue. Juan was again made co-curator of the show. During the process of planning for the exhibition, O'Keeffe asked Greenough if she and Hamilton would be interested in editing the letters between herself and Stieglitz, still in a locked metal cabinet at Yale. After the Anita Pollitzer incident, and as the year 1976 had approached, when the O'Keeffe-Stieglitz letters were supposed to become accessible to scholars, O'Keeffe had changed the terms and placed the letters under restriction until her death. Her imperious insistence on privacy was made clear: she had arrived at the Beinecke Library herself and placed a padlock on the metal cabinet that held the famous letters. To edit the locked and secret treasures of the collection was the great dream of every O'Keeffe scholar. Unsurprisingly, Greenough agreed to take on the project.

This was not the first time the famous letters had been offered to a scholar. During the seventies, the art critic Barbara Rose had been offered the plum of writing about O'Keeffe's life and work. Rose was well known as an exponent of the art of the sixties; opinionated and intelligent, she was also forceful, aggressive, and, like Doris Bry, possessive of her territory. O'Keeffe had given her access to some of the O'Keeffe-Stieglitz letters and her blessing, but the project began to founder. Hamilton's proprietary feelings may have played a part in O'Keeffe's disenchantment with Rose. In any case, the affair ended badly, and O'Keeffe abruptly withdrew her support from Rose's project as she had from Anita Pollitzer's.

The idea of permitting a scholar to investigate her life was both appealing and appalling to O'Keeffe. Though she realized that a solid and scholarly biography should be written, she could

not bring herself to permit the invasion of her own privacy. Laurie Lisle, a researcher at *Newsweek,* bravely announced her plan to write an unauthorized biography and asked for an interview, but O'Keeffe refused to see her. When Lisle's book, *Portrait of an Artist,* came out in 1980, O'Keeffe was enraged by its intrusion into her life.

Another facet of her professional life involved the complicated and infelicitous relationship that existed between O'Keeffe and the Museum of New Mexico in Santa Fe. In 1936 there had been a proposal that O'Keeffe paint a mural for the museum. A letter to the museum's president by a curator described O'Keeffe as "a strange sort of freak with big hands," and the president had responded with distaste to the notion. Hostility had figured thereafter in museum responses to O'Keeffe, and as one museum official said wryly, "It seemed as though every time O'Keeffe and the museum got together, something went wrong. One time we even spelled her name wrong in a publication: something that happens all over the country, but which shouldn't happen in Santa Fe."

In 1980, a more positive relationship was established. O'Keeffe sent the museum a check for $100,000, and discussions got under way regarding a loan exhibition of O'Keeffe's work. Still, the negotiations were seen by some as suspect. A verbal arrangement stipulated that the money be used to purchase sculpture by Hamilton and to contribute toward the purchase price of a painting by O'Keeffe, *Summer Days.* In the resulting debate the negotiations ground to a halt, and later O'Keeffe removed the museum from her will.

In November 1983, a first codicil was appended to O'Keeffe's 1979 will. This removed the bequest of the Abiquiu house to the National Park Service and directed Hamilton to give it to a charitable organization or to sell it and donate the proceeds to one. Whether or not he was executor, Hamilton was given the same choice of art works. Moreover, it directed Hamilton, as executor, to receive $200,000 for his services.

In 1984, Claudia died, at the age of eighty-five. In March of that year, Georgia, ninety-six, suffered a coronary attack while visiting Anita in Florida. She was flown home and placed on medication, but the episode persuaded Hamilton that her physical frailty required closer proximity to a hospital than the house at Abiquiu allowed. Juan and Anna Marie and their two sons,

Brandon and Albert, moved with O'Keeffe to a large house in Santa Fe. One commodious downstairs room with a separate entrance was assigned to O'Keeffe, and the Hamilton family occupied the rest of the house. O'Keeffe was seriously failing. She was often lucid, but not always. The year before, in 1983, Donald Gallup had found her unable to remember the redoubtable Harvard Agreement, so carefully expounded in 1972. According to one friend, after the attack and her move to Santa Fe, a substantial change was visible: "she became very quiet . . . It could have been age, it could have been illness, it could have been that she was no longer in Abiquiu." [26]

What is expected of a nonagenarian is different from what is expected of someone younger. Deafness and blindness add to the confusion, and conversation is often reduced to loudly stated essentials. Smiling composedly and making a few Delphic comments, an ancient lady may appear to be entirely alert when she is in fact erratically so. Dr. Brad Stamm, who attended Georgia regularly during her last several years, found her "like any old person. There were fairly lucid periods, times when she was conversational and chatty, and other times when she was not, when she was confused." [27]

In 1984, Hamilton had purchased the Santa Fe property, called Sol y Sombra, from his friend and business associate Gerald Peters. A block of land and the house were bought in O'Keeffe's name; an adjoining piece of land was bought in Hamilton's. Three new Mercedes-Benzes were acquired. O'Keeffe was put under the care of round-the-clock nurses. She continued to eat her accustomed health foods and to take her vitamins. Her friends continued to see her; Aline Porter sat with her for most of a morning, mostly in silence. "She liked having her hand held," said Porter. Jerrie Newsom paid her a sad visit; she found Georgia pitifully cold, her limbs chilled. When Jerrie wrapped a blanket around her, Georgia said wistfully, "Jerrie, don't go." The Santa Fe Chamber Music Festival gave her a small performance that summer, and the violinist stood right in front of her to play a Bach sonata. Afterward he stepped forward to shake hands. Georgia did not speak. "She held my hand very sincerely," said the violinist. "It was more than a heartfelt thank you." [28] Her connection to the rest of the world seemed, by that summer, to be reduced to a mute and tactile one.

Catherine visited Georgia in the fall of 1984, and the follow-

ing year her daughter Catherine came. But the family was finding it increasingly difficult to see Georgia. June O'Keeffe Sebring, who had lent her drawing to the small exhibition being held at the museum in Santa Fe, planned to drive down with her daughter to see the exhibition and Georgia. She called to arrange a visit, but Anna Marie hung up on her. Pita Lopez, who had worked for Georgia for years, called June back and apologized for the situation, urging June to call when she reached Santa Fe. Upon arrival, she was informed by Pita that it would not be possible to see Georgia. When Ray tried to visit that same year, he was told that it "would not be appropriate." The inappropriateness of visiting applied apparently only to family members, for the friends whom Juan liked visited regularly with Georgia during that period.

On August 8, 1984, O'Keeffe signed a second codicil, one that altered dramatically the terms of all other O'Keeffe wills. Before that codicil, besides the paintings designated to go to museums and the few Hamilton was permitted to choose for himself, her paintings and the "rest, residue and remainder" of her estate had been directed to go to charitable organizations. In the last codicil, virtually everything was left to John Bruce Hamilton. As it was later described in court, the terms of the codicil moved "just under $40,000,000.00 worth of O'Keeffe's art work . . . and approximately $50,000,000.00 worth of property, as a whole, from charitable institutions to Mr. Hamilton himself." [29] O'Keeffe's blind signature, affirming the fifty-million-dollar switch, wandered wildly across the page.

Judge Oliver Seth was asked to witness the codicil, as he had earlier. He knew the terms of it and was unsurprised: things had been moving in that direction for years, he felt. That morning he entered the house through Georgia's door and found her in her room, dressed in white. He talked to her briefly and went through to the main part of the house, where he found Hamilton with a lawyer from New York, Gerald Dickler. Dickler, who specialized in art cases, had represented O'Keeffe in her suit against Doris Bry. He had also helped draw up the codicil. Judge Seth is a tall, solid man with a courtly manner and an air of thoughtful reserve. He took an immediate dislike to Dickler's manner. Announcing that he would have nothing further to do with the transaction, Seth went back into Georgia's room and sat with her again before he left. Georgia held on to his hand; she didn't want

him to go. This had happened to him before, and he sat still with the elderly woman, letting her hold on to him.

Hamilton then called on Benjamin Sanders and his wife, friends of O'Keeffe's for thirty years, and asked them to witness the document. Sanders found everything in order: he believed O'Keeffe was lucid, and the codicil was read to her before she signed it.

For the next year and a half, Georgia spent her days sitting quietly in the big spare room, turned toward the light from the windows, saying little, and waiting. A nurse was on constant duty, and Hamilton visited her in the morning and at night. Georgia was peaceful, quiet, and otherworldly.

In the early spring of 1986 an old friend from Abiquiu came to see her. He found the distance widening between his world and hers. Kind and remote, Georgia remembered him from his childhood, nodding into the air at his name. When he asked how she felt, she told him that it was time for her to go.

That week, the first week of March, Hamilton was vacationing in Mexico with his family. On the evening of the sixth, the housekeeper phoned to tell Juan that O'Keeffe was sinking. Hamilton told her to call him back if things got worse. Things were already worse, the housekeeper said insistently. It seemed that, for Hamilton, the call was one more intrusion into his life on the part of the exigent, difficult woman whom he had sought out, to his eventual pleasure and distress. For thirteen years, her demands had relentlessly invaded his days. This time, Hamilton refused the intrusion. He repeated his order to the housekeeper and hung up.

O'Keeffe was taken that night to the hospital in Santa Fe, where she died. She was ninety-eight. According to her wishes, her ashes were later scattered into the windy landscape near her house at Ghost Ranch.

33

Part of what she liked about me . . . was that I didn't put her on a pedestal.

—JUAN HAMILTON

IN EARLY MARCH of 1986, Ray Krueger had traveled to Santa Fe again to see his great-aunt Georgia. This time, his mother had interceded for him, insisting that he be allowed to see her. When he arrived in Santa Fe, Krueger was told of Georgia's death. He requested and was given copies of the power of attorney, the will, and the subsequent two codicils.

On April 21, at a court hearing, their counsels announced that Catherine Klenert, Catherine Krueger, Raymond Krueger, and June O'Keeffe Sebring would oppose probate. June Sebring challenged both codicils and the 1979 will. The Klenert-Krueger group challenged only the codicils and accepted the terms of the 1979 will, in which they were not named. Their intention was to ensure that the great bulk of the paintings would go to the public, as the 1979 will, and all the wills of the preceding decade, had directed. If their challenge was successful, they would inherit nothing themselves.

By refusing to challenge the 1979 will, the Klenerts had adopted an ethically impressive but strategically fragile posture, which placed their legal standing in jeopardy: a person with no claim to an estate cannot challenge it in court. Had they chal-

lenged the will as well as the codicils, the possibility existed of invalidating the will and declaring O'Keeffe to have died intestate. In this case, the relatives would have been legatees, which they were not by the terms of the 1979 will.

Their lawyer, Larry Maldegen, is a bluff, outgoing man, intelligent and articulate. At first he found his clients' position difficult to believe. "I kept waiting to hear the rest of their intentions, besides the altruistic ones, but those were the only ones they had." Deeply impressed by his clients' integrity, he was professionally frustrated by it. They refused, however, to change their position. Later it was decided that all heirs were interested parties, and the point became moot.

Juan Hamilton was charged with using undue influence over Georgia O'Keeffe. Under New Mexican law this is defined rather precisely. It may be directly or indirectly shown; initially, a confidential or fiduciary relationship must be demonstrated. Beyond this, there must be one or more suspicious circumstances that the testatrix was dominated or controlled, that the beneficiary participated in procuring the will, that the testatrix was weak-minded or in frail health and susceptible, that the provisions of the will were unnatural or unjust, or that the beneficiary benefited unduly from the bequest.

At the outset, the case against Hamilton was damning. A fiduciary relationship had clearly been established by the unusually broad power of attorney in 1978. Hamilton had obviously aided in procuring the will; the testatrix could be shown to have been in frail health and not always lucid; lawyers for the family argued that the provisions of the will seemed unjust, in that others who had cared for O'Keeffe for a similar number of years with equal devotion were not inheriting proportionately; and finally it could be argued with great vigor that Juan Hamilton would benefit unduly from the bequest. It was a situation that laid itself open to challenge, and the lawyers on the family side expressed surprise that the situation had been allowed by legal counsel. "If a young associate of mine had set up that situation and written that codicil, in the belief that it would not be challenged, I'd tell him to get his résumé in order," said one of them.

The two law firms had been retained by Sebring and the Klenerts on a contingency basis, and they set to work to produce evidence for their suit. During the discovery process, more than 100,000 pages of documents were amassed, more than fifty peo-

ple interviewed, and 2,500 pages of deposition transcripts compiled. Doris Bry was subpoenaed, and two doctors and a registered nurse were engaged to analyze O'Keeffe's medical condition.

Under the intense scrutiny of the investigating lawyers, the somber side of Juan Hamilton's life began to emerge. People who worked within the house revealed the hostility he had felt toward O'Keeffe and the shifting of power between them. The change had been subtle, slow, and largely invisible to their friends. As in many complicated marriages, before the public eye the couple had seemed exemplary. Georgia's love and dependence were evident to her friends; Juan's temper was not.

"He might have felt affection for her in the beginning," said one source close to the household, "but only in the beginning. In the end it was the estate." In the last years, Juan, his patience frayed, his sense of burden overwhelming because of the aged woman who would never, it seemed, leave him alone, vented his rage on Georgia. She was by then frail, and Hamilton could intimidate her by shouting.

Juan was large and he could be fierce, and Georgia was afraid of him. "There were things she would have liked to do; she would have liked to see other people, or go around more, but she was afraid of making him angry," one of the women said. A housekeeper who long preceded Juan told a friend, simply, "He was mean to her a lot."

One of the young women had stood up for her. "Let her alone," she said sturdily to Juan. "She's an old woman. Let her have an apple if she wants one." The women talked among themselves, but did not interfere. It was a difficult issue: Georgia was physically well looked after, she was medically attended and properly cared for. As she grew frailer and more often confused, things were done for her own good, as for a child's.

Juan had been an authoritative figure to the other employees for a number of years. His anger was well known, and then there were the agreements to secrecy. The women watched Miss O'Keeffe. "They waited for her to ask for help, but they didn't want to take the initiative."

O'Keeffe did not, of course, ask for help—it was not in her nature. The situation was one she had created, just as she had created the rest of the life she lived. Her domineering personality and her solitary habits kept her outside a communal system of

care and support. (The notion of Georgia O'Keeffe in a nursing home is not a credible one.) Her childlessness and her great age and that of her sisters set her outside the normal familial network. She had cut herself off from a great many friends. Finally, and most important, she had fallen in love with Juan Hamilton, and Georgia O'Keeffe was no less vulnerable to that emotion than anyone else. As she had given up too much to Alfred Stieglitz, so she gave up too much to Juan Hamilton. In both relationships, she exchanged liberty for affection. The fact that her second love flourished while her mind and capabilities declined made the spectacle a sad one, but her intentions were no less firm.

As the relationship between herself and Juan first began to alter, Georgia had believed, as lovers do, that it would change back, that the beloved would once again become doting, fond, infinitely kind. She had never required the men she loved to be perfect, or even ethical: that she believed one of them had been in jail three times before he was twenty-one had altered Georgia's affection not at all. Her sense of loyalty and commitment were as strong to Hamilton as they had been to Stieglitz. As she had never complained about Stieglitz, so she was silent about Juan's unkindnesses. Her sense of privacy was inviolate.

"You do your best to destroy each other," she had remarked without rancor about her marriage. When she and Stieglitz had finally confronted each other, however, she had been in her early forties, vigorous and healthy, with the physical capacity to leave her husband and travel two thousand miles. When the confrontations began between herself and Juan, Georgia was frail, becoming blind, and beginning to be deaf. By the time she had become confused as well, the power Hamilton held over her would be complete. Innate power lies in the conviction of the individual; once confusion sets in, power is lost.

The vision of Georgia O'Keeffe's final years is a painful one, given her high-hearted independence and her excruciating battle to achieve it in earlier years. But her double-edged connection to Juan Hamilton, full of pain as well as rewards, was one she had forged herself. She had created a bond between the two of them, which held fast in a vise first Hamilton and then herself, both linked by love and responsibility, dependence and need.

· · ·

THE KLENERT and Sebring teams hoped that they would be joined in their suit by the state of New Mexico, which had appeared in the 1979 will as a devisee and had been written out of the second codicil. By successfully challenging this codicil, the state would receive works of art under the terms of the 1979 will.

In 1986, Cleta Downey was president of the board of regents of the Museum of New Mexico. She came from an academic and curatorial background and had taught art history at the University of New Mexico at Albuquerque, where Sarah Greenough had been her graduate assistant. Early one Sunday morning in late April, Downey received a telephone call from Clara Apodaca, head of the Office of Cultural Affairs in Santa Fe. Apodaca told Downey of a plan both urgent and secret: Juan Hamilton had agreed to give the museum $1.5 million worth of art work from the O'Keeffe estate in lieu of taxes. In return, he required the state's agreement to drop any legal claims during the probate of the will. The secrecy and urgency were his requirements: secrecy was a matter of course, and he had given the museum only until eight-thirty the next morning to comply with his offer.

Apodaca had had a document drawn up accepting Hamilton's terms, and she asked Downey, who lived in Albuquerque, to come to Santa Fe and sign it. Downey could not, whereupon Apodaca offered to have the document sent to her. Downey felt that the thirteen-page document warranted careful consideration, and another board member agreed that a legal opinion should be obtained. Downey tried to confer with the attorney general. She was told by the Cultural Affairs Office that he was out of town, but that the document had been read to him by telephone and he would urge her to sign it. The attorney general was conscientious, and to Downey this response seemed unlikely. (He was not out of town, and it was improbable that the document had been read to him over the telephone, since the area in which he lived was without telephone service that day.)

Downey refused to sign the document and was beset by telephone calls from both the Office of Cultural Affairs and the governor's office, criticizing her for the delay and announcing the governor's displeasure. In the end, Downey agreed to sign, with the proviso that the board be given two weeks to consider the proposal, during which time they could revoke their decision.

The offer of art was a tempting one for the museum, which

had a meager O'Keeffe collection. As Hamilton's lawyers pointed out, the 1979 will did not specify the art work to be given to the state, nor did it specify its worth. Hamilton's offer, however, was highly specific: $1.5 million worth of work, in the form of six paintings.

An attorney, David Cunningham, was retained by the state of New Mexico. Cunningham hired Forrest Putnam, a retired FBI agent, to investigate Juan Hamilton, in order to determine the chances of winning the lawsuit against him. Cunningham's report to the assistant attorney general, Kevin Reilly, was based on the detective's findings and was presented in the form of a letter dated April 21, which was later circulated to the board of regents.

The report began by defining and discussing undue influence. Inconclusive evidence was presented: there were those who believed O'Keeffe was in control of her senses during her last years and those who did not. The text was measured and cautious until an electrifying passage, which altered irrevocably the public perception of the Hamilton-O'Keeffe relationship.

Cunningham's evidence showed that Juan Hamilton had convinced Georgia O'Keeffe to marry him, after he divorced his wife, Anna Marie. According to the letter, he had so consistently and deliberately confused O'Keeffe that at least one of the witnesses believed that O'Keeffe was under the apprehension that she was marrying Juan when in fact she was signing the second codicil. This evidence was based on many conversations, but particularly on the transcript of an exchange between O'Keeffe and a nurse, which took place on July 10, 1984. In this, O'Keeffe discussed the prospective divorce and her marriage, and the sleeping habits of the people involved. All the witnesses spoken to had evinced fear of Juan Hamilton and reluctance to make any public statement.

Faced with evidence both convincing and distressing, the board felt it was unlikely that Hamilton would prevail in his lawsuit. They unhappily voted to accept his offer of art work. None of them liked the circumstances, and the margin was a slim one. Of six present members, two were opposed. Though the ballot was secret, Governor Anayo announced publicly that Cleta Downey had cast one of the opposing votes. Eight days later, on April 29, she was fired by Anayo for malfeasance of duty.

• • •

THE LAWYERS for June Sebring had possession of a copy of the April 21 letter and attempted to read it during a court hearing, but Hamilton's lawyers successfully prevented this and had the letter sealed. Moreover, they succeeded in obtaining a confidentiality rule to be placed over the entire proceedings. Citing an article that named a six-figure sum going to a chronicler of O'Keeffe and Stieglitz, Hamilton maintained that O'Keeffe material was so valuable that it would be unfair to the estate for it to be allowed into the public domain. He also stated that information made public about his private life would put him at a disadvantage among his competitors in the potting world.

It is easy to confuse the elderly; as their grasp on the world loosens, it is easy to tell them things that they will understand instead of trying laboriously to explain things they will not. It will never be known exactly what Georgia O'Keeffe thought she was doing when she put her signature to the second codicil. It would be easier to dismiss the wedding story if there were fewer discrepancies. Hamilton himself dismissed the whole notion as the product of one employee with a grudge. The house was said to have been filled that day with flowers; Hamilton gave his wife credit for bringing these in from the garden, but a florist's bill had been found that contradicted that claim. To one interviewer Hamilton said he was spending eight hours a day, five days a week, caring for O'Keeffe at the end of her life; a nurse for O'Keeffe during the last year remembered him coming in twice a day, morning and evening, for a brief visit.

The fund of information about Hamilton had grown. The lawyers for the family had subpoenaed a psychiatrist, Dr. Donald Fineberg, and questioned him as to whether Hamilton was ever treated for drug-related problems. Fineberg refused to answer questions, but Hamilton's drinking problem, the stories of his intimidation of O'Keeffe, and the very murky story of the wedding, all coupled with the definition of undue influence, combined to give the lawyers for the O'Keeffe family a sense of healthy optimism.

Apparently Hamilton's lawyers acquired a corresponding sense of despondency, for in January 1987, less than a year after O'Keeffe's death, an out-of-court settlement plan was announced. On June 5, 1987, Hamilton and his lawyers agreed to the conditions offered by the family teams. To the press, Hamilton gave his reasons for giving up the fifty-million-dollar inheri-

tance; they are exemplary. "I have young children, and my own work, I just didn't think it worth it to fight over wealth and property."[1] An editorial in a Santa Fe newspaper commended Hamilton for his "amazingly generous decision . . . he put personal privacy, personal creativity, personal integrity over the chance to become fabulously rich . . . we would like to say: well done."[2] That fall, the O'Keeffe Centennial Exhibition opened at the National Gallery. Juan Hamilton shared the dais with the gallery's distinguished director, J. Carter Brown, and Jack Cowart and Sarah Greenough, the other two co-curators.

Despite agreement among the three parties that the lawsuit would not be discussed with the press, Hamilton kept making slips. "If Miss O'Keeffe had been so interested in leaving her estate to institutions she could have done so during her lifetime," he remarked suggestively to one reporter, ignoring the fact that she had done exactly that, in will after will, year after year. An interviewer from *ARTnews* found Hamilton "sliding into harsh comments about her relatives, who, in his opinion, contested her will and codicils out of greed . . . questioning the relatives' seemingly pure motives and wondering why, if they were so concerned about O'Keeffe's state of mind and well-being, they had only distant relationships with her when she was alive."[3] Krueger and Sebring, who felt obliged to honor their agreement, could not respond.

Apart from the nobility of Hamilton's motives, both the speed at which Hamilton's lawyers suggested a settlement and the terms they accepted implied that the Hamilton team of litigators felt that their chances of winning were microscopic. The agreement led one of the lawyers involved to remark, "It wasn't a compromise, it was a capitulation."

By the terms of the settlement, the two family contestants received equal dollar value in cash and paintings, of a million dollars each. Hamilton's share left him "art work and personal property to reflect the role he played in O'Keeffe's life. His disposition is essentially comparable to the 1979 will," according to Larry Maldegen in the settlement hearing. This translated into twenty-four paintings, the Ghost Ranch house, all of O'Keeffe's letters to him, and certain copyrights. According to the settlement records, Catherine Klenert took five paintings and $295,000 in cash, and June Sebring took eight paintings and $489,600 in cash.

Of the fifty-two paintings originally designated for museums, there were only forty-two left; ten had been sold before O'Keeffe's death. The remaining paintings were to be distributed as planned. The rest of O'Keeffe's papers would go to the Beinecke Library at Yale, and all the remaining art works would be distributed to other nonprofit organizations by a foundation.

A charitable foundation had been O'Keeffe's intention since the early 1970s, when Virginia Robertson helped her draft the first plans for it. The principal intent of the foundation as it stands is to "perpetuate the artistic legacy of Georgia O'Keeffe for the public benefit." Run by a board composed of Ray Krueger, June O'Keeffe Sebring, Juan Hamilton, and two others, it will, by the terms of its charter, have distributed all the paintings in its possession to charitable institutions by the year 2006.

Once the settlement was put behind them, the three parties involved began to work together, in a spirit of determined amicability. "From the beginning we have recognized that Juan Hamilton played an important part in Georgia O'Keeffe's life," said Ray Krueger diplomatically. "We are trying now to look ahead."

Anita O'Keeffe Young died in 1985, and Catherine O'Keeffe Klenert, the last of her generation, died on New Year's Eve, 1987. Ida's children, strong, independent, self-assured, difficult, and talented, are gone. The paintings are left, and thanks to another O'Keeffe legacy—stubborn conviction—they will now be available to the public.

• • •

IN MANY WAYS, Georgia O'Keeffe was an exemplar. Simply by its existence, example is enabling. The fact of it permits other people to behave in a similar manner. Georgia O'Keeffe, by her example, gave permission to following generations of women to give work priority in their lives, to consider it crucial.

She demonstrated the need to honor art and creativity, but she demonstrated as well the need for love and tenderness, the need for passion and human connection. She made this explicit in her life. She never abandoned her commitment to Alfred Stieglitz, and she faithfully honored his needs in the only fashion possible between two humans: through an untidy compromise, constantly changing, between love and survival. She demonstrated the necessity for love by making it grandly and passion-

ately explicit in her work. Her paintings were about emotion and tenderness, pain and solitude. They were about something that had never been before so clearly revealed: the female experience.

At the center of Georgia O'Keeffe's life was her work. It entirely engaged her, but rather than isolating her from life, it required her involvement. The feelings that overpowered her in 1916 never altered:

> I've been working like mad all day—had a great time—
> Anita it seems I never had such a good time— I was just
> trying to say what I wanted to say—and it is so much fun to
> say what you want to— I worked till my head all felt tight
> in the top . . . I really doubted the soundness of the
> mentality of a person who can work so hard and laugh like I
> did and get such genuine fun out of that sort of thing—who
> can make anything like that as seriously as I did.[4]

That sense of passionate commitment lasted Georgia O'Keeffe a lifetime. It reverberates bravely through her work, ringing the changes through excitement, bliss, pain, solitude, and a sublime and final distance. The work of Georgia O'Keeffe reveals the life. The two are inextricable; they reflect and inform each other. Both reveal what lies at the core of the woman: clarity, integrity, and courage.

SOURCES AND CODES FOR NOTES

Letters

The dating of the letters is often imprecise. O'Keeffe did not generally date her letters until the late forties. The letters in this book are given the dates that seem most probable on the basis of other available information. If the date is conjectural, a question mark follows it.

Many of the letters are still in private hands. In some of these cases, no source is given.

The following abbreviations have been used to indicate archival sources for O'Keeffe's letters:

AAA Archives of American Art, Smithsonian Institution, Washington, D.C. This material is on microfilm.

AAPRT Ansel Adams Publishing Rights Trust

AIC Ryerson and Burnham Libraries, Art Institute of Chicago

CCP Photographic Archives at the Center for Creative Photography, University of Arizona, Tucson

MKP Mitchell Kennerly Papers, Rare Books and Manuscript Division, The New York Public Library

MNM Museum of Fine Arts, Museum of New Mexico, Santa Fe, New Mexico (The letters here, from Claudia O'Keeffe to her sister Georgia, are not originals but facsimiles.)

NBL Newberry Library, Chicago

NYPL The New York Public Library, Astor, Lenox, and Tilden Foundations

PSA Paul Strand Archive, Paul Strand Collection, Center for Creative Photography, University of Arizona, Tucson, Arizona.

YCAL Collection of American Literature, Beinecke Rare Book and Manuscript Library, Yale University, New Haven

The following abbreviations refer to copyrighted material:

CHG *Georgia O'Keeffe: Art and Letters.* By Jack Cowart, Juan Hamilton, and Sarah Greenough. (New York: National Gallery of Art in association with New York Graphic Society Books, Little, Brown

and Company, Boston, 1987.) Copyright © 1987 Board of Trustees, National Gallery of Art. Copyright © 1987 Estate of Georgia O'Keeffe.

EGOK Copyright © 1989 Estate of Georgia O'Keeffe.

PAS *Georgia O'Keeffe: A Portrait by Alfred Stieglitz.* Introduction by Georgia O'Keeffe. (New York: Metropolitan Museum of Art, 1978.) Copyright © 1978 The Metropolitan Museum of Art. Copyright © 1978 Estate of Georgia O'Keeffe.

APSA Copyright © Aperture Foundation, Inc., Paul Strand Archive.

The following abbreviations refer to the writers and recipients of the letters:

SA Sherwood Anderson
MRB Marie Rapp Boursault
DB Dorothy Brett
GD George Dannenberg
ESD Elizabeth Stieglitz Davidson
AGD Arthur G. Dove
RVH Russell Vernon Hunter
MK Mitchell Kennerly
MDL Mabel Dodge Luhan
HMcB Henry McBride
AWM Arthur Whittier Macmahon
LM Louise March
BM Blanche Matthias
AOK Alexis O'Keeffe
BOK Betty O'Keeffe
COK Claudia O'Keeffe
COKK Catherine O'Keeffe Klenert
GOK Georgia O'Keeffe
IOK Ida O'Keeffe
AP Anita Pollitzer
WHS William H. Schubart
HJS Herbert J. Seligmann
AS Alfred Stieglitz
PS Paul Strand
RSS Rebecca Salsbury Strand
JT Jean Toomer
MCT Marjorie Content Toomer
CW Cady Wells

Other Archival Sources

Notebooks compiled by Rosalind Irvine, updated by Doris Bry, at the Whitney Museum of American Art, New York

Materials on microfilm in the Archives of American Art, Smithsonian Institution, Washington D.C.

Materials in the Collection of American Literature, Beinecke Rare Book and Manuscripts Library, Yale University, New Haven

Materials in the University of Virginia Library

Other Sources

Calvin Tomkins, notes on an interview with Georgia O'Keeffe, Sept. 24, 1973, from which was written "The Rose in the Eye Looked Pretty Fine," *The New Yorker*, Mar. 4, 1974

Interviews with numerous people, some of whom are named in the Notes, many of whom wish to remain anonymous

Films and Recordings

Ansel Adams, Photographer, documentary film directed by John Huszar, 1981

Georgia O'Keeffe, documentary film produced and directed by Perry Miller Adato for WNET/13, the Public Broadcasting Service, 1977

Georgia O'Keeffe Remembered: 1914–1918, taped interviews directed by Al Koschka for the Amarillo Art Center, 1987

NOTES

NB: Quotations from sources who wish to remain anonymous are not cited in the Notes.

Chapter 1

1. Sharon O'Brien, *Willa Cather: The Emerging Voice* (New York: Oxford University Press, 1987), p. 22.

2. Ibid., p. 34.

3. Willa Cather, *My Ántonia* (Boston: Houghton Mifflin, 1977), p. 7.

4. Nancy Chodorow, *The Reproduction of Mothering: Psychoanalysis and the Sociology of Gender* (Berkeley: University of California Press, 1978), p. 169. Ms. Chodorow's thesis holds that the crucial differentiating experience for the child is the recognition of the self as different from or similar to the primary parent—the mother. The resulting perception of self, as separate or connected, influences the world perception for men and for women. The feeling of connectedness makes for an empathic response and "permeable ego boundaries" for women, and the possibility of confusion between self and world. Conversely, men's feeling of separation makes it possible for them to view the alteration of a landscape or the killing of a creature in entirely different terms from those of women.

5. According to a letter from the U.S. consul in Budapest to Alletta Totto, dated January 12, 1900, Totto came to America in 1848. This is contrary to family tradition, which held that Totto came over as an aide-de-camp of Lajos Kossuth in 1851.

 The name was probably changed to Totto from Tottos or Tottis on his arrival: the Hungarian book of peerage has entries under both "Tottos" and Tottosy," and a relative in Budapest was called "Tottis." Names flowed casually from one form to another in the nineteenth century, especially when a foreign language was involved: on Totto's own marriage certificate his name is spelled "Tatto."

6. The flamboyant Augustus Haraszthy came to America in 1840 for a visit, then returned in 1842 to settle in Wisconsin. The account of his American experiences was published in Hungary in 1844 and aroused considerable interest.

It was probably this enthusiastic report that was responsible for Totto's plan to move to the small, raw community.

7. A later arrival, Coenradt Ten Eyck, disembarked in 1650. Pieter Claesen, the first of the Wyckoffs, arrived in 1637; Claesen was changed to Wyckoff when the English took over the Dutch colony and requested names that fit their tongues more easily. Pieter Claesen had been a local judge, and "Wyk" means parish, "Hof" means court. The Wyckoffs originally had considerable stature in the community, but this had dwindled by the mid-nineteenth century.

8. Her name is spelled variously, but her grandchildren knew her as Isabella.

9. The family genealogy lists Charles as innkeeper in Somerville, Bound Brook, Whitehouse (all in New Jersey), Philadelphia, and New York. During the 1840s he managed, serially, three different hotels on Cortlandt Street in New York. New York directories of 1844 and 1845 list Charles at the National Hotel. A tiny engraving of this establishment survives; it is a modest four-story town house, with elegant script on either side announcing: "National Hotel, No. 5 Cortlandt St. by Chas. Wyckoff & Co. $1.50 Per Day."

The next few years are something of a mystery, as Wyckoff's name is absent from New York directories until 1853. Presumably he was present intermittently, as it was during this period that George Victor Totto arrived in New York. According to family history, Totto stayed at a hotel run by Charles Wyckoff, and it was there that he met not only Charles but his two daughters.

10. Letter from Frank Dyer Chester, U.S. Consul, Budapest, to Alletta Totto, Jan. 12, 1900.

11. Though other sources spell it "Calixtus," the family genealogy gives his name as "Calyxtus."

Chapter 2

1. Though the philosophical premise equated godliness and industry, the midwestern experience was essentially secular. Religion played a part in these communities, but the church did not wield absolute control. Ethnic heterogeneity made for a wide variety of different churches, no one of which was supreme. And the laws of this ethical system were upheld, not by elders, but by the land itself. Physical indolence—equated with moral laxity—resulted in a consequent diminution of the harvest. The experience of the early settlers tended to demonstrate the power of the individual, not that of institutions, either secular or religious. The midwestern ethos was, in fact, based on transcendental notions of a direct compact between man and nature rather than on one between man and god, implemented through nature.

2. Claudia may have called her "Aunt Jennie," but Catherine and Georgia remembered her as "Auntie." Catherine O'Keeffe Klenert, interview with author, May 18–20, 1987.

3. Anita Pollitzer, *A Woman on Paper* (New York: Simon & Schuster, 1988), p. 59.

4. Ibid., p. 58.

5. Klenert interview.

6. Mary Daniels, "The Magical Mistress of Ghost Ranch," *Chicago Sunday Tribune*, June 24, 1973.

7. Archer Winsten, "Georgia O'Keeffe Tries to Begin Again in Bermuda." *New York Post*, Mar. 19, 1934.

8. Calvin Tomkins, "The Rose in the Eye Looked Pretty Fine," *The New Yorker*, Mar. 4, 1974.

9. GOK to MK, Jan. 20, 1929 (MKP, NYPL). Copyright © 1989 Estate of Georgia O'Keeffe. All further references to materials so copyrighted will be designated as EGOK.

10. Klenert interview.

11. Ibid.

12. Calvin Tomkins, notes from interview with Georgia O'Keeffe, Sept. 24, 1973.

13. Laurie Lisle, *Portrait of the Artist: A Biography of Georgia O'Keeffe* (Albuquerque: University of New Mexico, 1986), p. 16.

14. Tomkins, notes.

15. Mary Braggiotti, "Her Worlds Are Many," *New York Post*, May 16, 1946.

16. Tomkins, notes.

17. Ibid.

18. *Sun Prairie Countryman*, Aug. 19, 1897.

Chapter 3

1. Tomkins, notes.

2. Mary Lynn Kotz, "A Day with Georgia O'Keeffe," *ARTnews*, December 1977.

3. Georgia O'Keeffe, *Georgia O'Keeffe* (New York: Viking, 1976), unpaged.

4. Though O'Keeffe suggests in her book that she was older—eight or nine months—her emphasis on the novelty of the light and the sensation of being outdoors suggests that it was the first time she had been brought outside. This would surely have happened when the weather turned fine in May or June, when she was only six or seven months old.

5. O'Keeffe, *O'Keeffe*.

6. Lisle, *Portrait of the Artist*, p. 356.

7. Gaston Bachelard, *The Poetics of Space* (Boston: Beacon Press, 1969), xvii.

8. O'Keeffe, *O'Keeffe*.

9. Tomkins, notes.

10. O'Keeffe, *O'Keeffe*.

11. Ibid.

12. Tomkins, notes.

13. David V. Mollenhoff, *Madison: A Short History of the Formative Years* (Dubuque: Kendall, n.d.), p. 419.

14. O'Brien, *Willa Cather*, p. 98.

15. "I Can't Sing So I Paint," *New York Sun*, Dec. 5, 1922.

16. Braggiotti, "Her Worlds Are Many."

17. Cather, *My Ántonia*, p. 172.

Chapter 4

1. O'Brien, *Willa Cather*, p. 60.
2. Anita Pollitzer, unpublished biography of Georgia O'Keeffe.
3. GOK to Neith Hapgood, in Hutchins Hapgood, *Victorian in the Modern World* (New York: Harcourt Brace, 1939).
4. Tomkins, notes.
5. Christine McRae Cocke, "Georgia O'Keeffe as I Knew Her," *The Angelos*, Nov. 1934.
6. Tom Zito, "Georgia O'Keeffe," *Washington Post*, Nov. 9, 1977.
7. GOK to MDL, Summer 1929 (YCAL, EGOK).
8. Cocke, "Georgia O'Keeffe."
9. Ibid.
10. Ibid.
11. Klenert interview.
12. GOK to COKK, Nov. 3, 1904. (Family of Catherine O'Keeffe Klenert, EGOK). The envelope appears to be dated 1907, but this date could not be correct, as Georgia was then registered at courses at the Art Students League in New York. Probably a 1904 letter was mistakenly placed in a 1907 envelope.
13. Lisle, *Portrait of the Artist*, p. 25.
14. Charlotte Willard, "Georgia O'Keeffe," *Art in America*, Oct. 1963.
15. Cocke, "Georgia O'Keeffe."
16. Frances Hallam Hurt, "Famed Artist Georgia O'Keeffe Still Has Ties with Virginia," *Richmond Times-Dispatch*, Apr. 16, 1978.
17. Pollitzer, unpublished biography.

Chapter 5

1. GOK to AP, Feb. 1916? (YCAL, EGOK).
2. Art Institute of Chicago, Circular of Instruction of the School, 1905.
3. Ibid.
4. Lisle, *Portrait of an Artist*, p. 32.
5. Ibid.

Chapter 6

1. *Scribner's* 19 (Jan.–June 1896).
2. Ron Pisano, *William Merritt Chase* (New York: Watson-Guptill, 1986), p. 12.
3. Ibid., p. 11.
4. GOK to R. Pisano, Sept. 18, 1972 (Ron Pisano, New York, EGOK).
5. Pisano, *Chase*, p. 48.
6. GOK to R. Pisano, Aug. 18, 1972 (Ron Pisano, New York, EGOK).
7. Frank Goodyear, *Cecilia Beaux* (Philadelphia: Pennsylvania Academy of the Fine Arts, 1974), p. 17.

8. Kotz, "A Day with O'Keeffe."

9. Tomkins, notes.

10. Kotz, "A Day with O'Keeffe."

11. Ibid.

Chapter 7

1. As is true of many art historical theories, and of almost all of those concerning Alfred Stieglitz, there are nearly as many examples that disprove this precept as that prove it. Many of Stieglitz's early photographs in Europe demonstrate his interest in documenting the time and place through which he passed; his famous work *The Steerage* unquestionably makes an appeal to a social conscience; and he himself became an avid recorder of city life at all levels.

The philosophical gap was a legitimate one, however. There is a real difference between the photographer whose work was primarily intended as a work of art and one whose work was primarily a visual document, and this difference was central to Stieglitz's crusade in this country. The American art world resolutely refused to accept photographs as aesthetic works, and though Stieglitz and his allies did finally manage to change this attitude, it would have been a more difficult struggle had they claimed that images of slums and Indians, instead of smooth and languid nudes, were works of art.

2. William Innes Homer, *Alfred Stieglitz and the American Avant-Garde* (Boston: New York Graphic Society, 1979), p. 28.

3. In his house in New York Stieglitz hung reproductions of works by Franz von Stuck and one by Arnold Böcklin—*Island of the Dead,* full of somber portent. Both these painters' work celebrated a mood of romantic mystery.

4. Stieglitz demonstrated this conviction by his exhibition, in 1912 and 1914, of works done by the children, aged two to eleven, from a Lower East Side settlement house where Walkowitz taught. Similarly, in 1916, he showed the work of René Lafferty, an artist who had spent the preceding two years in a mental institution.

5. Homer, *Stieglitz*, p. 43.

6. Ibid.

7. Ibid., p. 70.

8. Georgia O'Keeffe, "Alfred Stieglitz: His Pictures Collected Him," *New York Times*, Dec. 11, 1949.

9. *Georgia O'Keeffe: A Portrait by Alfred Stieglitz*, Introduction by Georgia O'Keeffe (New York: Metropolitan Museum of Art, 1978), unpaged. Copyright © 1978 The Metropolitan Museum of Art. Copyright © 1978 Estate of Georgia O'Keeffe. All further references to material so copyrighted will be designated as PAS.

Chapter 8

1. *Lake George Mirror*, 1909, in "Yaddo Newsletter," Summer 1985.

2. O'Keeffe, *O'Keeffe*.

3. Ibid.

4. George Dannenberg appears to have been the first man with whom Georgia was emotionally involved. A group of letters to Georgia from an unidentified

man, written between 1910 and 1916?, were given to Georgia's first biographer, Anita Pollitzer. The writer is evidently an artist, and Georgia describes him as a young man "from the Far West." Dannenberg, an enterprising scholarship student at the league while Georgia was there, was from San Francisco. It was he who accompanied her when she dressed as Peter Pan, as well as to other student parties. To a later biographer, Laurie Lisle, he acknowledged a close emotional relationship between himself and Georgia. It seems likely that Dannenberg was the author of the letters, and so it will be assumed for the purposes of this biography, although the evidence is far from complete. At any rate, the writer of the letters is as described, and naming him "Dannenberg" may be viewed as a convenience.

5. Francis Hallam Hurt, "The Virginia Years of Georgia O'Keeffe," *Commonwealth*, Oct. 1980.

6. GOK to F. Cooney, Nov. 3, 1908, in Pollitzer, unpublished biography.

7. Tomkins, notes.

8. There are conflicting opinions about the dates of Georgia's second sojourn in Chicago. Laurie Lisle's biography gives the dates as 1908–10; Anita Pollitzer's, 1910–12. The truth is difficult to determine: since Georgia worked as a free-lance artist and lived with her family, there are no records that would show Georgia's presence. A letter from Dannenberg in February 1912, however, mentions his hope to travel to see her in Virginia, so the earlier dates seem the more likely. Though Pollitzer's information would have come directly from O'Keeffe herself, O'Keeffe often was wrong about dates.

9. GOK to COKK, Feb. 8, 1924.

10. There is some confusion about the dates and the movements of the O'Keeffes during the next few years, but from available information it appears that Ida and the children moved to Charlottesville in 1909.

11. GD? to GOK, Feb. 1910, in Pollitzer, unpublished biography.

12. Ibid., July 13, 1910, in Pollitzer, unpublished biography.

13. GD? to GOK, Sept. 7, 1910, in Anita Pollitzer, *A Woman on Paper: Georgia O'Keeffe* (New York; Simon & Schuster, 1988), p. 100. The complete unpublished text referred to in notes 11 and 12 was the source for this book.

14. GD? to GOK, Feb. 19, 1911, in ibid., p. 100.

15. GD? to GOK, Nov. 30, 1910, in Pollitzer, unpublished biography.

16. GD? to GOK, Feb. 19, 1911, in Pollitzer, *A Woman on Paper*, p. 100.

17. Katherine Kuh, *The Artist's Voice* (New York: Harper & Row, 1962), p. 189.

18. Sandra Gilbert and Susan Gubar, *The Madwoman in the Attic* (New Haven and London: Yale University Press, 1979), p. 47.

19. Kuh, *The Artist's Voice*, p. 189.

20. GOK to R. Pisano, Sept. 18, 1972.

21. Lisle, *Portrait of the Artist*, p. 40.

22. GOK to AP, 1916 (YCAL).

23. Ibid.

24. Ibid.

25. Arthur Warren Johnson, "Arthur Wesley Dow," *Ipswich Historical Society*, no. 28, 1934.

26. Ibid.
27. Ibid.
28. Ibid.
29. Willard, "Georgia O'Keeffe."
30. GOK to AP, Aug. 25, 1915 (YCAL, EGOK).

Chapter 9

1. Tomkins, notes.
2. *Amarillo Daily News*, May 5, 1912.
3. Ibid., Oct. 6, 1912.
4. Ibid., Sept. 1, 1912.
5. Tomkins, notes.
6. O'Keeffe, in Vivian Robinson, "Famed Artist Remembers Amarillo as Brown Town," *Amarillo Globe-Times*, Aug. 26, 1965.
7. Tomkins, notes.
8. Cornelia Patton Wolflin, interview with Al Koschka, Amarillo Art Center.
9. Ibid.
10. Ibid.
11. Tomkins, notes.
12. Ibid.
13. Kotz, "A Day with O'Keeffe."
14. Ibid.
15. Wolflin interview.
16. Tomkins, notes.
17. Kotz, "A Day with O'Keeffe."
18. GD? to GOK, Feb. 1912.
19. Kotz, "A Day with O'Keeffe."
20. Hurt, "The Virginia Years."

Chapter 10

1. Milton Brown et al., *American Art* (New York: Abrams, 1979), p. 356.
2. Ibid.
3. Jonathan Green, ed., *Camera Work: A Critical Anthology* (Millerton, N.Y.: Aperture, 1973), p. 143.
4. AS to W. Orison Underwood, 1914, in Sarah Greenough and Juan Hamilton, *Alfred Stieglitz: Photographs and Writings* (Washington: National Gallery of Art, 1983), 197.
5. Brown, *American Art*, p. 381.
6. Ibid.
7. Anita Pollitzer, "That's Georgia!" *Saturday Review*, Nov. 4, 1950.
8. Dorothy Norman, *Stieglitz: An American Seer* (New York: Random House, 1960), p. 129.

9. Tomkins, notes.

10. AP to GOK, October 14, 1915 (YCAL). These are *Unidentified Portrait of a Woman* and *Lady with Red Hair* (nos. 1 and 4 in *GOK*, Peters and Hirschl & Adler, June 1986).

Unidentified Portrait of a Woman (Anita Pollitzer?) is a tiny, three-quarter-length portrait of the young woman standing at her easel. This picture, with its shadowy, dissolving forms and mysterious lighting, reflects pictorialist influence.

In *Lady with Red Hair (Dorothy True?)*, the composition is bold and highly simplified: a sweep of collar cuts the picture diagonally; above that is the stylized shape of Miss True's head in profile. The skin is flat white and the hair is clear carrot; behind the face is a scattered pattern of white polka dots. The picture is abstract in feeling, though the subject is recognizable, and the feeling for form, pattern, and color is strong. Its flattened, two-dimensional aspect, large masses of bold, undifferentiated color, the even, diffuse light, and the use of purely decorative patterning all refer indirectly to Dow's influence, but a much more direct connection can be made to the poster style that was popular in the first decade of the century.

The poster artists created bold, graphic images through the dead flattening of a realistic outline, without internal line or shadow. This resulted in a deliberate visual disorientation, and a modernist reinterpretation of space, as did cubism. The poster school's approach was deliberately dramatic, however, as opposed to the subdued color and complicated composition of the cubists. The poster school's images could be read in purely conventional terms; they achieved their strength through the vivid use of color and a subtle rearrangement of visual rules. All these were characteristics of Georgia's work: even during this moment of high excitement over the cubists, Georgia stayed aloof from their cool, analytical deliberations.

11. AP to GOK, Oct. 3, 1915 (YCAL).

12. GOK to AP, Feb. 10, 1916 (YCAL, EGOK).

13. Tomkins, notes.

14. GOK to AP, Feb. 21, 1916 (YCAL, EGOK).

15. AS to AP, Aug. 9, 1915 (YCAL, EGOK).

16. Georgia O'Keeffe, "Alfred Stieglitz: His Pictures Collected Him," *New York Times Magazine*, Dec. 11, 1949.

17. *O'Keeffe: A Portrait by Stieglitz*. (PAS).

18. Morning Pastorok, notes on a visit to O'Keeffe, June 1980.

19. GOK to AP, Oct. 1915 (YCAL, EGOK).

20. Wassily Kandinsky, *Concerning the Spiritual in Art* (New York: Dover, 1977), p. 2.

21. Roxana Barry (Robinson), "The Age of Blood and Iron: Marsden Hartley in Berlin," *Arts*, Oct. 1979, p. 166.

22. Ibid., p. 167. Using biblical metaphors, Kandinsky described the artist's task as an instructor: "[The artist] sees and points the way. The power to do this he would sometimes fain lay aside, for it is a bitter cross to bear." The artist's adviser is "Moses [who] descends from the mountain . . . he brings with him fresh stores of wisdom."

Religious overtones began to figure heavily in writing about art as the century progressed, but Kandinsky was one of the first to make a direct corre-

lation between the two systems of thought. Roger Fry, the English painter and critic, made the equation between art and religion even more specific. Fry was an important influence in England and in 1912 had arranged the first exhibition there of Postimpressionist work. He announced bluntly: "Art is a religion. It is an expression of and a means to states of minds as holy as any that men are capable of experiencing . . . It is towards art that modern minds turn, not only for the most perfect expression of transcendent emotion, but for an inspiration by which to live" (Gertrude Himmelfarb, *Marriage and Morals Among the Victorians* [New York: Knopf, 1985], p. 30). In America, this direct correlation between religion and art would emerge in the collective consciousness more slowly. Kandinsky's influence plays an important role in this gradual transference of moral responsibility from religion to art, from priest to painter.

23. Kandinsky, *Concerning the Spiritual,* p. 54.

24. Ibid, p. 48.

25. To this effect he wrote: "it is essential for [the people at large, and for that matter the artists themselves] to be taught the real meaning of art. That is what I am trying to do . . . and this work I am trying to do in such a conclusive manner that it will be done for all time" (AS to George D. Pratt, in Greenough and Hamilton, *Stieglitz*).

26. GOK to AP, c. June 10, 1915 (YCAL, EGOK).

27. Arthur Dow to C. J. Scott, Superintendent of Schools, Wilmington, Del., July 12, 1915, in Katherine Hoffman, *An Enduring Spirit: The Art of Georgia O'Keeffe* (Metuchen: Scarecrow Press, 1984).

28. AP to GOK, Sept. 25, 1915 (YCAL).

Chapter 11

1. AP to GOK, June 10, 1915 (YCAL).

2. GOK to AP, after June 10, 1915 (YCAL, EGOK).

3. AP to GOK, Aug. 7, 1915 (YCAL).

4. GOK to AP, Aug. 25, 1915 (YCAL, EGOK).

5. Ibid., Feb. 16, 1916 (YCAL, EGOK).

6. Ibid., after Oct. 4, 1915 (YCAL, EGOK).

7. Klenert interview.

8. GOK to AP, July 26–Aug. 7, 1915 (YCAL, EGOK).

9. Ibid., Aug. 25, 1915 (YCAL, EGOK).

10. AP to GOK, Feb. 8, 1916?/Dec. 1915? (YCAL).

11. GOK to AWM, Aug. 1915? (family of Arthur W. Macmahon, EGOK).

12. Ibid., Sept. 4, 1915 (family of Arthur W. Macmahon, EGOK).

13. Ibid., Sept. 12, 1915 (family of Arthur W. Macmahon, EGOK).

14. GOK to AP, Aug. 25, 1915 (YCAL, EGOK).

15. Ibid., before Sept. 18, 1915 (YCAL, EGOK).

16. GOK to AWM, Sept. 17, 1915 (family of Arthur W. Macmahon, EGOK).

17. GOK to AP, Oct. 1915 (YCAL, EGOK).

18. Ibid.

19. AP to GOK, Oct. 3, 1915 (YCAL).

20. GOK to AP, before Oct. 26, 1915 (YCAL, EGOK).

21. GOK to AWM, before Oct. 12?, 1915 (family of Arthur W. Macmahon, EGOK).

22. GOK to AP, after Oct. 4, 1915 (YCAL, EGOK).

23. Ibid., before Oct. 16, 1915 (YCAL, EGOK).

24. Ibid.

25. Lisle, Portrait of the Artist, p. 62.

26. Charlotte Perkins Gilman, "The Dress of Women," *The Forerunner*, 1915. "Woman, no matter what form of labor she was expected to follow in the home, found her main line of economic advantage in pleasing man. Through him came wealth and pleasure, as also social station, home and family. . . . As one honest man explained, the reason men admire paint on a woman is because it shows her ardent wish to attract; and the cruder her performance the more plainly it shows that alone to be her motive." The clothes women wore, she explained, had little relevance to their daily activities. The guiding force behind their choice of dress was the attracting of men. Thus housewives wore heavy, flammable dresses that increased risk of fire around grease and stoves, and of illness around laundry vats and drying lines.

Gilman took on the whole spectrum of clothes and their support of the social system. Starch, she pointed out, was an absurd element in clothing, neither comfortable nor necessary. "One might as well hang a dinner-plate across his chest, as the glaring frontlet [starched shirtfront] so beloved to the masculine heart."

The essay was full of reasonable but radical thoughts that stripped away conventional artifice. Her brisk assessment of civilized manners was pithy and incisive, and directly antithetical to the received custom of the times:

> We mean by modesty a form of sex consciousness, especially peculiar to woman. For a maiden to blush and cast down her eyes when a man approaches her is an instance of this "modesty." It shows that she knows he is a male and she is a female, and her manner calls attention to the fact. If she met him clear-eyed and indifferent, as if she was a boy, or he was a woman, this serene indifference is not at all "modest."

Reminding her readers that the functions of the human foot were to support and permit movement, she reasoned that anything that interferes with these uses was mechanically wrong. Women's shoes, she pointed out, were "not only mechanically defective, but sometimes instruments of torture." She described the absurdity of the high heel and the narrow toe: "Naturally the foot is narrow at the heel and broad across the toes—that is the shape of a foot. But it is not the shape of a shoe."

27. GOK to AP, before Oct. 26, 1915/before Dec. 14, 1915 (YCAL, EGOK).

28. AP to GOK, Oct. 8, 1915 (YCAL).

29. GOK to AP, Oct. 14, 1915 (YCAL, EGOK).

30. Ibid., Oct. 11, 1915 (YCAL, EGOK).

31. Ibid., Oct. 26, 1915 (YCAL, EGOK).

32. Ibid., after Oct. 12, 1915 (YCAL, EGOK).

33. Ibid., Jan. 1916 (YCAL, EGOK).

34. AP to GOK, Oct. 14, 1915 (YCAL).

35. AP to GOK, Nov. 8, 1915 (YCAL).

36. O'Keeffe, *O'Keeffe*.

37. GOK to AP, before Oct. 26, 1915 (YCAL, EGOK).

38. AP to GOK, Oct. 26, 1915 (YCAL).

39. Ibid.

40. GOK to AWM, Nov. 19, 1915 (family of Arthur W. Macmahon, EGOK).

41. GOK to AP, Nov. 1915? (YCAL, EGOK).

42. Ibid., Dec. 4, 1915 (YCAL, EGOK).

43. Ibid., early Dec.? 1915 (YCAL, EGOK).

44. Ibid., Dec. 4, 1915 (YCAL, EGOK).

45. GOK to AWM, Nov. 30, 1915 (family of Arthur W. Macmahon, EGOK).

46. GOK to AP, Dec. 13?, 1915 (YCAL, EGOK).

47. GOK to AWM, Dec. 25, 1915 (family of Arthur W. Macmahon, EGOK).

48. AP to GOK, Jan. 1, 1916 (YCAL, EGOK).

49. Ibid.

50. GOK to AP, Jan. 4, 1916 (YCAL, EGOK).

51. Ibid.

52. GOK to AWM, Jan. 6?, 1916 (family of Arthur W. Macmahon, EGOK).

Chapter 12

1. GOK to AS, Jan. 1916, Quoted in Pollitzer, Anita, *A Woman on Paper, op. cit.,* p. 123.

2. AS to GOK, Jan. 1916, in Pollitzer, *A Woman on Paper*, p. 124.

3. GOK to AS, Jan. 1916, in Alexander Eliot, *Three Hundred Years of American Painting* (New York: Time, 1957), p. 188.

4. GOK to AP, Jan. 1916 (YCAL, EGOK).

5. Ibid., Feb. 16, 1916 (YCAL, EGOK).

6. Ibid.

7. GOK to AWM, Feb. 8, 1916 (family of Arthur W. Macmahon, EGOK).

8. GOK to AP, Feb. 9, 1916 (YCAL, EGOK).

9. Ibid.

10. GOK to AWM, Feb. 9, 1916 (family of Arthur W. Macmahon, EGOK).

11. GOK to AP, before Feb. 25, 1916 (YCAL, EGOK).

12. GOK to AWM, before Jan. 6?, 1916 (family of Arthur W. Macmahon, EGOK).

13. Ibid., Dec. 28, 1916 (family of Arthur W. Macmahon, EGOK).

14. *O'Keeffe: A Portrait by Stieglitz* (PAS).

15. Conflicting statements make this exhibition impossible to date: O'Keeffe mentions that it occurred after the Hartley exhibition and that it was just after Marin had bought his island in Maine. The island was bought in 1915, however, according to Lowe, and Hartley's exhibition of German oils was in the winter of

1915–16. Probably it was the Marin show of Jan. 18–Feb. 12, 1916, just before the Hartley show of Apr. 4–May 22.

16. Norman, *Stieglitz*, p. 130.

17. Herbert J. Seligmann, *Alfred Stieglitz Talking* (New Haven: Yale University Press, 1966), p. 24.

18. Enclosed in letter, AP to GOK, after Aug. 20, 1916 (YCAL).

19. GOK to AP, before Feb. 25?, 1916 (YCAL, EGOK).

20. Ibid.

21. Norman, *Stieglitz*, p. 130.

22. Hapgood, *Victorian in the Modern World*, p. 338.

23. Sue Davidson Lowe, *Stieglitz: A Memoir/Biography* (New York: Farrar, Straus & Giroux, 1983), p. 20.

24. Horace Bushnell, "Women's Suffrage: The Reforms Against Nature," 1869, in Bram Dijkstra, *Idols of Perversity* (New York: Oxford University Press, 1986), p. 11.

25. Ibid., p. 13.

26. Lowe, *Stieglitz*, p. 15.

27. Ibid., p. 38.

28. Ibid., p. 50.

29. Ibid., p. 94.

30. AS to M. N. Aisen, June 30, 1913 (YCAL).

31. Lowe, *Stieglitz*, p. 103.

32. AS to E. O. Stieglitz, Aug. 6, 1916 (YCAL).

33. GOK to AP, before July 22, 1916 (YCAL, EGOK).

34. Ibid.

35. AS to GOK, June 1916, in Pollitzer, *A Woman on Paper*, p. 139.

36. Ibid.

37. Ibid.

38. AS to GOK, July 10, 1916, in Pollitzer, *A Woman on Paper*, p. 140.

39. AS to GOK, July 16, 1916, in ibid.

40. GOK to AS, July 27, 1916. Quoted in Jack Cowart, Juan Hamilton, and Sarah Greenough, *Georgia O'Keeffe: Art and Letters*, p. 154 (New York: National Gallery of Art in association with New York Graphic Society Books, Little, Brown and Company, Boston, 1987.) Copyright © 1987 Board of Trustees, National Gallery of Art. Copyright © 1987 Estate of Georgia O'Keeffe. All further references to materials so copyrighted will be designated as CHG.

41. AS to GOK, July 31, 1916, in Pollitzer, *A Woman on Paper*, p. 141.

42. Ibid.

Chapter 13

1. GOK to AWM, May 3, 1916 (family of Arthur W. Macmahon, EGOK).

2. A letter from Stieglitz in 1928 mentions that Georgia "hadn't been there [Madison] in twelve years" (AS to MRB, Aug. 26, 1928 [YCAL]), which places

her previous visit in 1916. Presumably this would have been to her mother's funeral. No decisively corroborating evidence survives regarding this trip, but on June 11 she wrote to Macmahon that she might "go" on the following night, and that she would leave soon in any case. Her destination was not named.

3. GOK to AWM, June 19, 1916 (family of Arthur W. Macmahon, EGOK).

4. Ibid.

5. GOK to AP, June 21, 1916 (YCAL, EGOK).

6. Ibid., Oct.? 1915 (YCAL, EGOK).

7. Ibid., June 21, 1916 (YCAL, EGOK).

8. Ibid., before Oct. 16, 1915 (YCAL, EGOK).

9. GOK to AWM, June 28, 1916 (family of Arthur W. Macmahon, EGOK).

10. Ibid., June 20, 1916 (family of Arthur W. Macmahon, EGOK).

11. GOK to AP, Sept. 27, 1916 (YCAL, EGOK). Several versions of it are still extant. The series was not limited to blue: Anita mentions "the tiny little emerald and cobalt hillside and trees" (AP to GOK, Sept. 27, 1916 [YCAL]). Several small mountain landscapes, such as "Landscape and Layered Mountain," "Pink and Green Mountain #1" and "Blue Hill #2," may well be from that series, though the first two are generally dated 1917.

The same is true of "Tent Door at Night," of which there are at least three known versions. This is generally dated c. 1913, but photographs show that it was exhibited at "291" in 1917, with works of 1916; it seems unlikely that a work from three years earlier would be included with this group. It is, more likely, from this Summer 1916 series. The works are stylistically similar: looser and bolder than surviving work from the earlier years, they contain the predominant blues that are characteristic of this period. Moreover, the tent and mountain pictures suggest the southeastern landscape, not the western one: these gentle wooded slopes are not in Texas. And, as circumstantial evidence, in August 1916 Georgia went on an extended camping trip in the mountains near Asheville: "We camped nights—had a tent . . . You can't imagine how much fun it was . . . I got up in those mountains and I simply couldn't leave" (GOK to AP, before Sept. 11, 1916 [YCAL]). At the end of the summer she wrote Stieglitz: "It seems so funny that a week ago it was the mountains I thought the most wonderful—and today its the plains. I guess its the feeling of bigness in both that carries me away" (GOK to AS, Summer 1916, in Pollitzer, unpublished biography).

12. AS to MRB, Aug. 26, 1916 (YCAL). Marie Rapp (Boursault) was an early worker at "291," model for Stieglitz, and a good friend to him for years.

13. GOK to AWM, before Sept. 7, 1916 (family of Arthur W. Macmahon, EGOK).

14. GOK to AP, before Sept. 11, 1916 (YCAL, EGOK).

15. *Bulletin*, West Texas State Normal College, June 1918.

16. GOK to AS, Sept. 4, 1916, in Cowart, Hamilton, and Greenough, *Art and Letters*, p. 155 (CHG).

17. GOK to AP, before Sept. 11, 1916 (YCAL, EGOK).

18. Ibid.

19. Ibid.

20. Ibid., answered Oct. 3, 1916 (YCAL, EGOK).

21. GOK to PS, July 24, 1917 (PSA, CCP, EGOK).

22. Ruby Cole Archer, interview with Al Koschka, Amarillo Art Center.

23. *Bulletin,* West Texas State Normal College, May 1916.

24. GOK to AP, before Sept. 11, 1916 (YCAL, EGOK).

25. The texts O'Keeffe used at West Texas were: Charles Caffin, *A Guide to Pictures* and *How to Study Pictures;* Reinach's *Apollo;* Arthur Wesley Dow, *Composition* and *Theory and Practice of Teaching Art;* Willard Huntington Wright, *The Creative Will* and *Modern Painting;* Clive Bell, *Art;* Frank Alva Parsons, *Interior Decoration;* and two unidentified texts, *History of Costume* and *Primitive Art.*

26. Archer interview.

27. Ibid.

28. GOK to AP, Feb. 19, 1917 (YCAL, EGOK).

29. GOK to AWM, Sept. 25, 1916 (family of Arthur W. Macmahon, EGOK).

30. GOK to AP, Sept. 11, 1916 (YCAL, EGOK).

31. Wolflin interview.

32. GOK to AP, Oct.? 1916 (YCAL, EGOK).

33. Ibid., Sept. 11–19, 1916 (YCAL, EGOK).

34. GOK to AP, after Jan. 24, 1917 (YCAL, EGOK).

35. GOK to AWM, before Sept. 7, 1916 (family of Arthur W. Macmahon, EGOK).

36. Ibid., Sept. 25, 1916 (family of Arthur W. Macmahon, EGOK).

37. GOK to AP, Sept. 11–19, 1916 (YCAL, EGOK).

38. Ibid., Oct.? 1916 (YCAL, EGOK).

39. Ibid., Nov. 1916 (YCAL, EGOK).

40. GOK to AP, before Oct. 2, 1916 (YCAL, EGOK).

41. Ibid., Oct. 30, 1916 (YCAL, EGOK).

42. Green, *Camera Work,* p. 289.

43. Kotz, "A Day with O'Keeffe."

44. GOK to AS, July 27, 1916, in Cowart, Hamilton, and Greenough, *Art and Letters,* p. 153 (CHG).

45. Kotz, "A Day with O'Keeffe."

46. GOK to AWM, rec. Sept. 8, 1916 (family of Arthur W. Macmahon, EGOK).

47. Ibid., Oct. 15, 1916 (family of Arthur W. Macmahon, EGOK).

48. Ibid., Dec. 28, 1916 (family of Arthur W. Macmahon, EGOK).

49. Ibid.

50. Ibid.

51. GOK to AP, Oct. 30, 1916 (YCAL, EGOK).

52. Ibid., Jan. 17, 1917 (YCAL, EGOK).

53. Ibid., Oct. 30, 1916 (YCAL, EGOK).

54. Ibid., Sept. 11–19, 1916 (YCAL, EGOK).

55. Ibid., Feb. 19, 1917 (YCAL, EGOK).

56. Ibid., Sept. 19? (before Oct. 2), 1916 (YCAL, EGOK).

57. Ibid., Jan. 17, 1917 (YCAL, EGOK).

58. AP to GOK, Feb 10. 1917 (YCAL, EGOK). Anita had earlier sent her an application form and suggested that she join and submit work to the Society of Independent Artists exhibition. Sarah Greenough, in her excellent "Notes" accompanying the National Gallery exhibition of O'Keeffe's work, remarks that her work was accepted for the Independent Artists exhibition but it was Alfred Stieglitz who sent it. This is probably not the case; it seems to have been Georgia who submitted her work. From the guild records, it is clear that it was Stieglitz who was responsible for the People's Art Guild show entry.

59. GOK to PS, Aug. 16, 1917 (PSA, CCP, EGOK).

60. Ibid.

61. Seligmann, *Stieglitz Talking,* p. 12.

Chapter 14

1. Clement Greenberg, *The Nation,* June 15, 1946.

2. W. C. Brownell, "Recent Work by Elihu Vedder," *Scribner's* 17 (Jan.–June 1895), p. 162.

3. Greenberg, *The Nation.*

4. AP to GOK, Oct. 30, 1916 (YCAL).

5. GOK to AP, June 20, 1917 (YCAL, EGOK).

6. Calvin Tomkins, "Look to the Things Around You," *The New Yorker,* Sept. 16, 1974, p. 44.

7. Ibid.

8. GOK to PS, June 3, 1917, in Cowart, Hamilton, and Greenough, *Art and Letters,* p. 161 (CHG).

9. GOK to PS, June 25, 1917 (PSA, CCP, EGOK).

10. Ibid., June 12, 1917 (PSA, CCP, EGOK).

11. Ibid., June 25, 1917 (PSA, CCP, EGOK).

12. Ibid.

13. Ibid.

14. Ibid.

15. Ibid., June 21, 1917 (PSA, CCP, EGOK).

16. Ibid., June 25, 1917, in Cowart, Hamilton, and Greenough, *Art and Letters,* p. 163 (CHG).

17. Ibid., July 1, 1917 (PSA, CCP, EGOK).

18. GOK to AWM, rec. June 20, 1917 (family of Arthur W. Macmahon, EGOK).

19. Ibid., June 21, 1917 (family of Arthur W. Macmahon, EGOK).

20. Ibid., July?, 1917 (family of Arthur W. Macmahon, EGOK).

21. AP to GOK, Sept. 24, 1917 (YCAL).

22. GOK to PS, June 12, 1917 (PSA, CCP, EGOK).

23. AS to MRB, Sept. 10, 1917 (YCAL).

24. AS to PS, possibly a draft, Aug. 19, 1917 (YCAL).

25. GOK to PS, Aug. 16, 1917 (PSA, CCP, EGOK).

26. Ibid.

27. Willard, "Georgia O'Keeffe."

28. In an undated letter to Blanche Matthias from the hotel, Georgia mentioned that she had stayed there before (YCAL).

29. AS to MRB, Sept. 12, 1917 (YCAL).

30. GOK to PS, Sept. 1, 1917 (PSA, CCP, EGOK).

31. Ibid.

32. AS to MRB, Sept. 12, 1917 (YCAL).

33. Willa Cather, in *Lincoln State Journal*, Nov. 2, 1921.

34. GOK to PS, Sept. 12, 1917 (PSA, CCP, EGOK).

35. Ibid.

36. Ibid., June 3, 1917 (PSA, CCP, EGOK).

37. GOK to Anna Barringer, Dec.? 1917. Barringer Family Papers (#9431-a), Manuscripts Division, Special Collections Department, University of Virginia Library (EGOK).

38. GOK to PS, Oct. 30, 1917 (PSA, CCP, EGOK).

39. GOK to ESD, Christmas, 1917 (YCAL, EGOK).

40. This incident is shrouded in mystery. According to Claudia O'Keeffe, Georgia's advice to Ted Reid caused difficulties with the administration. Anita Pollitzer received the same information, from either Georgia, Ted, or both. Reid, however, in an interview on tape, states that as far as he knew, Georgia's advice to him had no repercussions from the administration and that she left Canyon for reasons unrelated to him. To confuse things further, a letter from Georgia to Paul Strand dated November 15, 1917, comments that Ted was then at the station, leaving for the war. Reid, however, asserted that he helped Georgia pack her things to go to San Antonio, which she did two months later, in February 1918.

41. GOK to ESD, early 1918, no. 3 (YCAL, EGOK).

42. AS to MRB, July 23, 1917 (YCAL).

43. AS to PS, possibly a draft, Aug. 19, 1917 (YCAL).

44. GOK to ESD, early 1918, no. 3 (YCAL, EGOK).

45. AS to GOK, Mar. 31, 1918, in Pollitzer, *A Woman on Paper*, p. 159.

46. AS to PS, possibly a draft, May 18?, 1918 (YCAL).

47. Nancy Newhall, in Homer, *Stieglitz*, p. 11.

48. GOK to ESD, April 27, 1917, in Pollitzer, *A Woman on Paper*, p. 160.

49. PS to AS, May 29, 1918 (YCAL, APSA).

50. Georgia acknowledged at the end of 1917 that she had not worked since September. It is unlikely that she painted anything before February 1918, when she went to Waring to recover from her influenza and depression. In late May or early June 1918, Stieglitz wrote that he had received "a package of O'Keeffe's —packed beautifully by Strand. Several . . . very beautiful—a couple of Nudes —marvels of Expression—Development— There are landscapes and houses and people—and nudes of a friend—girl—all truly O'Keeffe" (AS to ESD, late May–early June 1918 [YCAL]).

51. These works are not derivative, however, as Lisa Mintz Messinger points out; she uses no pencil lines to define the outlines of the figures, and she demonstrates clearly her intense commitment to voluptuous color. Her hues are more high-keyed than the Rodin works, her shapes more modeled. Her control of the medium is impressive—O'Keeffe was a brilliant watercolorist—and the composition in these works is informed by the fluid nature of the medium and the flowing, voluptuous quality of the line. For further discussion of these works, see Lisa Mintz Messinger, *Georgia O'Keeffe* (New York: Metropolitan Museum of Art, 1988).

52. AS to PS, possibly a draft, May 17, 1918 (YCAL).

53. GOK to AP, Oct. 16, 1915 (YCAL, EGOK).

Chapter 15

1. AS to ESD, June 16, 1918 (YCAL).

2. Ibid.

3. AS to AGD, June 18, 1918 (YCAL).

4. AS to ESD, June 16, 1918 (YCAL).

5. O'Brien, *Willa Cather*, p. 92.

6. IOK to AS, July 4, 1925 (YCAL).

7. O'Keeffe, *O'Keeffe*.

8. AS to ESD, July 2, 1918 (YCAL).

9. GOK to AP, Oct. 16?, 1915 (YCAL, EGOK).

10. AS to AGD, c. July 9, 1918 (YCAL).

11. *O'Keeffe: A Portrait by Stieglitz* (PAS).

12. AS to ESD, June 13?, 1918 (YCAL).

13. *O'Keeffe, A Portrait by Stieglitz* (PAS).

14. AS to ESD, c. June 13, 1918 (YCAL).

15. Ibid., June 16, 1918 (YCAL).

16. The pictures taken that day may be the 1918 series of Georgia in a black hat, against some of her pictures on the wall. It is unlikely that her pictures would have been put up on Elizabeth's lemon-yellow walls, and there was, by then, no gallery in which to hang them. Stieglitz had told a friend that he had taken O'Keeffe's pictures home to his own small dressing room. Besides a purely self-destructive one, there seems no other reason for Stieglitz to bring Georgia to 1111 Madison Avenue than to use her work as a background for her portrait.

17. Lowe, *Stieglitz*, p. 217.

18. AS to MRB, July 9, 1918 (YCAL).

19. AS to AGD, Aug.? 1918 (YCAL).

20. AS to MRB, July 10, 1918 (YCAL).

21. AS to E.O. Stieglitz, June 1918? (YCAL).

22. *O'Keeffe: A Portrait by Stieglitz* (PAS).

23. O'Keeffe's comment refers to a photograph by AS, which is almost certainly "My Parents' Home—Lake George" of 1907 (Georgia O'Keeffe, "Can a Photograph Have the Significance of Art?" *MSS*, Dec. 1922).

24. Tomkins, notes.
25. AS to PS, possibly a draft, Aug.? 1918 (YCAL).
26. AS to MRB, Aug. 13, 1917 (YCAL).
27. Seligmann, *Stieglitz Talking*, p. 67.
28. AS to AGD, c. July 9, 1918 (YCAL).
29. GOK to ESD, Aug. 1918? (YCAL, EGOK).
30. Pastorok, notes.
31. *O'Keeffe: A Portrait by Stieglitz* (PAS).
32. Ansel Adams, *Ansel Adams: An Autobiography* (Boston: New York Graphics Society/Little, Brown, 1985), p. 79.
33. Janet Malcolm, "Artists and Lovers," *The New Yorker*, March 12, 1979.
34. Ibid.
35. Kotz, "A Day with O'Keeffe."

Chapter 16

1. AS to MRB, Aug. 8, 1918 (YCAL).
2. AS to ESD, Aug. 18, 1918 (YCAL).
3. Lowe, *Stieglitz*, p. 218.
4. AS to MRB, Aug. 8, 1918 (YCAL).
5. K. Stieglitz to AS, Spring 1919? (YCAL).
6. Klenert interview.
7. Though Georgia and Catherine were both quoted as saying they were not a close family, this was not borne out by the facts, and Catherine later retracted her statement. (The comment also indicated sheer contrariness: Georgia often, and Catherine sometimes, took a mildly perverse pleasure in shocking earnest questioners.)
8. AS to ESD, Aug. 18, 1918 (YCAL).
9. Lowe, *Stieglitz*, p. 218.
10. AS to ESD, Aug. 18, 1918 (YCAL).
11. Tomkins, notes.
12. Ibid.
13. Ibid.
14. AS to ESD, Aug. 18, 1918 (YCAL).
15. Ibid., Nov. 4, 1924 (YCAL).
16. Ibid., Nov. 9, 1925 (YCAL).
17. AS to PS, possibly a draft, Sept. 15, 1918 (YCAL).
18. Dorothy Seiberling, "Horizons of a Pioneer," *Life*, Mar. 1, 1968.
19. Pastorok, notes.
20. Tomkins, notes.
21. GOK to SA, Oct. 1924 (NBL, EGOK).
22. Seiberling, "Horizons."
23. Pastorok, notes.

24. Seiberling, "Horizons."

25. AS to PS, Sept. 15, 1918 (YCAL).

26. GOK to ESD, Summer 1921? (YCAL, EGOK).

27. Ibid.

28. AS to ESD, Nov. 14, 1920 (YCAL).

29. Ibid., Oct. 18, 1923 (YCAL).

30. Cynthia Earl Kerman and Richard Eldridge, *The Lives of Jean Toomer* (Baton Rouge: Louisiana State University Press, 1987), p. 102.

31. Peyton Boswell, "Notes on Painting and Sculpture," *Vanity Fair*, Jan. 1922.

32. In Kerman and Eldridge, *Toomer*, p. 102.

33. The date of 1920 for this first trip to Maine is given only in O'Keeffe, *O'Keeffe*; it is not verified anywhere else. Many of the dates O'Keeffe gives are incorrect: for example, she says that Stieglitz began photographing her when she was about twenty-three—in fact, she was thirty. There is no mention of a 1920 trip in any letters, and her first trip may not have taken place until 1922, when one is well documented. Regardless of the date, the dynamics of the experience remain the same.

34. AS to HMcB, July 6, 1939 (YCAL, APSA).

35. AS to ESD, Aug. 21, 1920 (YCAL).

36. PS to AS, July 26, 1928 (YCAL).

37. AS to HJS, Sept. 9, 1922 (YCAL).

38. AS to ESD, Aug. 21, 1920 (YCAL).

39. Ibid.

40. AS to MRB, Oct. 21, 1920 (YCAL).

41. Ibid.

42. Ibid.

43. Ibid., Sept. 3, 1920 (YCAL).

44. Ibid.

45. Ibid., Oct. 6, 1920 (YCAL).

46. Ibid.

47. GOK to AGD, Apr. 6, 1921 (YCAL, EGOK).

48. ESD to AS, Oct. 12, 1920? (YCAL).

49. Ibid.

50. Ibid.

51. Ibid.

52. AS to ESD, Nov. 14, 1920 (YCAL).

53. Lowe, *Stieglitz*, p. 247.

54. Klenert, interview.

Chapter 17

1. Henry McBride, "Stieglitz's Life Work," *New York Herald*, Feb. 13, 1921.

2. Ibid.

3. Seligmann, *Stieglitz Talking*, p. 136.

4. GOK to ESD, Summer 1921 (YCAL).

5. Henry McBride, "Curious Responses to Work of Miss O'Keefe [*sic*] on Others," *New York Herald*, Feb. 4, 1923.

6. Ibid.

7. Henry McBride, "O'Keeffe at the Museum," *New York Sun*, May 18, 1946, in Lisle, *Portrait of an Artist*, p. 102.

8. Paul Rosenfeld, "American Painting: Women, One," *The Dial*, Dec. 1921, pp. 666–70.

9. GOK to MK, Summer 1922 (MKP, NYPL, EGOK).

10. Marsden Hartley, "Some Women Artists," in *Adventures in the Arts* (New York: Boni and Liveright, 1921; Hacker Art Books, 1972), pp. 116–19.

11. GOK to MK, Summer 1922 (MKP, NYPL, EGOK).

12. Abba Goold Woolson, *Woman in American Society*, in Dijkstra, *Idols of Perversity*, p. 29.

13. GOK to MK, Summer 1921 (MKP, NYPL, EGOK).

14. Ibid.

15. Ibid.

16. GOK to D. McMurdo, July 1, 1922, in Cowart, Hamilton, and Greenough, *O'Keeffe*, p. 169 (CHG).

17. Ibid.

18. AS to HJS, Sept. 2, 1922 (YCAL).

19. COK to AS, Sept. 29, 1921 (YCAL).

20. Ibid., Nov. 11, 1920 (YCAL).

21. Ibid.

22. Peggy Bacon, *Off With Their Heads*, in Lisle, *Portrait of the Artist*, p. 203.

23. Tomkins, notes.

24. Ibid.

25. Ibid.

26. Ibid.

27. GOK to BM, Feb. 1926? (YCAL, EGOK).

28. Seiberling, "Horizons."

29. Tomkins, notes.

30. O'Keeffe, "Alfred Stieglitz."

31. GOK to BM, Apr. 1929 (YCAL, EGOK).

32. Seligmann, *Stieglitz Talking*, in Lisle, *Portrait of the Artist*, p. 117.

33. Tomkins, notes.

34. Roxana Barry (Robinson). Introduction, in Ann Lee Morgan, *Arthur Dove: Life and Work* (Newark: University of Delaware Press, 1984).

35. Ibid.

36. Tomkins, notes.

37. AS to RSS, July 5, 1922 (YCAL).

38. Ibid., July 15, 1922 (YCAL).

39. AS to Ward Muir, then to R. Child Bayley, pub. Sept. 1923; in Greenough and Hamilton, *Stieglitz*, pp. 206–8, 232 (CHG).

40. AS to ESD, Oct. 11, 1923 (YCAL).

41. GOK to F. Herrmann, Sept. 22, 1922; in Phillips Auction Gallery Catalogue (EGOK).

42. AS to RSS, Oct. 19, 1922 (YCAL).

43. Ibid., Oct. 28, 1922 (YCAL).

44. GOK to MDL, Sept. 1929 (YCAL, EGOK).

45. GOK to COKK, Oct. 4, 1960 (family of Catherine O'Keeffe Klenert, EGOK).

46. "I Can't Sing So I Paint."

47. AS to ESD, Aug. 12, 1919 (YCAL).

48. AS to HJS, Oct. 8, 1922 (YCAL).

49. Ibid., Oct. 29, 1922 (YCAL).

50. Ibid.

Chapter 18

1. Tomkins, notes.

2. McBride, "Curious Responses."

3. GOK to SA, Oct. 1924 (NBL, EGOK).

4. McBride, "Curious Responses."

5. GOK to HMcB, Feb. 1923 (YCAL, EGOK).

6. Ibid.

7. Exhibition catalogue, Anderson Galleries, Jan. 28–Feb. 10, 1923.

8. GOK to SA, Aug. 1?, 1923 (NBL, EGOK).

9. Ibid.

10. AS to ESD, Oct. 11, 1923 (YCAL).

11. Klenert, interview.

12. AS to RSS, Aug. 23, 1923 (YCAL).

13. Ibid., Aug. 15, 1923 (YCAL).

14. To Elizabeth he wrote of an unresolved issue: "Beck . . . seemed millions of miles removed from me— She's all right—but there is a messiness somewhere which will ever remain messy— I'm sorry (AS to ESD, Sept. 24 [YCAL]). And several years later, discussing Alfred's involvement with another woman, Elizabeth wrote him: "Even in the case of a stupidity—Beck or such—it should not go deep" (ESD to AS, July 26, 1928 [YCAL]).

15. AS to RSS, Oct. 2, 1923 (YCAL).

16. Ibid., Oct. 16, 1923 (YCAL).

17. GOK to ESD, Sept. 1923? (YCAL, EGOK).

18. AS to ESD, Sept. 24, 1923 (YCAL).

19. Ibid., Oct. 2, 1923 (YCAL).

20. Though Lowe states that the presence of the demanding infant cured Georgia of wanting children, Alfred's letters suggest that the baby beguiled both himself and Georgia.

21. GOK to SA, June 11, 1924 (NBL, EGOK).

22. AS to ESD, Oct. 2, 1923 (YCAL).

23. Ibid., Nov. 14, 1923 (YCAL).

24. IOK to AS, Nov. 24, 1923 (YCAL).

25. AS to RSS, Nov. 1, 1923 (YCAL).

26. AS to ESD, Oct. 2, 1923 (YCAL).

27. AS to RSS, Oct. 9, 1923 (YCAL).

28. GOK to SA, Feb. 11, 1924 (NBL).

29. GOK to RSS, Nov. 26, 1923 (YCAL).

30. GOK to COKK, Feb. 8, 1924.

31. Ibid.

32. Ibid.

33. *The Prairie*, Canyon, Tex., Oct. 23, 1923.

34. Exhibition catalogue, Anderson Galleries, Mar. 3–16, 1924.

35. Paul Strand, "Georgia O'Keeffe," *Playboy*, July 1924.

36. GOK to COKK, Feb. 8, 1924 (family of Catherine O'Keeffe, EGOK).

37. Seligmann, *Stieglitz Talking*, p. 94.

38. Anderson's letters to Stieglitz had been a great comfort to both him and O'Keeffe during the previous summer, 1923, when Stieglitz was sick. O'Keeffe was grateful for this, and she also felt an affinity for Anderson as revealed through his writing. His earthy style and background appealed to her. After reading his *Many Marriages*, she asked him to write an introduction to her show in 1924. Anderson pleaded illness but bought a painting from the exhibition, and their friendship flourished for a time. According to another friend, O'Keeffe did not like one of his subsequent books. She was candid, he was offended, and the friendship dissolved.

39. GOK to SA, Oct. 1924 (NBL, EGOK).

40. Ibid.

41. Ibid., June 11, 1924 (NBL, EGOK).

42. Ibid.

43. Ibid.

44. AS to RSS, June 26, 1924 (YCAL).

45. GOK to SA, June 11, 1924 (NBL, EGOK).

46. Ibid.

47. AS to RSS, July 17, 1924 (YCAL).

48. Ibid., Oct. 3, 1924 (YCAL).

49. AS to ESD, Aug. 3, 1924 (YCAL).

50. AS to RSS, Oct. 3, 1924 (YCAL).

51. GOK to SA, Oct. 1924? (NBL, EGOK).

52. AS to ESD, Aug. 4, 1918 (YCAL).

53. *O'Keeffe: A Portrait by Stieglitz* (PAS).

54. O'Keeffe, "Alfred Stieglitz."

55. Tomkins, notes.

56. AS to RSS, July 25, 1924 (YCAL).

57. GOK to BM, late 1920s? (YCAL, EGOK).

58. AS to ESD, Sept. 23, 1924 (YCAL).

59. GOK to SA, 1920s? (NBL, EGOK).

60. IOK to AS, July 11, 1924 (YCAL).

61. Ibid., June 9, 1924 (YCAL).

62. Ibid., Nov. 24, 1923 (YCAL).

63. Tomkins, notes.

64. O'Brien, *Willa Cather*, p. 105.

65. Seiberling, "Horizons."

Chapter 19

1. In the following year she turned to orchids, executed in pastel (AS to HJS, Aug. 9, 1920 [YCAL]).

2. AS to ESD, Sept. 23, 1924 (YCAL).

3. Ida filled the house with "many vases of wildflowers. She is a wonder at that" (AS to ESD, Sept. 23, 1924 [YCAL]).

4. Kotz, "A Day with O'Keeffe."

5. Kuh, *The Artist's Voice*, pp. 190–91.

6. Braggiotti, "Her Worlds Are Many."

7. GOK to art editor, *New York Times*, Feb. 23, 1941.

8. Kotz, "A Day with O'Keeffe."

9. GOK to PS, June 3, 1917 (PSA, CCP, EGOK).

10. Kuh, *The Artist's Voice*, p. 191.

11. Exhibition catalogue, Anderson Galleries, Jan. 29–Feb. 10, 1923.

12. Dijkstra, *Idols of Perversity*, pp. 15–16.

13. Edmund Wilson, *The Twenties*, ed. Leon Edel (New York: Farrar, Straus, 1975), p. 193.

14. Lewis Mumford, *Findings and Keepings* (New York: Harcourt, Brace, 1975), pp. 355–56.

15. Tomkins, "The Rose in the Eye."

16. Pastorok, notes.

17. Edmund Wilson, "The Stieglitz Exhibition," *New Republic*, Mar. 18, 1925.

18. Seligmann, *Stieglitz Talking*, p. 69.

19. Lowe, *Stieglitz*, p. 225.

20. Ibid.

Chapter 20

1. GOK to COKK, Dec. 24, 1926 (family of Catherine O'Keeffe Klenert, EGOK).
2. GOK to IOK, Nov–Dec. 1925? (YCAL, EGOK).
3. Ibid.
4. Ibid.
5. Seligmann, *Stieglitz Talking*, p. 66.
6. Ibid., p. 41.
7. GOK to BM, Feb. 1926? (YCAL).
8. Seligmann, *Stieglitz Talking*, pp. 30–31.
9. Ibid., p. 117.
10. Seiberling, "Horizons."
11. GOK to MDL, 1925? (YCAL). In Cowart, Hamilton, and Greenough, *Art and Letters*, p. 180 (CHG).
12. Seligmann, *Alfred Stieglitz Talking*, pp. 63–4.
13. AS to ESD, June 16, 1918 (YCAL).
14. AS to PS, May 17, 1918 (PSA, CCP).
15. GOK to COKK, Dec. 24, 1926 (family of Catherine O'Keeffe Klenert, EGOK).
16. Kotz, "A Day with O'Keeffe."
17. GOK to BM, early 1920s (YCAL, EGOK).
18. Blanche Matthias, "Georgia O'Keeffe and the Intimate Gallery," *Chicago Evening Post*, Mar. 2, 1926.
19. Ibid.
20. GOK to BM, Mar.? 1926 (YCAL, EGOK).
21. Ibid.
22. Ibid.
23. Ibid.
24. GOK to IOK, Nov.–Dec. 1925 (YCAL, EGOK).
25. GOK to BM, Mar.? 1926 (YCAL, EGOK).
26. GOK to W. Frank, Summer 1926, in Cowart, Hamilton, and Greenough, *Art and Letters*, p. 184 (CHG).
27. GOK to SA, June 1926? (NBL, EGOK).
28. AS to ESD, June 3, 1926 (YCAL).
29. Ibid., July 27, 1926 (YCAL).
30. AS to HJS, Aug. 20, 1926 (YCAL).
31. Ibid., Aug. 22, 1926 (YCAL).
32. Ibid., Sept. 5, 1926 (YCAL).
33. Ibid., Sept. 14, 1926 (YCAL).
34. Ibid., Aug. 16, 1926 (YCAL).
35. Ibid., Oct. 7, 1926 (YCAL).

36. Dorothy Norman, *Encounters* (New York: Harcourt Brace Jovanovich, 1987), p. 54.

37. AS to ESD, June 16, 1927 (YCAL).

38. Seiberling, "Horizons."

39. AS to RSS, Sept. 10, 1927 (YCAL).

40. AS to MRB, Oct. 25, 1927 (YCAL).

41. Norman, *Encounters*, p. 56.

42. Ibid., p. 57.

43. Ibid., pp. 57–8.

44. Tomkins, notes.

45. Sheldon Cheney, *A Primer of Modern Art* (New York: Boni and Liveright, 1924), p. 171.

46. Helen Torr, *Diaries*, Dec. 17, 1927 (AAA).

47. HMcB to GOK, Christmas, 1927 (YCAL, AAA).

48. IOK to GOK, June 1925? (YCAL).

49. IOK to AS, June 11, 1925 (YCAL).

50. Ibid., July 4, 1925 (YCAL).

51. Ibid., Aug. 13, 1925 (YCAL).

52. AS to HJS, Aug. 16, 1926 (YCAL).

53. Torr, *Diaries*, Dec. 30, 1927 (AAA).

54. Henry McBride, "O'Keeffe's Recent Work," *New York Sun*, Jan. 14, 1928.

55. GOK to HMcB, May 11, 1928 (YCAL, EGOK).

56. HMcB to GOK, May 20, 1928 (YCAL, AAA).

57. Lillian Sabine, "Record Price for Living Artist," *Brooklyn Eagle Sunday Magazine*, May 27, 1928.

58. AS to Mr. and Mrs. Allen, Mar. 26, 1927 (of a Gaston Lachaise sculpture) (YCAL).

59. B. V. Berman, "She Painted the Lily and Got $25,000 and Fame for Doing It!" *New York Evening Graphic Magazine*, May 12, 1928.

60. Anaïs Nin, *The Diaries of Anaïs Nin*, vol. 3, 1939–1944 (New York: Harcourt Brace, 1969), p.14.

61. Lowe, *Stieglitz*, p. 311.

62. Ibid., p. 310.

63. GOK to COKK, May 29, 1928 (family of Catherine O'Keeffe Klenert, EGOK).

64. GOK to HMcB, May 11, 1928 (YCAL, AAA, EGOK).

65. Ibid.

66. GOK to COKK, May 29, 1928 (family of Catherine O'Keeffe Klenert, EGOK).

67. AS to HJS, June 28, 1928 (YCAL).

68. Ibid., July 10, 1928 (YCAL).

69. ESD to AS, July 26, 1928 (YCAL).

70. Georgia may have stayed at York Beach right up until her departure for the Midwest. Paul Strand, who went there in late July, mentioned that Mrs. Schauffler showed him a letter from Stieglitz to Georgia, which she planned to forward to Wisconsin.

71. GOK to MK, Jan. 20, 1929 (MKP, NYPL, EGOK).

72. Klenert interview.

73. Margery Latimer, "Catherine Klenert," *Bulletin of the Milwaukee Art Institute*, Dec. 1931.

74. Klenert interview.

75. GOK to E. Stettheimer, Sept. 21, 1928 (YCAL, EGOK).

76. GOK to COKK, Dec. 9, 1928 (family of Catherine O'Keeffe Klenert, EGOK).

77. Catherine and her small daughter stayed not with Georgia but with Anita. The visit did not coincide with Georgia's exhibition, and her paintings were not on view. Georgia, who was in a state of near exhaustion, may not have taken the trouble to pull paintings out of storage areas for her sister. It is possible that Catherine did not see any of Georgia's flower paintings, as she once asserted. It is equally possible that she did see some of the work; on another occasion she allowed that she had seen one of the flower paintings. It can now be only a matter of speculation.

78. GOK to COKK, Dec. 25, 1928 (family of Catherine O'Keeffe Klenert, EGOK).

79. Ibid., Feb. 24, 1929 (family of Catherine O'Keeffe Klenert, EGOK).

80. Ibid., Dec. 25, 1928 (family of Catherine O'Keeffe Klenert, EGOK).

81. AS to COKK, Dec. 23, 1928 (family of Catherine O'Keeffe Klenert, EGOK).

Chapter 21

1. AS to PS, possibly a draft, Sept. 2, 1928 (YCAL).

2. Ibid.

3. GOK to E. Stettheimer, Aug. 24, 1929 (YCAL, EGOK).

4. GOK to HMcB, Spring 1929? (YCAL, EGOK).

5. Louise March, interview with author, April 27, 1987.

6. Zito, "O'Keeffe."

7. Tomkins, notes.

8. GOK to DB, Fall 1930? (YCAL, EGOK).

9. *O'Keeffe: A Portrait by Stieglitz* (PAS).

10. Norman, *Encounters*, p. 60.

11. Ibid., p. 71.

12. Ibid.

13. Ibid., pp. 73, 106.

14. Ibid., p. 107.

15. GOK to DB, early April 1930 (YCAL, EGOK).

16. GOK to BM, April 1929 (YCAL, EGOK).

17. Tomkins, notes.

18. Lisle, *Portrait of the Artist*, p. 261.

19. March interview.

20. Tomkins, notes.

21. *O'Keeffe: A Portrait by Stieglitz* (PAS).

22. Charles Eldredge, Julie Schimmel, and William Truettner, *Art in New Mexico* (New York: Abbeville, 1986), p. 103.

23. Ibid., p. 333.

24. AS to W. Frank, Aug. 25, 1925 (YCAL).

25. AS to IOK, Sept. 19, 1925 (YCAL).

26. GOK to MDL, 1925? (YCAL, EGOK).

27. PS to AS, Sept. 20, 1926 (YCAL, APSA).

28. Joseph Foster, *D. H. Lawrence in Taos* (Albuquerque: University of New Mexico Press, 1972), p. 28.

29. Dorothy Brett, "My Beautiful Journey," *South Dakota Review,* Summer 1967.

30. Ibid.

31. Edmund Wilson, "Indian Corn Dance," *Jitters* (New York: Scribner, 1932).

32. GOK to COKK, July 13, 1929 (family of Catherine O'Keeffe Klenert, EGOK).

33. RSS to PS, April 29, 1929 (PSA, CCP).

34. Ibid., April 28?, 1929 (PSA, CCP).

35. Ibid., April 29, 1929 (PSA, CCP).

36. Ibid., April 30, 1929 (PSA, CCP).

37. Ibid., May 2, 1929 (PSA, CCP).

38. D. H. Lawrence in Sean Hignett, *Brett: From Bloomsbury to New Mexico* (New York: Franklin Watts, 1983), p. 153.

39. Brett, "My Beautiful Journey."

40. GOK to COKK, July 13, 1929? (Family of Catherine O'Keeffe Klenert, EGOK).

41. Tomkins, notes.

42. GOK to COKK, July 13, 1929? (Family of Catherine O'Keeffe Klenert, EGOK).

43. Foster, *Lawrence in Taos*, p. 27.

44. Tomkins, notes.

45. RSS to PS, May 2, 1929 (PSA, CCP).

46. Ibid., May 5, 1929 (PSA, CCP).

47. Ibid., May 11, 1929 (PSA, CCP).

48. GOK to PS, May 1929 (PSA, CCP, EGOK).

49. Tomkins, notes.

50. RSS to PS, May 11?, 1929 (PSA, CCP).

51. Foster, *Lawrence in Taos*, p. 7.

52. GOK to RVH, Oct. 1932, in Cowart, Hamilton, and Greenough, *Art and Letters*, p. 211 (CHG).

53. RSS to PS, June 3, 1929 (PSA, CCP).

54. Ibid., June 16, 1929 (PSA, CCP).

55. Ibid., June 16, 1929 (PSA, CCP).

56. Ibid., June 5, 1929 (PSA, CCP).

57. Ibid., May 24, 1929 (PSA, CCP).

58. Ibid., May 12, 1929 (PSA, CCP).

59. GOK to HMcB, July 1931 (YCAL, EGOK).

60. RSS to PS, May 2, 1929 (PSA, CCP).

61. Ibid., May? 1929 (PSA, CCP).

62. Ibid., May 23, 1929 (PSA, CCP). The sequence seems clear from the evidence. That same summer, Georgia did paint the white artificial rose, but according to Beck's report, while she herself was painting the white roses, Georgia had done only three paintings: one of trees, the "lady santo," and the one of Mabel's porcelain rooster.

63. Ibid., June 11, 1929? (PSA, CCP). O'Keeffe had used the sky alone as a subject when she painted her version of Stieglitz's "Equivalent" series, *A Celebration* of 1924. After she began her annual sojourns in New Mexico, the sky figured increasingly importantly in her work. Beck's use of the sky as subject may have referred indirectly to Stieglitz's "Equivalents" just as Georgia's *Celebration* must have.

64. "In the morning I went to town and did some chores and then took the pastels and paper and went out behind the morada to try a whack at that cross but the sun was so hot it actually made the paper burn my fingers and what with the flies and mosquitoes (in very few numbers) I went back to the house and tried to finish it there. A mountain is still beyond me. I can't make it go, but will plug away. Must see if Georgia can give me a clue to the principle of drawing a foreground." (It is ironic that Beck should ask Georgia for advice on the foreground regarding this particular image, since Georgia's foreground is the flat plane of the cross itself, nearly the picture plane.) RSS to PS, June 5, 1929 (PSA, CCP). At the time, Georgia was working on the pueblo, where she went on June 4 and began drawing; on June 11 she began her painting of the pueblo, and was still working on it on June 19.

65. RSS to PS, June 24, 1929 (PSA, CCP).

66. Ibid., May 23, 1929 (PSA, CCP).

67. Ibid., May 24, 1929 (PSA, CCP).

68. Emily Hahn, *Mabel: A Biography of Mabel Dodge Luhan* (Boston: Houghton Mifflin, 1977), p. 120.

69. Tomkins, notes.

70. GOK to COKK, July 13, 1929 (family of Catherine O'Keeffe Klenert, EGOK).

71. GOK to MDL, Summer 1929 (YCAL, EGOK).

72. Ibid.

73. D. H. Lawrence, "New Mexico," *Survey*, May 1, 1931.

74. O'Keeffe, *O'Keeffe*.

75. GOK to MDL, Summer 1929 (YCAL, EGOK).

76. RSS to PS, June 4, 1929 (PSA, CCP).

77. IOK to AS, August 1929 (YCAL).

78. This painting was titled *Pine Tree with Stars at Brett's, N.M.* in the list of paintings in O'Keeffe's 1930 exhibition.

79. Tomkins, notes.

80. RSS to AS, May 14, 1929 (YCAL).

81. AS to RSS, May 17, 1929 (YCAL).

82. AS to HJS, June 17, 1929 (YCAL).

83. AS to ESD, June 27, 1929 (YCAL).

84. Ibid., July 2, 1929 (YCAL).

85. Ibid., July 22, 1929 (YCAL).

86. AS to Nancy Newhall, in Meridel Rubenstein, "The Circles and the Symmetry" (Master's thesis, University of New Mexico, 1977), p. 70.

87. AS to ESD, July 28/29, 1929 (YCAL).

88. GOK to MDL, Summer 1929? (YCAL, EGOK).

89. GOK to MDL, Summer 1929? (YCAL, EGOK).

90. GOK to MDL, July 1, 1929 (YCAL, EGOK).

91. GOK to MDL, Summer 1929? (YCAL, EGOK).

92. GOK to MDL, Summer 1929? (YCAL).

93. GOK to MDL, Summer 1929? (YCAL).

94. AS to ESD, July 29, 1929 (YCAL).

95. ESD to AS, Aug. 17, 1929 (YCAL).

96. GOK to MDL, Aug. 1, 1929 (YCAL, EGOK).

97. Ibid., July 1929 (YCAL).

98. HMcB to GOK, Sept. 27, 1929 (YCAL, EGOK).

99. Tomkins, notes.

100. GOK to MDL, Summer 1929 (YCAL, EGOK).

101. AS to ESD, Aug. 18, 1929 (YCAL).

102. Ibid.

103. ESD to AS, after Aug. 18, 1929? (YCAL). YCAL dates this letter 8/16/22, but the letter makes reference to "Monsey," a house that was not bought until 1925; and internal references make the letter almost certain to be the answer to AS's letter of August 18, 1929, to wit: "I hear an airplane," writes Elizabeth; "wonder will you take your trip."

104. AS to ESD, Aug. 18, 1929 (YCAL).

105. GOK to RSS, Aug. 24, 1929, in Cowart, Hamilton, and Greenough, *Art and Letters*, p. 193 (CHG).

106. Ibid., p. 194 (CHG).

107. GOK to MDL, late August 1929? in Cowart, Hamilton, and Greenough, *Art and Letters*, p. 192 (CHG).

108. AS to ESD, Aug. 25, 1929 (YCAL).

109. Ibid., Aug. 28, 1929 (YCAL).

110. AS to ESD, Sept. 2, 1929 (YCAL).

111. GOK to MDL, Sept. 1929? in Cowart, Hamilton, and Greenough, *Art and Letters*, p. 196 (CHG).

112. Ibid.

113. Ibid., p. 198 (CHG).

114. GOK to MDL, Fall 1929? (YCAL, EGOK).

115. GOK to DB, Fall 1929? (YCAL, EGOK).

116. Ibid.

117. RSS to PS, May 31, 1929 (PSA, CCP). Marin's cubist style was assertive, and in its assertiveness it effectively devalued the subjects of his paintings. He recognized that this prevented him from doing justice to New Mexico and went on to say that he felt he had no right to make the country into what he saw it; he felt it should be done "as it is."

118. GOK to DB, Sept. 1929? (YCAL, EGOK).

119. Ibid.

120. Ibid. This is probably *Pink Abstraction*, no. 26 in the 1930 exhibition.

121. GOK to DB, Fall 1929? (YCAL, EGOK).

122. AS to ESD, Oct. 21, 1929 (YCAL).

123. Ibid.

Chapter 22

1. AS to RSS, Oct. 28, 1929 (YCAL).

2. Ibid., Oct. 24, 1929 (YCAL).

3. Ibid., Oct. 22, 1929 (YCAL).

4. Tomkins, notes.

5. Ibid.

6. GOK to B. O'Keeffe, Jan. 24, 1930 (June O' Keefe Sebring, EGOK).

7. AS to F. Herrmann, Feb. 9, 1930.

8. O. O. McIntyre, "Seen About New York," in "O'Keefe [sic] Craze in Art Circle, Says McIntire, Is Great," *The Prairie*, Nov. 26, 1929.

9. Ibid.

10. Henry McBride, "O'Keeffe in Taos," *New York Sun*, Jan 8, 1930.

11. GOK to HMcB, June 8, 1942 (AAA, YCAL, EGOK).

12. Woolf quoted H. G. Wells, who complained, "There has been no perceptible woman's movement to resist the practical obliteration of their freedom by Fascists or Nazis" (in *Three Guineas*, p. 43). Woolf pointed out that women as a class must set about fighting the dictator at home before they can have the power to seek him out abroad. The male inclination to keep women in their homes, without property, education, or the right to work or vote, was, she pronounced, just as oppressive, just as dictatorial, as the threats from abroad. Moreover, until women were freed from those restrictions, they would remain politically powerless, and it was hardly fair to malign them for not resisting the Nazis.

13. Gladys Oaks, "Radical Writer and Woman Artist Clash on Propaganda and Its Uses," *New York World*, Mar. 16, 1930.

14. C. Kay Scott to GOK, in exhibition catalogue, Intimate Gallery, Jan. 9–Feb. 27, 1928.

15. GOK to DB, April 1930? (YCAL, EGOK).

16. Ibid.

17. GOK to MDL, Spring 1930? (YCAL, EGOK).

18. Ibid.

19. GOK to DB, May 1930? (YCAL, EGOK).

20. GOK to DB, early April 1930? (YCAL, EGOK).

21. GOK to MDL, Spring 1930? (YCAL, EGOK).

22. GOK to MDL, Fall 1929? (YCAL, EGOK).

23. GOK to DB, early April 1930? (YCAL, EGOK).

24. Tomkins, notes.

25. Ibid.

26. Ibid.

27. Ibid.

28. Ibid.

29. Marta Weigle and Kyle Fiore, *Santa Fe and Taos: The Writers' Era, 1916–1941* (Santa Fe: Ancient City Press, 1982), p. 164.

30. Tomkins, notes.

31. Ibid.

32. The following year, Mabel wrote an article about Georgia in Taos. In spite of her role as "the intellectual priestess of Taos," Mabel's writing was vague and woolly-headed. There was an extravagant description of the spiritual effect of Taos on Georgia's psyche: "in her being she became intensified and deepened," but Mabel tiptoed gingerly around Georgia's painting, concentrating instead on anecdotes about her learning to become a "demon driver." The tone was an odd mix of romantic and chatty, describing "an exquisite sensitive mortal like Georgia O'Keeffe . . . making whoopee!" (*Creative Art*, June 1931).

When Georgia saw the manuscript she wrote Mabel a pleasant, friendly letter in which she mentioned that both Stieglitz and McBride liked it. Her own reaction was conspicuous by its absence. To Henry McBride, Georgia wrote that the article was "rather beautiful—a bit disjointed—something of a lie—because she doesn't say something poisonous she wants to say—and that wouldn't be true either" (GOK to HMcB, July 1931 [YCAL]).

33. GOK to DB, Oct. 12? 1930 (YCAL, EGOK).

34. GOK to RSS, Sept. 4, 1930 (YCAL, EGOK).

35. Ibid., Sept. 10, 1930 (YCAL, EGOK).

36. GOK to C. Van Vechten, 1930 (YCAL, EGOK).

37. GOK to DB, Oct. 12? 1930 (YCAL, EGOK). Georgia was encouraging Brett to write a memoir about her relationship with D. H. Lawrence, which was both platonic and romantic, and which had largely excluded Frieda Lawrence. It was a counterpart to the relationship Georgia was painfully watching between Stieglitz and Norman. And as a counterpart to her own efforts to work in spite of and because of this relationship, Georgia urged Brett to write "an impersonal picture of what you went through—colored as it would be by love rather than —other things." Ibid.

38. GOK to DB, Apr. 1931 (YCAL, EGOK).

39. "H & M" may have stood for Henwar and Marie.

40. Weigle and Fiore, *Santa Fe and Taos*, p. 130.

41. GOK to RVH, late Aug, 1931? in Cowart, Hamilton, and Greenough, *Art and Letters*, p. 204 (CHG).

42. Tomkins, notes.

43. "Fusion does not mean obliteration, for this erasure of personality offers transcendence rather than annihilation." (O'Brien, *Willa Cather*, p. 70).

44. GOK to RVH, Aug. 1931? in Cowart, Hamilton, and Greenough, *Art and Letters*, p. 204 (CHG).

45. Norman, *Encounters*, p. 103.

46. Ibid., p. 106.

47. Ibid.

48. Ibid.

49. Ibid., p. 107.

50. Lowe, *Stieglitz,*, p. 314.

51. GOK to RSS, Aug. 9, 1931 (YCAL, EGOK).

52. Ibid., Sept. 14, 1931 (YCAL, EGOK).

53. GOK to RVH, late Aug. 1931? in Cowart, Hamilton, and Greenough, *Art and Letters*, p. 204 (CHG).

54. AS to PS, possibly a draft, July 27, 1931 (YCAL).

55. GOK to DB, Oct. 1931? (YCAL, EGOK).

Chapter 23

1. Goodyear, *Cecilia Beaux*, p. 41.

2. Ibid., p. 41.

3. Stieglitz is said to have complained at the cost of shipping a barrel of them east in 1930, but it is not until 1931 that both O'Keeffe and Stieglitz mention the bones in the prim Victorian interiors at Lake George, as a novelty. Alfred wrote Beck: "The house is full of bones and skeleton heads—Mexican flowers etc." (AS to RSS, Aug. 2, 1931 [YCAL]). And Georgia wrote Beck: "My bones cause much comment" (GOK to RSS, Aug. 9, 1931 [YCAL]), her own comment suggesting that this was their first appearance.

4. Though this painting is dated 1930 on the backing, it was not listed in the 1931 show, and a note in the Whitney archive suggests that it may actually have been done the following year.

5. GOK to HMcB, July 1931 (YCAL, EGOK).

6. O'Keeffe made this into a larger metaphor, and described her feelings about the painting in her book: the American artists in the East talked with enthusiasm about America and the Great American Novel. O'Keeffe suspected that they would have moved to Europe if they could have. She had respect for the great American landscape, and she made her painting red, white, and blue in celebration of that landscape.

7. Henry McBride, "Skeletons on the Plain," *New York Sun*, Jan. 1, 1932.

8. *ARTnews*, Jan. 2, 1932, in Lisle, *Portrait of the Artist*, p. 203.

9. GOK to DB, Oct. 1931? (YCAL, EGOK).

10. Braggiotti, "Her Worlds Are Many."

11. Tomkins, notes.

12. GOK to BM, Apr. 1929? (YCAL, EGOK).

13. GOK to DB, Feb. 1932 (YCAL, EGOK).

14. Malcolm, "Artists and Lovers."

15. GOK to RVH, Spring 1932, in Cowart, Hamilton, and Greenough, *Art and Letters*, p. 207 (CHG).

16. GOK to DB, Sept.? 1932 (YCAL, EGOK).

17. GOK to RSS, Oct. 6, 1932 (YCAL, EGOK).

18. Kuh, *The Artist's Voice*, p. 202.

19. Tomkins, notes.

20. AS to HJS, Sept. 6, 1932 (YCAL).

21. Kuh, *The Artist's Voice*, p. 202.

22. GOK to HMcB, Feb. 1923 (YCAL, EGOK).

23. GOK to RSS, Oct. 6, 1932 (YCAL).

24. Ibid., Fall, 1932? (YCAL).

25. GOK to RVH, Oct.? 1932, in Cowart, Hamilton, and Greenough, *Art and Letters*, pp. 210–11 (CHG). This date is probably wrong; the month is more likely to be November, since November was when she walked off the project.

26. Tomkins, notes.

27. Ibid.

28. GOK to HMcB, July 22, 1938 (YCAL, EGOK).

29. GOK to RSS, Oct. 6?, 1932 (YCAL, EGOK).

30. GOK to DB, Sept.? 1932 (YCAL, EGOK).

31. GOK to RSS, Oct. 6, 1932 (YCAL, EGOK).

Chapter 24

1. O'Keeffe was still menstruating in the spring of 1934, and later (GOK to RSS, Apr. 26, 1934 [YCAL], EGOK).

2. AS to HJS, Dec. 10, 1932 (YCAL).

3. Ibid., Jan. 16, 1933 (YCAL).

4. "Whether she is a passive angel or an active monster, the woman writer feels herself to be literally or figuratively crippled by the debilitating alternatives her culture offers her." Illness was a frequent consequence of the patriarchal response to creative effort, though it was often seen as a consequence of the effort itself. The governor of the Massachusetts Bay Colony, in 1645, wrote that one Anne Hopkins "has fallen into a sad infirmity, the loss of her understanding and reason . . . by occasion of her giving herself wholly to reading and writing . . . if she had attended her household affairs, and such things as belong to women . . . she had kept her wits." (Gilbert and Gubar, *Madwoman in the Attic*, p. 55; for a full explication of the thesis, the reader is directed to this book.) The cycle of repression and illness was still active in the late nineteenth century, when Alice James, the sister of Henry and William, spent her unhappy life "fighting and succumbing to the effects of ailments . . . That her condition was

directly related to her desperate attempts to suppress her own active, inquisitive nature in order to be more perfectly the infinitely tolerant, pliant woman she was expected to be is movingly reflected . . . 'How sick one gets of being "good," ' she wrote, 'how much I should respect myself if I could burst out and make everyone wretched for twenty-four hours' " (Dijkstra, *Idols of Perversion*, p. 28).

5. "I Can't Sing So I Paint."

6. AS to A. M. Liebman, Nov. 18, 1918, in Margaret Berger, *Aline Meyer Liebman* (New York: W. F. Humphrey Press, 1982), p. 21.

7. IOK to AS, July 2, 1925 (YCAL).

8. HMcB to GOK, July 19, 1927 (YCAL).

9. Leo Janis, "Georgia O'Keeffe at Eighty-four," *Atlantic Monthly*, Dec. 1971, in Lisle, *Portrait of the Artist*, p. 198.

10. Charlotte Perkins Gilman's famous short novel *The Yellow Wallpaper* gives a chilling account of a sick woman who is prohibited from the dangerous excitement of writing, and her subsequent lapsing into madness. It was a nearly autobiographical account of Gilman's own experience, and she sent it later to the doctor who had treated her. (She was gratified to hear that he changed his form of treatment as a result.)

11. GOK to B. O'Keeffe, Jan. 24, 1930 (June O'Keeffe Sebring, EGOK).

12. *Springfield Leader*, Nov. 1930.

13. Ibid., Dec. 1930.

14. GOK to COKK, Fall 1931? (family of Catherine O'Keeffe Klenert, EGOK).

15. Ibid., Oct. 29, 1931 (family of Catherine O'Keeffe Klenert, EGOK).

16. *New York Post*, Mar. 4, 1933.

17. Edward Alden Jewell, "Another O'Keeffe Emerges," *New York Times*, Mar. 29, 1933.

18. Klenert interview.

19. Henry McBride, "Star of An American Place Shines in Undiminished Luster," *New York Sun*, Jan. 14, 1933.

20. "Her sister" is referred to, and the sister is presumably Anita, with whom Georgia had been staying.

21. AS to PS, Feb. 13, 1933 (PSA, CCP).

22. GOK to RSS, Mar. 1933 (YCAL, EGOK).

23. Ibid., Mar. 18, 1933 (YCAL, EGOK).

24. Ibid.

25. GOK to RSS, Apr. 1933 (YCAL, EGOK).

26. Ibid.

27. GOK to MCT, May 1933 (YCAL, EGOK).

28. GOK to RSS, June 7, 1933 (YCAL, EGOK).

29. GOK to MCT, Spring 1933 (YCAL, EGOK).

30. AS to HJS, June 26, 1933 (YCAL).

31. AS to DB, June 23, 1933 (YCAL).

32. GOK to RSS, Aug. 1933 (YCAL, EGOK).

33. AS to HJS, Aug. 17, 1933 (YCAL).

34. GOK to MCT, Fall 1933 (YCAL, EGOK).

35. GOK to RVH, Oct. 21, 1933, in Cowart, Hamilton, and Greenough, *Art and Letters*, p. 213 (CHG).

36. AS to A. Adams, Oct. 20, 1933 (CCP, AAPRT).

37. GOK to MCT, Fall 1933 (YCAL, EGOK).

38. GOK to RSS, Nov. 1933 (YCAL, EGOK).

39. Gurdjieff's theories involved a balancing of the three parts of the self— mental, emotional, and physical. This balance, once achieved, would result in a higher level of existence called Being. The theories behind this were based on the "noumenal world," one beyond logic, which recognizes the unity of all opposites, and which transforms "outer-world energies by connecting the inner-world energy with the spirit of the universe." The Gurdjieff method involved exercises in intense awareness and control, in order "to bring the competitive segments of the organism into balance and harmony" (Kerman and Eldridge, *Lives of Jean Toomer*, p. 115).

40. M. Latimer to GOK, Aug. 27, 1928 (YCAL).

41. Ibid., Oct. 23, 1928 (YCAL).

42. Ibid., Feb. 12, 1929 (YCAL).

43. Kerman and Eldridge, *Lives of Jean Toomer*, p. 204.

44. GOK to PS, Dec. 26, 1933 (CCP, PSA, EGOK).

45. AS to JT, in Kerman and Eldridge, *Lives of Jean Toomer*, p. 213.

46. GOK to RSS, Dec. 1933 (YCAL, EGOK).

47. Ibid.

48. GOK to MCT, Dec. 1933 (YCAL, EGOK).

49. JT to AS, Dec. 8, 1933 (YCAL).

50. Ibid., Dec. 21, 1933 (YCAL).

51. GOK to MCT, Dec. 1933 (YCAL).

52. GOK to PS, Dec. 26, 1933 (CCP, PSA).

53. JT to AS, Dec. 30, 1933 (YCAL).

54. GOK to JT, Jan. 2, 1934 (YCAL).

55. Ibid., Jan. 5, 1934 (YCAL).

56. Ibid.

57. Ibid.

58. Ibid.

59. Ibid., Jan. 9, 1934 (YCAL).

60. Ibid., Jan. 10, 1934 (YCAL).

61. Ibid.

62. In Cowart, Hamilton, and Greenough, *O'Keeffe,* p. 285 n.

63. GOK to JT, Jan. 10, 1934 (YCAL).

64. Ibid.

65. Ibid., Spring 1934? (YCAL).

66. JT to GOK, Jan. 3, 1934. In Cowart, Hamilton, and Greenough, *Art and Letters*, p. 285.

67. GOK to JT, Jan. 10, 1934 (YCAL).

68. Ibid., Winter 1934? (YCAL).

Chapter 25

1. GOK to JT, Jan. 7, 1934 (YCAL, EGOK).

2. Ibid., Jan. 19, 1934 (YCAL, EGOK).

3. Ibid., Feb. 8, 1934 (YCAL, EGOK).

4. Lewis Mumford, "The Art Galleries, Sacred and Profane," *The New Yorker*, Feb. 10, 1934.

5. Winsten, "O'Keeffe . . . in Bermuda."

6. GOK to JT, Feb. 8, 1934 (YCAL, EGOK).

7. Ibid.

8. Ibid.

9. Ibid., Feb. 14, 1934 (YCAL, EGOK).

10. Ibid.

11. GOK to RVH, Oct. 21, 1933, in Cowart, Hamilton, and Greenough, *Art and Letters*, p. 213 (CHG).

12. GOK to JT, Feb. 14, 1934 (YCAL, EGOK).

13. Ibid., Mar. 5, 1934 (YCAL, EGOK).

14. Ibid.

15. GOK to RSS, Apr. 26, 1934 (YCAL, EGOK).

16. Though *Banana Flower #1* is generally given an execution date of 1933, this dating contradicts contemporary evidence. None of these drawings were exhibited in 1934, but in O'Keeffe's 1935 exhibition at An American Place there was a series of four works titled "Drawings—Banana Flowers," dated 1934. Moreover, in *Some Memories of Drawings*, ed. Doris Bry (Albuquerque: University of New Mexico Press, 1988), O'Keeffe refers specifically to this series as having been done in the year she stayed at Marie Garland's house in Bermuda, which was 1934.

17. GOK to JT, Apr. 16, 1934 (YCAL, EGOK).

18. GOK to RSS, Apr. 26, 1934 (YCAL, EGOK).

19. GOK to JT, May 11, 1934 (YCAL, EGOK).

20. Ibid.

21. GOK to MDL, Winter 1933–34? (YCAL, EGOK).

22. Weigle and Fiore, *Santa Fe and Taos*, p. 138.

23. AS to DB, June 1934 (YCAL).

24. Sheila Tryk, "O'Keeffe," *New Mexico*, Jan.–Feb. 1973.

25. Such are the facts as related by Arthur Pack. A soberer account is given by the Ghost Ranch brochure, which mentions the discovery of a modest six-foot-long dinosaur in 1947 and the fact that many fossil remains have been found of the Phytosaur, an alligator-like creature, common during the Triassic period.

26. Tomkins, notes.

27. GOK to R. Pisano, Aug. 18, 1972 (Ron Pisano, New York, EGOK).

28. Torr, *Diaries,* Mar. 5, 1931 (AAA).

29. Torr, *Diaries,* Apr. 3, 1935 (AAA). Torr also records that she wrote to O'Keeffe that same day, but the letter does not survive.

30. AS to A. Adams, possibly a draft, Apr. 6, 1936 (YCAL).

31. Ibid. Although Lisle dates this move in the fall of 1936, Stieglitz's letter to Ansel Adams in April suggests otherwise.

Chapter 26

1. GOK to AS, Sept. 2, 1937, in exhibition catalogue, An American Place, Dec. 27, 1937–Feb. 11, 1938.

2. GOK to RSS, Apr. 26, 1934 (YCAL, EGOK).

3. Kuh, *The Artist's Voice.* p. 191.

4. GOK to AS, July 29, 1937, in catalogue, Dec. 27, 1937–Feb. 11, 1938.

5. GOK to AS, Aug. 25, 1937, in ibid.

6. Tomkins, notes.

7. GOK to AS, Aug. 25, 1937, in catalogue, Dec. 27, 1937–Feb. 11, 1938.

8. GOK to AS, Aug. 20, 1937, in ibid.

9. GOK to AS, Aug. 16, 1937, in ibid.

10. GOK to AS, July 27, 1916, in Cowart, Hamilton, and Greenough, *O'Keeffe,* pp. 153–54.

11. The famous rattlesnakes at Ghost Ranch, so deeply entrenched in the O'Keeffe myth, seem to have posed very little real threat: Arthur Pack dismissed the ones around Ghost Ranch as "green rattlesnakes," which were not belligerent. He pointed out that in a quarter of a century only one person had ever been bitten by one.

12. GOK to HMcB, July 1931 (YCAL, EGOK).

13. GOK to DB, Fall 1930? (YCAL, EGOK).

14. Kotz, "A Day with O'Keeffe."

15. GOK to DB, mid-Feb. 1932 (YCAL, EGOK).

16. Kotz, "A Day with O'Keeffe."

17. In exhibition catalogue, An American Place, Jan. 22–Mar. 17, 1939.

18. O'Keeffe, *O'Keeffe.*

19. Letter from Dr. Michael Novacek, Dept. of Vertebrate Paleontology, Museum of Natural History, New York, July 14, 1987.

20. Lowe, *Stieglitz,* pp. 223–24.

21. GOK to W. Einstein, 1937 (YCAL, EGOK).

22. GOK to RSS, between Dec. 1933–Feb. 1934? (YCAL, EGOK).

23. In Lisle, *Portrait of the Artist,* p. 242.

24. GOK to RSS, Sept. 14, 1931 (YCAL, EGOK).

25. Tomkins, notes.

26. GOK to W. Einstein, July 19, 1938 (YCAL, EGOK).

27. Ibid.

28. GOK to MDL, 1941–42? (YCAL, EGOK).

29. A. Adams to AS, Sept. 10, 1938 (CCP, AAPRT).

30. A. Adams to D. McAlpin, April 4, 1938 (CCP, AAPRT).

31. Frank Lloyd Wright Foundation Brochure, 1986.

32. Lisle, *Portrait of an Artist*, p. 243.

33. GOK to HMcB, July 22, 1939 (AAA, YCAL, EGOK).

34. GOK to W. Einstein, June 8, 1939 (YCAL, EGOK).

35. GOK to CW, mid-October 1939? (AAA, EGOK).

36. GOK to AGD, n.d., 1940? (AAA, EGOK).

37. O'Keeffe, "Can a . . . Photograph [Be] Art?"

38. Exhibition catalogue, "Cady Wells," Durlacher Brothers Gallery, 1944.

39. GOK to CW, Feb. 1938? (AAA, EGOK).

40. GOK to CW, Spring 1938? (AAA, EGOK).

41. GOK to CW, n.d. (AAA, EGOK). Internal evidence suggests that this letter followed Stieglitz's rejection of Wells's work, but the dating is speculative.

42. GOK to CW, n.d. (AAA, EGOK).

43. Ibid.

44. Ibid.

45. Ibid.

46. Quoted in Lisle, *Portrait of the Artist*, p. 256.

47. GOK to CW, n.d. (AAA, EGOK).

48. George L.K. Morris, "Some Personal Letters to American Artists Recently Exhibiting in New York," *Partisan Review*, March 1938.

49. McBride, "Star . . . Shines in Undiminished Luster."

Chapter 27

1. Klenert interview.

2. Ida O'Keeffe's *The Highland Lighthouse*, shown at Delphic in 1933, is an elegant composition of the Precisionist school, comprising smooth geometric curves and planar intersections. Clean and unreal, it depicts a landscape governed by physics, not passion. *My Table*, of seven years later, is a competent still life, showing a strong cubist influence, but the composition is awkward and emanates a feeling of confusion.

3. GOK to COK, 1939–40? (MNM, EGOK).

4. Ibid.

5. Ibid.

6. Ibid.

7. Ibid., Feb. 18, 1960 (MNM, EGOK).

8. Ibid., n.d. (MNM, EGOK).

9. Ibid., early 1940s? (MNM, EGOK).

10. Ibid., n.d. (MNM, EGOK).

11. Ibid., Jan. 3, 1958 (MNM, EGOK).

12. Ibid., n.d. (MNM, EGOK).

13. GOK to L. March, early 1940s (Louise March, EGOK).

14. GOK to COK, July 8, 1950 (MNM, EGOK).

15. GOK to B. O'Keeffe, Mar. 16, 1930 (June O'Keeffe Sebring, EGOK).

16. June O'Keeffe Sebring, interview with author, Nov. 1, 1988.

17. Klenert interview.

18. GOK to COK, 1939? (MNM, EGOK).

19. GOK to COKK, Dec. 9, 1928 (family of Catherine O'Keeffe Klenert, EGOK).

20. Ibid., Dec. 25, 1928 (family of Catherine O'Keeffe Klenert, EGOK).

21. GOK to RVH, Oct.–Nov. 1939?, in Cowart, Hamilton, and Greenough, *O'Keeffe*, p. 229.

22. GOK to COK, Summer 1943? (MNM).

23. Pollitzer, *A Woman on Paper*, p. 234.

24. Pollitzer, Unpublished biography of Georgia O'Keeffe.

25. GOK to E. Stettheimer, April–May 1944? (YCAL).

26. GOK to C. Fesler, Mar. 21, 1944 (AAA).

27. Ibid.

28. Ibid., 1941? (AAA).

29. Maria Chabot, interview with author, Dec. 1, 1987.

30. GOK to M. Chabot, Nov. 1941, in Cowart, Hamilton, and Greenough, *O'Keeffe*, p. 231.

31. GOK to COK, n.d. (MNM).

32. Ibid.

33. GOK to E. and C. Stettheimer, April–May 1944?, in Cowart, Hamilton, and Greenough, *O'Keeffe*, p. 238.

34. O'Keeffe, *O'Keeffe*.

35. GOK to COK, Summer 1943? (MNM).

36. Seiberling, "Horizons."

37. GOK to C. Fesler, Sept. 11, 1947 (AAA).

Chapter 28

1. GOK to BOK, Jan. 14, 1930.

2. GOK to C. Fesler, Mar. 19, 1941 (AAA).

3. Ibid., Mar. 21, 1944 (AAA, EGOK).

4. Clement Greenberg, *The Nation*, June 5, 1946. As was discussed earlier, Greenberg's main complaint was O'Keeffe's inclination to follow the German expressionist movement, with its focus on intuition and emotion, rather than the school Greenberg admired—the more abstract and analytical French school of artists, such as Matisse and Picasso.

5. Marya Mannes, "Gallery Notes," *Creative Art*, Feb. 1928.

6. GOK to J. J. Sweeney, July 28, 1945, in Cowart, Hamilton, and Greenough, *Art and Letters*, p. 242 (CHG).

7. Seligmann, *Stieglitz Talking*, p. 30.

8. GOK to MK, Jan. 20, 1929 (NYPL, EGOK).

9. GOK to J.J. Sweeney, June 11, 1945, in Cowart, Hamilton, and Greenough, *Art and Letters*, p. 241 (CHG).

10. Examples of this are: *Series I, No. 8*, 1919; *Pink and Blue Lines*, 1923; *Pattern of Leaves*, c. 1923; *Corn, Dark I*, 1924; *Open Clam Shell* and *Closed Clam Shell*, 1926; *Abstraction, Blue*, 1927; *Street, New York, No. 1*, 1926; *Cow's Skull with Calico Roses*, 1931; *Jack in the Pulpit, No. IV*, 1930; *Black Place III*, 1944.

11. Seiberling, "Horizons."

12. Braggiotti, "Her Worlds Are Many."

13. Tomkins, notes.

14. GOK to L. March, 1943? (Louise March, EGOK).

15. Tomkins, notes.

16. GOK to C. Fesler, Dec. 24, 1945 (AAA), in Cowart, Hamilton, and Greenough, *Art and Letters*, p. 243 (CHG).

17. AS to A. Adams, possibly a draft, Jan 17, 1937 (YCAL).

18. GOK to HMcB, early 1940s? (YCAL, EGOK).

19. Ibid.

20. AS to GOK, June 3, 1946, in Pollitzer, *A Woman on Paper*, pp. 249–50.

21. AS to GOK, June 4, 1946, in ibid., p. 250.

22. AS to GOK, June 5, 1946, in ibid.

23. AS to GOK, June 6, 1946, in ibid.

24. Beaumont Newhall, interview with author, Oct. 28, 1987.

25. AS to GOK, July 8, 1946, in Pollitzer, *A Woman on Paper*, p. 251.

26. AS to GOK, July 9, 1946, in ibid.

27. Nancy Newhall to Ansel Adams, July 15, 1916, in Mary Street Alinder and Andrea Gray Stillman, eds., *Ansel Adams: Letters and Images, 1916–1984* (Boston: Little, Brown, 1988), p. 176.

28. GOK to WHS, Aug. 4, 1950, in Cowart, Hamilton, and Greenough, *Art and Letters*, p. 254 (CHG).

Chapter 29

1. GOK to M. B. Kiskadden, Fall 1947?, in Cowart, Hamilton, and Greenough, *Art and Letters*, p. 246 (CHG).

2. Besides the intimate, affectionate tone of the correspondence, O'Keeffe mentions a proposed trip to Ireland by the two of them. The trip did not take place.

3. Working as a mature artist, O'Keeffe did very few portraits. Only two are known, those of Beaufort Delaney and Dorothy Schubart (she did more than one picture of each sitter). Both sets of portraits are drawings, and both present a smooth, hard, and stylized image. They record the sitter's character, but both come perilously close to a cartoonlike, commercial style.

4. GOK to L. March, early 1940s? (Louise March, EGOK).

5. GOK to D. C. Rich, Nov. 13, 1949, in Cowart, Hamilton, and Greenough, *Art and Letters*, p. 249 (CHG).

6. Ibid.

7. Donald Gallup, *Pigeons on the Granite* (New Haven and London: Yale University Press, 1988), p. 223.

8. Morning Pastorok, interview with author, Sept. 2, 1987.

9. Seligmann, *Stieglitz Talking*, p. 60.

10. O'Keeffe, "Can a Photograph . . . [Be] Art?"

11. Tomkins, notes.

12. David McIntosh, interview with author, Feb. 13, 1987.

13. Kuh, *The Artist's Voice*.

14. Tomkins, notes.

15. Ibid.

16. Ibid.

17. Ibid.

18. Chabot interview.

19. Tomkins, notes.

20. Ibid.

21. Ibid.

22. GOK to WHS, Oct. 26, 1950, in Cowart, Hamilton, and Greenough, *Art and Letters*, p. 256 (CHG).

23. GOK to M. B. Kiskadden, Sept. 3, 1950, in ibid., p. 254 (CHG).

24. Kuh, *The Artist's Voice*.

25. O'Keeffe was in New Mexico for a few weeks before Stieglitz died, in the summer of 1946. She returned there in the late fall, after his death. Many of the pictures she painted that year were of the winter landscape; it is likely that the patio door picture, which contains no hint of winter, was done in the summer, weeks before his death.

26. Kuh, *The Artist's Voice*.

27. Lisle, *Portrait of an Artist*, p. 292.

28. GOK to WHS, Aug. 4, 1950, in Cowart, Hamilton, and Greenough, *Art and Letters*, p. 254 (CHG).

29. GOK to WHS, July 28, 1950, in Cowart, Hamilton, and Greenough, *Art and Letters*, p. 253 (CHG).

30. Nordness, Lee. *Art USA Now*, vol. 1, "GOK," 1962.

31. GOK to WHS, Aug. 4, 1950, in Cowart, Hamilton, and Greenough, *Art and Letters*, p. 254 (CHG).

Chapter 30

1. GOK to WHS, July 28, 1950, in Cowart, Hamilton, and Greenough, *Art and Letters*, p. 253 (CHG).

2. GOK to WHS, Oct. 26, 1950, in ibid., pp. 255–56 (CHG).

3. Ibid., p. 256 (CHG).

4. GOK to HMcB, July 19, 1948 (AAA, YCAL, EGOK).

5. Ibid.

6. GOK to AP, Oct. 24, 1955 (YCAL, EGOK).

7. GOK to COK, Oct. 20, 1958 (MNM, EGOK).

8. GOK to Frances Steloff, Dec. 25, 1953 (The Henry W. and Alfred A. Berg Collection of English and American Literature in The New York Public Library [Astor, Lenox and Tilden Foundations]).

9. GOK to WHS, Apr. 6, 1950, in Cowart, Hamilton, and Greenough, *Art and Letters*, pp. 251–52 (EGOK).

10. GOK to WHS, Dec. 23, 1950, in ibid., p. 257 (CHG).

11. Tomkins, notes.

12. GOK to AP, n.d. (YCAL, EGOK).

13. Father Vidal Martinez, interviews with author, Feb. 10, Oct. 15, Nov. 30, 1987.

14. GOK to AP, Oct. 24, 1955 (YCAL, EGOK).

15. Tomkins, notes.

16. Ibid.

17. GOK to WHS, July 25, 1952, in Cowart, Hamilton, and Greenough, *Art and Letters*, p. 262 (CHG).

18. Ibid.

19. GOK to WHS, Mar. 27, 1951, in Cowart, Hamilton, and Greenough, *Art and Letters*, p. 260 (CHG).

20. Ibid.

21. Tomkins, notes.

22. Ibid.

23. O'Keeffe, "Can a Photograph . . . [Be] Art?"

24. Tomkins, notes.

25. Kotz, "A Day with O'Keeffe."

26. GOK to AP, May 31, 1955 (YCAL, EGOK).

27. McIntosh interview.

28. Tomkins, notes.

29. GOK to COK, Nov. 5, 1951 (MNM, EGOK).

30. GOK to BM, Jan. 1, 1953 (YCAL, EGOK).

31. GOK to BM, Jan 19, 1961. (YCAL, EGOK).

32. GOK to Todd Webb, Nov. 20, 1981, in Cowart, Hamilton, and Greenough, *Art and Letters*, p. 272 (CHG).

33. GOK to COK, Oct. 12, 1962 (MNM).

34. GOK to Todd Webb, Nov. 20, 1981, in Cowart, Hamilton, and Greenough, *Arts and Letters*, p. 272 (CHG).

35. Tomkins, notes.

36. Willard, "Georgia O'Keeffe."

37. GOK to M. Chabot, Nov. 1941, in Cowart, Hamilton, and Greenough, *Art and Letters*, p. 231 (CHG).

Chapter 31

1. GOK to COK, Oct. 20, 1958 (MNM, EGOK).

2. Seligmann, *Stieglitz Talking*, p. 73, 78.

3. GOK to COK, Sept. 19, 1960 (MNM, EGOK).

4. Benjamin Forgey, "O'Keeffe at 90: OK," *Washington Star*, Nov. 10, 1977.

5. GOK to COK, Aug. 6, 1961 (MNM, EGOK).

6. Pollitzer, "That's Georgia!"

7. GOK to AP, Dec. 7, 1950 (YCAL, EGOK).

8. Ibid., Jan. 17, 1956.

9. Ibid., Feb. 28, 1968.

10. GOK to William Pollitzer, May 19, 1974 (William Pollitzer, EGOK).

11. Ibid.

12. Pollitzer, *A Woman on Paper*, p. 3.

13. GOK to Frank Sebring, Nov 28, 1960 (June O'Keeffe Sebring, EGOK).

14. GOK to RSS, Dec. 2, 1962 (YCAL, EGOK).

15. Robert M. Coates, "Abstraction—Flowers," *The New Yorker*, July 6, 1929.

16. GOK to M. Hoffman, Feb. 25, 1943 (Getty Center for the History of Art and the Humanities, EGOK).

17. GOK to E. Roosevelt, Feb. 10, 1944, in Cowart, Hamilton, and Greenough, *Art and Letters*, p. 235 (CHG).

18. GOK to B. O'Keeffe, Mar. 16, 1930 (June O'Keeffe Sebring, EGOK).

19. Grace Glueck, "It's Just What's in My Head," *New York Times*, Oct. 18, 1970.

20. Zito, "O'Keeffe."

21. Tomkins, notes.

22. Jerrie Newsom, interview with author, Oct. 14, 1986; Feb. 10, 1987.

23. "I Can't Sing So I Paint."

24. Andy Warhol, "Georgia O'Keeffe & Juan Hamilton," *Interview*, Sept. 1983.

25. Ibid.

26. David McIntosh, interview with author, Feb. 13, 1987.

27. Maria Chabot, interview with author, Dec. 1, 1987.

28. Virginia Robertson, interview with author, Oct. 4, 1987.

29. Zito, "O'Keeffe."

30. Ruth-Claire to author, Oct. 17, 1986.

Chapter 32

1. Jesse Kornbluth, "View from Abiquiu," *House & Garden*, June 1984.

2. Kristin McMurran, "Georgia O'Keeffe," *People*, Feb. 12, 1979.

3. Tomkins, notes.

4. Ibid.

5. *Georgia O'Keeffe*, documentary film, produced and directed by Perry Miller Adato, for WNET/13, the Public Broadcasting Service, 1977.

6. Tomkins, notes.

7. Robertson interview.

8. David Johnston, "Portrait of the Artist and the Young Man," *Los Angeles Times*, July 23, 1987.

9. Kotz, M. L., "A Day with Georgia O'Keeffe."

10. McMurran, "O'Keeffe."

11. Andrew Decker, "The Battle over Georgia O'Keeffe's Multi-Million Dollar Legacy," *ARTnews*, April 1987.

12. McMurran, "O'Keeffe."

13. Franklin Feldman and Stephen E. Weil, *Art Law: Rights and Liabilities of Creators and Collectors* (Boston: Little, Brown, 1986), pp 350–57.

14. Peggie Kiskadden interview.

15. Pastorok, notes.

16. McMurran, "O'Keeffe."

17. Johnston, "Portrait."

18. Hope Aldrich, "Art Assist: Where Is Credit Due?" *Santa Fe Reporter*, July 31, 1980.

19. Ibid.

20. Ibid.

21. GOK to J. Hamilton, 1976, in Cowart, Hamilton, and Greenough, *Art and Letters*, p. 271 (CHG).

22. Jerry Wertheim, attorney for June Sebring, quoted in court records, Settlement Hearing, "In the Matter of the Estate of Georgia O'Keeffe," July 25, 1987, p. 25.

23. GOK to CT, May 9, 1958.

24. GOK to COK, Jan. 24, 1961 (MNM).

25. Ray Krueger, interview with author, November 14, 1988.

26. Decker, "Battle."

27. Dr. Brad Stamm, telephone interview with author, Jan. 5, 1989.

28. Bob Groves, "Georgia O'Keeffe and the Color of Music," *Impact* (*Albuquerque Journal* magazine), July 28, 1987.

29. Wertheim, Settlement Hearing, p. 22.

Chapter 33

1. Jo Ann Lewis, "The O'Keeffe Heir's Battle," *Washington Post*, Mar. 3, 1987.

2. Editorial, *Santa Fe Reporter*, Aug. 5, 1987.

3. Decker, "Battle."

4. GOK to AP, Feb. 9, 1916 (YCAL, EGOK).

SELECTED BIBLIOGRAPHY

Articles and Periodicals

Aldrich, Hope. "Art Assist: Where is Credit Due?" *Santa Fe Reporter*, July 31, 1980.

"An Art Sisterhood." *Art Digest*, Apr. 1, 1933.

Art Institute of Chicago. *Circular of Instruction 1905–1906* with *A Catalogue of Students 1904–1905*.

Asbury, Edith Evans. "Georgia O'Keeffe Dead at 98; Shaper of Modern Art in US," *New York Times*, Mar. 7, 1986.

———. "Georgia O'Keeffe Is Involved in 2 Suits Linked to Agent Fees on Her Paintings." *New York Times*, Nov. 20, 1978.

———. "Silent Desert Still Charms Georgia O'Keeffe, Near 81." *New York Times*, Nov. 2, 1968.

Barry, Roxana (Robinson). "The Age of Blood and Iron: Marsden Hartley in Berlin," *Arts*, Oct. 1979.

Boswell, Peyton. "Notes on Painting and Sculpture." *Vanity Fair*, Jan. 1922.

Braggiotti, Mary. "Her Worlds Are Many." *New York Post*, May 16, 1946.

Brett, Dorothy. "My Beautiful Journey." *South Dakota Review*, Summer 1967.

Bry, Doris. "Georgia O'Keeffe." *Journal of the American Association of University Women*, Jan. 1952.

Budnik, Dan. "Georgia O'Keeffe at 88 Finds Contentment—and a New Art—in the New Mexican Desert." *People*, Dec. 15, 1975.

"Career Women Are to Be Feted." *New York Sun*, Mar. 20, 1935.

Coates, Robert M. "Abstraction—Flowers." *The New Yorker*, July 6, 1929.

Cocke, Christine McRae. "Georgia O'Keeffe as I Knew Her." *The Angelos*, Nov. 1934.

Cortissoz, Royal. "An American Place." *New York Herald Tribune*, Mar. 4, 1934.

———. "Georgia O'Keeffe." *Herald Tribune*, Feb. 3, 1935.

———. "Georgia O'Keeffe." *Herald Tribune*, Feb. 7, 1937.

Daniels, Mary. "The Magical Mistress of Ghost Ranch." *Chicago Sunday Tribune*, June 24, 1973.

Decker, Andrew. "The Battle over Georgia O'Keeffe's Multi-Million Dollar Legacy." *ARTnews*, April 1987.

Drojowska, Hunter. "Georgia O'Keeffe, 1887–1986." in *ARTnews*, Summer 1986.

"Dumb Ecstasies, Nameless Fears." *Art Digest*, Feb. 1, 1933.

Engelhard, Georgia. "Alfred Stieglitz, Master Photographer." *American Photography*, Apr. 1945.

"Esoteric Art at '291.' " *Christian Science Monitor*, May 4, 1917.

Ewing, Betty. "Georgia O'Keeffe Satisfies the Crowd That Idolizes Her." *Houston Chronicle*, Jan. 13, 1980.

"The Female of the Species Achieves a New Deadliness." *Vanity Fair*, July 1922.

Forgey, Benjamin. "O'Keeffe at 90: OK." *Washington Star*, Nov. 10, 1977.

"Former Head Art Dept. at W. T. Is Famous Artist." Canyon *Prairie*, Oct. 23, 1928.

"Georgia O'Keeffe One of Ten to Be Honored Saturday." *The Sun Prairie Star and The Countryman*, Sept. 2, 1948.

Gilman, Charlotte Perkins. "The Dress of Women." *The Forerunner*, 1915–1916.

Glueck, Grace. "It's Just What's in My Head." *New York Times*, Oct. 18, 1970.

Greenberg, Clement. "Art." *The Nation*, June 15, 1946.

Greenough, Sarah. "The Letters of Georgia O'Keeffe." *Antiques*, Nov. 1987.

Groves, Bob. "Georgia O'Keeffe and the Color of Music." *Impact (Albuquerque Journal)*, July 28, 1987.

Hall, Jim. "Memories of Georgia O'Keeffe." *Ghost Ranch Foundation Quarterly* 1, no. 1 (Spring 1986).

"Honor Dr. Meitner for Work on Atom." *New York Times*, Feb. 10, 1946.

Hughes, Robert. "A Vision of Steely Finesse." *Time*, Mar. 17, 1986.

Hunter, Russell Vernon. "A Note on Georgia O'Keeffe." *Contemporary Arts of the South and Southwest*, Nov.–Dec. 1932.

Hurt, Frances Hallam. "Famed Artist Georgia O'Keeffe Still Has Ties in Virginia." *Richmond Times-Dispatch*, Apr. 16, 1978.

———. "The Virginia Years of Georgia O'Keeffe." *Commonwealth*, Oct. 1980.

"I Can't Sing So I Paint." *New York Sun*, Dec. 5, 1922.

"Ida Ten Eyck O'Keeffe and Gladys Mock at the Delphic Studios." *Art Digest*, Feb. 1, 1937.

"Jazz Age Priestess Brings Forth Paintings." *New York Post*, Apr. 3, 1934.

Jewell, Edward Alden. "A Family of Artists." *New York Times*, Feb. 28, 1933.

———. "An American Place." *New York Times*, Feb. 4, 1934.

———. "Another O'Keeffe Emerges." *New York Times*, Mar. 29, 1933.

———. "Georgia O'Keeffe." *New York Times*, Feb. 3, 1935.

———. "Georgia O'Keeffe Gives an Art Show." *New York Times*, Jan. 7, 1936.

———. "Georgia O'Keeffe in an Art Review." *New York Times*, Feb. 2, 1934.

———. "Georgia O'Keefe's [sic] Paintings Offer Five-Year Retrospect at An American Place." *New York Times*, Jan. 13, 1933.

Jewett, Eleanor. "Good Flower Paintings Put on Exhibition: Catherine Klenert Given Critic's Praise." *Chicago Tribune,* June 15, 1932.

Johnson, Arthur Warren. "Arthur Wesley Dow." *Ipswich Historical Society Bulletin,* no. 28, 1934.

Johnston, David. "Portrait of the Artist and the Young Man." *Los Angeles Times,* July 23, 1987.

Keller, Allan. "Animal Skulls Fascinate Miss O'Keefe [*sic*], but Why?" *New York World-Telegram,* Feb. 13, 1937.

Klein, Jerome. "Georgia O'Keeffe." *New York Post,* Feb. 20, 1937.

———. "O'Keeffe Works Highly Spirited." *New York Post,* Jan. 11, 1936.

Kornbluth, Jesse. "View from Abiquiu." *House & Garden,* June 1984.

Kotz, Mary Lynn. "A Day with Georgia O'Keeffe." *ARTnews,* Dec. 1977.

Latimer, Margery. "Catherine Klenert." *Bulletin of the Milwaukee Art Institute,* Dec. 1931.

Lawrence, D. H. "New Mexico." *Survey,* May 1, 1931.

Lewis, JoAnn. "The O'Keeffe Heir's Battle." *Washington Post,* Mar. 3, 1987.

Luhan, Mabel Dodge. "Georgia O'Keeffe in Taos." *Creative Art,* June 1931.

Malcolm, Janet. "Artists and Lovers." *The New Yorker,* Mar. 12, 1979.

Mannes, Marya. "Gallery Notes." *Creative Art,* Feb. 1928.

Matthias, Blanche. "Georgia O'Keeffe and the Intimate Gallery." *Chicago Evening Post,* Mar. 2, 1926.

McBride, Henry. "Curious Responses to Work of Miss O'Keefe [*sic*] on Others." *New York Herald,* Feb. 4, 1923.

———. "Miss O'Keeffe's Bones: An Artist of the Western Plains Just Misses Going Abstract." *New York Sun,* Jan. 15, 1944.

———. "O'Keeffe in Taos." *New York Sun,* Jan. 8, 1930.

———. "O'Keeffe's Recent Work." *New York Sun,* Jan. 14, 1928.

———. "Skeletons on the Plain." *New York Sun,* Jan. 1, 1932.

———. "Star of An American Place Shines in Undiminished Luster." *New York Sun,* Jan. 14, 1933.

———. "Stieglitz's Life Work." *New York Herald,* Feb. 13, 1921.

McMurran, Kristin. "Georgia O'Keeffe." *People,* Feb. 12, 1979.

"Miss Georgia O'Keeffe Becomes Famous." *Canyon Prairie,* Oct. 23, 1923.

Morris, George L. K. "Some Personal Letters to American Artists Recently Exhibiting in New York." *Partisan Review,* Mar. 1938.

Mumford, Lewis. "The Art Galleries, Sacred and Profane." *The New Yorker,* Feb. 10, 1934.

———. "Autobiographies in Paint." *The New Yorker,* Jan. 18, 1936.

———. "Georgia O'Keeffe." *The New Yorker,* Feb. 9, 1935.

Oaks, Gladys. "Radical Writer and Woman Artist Clash on Propaganda and Its Uses." *New York World,* Mar. 16, 1930.

O'Brien, Frances. "Americans We Like: Georgia O'Keeffe." *The Nation,* Oct. 12, 1927.

"O'Keefe [*sic*] Craze in Art Circle, Says McIntire, Is Great." *Canyon Prairie,* Nov. 26, 1929.

O'Keeffe, Georgia. "Alfred Stieglitz: His Pictures Collected Him." *New York Times Magazine,* Dec. 11, 1949.

———. "Can a Photograph Have the Significance of Art?" *MSS,* Dec. 1922.

———. "Letter to the Art Editor." *New York Times,* Feb. 23, 1941.

"Old and New Works by Georgia O'Keeffe." *New York Herald Tribune,* Jan. 15, 1933.

Plagens, Peter. "A Georgia O'Keeffe Retrospective in Texas." *Artforum,* May 1966.

Pollitzer, Anita. "That's Georgia!" *Saturday Review,* Nov. 4, 1950.

Read, Helen Appleton. "Georgia's O'Keeffe—Woman Artist Whose Art Is Sincerely Feminine." *Brooklyn Eagle,* Mar. 2, 1924.

Rose, Barbara. "Georgia O'Keeffe, 1887–1986." *Vogue,* May 1986.

———. "The Great Big Little Paintings of Georgia O'Keeffe." *House & Garden,* Dec. 1987.

———. "O'Keeffe's Trails." *New York Review of Books,* Mar. 31, 1977.

Rosenfeld, Paul. "American Paintings." *The Dial,* Dec. 1921.

———. "The Paintings of Georgia O'Keeffe." *Vanity Fair,* Oct. 1922.

Rutter, Bernice. "Sun Prairie Sisters' Art Exhibited Here." *Wisconsin State Journal,* Jan. 22, 1933.

Sabine, Lillian. "Record Price for Living Artist." *Brooklyn Eagle Sunday Magazine,* May 27, 1928.

Schwartz, Sanford. "Georgia O'Keeffe Writes a Book." *The New Yorker,* Aug. 28, 1978.

Seiberling, Dorothy. "Horizons of a Pioneer." *Life,* Mar. 1, 1968.

"Should the American Art Student go Abroad." *Creative Art,* Jan. 1928.

Stevens, Mark. "The Gift of Spiritual Intensity." *Newsweek,* Mar. 17, 1986.

Strand, Paul. "Georgia O'Keeffe." *Playboy,* July 1924.

Tomkins, Calvin. "Look to the Things Around You." *The New Yorker,* Sept. 16, 1974.

———. "The Rose in the Eye Looked Pretty Fine." *The New Yorker,* Mar. 4, 1974.

Tryk, Sheila. "O'Keeffe." *New Mexico,* Jan.–Feb. 1973.

Warhol, Andy. "Georgia O'Keeffe and Juan Hamilton." *Interview,* Sept. 1983.

Watson, Ernest. "Georgia O'Keeffe." *American Artist,* June 1943.

West Texas State Normal College. *Bulletin: Catalogue 1915–1916* and *Courses of Study 1916–1917.*

Willard, Charlotte. "Georgia O'Keeffe." *Art in America,* Oct. 1963.

Wilson, Edmund. "The Stieglitz Exhibition." *New Republic,* Mar. 18, 1925.

———. "Wanted: A City of the Spirit." *Vanity Fair,* Jan. 1924.

Winn, Marcia. "Front Views and Profiles." *Chicago Daily Tribune,* Jan. 22, 1943.

———. "Georgia O'Keeffe: Outstanding Artist." *Chicago Sunday Tribune,* Feb. 28, 1943.

Winsten, Archer. "Georgia O'Keeffe Tries to Begin Again in Bermuda." *New York Post,* Mar. 19, 1934.

Zito, Tom. "Georgia O'Keeffe." *Washington Post,* Nov. 9, 1977.

Books

Adams, Ansel. *Ansel Adams: An Autobiography.* Boston: New York Graphic Society/Little, Brown, 1985.

Alinder, Mary Street and Andrea Gray Stillman, eds. *Ansel Adams: Letters and Images, 1916–1984.* Boston: Little, Brown, 1988.

Bachelard, Gaston. *The Poetics of Space.* Boston: Beacon Press, 1969.

Bell, Clive. *Art.* New York, 1913.

Berger, Margaret Liebman. *Aline Meyer Liebman: Pioneer Collector and Artist.* New York: W. F. Humphrey Press, 1982.

Brown, Milton, et al. *American Art.* New York: Abrams, 1979.

Bry, Doris. *Alfred Stieglitz: Photographer.* Boston: New York Graphic Society, 1965.

Castro, Jan Garden. *The Art and Life of Georgia O'Keeffe.* New York: Crown, 1985.

Cheney, Sheldon. *A Primer of Modern Art.* New York: Boni & Liveright, 1924.

Chodorow, Nancy. *The Reproduction of Mothering: Psychoanalysis and the Sociology of Gender.* Berkeley: University of California Press, 1978.

Cowart, Jack, Juan Hamilton, and Sarah Greenough, *Georgia O'Keeffe: Art and Letters.* Washington and Boston: New York Graphic Society/Little, Brown, 1987.

Dijkstra, Bram. *Idols of Perversity.* New York: Oxford University Press, 1986.

Dow, Arthur. *Composition.* Garden City, New York, 1913.

Eldredge, Charles, Julie Schimmel, and William H. Truettner. *Art in New Mexico.* New York: Abbeville, 1986.

Eliot, Alexander. *Three Hundred Years of American Painting.* New York: Time-Life, 1957.

Foster, Joseph. *D. H. Lawrence in Taos.* Albuquerque: University of New Mexico Press, 1972.

Frank, Waldo. *Our America.* New York: Boni & Liveright, 1919.

———. *Time Exposures.* New York: Boni & Liveright, 1926.

Gallup, Donald. *Pigeons on the Granite.* New Haven and London: Beinecke Rare Book and Manuscript Library, distributed by Yale University Press, 1988.

Gilbert, Sandra, and Susan Gubar. *The Madwoman in the Attic.* New Haven and London: Yale University Press, 1979.

———. *No Man's Land: The Place of the Woman Writer in the Twentieth Century.* New Haven and London: Yale University Press, 1988.

Gilman, Charlotte Perkins. *Herland.* New York: Pantheon, 1979.

———. *The Yellow Wallpaper.* New York: Feminist Press, 1973.

Goodrich, Lloyd, and Doris Bry. *Georgia O'Keeffe: Retrospective Exhibition.* New York: Whitney Museum of American Art, 1970.

Goodyear, Frank. *Cecilia Beaux*. Philadelphia: Pennsylvania Academy of the Fine Arts, 1974.

Green, Jonathan. *Camera Work: A Critical Anthology*. Millerton, New York: Aperture, 1973.

Greenough, Sarah, and Juan Hamiliton. *Alfred Stieglitz: Photographs and Writings*. Washington: National Gallery of Art, 1983.

Hahn, Emily. *Mabel: A Biography of Mabel Dodge Luhan*. Boston: Houghton Mifflin, 1977.

Hapgood, Hutchins. *Victorian in the Modern World*. New York: Harcourt, Brace, 1939.

Hartley, Marsden. *Adventures in the Arts*. New York: Hacker, 1972.

Haskell, Barbara. *Arthur Dove*. San Francisco: New York Graphic Society, 1974.

———. *Charles Demuth*. New York: Whitney Museum of American Art/Abrams, 1987.

———. *Georgia O'Keeffe: Works on Paper*. Santa Fe: Museum of New Mexico Press, 1985.

Heilbrun, Carolyn G. *Writing a Woman's Life*. New York: Norton, 1988.

Hignett, Sean. *Brett: From Bloomsbury to New Mexico*. New York: Franklin Watts, 1983.

Hills, Patricia. *Turn-of-the-Century America*. New York: Whitney Museum of American Art, 1977.

Hoffman, Katherine. *An Enduring Spirit: The Art of Georgia O'Keeffe*. Metuchen, N.J.: Scarecrow Press, 1984.

Homer, William Innes. *Alfred Stieglitz and the Americann Avant Garde*. Boston, New York Graphic Society, 1977.

Homer, William Innes. *Alfred Stieglitz and the Photo-Secession*. Boston: New York Graphic Society, 1983.

Kandinsky, Wassily. *Concerning the Spiritual in Art*. New York: Dover, 1977.

Kerman, Cynthia Earl, and Richard Eldridge. *The Lives of Jean Toomer*. Baton Rouge and London: Louisiana State University Press, 1987.

Kuh, Katherine. *The Artist's Voice*. New York: Harper & Row, 1962.

Lisle, Laurie. *Portrait of an Artist: A Biography of Georgia O'Keeffe*. Albuquerque: University of New Mexico Press, 1986.

Lowe, Sue Davidson. *Stieglitz: A Memoir/Biography*. New York: Farrar, Straus & Giroux, 1983.

Mellquist, Jerome. *The Emergence of an American Art*. New York: Scribner, 1942.

Mollenhoff, David V. *Madison: A Short History of the Formative Years*. Dubuque: Kendall/Hunt, 1984.

Morgan, Ann Lee. *Arthur Dove: Life and Work*. Introduction by Roxana Barry (Robinson). Newark: University of Delaware Press, 1984.

Mumford, Lewis. *Findings and Keepings*. New York: Harcourt, Brace, 1975.

Nordness, Lee, ed. *Art USA Now*, vol. 1. "Georgia O'Keeffe." Lucerne, Switz.: C. J. Bucher, 1962.

Norman, Dorothy. *Alfred Stieglitz: An American Seer*. New York: Random House, 1960.

————. *Encounters*. New York: Harcourt Brace Jovanovich, 1987.

Nussbaum, Rosemary. *Tierra Dulce: Reminiscences from the Jesse Nussbaum Papers.* Santa Fe: New Mexico, 1980.

O'Brien, Sharon. *Willa Cather: The Emerging Voice*. New York: Oxford University Press, 1987.

Georgia O'Keeffe: A Portrait by Alfred Stieglitz. Introduction by Georgia O'Keeffe. New York: Metropolitan Museum of Art, 1978.

O'Keeffe, Georgia. *Georgia O'Keeffe*. New York: Viking, 1976.

————. *Some Memories of Drawings*, edited by Doris Bry. Albuquerque: University of New Mexico Press, 1988.

Pack, Arthur. *The Ghost Ranch Story*. Board of Christian Education of the Presbyterian Church, 1960.

Peters, Sarah Whitaker. "Georgia O'Keeffe and Photography: Her Formative Years." Ph.D diss., City University of New York, 1987.

Pisano, Ron. *William Merritt Chase*. New York: Watson-Guptill, 1986.

Pollitzer, Anita. *A Woman on Paper: Georgia O'Keeffe*. New York: Simon & Schuster, 1988.

Rubenstein, Meridel. *The Circles and the Symmetry*. Master's thesis, University of New Mexico, Albuquerque, 1977.

Seligmann, Herbert J. *Alfred Stieglitz Talking*. New Haven: Yale University Press, 1966.

Szeplaki, Joseph. *The Hungarians in America*. Dobbs Ferry, N.Y.: Oceana, 1975.

Weigle, Marta, and Kyle Fiore. *Santa Fe and Taos: The Writer's Era, 1916–1941.* Santa Fe: Ancient City Press, 1982.

Wilson, Edmund. *The Thirties*, edited by Leon Edel. New York: Farrar, Straus, 1975.

————. *The Twenties*, edited by Leon Edel. New York: Farrar, Straus, 1975.

INDEX

ILLUSTRATIONS: SOURCES AND CREDITS

Unless otherwise noted, each photograph is copyrighted by its owner.

Section One

1. Courtesy of Catherine Krueger.
2. Courtesy of Catherine Krueger.
3. Courtesy of Brother Carl Tiedt.
4. Courtesy of Catherine Krueger.
5. Georgia O'Keeffe, "My Auntie"; Museum of Fine Arts, Museum of New Mexico. From the Estate of Claudia O'Keeffe, 1988.
6. Courtesy of Catherine Krueger.
7. Iconographic Collection, State Historical Society of Wisconsin.
8. Roger Burlingame, New York.
9. Courtesy of Catherine Krueger.
10. Courtesy of Catherine Krueger.
11. Courtesy of Catherine Krueger.
12. Courtesy of Catherine Krueger.
13. Courtesy of Catherine Krueger.
14. Courtesy of Catherine Krueger.
15. Courtesy of Catherine Krueger.
16. Chatham Hall, Chatham, Virginia.
17. Graduation program and photo courtesy of Catherine Krueger.
18. Courtesy of Catherine Krueger.
19. Courtesy of Catherine Krueger.
20. Frances Hallam Hurt, Chatham, Virginia.
21. William Thomas Smedley, 1891; courtesy of The Granger Collection, New York.
22. Special Collections, Milbank Memorial Library. Teachers College, Columbia University, New York.
23. Courtesy of William Pollitzer.
24. Georgia O'Keeffe, *Lady with Red Hair (Portrait of Dorothy True, 1915?)*, courtesy of Gerald Peters Gallery, Santa Fe, New Mexico.
25. Alfred Stieglitz; Collection of American Literature, Beinecke Library, Yale University.
26. Alfred Stieglitz; The Granger Collection, New York.
27. Courtesy of the family of Arthur W. Macmahon.
28. Rufus Holsinger, "Miss Georgia O'Keeffe, July 19, 1915"; Holsinger Studio Collection, University of Virginia Library.
29. Arthur W. Macmahon; photograph courtesy of his family.
30. Arthur W. Macmahon; photograph courtesy of his family.
31. Georgia O'Keeffe, *Special, No. 13, 1915*; The Metropolitan Museum of Art, Alfred Stieglitz Collection, 1950.
32. Courtesy of the Panhandle-Plains Historical Museum, Canyon, Texas.

33. Courtesy of the Panhandle-Plains Historical Museum, Canyon, Texas.
34. Courtesy of the Panhandle-Plains Historical Museum, Canyon, Texas.
35. Courtesy of Catherine Krueger.
36. Courtesy of Catherine Krueger.
37. Alfred Stieglitz, "Portrait of Paul Strand, 1917," copyright © 1958, Aperture Foundation, Inc., Paul Strand Archive.
38. Courtesy of Catherine Krueger.
39. Alfred Stieglitz, "Self Portrait, ca. 1894," as published in Sue Davidson Lowe, *Stieglitz: A Memoir/Biography*. New York: Farrar, Straus & Giroux, 1983. Photograph courtesy of Sue Davidson Lowe.
40. Courtesy of Catherine Krueger.
41. Courtesy of the family of Alexis O'Keeffe.
42. Courtesy of Catherine Krueger.

Section Two

43. Alfred Stieglitz, "Lake George, 1932"; Collection of American Literature, Beinecke Library, Yale University.
44. Georgia O'Keeffe, *Corn, Dark I,* 1924; The Metropolitan Museum of Art, Alfred Stieglitz Collection, 1949.
45. Alfred Stieglitz, "Lake George, 1932"; The Cleveland Museum of Art, Gift of Cary Ross, 35.100.
46. Eduard Steichen, "Mrs. Steiglitz and Daughter" (Emmy and Kitty), 1904; The Metropolitan Museum of Art, Alfred Stieglitz Collection, 1933.
47. Alfred Stieglitz, "Family, Westchester, 1918" as published in Sue Davidson Lowe, *Stieglitz: A Memoir/Biography*. New York: Farrar, Straus & Giroux, 1983. Photograph courtesy of Sue Davidson Lowe. From left to right, standing: Elizabeth Stieglitz, Agnes Stieglitz Engelhard, George Herbert Engelhard, Alie Morling (a friend of Elizabeth), Selma Stieglitz Schubart, Hugh Grant Straus, Mary Steichen, Elizabeth Stieffel Stieglitz. Seated, chairs: Hedwig Stieglitz, Jacobine Sterck Stieffel. Seated, ground: Leopold Stieglitz, Georgia Engelhard, Flora Stieglitz Straus.
48. Alfred Stieglitz, "Kitty and Alfred Stieglitz, Oaklawn, 1908," as published in Sue Davidson Lowe, *Stieglitz: A Memoir/Biography*. New York: Farrar, Straus & Giroux, 1983. Photograph courtesy of Elizabeth Davidson Murray.
49. Georgia O'Keeffe, "Pattern of Leaves, c. 1923"; The Phillips Collection, Washington, D.C.
50. Alfred Stieglitz, "Elizabeth Stieglitz, the Farmhouse, 1917," as published in Sue Davidson Lowe, *Stieglitz: A Memoir/Biography*. New York: Farrar, Straus & Giroux, 1983. Photograph courtesy of Sue Davidson Lowe.
51. Paul Strand, "Rebecca, New York, c. 1922," copyright © 1976, Aperture Foundation, Inc., Paul Strand Archive.
52. Alfred Stieglitz (?), "Georgia and Ida, Lake George, c. 1925"; courtesy of Catherine Krueger.
53. Alfred Stieglitz, "John Marin," 1922, The Metropolitan Museum of Art, Alfred Stieglitz Collection.
54. Alfred Stieglitz, "Marsden Hartley," ca. 1915, The Metropolitan Museum of Art, Alfred Stieglitz Collection.
55. Alfred Stieglitz, "Charles Demuth," 1922, The Metropolitan Museum of Art, Alfred Stieglitz Collection.
56. Alfred Stieglitz, "Arthur Dove," 1915, photograph courtesy of William Dove.
57. Bob Davis, "Henry McBride, 1933"; photograph courtesy of Maximilian H. Miltzlaff.
58. Paul Strand, "Alfred Stieglitz, Lake George, New York, 1920," copyright © 1989, Aperture Foundation, Inc., Paul Strand Archive.
59. Alfred Stieglitz, "Breast and Hands," 1919; The Metropolitan Museum of Art, Alfred Stieglitz Collection.
60. Nancy Newhall, "Dorothy Norman," photograph from the collection of Beaumont Newhall.
61. Miguel Covarrubias, "The Lady of the Lilies: Georgia O'Keeffe," copyright 1929, 1957. Courtesy of The New Yorker Magazine, Inc.

62. Georgia O'Keeffe, *Black Iris III, 1926,* The Metropolitan Museum of Art, Alfred Stieglitz Collection.
63. Courtesy of Henriette Harris.
64. Collection of American Literature, Beinecke Library, Yale University.
65. Georgia O'Keeffe, *Black Cross, New Mexico, 1929,* oil on canvas, 99 x 77.2 cm, 1943.95, The Art Institute of Chicago, Art Institute Purchase Fund.
66. Alfred Stieglitz, "Equivalent," The Metropolitan Museum of Art, Alfred Stieglitz Collection.
67. Courtesy of the family of Alexis O'Keeffe.
68. Courtesy of the family of Alexis O'Keeffe.
69. UPI/Bettman Newsphotos.
70. Courtesy of the family of Marjorie Content Toomer.
71. Courtesy of Catherine Krueger.
72. Collection of American Literature, Beinecke Library, Yale University.
73. Front, left to right: Dr. Esther Loring Richards, Agnes de Mille, Dr. Lise Meitner, Ida A. R. Wylie, and Anne O'Hare McCormick. Rear, left to right: Margaret Webster, Georgia O'Keeffe, Ruth M. Leach, Margaret Cuthbert. From the *New York Times,* February 10, 1946. UPI/Bettman Newsphotos.
74. Ansel Adams, "Georgia O'Keeffe, 1937," courtesy of the Ansel Adams Publishing Rights Trust. All rights reserved.
75. Ansel Adams, "Georgia O'Keeffe, 1937," courtesy of the Ansel Adams Publishing Rights Trust. All rights reserved.
76. Ansel Adams, "Georgia O'Keeffe, 1937," courtesy of the Ansel Adams Publishing Rights Trust. All rights reserved.
77. Josephine B. Marks, "Georgia O'Keeffe and Alfred Stieglitz, Lake George, ca. 1938," as published in Sue Davidson Lowe, *Stieglitz: A Memoir/Biography.* New York: Farrar, Straus & Giroux, 1983. Photograph courtesy of Sue Davidson Lowe.
78. Georgia O'Keeffe, "Grey Hills," 1942, Indianapolis Museum of Art, Gift of Mr. and Mrs. James W. Fesler. Copyright © 1989.
79. Courtesy of *Town and Country* magazine, 1986.
80. Photograph courtesy of Maria Chabot.
81. Marjorie Content Toomer, "House at Ghost Ranch," courtesy of her family.
82. Marjorie Content Toomer, "Beau," courtesy of her family.
83. Courtesy of Catherine Krueger.
84. Courtesy of Catherine Krueger.
85. John Loengard/*Life* magazine. Copyright © 1966, Time Inc.
86. John Loengard/*Life* magazine. Copyright © 1966, Time Inc.
87. Basil Langton, copyright © 1971/Photo Researches.
88. John Loengard/*Life* magazine. Copyright © 1966, Time Inc.
89. Dan Budnik, copyright © 1979, Woodfin Camp.
90. Courtesy of Ogden Robertson, Hickey-Robertson, Photography, Houston.
91. Courtesy of Catherine Krueger.
92. Courtesy of Raymond Krueger.
93. Courtesy of Catherine Krueger.
94. Courtesy of June O'Keeffe Sebring.